Photoshop Elements 10

the missing manual[®]

The book that should have been in the box*

Barbara Brundage

Beijing | Cambridge | Farnham | Köln | Sebastopol | Tokyo

Photoshop Elements 10: The Missing Manual

by Barbara Brundage

Copyright © 2011 O'Reilly Media, Inc. All rights reserved.

Printed in Canada.

Published by O'Reilly Media, Inc., 1005 Gravenstein Highway North, Sebastopol, CA 95472.

O'Reilly Media books may be purchased for educational, business, or sales promotional use. Online editions are also available for most titles: *http://my.safaribooksonline.com*. For more information, contact our corporate/institutional sales department: 800-998-9938 or *corporate@oreilly.com*.

Printing History:

September 2011: First Edition.

Nutshell Handbook, the Nutshell Handbook logo, the O'Reilly logo, and "The book that should have been in the box" are registered trademarks of O'Reilly Media, Inc. *Photoshop Elements 10: The Missing Manual*, The Missing Manual logo, Pogue Press, and the Pogue Press logo are trademarks of O'Reilly Media, Inc.

Many of the designations used by manufacturers and sellers to distinguish their products are claimed as trademarks. Where those designations appear in this book, and O'Reilly Media, Inc. was aware of a trademark claim, the designations have been printed in caps or initial caps.

While every precaution has been taken in the preparation of this book, the publisher and authors assume no responsibility for errors or omissions, or for damages resulting from the use of the information contained herein.

ISBN: 9781449398507

[TI]

Table of Contents

The Missing Credits						•		•		•	•	•	•	•	•	•	X	iii
Introduction																		1

Part One: Introduction to Elements

hapter 1: Finding You	r	W	a	y /	Aı	ro	u	nd	E	le	m	le	nt	s														15
Getting Started				-																								
The Welcome Screen																												
Organizing Your Photos																												
Photo Downloader																												
Photoshop.com																												
Editing Your Photos																												
Panels, Bins, and Tabs																												
Elements' Tools																												
Getting Help																												
Escape Routes																												
Getting Started in a Hurry.	•	• •	·	•	•	·	•	• •		• •			• •		•	•		•		•		• •	•	·	·			
0																												
hapter 2: Importing, N	Nā	an	a	gi	nş	g,	aı	nd	S	a	vi	ng	F	Ph	0	to	S											41
hapter 2: Importing, N Importing from Cameras	Ma	an	a	gi	nş	g ,	a	nd	S	a	vi	ng	ş F	Ph	0	to	S	•	•	•	•	•			•	•	•	41 41
hapter 2: Importing, N Importing from Cameras The Photo Downloader.	Ma	an	a	gi	nş	g,	a	nd	S	a	vii	ng	5 F	Ph	0	to	S	•	•	•		•			•	•	•	41 41 42
hapter 2: Importing, N Importing from Cameras The Photo Downloader. Opening Stored Images	Ma	a n		gi	nş	g,	aı	nd 	S	a	vii	ng	; 	Ph	0	to	S	•	•	•		•			•	•	•	41 41 42 47
hapter 2: Importing, N Importing from Cameras The Photo Downloader. Opening Stored Images. Working with PDF Files.	Ma	a r i		gi	ng	g,	aı	nd 	S	a		ng	F	Ph	0	to	S	•	•	•	•	•				•	•	41 41 42 47 49
hapter 2: Importing, N Importing from Cameras The Photo Downloader. Opening Stored Images. Working with PDF Files. Scanning Photos.	Ma	ar i		gi	ng	g,	ai	nd	S		vi:	ng	F	Ph	0	to	S	•	•	•	•	• •				•	•	41 41 42 47 49 49
hapter 2: Importing, N Importing from Cameras The Photo Downloader. Opening Stored Images Working with PDF Files. Scanning Photos Capturing Video Frames	Na	an 		gi	ng	S ,	aı	nd	S		vi i	ng	; F	Ph	0	to	S	•	• • • • • •	•		• •				•	•	41 41 42 47 49 49 51
hapter 2: Importing, N Importing from Cameras The Photo Downloader. Opening Stored Images Working with PDF Files. Scanning Photos. Capturing Video Frames Creating a New File	Ma	ar 		gi	nş	B ,	a	nd	S			ng	, I	Ph		to	S	•	• • • • • • • •	• • • • • •		•				• • • • • • •	•	41 41 42 47 49 49 51 51
hapter 2: Importing, N Importing from Cameras The Photo Downloader. Opening Stored Images Working with PDF Files. Scanning Photos. Capturing Video Frames Creating a New File Picking a File Size.	Ma	a n 		gi	n §	5 ,	ai	nd	S			ng	, F 	Ph		to	S		• • • • • • • •	• • • • • • • •						• • • • • • • •	•	41 42 47 49 49 51 52 53
hapter 2: Importing, N Importing from Cameras The Photo Downloader. Opening Stored Images Working with PDF Files. Scanning Photos. Capturing Video Frames Creating a New File	Ma			gi	n g	B ,	a	nd	S		vi i	ng	F	Ph		to	S	• • • • • •	• • • • • • • • •	• • • • • • • •	• • •					• • • • • • • • •	•	41 41 42 47 49 51 51 52 53 53

Using the Organizer.								56
The Media Browser.								58
Creating Categories and Tags								61
Albums and Smart Albums.								66
Searching for Photos				•				68
Browsing Through Photos		÷						68
Using Tags and Categories to Find Photos								69
Searching by Metadata								70
Visual Searches								70
Saving Your Work		ž			÷			74
File Formats Elements Understands								75
Changing the File Format.								81
Backing Up Your Files								81
Online Syncing and Backups								82
Organizer Backups								83
Making Quick CDs/DVDs		÷						86
Chanter 7. Detating and Design Distant								~~
Chapter 3: Rotating and Resizing Photos	•	•		i i	•	•		89
Straightening Scanned Photos								89
Straightening Two or More Photos at a Time								89
Straightening Individual Photos								91
Rotating Images								91
Rotating and Flipping Options								93
Straightening the Contents of an Image								94
Straighten Tool								94
Free Rotate Layer								97
Cropping Pictures							·	99
the (rop lool								100
The Crop Tool.				•				104
Cropping with the Marquee Tool								106
Cropping with the Marquee Tool.								
Cropping with the Marquee Tool. Zooming and Repositioning Your View Image Views	•		•					107
Cropping with the Marquee Tool. Zooming and Repositioning Your View Image Views The Zoom Tool		•					÷	111
Cropping with the Marquee Tool. Zooming and Repositioning Your View Image Views The Zoom Tool The Hand Tool		•						111 113
Cropping with the Marquee Tool. Zooming and Repositioning Your View. Image Views The Zoom Tool The Hand Tool Changing the Size of an Image		•		•				111 113 114
Cropping with the Marquee Tool. Zooming and Repositioning Your View. Image Views The Zoom Tool. The Hand Tool Changing the Size of an Image. Resizing Images for Email and the Web		• • • •	· · · · · ·	· · ·	•			111 113 114 115
Cropping with the Marquee Tool. Zooming and Repositioning Your View. Image Views The Zoom Tool The Hand Tool Changing the Size of an Image		•	• • • • •	· · · · · · ·	• • • •	• • • •		111 113 114 115 119

Part Two: Elemental Elements

Chapter 4: The Quick Fix	127
The Quick Fix Window	128
The Quick Fix Toolbox	130
The Quick Fix Panel Bin	. 131
Different Views: After vs. Before and After.	132

Editing Your Photos			 							132
Fixing Red Eye			 					 e - 2		133
Smart Fix			 					 		135
Adjusting Lighting and Contrast			 							138
Color			 							140
Sharpening			 							142
Touch-Ups										143
Quick Fix Suggested Workflow										146
Adjusting Skin Tones										147
Chapter 5: Making Selections										151
Selecting Everything										152
Selecting Rectangular and Elliptical Areas										153
Selecting Irregularly Sized Areas										155
Controlling the Selection Tools										155
Selecting with a Brush										156
Refine Edge			 		• •					159
The Selection Brush			 . ,							160
The Magic Wand			 							163
The Lasso Tools			 							166
Removing Objects from an Image's Background	d		 							169
Changing and Moving Selections			 					 		 175
Inverting a Selection			 							 175
Making a Selection Larger or Smaller			 							 177
Moving Selected Areas			 						. 1	 179
Saving Selections			 							182
Chamber C. Louise The Heart of Flor		40								105
Chapter 6: Layers: The Heart of Eler										
Understanding Layers.										186
The Layers Panel										188
The Background										190
Creating Layers										
Adding a Layer										192
Deleting Layers										193
Duplicating a Layer										193
Copying and Cutting from Layers										194
Managing Layers			 	• •		· ·	• •	 ÷	· ·	196
Hiding Layers										196
Adjusting Layer Opacity			 • •		• •					 197
Locking Layers			 			r 7				198
Blend Mode.			 					 ÷	1	199
Rearranging Layers			 							200
Aligning and Distributing Layers			 							203
Grouping and Linking Layers.			 							204
Merging and Flattening Layers			 					 i i		208
Layer Masks			 							 211

Adjustment and Fill Layers				 							 	216
Adding Fill and Adjustment Layers.												
Moving Objects Between Images						 						220

Part Three: Retouching

Chapter 7: Basic Image Retouching	 227
Fixing Exposure Problems.	 228
Deciding Which Exposure Fix to Use	 228
Fixing Major Exposure Problems	 229
The Shadows/Highlights Command	 . 231
Correcting Part of an Image	 233
Controlling the Colors You See	 237
Calibrating Your Monitor	 239
Choosing a Color Space	 241
Using Levels	 244
Understanding the Histogram	 245
Adjusting Levels: The Eyedropper Method	 247
Adjusting Levels: The Slider Controls	
Removing Unwanted Color	 . 251
The Remove Color Cast Command	
Using Color Variations	 253
Choosing Colors.	
The Color Picker	 256
The Eyedropper Tool	
The Color Swatches Panel	 259
Sharpening Images	 260
Unsharp Mask	 261
Adjust Sharpness	 263
The High-Pass Filter	 265
The Sharpen Tool.	 268
Chapter 8: Elements for Digital Photographers.	
The Raw Converter	
Using the Raw Converter	
Adjusting White Balance	
Adjusting Tone	
Adjusting Vibrance and Saturation	
Adjusting Sharpness and Reducing Noise	
Finishing Up	
Converting to DNG	
Blending Exposures	
Automatic Merges	
Manual Merges.	
Photo Filter	 297

Processing Multiple Files Choosing Files Renaming Files Changing Image Size and File Type Applying Quick Fix Commands. Attaching Labels	. 300 . 301 . 302 . 303
Chapter 9: Retouching: Fine-Tuning Images.	. 307
Fixing Blemishes.	. 307
The Spot Healing Brush: Fixing Small Areas	
The Healing Brush: Fixing Larger Areas	
The Clone Stamp	
Applying Patterns	
The Healing Brush	
The Pattern Stamp	
Recomposing Photos	
Color Curves: Enhancing Tone and Contrast	
Making Colors More Vibrant	
The Hue/Saturation Dialog Box	
Adjusting Saturation with the Sponge Tool	
Changing an Object's Color.	
Using an Adjustment Layer.	
The Color Penlacement Teel	330
The Color Replacement Tool	
Special Effects	. 341
Special Effects Chapter 10: Removing and Adding Color	. 341 . 345
Special Effects Chapter 10: Removing and Adding Color Method One: Making Color Photos Black and White	341 . 345 . 345
Special Effects Chapter 10: Removing and Adding Color Method One: Making Color Photos Black and White Method Two: Removing Color from a Photo	341 . 345 . 345 . 348
Special Effects Chapter 10: Removing and Adding Color Method One: Making Color Photos Black and White Method Two: Removing Color from a Photo Creating Spot Color	341 . 345 . 345 . 348 . 350
Special Effects Chapter 10: Removing and Adding Color Method One: Making Color Photos Black and White Method Two: Removing Color from a Photo Creating Spot Color Brushing Away Color.	341 345 345 348 350 351
Special Effects Chapter 10: Removing and Adding Color Method One: Making Color Photos Black and White Method Two: Removing Color from a Photo Creating Spot Color Brushing Away Color Erasing Colors from a Duplicate Layer.	341 345 345 348 350 351 353
Special Effects Chapter 10: Removing and Adding Color Method One: Making Color Photos Black and White Method Two: Removing Color from a Photo Creating Spot Color Brushing Away Color Erasing Colors from a Duplicate Layer Removing Color from Selections	341 . 345 . 345 . 348 . 350 . 351 . 353 . 353
Special Effects Chapter 10: Removing and Adding Color Method One: Making Color Photos Black and White Method Two: Removing Color from a Photo Creating Spot Color Brushing Away Color. Erasing Colors from a Duplicate Layer. Removing Color from Selections. Using an Adjustment Layer and the Saturation Slider.	341 345 345 348 350 351 353 353 354
Special Effects Chapter 10: Removing and Adding Color Method One: Making Color Photos Black and White Method Two: Removing Color from a Photo Creating Spot Color Brushing Away Color Erasing Colors from a Duplicate Layer. Removing Color from Selections Using an Adjustment Layer and the Saturation Slider. Colorizing Black-and-White Photos.	341 345 345 348 350 351 353 353 354 356
Special Effects Chapter 10: Removing and Adding Color Method One: Making Color Photos Black and White Method Two: Removing Color from a Photo Creating Spot Color Brushing Away Color. Erasing Colors from a Duplicate Layer. Removing Color from Selections. Using an Adjustment Layer and the Saturation Slider.	341 345 345 348 350 351 353 353 354 356
Special Effects Chapter 10: Removing and Adding Color Method One: Making Color Photos Black and White Method Two: Removing Color from a Photo Creating Spot Color Brushing Away Color Erasing Colors from a Duplicate Layer. Removing Color from Selections Using an Adjustment Layer and the Saturation Slider. Colorizing Black-and-White Photos.	341 345 345 348 350 351 353 353 354 356
Special Effects Chapter 10: Removing and Adding Color Method One: Making Color Photos Black and White Method Two: Removing Color from a Photo Creating Spot Color Brushing Away Color Erasing Colors from a Duplicate Layer. Removing Color from Selections. Using an Adjustment Layer and the Saturation Slider. Colorizing Black-and-White Photos. Tinting a Whole Photo	341 345 345 348 350 351 353 353 354 356 358
Special Effects Chapter 10: Removing and Adding Color Method One: Making Color Photos Black and White Method Two: Removing Color from a Photo Creating Spot Color Brushing Away Color Erasing Colors from a Duplicate Layer Removing Color from Selections Using an Adjustment Layer and the Saturation Slider. Colorizing Black-and-White Photos. Tinting a Whole Photo Chapter 11: Photomerge: Creating Panoramas, Group Shots,	341 345 345 348 350 351 353 353 354 356 358 366
Special Effects Chapter 10: Removing and Adding Color Method One: Making Color Photos Black and White Method Two: Removing Color from a Photo Creating Spot Color Brushing Away Color Erasing Colors from a Duplicate Layer Removing Color from Selections. Using an Adjustment Layer and the Saturation Slider. Colorizing Black-and-White Photos Tinting a Whole Photo Chapter 11: Photomerge: Creating Panoramas, Group Shots, and More	341 345 345 348 350 351 353 353 354 356 358 358 366
Special Effects Chapter 10: Removing and Adding Color Method One: Making Color Photos Black and White Method Two: Removing Color from a Photo Creating Spot Color Brushing Away Color. Erasing Colors from a Duplicate Layer. Removing Color from Selections. Using an Adjustment Layer and the Saturation Slider. Colorizing Black-and-White Photos. Tinting a Whole Photo Chapter 11: Photomerge: Creating Panoramas, Group Shots, and More Creating Panoramas Manual Positioning with Interactive Layout Merging Different Faces.	341 345 345 348 350 351 353 353 354 356 358 358 366 371 373
Special Effects Chapter 10: Removing and Adding Color Method One: Making Color Photos Black and White Method Two: Removing Color from a Photo Creating Spot Color Brushing Away Color. Erasing Colors from a Duplicate Layer. Removing Color from Selections. Using an Adjustment Layer and the Saturation Slider. Colorizing Black-and-White Photos. Tinting a Whole Photo Chapter 11: Photomerge: Creating Panoramas, Group Shots, and More. Creating Panoramas Manual Positioning with Interactive Layout Merging Different Faces. Arranging a Group Shot.	341 345 345 348 350 351 353 353 354 356 358 366 371 373 376
Special Effects Chapter 10: Removing and Adding Color Method One: Making Color Photos Black and White Method Two: Removing Color from a Photo Creating Spot Color Brushing Away Color Erasing Colors from a Duplicate Layer. Removing Color from Selections. Using an Adjustment Layer and the Saturation Slider. Colorizing Black-and-White Photos. Tinting a Whole Photo Chapter 11: Photomerge: Creating Panoramas, Group Shots, and More Creating Panoramas Manual Positioning with Interactive Layout Merging Different Faces. Arranging a Group Shot. Tidying Up with Scene Cleaner	341 345 345 348 350 351 353 353 354 356 358 366 371 373 376 377
Special Effects Chapter 10: Removing and Adding Color Method One: Making Color Photos Black and White Method Two: Removing Color from a Photo Creating Spot Color Brushing Away Color. Erasing Colors from a Duplicate Layer. Removing Color from Selections. Using an Adjustment Layer and the Saturation Slider. Colorizing Black-and-White Photos. Tinting a Whole Photo Chapter 11: Photomerge: Creating Panoramas, Group Shots, and More. Creating Panoramas Manual Positioning with Interactive Layout Merging Different Faces. Arranging a Group Shot. Tidying Up with Scene Cleaner Merging Styles.	 341 345 345 348 350 351 353 354 356 358 366 371 373 376 377 379
Special Effects Chapter 10: Removing and Adding Color Method One: Making Color Photos Black and White Method Two: Removing Color from a Photo Creating Spot Color Brushing Away Color Erasing Colors from a Duplicate Layer. Removing Color from Selections. Using an Adjustment Layer and the Saturation Slider. Colorizing Black-and-White Photos. Tinting a Whole Photo Chapter 11: Photomerge: Creating Panoramas, Group Shots, and More Creating Panoramas Manual Positioning with Interactive Layout Merging Different Faces. Arranging a Group Shot. Tidying Up with Scene Cleaner	 341 345 345 348 350 351 353 354 356 358 366 371 373 376 377 379

Transforming Images	 	÷										389
Skew, Distort, and Perspective												
Free Transform												393

Part Four: Artistic Elements

Chapter 12: Drawing with Brushes, Shapes, and (397
Picking and Using a Basic Brush		 	399
Modifying Your Brush		 	403
Saving Modified Brush Settings		 	405
The Specialty Brushes.		 	406
Making a Custom Brush		 	407
The Impressionist Brush			408
The Pencil Tool			408
The Paint Bucket		 	409
Dodging and Burning		 	. 410
Dodging.		 	. 412
Burning		 	. 413
Blending and Smudging		 	. 413
Blend Modes		 	. 413
The Smudge Tool		 	. 416
The Eraser Tool		 	. 418
Using the Eraser			
The Magic Eraser			. 419
The Background Eraser.		 	420
Drawing with Shapes		 	422
Rectangle and Rounded Rectangle.			424
Ellipse			425
Polygon			425
Line Tool			427
The Custom Shape Tool		 	428
The Shape Selection Tool			429
The Cookie Cutter Tool		 	430
Chapter 13: Filters, Effects, Layer Styles, and Grad	dianta		433
Using Filters			435
Applying Filters			435
Filter Categories			435
Useful Filter Solutions		 	439
Adding Effects			441
Using Actions			450
Special Effects in Guided Edit			452
Adding Layer Styles			456
0-1-01.00		 	150

Applying Gradients				 									 . x				460
The Gradient Tool				 		 ÷				÷							461
Gradient Fill Layers				 													463
Editing Gradients																	465
Saving Gradients				 													470
Gradient Maps		 ÷		 		 ł											470
Chapter 14: Text in Elemen	nts .		 														473
Adding Text to an Image																	474
Text Options				 													475
Creating Text																	478
Editing Text																	480
Warping Text				 													482
Adding Special Effects																	485
Text Effects				 									 				485
Text Gradients.					 ÷			·				·	 				486
Applying the Liquify Filter to	Text											ł					487
Type Masks: Setting an Image in	Text.			 •					÷				 				490
Using the Type Mask Tools .																	491
Creating Outlined Text					 ł.			÷		·	·	·	 		·	·	492
Artistic Text														•	·		495
Adding Text to a Selection								·				÷	 	•		÷	496
Making Text Outline a Shape																	498
Creating Your Own Path		 											 			÷	500

Part Five: Sharing Images

Chapter 15: Creating Projects	05
Photo Collages	505
Customizing Your Project.	510
Creating Multipage Documents in the Editor	515
Photo Books.	517
Greeting Cards	520
Photo Calendars.	520
CD/DVD Jackets	521
CD/DVD Labels	521
Photo Stamps	522
Working with the Content and Favorites Panels	522
The Content Panel	522
The Favorites Panel.	524

Chapter 16: Printing Photos	525
Getting Ready to Print.	526
Ordering Prints	526
Printing at Home	530
Making Individual Prints	530
Positioning Your Image.	536
Additional Print Options	539
Color Management.	540
Printing Multiple Images (Windows)	543
Contact Sheets	544
Picture Packages	545
Printing Multiple Images (Mac).	546
Contact Sheets	547
Picture Packages	549
Chapter 17: Email and the Web	
Image Formats and the Web	553
Saving Images for the Web or Email	554
Using Save For Web	556
Previewing Images and Adjusting Color	559
Creating Animated GIFs.	561
Emailing Photos	563
Individual Attachments (Mac and Windows)	564
Photo Mail (Windows only)	566
PDF Slideshows (Mac and Windows)	568
Chapter 18: Online Albums and Slideshows.	571
Online Albums	
Sharing a New Album	572 572
Other Ways to Share	
Other Ways to Share	575
	576
Full Screen View	577
PDF Slideshows	579
The Slide Show Editor (Windows only)	580
Flipbooks (Windows only)	591
A Few More Ways to Share	594

Part Six: Additional Elements

Chapter 19: Beyond the Basics.	599
Graphics Tablets.	599
Stuff from the Internet	602
When You Really Need Photoshop	604
Beyond This Book.	605

Part Seven: Appendix

Appendix A: Installation and	Troubleshooting .							3							60)9
------------------------------	-------------------	--	--	--	--	--	--	---	--	--	--	--	--	--	----	----

Note: Head to this book's Missing CD page on *www.missingmanuals.com* to download two more appendixes: "The Organizer, Menu by Menu" and "The Editor, Menu by Menu."

The Missing Credits

About the Author

Barbara Brundage is the author of *Photoshop Elements 9: The Missing Manual*, an Adobe Community Expert, and a member of Adobe's prerelease groups for Elements 3–10. She's been teaching people how to use Photoshop Elements since it came out in 2001. Barbara first started using Elements to create graphics for use in her day job as a harpist, music publisher, and arranger. Along the way, she joined the large group of people finding a renewed interest in photography thanks to digital cameras. If she can learn to

use Elements, you can, too! You can reach her at *barb@barbarabrundage.com* and read her blog at *www.barbarabrundage.com* (sometimes it's even about Photoshop Elements).

About the Creative Team

Dawn Mann (editor) is associate editor for the Missing Manual series. When not working, she beads, hangs out with her cat, and causes trouble. Email: *dawn@oreilly.com*.

Kristen Borg (production editor) is a graduate of the publishing program at Emerson College. Now living in Boston, she originally hails from sunny Arizona, and considers New England winters an adequate trade for no longer finding scorpions in her hairdryer.

Sara Froehlich (tech reviewer) has been in love with computer graphics and digital photography since she discovered them in 1995, and has been teaching online classes in Photoshop Elements since its first release. (You can see her classes at *www. lvsonline.com.*) She's also the author of *Microsoft Expression Design Step by Step.* Sara enjoys traveling with her husband, Tom, and their papillon, Jasmine, and is especially fond of Florida, where she can get away from Minnesota winters! Website: *www.northlite.net.* Email: *northie@hickorytech.net.*

Carla Spoon (proofreader) is a freelance writer and copy editor. An avid runner, she works and feeds her tech gadget addiction from her home office in the shadow of Mount Rainier. Email: *carla_spoon@comcast.net*.

Julie Hawks (indexer) is an indexer for the Missing Manual series. She is currently pursuing a master's degree in Religious Studies while discovering the joys of warm winters in the Carolinas. Email: *juliehawks@gmail.com*.

Acknowledgments

Many thanks to Sara Froelich and Ray Robillard for reading this book and giving me the benefit of their advice and corrections. I'm also grateful for the help I received from everyone at Adobe, especially Bob Gager, P. Ram Prasad, Priyanka Azad, Deepak Sawant, Krishna Singh Karki, and Chhaya Pandey.

Special thanks also to graphic artist Jodi Frye (*lfrye012000@yahoo.com*) for allowing me to reproduce one of her Elements drawings to show what can be done by those with more artistic ability than I have. My gratitude also to Florida's botanical gardens, especially McKee Botanical Garden (*www.mckeegarden.org*), Historic Bok Sanctuary (*www.boktower.org*), Heathcote Botanical Gardens (*www.heathcotebotanicalgardens.org*), and Harry P. Leu Gardens (*www.leugardens.org*) for creating oases of peace and beauty in our hectic world. Finally, I'd like to thank everyone in the gang over at the Adobe Photoshop Elements support forum for all their help and friendship.

The Missing Manual Series

Missing Manuals are witty, superbly written guides to computer products that don't come with printed manuals (which is just about all of them). Each book features a handcrafted index and cross-references to specific pages (not just chapters).

Access 2010: The Missing Manual by Matthew MacDonald

Buying a Home: The Missing Manual by Nancy Conner

CSS: The Missing Manual, Second Edition, by David Sawyer McFarland

Creating a Website: The Missing Manual, Third Edition, by Matthew MacDonald

David Pogue's Digital Photography: The Missing Manual by David Pogue

Dreamweaver CS5.5: The Missing Manual by David Sawyer McFarland

Credits

Droid X: The Missing Manual by Preston Gralla Droid X2: The Missing Manual by Preston Gralla Excel 2010: The Missing Manual by Matthew MacDonald *Facebook: The Missing Manual, Third Edition* by E.A. Vander Veer FileMaker Pro 11: The Missing Manual by Susan Prosser and Stuart Gripman Flash CS5.5: The Missing Manual by Chris Grover Google Apps: The Missing Manual by Nancy Conner *Google SketchUp: The Missing Manual* by Chris Grover iMovie '11 & iDVD: The Missing Manual by David Pogue and Aaron Miller *iPad 2: The Missing Manual* by J.D. Biersdorfer iPhone: The Missing Manual, Fourth Edition by David Pogue *iPhone App Development: The Missing Manual* by Craig Hockenberry *iPhoto '11: The Missing Manual* by David Pogue and Lesa Snider iPod: The Missing Manual, Ninth Edition by J.D. Biersdorfer and David Pogue JavaScript: The Missing Manual by David Sawyer McFarland *Living Green: The Missing Manual* by Nancy Conner Mac OS X Snow Leopard: The Missing Manual by David Pogue Microsoft Project 2010: The Missing Manual by Bonnie Biafore Motorola Xoom: The Missing Manual by Preston Gralla Netbooks: The Missing Manual by J.D. Biersdorfer Office 2010: The Missing Manual by Nancy Connor, Chris Grover, and Matthew MacDonald Office 2011 for Macintosh: The Missing Manual by Chris Grover Palm Pre: The Missing Manual by Ed Baig Personal Investing: The Missing Manual by Bonnie Biafore Photoshop CS5: The Missing Manual by Lesa Snider Photoshop Elements 9: The Missing Manual by Barbara Brundage PowerPoint 2007: The Missing Manual by E.A. Vander Veer Premiere Elements 8: The Missing Manual by Chris Grover QuickBase: The Missing Manual by Nancy Conner

QuickBooks 2011: The Missing Manual by Bonnie Biafore Quicken 2009: The Missing Manual by Bonnie Biafore Switching to the Mac: The Missing Manual, Snow Leopard Edition by David Pogue Wikipedia: The Missing Manual by John Broughton Windows 7: The Missing Manual by David Pogue Word 2007: The Missing Manual by Chris Grover Your Body: The Missing Manual by Matthew MacDonald Your Brain: The Missing Manual by Matthew MacDonald Your Money: The Missing Manual by J.D. Roth

Introduction

It's a visual world these days. Want your Facebook friends to see what you're having for lunch? Post a picture. Need an extra whatchamacallit from the hardware store? Just show them a photo. It's just so much easier than trying to describe such things with words. *Everybody* has a digital camera now. Most likely, even your cellphone is a pretty competent little camera. But there are two problems with all this photo-y goodness: People's expectations of photos are pretty high now, and keeping track of so many images can be a nightmare that may make you long for the days when all your family photos fit in one shoebox.

Enter Photoshop Elements. Not only does Elements 10 give you terrific tools for editing and improving your photos, but you also get a free account at Photoshop.com, making it incredibly easy to share photos on your personal Photoshop.com web page, back them up automatically, *and* sync them between your computers.

Note: For now, you have to be in the United States to use Photoshop.com. If you're in another country, you can create and share online albums at Adobe's Photoshop Showcase (*www.photoshopshowcase.com*), a site first created for folks using Elements 6. Alas, a few features are available only with Photoshop.com, so for now, these features are U.S.-only.

Elements also includes a great photo organizer (aptly named the Organizer), which used to be available only in the Windows version of Elements, but now Mac folks get it, too. And since more and more people are using a mix of Windows computers and Macs, as long as you buy the boxed version (not the download) you can install the same copy of Elements 10 on either platform, so you don't have to buy two separate versions of the program (see page 610 for more about this).

1

Why Photoshop Elements?

Adobe Photoshop is the granddaddy of all image-editing programs. It's the Big Cheese, the industry standard against which everything else is measured. Every photo you've seen in a book or magazine in the past 15 years or so has almost certainly passed through Photoshop on its way to being printed. You just can't buy anything that gives you more control over your pictures than Photoshop does.

But Photoshop has some big drawbacks: It's darned hard to learn, it's horribly expensive, and many of the features in it are just plain overkill if you don't work on pictures for a living.

For several years, Adobe tried to find a way to cram many of Photoshop's marvelous powers into a package that normal people could use. Finding the right formula was a slow process. First came PhotoDeluxe, a program that was lots of fun but came up short when you wanted to fine-tune *how* the program worked. Adobe tried again with Photoshop LE, which many people felt included all the difficulty of full Photoshop, but still gave too little of what you needed to do top-notch work.

Finally—sort of like "The Three Bears"—Adobe got it just right with Photoshop Elements, which took off like crazy because it offers so much of Photoshop's power in a program that almost anyone can learn. With Elements, you too can work with the same wonderful tools that the pros use. Elements has been around for quite a while now and, in each new version, Adobe has added lots of push-button-easy ways to correct and improve your photos.

What You Can Do with Elements 10

Elements not only lets you make your photos look great, but also helps you organize your photos and gives you some pretty neat projects in which to use them. The program even comes loaded with lots of easy ways to share photos. The list of what Elements can do is pretty impressive. You can use it to:

- Enhance photos by editing, cropping, and color-correcting them, including fixing exposure and color problems.
- Add all kinds of special effects to images, like turning a garden-variety photo into a drawing, painting, or even a tile mosaic.
- Combine photos into a panorama or montage.
- Move someone from one photo to another, and even remove people (your ex?) from last year's holiday photos.
- Repair and restore old and damaged photos.
- Organize your photos and assign keywords to them so you can search by subject or name.
- Add text to images and turn them into things like greeting cards and flyers.
- Create slideshows to share with friends, regardless of whether they use Windows, a Mac, or even just a cellphone.

- Automatically resize photos so they're ready to email either as regular email attachments or in specially designed emails.
- Create digital artwork from scratch, even without a photo to work from.
- Create and share incredible online albums and email-ready slideshows that will make your friends actually *ask* to see your vacation photos.
- Store photos online so you can get to them from any computer. You can organize your photos online, and upload new images directly to your personalized Photoshop.com website. You can also keep an online backup of your photos, and even sync albums so that when you add a new photo from another computer, it automatically gets sent to your home computer, too.
- Create and edit graphics for websites.
- Create wonderful projects like collages and calendars that you can print or share with your friends digitally. Scrapbookers—get ready to be wowed.

It's worth noting, though, that there are still a few things Elements *can't* do. While the program handles text quite competently, at least as photo-editing programs go, it's still no substitute for QuarkXPress, InDesign, or any other desktop-publishing program. And Elements can do an amazing job of fixing problems in your photos, but only if you give it something to work with. If your photo is totally overexposed, blurry, and the top of everyone's head is cut off, there's a limit to what even Elements can do to salvage it. (C'mon, be fair.) The fact is, though, you're more likely to be surprised by what Elements *can* fix than by what it can't.

What's New in Elements 10

Elements 10 doesn't have quite as many new features as the last few versions have had, since this time around Adobe put a lot of their effort into fixing bugs in the underlying code, but it's still got some great new features:

- Text on a path (page 495). In Elements 10 you can create text that runs around in a circle or follows the outline of a shape or an object in your photo.
- **Brush-on textures (page 237).** The Smart Brush tools now let you add textures to areas in your photos. These new settings are especially nice for creating the digital equivalent of photographer's backdrops.
- New crop overlays (page 101). When you decide to trim down a photo, Elements 10 has a new overlay feature to help you decide where to crop it. You can choose a basic grid or one that helps you position your subjects according to the Rule of Thirds or the Golden Ratio.
- New Guided Edits (page 34). Elements 10 gives you two new Guided Edits, where the program walks you through the steps for creating effects that might be difficult to figure out on your own. You can now create the popular Orton effect (where everything is dreamily blurred) or make a photo look like it's been split up into many photos. And there's one to help you create the look of a shallow depth of field, with only the subject in focus, from photos where everything in the background was originally in focus, too.

- New Organizer searches (page 70). Elements has been able to search for and identify people in your photos for a while now, but Elements 10 can also search through your photos to find pets or objects.
- **Mobile app compatibility.** If you have a touch-sensitive tablet like an iPad, you can use Adobe's special apps to help control Elements or to create new colors or artwork and send them wirelessly, straight to Elements. (As of this writing, these apps are only for iPad, but Adobe plans to make them available for Android tablets, too.)
- Windows screen resolution fix. If you've used past versions of the Windows Organizer, you know it had some problems if you set your screen resolution too high, like not being able to read the bar at the top of the Organizer. These have been fixed in Elements 10.

Elements vs. Photoshop

You could easily get confused about the differences between Elements and the full version of Adobe Photoshop. Because Elements is so much less expensive, and because many of its more advanced controls are tucked away, a lot of Photoshop aficionados tend to view Elements as some kind of toy version of their program. They couldn't be more wrong: Elements *is* Photoshop, but it's Photoshop adapted for use with a home printer, and for the Web.

The most important difference between Elements and Photoshop is that Elements doesn't let you work or save in CMYK mode, which is the format used for commercial color printing. (CMYK stands for Cyan, Magenta, Yellow, and blacK. Your inkjet printer also uses those ink colors to print, but it expects you to give it an RGB file, which is what Elements creates. Don't worry—this is all explained in Chapter 7.)

Elements also lacks several tools that are basic staples in any commercial art department, like the ability to write *actions* (to help automate repetitive tasks), the extra color control you can get from Selective Color, and the Pen tool's special talent for creating vector paths. Also, for some special effects, like creating drop shadows or bevels, the tool you'd use—Layer styles—doesn't have as many settings in Elements as it does in Photoshop. The same holds true for a handful of other Elements tools.

And although Elements is all most people need to create graphics for the Web, it doesn't come with the advanced tools in Photoshop, which let you do things like automatically slice images into smaller pieces for faster web display. If you use Elements, then you have to look for another program to help out with that.

The Key to Learning Elements

Elements may not be quite as powerful as Photoshop, but it's still a complex program, filled with more features than most people ever use. The good news is that the Quick Fix window (Chapter 4) lets you get started right away, even if you don't understand every last option that Quick Fix presents you with. And you also get Guided Edit mode (page 34), which provides step-by-step walkthroughs of some popular editing tasks, like sharpening a photo or cropping it to fit on standard photo paper.

As for the program's more complex features, the key to learning how to use Elements—or any other program, for that matter—is to focus only on what you need to know for the task you're currently trying to accomplish.

For example, if you're trying to use Quick Fix to adjust the color of your photo and crop it, don't worry that you don't get the concept of "layers" yet. You won't learn to do everything in Elements in a day or even a week. The rest will wait until you need it, so take your time and don't worry about what's not important to you right now. You'll find it much easier to master Elements if you go slowly and concentrate on one thing at a time.

If you're totally new to the program, then you'll find only three or four big concepts in this book that you really need to understand if you want to get the most out of Elements. It may take a little time for some concepts to sink in—resolution and layers, for instance, aren't the most intuitive concepts in the world—but once they click, they'll seem so obvious that you'll wonder why they were confusing at first. That's perfectly normal, so persevere. You *can* do this, and there's nothing in this book that you can't understand with a little bit of careful reading.

The very best way to learn Elements is just to dive right in and play with it. Try all the different filters to see what they do. Add a filter on top of another filter. Click around on all the different tools and try them. You don't even need to have a photo to do this. See page 52 to learn how to make an image from scratch in Elements, and keep an eye out for the many downloadable practice images you'll find at this book's companion website, *www.missingmanuals.com*. Get crazy—you can stack up as many filters, effects, and Layer styles as you want without crashing the program.

About This Book

Elements is a cool program and lots of fun to use, but figuring out how to make it do what you want is another matter. Elements comes only with a quick reference guide, and it doesn't go into as much depth as you might want. Elements' Help files are very good, but of course you need to know what you're looking for to use them to your best advantage. (Elements' Help files are online now; you can download a PDF of them from Adobe's Elements support pages at *www.adobe.com/support/ photoshopelements.*)

You'll find a slew of Elements titles at your local bookstore, but most of them assume that you know quite a bit about the basics of photography and/or digital imaging. It's much easier to find good intermediate books about Elements than books designed to get you going with the program.

That's where this book comes in. It's intended to make learning Elements easier by avoiding technical jargon as much as possible, and explaining *why* and *when* you'll want to use (or avoid) certain features of the program. That approach is as useful to people who are advanced photographers as it is to those who are just getting started with their first digital cameras.

Note: This book periodically recommends *other* books, covering topics too specialized or tangential for a manual about Elements. Careful readers may notice that not all of these titles are published by Missing Manual parent O'Reilly Media. While we're happy to mention other Missing Manuals and books in the O'Reilly family, if there's a great book out there that doesn't happen to be published by O'Reilly, we'll still let you know about it.

You'll also find instructions throughout this book that refer to files you can download from the Missing Manual website (*www.missingmanuals.com*) so you can practice the techniques you're reading about. And in various spots, you'll find several different kinds of short articles (a.k.a. boxes). The ones labeled "Up to Speed" help newcomers to Elements do things, or they explain concepts with which veterans are probably already familiar. Those labeled "Power Users' Clinic" cover more advanced topics that won't be of much interest to casual photographers.

A Note About Operating Systems

This book covers using Elements with both Windows computers and Macs, and you'll see both platforms represented in the illustrations. (Frankly, you'll see more Mac screenshots here simply because some things are easier to read in the Mac version of the program. For example, pop-out menus are more likely to have a white background on a Mac instead of a dark one.) The Editor (the part of Elements where you tweak photos) works exactly the same way regardless of what kind of computer you're using, but there are some differences in the Organizer and the projects available to you, and those are noted as necessary. Also, most of the keyboard shortcuts you use to run commands are different in Windows and on Macs; page 10 explains how those shortcuts are listed in this book.

Note: If you bought Elements 10 from the Mac App Store, you got a special version that doesn't include the Organizer component, so the parts of this book about Organizer's features (like tagging and categorizing photos) don't apply. However, the Editor is exactly the same in all versions of Elements.

So remember: It doesn't matter which version of the program is shown in the illustrations; unless the book says otherwise, the differences are just slight cosmetic ones, like the fact that you close Mac program windows by clicking a button on their left, whereas in Windows the button is on the right.

Note: Adobe's video-editing program, *Premiere* Elements, also uses the Elements Organizer, and if you install both programs, your Photoshop Elements menus will show a lot of Premiere Elements choices, too. These are normally turned off when you install only Photoshop Elements, but if they get turned on by mistake, you can turn most of them off if you don't care to see them; page 58 tells you how. (Appendix B, which you can download from this book's Missing CD page at *www.missingmanuals.com/cds*, explains all the Organizer's menus. Appendix C, also online, covers the Editor's menus.)

About the Outline

This book is divided into seven parts, each focusing on a certain kind of task:

- Part One: Introduction to Elements. The first part of this book helps you get started with the program. Chapter 1 shows how to navigate Elements' slightly confusing layout and mishmash of programs within programs. You'll learn how to decide where to start from and how to customize Elements so it best suits your working style, and how to set up your Photoshop.com account. You'll also read about some important keyboard shortcuts, and where to look for help when you get stuck. Chapter 2 covers how to get photos into Elements, the basics of organizing them, and how to save and back up your images, either on your home computer or using Photoshop.com. Chapter 3 explains how to rotate and crop photos, and includes a primer on that most important digital imaging concept—resolution.
- **Part Two: Elemental Elements.** Chapter 4 shows how to use the Quick Fix window to dramatically improve your photos. Chapters 5 and 6 cover two key concepts that you'll use throughout this book: making selections and layers.
- Part Three: Retouching. Having Elements is like having a darkroom on your computer. In Chapter 7, you'll learn how to make basic corrections, such as fixing exposure, adjusting color, sharpening images, and removing dust and scratches. Chapter 8 covers topics unique to people who use digital cameras, like Raw conversion and batch-processing photos. In Chapter 9, you'll move on to more sophisticated fixes, like using the clone stamp for repairs, making photos livelier by adjusting their color intensity, and adjusting light and shadows in images. Chapter 10 shows you how to convert color photos to black and white, and how to tint and colorize black-and-white photos. Chapter 11 helps you to use Elements' Photomerge feature to create a panorama from several photos, and to correct perspective problems in your images.
- **Part Four: Artistic Elements.** This part covers the fun stuff: painting on photos and drawing shapes (Chapter 12), using filters and effects to create more artistic looks (Chapter 13), and adding text to images (Chapter 14).
- **Part Five: Sharing Images.** Once you've created a great image in Elements, you'll want to share it, so this part is about how to create fun projects like photo books (Chapter 15), how to get the most out of your printer (Chapter 16), how to create files to use on the Web and in email (Chapter 17), and how to make slideshows and share them online (Chapter 18).
- Part Six: Additional Elements. You can get hundreds of plug-ins and additional styles, brushes, and other nifty tools to customize your copy of Elements and increase its abilities; the Internet and your local bookstore are chock full of additional info. Chapter 19 offers a look at some of these resources, as well as information about using a graphics tablet with Elements, and suggests some places to turn after you finish this book.

• Part Seven: Appendixes. Appendix A helps you get your copy of Elements up and running, and suggests what to do if it starts misbehaving. Appendixes B and C—which you can download from this book's Missing CD page (see page 11)—cover all the menu items in the Organizer and Editor, respectively.

For Newcomers to Elements

This book contains a lot of information, and if you're new to Elements, it can be a little overwhelming. But you don't need to digest it all at once, especially if you've never used any kind of photo-editing software before. So what do you need to read first? Here's a simple five-step way to use this book if you're brand new to photo editing:

1. Read all of Chapter 1.

That's important for understanding how to get around in Elements.

2. If your photos aren't on your computer already, then read about the Photo Downloader in Chapter 2.

The Downloader gets your photos from your camera's memory card into Elements.

3. If you want to organize your photos, then read about the Organizer (also in Chapter 2).

It doesn't matter where your photos are right now. If you want to use the Organizer to label and keep track of them, then read Chapter 2.

4. When you're ready to edit your photos, read Chapters 3 and 4.

Chapter 3 explains how to adjust your view of photos in the Editor. Chapter 4 shows you how to use the Quick Fix window to easily edit and correct photos. Guided Edit (page 34) can also be very helpful when you're just getting started. If you skipped Chapter 2 because you're not using the Organizer, go back there and read the part about saving photos (page 74) so you don't lose your work.

5. When you're ready to print or share your photos, flip to the chapters on sharing images.

Chapter 16 covers printing, both at home and from online services. Chapter 17 explains how to email photos, and Chapter 18 teaches you how to post photos at Photoshop.com.

That's all you need to get started. You can come back and pick up the rest of the info in the book as you get more comfortable with Elements and want to explore more of the wonderful things you can do with it.

The Very Basics

This book assumes that you know how to perform basic activities on your computer like clicking and double-clicking your mouse buttons and dragging objects onscreen. Here's a quick refresher: To *click* means to move the point of your mouse or trackpad cursor over an object on your screen, and then to press the left mouse or trackpad button once. To *right-click* means to press the right mouse button once, which calls up a menu of special features. To *double-click* means to press the left button twice, quickly, without moving the mouse between clicks. To *drag* means to click an object and then to hold down the left button (so you don't let go of the object) while you use the mouse to move the object. Most onscreen selection buttons are pretty obvious, but you may not be familiar with *radio buttons*: To choose an option, click the little empty circle next to it. If you're comfortable with basic concepts like these, then you're ready to get started with this book.

In Elements, you'll often want to use keyboard shortcuts to save time, and this book tells you about keyboard shortcuts when they exist (and Elements has a lot). In this book, unless otherwise specified, keyboard shortcuts are always presented as Windows keystroke/Mac keystroke. So if you see a sentence like, "Press Ctrl+S/#-S to save your file," that means that if you use Windows, you should hold down the Control key while pressing the S key, and if you have a Mac, you should hold down the \Re key while pressing the S key. There's one slight exception to this: When you see "right-click/Control-click," if you have a Mac and a two-button mouse, you can right-click. But if you have a one-button mouse, you can *Control-click* instead—that means to press the Control key on your keyboard and then press your mouse button once.

About→These→Arrows

Throughout this book (and the Missing Manual series, for that matter) you see sentences like this: "Go to the Editor and select Filter—Artistic—Paint Daubs." This is a shorthand way of helping you find files, folders, and menu items without having to read through excruciatingly long, bureaucratic-style instructions. So the sample sentence above is a short way of saying this: "Go to the Editor component of Elements. In the menu bar at the top of the screen, click the word 'Filter.' In the menu that appears, choose the Artistic section, and then go to Paint Daubs in the pop-out menu." Figure I-1 shows you an example in action.

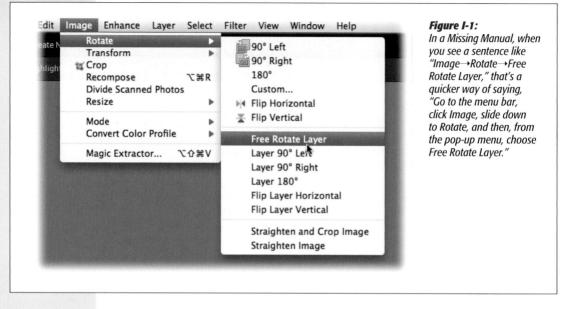

Mac file paths are shown using the same arrows. Windows file paths, on the other hand, are shown in the conventional Windows style, so if you see, "Go to *C:\Documents and Settings\<your user name>\My Documents\My Pictures*," that means you should go to your C drive, open the Documents and Settings folder, look for your user account folder, and then find the My Documents folder. In that folder, open the My Pictures folder that's inside it. When there are different file paths for Windows 7, Vista, and Windows XP, then you'll find them all listed.

Like keyboard shortcuts, file paths are shown as Windows file path/Mac file path when all versions of Windows use the same file path. Otherwise, all the different versions are specified. If you're using Mac OS X 10.7 (Lion), there's one special challenge finding some of the files mentioned in this book; specifically, the ones located in the Library folders. (Figure I-2 explains.) Also, if you buy Elements from the Mac App Store, all the files are actually inside the Application itself, which means your file paths will be different, so you'll see different instructions for the App Store version throughout this book.

Note: If you're using a 64-bit version of Windows, you have two folders labeled "Program Files." Windows puts 64-bit programs into the folder simply called "Program Files," but Elements, like many programs you may install, is a 32-bit program, and Windows puts 32-bit programs into a folder called "Program Files (x86)." If you have a folder called "Program Files (x86), that's where you should always look for Elements' files. This book includes a reminder note every time this applies, such as, "Go to C:] *Program Files (x86) if you have a 64-bit system]* Adobe Elements 10 Organizer."

Figure I-2:

In Mac OS X 10.7, a.k.a. Lion, Apple has made it a little harder to find your Library folders. The one you'll need most often is the Library folder that resides at the very top level of your hard drive. This isn't exactly hidden in 10.7, but it never appears unless you change your settings to make it accessible. To do that, in the Finder, go to Finder—Preferences—Sidebar and, in the Devices section, turn on the "Hard disks" checkbox (circled). After that, you can always find the Library folder by just clicking the name of your hard drive in the list on the left side of a Finder window.

The other Library folder you may need is the one for your user account, which is a hidden file in Lion. To make it visible, in the Finder, open the Go menu and then press the Option key. Your user account's Library folder will appear in the menu just below your Home folder.

About the Online Resources

As the owner of a Missing Manual, you've got more than just a book to read. Online, you'll find example files so you can get some hands-on experience. You can also communicate with the Missing Manual team and tell us what you love (or hate) about the book. Head over to *www.missingmanuals.com*, or go directly to one of the following sections.

Missing CD

This book doesn't have a CD pasted inside the back cover, but you're not missing out on anything. Go to *www.missingmanuals.com/cds* to download sample files mentioned in this book as well as a few tutorials and two additional appendixes. And so you don't wear down your fingers typing long web addresses, this book's Missing CD page also offers a list of clickable links to the websites mentioned in these pages.

Registration

If you register this book at oreilly.com, you'll be eligible for special offers—like discounts on future editions of *Photoshop Elements 10: The Missing Manual*. Registering takes only a few clicks. To get started, type *http://tinyurl.com/registerbook* into your browser to hop directly to the Registration page.

Feedback

Got questions? Need more information? Fancy yourself a book reviewer? On our Feedback page, you can get expert answers to questions that come to you while reading, share your thoughts on this Missing Manual, and find groups for folks who share your interest in Elements. To have your say, go to *www.missingmanuals.com/feedback*.

Errata

In an effort to keep this book as up to date and accurate as possible, each time we print more copies, we'll make any confirmed corrections you've suggested. We also note such changes on the book's website, so you can mark important corrections into your own copy of the book, if you like. To report an error or view existing corrections, go to *http://missingmanuals.com/library.html*, click the title of this book, and then click the "View/Submit Errata" link on the page that appears.

Safari[®] Books Online

Safari Books Online is an on-demand digital library that lets you easily search over 7,500 technology and creative reference books and videos to find the answers you need quickly.

With a subscription, you can read any page and watch any video from our library online. Read books on your cellphone and mobile devices. Access new titles before they're available for print, and get exclusive access to manuscripts in development and post feedback for the authors. Copy and paste code samples, organize your favorites, download chapters, bookmark key sections, create notes, print out pages, and benefit from tons of other time-saving features.

Part One: Introduction to Elements

Chapter 1: Finding Your Way Around Elements Chapter 2: Importing, Managing, and Saving Photos Chapter 3: Rotating and Resizing Photos

CHAPTER 1

Finding Your Way Around Elements

Photoshop Elements lets you do practically anything you want to your digital images. You can colorize black-and-white photos, remove demonic red-eye stares, or distort the facial features of people who've been mean to you. The downside is that all those options can make it tough to find your way around Elements, especially if you're new to the program.

This chapter helps get you oriented. You'll learn what to expect when you launch the program, how to use Elements to fix photos with just a couple of keystrokes, and how to sign up for and connect to all the goodies that await you on Photoshop.com. You'll also learn how to use Guided Edit mode to get started editing your photos. Along the way, you'll find out about some of Elements' basic controls and how to get to the program's Help files.

Getting Started

Unlike the past several versions of Elements, with Elements 10 there's not much difference in how you start up the program, regardless of whether you have a Mac or a Windows computer.

When you install Elements in Windows, the installer creates a desktop shortcut for you. Just double click that to launch Elements.

In the Mac version, you can launch Elements as the last step in the installation process (page 609 explains how to install Elements), or you can go to Applications→Adobe Photoshop Elements 10 and double-click its icon there. (Incidentally, the only other thing in there besides the uninstaller is a folder called Support Files [you won't see this if you have the App Store version]. That's where you'll find the actual Editor application.) If you want to make a Dock icon for future convenience, start Elements and then go to the Dock and click its icon. Keep holding the mouse button down till you see a menu, and then choose Options→Keep in Dock.

Note: If you don't care for Elements' dark color scheme, unfortunately you're out of luck in Elements 10. While some previous versions gave you a way to choose a lighter color for the background of the program's windows, this is gone from Elements now. On the plus side, the contrast between the program's background and the text on it is a bit better than in previous versions.

UP TO SPEED

Which Version of Elements Do You Have?

This book covers Photoshop Elements 10. If you're not sure which version you've got, the easiest way to find out is to look at the program's icon (the one you click to launch Elements). The icon for Elements 10 is a dark blue square with a stylized outline of two photographs on it in lighter blue.

If you're still not sure, in Windows, click once on the Elements icon on your desktop, and Windows displays the full name of the program—including the version number below the icon, if it wasn't already visible. You can also check the Windows Start menu, where Elements is listed along with its version number. On a Mac, check in your Applications folder to see the version number. Or, if Elements is already running, go to Help—About Photoshop Elements in Windows or Adobe Photoshop Elements Editor—About Photoshop Elements on a Mac.

You can still use this book if you have an earlier version of Elements because a lot of the basic editing procedures are the same. But Elements 10 is a little different, so you'd probably feel more comfortable with a reference book for the version you have. There are Missing Manuals for Elements 3 through 9, too, and you may prefer to track down the book that matches your version of Elements. (For Elements 6 and 8, there are separate editions for the Mac and Windows versions.)

The Welcome Screen

When you launch Elements for the first time, you're greeted by the Welcome screen (Figure 1-1). This is where you sign up for your free Photoshop.com account (which you can only get if you live in the U.S.; page 21 explains how), which also registers Elements. (If you have a Mac, you also have the option to create your account while installing Elements, as well as doing that here.)

Note: The App Store version has no Welcome Screen and no option for a free Photoshop.com account. When you launch this version, you go straight to the Editor (page 23).

EDIT	Sign in or create an Adobe ID to regis your software and enable your backu and sharing services. Create Adobe ID Aiready have an Adobe ID? Sign in below. <u>Learn more</u>	p casionally, so not exactly me image. The left the window is the same, tho it's where you choose wheth organize or ec photos. The bo
n In With Your Adobe ID : undage®bellsouth.net sword ? Sign In	Don't have an Adobe ID ? Benefits of an A Create New Adobe ID Learn More Help and Supp Adobe Privacy Policy	account, if you one. You can't the Welcome
		just by clicking upper-right Cli (X) button. If y that, this scree away—but so o Elements. Fort the box on pay tells you how o manently say

The Welcome screen is a launchpad that lets you choose which part of Elements you want to use:

- Organize button. This starts the Organizer, which lets you store and organize your image files.
- Edit button. Click this for the Editor, which lets you modify your images.

You can easily hop back and forth between the Editor and the Organizer—which you can think of as the two halves of Elements-and you probably won't do much in one without eventually needing to get into the other. But in some ways, they function as two separate programs. For example, if you start in the Organizer, then once you've picked a photo to edit, you have to wait a few seconds while the Editor loads. And when you have both the Editor and the Organizer running, quitting the Editor doesn't close the Organizer-you have to close both parts of Elements independently.

In the upper-right part of the Editor's main window is a button that you can click to launch the Organizer or switch over to it if it's already running. Click the word "Organizer" or the dark blue square with four smaller light blue squares on it. If you

want to do the opposite—get photos from the Organizer to the Editor—select the photo(s) and then either right-click/Control-click one of the selected thumbnails and choose "Edit with Photoshop Elements;" go to Fix→Edit Photos; or click the down arrow to the right of the word "Fix" and choose Full, Quick, or Guided Edit. Whichever method you use, your photo(s) appear in the Editor so you can work on them. Once both programs are running, you can also just click the Editor's or the Organizer's icon in the Windows taskbar or the Mac Dock to switch from one to the other.

One helpful thing to keep in mind is that Adobe built Elements around the assumption that most people work on their photos in the following way: First, you bring photos into the Organizer to sort and keep track of them. Then, you open photos in the Editor to work on them and save them back to the Organizer when you've finished making changes. You can work differently, of course—by opening photos directly in the Editor and bypassing the Organizer altogether, for example—but you may feel like you're always swimming against the current if you choose a different workflow. (The next chapter has a few hints for disabling some of Elements' features if you find they're getting in your way.)

The Welcome screen can also serve as your connecting point for signing onto Photoshop.com. Page 21 has more about this website, but for now you just need to know that a basic account is free if you're in the United States (it's not available in other countries), and it gives you access to all the interesting features in Elements that require an Internet connection.

If you're already signed into Photoshop.com, you can see how much of your online storage you've already used by looking at the graph at the bottom of the Welcome screen. There's also a reminder of your personal URL at Photoshop.com and links to online help, tips, and tricks for using Elements. However, you can also get to all these things from within the Editor or the Organizer, so there's no need to keep the Welcome screen around just for that. The box below explains how to get rid of the Welcome Screen.

FREQUENTLY ASKED QUESTION

Say Goodbye to the Welcome Screen

How do I get rid of the Welcome screen?

If you get to feeling welcomed enough, you may want to turn off the Welcome screen so you don't have to click through it every time you start Elements. To tell the Welcome Screen you don't want to see it anymore, click Settings in the upper-right corner. This displays a popup window where you can choose to have the Editor or the Organizer start from now on instead of the Welcome Screen. Just choose the program you want from the list that appears. (If you've used an earlier version of Elements, this is a great change from the persistent Welcome screen of old.)

If you change your mind later on about how you want Elements to open, at the top right of either the Editor or the Organizer, just click the little house icon to bring back the Welcome Screen, then head back to the Settings menu described above and make your change.

Organizing Your Photos

Organizing Your Photos

The Organizer is where your photos come into Elements *and* go out again when it's time to print or email them. The Organizer catalogs and keeps track of your photos, and you automatically come back to it for many activities that involve sharing photos, like emailing them (page 563) or creating an online gallery of them (page 572). The Organizer's main window (Figure 1-2), which is sometimes called the *Media Browser*, lets you view your photos, sort them into albums, and assign keyword labels to them. (In some previous versions of Elements it was called the *Photo Browser*, so you may hear that term, too.)

Figure 1-2:

The Media Browser is vour main Oraanizer workspace. Click the Create tab in the upper riaht and vou can start all kinds of new projects with your photos, or click the Share tab for ways to let other people view vour imaaes. Click the arrow to the right of the Fix tab (circled) for a menu that aives vou a choice of going to Full Edit, Quick Fix, or Guided Edit. The Fix tab gives you access to some quick fixes riaht in the Oraanizer. The Organizer also gives you another way to look at your photos, Date view, which is explained in Chapter 2.

The Organizer has lots of really cool features you'll learn about throughout this book when they're relevant to the task at hand. The next chapter shows you how to use the Organizer to import and organize your photos, and online Appendix B covers all the Organizer's different menu options (head to *www.missingmanuals.com/cds*). What's more, if you sign up for a Photoshop.com account (page 21), then you can access and organize your photos from any computer, not just at home.

Photo Downloader

Elements has yet another component that you may have seen already if you've plugged a camera into your computer after installing Elements: the Photo Down-loader (Figure 1-3), which helps get photos into the Organizer directly from your camera's memory card.

Figure 1-3:

Adobe's Photo Downloader is yet another program you get when you install Elements. Its job is to pull photos from your camera (or other storage device) into the Organizer. To use the Downloader in Windows, just click "Organize and Edit using Adobe Elements Organizer 10.0" (circled) in Windows 7's or Vista's AutoPlay dialog box. (If you use Windows XP, you'll see a dialog box with similar options.) After the Downloader does its thing, you end up in the Organizer.

In Windows, the Downloader appears as one of your options in the Windows dialog box that you see when you connect a device. If you want to use the Downloader, then just choose it from the list.

On a Mac, you launch the Downloader from the Organizer by going to File→"Get Photos and Videos"→"From Camera or Card Reader." There's no way to make the Downloader run automatically on a Mac—you have to go through the Organizer to start it.

You can read more about the Downloader in Chapter 2. If you plan to use the Organizer to catalog photos and assign keywords to them, then reading the section on the Downloader (page 42) can help you avoid hair-pulling moments.

UP TO SPEED

Where the Heck Did Elements Go?

If you've installed Elements but can't figure out how to launch it, no problem.

Windows automatically creates a shortcut to Elements on your desktop when you install the program. (If you need help installing Elements, turn to Appendix A.) You can also go to the Start menu, and then click the Adobe Photoshop Elements 10 icon. If you don't see Elements in the Start menu, then click the arrow next to All Programs, and you should see it in the pop-up menu.

On a Mac, go to Applications→Adobe Photoshop Elements 10.0, and then double-click the Adobe Photoshop Elements 10 icon.

Photoshop.com

Adobe also gives you easy access to its Photoshop.com service as part of Elements. A basic account is free, and it's nicely integrated into Elements, making it super simple to use. With a Photoshop.com account, you can:

- **Create your own website.** You can make beautiful online albums that display your photos in elaborate slideshows—all accessible via your own personal Photoshop.com URL (web address). It's great for dazzling friends and family. They can even download your photos or order prints, if you choose to let them (see page 574).
- Automatically back up and sync your photos. You can set Elements to sync the photos from your computer to storage space on Photoshop.com, creating a backup, just in case. What's more, you can upload photos to your albums from *other* computers, and they automatically appear in the Organizer the next time you start Elements. See page 82 for more about how to use this feature.
- Access your photos from other computers. When you're not at home, pop over to your Photoshop.com account to see and even organize your photos. That way, when you visit friends, you don't need to lug your computer along—just log into your account from their computers.
- **Download extra goodies.** The Content panel (page 522) displays thumbnails for additional backgrounds, frames, graphics, and so on, that you can download from Photoshop.com.
- Get lots of great free advice. Call up the Photoshop Inspiration Browser (page 35), and you can choose from a whole range of helpful tutorials for all sorts of Elements tasks and projects.

Note: These Photoshop.com features are available only in the United States, though Adobe has said for years that it plans to expand these offerings worldwide—someday. As of this writing, folks outside the United States can get some of the same features, like the ability to create online albums and galleries, at Adobe's Photoshop Showcase site *http://photoshopshowcase.com*. (See page 612 for more about the regional differences.)

You automatically get your Photoshop.com account when you register Elements. If you created an Adobe ID or entered an existing one the first time you launched Elements (in Windows) or when you installed Elements (on a Mac), you're all set. If you didn't create an account or log in, here's how to sign up for a free account:

1. Tell Adobe you want an account.

Just click the Create New Adobe ID button on the Welcome screen (page 16) or at the top of either the Organizer's or Editor's main window. (FYI, this also registers Elements—see page 612.)

2. In the window that opens, fill in your information to create your Adobe ID.

You need to enter the usual—address, phone, email, and so on—and pick what you'd like as your unique Adobe web address. (Hint: something like *http://johnspictures.photoshop.com* is probably already taken, so you may need to try a few alternatives. When you click Create Account, you get a message if the web address you chose is already in use.) Turn on the checkbox that says you agree to Adobe's terms and conditions. Finally, for security purposes, you need to enter the text you see in a box on the sign-up screen.

3. Create your account.

Click the Create Account button. Adobe tells you if it finds any errors in what you submitted and gives you a chance to go back and fix them.

4. Confirm your account.

You'll get an email from Adobe that contains a link. Just click the link to confirm that you want to create an account, and you're all set. (You need to click the link within 24 hours of creating your account, or you may have to start the whole process again.)

Once you have an account, you can get to it by clicking Sign In at the top of the Editor or Organizer. After you sign in, you see "Welcome <your name>" instead of "Sign In," and you can click that to go to your account settings. (You can also look at the bottom of the Welcome screen to see how much free space you have left, as shown in Figure 1-4.)

Welcome back, Barbara! Your Personal URL : <u>http://barbsphotosPSE.photoshop.com</u> Manage My Adobe ID	Your Adobe Online Storage : 2.0GB Used : 167.0MB Free : 1.8GB Manage My Backup	Figure 1-4: Once you sign into your Photoshop.com account, the bottom
		of the Welcome screen shows how much online storage space you're current using and includes a link for managing backups and syncing You also see a link to your personalized web address.

Note: If you already have an Adobe ID (maybe you created one for another Adobe program or you have a Mac and you created one while installing Elements), you claim your Photoshop.com space by logging into your Adobe account from Elements. You'll see a screen where you can choose a web address and tell Adobe whether you want a free or paid account.

A free Photoshop.com account is a pretty nice deal. It includes 2 GB of space on Adobe's servers for backing up and storing your photos. You can also upgrade to a paid account (called Plus), which gives you a bit more of everything: more template designs for Online Albums, more downloads from the Content panel, more tutorials, and more storage space (20–100 GB depending on what level membership you choose). However, the Plus account costs \$49.99 per year for 20 GB, and additional storage costs more, so you might want to try the free account first to see whether you'll really use it enough to justify the expense. This service has been available for a few years now, so you can also investigate Adobe's Photoshop.com support forum (*http://forums.adobe.com/community/photoshopdotcom*) as well as the independent forum sites (page 605) to see what people think about it.

Tip: If you haven't bought Elements yet, Adobe tends to promote the combination of Elements and a Plus account on their website. You have to hunt around a bit to find where to purchase Elements with just the free account, so look carefully before you buy if you don't want to start off with the paid version.

Once you sign into your account, Elements logs you in automatically every time you launch the program. If you don't want that to happen, just click your name at the top of the Elements window (in either the Organizer or Editor), and then, in the window that opens, choose Sign Out. You may also need to turn off syncing in the Organizer (in the Windows Notification area at the bottom right of your screen or in the OS X menubar at the upper right of your screen) to stay logged out.

Editing Your Photos

The Editor (Figure 1-5) is the other main component of Elements. This is the fun part of the program, where you get to adjust, transform, and generally glamorize your photos, and where you can create original artwork from scratch with drawing tools and shapes.

You can operate the Editor in three different modes:

• Full Edit. The Full Edit window gives you access to Elements' most sophisticated tools. You have far more ways to work on your photo in Full Edit than in Quick Fix (explained next), and if you're fussy, it's where you'll do most of your retouching work. Most of the Quick Fix commands are also available via menus in the Full Edit window.

Figure 1-5: The main Elements editing window, which Adobe calls Full Edit. This is where you have access to all the Elements editing features.

- **Quick Fix.** For many Elements beginners, Quick Fix (Figure 1-6) ends up being their main workspace. It's where Adobe has gathered together the basic tools you need to improve most photos. It's also one of the two places in Elements where you can choose to have a before-and-after view while you work (the other is Guided Edit, described next). Chapter 4 gives you all the details on using Quick Fix.
- **Guided Edit.** This window can be a big help if you're a newcomer to Elements. It provides step-by-step walkthroughs of popular projects such as cropping photos and removing blemishes from them. It also hosts some fun special effects and workflows for more advanced users (see page 454).

Use the Full, Quick, and Guided tabs near the top right of the Elements window to switch modes. The rest of this chapter covers some of the Editor's basic concepts and key tools.

Tip: If you leave a photo open in the Editor, then when you switch back to the Organizer, you'll see a red band with a padlock across the photo's Organizer thumbnail as a reminder. To get rid of the lock and free up your image for Organizer projects, go back to the Editor and close the photo there.

Figure 1-6: The Quick Fix window. To compare your fixes with the original photo, fire up Before & After view, which you get to by clicking the View menu (circled).

Panels, Bins, and Tabs

When you first open the Editor, you may be dismayed at how cluttered it looks. There's stuff everywhere, and maybe not a lot of room left for the photos you're editing, especially if you have a small screen. Don't fret: One of Elements' best features is the way you can customize the Editor's workspace—there's practically no limit to how you can rearrange it. You can leave everything the way it is if you like a cozy area with everything at hand. Or, if you want a Zen-like empty workspace with nothing visible but your photo, you can move, hide, and turn off almost everything. Figure 1-7 shows two different views of the same workspace.

What's more, you can hide *everything* in your workspace except for your images and the menu bar: no tools, panels, or Options bar. This is handy when you want a good, undistracted look at what you've just done to your photo. To do that, just press the Tab key; to bring everything back into view, press Tab again.

Note: You may notice that in Elements 10 for Windows, the menu bar at the very top of the program's window changes a little depending on the size of your monitor and whether you've got the Elements window maximized to fill your screen. You'll either see a single row above the Options bar (page 31) with the PSE logo at the left and the Arrange menu (page 109) and the Photoshop.com login area at the middle of the screen (as in Figure 1-5), or these items may be in a separate row *above* the menus that say File, Edit, Image, and so on (as in Figure 1-6). Both are perfectly normal, and you'll see both arrangements in this book's illustrations, as well as seeing the Mac version, where the menu bar (the one that says File, Edit, Image, and so on) is at the top of the screen instead of being attached to the main Elements window.

The Panel bin

When you're in Full Edit, the right side of the Elements window displays the *Panel bin*. Panels let you do things like keep track of what you've done to your photo (with the Undo History panel) and apply special effects to your images (with the Effects and Content panels). You'll learn about the various panels in detail throughout this book.

Note: In older versions of Elements and Photoshop, panels were called "palettes." If you run across a tutorial that talks about the "Content palette," for example, that's the same thing as the Content panel.

Figure 1-7:

Two different ways of working with the same images, panels, and tools. You can use any arrangement that suits you.

Top: The panels in the standard Elements arrangement, with the images in the regular tabbed view (page 107).

Bottom: This image shows how you can customize your panels. Here, the Project bin has been combined with other floating panels and the whole group is collapsed to icons. Click a panel's icon and that panel pops out so you can work with it, like the Project bin here. The images here are in floating windows (page 107).

You might like the Panel bin, but many people don't. If you have a small monitor, you may find it wastes too much desktop acreage, and in Elements you need all the working room you can get. Fortunately, you don't have to keep your panels in the bin; you can close the bin and just keep your panels floating around on your desktop, or you can minimize them.

Unlike in some previous versions of Elements, you can't close the Panel bin *complete-ly* in Elements 10, but you can pull the panels out of the bin and put them someplace else to give yourself more room. If you use tabbed image windows (page 107), you can't expand the image area to include the empty bin space, though—you have to switch to floating windows (page 107) to make use of that space.

Tip: While you can't collapse the Panel bin, you can reclaim its space by pulling your panels out of the bin and going to Window—Panel Bin to turn it off. The downside of this technique is that you lose the ability to switch from Full to Quick to Guided Edit if you do this. To get those navigation buttons back, you have to go back to the Window menu and turn the Panel bin on again.

To pull a panel out of the bin, drag the panel's top tab (the one with its name on it); you've now got yourself a floating panel. (You can float panels even if you haven't turned on floating image windows.) Figure 1-8 shows how to make panels even smaller once they're out of the bin by collapsing them in one of two ways. You can also combine panels, as shown in Figure 1-9; this works with both panels in the bin and freestanding panels.

Figure 1-8:

You can free up lots of space by collapsing panels accordion-style once they're out of the bin.

Top: A full-sized panel.

Bottom left: A panel collapsed by double-clicking where the cursor is.

Bottom right: The same panel collapsed to an icon by double-clicking the very top of it (where the cursor is here). Double-click the top bar again to expand it.

Figure 1-9:

You can combine two or more panels once you've dragged them out of the Panel bin.

Top: Here, the Histogram panel is being pulled into, and combined with, the Layers panel. To combine panels, drag one of them (by clicking on the panel's name tab) onto the other panel. When the moving panel becomes ghosted and you see the blue outline shown here, they'll combine as soon as you let go of your mouse button. (You can also make a vertical panel group—where one panel appears above another—by letting go when you see a blue line at the bottom of the of the host panel, instead of an outline all the way around it as shown here.)

Bottom: To switch from one panel to another after they're grouped, just click the tab of the one you want to use. To remove a panel from a group, simply drag it out of the group. If you want to return everything to how it looked when you first launched Elements, click Reset Panels (not visible here) at the top of your screen.

When you launch Elements for the first time, the Panel bin contains three panels: Layers, Content, and Effects. To see how many more panels Elements actually gives you, check out the Editor's Window menu (the one at the top of your screen): Everything listed in the menu's middle section—from Adjustments to Undo History—is a panel you can put in the Panel bin.

When you select a new panel from the Window menu, it appears in the Panel bin (if you're using the bin) or floating on your desktop. In addition to combining panels as shown in Figure 1-9, you can also collapse any group of panels into icons (as shown in Figure 1-8). To use an iconized panel, click its icon and it jumps out to the side of the group, full size. To shrink it back to an icon, click its icon again. You can combine panels in the bin by dragging their icons onto each other. Then those panels open as a combined group, like the panels in Figure 1-9. Clicking one of the icons in the group collapses the opened, grouped panels back to icons. (Combined panel icons don't show a dark gray line between them in the group the way separate icons do.) You can also separate combined panels in icon view by dragging the icons away from each other.

Adobe sometimes refers to floating panels as "tabs" in Elements' menus. To close a floating tab, click its Close button (in Windows, the X at its upper right; on a Mac, the dot at its upper left) or click the little white square made of four horizontal lines in the panel's upper right, and then choose Close from the menu that appears. If you want to put a panel back in the Panel bin, drag it over the bin and let go when you see a blue line, or drag it onto the tab of a panel that's already in the bin to create a combined panel within the bin.

Tip: If you lose panels or you move them around so much that you can't remember where you put things, you can always go home again by clicking the Reset Panels button at the top of the Editor window, which puts *all* the panels back in their original spots.

The Project bin

In the Editor, the long narrow photo tray at the bottom of your screen is called the *Project bin* (Figure 1-10). It shows you what photos you have open, but it also does a lot more than that. You can drag your photos' thumbnails in the bin to rearrange them if you want to use the images in a project. The bin has two drop-down menus:

Figure 1-10:

The Project bin, which runs across the bottom of the Editor's screen, holds a thumbnail of every photo you have open, as well as photos you've sent over from the Organizer that are waiting to be opened. Here you see the bin three ways: as it normally appears (top), as a floating panel (bottom left), and collapsed to an icon (bottom right). You can also click the Close button (in Windows, that's the X at its upper right; on a Mac, it's the dot at its upper left), or right-click its tab and then choose Close to hide it completely. To bring it back, go to Window-Project bin.

• Show Open Files. This menu at the bin's upper left lets you determine what the Project bin displays: the photos currently open in the Editor, selected photos from the Organizer, or any of the albums (page 59) you've made. If you send a bunch of photos over from the Organizer at once, you may think something went awry because no photo appears on your desktop or in the Project bin. If you switch this menu over to "Show Files from Elements Organizer," then you'll see the photos waiting for you in the bin.

Tip: If you regularly keep lots of photos open and you have an iPad, check out the Adobe Nav app, which lets you sort through open photos in Elements, see info about your photos, and switch tools without using your mouse. You can read more about Nav at *www.photoshop.com/products/mobile/nav*.

• **Bin Actions.** This is where the Project bin gets really useful, but it's not easy to spot this menu: it's the little four-line square in the bin's upper right. This menu lets you choose to use the photos in the bin in a project (via the Create tab), share them by any of the means listed under the Task panel's Share tab, print them, or make an album right there in the Project bin without ever going to the Organizer. (You can also use this menu to reset the style source images you use in the Style Match feature, explained on page 379.)

Tip: If you don't use the Organizer, then the Project bin is a particularly great feature because it lets you create groups of photos you can call up together: Just put them in an album (page 59), and then, from the bin's Show Open Files menu, select the album's name to see that group again.

The Project bin is useful, but if you have a small monitor, you may prefer to use the space it takes up for your editing work. The Project bin behaves just like any of the other panels, so you can drag it loose from the bottom of the screen and combine it with the other panels. You can even collapse it to an icon or drag it into the Panel bin. (If you combine it with other panels, the combined panel may be a little wider than it would be without the Project bin, although you can still collapse the combined group to icons.)

Note: In the Project bin, you may notice strange little paintbrush icons appearing on the top-right corner of your photos' thumbnails. They indicate that you've edited a photo but not saved your changes.

Image windows

You also get to choose how you want to view the images you're working on. Older versions of Elements used floating windows, where each image appears in a separate window that you could drag around. Elements now starts you out with a tabbed view—which uses something like the tabs in a web browser, or the tabs you'd find on paper file folders—but you can still put your images into floating windows, if you prefer (page 109 explains how). The advantage of tabbed view is that it gives you plenty of workspace around your image, which is handy when you're working near the edges of an image or using a tool that requires you to be able to get outside the image's boundaries. Many people switch back and forth between floating and tabbed windows as they work, depending on which is most convenient. All the things you can do with image windows—including how to switch between tabbed view and floating windows—are explained on page 107. (Incidentally, clicking Reset Panels doesn't do anything to your image windows or tabs; it only resets your panels.)

Note: Because your view may vary, most of the illustrations in this book show only the image itself and the tool in use, without a window frame or tab boundary around it.

Elements' Tools

Elements gives you an amazing array of tools to use when working on your photos. You get almost two dozen primary tools to help select, paint on, and otherwise manipulate images, and some of the tools have as many as six subtools hiding beneath them (see Figure 1-11). Bob Vila's workshop probably isn't any better stocked than Elements' virtual toolbox.

Figure 1-11:

Like any good toolbox, Elements' Tools panel has lots of hidden drawers tucked away in it. Many Elements tools are actually groups of tools, which are represented by tiny black triangles on the lower-right side of the tool's icon (you can see several of these triangles here). Right-clicking or holding the mouse button down when you click the icon reveals the hidden subtools. The white square to the left of the Eraser tool's icon here indicates that it's the active tool right now.

Tip: To explore every nook and cranny of Elements, you need to open a photo (in the Editor, choose File \rightarrow Open). Lots of the menus are grayed out (unavailable) if you don't have a file open.

The long, skinny strip on the left side of the Full Edit window (shown back in Figure 1-5 on page 24) is the Tools panel. It stays perfectly organized so you can always find what you want without ever having to tidy it up. If you forget what a particular tool does, just hover your cursor over the tool's icon and a label (called a *tooltip*) will appear telling you the tool's name. To activate a tool, click its icon. Each tool comes with its own collection of options, as shown in Figure 1-12.

As the box on page 33 explains, you may have either a single- or double-columned Tools panel. Other windows in Elements, like Quick Fix and the Raw Converter, also have toolboxes, but none is as complete as the one in Full Edit.

Note: If you've used Elements 5 or earlier, you'll notice an important difference in getting to subtools in Elements 10: You can't switch from one tool in a subgroup to another by using the Options bar anymore. Now you can choose a tool from a group only by using the tool's pop-out menu in the Tools panel or by pressing its shortcut key repeatedly to cycle through the tool's subgroup (stop tapping the key when you see the icon for the tool you want).

Don't worry about learning the names of every tool right now, but if you want to see them all, they're on display in Figure 1-13. It's easier to remember what a tool is once you've used it. And don't be overwhelmed by all of Elements' tools. You probably have a bunch of Allen wrenches in your garage that you only use every year or so. Likewise, you'll find that you tend to use certain Elements tools more than others.

Figure 1-13:

The mighty Tools panel. Because some tools are grouped together in the same slot (indicated by the little black triangles next to the tools' icons), you can't ever see all the tools at once. For grouped tools, the icon you see is the one for the last tool in the group you used. (This Tools panel has two columns; the box on page 33 explains how to switch from one column to two.)

Tip: You can save a *ton* of time by activating tools with their keyboard shortcuts, since that way you don't have to interrupt what you're doing to trek over to the Tools panel. To see a tool's shortcut key, hover your cursor over its icon; a label pops up indicating the shortcut key (it's the letter to the right of the tool's name). To activate the tool, just press the appropriate key. If the tool you want is part of a group, all the tools in that group have the same keyboard shortcut, so just keep pressing that key to cycle through the group until you get to the tool you want.

POWER USERS' CLINIC

Doubling Up

Your monitor determines whether you start with one or two columns in your Tools panel. If your screen is large enough, Elements starts you off with a single column; if not, you get two.

If you have a single-column Tools panel and you'd prefer a double-columned one, just drag the Tools panel downward to pull it loose from the Options bar, and then click the double arrows that appear at the top of the panel. If you had a single-row panel when you clicked, it changes to a nice, compact double-column panel with extra-large color squares (see Figure 1-13). You can reverse this by clicking the arrows again. Be careful, though—you can close the Tools panel just like any other panel by clicking the Close button (the X) at the panel's upper right (on a Mac, it's the dot at the panel's upper left). (To bring it back, go to Window→Tools.) You can also move the Tools panel like any other panel, but you can't combine it with other panels or collapse it. If you want to hide it temporarily, press the Tab key and it disappears along with your other panels; press Tab again to bring them back.

FREQUENTLY ASKED QUESTION

The Always-On Toolbox

Do I always need to have a tool selected?

When you look at the Tools panel, you'll probably notice that one tool's icon is highlighted, indicating that the tool is active. You can deactivate it by clicking a different tool. But what happens when you don't want *any* tool to be active? How do you fix things so that you don't have a tool selected?

You don't. In the Editor, one tool always has to be selected, so you probably want to get in the habit of choosing a tool that won't do any damage to your image if you click accidentally. For instance, the Pencil tool, which leaves a spot or line where you click, probably isn't a good choice. But the Marquee selection tool (page 153), the Zoom tool (page 111), and the Hand tool (page 113) are all safe bets. (When you open the Editor, Elements activates the tool you were using the last time you closed the program.)

Getting Help

Wherever Adobe found a stray corner in Elements, they stuck some help into it. You can't move anywhere in this program without being offered some kind of guidance. Here are a few of the ways you can summon assistance if you need it:

• Help menu. Choose Help→Photoshop Elements Help or press F1/æ-?. When you do, Elements launches your web browser, which displays Elements' Help files, where you can search or browse a topic list and glossary. The Help menu also contains links to online video tutorials and Adobe's support forum for Elements.

- **Tooltips.** When you see a tooltip (page 31) pop up under your cursor as you move around Elements, if the tooltip's text is blue, that means it's linked to the appropriate section in Elements' Help. You can click blue-text tooltips for more information about whatever your cursor is hovering over.
- **Dialog box links.** Most dialog boxes have a few words of bright blue text somewhere in them. That text is actually a link to Elements Help. If you get confused about what the Remove Color Cast feature does, for instance, then, in the Remove Color Cast dialog box, click the blue words "color cast" for a reminder.

Guided Edit

If you're a beginner, Guided Edit (Figure 1-14) can be a big help. It walks you through a variety of popular editing tasks, like cropping, sharpening, correcting colors, and removing blemishes. It also includes some features that are useful even if you're an old Elements hand, like the Action Player (page 452) and the Photo Play edits (page 455). Guided Edit is really easy to use:

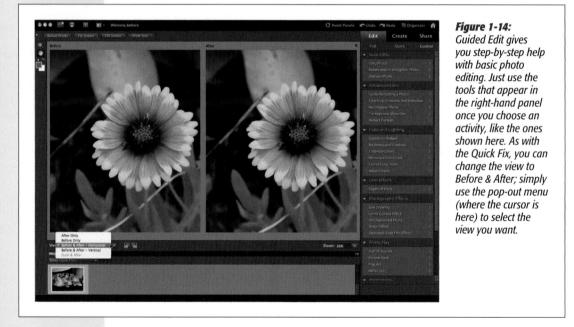

1. Go to Guided Edit.

In the Editor, click the Edit tab \rightarrow Guided.

2. Open a photo.

If you already have an image open, it appears in the Guided Edit window automatically. Press Ctrl+O/ૠ-O, and then, in the window that appears, choose your photo. If you have several photos in the Project bin, then you can switch images by double-clicking the thumbnail of the one you want to work on.

3. Choose what you want to do.

Your options are grouped into major categories like Basic Edits and Lens Effects, with a variety of specific projects under each heading. Just click the task you want in the list on the right side of the window, and the panel displays the relevant buttons and/or sliders for that task.

4. Make your adjustments.

Simply move the panel's sliders and click its buttons till you like what you see. If several steps are involved, then Elements shows you only the buttons and sliders you need to use for the current step, and then switches to a new set of choices for the next step as you go along. If you need to adjust your view of your photo while you work on it, Guided Edit has a little toolbox with the Hand (page 111) and Zoom (page 113) tools to help you out.

If you want to start over, click Reset. If you change your mind about the whole project, click Cancel.

5. Click Done to finish.

If there are more steps, then you may see another set of instructions. If you see the main list of topics again, you're all through. Don't forget to save your changes (page 74). To close your photo, press Ctrl+W/æ-W; or leave it open and switch to another tab to share it or use it in a project.

Tip: Guided Edit shows you quick and easy ways to change your image, but you don't always get the best possible results. It's a great tool for starting out; just remember that what you see here isn't necessarily the best you can possibly make your images look. Once you're more comfortable in Elements, Quick Fix (Chapter 4) is a good next step. You'll find that most of the tools there will be familiar if you've been using Guided Edit.

The Inspiration Browser

You've probably noticed the little text alerts that zip in and out at the bottom of both the Editor and the Organizer windows. If you click one, up pops the Adobe Elements Inspiration Browser, a mini-program that lets you watch tutorials, as you can see in Figure 1-15. (You can also get to it from Help→Elements Inspiration Browser.) You need a Photoshop.com account (available only to U.S. residents; see page 21) to use the Browser. (If you call up the Browser and you change your mind about using it or don't have an account, press the Esc key to close it.) It's well worth checking out, because the Browser is a direct connection to a slew of tutorials about things you might want to do with Photoshop Elements or Premiere Elements (Adobe's movie-editing program).

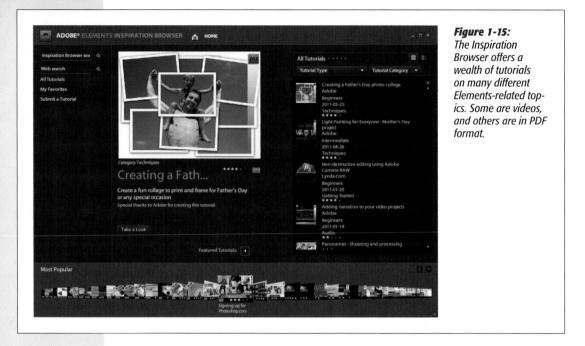

The first time you start the Inspiration Browser, you may see a license agreement for yet *another* program: Adobe AIR, which lets other programs show you content stored online without you having to launch a web browser and navigate to a website. (Adobe AIR got installed automatically along with Elements.)

This process may seem like a lot of work, but it's well worth the effort, since you can find tutorials on everything from beginner topics like creating albums to advanced subjects like working with Displacement Maps (a sophisticated technique used for things like making your photo look like it's painted on a brick wall, or making a page of text look like a crumpled newspaper). The tutorials are all in either PDF or video format. Some are by well-known Elements gurus, but *anyone* can submit a tutorial for the Inspiration Browser. So if you figure out how to do a project you think might be useful to others, you can create a tutorial and send it in for approval by clicking "Submit a Tutorial" and entering the requested information in the window that appears. (You need to create your tutorial as either a PDF or, for a video, in Flash FLV or SWF format.)

You can search for tutorials using the box on the Browser's left, or click All Tutorials and then filter them by category or product (so you don't see Premiere Elements topics if you have only Photoshop Elements, for example). You can also click one of the column headings to see the available tutorials arranged by title, author, difficulty, date posted, category, type (video or PDF), or the average star rating people have given it. Use the buttons at the window's upper right to change the view from a list to thumbnails (info about each tutorial appears below its thumbnail). The Inspiration Browser is a great resource and may well give you most of the Elements help you need beyond this book.

Tip: If the author of a tutorial has a website, then the tutorial's page has a link to it. Exploring these links can help you find lots of useful Elements-related resources, as well as useful add-on tools that extend Elements' capabilities (see Chapter 19).

Escape Routes

Elements has a couple of really wonderful features to help you avoid making permanent mistakes: the Undo command and the Undo History panel. After you've gotten used to them, you'll probably wish it were possible to use these tools in all aspects of your life, not just Elements.

Undo

No matter where you are in Elements, you can almost always change your mind about what you just did. Press Ctrl+Z/æ-Z, and the last change you made goes away. Pressing Ctrl+Z/æ-Z works even if you've just saved your photo, but only while the image is still open—if you close the file, your changes are permanent. Keep pressing Ctrl+Z/æ-Z to keep undoing your work, step by step.

If you want to *redo* what you just undid, press Ctrl+Y/#-Y. These keyboard shortcuts are great for toggling changes on and off while you decide whether you want to keep them. The Undo/Redo keystroke combinations work in both the Organizer and the Editor.

Note: If you don't like Ctrl+Z/æ-Z and Ctrl+Y/æ-Y, you have a bit of control over the key combinations you use for Undo and Redo. Go to Edit→Preferences→General/Adobe Photoshop Elements Editor→ Preferences→General, where the Step Back/Fwd menu gives you two other choices, both of which involve pressing the Z key in combination with the Control, Alt, and Shift keys in Windows, and with the æ, Option, and Shift keys on a Mac.

Undo History panel

In the Full Edit window, you get even more control over the actions you can undo, thanks to the Undo History panel (Figure 1-16), which you open by choosing Window→Undo History.

Figure 1-16:

For a little time travel, just slide the pointer on the left (it's under the cursor in this image) up and watch your changes disappear. You can only go back sequentially. Here, for instance, you can't go back to the Crop tool without first undoing what you did with the Paint Bucket and the Eraser. You can also hop to a given spot in the list by clicking the place where you want to go instead of using the slider.

Slide the pointer down to redo your work.

This panel holds a list of the changes you've made since you opened your image. Just drag the slider up and watch your changes disappear one by one as you go. Like the Undo command, Undo History even works if you've saved your file: As long as you haven't *closed* the file, the panel tracks every action you take. You can also slide the pointer the other way to redo changes that you've undone.

Be careful, though: You can back up only as many steps as Elements is set to remember. The program is initially set up to record 50 steps, but you can change that number by going to Edit→Preferences→Performance→History & Cache/Adobe Photoshop Elements Editor→Preferences→Performance→History & Cache and adjusting the History States setting. You can set it as high as 1,000, but remembering even 100 steps may slow your computer to a crawl if you don't have a superpowered processor, plenty of memory, and loads of disk space. If Elements runs slowly on your machine, then reducing the number of history states it remembers (try 20) may speed things up a bit.

The one rule of Elements

As you're beginning to see, Elements lets you work in lots of different ways. What's more, most people who use Elements approach projects in different ways; what works for your neighbor with her pictures may be quite different from how you'd work on the very same shots. But you'll hear one suggestion from almost every Elements veteran, and it's an important one: *Never, ever work on your original. Always, always, always make a copy of your image and work on that instead.*

The good news is that, if you store your photos in the Organizer, you don't need to worry about accidentally trashing your original. If you save your files as *version sets* (page 75), Elements automatically creates a copy when you edit a photo that's cataloged in the Organizer, so you can always revert to your original. Other imagemanagement programs, like iPhoto and Adobe's Lightroom, also make versions for you if you set up Elements as your external editor (page 48). If you're determined not to use the Organizer or version sets, then follow these steps to make a copy of your image in the Editor:

1. Go to File→Duplicate.

The Duplicate Image dialog box appears.

2. Name the duplicate and then click OK in the dialog box.

Elements opens the new, duplicate image in the main image window.

3. Find the original image and click its Close button (the X or the red dot).

If you have floating windows (page 26), the Close button is the standard Windows or Mac Close button you'd see in any window. If you have tabs, the close X is on the right side of the image's tab in Windows, and on the left side on a Mac. Now the original is safely tucked out of harm's way.

4. Save the duplicate by pressing Ctrl+S/\#-S.

Choose Photoshop (.psd) as the file format when you save it. (You may want to choose another format after you've read Chapter 3 and understand more about your different format options.)

Now you don't have to worry about making a mistake or changing your mind, because you can always start over.

Note: Elements doesn't have an autosave feature, so you should get into the habit of saving frequently as you work. Page 74 has more about saving. Even if you're using Mac OS X 10.7 (Lion), this is still true–Elements isn't currently able to use Lion's Auto Save feature.

Getting Started in a Hurry

If you're the impatient type and you're starting to squirm because you want to be up and doing something to your photos, here's the quickest way to get started in Elements: Adjust an image's brightness and color balance all in one step.

1. In the Editor, open a photo.

Press Ctrl+O/#-O and navigate to the image you want, and then click Open.

2. Press Alt+Ctrl+M/Option-#-M.

You've just applied Elements' Auto Smart Fix tool (Figure 1-17).

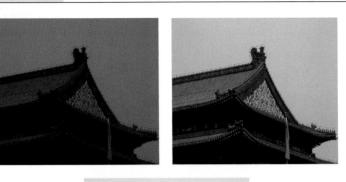

Figure 1-17:

Auto Smart Fix is the quickest, easiest way to improve the quality of your photos.

Top left: The original, unedited picture.

Top right: Auto Smart Fix makes quite a difference, but the colors are still slightly off.

Bottom: By using some of the other tools you'll learn about in this book (like Auto Contrast and Adjust Sharpness), you can make things look even better.

Voilà! You should see quite a difference in your photo, unless the exposure, lighting, and contrast were almost perfect before. (If you don't like what just happened to your photo, no problem—simply press Ctrl+Z/#-Z to undo it.) The Auto Smart Fix tool is one of Elements' many easy-to-use features.

If you're really raring to go, jump ahead to Chapter 4 to learn about using the Quick Fix commands. But it's worth taking the time to read the next two chapters so you understand which file formats to choose and how to make some basic adjustments to your images, like rotating and cropping them.

Don't forget to give Guided Edit a try if you see what you want to do in its list of topics. Guided Edit (page 34) can be a big help while you're learning your way around.

CHAPTER 2

Importing, Managing, and Saving Photos

Now that you've had a look around Elements, it's time to start learning how to get photos into the program and how to keep track of where these photos are stored. As a digital photographer, you don't have to deal with shoeboxes stuffed with prints, but you've still got to face the menace of photos piling up on your hard drive. Fortunately, Elements gives you some great tools for organizing your collection and quickly finding individual pictures.

In this chapter, you'll learn how to import photos from cameras, memory card readers, and scanners. You'll also find out how to import individual frames from videos, create new files from scratch, and open files already on your computer. Then you'll be ready for a quick tour of the Organizer, where you can sort and find pictures once they're in Elements. Finally, you'll learn about saving and backing up your precious files.

Note: If you bought Elements 10 from the Mac App Store, you got a special version that doesn't include the Organizer, so the parts of this chapter about using the Organizer don't apply.

Importing from Cameras

Elements gives you lots of different ways to get photos from camera to computer, but if you use the Organizer, the simplest way is using Adobe's Photo Downloader. Later in this section, you'll learn about other ways to import photos.

Note: Take a moment to carefully read the instructions from your camera's manufacturer. If those directions conflict with anything you read here, follow the manufacturer's instructions.

The Photo Downloader

What happens when you plug a camera or memory card reader into your computer depends on your operating system. If you have Windows 7 or Vista, you get a standard Windows dialog box (shown on page 20) asking what you want to do. To use the Photo Downloader to get your photos into Elements, just click "Organize and Edit using Adobe Photoshop Elements Organizer 10.0." (If you're using Windows XP, choose Elements Organizer 10.0 from the dialog box that appears.) On a Mac, you won't see the Downloader at all unless you specifically tell your Mac to use it, which you do in the Organizer: Go to File \rightarrow Get Photos and Videos \rightarrow From Camera or Card Reader, or press \mathfrak{A} -G. You can't set the Mac Downloader to run automatically whenever you plug in a camera or card reader—you have to launch it from the Organizer.

Note: Although much of this chapter talks about importing pictures from a *camera*, most memory card readers work the same way. Use a card reader if you have one, since that will spare the camera's batteries and subject your camera to less wear and tear.

The Downloader's job is pretty straightforward: to shepherd your photos as they make the trip from camera to PC, and to make sure Elements knows where your images are stored. Your job is to help it along by adjusting the following settings (on display in Figure 2-1):

- Get Photos from. Your first step in downloading is to choose your camera or card reader from the list of available devices. (You may see a more generic "Camera or Card Reader" choice rather than the name of your camera; if that's all you see, pick that option.) Just below this menu, the Downloader lists how many photos it found and how many duplicates (of images already in the Organizer) it plans to skip.
- Location. Your photos usually get stored in a folder named for the date you shot them. In Windows 7 or Vista, this folder lives in *C*:*Users*\<*your user-name*>*Pictures*; in XP, it's *C*:*expour user name*>*My Documents**My Pictures*\ *Adobe**Digital Camera Photos*. On a Mac, it's your hard drive→Users→<*your username*>→Pictures. If you want to change where your photos are headed, click the Browse button and choose another location. You can permanent-ly change the standard save location by opening the Organizer and going to Edit→Preferences→"Camera or Card Reader" and changing the Save Files In setting. From then on, the Downloader will put your photos in the folder you chose.

	Get Photos from:	
20	E:\ 	•
	976 Files Selected - 6.5GB	
Import Settings		
Location:	C: \Users\Barbara\Pictures\[Shot Date]	Browse
<u>C</u> reate Subfolder(s):	Shot Date (yyyy mm dd)	-
<u>R</u> ename Files:	Do not rename files	
		+
	Example: IMG_0540.JPG	
	☑ Open Organizer when Finished	
Delete Options:	After Copying, Do Not Delete Originals	<u>•</u>
	T Automatic Do <u>w</u> nload	

Figure 2-1:

When the Photo Downloader first launches, you see this dialog box, which lets you choose where Elements puts your photos and what it names them (say goodbye to names like IMG_0327.JPG). To start, choose your camera or card reader from the "Get Photos from" list at the top of the dialog box.

If you want to import only specific images, click the Advanced Dialog button (circled) so you can choose which photos to grab and fine-tune other settings.

• **Create Subfolder(s).** If you want to have more levels of organization, you can put your files into a subfolder *inside* the folder you chose for the Location. This subfolder can be labeled with today's date, the shot date (in your choice of several different formats), or a custom name.

Tip: When you name the subfolder, you can create an album (page 59) of all the photos in the subfolder with just one click once you're in the Media Browser window (page 56).

• **Rename Files.** Here, you can choose to give all the files you're importing a custom name. If you type in *obedience_school_graduation*, for example, then you get photos named obedience_school_graduation001, obedience_school_graduation002, and so on. Or you can use a combination of a custom name and the date you shot the photo. You can also use just the shot date or today's date, or the name of the subfolder. No matter which naming scheme you choose, Elements

adds a three-digit number to the end of each file's name (as in the obedienceschool example) to help you distinguish between them. You can also choose Advanced Rename to bring up a window where you can set a very complex group of parameters for naming your photos. If you leave the Rename Files field set to "Do not rename files," then Elements keeps the camera's filenames and numbers.

- **Preserve Current Filename in XMP.** Turn this checkbox on if you want the photos' current filenames to be stored in the photos' *metadata* (page 71).
- Open Organizer when Finished (Windows only). If you're going to put your files in the Organizer, leave this checkbox turned on. Turn it off if you don't use the Organizer, or if you'd rather wait till later to get organized. (You won't see this checkbox if the Organizer is already running when you import your photos.)
- **Delete Options.** You can have the Downloader delete your files off your camera's memory card when it's done importing them. Figure 2-2 explains more about this option.

Delete Options:	After Copying, Do	Not Delete Original	s	•
	After Copying, Do After Copying, Ver	Not Delete Origina	ls inals	
	After Copying, De			5
Advanced Dialog			Get Media	Cancel

Figure 2-2:

The Photo Downloader can delete the files from your camera or memory card reader once it's done importing them. This feature seems handy, but think twice about using it. The Downloader is pretty reliable, but it's always good to wait until you've reviewed all your photos in Elements before deleting the originals. If you really want the Downloader to delete your files, at least choose "After Copying, Verify and Delete Originals" from the Delete Options Menu to make Elements check that it has copied your files correctly before vaporizing the originals.

Automatic Download (Windows only). If you like to live dangerously, you can turn on this checkbox and Elements will download any new photos it detects without showing you the Downloader dialog box. It's almost always best to leave Automatic Download off so that you have some control over what's going on. (This checkbox appears only after you've selected a device in the "Get Photos from" menu.) If you decide to take this risky route, you can tell Elements where to put your photos and whether it should delete the originals by going to the Organizer and choosing Edit→Preferences→"Camera or Card Reader."

The Downloader is smart enough to recognize any photos that it's already imported, and it doesn't reimport those. If you want to see your duplicates and for some reason download them again, or if you want to pick and choose which photos to import,

Importing from Cameras

then click the Advanced Dialog button at the bottom of the Downloader window to bring up the dialog box shown in Figure 2-3. (If you change your mind and want to switch back to the standard dialog box, click the Standard Dialog button.)

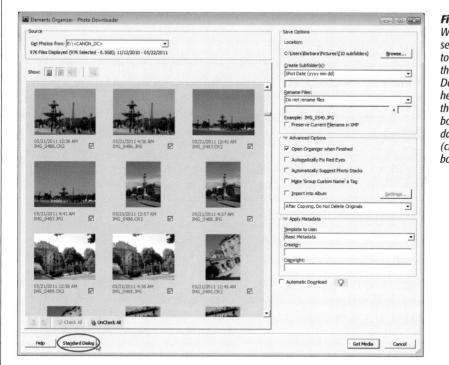

Figure 2-3:

When you want to select which photos to import, summon the advanced Photo Downloader, shown here. To get back to the standard dialog box, click the Standard Dialog button (circled) near the bottom-left corner.

The advanced dialog box gives you all the options found in the standard Downloader window, plus a few more. The advanced dialog box is divided into two main parts. On the left side are the thumbnails of your photos. The little checkmarks next to each image indicate which photos Elements plans to import; just turn off the checkboxes for the ones you don't want to bring into the Organizer. If you plan to import only a few images, save yourself some time by clicking Uncheck All below the preview area and then turn on the checkboxes for the ones you want. (If you've already imported some of the images, the Organizer tells you so and doesn't import them again.) You can also import video and sound files.

The four buttons above the preview area (next to the word "Show") let you choose which files you see. From left to right, the buttons are:

• Show/Hide Images. If you want to temporarily hide your photos (so you can look at just your video files, for instance), click this button or press Ctrl+M/ ℜ-M.

- Video files. This button is grayed out unless Elements finds any movie or video files on your memory card. If it does, you can hide them by clicking this button. You might do that if, say, you're only interested in importing still photos right now. To see the video files again, just click this button.
- Audio files. This button works just like the video button, but it becomes active when Elements finds audio files you may want to import.
- Show Duplicates. If Elements has already imported some of the photos on your memory card and you want to see those files again, click this button and you can reimport them (or just see them for comparison's sake). In the preview area, the thumbnails of the files you've already imported display an icon that looks just like this button in their upper-right corners to indicate that they're duplicates.

Note: If you want to search for duplicates among the images already on your computer, you may think you've lucked out with Elements 10. Going to Find—By Visual Searches—"Search for Duplicate photos" in the Organizer sounds like just the ticket, doesn't it? Unfortunately, this is just a visually based search and, while Elements *may* find some duplicates this way (as well as a lot of photos you probably don't consider duplicates), there's no easy way to cull through the photos it finds, since you can't see any file information here to help you decide which of two visually identical images is the one you want to keep. All you can really do in the search results window is stack them.

The right side of the dialog box is where you can adjust the settings for where your pictures are stored on your computer and how their folders are named. Most of these choices are the same ones you get in the Photo Downloader's standard dialog box, but you also get a few extras:

- Automatically Fix Red Eyes. If you turn this checkbox on, Elements searches through all your newly imported photos looking for people with red eyes (caused by camera flash) and fixes them automatically. It sounds great, but it's not 100 percent reliable and tends to "fix" things like bright white teeth, as well. Fortunately, these changes aren't permanent because Elements makes a version set (page 75) with your original, so you can ditch the new version if you don't like what Elements did. But the extra time it takes for Elements to analyze all your photos *and* the time you'll waste looking for mistakes mean you're better off leaving this option turned off and using another method to fix red eyes later. See page 133 for more about Elements' Red Eye Removal tool. (You may find you also need to turn off Automatically Fix Red Eyes in the Organizer by going to Edit→Preferences→"Camera or Card Reader" to keep this setting from turning itself back on again.)
- Automatically Suggest Photo Stacks. The Organizer lets you group related photos together into *stacks* (Appendix B). Turn this checkbox on to use the auto-stack feature, where Elements automatically finds photos that should be grouped together. This feature works best for photos taken in your camera's burst (rapid advance) mode—in other words, photos of the same subject taken very close together in time.

- Make 'Group Custom Name' a Tag. If you chose a custom name for your images, you can assign that name as a tag here. (Tags are explained on page 61.)
- **Import into Album**. Turn this checkbox on and Elements automatically adds the files you're currently downloading to the album you choose. Click the Settings button to select an existing album or create a new one. This feature is especially useful if you've set up albums to automatically sync to Photoshop.com (page 82).
- **Apply Metadata.** If you want to write your name or copyright info right into the files' *metadata* (page 71) so that anyone who views your files will know they're yours, you can do that here.

Once you're done adjusting the Downloader's settings, click Get Media. The Downloader slurps down the photos and launches the Organizer so you can review your pictures.

Tip: In Windows, you can tell the Organizer to "watch" folders that you often bring graphics—or even sound files or videos—into. (Sorry, folder watching isn't available on Macs.) Elements automatically starts out by watching your Pictures folder, which means the program will find all the new photos that you put there. But you can have it watch other folders, too. When you set a watched folder, Elements keeps an eye on it and, when new photos appear there, either imports the new files or tells you they're waiting for you, depending on which option you choose. In the Organizer, go to File→Watch Folders and click the Add button, and then browse to the folder you want Elements to watch. And if you don't want Elements to watch any folders, this is where you turn this feature off.

Opening Stored Images

If you've got photos already stored on your computer, you have several options for opening them with Elements. If you don't have Elements running but the file's format is set to open in Elements, then simply double-click the file's icon to launch Elements and open the image. (To change which files open automatically in Elements, see the box on page 49.) You've also got a few ways to open files from within Elements:

- From the Organizer, for files not yet in the Organizer: Go to File→"Get Photos and Videos"→"From Files and Folders" or press Ctrl+Shift+G/Shift-ℜ-G, navigate to your photos, and then select them and click Get Media. (The other options in the "Get Photos and Videos from Files and Folders" dialog box—like fixing red eye and automatically suggesting photo stacks—are covered on page 46.) Then follow the steps in the next bullet point for opening your photos in the Editor.
- From the Organizer, for files already in the Organizer: You can select an image that's in the Organizer and open it in the Editor. To do so, in the Organizer, either click the file's thumbnail and then press Ctrl+I/#-I; right-click the thumbnail and choose "Edit with Photoshop Elements Editor;" or click the little triangle to the right of the Fix tab (in the upper right of the Organizer window), and then select Full Photo Edit (if you'd rather go to Quick Fix [page 127] or Guided Edit [page 34], then select Quick Photo Edit or Guided Photo Edit

instead). You can also Shift-click or Ctrl-click/#-click to select multiple photos before using any of these commands, and *all* those photos go to the Editor.

Tip: When your photos get to the Editor, they should appear in the main editing space. If you don't see anything there, go down to the Project bin, and, from the drop-down menu, choose "Show Files selected in Organizer."

- From the Editor, for files anywhere on your computer. Go to File→Open or press Ctrl+O/#-O and select your file(s). You can also drop a file right onto the Editor's main window and it'll open, as long as you're in Full Edit rather than Guided, or Quick Fix.
- From other programs. If you use another program to manage and organize your photos, like Lightroom, Aperture, or iPhoto, it's best to set Elements up as your external editor for that program and send your files to the Editor that way, rather than trying to use Elements' File→Open command. There are two reasons for this: First of all, your other program may be able to create and save *version sets* (page 75) like the Organizer does, but it won't be able to do that unless you send your files out for editing from within your other program. Also, the *library* file (the data the program stores about your photos) may be corrupted if you don't handle it exactly the way it's meant to be used. iPhoto's library is particularly resentful of being poked and prodded from outside the program itself.

The exact method for setting up an external editor depends on which program you're using, but there's typically a place to do that in the program's preferences. In Windows, you probably get to them by going to Edit \rightarrow Preferences, and on a Mac, it's likely <Application name> \rightarrow Preferences.

People who are new to Elements often get confused by the message shown in Figure 2-4, which appears in the Organizer when you leave a photo open in the Editor.

Figure 2-4:

This red "locked" band just means that you left your photo open in the Editor when you came back to the Organizer. To unlock it so that you have access to it in the Organizer, switch back to the Editor and close the photo.

FREQUENTLY ASKED QUESTION

Picking the File Types That Elements Opens

How do I stop Elements from opening all my files?

Many people are dismayed to discover that once they install Elements, it opens every time they double-click any kind of graphics file—whether they want the file to open in Elements or not. You can fix that easily enough:

In Windows: First, find a file of the type you want to change (like a JPEG, for example). Then, right-click the closed file's icon and, if you're using Windows 7 or Vista, select "Open with"→"Choose Default Program" from the pop-up menu. (If you're in Windows XP, select Open With→Choose Program instead.) In the list that appears,

select the program you want to use to open the file. Turn on the "Always use the selected program to open this kind of file" checkbox to set that program for all files of this type.

On a Mac: In the Finder, find a file of the type you want to change (like a JPEG, say). Click once to select it, and then press **#**-I to bring up the Get Info window, which has lots of data about your file. Expand the "Open with" section by clicking the flippy triangle next to it, choose the program you want from the pull-down menu, and then click the Change All button. Voilà–from now on, those kinds of files will open in the program you chose.

Working with PDF Files

If you open a PDF file in Elements, you'll see the Import PDF dialog box (Figure 2-5), which gives you lots of options for how Elements treats your file. You can choose to import whole pages or just the images on the pages, import multiple pages (if the PDF is more than one page long), and choose the color mode (page 54) and the resolution of the imported files, as well as whether you want Elements to use anti-aliasing (page 165).

Scanning Photos

Elements comes bundled with many scanners because it's the perfect program for making scans look their best. You have two main ways of getting scanned images into Elements. Some scanners come with a *driver plug-in*, a little program that lets you scan directly into Elements. Look on your scanner's installation software for info about Elements compatibility, or check the manufacturer's website for a Photoshop plug-in to download. (If the scanner lets you scan into Photoshop, you should be able to scan into Elements, too.) You may also be able to scan into Elements if your scanner uses the *TWAIN interface*, an industry standard used by many scanner manufacturers.

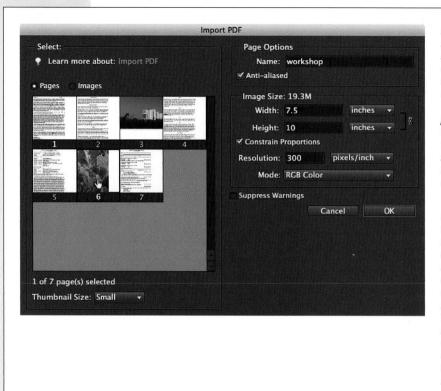

Figure 2-5:

Elements can open multipage PDFs. To open just one page of the file, double-click the page's thumbnail. To open multiple pages, Ctrl-click/ \$\$-click the ones you want, or Shift-click to select a range and then double-click to open them.

You can catalog PDF files in the Organizer, too. To do that, go to File→"Get Photos and Videos"→"From Files and Folders," and, in the dropdown menu in the bottom part of the window (on a Mac it's labeled "Enable"), choose PDF Files, and then navigate to the PDF you want to import.

Note: In Elements 10, you'll need to move the Adobe TWAIN driver (Twain_32.8ba), if your scanner requires it, before you can scan into Elements. In Windows, go to *C:\Program Files [Program Files(x86) for 64-bit systems]\Adobe\Photoshop Elements 10\Optional Plug-Ins\Import-Export*, find the Adobe TWAIN driver, and move it to *C:\Program Files [Program Files(x86) for 64-bit systems]\Adobe\Photoshop Elements 10\Cocales\en_US\Plug-Ins\Import-Export* (the "en_US" part will be different if you aren't in the US).

On a Mac, go to Applications—Adobe Photoshop Elements 10—Support Files—Optional Plug-Ins— ImportModules, and move TWAIN.plugin from there into Applications—Adobe Photoshop Elements 10— Support Files—Plug-Ins—Import Modules. For the App Store version, go to Applications and Right-click/ Control-click Adobe Photoshop Elements 10 Editor and choose Show Package Contents—Contents and move TWAIN.plugin from Optional Plug-ins—ImportModules to Plug-ins—ImportModules. (When you start to move it, you'll see a message warning that plug-ins can't be modified. Click Authenticate and enter your OS X account password, and then you'll be able to move it.)

If you have a Mac, you need to be aware that not all Photoshop-compatible plug-ins will work with Elements 10. If you install your scanner, launch Elements, and then see a window that says, "One or more plug-ins are currently not available..." that usually means that your scanner plug-in isn't compatible with Elements 10, probably because you're trying to run a PowerPC plug-in on your Intel Mac. Here's why that's

important: Beginning with Elements 8, Adobe decided not to let Elements run in Rosetta, the part of OS X that allows programs written for the older PowerPC Macs (G5 and earlier) to run on Intel Macs (newer Macs that use Intel processors). So your old scanner plug-in isn't going to work in Elements 10.

There are a couple of workarounds: If you're using Mac OS X 10.6 (Snow Leopard), you can keep an older version of Elements around for scanning, if you have one, or you can use the standalone scanner software that your scanner manufacturer may provide. (In OS X 10.7 [Lion], Rosetta isn't available for *any* program.) In OS X 10.6 and 10.7, you can also scan from Preview and send the scan straight to Elements. To do that, launch Preview with your scanner connected and then go to File→"Import from Scanner." You can even tell Preview to send your scan to Elements when you're done scanning. However, if you have a really old scanner, the scanning features in 10.6 or 10.7 may not acknowledge its existence, in which case you have to use the software provided by the manufacturer.

To control your scanner from within Elements, you can scan from the Editor and (in Windows) the Organizer. In the Editor, go to File→Import, and you'll see your scanner's name in the list that appears. In the Windows Organizer, go to File→"Get Photos and Videos"→From Scanner, or press Ctrl+U. You should check out your available options for both locations because they're probably different. For instance, you may find that you have different file formats available to you in the Editor than you do in the Organizer.

If you don't have an Elements plug-in for your scanner and the Adobe TWAIN driver doesn't work for you, you'll need to use the software that came with your scanner. Then, once you've saved your scanned image in a format that Elements understands, like TIFF (.tiff, .tif) or Photoshop (.psd), open the file in Elements like you would any other photo. (Page 75 explains which formats Elements can use.)

Tip: If you do a lot of scanning, check out the Divide Scanned Photos command (page 89), which lets you quickly scan in lots of photos at the same time. Also, you can save yourself a lot of drudgery in Elements if you make sure that both your scanner's glass and the prints you're scanning are as dust-free as possible before you start.

Capturing Video Frames

Elements lets you snag a single frame from a video and use it the way you would any still photo. This feature works only with movie files that are already on your computer (meaning you can't snag a frame from a video that's streaming to your computer from the Web). You're also limited to the formats that your operating system understands. So, for example, if you have a Mac, you may be able to watch videos in Windows Media (.wmv) format if you have Flip4Mac (*www.flip4mac.com*) installed, but you won't be able to import frames from those files, because OS X can't read them without a special program to help it out. Likewise, in Windows you can install Quicktime (it comes with iTunes, so you probably have it if you have an iPod, iPad,

or iPhone), but you can't open Quicktime (.mov) files in Elements. And no matter what kind of computer you have, this Elements feature doesn't work with HD (high-definition) videos.

Note: Elements' video-capture tool isn't really designed for use with long movies. You'll get the best results with clips that are less than a minute or two long.

To import a video frame, in the Editor, go to File \rightarrow Import \rightarrow Frame From Video, and then in the Frame From Video dialog box:

1. Find the video that contains the frame you want to copy.

Click the Browse button and navigate to the movie file you want. After you choose the movie, the first frame appears in the dialog box's preview window.

2. Navigate to the frame you want.

Either click the Play button (the single triangle), or use the slider below the window to move through the movie until you see what you want.

3. Copy the frame by clicking the Grab Frame button.

You can capture as many frames as you want by repeating this process. Each frame shows up in the Editor as a separate file.

4. When you have everything you need, click Done.

While grabbing video frames is fun, it does have certain limitations. Most important, your video appears at a fairly low resolution, so don't expect to get a great print from a video frame.

Creating a New File

You may want to create a new, blank document when you're using Elements as a drawing program or when you're combining parts of images, for example.

To create a new file, go to the Editor, and choose File→New→Blank File or press Ctrl+N/æ-N. Either way, you see the New dialog box. You have lots of choices to make each time you start a new file, including what to name it. All your other options are covered in the following sections.

Tip: You can't create a new, blank file in the Organizer, but Elements gives you a quick shortcut from the Organizer to the Editor so you can open up a new file there. In the Organizer, choose File \rightarrow New \rightarrow Photoshop Elements Image File, and Elements sends you over to the Editor and creates a virgin file for you. If you want to create a new file based on a photo that's in the Organizer, select the image's thumbnail, press Ctrl+C/**#**-C to copy the image, and then choose File \rightarrow New \rightarrow "Image from Clipboard." Elements switches you to the Editor, where you'll see your copied photo awaiting you, all ready to work on.

Picking a File Size

After you type a name for your file in the New dialog box, the next thing you need to decide is how big you want it to be. There are two ways to do this:

• Start with a Preset. The Preset menu, the second item in the New dialog box, lets you choose the general kind of document you want. If you want to create a file for printing, pick from the menu's second group. The third group contains choices for onscreen viewing. Once you make a selection here, the next menu—Size—changes to show you suitable options for your choice. Figure 2-6 shows you how it works.

Cancel
Image Siz

Figure 2-6:

Elements helps you pick an appropriate size when you use the Preset menu. Here, Photo is selected, so the Size menu includes standard sizes for photo paper, each available in either landscape or portrait orientation. (What Elements calls the "Default Photoshop Elements Size" is 4"×6" at 300 pixels per inch, which works well if you're just playing around and trying things out.)

Tip: If you're into scrapbooking, you'll be pleased to see that Elements offers some standard scrapbook page sizes as presets.

• Enter the numbers yourself. If you prefer, just ignore the Preset and Size menus, and type what you want in the Width and Height boxes. The drop-down menus next to the boxes let you choose inches, pixels, centimeters, millimeters, points, picas, or columns as your unit of measurement.

Choosing a Resolution

If you decide not to use one of the size presets, you'll need to choose a resolution for your file. You'll learn a lot more about resolution in the next chapter (page 115), but a good rule of thumb is to go with 72 pixels per inch (ppi) for files that you'll look at only on a monitor, and 300 ppi for files you plan to print.

Selecting a Color Mode

Elements gives you lots of color choices throughout the program, but *color mode* is probably the most important one because it determines which tools and filters you can use on your document. Your options are:

- **RGB Color.** Choosing this mode (whose name stands for red, green, and blue) means that you're creating a color document, as opposed to a black-and-white one. (Page 241 has more about color in Elements.) You'll probably use this mode most of the time, even if you don't plan on having color in your image, because RGB gives you access to all of Elements' tools. That's right: You can use RGB Color mode for black-and-white images—and many people do, since it gives you the most options for editing your photo.
- **Bitmap.** Every pixel in a bitmap mode image is either black or white. Use Bitmap mode for *true* black-and-white images—shades of gray need not apply here.
- **Grayscale.** Black-and-white photos are technically called *grayscale* images because they're really made up of many shades of gray. In Elements, you can't do as much editing on a grayscale photo as you can on an RGB one (for example, you can't use some of the program's filters on a grayscale image).

Tip: Sometimes you may need to change the color mode of an existing file to use all of Elements' tools and filters. For example, there are quite a few things you can do only if your file is in RGB color mode. So if you need to use a filter (page 435) on a black-and-white photo and the menu item you want is grayed out, go to Image—Mode—RGB Color. Don't worry, changing the color mode won't suddenly colorize your photo; it just changes the way Elements handles the file. (You can always change back to the original color mode when you're done.) If you use Elements' "Convert to Black and White" feature (page 345), you'll still have an RGB-mode photo afterward, not a grayscale mode image.

If your image is in RGB and you *still* don't have access to the filters, check to see if the file is 16 bit (page 285). If so, you need to convert it to 8-bit color to get everything working. Make that change by choosing Image→Mode→8 Bits/Channel. You're most likely to have 16-bit files if you import your images in Raw format (page 270), and some scanners also let you create 16-bit files. JPEG files are always 8-bit.

Choosing a Background

The last choice you have to make when creating a new file is the file's *background contents*, which tells Elements what color to use for the empty areas of the file, like, well, the background. You can be a traditionalist and leave the New dialog box's Background Contents menu set to white (almost always a good choice), or choose a particular color or *transparency* (more about transparency in a minute). To pick a color other than white, use the Background color square, as shown in Figure 2-7, and then select Background Color from the New dialog box's Background Contents menu.

Figure 2-7:

To choose a new Background color, just click the Background color square in the Tools panel (here, that's the red one) to bring up the Color Picker. Then select the color you want. Your new color appears in the square, and the next time you do something that involves using a Background color, that's the shade you get. The color-picking process is explained in much more detail on page 254.

"Transparent" is the most interesting option. To understand transparency and why it's such a wonderful invention, you need to know that *every* digital image is either rectangular or square. Digital images *can't* be any other shape, but they can *appear* to be a different shape—sunflowers, sailboats, or German Shepherds, for example. How? By placing an object on a transparent background so that it looks like it was cut out and only its shape appears, as shown in Figure 2-8. The actual photo is still a rectangle, but if you placed it into another image, you'd see only the shell and not the surrounding area, because the rest of the photo is transparent.

Figure 2-8:

This checkered background is Elements' way of indicating that an area is transparent. (It doesn't mean you've somehow selected a patterned background.) If you place this photo into another image, all you'll see is the seashell, without the checkerboard or the rectangular outline of the photo. If you don't like the size and color of the checkerboard, you can adjust them in Edit→Preferences→Transparency/ Adobe Photoshop Elements Editor→ Preferences→Transparency. To keep the clear areas transparent when you close your image, you need to save the image in a format that allows transparency. JPEGs, for instance, automatically fill transparent areas with solid white, so they're not a good choice. TIFFs, PDFs, and Photoshop files (.psd), on the other hand, let the transparent areas stay clear. Page 553 has more about which formats allow transparency.

Using the Organizer

The Organizer is where you keep track of your photos and start most of the projects that involve sharing images with others (like posting them online, for example). You can see thumbnails of all your photos in the Organizer, assign them keywords (called *tags*) to make them easier to find, and search for them in lots of different ways. If you have a Photoshop.com account (page 21), that site also includes a version of the Organizer that works just the way it does on your desktop.

The *Media Browser* is the Organizer's main window. *Date view* (go to Display \rightarrow Date View, or press Ctrl+Alt+D/Option- \Re -A) is an alternate, calendar-based way of looking at and searching for photos, as explained in Figure 2-9. But the Media Browser is more versatile: It's your main Organizer workspace, which is what the rest of this section is about.

Figure 2-9:

Date view offers you the same menu options as the main Media Browser window, but instead of a contact sheet-like view of your photos, your images are laid out on a calendar. Click a date (here, November 1 is selected), and in the upper-right corner of the screen, you can view or advance through a slideshow of that day's pictures by using the controls circled here. Date view is fun and sometimes handy for searching, but it doesn't offer many useful features that aren't also in the Media Browser.

DECISIONS, DECISIONS

Should I Use the Mac Organizer?

Adobe now includes the Organizer in the Mac version of Elements, instead of Adobe Bridge, which came with older versions (Elements 8 and earlier). So if you have a Mac, you need to decide whether to use the Organizer to keep track of your photos (unless, of course, you bought Elements from the Mac App Store, in which case you got the Organizer-free version).

If you've been using the Organizer in Windows and you just got a Mac, you definitely want to use the Mac Organizer, since that's the easiest way to move everything over. (You can only move catalogs made with Elements 9 or 10 from one platform to the other, so if you have an older version of Elements for Windows, install Elements 10 in Windows and use it to upgrade your existing catalog. Next, make a full backup of your catalog to a removable hard drive. Then install Elements 10 on your Mac-you get both versions of the program in the same box-and restore the backup on the Mac [page 85 explains how]. Once you're sure everything's working okay, you can deactivate Elements on the Windows computer [page 614] if you no longer need it.) Also, if you have Premiere Elements, Adobe's video-editing program, the Organizer is much more important to that program than it is to Photoshop Elements.

If you use iPhoto, it's easy to siphon your images into the Organizer using the "From iPhoto" command in the File→"Get Photos and Videos" menu. You can import your entire iPhoto library or specific events (click More Options in the Import from iPhoto window to choose events) into Elements in a way that won't harm your photos. Elements reads your iPhoto library to get info about your photos, but if you create new files or edit existing files, Elements saves that information in another folder outside the iPhoto library (page 74 has more about saving files). This is good, because the iPhoto library gets very cranky if you poke at it from outside iPhoto (don't try to make Elements save back into the iPhoto library or you could lose your photos entirely). However, the Windows Organizer has been known to make unexpected changes to the metadata (page 71) of files in the Organizer; if this happened to an image that's already in iPhoto it's hard to tell what the effect might be. So if you're feeling brave, go ahead and give the Organizer a try. Just know that there's a slight risk involved.

If you want to move only some of your photos to the Organizer or just try it out, export your photos from the photomanagement program you currently use, or create duplicate files to use as your test catalog. Put them where you want to keep them, then import them by going to File—Get Photos—"From Files and Folders" in the Organizer.

The two big advantages to using the Organizer are that you can use all of Elements' features and Elements lets you save unlimited versions of your photos (see page 75). iPhoto, on the other hand, only keeps a single version plus the original. That means that if you edit a photo and then save it again, iPhoto overwrites the previous version (unless you import your saved files into iPhoto as new documents, which is a pain). The big disadvantages of using the Organizer are that it's not as smoothly integrated with other OS X programs as iPhoto is, and the Organizer is missing a lot of features that are in the Windows version. So while it's worth giving the Organizer a try, you may want to hold off until a later version of Elements before you go whole hog with it. Whatever you do, don't use both the Organizer and iPhoto to keep track of all your photos because the two programs don't understand each other very well and you'll just get confused.

If you decide to avoid the Organizer, Adobe makes it easy to ignore it on a Mac. Just turn off the "Include in the Elements Organizer" checkbox in the Save As window (it should stay off, at least for that editing session). If photos accidentally get Organized, it's not a big deal, since the Organizer is just a database, which means it's not making copies of your photos and wasting gobs of space with duplicate images. If you're a fan of Adobe Bridge, you can keep using it. You just can't update it anymore, which is likely to be a problem if you shoot in Raw format (page 270) and buy a new model camera whose Raw format Bridge doesn't understand. (You can learn more about using Elements with iPhoto and using Bridge with later versions of Elements at *www.barbarabrundage.com.*) The Organizer stores information about your photos in a special database called a *catalog*. You don't have to do anything special to create your catalog—Elements creates it automatically the first time you import photos (and creatively names it *My Catalog*). It's possible to have more than one catalog, but most people don't because you can't search more than one catalog at a time. If you really want to have more than one catalog, or if you ever want to start over with a new catalog, in the Organizer go to File→Catalog, and then click the New button. Enter a name for it and then click OK.

Your catalog can include photos stored anywhere on your computer, and even photos that you've moved to external hard drives and CDs or DVDs. There aren't any limits on where you can keep your originals. That's how it's supposed to work, anyway. But in practice, Elements sometimes has a tough time finding files stored on network drives and other externals, so you may run into trouble if you want Elements to find photos you've saved on such devices. (The Mac Organizer, in particular, can't deal with network drives at all, although it should see removable drives, like FireWire or USB drives.)

Once your photos appear in the Organizer, if you want to move them, you have to use the Organizer to do that—as opposed to using another method like Windows Explorer—if you want the Organizer to know where they are. You aren't limited to photos, either—you can store videos and audio files in the Organizer as well.

Tip: If you want to edit photos in programs other than Elements, the Organizer lets you do that. Just go to Edit—Preferences—Editing—Supplementary Editing Application and select your preferred program. (If you have Photoshop installed on your computer, it's automatically listed as an editing option.) This is handy if you want to supplement Elements with a program like Paint Shop Pro or Pixelmator.

The Media Browser

Although the Media Browser (Figure 2-10) may look a little intimidating at first, it's really quite logical. By using its different menu options, you can import photos; print, edit, and share them; create projects; and customize your view. The Media Browser displays thumbnails of all your images in the main part of the window (sometimes called the *image well*).

Tip: In some previous versions of Elements, the Media Browser was called the Photo Browser, in case you run across that term in any tutorials. Adobe changed the name to reflect the fact that now it's also meant for use with their Premiere Elements video-editing program, too. You may see lots of references to Premiere Elements in the Organizer's menus. If you don't use Premiere Elements, you can get rid of most of them by going to the Organizer and choosing Edit—Preferences—Editing, and turning off the "Show Premiere Elements Editor Options" checkbox.

Figure 2-10:

The Media Browser is vour main Oraanizer workspace. Click the divider (circled, left) to hide or show the Oraanize bin (the cursor morphs into a double-headed arrow when vou're in the correct spot for clicking). If you want to change the way your photos are sorted. click the Display menu in the upper-riaht corner (circled, top).

On the right side of the Media Browser is the *Task pane*, which you also see in the Editor. It has the same Create and Share tabs as in the Editor, and two tabs unique to the Organizer. The first is the Organize tab, which is home to the *Organize bin*, where you *tag* (label) your photos with keywords to make them easier to find. (Tagging is probably the first thing you'll want to do to your photos in the Organizer; you'll learn how to tag in the next section.) You can also group your photos together into collections, called *albums*, here (see page 59). To the right of the Organize tab is the Fix tab, where you can choose to send your photos over to the Editor or to another editing program to work on them, or apply many basic quick fixes (see page 129).

If you'd like to see both the pictures *and* the folders where they're stored, go to Display→Folder Location. A new pane appears on the left side of the Media Browser showing the folders on your computer. If you click a thumbnail when you're in Folder Location view, the Folders pane shows you exactly where the current batch of photos lives. Click a folder's icon to see its photos displayed in the image well.

Tip: If you've used early versions of the Organizer and you miss the Timeline, go to Window \rightarrow Timeline or press Ctrl+L/ \Re -L to bring back your old friend. For folks new to Elements, the Timeline is explained on page 69.

You can also move your photos directly in the Folders pane by dragging them. Moving your photos this way is better than moving them by using, say, Windows Explorer or the Finder on a Mac, because it lets Elements keep track of where your photos are (Figure 2-11). But Folder Location view can be rather buggy, so your best bet is to just stop worrying about where your images are and to let the Organizer figure that out for you.

Figure 2-11:

If you want to move photos around on your computer after you've brought them into the Organizer, you can drag them within this pane of the Media Browser, but it's safer to go to File \rightarrow Move instead, since Folder Location view has a number of quirks and bugs. If you move photos around when you're not in the Organizer, Elements can't easily find them. If Elements loses track of a photo, you can use the Reconnect command (File \rightarrow Reconnect) to help Elements find it again.

Full Screen view

One of the handiest features in the Organizer is Full Screen view. Once you get your photos into the Organizer, go to Display→"View, Edit, Organize in Full Screen" (keyboard shortcut: F11/ૠ-F11) or "Compare Photos Side by Side" (F12/ૠ-F12) to see a larger, slideshow-like view of your photos (either singly or in pairs, depending on the option you select) so you can pick the ones you want to print or edit. You can even choose music to accompany them. (If you don't want anything that elaborate, just double-click a thumbnail in the Media Browser to see your photo enlarged to fit the available space. Double-click it again to go back to thumbnail view.)

Elements also lets you apply many quick editing commands right in Full Screen or Side by Side view (see page 577). Just hover your cursor over the Quick Edit panel on the left side of your screen, and it pops out to give you access to all the one-button fixes available in the Editor's Quick Fix mode (page 127). You can also rate your photos here (page 65) by using the stars at the top of the panel. The Quick Organize panel (also on the left side of the screen) lets you apply keyword tags in Tag Cloud view (page 62), or put your photos into albums (page 59). **Tip:** The Organizer's Quick Edit and Quick Organize panels close back up each time a new image appears onscreen. If you want a panel to stay open, click the tiny pushpin icon on its right edge. To get rid of a panel entirely, click the Close button (the X in Windows, the dot on a Mac). To bring it back, use the controls at the bottom of the screen, which are described in detail on page 578.

You can even use Full Screen view as a quick slideshow to show off your latest images—see page 577 to learn how. To get back to the regular Media Browser view, press Esc.

WORKAROUND WORKSHOP

Avoiding the Organizer

People either love the Organizer or they hate it. If you're in the latter group and you have a Windows computer, try to see if you can come to terms with the Organizer, because it does have some useful features. You'll lose a lot if you give up the Organizer, as it's the only place in Elements where you get a visual preview of your images before opening them. Mac Organizer loathers, head over to the box on page 57; if you have a Windows computer, read on.

If you just can't abide the Organizer, or if you prefer to use a different program like Lightroom or Windows Live Photo Gallery to organize your photos—or you just like to be disorganized—then you can sidestep the Organizer. Simply adjust your settings on the Welcome Screen as described on page 18 so that you always start up in the Editor. Also, remember to keep "Include in the Elements Organizer" and version sets turned off in the Save dialog box whenever you're saving a picture. Once you turn off the "Include in the Elements Organizer" setting, it stays off until you turn it back on, or until you open a photo from the Organizer (after which it turns itself back on). You may find you need to turn it off once every editing session (maybe not, if you're lucky) but you *don't* have to keep turning it off every time you save. If you want to be extra sure that Elements doesn't interpret any of your photo-related activities as a call for the Organizer, go to your computer's Control Panel→Administrative Tools→Services and find Adobe Active File Monitor V10. (In Windows XP or Vista you may need to choose Classic View first; and in Vista, you'll also see a dialog box or two asking for permission to continue.) This is a *service*, a small program that always runs in the background when your computer is on, even when Elements is closed. Click Adobe Active File Monitor, and then go to Action→Properties and set the "Startup type" option to Disabled.

There's a downside to disabling this service, though: The File Monitor also keeps track of the databases for the Content and Effects panels, so if you disable it, any new layer styles, effects, and so on that you add to Elements (see Chapter 19) may not appear in these panels. The workaround is to add the new material and then turn Adobe Active File Monitor back on before you start Elements again. Then, after the database has been rebuilt and you see all the thumbnails in the panels, you can disable it again till the next time you add something new.

Creating Categories and Tags

The Organizer has a great system for quickly finding photos, but it works only if you use special keywords, called *tags*, that the Organizer uses to track down your pictures. A tag can be a word, a date, or even a rating (as explained in the box on page 65). When you import photos to the Organizer, they're automatically tagged with

People Recognition

One interesting feature in Elements is *face recognition*, which was introduced in Elements 8. In earlier versions of the program, you could tell the Organizer to find all the people in your photos, but that was as far as it went: the Organizer presented you with everything it thought looked like a human face, and it was up to you to sort it out. Now, the Organizer finds faces and you help it out at first by naming the people it finds. After that, it should be able to automatically recognize and tag Cousin Serafina and Great Uncle William in future photos without you having to identify them.

Tip: While People Recognition is only meant to work with human faces, you can use the new Object search or the Visual Similarity search to find all the photos of pets, your new car, and so on. Page 70 explains how.

To get started:

1. Choose the photos you want Elements to analyze.

Select them in the Media Browser.

2. Tell Elements to start evaluating them.

In the Organize bin's Keyword Tags panel, click the Start People Recognition icon (it looks like a Polaroid photo of a person's head and shoulders) or go to Find \rightarrow "Find People for Tagging."

3. Confirm Elements' choices and identify the people it found.

After it analyzes your photos, Elements opens the People Recognition window with all the faces it found in those images. If it made a mistake or if you don't want to tag one of the people, click that face (or tree, or whatever) and then click the close button at the top-right corner of the thumbnail.

Tip: If Elements shows you something that isn't a face, it's worth taking a look at the photo itself. Occasionally there will be people in the photo but Elements just put the frame in the wrong place.

Below each person's face is the question, "Who is this?" Click that text and type the person's name. As you type, Elements suggests names based on the tags you've used before. If you see the one you want, just click it to select it.

Tip: You can download a list of your Facebook friends to make it easier to assign their names as tags. Just click the blue link at the bottom of the People Recognition window.

4. When you're through tagging people, click Save.

Elements displays a little congratulatory window and any names you've added appear in the Organize bin's Keyword Tags panel under the People category. If you want to move a tag to another category, like Family, just drag it where you want it. To see all the photos of a particular person you've tagged, double-click the person's name in the Keyword Tags panel, or double-click the thumbnail of an image where you've tagged the person. In the large single-image preview that appears, click the arrow to the right of the tag on the person's face and Elements shows you all the photos definitely identified as that person (confirmed) and those it thinks might be that person (unconfirmed). That way you can tag them all at the same time. If Elements missed someone in your photo or missed a photo altogether, you can easily remedy that. Just click the Add Missing Person button (the little human silhouette below the image's bottom right). A square outline appears on the image, and you just drag it till it's around the face Elements missed. If Elements misidentified someone, click the name it assigned and type the correct one.

Note: As mentioned on page 63, you probably want to disable the rest of Elements' Auto-Analyzer features. But to use People Recognition, go to Edit—Preferences—Media-Analysis and be sure that "Analyze Photos for People Automatically" is turned on. (If you aren't going to use People Recognition, you can save a little drain on your system's resources by turning it off.)

ORGANIZATION STATION

Special Tags

Elements starts you off with two special kinds of tags:

- Ratings. These tags let you assign a one- to five-star rating to your photos (a good way to mark the ones you want to print or edit). Ratings are a great search tool because you can tell Elements to find, say, all vour pictures rated four or more stars. To assign ratings, just click the star under the photo's thumbnail that corresponds to your rating (the third star from the left for a three-star rating, say). To search by ratings, click the appropriate star at the top right of the Media Browser and then choose a qualifier (like "and higher") from the drop-down menu to the right of the stars. You can search for all photos rated four stars or higher, for instance, or those rated two stars or lower, and so on. To change or remove a photo's rating, right-click/Control-click its thumbnail, choose Ratings from the menu that appears, and then pick the number of stars you want. You can also change a rating by clicking a different star under the thumbnail.
- Hidden. When you apply this tag to a photo, the photo disappears from the Media Browser. The Hidden tag is useful for archiving photos that didn't come out quite right but that you're not ready to trash; that way, you can save these pictures (just in case) without having them cluttering up your screen while you're working with your good photos. To assign the Hidden tag, right-click/Control-click a photo and choose Visibility→"Mark as Hidden." To bring it back, go to View→Hidden Files→Show All Files, or right-click a visible photo for the same menu choices, either of which makes even your hidden files visible. Then right-click/Control-click the photo again, and select Visibility→"Mark as Visible" to keep it in view. To put the rest of your hidden files back out of sight, choose View→Hidden Files→Hide Hidden Files. You can also see only your hidden files by going to View→Hidden Files→Show Only Hidden Files.

Albums and Smart Albums

Elements lets you group photos into *albums*, which are great for gathering together pictures taken at a particular event. You can also use them to prepare groups of photos that you want to use in a Create project like a slideshow or photo collage (page 505).

When you create an album, you don't actually make a copy of all the photos you include in it; you just create a group of virtual "pointers" to each image so Elements knows where to find them. That means albums can hold lots of pictures without taking up much space and, even better, you can easily include the same pictures in different albums. Photos in an album can appear in any order you choose, which is important if, for instance, you're preparing a slideshow.

Albums are particularly handy if you're using Photoshop.com, since they give you a convenient way to upload, sync, and back up your photos without working with your whole catalog at once.

Tip: Albums are also good for gathering together groups of photos you want to export for use with another program. Elements makes it very easy to do that: In the Organize bin's Album's panel, click the New Album button (the green + sign)—Save Albums to File.

Elements gives you several ways to create albums:

• From the Organizer. First Ctrl-click/第-click to select the photos you want to include. Then go to the Organize bin→Albums, click the New Album button (the green + sign), and then choose New Album. Name your album and assign it to an album group (explained in a moment) if you wish, and then click Done. Your new album joins the list of albums.

You can also make an album from files anywhere on your computer, even if they're not in the Organizer, by clicking the New Album button and then selecting From File from the pop-out menu.

- From the Editor. In the Editor, you can create an album from the Project bin's Bin Actions menu (page 30).
- From the Share tab (Editor or Organizer). To create an online album (one that you upload to Photoshop.com), just click Online Album in the list of projects.

Note: No matter which method you use to make your album, it will appear in the lists of albums in both the Organizer and the Project bin's Show menu.

You can share any album online as you create it (see page 572 for more info), or share existing albums by uploading them to your Photoshop.com account (just click the Edit Album button at the top of the Organize bin's Album panel [the pencil icon]). You can also share your album in other ways by right-clicking its name in the list of albums and then choosing the export method you want to use. (Albums you create by clicking the Share tab's Online Album button are uploaded automatically.) Elements gives you lots of options for displaying your photos in a gallery and sharing them with friends. Chapter 18 has more about working with and sharing online albums.

Note: You can also burn albums to CD or DVD, or upload your slideshows and galleries to your own website. Page 575 explains how.

Once you've created an online album and shared it to Photoshop.com, you can edit it using the online Organizer in any web browser, which lets you add or delete photos, reorganize photos, tag them, and so on. The online Organizer looks just like the Organizer on your computer, and you use it the same way. You can synchronize your online album(s) so that changes you make online are reflected in the album(s) stored on your computer, and vice versa (page 82 explains how). You can even sync albums between two desktop computers this way.

In the Organizer, to see the photos in an album, just click its name in the Albums panel. To return to viewing all your photos, click the Show All button above the left side of the thumbnail area.

You can also create *album categories*, which are just what they sound like. If you have a lot of albums, you can group them into categories to make them easier to keep track of. To make an album category, go to the Organize bin's Albums panel and click the New icon (the green + sign)→New Album Category. Name your category and it appears in the Albums list. To add albums to it, just drag their icons onto the category's icon. To remove an album from it, click the flippy triangle to the left of the category's name so you can see all the albums it contains, and then right-click the album you want to remove and choose "Edit <album name>." In the window that opens, go to Album Category→None (Top Level) and then click Done.

You can also create subcategories within categories. To do that, in the Albums panel, right-click a category and choose "Create new album category in <category name> category." The new category appears as a subcategory of the original one.

Smart Albums are another useful feature. They automatically collect all the photos that meet the criteria you specify, as shown in Figure 2-13. To create a new Smart Album, in the Organizer, go to the Albums panel and click New (the green + sign) \rightarrow New Smart Album.

	omatically collect files that match the criteria defined belo eria, and the Minus button to remove criteria.	w. ose the Aud Dutton t
 Name: Best Vacat 	Ion Pics	
Search Criteria		
Search for files which m	iatch: • Any one of the following search criteria[OR]	
	 All of the following search criteria[AND] 	
Keyword Tags	✓ Include Places ✓	
Rating	✓ Is higher than ✓ 3 ✓	stars -
Caption/Description	Contains vacation	
	The photo's caption or description	

Figure 2-13: When vou create a Smart Album, this dialog box appears so vou can choose criteria for it. Click the + sign to add a search parameter. Here. the Smart Album "Best Vacation Pics" is set up to include photos with tags in the Places category, ratings of more than three stars, and the word "vacation" in their caption or description. Elements automatically adds photos that meet all three of these criteria to this Smart Album.

Searching for Photos

If you've been diligent and assigned tags to all (or at least most) of your photos, you'll be pleased to learn how easy Elements makes finding tagged photos. And what about the untagged masses? The good news is that Elements still gives you some helpful ways to find your pictures. The next few sections take you through all your options.

Browsing Through Photos

When you don't know exactly which photo you're looking for, Elements gives you a few ways to search through groups of pictures. These methods are also great if you don't want to look through your whole collection:

- **Text search.** You can just type what you're looking for into the Search box at the upper left of the Media Browser. Enter a filename, caption, date, tag, or anything that's in the file's *metadata* (see the box on page 71) and Elements will find it. As you type, Elements displays a pop-out list of tags beginning with the letters you're typing. If you want to search for one of those tags, click it. You can also combine terms by using *and*, *or*, or *not*. You can even restrict what you want to search for; so if you enter, for example, *Caption:Birthday* in the Search box, you'll get photos with Birthday in their captions.
- **Visual Search.** You can show Elements a picture of your dog, your house, or just about anything, and tell it to find more photos with the same subject. This kind of search is explained beginning on page 70.

- Folders. You can navigate through the folders stored on your computer, just as you do when using a program like Windows Explorer or the Mac's Finder. First, turn on Folder Location view if you haven't already done so (go to Display→Folder Location or press Ctrl+Alt+3/Option-第-3). Then navigate by expanding the folders you want and working your way down to the ones that contain the photos you're looking for. When you reach a folder that contains photos, the pictures appear in the image well.
- **Timeline.** Go to Window Timeline, and the Timeline appears above the Find bar at the top of the image well. Each bar in the Timeline represents a group of photos. Click a bar to see the photos in that batch.
- Date View. To get to Date view, go to Display→Date View. You see your photos, listed by date, on a calendar page. Just click the date of the group you want to see.

Using Tags and Categories to Find Photos

When you're looking for a particular picture, you can use all the methods listed in the previous section and just keep clicking through groups of photos until you find the one you want. But searching by tags and categories is the easiest way to find a particular image:

- Keyword Tags panel. In the Organize bin's Keyword Tags panel, click the empty square to the left of a tag or category, and Elements finds all the photos associated with that tag or category. (A tiny pair of binoculars appears inside the square so you know that tag or category is being used to search.) Click as many tags and categories as you want, and Elements searches for them all. To exclude a tag from a search, right-click the tag's name and, in the menu that appears, choose Exclude. So, for instance, you could search for photos with the tags "sports" and "rock-climbing," but not "broken leg."
- Find bar. The Organizer's *Find bar* gives you another way to perform a tag search. Figure 2-14 shows how to use it.

Figure 2-14:

To use the Find bar to search for pictures, just drag any tag, category, or photo from the Media Browser or Organize bin onto the bar above the thumbnails, as shown here. When you get near the bar, in Windows, it gets lighter; on a Mac, the lettering turns from white to black to let you know you can let go now. (Your tag can hit the bar anywhere, not just where the lettering is.) When you let go, Elements displays your search results. Use the Options drop-down menu that appears to save your search as a Smart Album (page 67) or to further qualify your results.

Searching by Metadata

As explained in the box on page 71, your camera stores lots of information about your images in the form of *metadata*. In the Organizer, you can search by metadata to find, say, all the photos you took with a particular camera model at a certain aperture and exposure. Figure 2-15 explains how. You can save your results as a Smart Album (page 67) so that any future files with the same characteristics will be grouped together.

	Find by Details (Metadata)	Figure 2-15:
are albums that a	s that match the criteria entered below and save them as Smart Alburn. Smart Alburns automatically collect files that match the criteria defined below. Use the Add button to criteria, and the Minus button to remove criteria.	To perform a s using your pho metadata, go Find→"By Det
Search Criteria		(Metadata)" te
Search for files whic	h match: Any one of the following search criteria[OR]	up this dialog Choose the ca
	All of the following search criteria[AND]	of metadata fr
Shutter Speed	✓ Is less than ✓ 1/500 ✓ sec –	the drop-dowr
ISO Speed	✓ Is greater than 400 -	on the left, and enter your terr
Flash Status	Is Did not fire The second	choose the exe
	Choose whether or not the photo was taken using a flash	setting in the L on the right. C
Save this Search (Criteria as Smart Album	the + button to
		additional sea
Name:		terms (up to 1) remove a crite
	Search Cancel	click the search
		- button.

Tip: If you want to share your tag information with other people, it's easy to do. Just select the photos you want, and then go to File—"Write Keyword Tag and Properties Info to Photos." This transforms your tags into metadata keywords, which can then be read by lots of programs. Or you can use the Organizer's Export command (File—"Export As New File(s)"), which also writes your tags into the metadata.

Visual Searches

Elements' people recognition feature is really handy for finding all the photos of a particular individual, but the problem is that it only works on, well, people. But what if you want to find all the photos of your guinea pig, or the Golden Gate Bridge, or the radiator caps in your collection? People recognition won't help much with that. Elements 10 brings you some new ways to search for objects in your photos: by using Object search, or the improved (and brand-new to Mac) Visual Similarity search.

INFORMATION STATION

Viewing Data about Your Images

The Organizer is packed with information about your images, from captions you've written to statistics recorded by your camera. To see all this info, launch the Properties window: select any photo in the Organizer and then press Alt+Enter/Option-Return, or right-click any photo and then choose Show Properties from the pop-up menu.

You can see four different kinds of info by clicking the icons at the top of the window. From left to right they are:

- General. This includes the file's name, location on your computer, size, date you took the picture, caption (just put your cursor in the box and start typing to add one), and a link to any audio files associated with it (see page 588). You can also change the photo's filename here by highlighting its current name and typing a new one.
- Metadata. The information about the photo that's stored in the photo's file is called metadata. Most

notably, this is where you view your EXIF (Exchangeable Image Format) data, which is info your camera stores about your photos, including the camera you used, when you took the picture, the exposure, file size, ISO speed, aperture setting, and much more. (By paying attention to your EXIF data, you can learn a lot about what makes for good shots...and what doesn't.) The Metadata screen also includes many other kinds of info. Click the Complete radio button at the bottom of the window to see the full listing (or the Brief radio button to see only highlights).

- Keyword Tags. If you've assigned any tags to your photo (page 61), they're listed here.
- History. Look here to find out when the file was created, imported, and edited, and where you imported it from (your hard drive, for instance).

To find all the images with a particular subject (your cat, say), try Object search. It's quite easy to use:

1. In the Organizer, find a photo where it's easy to identify the subject you're looking for.

Just click the image to select it.

2. Start an Object search.

Go to Find→By Visual Searches→"Search for Objects within photos."

3. Make sure Elements knows what to search for.

Elements displays a large version of your photo with a bounding-box type frame in it, as shown in Figure 2-16. Adjust the frame to help Elements focus on the important part of the photo.

4. Start your search.

Click the Search Object button below the frame. If you want to use a different photo or if you decide not to search, click Cancel.

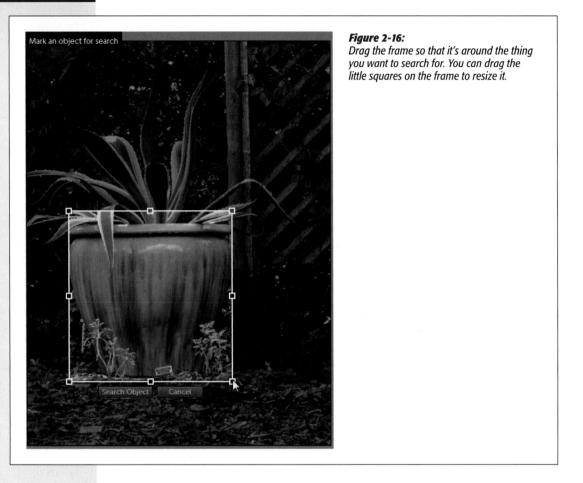

5. Refine your search results.

When Elements is through searching, you see the results in the Media Browser. The program puts a gold frame around the subject in each photo, and a percentage of similarity in the lower-left corner of each thumbnail (100% means Elements is sure this is the same object.) Use the controls at the top of the window (which are explained in a sec) to help Elements refine its search.

6. When you're done searching, click the Show All button at the top of the screen to return to all your photos.

If you want to save your search results, you can save them as a smart album, as explained below.

When you first see the results of Elements' search, you may be a little surprised. You probably never considered that a skunk and a poinsettia have much in common, for instance. You can help Elements out by using the controls at the top of the window. Here's what they do, from left to right:

- Add another photo. If your results include some accurate matches and some photos that aren't right, click one of the correct choices and then, in the bar above the thumbnails, click the + button. Elements recalculates your search results using both images as its guide.
- Help Elements prioritize. When your results appear, there should be a little slider at the top of the results area that goes from Color to Shape. (If you don't see it, click the little button with an icon that looks like a vertical slider.) Drag the slider left and Elements will give more weight to similarities in color; drag it right and it'll prioritize similarities in form.

For instance, if you're searching for all your photos of Mt. Rushmore, you'd move the slider towards Shape, since you want Elements to focus on the shape of the monument and ignore the fact that some photos are in bright morning light, others in warm late afternoon light, and still others in blue dusky light. On the other hand, if you're searching for photos of your kitchen remodel-in-progress, moving the slider towards Color will tell Elements to pay more attention to the brown studs than to other vertical objects, like aluminum ladders.

- Show All. When you're done searching, click here to go back to all your photos.
- **Options.** Click this button and you can save your search as a Smart Album, modify your search (if you've saved the results as a Smart Album), toggle the best search results on and off (if you want to search around more easily in the photos Elements missed, for example), and toggle the gold frames in the results off and on (Hide Highlights).

In addition to Object search, the Organizer also gives you way to search by visual similarity. Start by choosing Find \rightarrow By Visual Searches \rightarrow "Search for Visually similar photo(s) and video(s)." It works the same way the Object search does, except that you don't have to identify an object with the frame. If you drag the Color-Shape slider all the way to the left, this type of search can help you find images with similar color tones for use in projects.

Frankly, the results of both Object searches and Visual Similarity searches are pretty hit or miss, but they're worth trying out. If you consistently get terrible results, try going to File \rightarrow Catalog and repairing and optimizing your catalog, which sometimes helps.

Note: There's also a "Search for Duplicate Photos" command grouped with these searches in the Find \rightarrow By Visual Searches menu, but as explained on page 70, it's not terribly useful.

Saving Your Work

You've heard the advice before: save files early and often. Happily, saving your work is easy in Elements. You don't need to do anything special to save information like tags or collections in the Organizer; that happens automatically. You just need to save images you've created or changed in the Editor. When you're ready to save a file, go to File—Save As or press Ctrl+Shift+S/#-Shift-S to bring up the Save As dialog box, shown in Figure 2-17.

The top part of the Save As dialog box is pretty much the same as it is for any program: You choose where you want to save the file, what to name it, and the file format you want. (More about file formats in a moment.) You also get some important choices that are unique to Elements:

• **Include in the Organizer.** This checkbox is turned on the first time you use Elements. Leave it on and your photo gets saved in the Organizer. Turn it off if you don't want the new file to go to the Organizer. If you turn it off, Elements should remember to *leave* it off, at least for this editing session or until you save a photo that came from the Organizer.

• Save in Version Set with Original. This option tells the Organizer to save your image (including any edits you've made) as a new *version*, separate from the original. The image gets the same name as the original plus a suffix to indicate it's an edited version.

Elements lets you create as many versions as you want. That way, you can go directly to any state of your image that you've saved as a version, which is really handy. When you turn on this checkbox to start a version set, from then on, you'll be presented with the Save As dialog box every time you save. Elements does that to give you the chance to create a new version each time.

- Layers. If your image has *layers* (see Chapter 6), turn on this checkbox to keep them. If you turn this setting off, Elements usually forces you to save as a copy. To avoid having to do that, *flatten* your image (page 210) before saving it. But bear in mind that, once you close a flattened image, you can't get your layers back again—flattening is a *permanent* change.
- As a Copy. When you save an image as a copy, Elements makes the copy, names it "<Original filename> copy", and puts the copy away, but the original version remains open. If you want to work on the copy, you have to specifically open it. Sometimes Elements *forces* you to save it as a copy—for instance, when you want to save a layered image and you turn off the layers option in the Save As dialog box, as explained in the previous bullet point.
- **ICC Profile.** Turn on this checkbox to make Elements embed a color profile (page 243) in your file.
- Use Lower Case Extension (Windows only). This setting makes Elements save your file as *yourfile.jpg* rather than *yourfile.JPG*. Leave this setting on unless you have a reason to turn it off. (You don't see this checkbox on a Mac because OS X always uses lowercase extensions.)

File Formats Elements Understands

Elements gives you loads of file format options in the Save As dialog box. Your best choice depends on how you plan to use the image:

- Photoshop (.psd, .pdd). It's a good idea to save your photos as .psd files—the native file format for Elements and Photoshop—before you work on them. A .psd file can hold lots of information, and you don't lose any data by saving in this format. It also lets you keep layers, which is important even if you haven't used them for much yet.
- **BMP (.bmp).** This format is an old Windows standby. It's the file format that the Windows operating system uses for many graphics tasks.

GEM IN THE ROUGH

Saving Options

Elements gives you several ways to save files. Before choosing one, you need to consider whether you want to create version sets (page 75) of your photos.

To tell Elements how to react to the Save command, in the Editor, go to Edit→Preferences→Saving Files/Adobe Photoshop Elements Editor→Preferences→Saving Files. In the Preferences dialog box that appears, you see the On First Save drop-down menu. By making a selection here, you can control (to some extent) when you'll see a dialog box offering you options for saving your file, and when Elements will behave like any other program and just save your changes without asking you for any input.

For most people, it's fine to leave this menu set to "Ask if Original" (explained below). But if you want more control over how Elements saves your photos (if you always want the option to create a new version set without having to remember to choose Save As, for instance), you can configure Elements to suit you.

Here's what the three On First Save options do:

- Always Ask. Choose this setting and, when you press Ctrl+S/#-S to save, Elements brings up the Save As dialog box the first time you save—if this is the first time you've opened the file in this session of Elements. Close the file and reopen it while Elements is still running, and you won't see the Save As dialog box the next time you save. But once you exit Elements and launch it again, you get the Save As dialog box again the first time you press Ctrl+S/#-S. You can think of this option as short for "Always ask the first time I save a file in an editing session and then don't bug me anymore."
- Ask If Original. If you're editing your original file (as opposed to a version) and don't have any version sets, Elements opens the Save As dialog box the first time you save the file. On subsequent saves, or if you already have a version set, Elements just saves right over the existing version (unless you specifically do a

Save As to create a new version). This option is meant to help you avoid inadvertently creating dozens of versions of each file as you edit.

Save Over Current File. When you select this op-. tion, Elements overwrites your existing file when you press Ctrl+S/#-S, without offering you the Save As dialog box at all. This is the way most other programs behave when saving-if you save an existing file in Word, for instance, you don't get a dialog box; Word just saves your changes, writing over the previous version of the file. If you use Elements as the external editor for another photo-management program like iPhoto or Lightroom, this is the option you should use in order to create proper versions in the other program. If you choose this menu option and then, while you're working, decide you want to Save As instead of Save, press Ctrl+Shift+S/#-Shift-S (or just choose Save As from the Editor's File menu).

There are certain situations where Elements presents you with the Save As dialog box no matter *what* you choose here. For instance, say you add layers (explained in Chapter 6) to a JPEG file. You can't save a JPEG with layers, so Elements brings up the Save As dialog box to let you choose a different file format for saving your work.

The File Saving Options section of the Saving Files Preferences dialog box has two other menus–Image Previews and File Extensions–but you probably won't ever need to change those settings.

You can also use the Saving Files Preferences dialog box to control how well your image file works with other programs. If you leave the Maximize PSD File Compatibility drop-down menu set to Always, Elements embeds a flattened image file for the benefit of programs that don't understand layers. That makes for a substantially larger file, but with disk space so cheap these days, it's usually best to let Elements maximize compatibility. If you choose Ask from this menu instead, you'll see the dialog box in Figure 2-18 when you save a layered PSD file.

Photoshop Elements Format Options ✓ Maximize compatibility Turning off Maximize Compatibility may interfere with the use of PSD files in other applications or with future versions of Photoshop Elements. This dialog can be turned off in Preferences > Saving Files > File Compatibility. Gancel Comparison Compariso

- **CompuServe GIF (.gif).** Everywhere except this menu, this format is known simply as GIF; Adobe adds "CompuServe" here because CompuServe invented and owns the code for this format. This format is used primarily for web graphics, especially files without a lot of subtle shadings of color. For more on when to choose GIFs, see Chapter 17. Page 561 explains how to animate GIFs.
- Photo Project Format (.pse). This special format is only for multipage Elements files (see Figure 2-19 and page 517).

oto r E E E E E E E E E E E E E E E E E E

If you add pages to a file (page 515), you see this warning. Elements is telling you it needs to save your multipage project as a PSE file, a format that almost no other programs can open. To learn more about working with PSE files and how to get your project out of Elements for online printing or use by other programs, see the box on page 517.

- **Photoshop EPS (.eps).** EPS (Encapsulated PostScript) format is used to share documents among different programs. You generally get the best results when the documents in this format are printed on a PostScript printer (some laser printers are PostScript printers; inkjets usually aren't).
- **TIFF** (.tif, .tiff). This is another format that, like PSD, preserves virtually all your photo's info and lets you save layers. Also like PSD files, TIFFs can be really big. This format is used extensively in print production, and some cameras let you to choose it as a shooting option.
- **JPEG** (.jpg, jpeg, .jpe). Almost everyone who uses a computer has run into JPEGs, and most digital cameras offer this format as an option. Generally, when you bring a JPEG into Elements, you want to use another format when you save it to avoid losing data. Keep reading for more about why.

Note: If you're wondering why JPEG 2000 isn't on this list, see the box on page 80.

Figure 2-18:

Choose Always in the Maximize PSD File Compatibility menu if you want people who don't have Elements to be able to open your image. The downside: slightly larger files.

- Photoshop PDF (.pdf, .pdp). Adobe invented PDF (Portable Document Format), which lets you send files to people with Adobe Reader (a free program formerly called Acrobat Reader) so they can easily open and view the files. Elements uses PDF files to create presentations like slideshows. (People with Macs can also use OS X's Preview to view PDFs.)
- **PICT (.pct).** PICT is an older Mac format that's still used by some applications. AppleWorks, for example, handles PICTs better than any other graphics files. Also, sometimes larger file formats like Mac-created TIFFs generate their thumbnail previews as PICT Resource files (the type of PICT used within the TIFF file).
- **PNG.** Here's another web-graphic format, created to overcome some of the disadvantages of JPEGs and GIFs. It has its own disadvantages, though; see page 559 for details.
- Digital Negative (.dng). This format doesn't appear as a choice in the Save As dialog box's Format menu; it's only available in the Raw Converter. This format was developed by Adobe in an attempt to create a more universal way to store all the different Raw file formats (page 270). You can download a special DNG Converter from Adobe's website (*www.adobe.com/downloads*) that lets you convert your camera's Raw formatted photos into DNG files. DNG files aren't ready to use the way JPEG or TIFF files are—you have to run them through the Raw Converter before you can use them in projects. Page 288 has more about DNG files.

UP TO SPEED

File Formats

After you've spent hours creating a perfect image, you'll want to share it with others. If everyone who wanted to view your images needed a copy of Elements, you probably wouldn't have a very large audience for your creations. So, Elements lets you save in lots of different *file formats*.

What does that mean? It's pretty simple, really. A file format is a way in which your computer saves information so that another program or another computer can read and use the file. Because there are many different kinds of programs and several different computing platforms (Windows, Linux, and Mac, for example), the kind of file that's best for one use may be a poor choice for doing something else. That's why many programs, like Elements, can save your work in a variety of different formats. There are many formats, like TIFF and JPEG, that lots of different programs can read. Other formats–like the PUB files that Microsoft Publisher creates or the .pages files from Apple's Pages program–are easily read only by the program that created them.

Not-so-common file formats

Besides the garden-variety formats in the previous list, Elements lets you save in some formats you've probably never heard of. Here's a list of them—and then you can forget all about them:

- IFF (Interchange File Format). This format has no file extension, because it's a kind of wrapper for other data. It's best known for its use for 2-D images in Maya, the popular 3-D modeling program. This is a Mac-only format.
- Alias PIX (.pix). Another format originally used for creating 3-D images, .pix files were originally used by programs like Power Animater. It's also only available in the Mac Save As menu.
- **Filmstrip.** This format is designed for use with Premiere Elements, Adobe's video-editing program, so you won't see this option unless Premiere is installed on your computer.
- **PIXAR**. Yup, *that* Pixar. This is the special format for the movie studio's highend workstations, although if you're working on one of those, it's extremely unlikely that you're reading this book.
- Scitex CT. This format is used for prepress work in the printing industry.
- **Photoshop Raw.** This isn't the same as your camera Raw file; rather, it's an older Photoshop format that consists of uncompressed data.
- **Photoshop 2.0**. This is a very old, Mac-only format used in the early days of Photoshop (1992 or thereabouts). Unless you need to create sample files for exhibits in the Museum of Digital Antiquities, ignore this format.
- **Targa TGA or Targa.** Developed for systems using the Truevision video board, this format has become a popular graphics format, especially for games.
- **PCX.** This format was popular for graphics back in the days of DOS (remember PC Paintbrush?). Nowadays it's mostly used by some kinds of fax systems and a few document-management programs.

COMPATIBILITY CORNER

Opening Obscure File Formats

You may occasionally run into a file format that Elements doesn't understand. Sometimes you can fake Elements out and con it into opening the document by manually changing the *file extension* (the letters after the period near the end of the file's name, like "psd") to a more common one.

For the few file formats that make Elements throw up its hands in despair, in Windows try IrfanView (*www.irfanview.com*), a wonderful free program that can open almost any Windows-compatible format. You can sometimes even use IrfanView to salvage damaged files, especially if you get an "invalid JPEG marker" error. If Elements balks at one of your files, first try opening and resaving the photo in IrfanView. If you're lucky, that may be all you need to do to make Elements recognize the file. On a Mac, try Graphic Converter (*www.lemkesoft.com*), a great little program that can open darn near anything. It does great batch conversions, too, and even offers some basic image-editing features. Graphic Converter is shareware (it currently costs \$40) with a generous demo period, and it's worth every penny.

Very rarely, you'll run across a file that makes even Irfan-View or Graphic Converter give up. If that happens, try a Google search. (Use the file's three- or four-letter extension as your search term.) It's unlikely to help you open it, but if you can figure out what kind of file it is, you can probably figure out where it came from and ask whoever sent it to you to try again with a more standard format.

About JPEGs

In the next chapter, you'll read about how throwing away pixels can lead to shoddylooking pictures. It's also important to know that certain file formats are designed to make your files as small as possible—and they do that by throwing out information by the bucketful. These formats are known as *lossy* because they discard, or lose, some of the file's data every time you save it, to help shrink the file. Sometimes you want that to happen, like when you need a small (and hence, fast-loading) file for a website. Because of that, many of the file formats that were developed for the Web, most notably JPEG, favor smallness above all.

Note: Formats that preserve all your data are called *lossless*. (You may also run across the term *non-lossy*, which means the same thing.) The most popular file formats for people who are looking to preserve all their photos' data are PSD and TIFF.

If you save a file in JPEG format, every time you click the Save button and close the file, your computer squishes some of the data out of the photo. What kind of data? The info your computer needs to display and print the fine details. So you don't want to keep saving your file as a JPEG over and over again, because every time you do, you lose a little more detail from your image. You can usually get away with saving as a JPEG once or twice, but if you keep it up, sooner or later you'll start to wonder what happened to your beautiful picture.

It's OK that your camera takes photos and saves them as JPEGs—those are typically pretty enormous JPEGs. Just importing a JPEG won't hurt your picture, and neither will opening it to look at it, as long as you don't make any changes. But once you get your files into Elements, save your pictures as PSD or TIFF files while you work on them. If you want the final product to be a JPEG, change the format back to JPEG *after* you're done editing it.

MOMENT OF SILENCE

Bye-Bye, JPEG 2000

If you've been saving files in the useful lossless JPEG 2000 format (.jpf, .jpx, .jp2), you may be perplexed to find that in Elements you can't open those files in the Editor or import them to the Organizer (you can still see any existing JPEG 2000 files in a Windows Organizer catalog originally created in a previous version of Elements; you just can't *do* anything with them). That's right–Elements can no longer read these files. Fortunately, there are ways around this:

 Windows: Download the free ImageMagick program (www.imagemagick.org) and use it to convert your JPEG 2000 images to another lossless format. Mac: Use Preview (it's part of OS X) to open your JPEG 2000 files and save them in the format of your choice.

Keep this in mind, because many books that include practice images on discs and a lot of downloadable artwork use the JPEG 2000 format. **Tip:** Your camera may give you several different JPEG compression options to help fit more pictures on your memory card. Always choose the *least* compression possible. This makes the files slightly larger, but the quality is much, much better, so it's worth sacrificing the space.

Changing the File Format

It's super easy to change a file's format in Elements: Just press Ctrl+Shift+S/ \Re -Shift-S or go to File \rightarrow Save As and, from the Format drop-down menu, select the format you want. Elements makes a copy of your file in the new format and asks you to name it.

Backing Up Your Files

With computers, you just never know what's going to happen, so "Be prepared" is a good motto. If your computer crashes, it won't be nearly as painful if all your photos are safely backed up someplace else. Thanks to Elements' Photoshop.com service, you can back up your files automatically. Then, in the event of a problem with your home computer, you can restore your backed-up photos.

The Photoshop.com-as-backup system has two main downsides, however. First, it only comes with 2 GB of space; if you want more than that, you have to pony up for more storage, as explained on page 23. You can back up your whole catalog if you want, but for most people that means a paid account. If you have a small catalog or a paid account, go to Organizer→Edit→Preferences→"Backup/Synchronization" and click the "Backup/Sync Entire Catalog" button. (You need to be signed into your account to see this button.) The other big drawback is that Photoshop.com doesn't understand version sets, and if you aren't vigilant, you run the risk of accidentally overwriting a file you wanted to keep. See the note on page 83 for more about this.

Note: As of this writing, the Photoshop.com service is restricted to U.S. residents.

If those limitations turn you off, you'll be glad to know that Elements also makes it easy to save your files to any add-on storage device—like an external hard drive—or to a CD or DVD. All these options are covered in the pages ahead.

Note: In Windows, Elements offers one frequently requested feature for making backups: You can create *multisession* discs. That means you can tell Elements to leave your CD or DVD "open" so that you can come back later and add more files to it, instead of wasting a whole CD or DVD to save only a handful of pictures. To use this feature, in the Organizer, go to Edit—Preferences—Files and turn on "Enable multisession burning to CD/DVD." (Alas, this option isn't available in the Mac version.)

Straightening Scanned Photos

Start by scanning in the photos (Figure 3-1). It doesn't matter whether you scan directly into Elements or use the scanner's own software. (See page 49 for more about scanning images into Elements.) The only limit is how many can fit on your scanner at once.

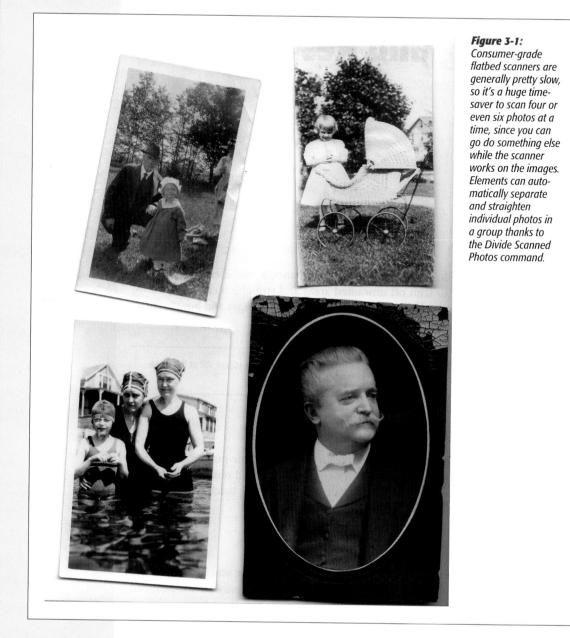

Tip: Sometimes it pays to be crooked. Divide Scanned Photos works best when your photos are fairly askew, so don't waste time trying to be precise when placing them on the scanner.

When you're done scanning, follow these steps:

1. Open your scanned image file in the Editor.

It doesn't matter what file format you used when saving your scanned group of photos: TIFF, JPEG, whatever. Elements can read 'em all (unless you used JPEG 2000, in which case see page 80).

2. Divide, straighten, and crop the individual photos.

Go to Image \rightarrow Divide Scanned Photos. Then just sit back and enjoy the view as Elements carefully calculates, splits, straightens out, and trims each image. You'll see the photos appear and disappear as Elements works through them.

3. Name and save each separated image.

When Elements is done, you'll have the original group scan as one image and a separate image file for each photo Elements carved out. All you need to do now is import the cut-apart photos into the Organizer. To do that, just make sure that "Include in Organizer" is turned on in the Save As dialog box (see page 74).

Elements usually does a crackerjack job splitting photos, but once in a while it chokes, leaving you with an image file that contains more than one photo. Figure 3-2 shows you what to do when Elements doesn't succeed in dividing things up.

Tip: Occasionally you may find that Elements can't accurately separate a group scan, no matter what you do. In that case, use the Marquee tool (page 153) to select an individual image, copy it (Ctrl+C/ \Re -C), paste it into its own document (File \rightarrow New \rightarrow "Image from Clipboard"), and then save it. You might also want to check your scanner driver—it may have a way to divide a group scan as part of the scanning process itself.

Straightening Individual Photos

Elements can also straighten and crop (trim) a single scanned image. Simply choose Image→Rotate→"Straighten and Crop Image," and Elements tidies things up for you (choose Straighten Image instead if you'd rather crop the edges yourself). Better still, you can actually use the Divide Scanned Photos command (explained in the previous section) on a single image. (Cropping is explained on page 99.)

Rotating Images

Owners of print photographs aren't the only ones who sometimes need a little help straightening their pictures. Digital photos sometimes have to be rotated because some cameras don't include data in their image files that tells Elements (or any other image-editing program) the correct orientation. Certain cameras, for example, send portrait-oriented photos out on their sides, and it's up to you to straighten things out.

Figure 3-2:

Sometimes Elements just can't figure out how to split photos, and you wind up with something like these two not-quite-separated images. If that happens to you, rescan the photos that confused Elements, but this time make sure they're more crooked on the scanner and leave more space between them. Elements should then be able to split them correctly.

Also, check for positioning problems like you see here, where Elements can't split the photos because it can't draw a straight line to divide these two without chopping off the corners. Put a little more space between the photos so Elements can split 'em.

Fortunately, Elements has rotation commands all over the place. If you need to do is get Dad off his back and stand him upright, here's a list of where you can perform a quick 90-degree rotation on any open photo:

- **Quick Fix** (page 127). Click either of the Rotation buttons at the bottom of the preview area.
- Full Edit. Go to Image→Rotate→90° Left (or 90° Right).
- Project bin. Right-click a thumbnail and choose Rotate 90° Left (or 90° Right).
- **Raw Converter** (page 270). Click the left or right arrow at the top of the Preview window.
- Organizer. You can rotate a photo almost any time in the Organizer by pressing Ctrl/ℜ plus the left or right arrow key. Another option is to choose Edit→Rotate 90° Left (or 90° Right). There are also Rotate buttons at the top of the Quick Edit panel in Full Screen view (page 60). Finally, there's a pair of Rotate buttons at the top of the Media Browser window.

Those commands all get you one-click, 90-degree changes. But Elements has all sorts of other rotational tricks up its sleeve, as the next section explains.

Rotating and Flipping Options

Elements gives you several ways to change your photo's orientation. To see what's available, in the Editor, go to Image \rightarrow Rotate. You'll notice two groups of rotate commands in this menu; for now, it's the top group you want to focus on. (The second group does the same things, only those commands work on layers, which are explained in Chapter 6.) The first group of commands includes:

- **90° Left or Right.** These commands do the same thing as the rotate buttons explained earlier; use them to fix digital photos that arrive in Elements on their sides.
- 180°. This turns your photo upside down and backward.
- **Custom.** Selecting this command brings up a dialog box where, if you're mathematically inclined, you can type in the precise number of degrees you want to rotate the photo.
- **Flip Horizontal.** Flipping a photo horizontally means that if your subject was gazing soulfully off to the left, now she's gazing soulfully off to the right.
- Flip Vertical. This command turns your photo upside down *without* changing the left/right orientation the way Rotate 180° does.

Tip: When you're flipping photos around, remember you're making a mirror image of *everything* in the photo. So someone who's writing right-handed becomes a lefty, any text in the photo will be backward, and so on.

Figure 3-3 shows these commands in action.

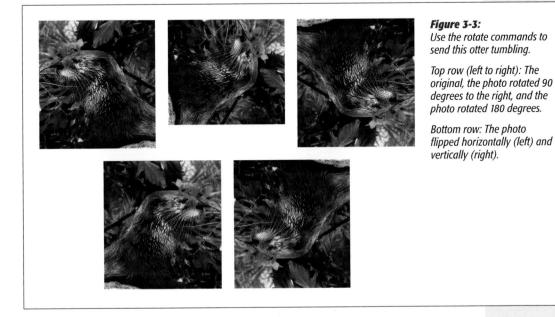

If you want to position your photo at an angle (as you might in a scrapbook), use Free Rotate Layer, described on page 97.

Straightening the Contents of an Image

What about all those photos you've taken where the main subject (a person or a building, say) isn't quite straight? You can flip those pictures around forever, but if your camera was off-kilter when you snapped the shot, your subjects will still lean like a certain tower in Pisa. Elements can help you with this problem, too. It includes a nifty Straighten tool that makes adjusting the horizon as easy as drawing a line.

Tip: About 95 percent of the time, the Straighten tool does the trick. But in the few cases where you can't get things looking perfect, you can still use the old-school method: the Free Rotate Layer command, described on page 97.

Straighten Tool

If you can never seem to hold a camera perfectly level, you'll love Elements' Straighten tool. It lives just below the Cookie Cutter tool (or next to it if you have two columns) in the Full Editor's Tools panel. To straighten a crooked photo:

1. Open the photo, and then activate the Straighten tool.

Its icon is two little photos, one crooked and one not. Or just press the P key.

2. Make any changes to the tool's Options bar settings before you use it.

Your choices are described after this list.

3. Tell Elements where the horizon is.

Drag to draw a line in your photo to show Elements where horizontal *should* be. Figure 3-4 shows how—by drawing a line that traces the boundary between the ocean and the sky. Your line appears at an angle when you draw it. That's fine, because Elements is going to level out your photo, making your line the true horizontal plane.

Tip: If you have a photo of trees, sailing ships, skyscrapers, or any other subject where you'd rather straighten vertically than horizontally, just hold down Ctrl/æ while you drag. That way, the line you draw determines the *vertical* axis of your photo. (It's important to press the mouse button *before* you press the Ctrl/æ key, or this trick won't work.)

4. Elements automatically straightens your photo (and crops it, if you chose that setting in the Options bar).

If you don't like what Elements did, press Ctrl+Z/æ-Z to undo it and draw another line. If you're happy, you're all done, except for saving your work (Ctrl+S/æ-S).

Figure 3-4:

Left: To correct the crooked horizon in this photo, simply draw a line along the part that should be level. It's easiest to do this by choosing a clearly marked boundary like the horizon here, but you can draw a line across anything you want to make level.

Right: Elements automatically rotates the photo to straighten its contents.

The Options bar gives you some control over how to handle the edges of your newly straightened photo. Once your picture is straightened, the edges are going to be a bit ragged, so you can choose what Elements should do about that:

- Grow or Shrink Canvas to Fit makes Elements add extra space around the edges of the photo so that every bit of the original is still there. It's up to you to crop the image afterward (see page 99).
- Crop to Remove Background tells Elements to chop off the ragged edges to give you a nice, rectangular image. The downside to this option is that you lose some of the perimeter of your photo—though just a bit, so it's not usually a big deal.
- **Crop to Original Size** makes Elements keep the photo's dimensions exactly the same—even if that means including some blank space along the perimeter. You may also lose some of the edges of the image, particularly the corners.

If your photo has layers (see Chapter 6), you can use the Straighten tool to straighten just the active layer (page 189) by going to the Options bar and turning off the Rotate All Layers checkbox. If you want Elements to straighten your whole photo, leave this checkbox turned on.

Straightening the Contents of an Image

The Straighten tool is best for photos where you were holding the camera crooked. If you try it and it makes things in your photo look very odd, perhaps straightening isn't what you need. Architectural photos, for instance, may look a bit crooked before you use this tool—but a lot worse afterward. If that house is *still* leaning even though you're sure the ground line has been leveled correctly, then most likely your real problem is *perspective distortion* (a visual warping effect). To fix that, use Correct Camera Distortion (page 383) instead.

Tip: You can also straighten photos in the Raw Converter. There's a Straighten tool in its toolbox, right between the Crop tool and the Red Eye Removal tool. You use it just like the Editor's Straighten tool. Page 276 tells you more.

ON THE SQUARE

Grids, Guides, and Rulers

Elements gives you plenty of help when it comes to getting things straightened and aligned. In the Editor, you can turn on several features that make it really easy to create all kinds of projects:

- Grid. This option puts your entire image under a network of gridlines, as in Figure 3-5. This is really helpful when you're doing a free rotation (below) and you're not sure where straight is. Just go to View→Grid to toggle the grid on and off. You can adjust the grid's spacing in Edit→Preferences→Guides & Grid/Adobe Photoshop Elements Editor→Preferences→Guides & Grid. That's also where you can change the grid's color to make it show up better. To do that, click the color square in the grid preferences window, and then choose a color from the Color Picker (page 254).
- Rulers. If you want to measure something in your image, go to View→Rulers, and rulers appear along the sides of your image. You can change the unit of measurement by going to Edit→Preferences→Units & Rulers/Adobe Photoshop Elements Editor→ Preferences→Units & Rulers if you'd rather see, say, pixels or percents rather than inches.
- Guides. Guides are a great way to get things lined up. You can create as many guides as you want in your image. Just go to View→New Guide and choose a

horizontal or vertical line; you can't change the orientation of a guideline once you create it. (If the rulers are visible, you can just drag a guide from the ruler without going to the menu.) You can also specify a position in your image, or just create it anywhere by clicking OK, and then use the Move tool to drag it where you want it. Once you get your guidelines set up, you can keep yourself from accidentally moving 'em by going to View→Lock Guides. To remove your guides, go to View→Clear Guides.

If you save a photo with guides in it and send it to someone else using a version of Elements that can display guides (versions 6–10; Elements 6 and 7 can see guides, they just can't create them) or using Photoshop, that person will see your guides. If someone sends you a file with guides in it, you can see their guides if you turn them on in the View menu (View→Guides).

Guides are really handy, particularly for projects like scrapbooking, because you can make anything you add into your file *snap* (jump) right to the guide's location by choosing View—Snap To—Guides. If you decide you'd rather move objects freely, just select the same menu option again to toggle snapping off. (You can also have objects snap to the grid, but you can only change this setting when the grid is visible.)

Figure 3-5:

If you need help figuring out where straight is, you can add a grid or guidelines in the Editor. The bright aqua lines are guides; the others are the grid. (Neither will show up when you print your photo.) Use the grid to help straighten your image. Guides are especially useful when you're adding items to your photo, since you can make things like text blocks (page 479) automatically line up by making them snap to the guidelines. The box on page 96 tells you how.

Free Rotate Layer

You can also use the rotate commands to straighten photos, or to turn them at angles for use in scrapbook pages or album layouts. The command that's best for this is Free Rotate Layer, which lets you grab a photo and spin it to your heart's desire. And if you aren't sure where straight is, Elements can help you figure it out, as the box above explains.

Tip: You can use all the rotate commands on individual layers. Chapter 6 explains layers, but you don't have to understand them to use the Free Rotate Layer command.

To use Free Rotate Layer:

1. Go to Image \rightarrow Rotate \rightarrow Free Rotate Layer.

If you have a Background layer, Elements automatically converts it to a regular layer for you. (You'll learn about layers in Chapter 6.)

2. Use the handle or the curved two-headed arrow to adjust your photo (see Figure 3-6).

Your picture may look kind of jagged while you're rotating. Don't worry about that—Elements will smooth things out once you're done.

3. When you've got your image positioned where you want it, click the Commit button (the green checkmark) or press Enter. (If you don't like what you did, click the Cancel button—the red No symbol—to cancel the rotation.)

If you were straightening your photo (rather than angling it), you've got a nice straight picture, but the edges are probably pretty ragged, since the original had slanted, unrotated sides. You can take care of that by cropping your photo as explained next.

Figure 3-6:

You have two ways to straighten the contents of your photo—or even to spin it around in a circle. Just grab either the handle at the bottom center of your photo or a corner, circled. (If you're on a Mac, you won't see the center handle, only the corner ones.) When you move your cursor near the image's corner, it turns into a curved, two-headed arrow.

When you've got ahold of your photo, drag to adjust it the way you'd straighten a crooked picture on the wall. Click the green checkmark Commit button when you're happy with what you've done, or the red Cancel button to cancel.

Cropping Pictures

Whether or not you straighten your digital photos, sooner or later you'll probably need to *crop* them—trim them to a certain size. Most people crop photos for one of two reasons: If you want to print on standard-size photo paper, you usually need to cut away part of the image to make it fit the paper. Then there's the "I don't want *that* in my picture" reason. Fortunately, Elements makes it easy to crop away distracting background objects or people you'd rather not see.

A few cameras take photos that are proportioned exactly right for printing to a standard paper size like 4"×6" or 8"×10". (An image's width-to-height ratio is also known as its *aspect ratio*.) But most cameras create images that aren't the same proportions as any of the standard paper sizes. Figure 3-7 shows an example of cropping to fit on standard photo paper.

The extra area most cameras provide gives you room to crop wherever you like. You can also crop out different areas for different size prints (assuming you save the original photo). If you'd like to experiment with cropping or changing resolution (explained on page 114), download the image in the figure (*river.jpg*) from this book's Missing CD page at *www.missingmanuals.com*.

Figure 3-7:

When you print on standard-sized paper, you may have to choose the portion of your digital photo you want to keep.

Left: The photo as it came from the camera.

Right: After cropping ready for a 4"×6" print. Elements 10 brings you some extra help in cropping photos to pleasing proportions with new crop overlays you can use as guides. They're explained in the next section.

Tip: If your photo isn't in the Organizer or another image-management program that automatically protects your originals, it's best to crop a copy of the image, since cropping throws away the pixels outside the area you choose to keep. And you never know—you may want those pixels back someday.

The Crop Tool

You can use the Crop tool in either the Full Edit or Quick Fix window. This tool includes a helpful list of preset sizes to make your job easier. In most cases, the preset sizes are what you need, but if you want to crop to a custom size, here's what you do:

1. Activate the Crop tool.

Click the Crop icon in the Tools panel (it shares a slot with the Recompose tool) or press C.

2. Drag anywhere in your image to select the area you want to keep.

The area outside the boundaries of your selection gets covered with a dark shield to show what you'll discard. To move the area you've chosen, just drag the *bounding box* (the outline) to wherever you want it.

Tip: You may find the Crop tool a little crotchety sometimes. See the box on page 103 for help making it behave.

3. Drag one of the handles on the sides and corners of the selection to resize it.

The handles look like little squares, as shown in Figure 3-8. You can drag in any direction, which lets you change the proportions of your crop if you want to.

You can rotate the crop area to any angle. This is a handy way to straighten *and* crop in one go. If you have a crooked image, turn the crop tool so that the outlines of the area are parallel to where straight should be in your photo and then crop. Elements straightens out your photo in the process. You can also turn on one of the new crop overlays, explained below, to help you create a more appealing image. In the Options bar, just go to the Overlay menu and choose the one you want.

If you change your mind, click the Cancel button or press Esc. Elements undoes the selection so you can start over.

4. When you're sure you've got the crop you want, press Enter, click the red Commit button, or double-click inside the area you're going to keep, and you're done.

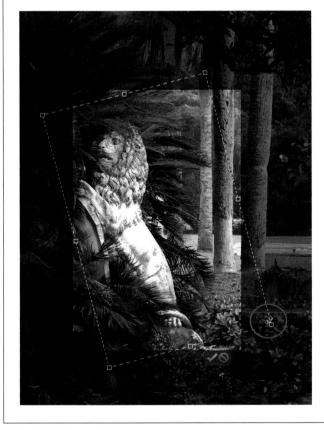

Figure 3-8:

If you want to change your selection from horizontal to vertical or vice versa, just move your cursor outside the cropped area and you'll see the rotation arrows (circled). Use them to rotate the crop's frame the same way you would a whole image.

Rotating your selection doesn't rotate the photojust the boundaries of the crop. When you're done, press Enter or click the green Commit button to tell Elements you're satisfied. The red Cancel button cancels your crop. (The symbols appear when you let go of the mouse button.)

Elements 10 includes a new features that can help you crop your photo in the most visually pleasing way: crop overlays. Choose an option from the Overlay menu at the right end of the Options bar, drag over the image, and you see guidelines that help you decide where to position your crop. Your options are:

- None. This choice gives you no visible overlay, just the empty crop mask.
- **Rule of Thirds.** This is the option Elements chooses automatically the first time you use the Crop tool. The crop area is divided into thirds, both vertically and horizontally. Figure 3-9 explains how to use this overlay.
- Grid. You see the regular Elements grid over your image.

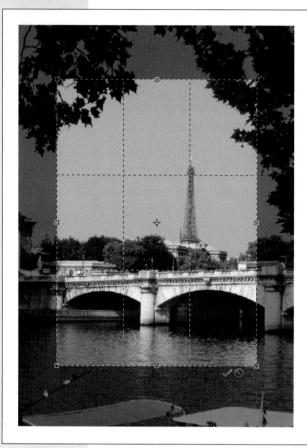

Figure 3-9:

The basic idea behind the Rule of Thirds is simple: Most people find images more pleasing to the eye if the main point of interest isn't placed squarely in the center. Instead, if you think of dividing your photo into by a grid of three lines, both horizontally and vertically, your subject will have more impact if it falls along one of those lines or, even better, where two lines intersect. Here, the crop places the Eiffel tower on a vertical line, the bridge on a horizontal one, and the place where the two points of interest meet falls where the two lines intersect.

Golden Ratio. This is the most complex of the overlays, a complicated arrangement of rectangles, squares, and diagonal lines. The Golden Ratio has been used as the basis for pleasing proportions in art and architecture ever since the pyramids, and it's been used extensively by artists and photographers to create the most effective compositions. If you want to understand how it works, a good place to start is http://tinvurl.com/6kuue7u, which explains all about Fibonnaci numbers (the basis for the Golden Ratio) in nature and art, as well the math involved. The most basic way to use this overlay is to make sure that the small busy area where the lines converge is on the focal point of your subject, and to try to align the important features in the image with one of the dotted lines. So for instance, if you have a photo of a woman standing in a long line of people, put them along a dotted line and put the focal point over her face. If you want to flip this overlay so it aligns better with your image, just click the button to the right of the Overlay menu (It looks like two triangles pointing at a dotted line). To change the overlay's orientation, just click the arrows between the crop numbers, as shown in Figure 3-11.

TROUBLESHOOTING MOMENT

Crop Tool Idiosyncrasies

The Crop tool is sometimes cantankerous. People have called it "bossy," and that's a good word for it. Here are some settings that may help you control it better:

 Turn off Snap To Grid. You may find that you just can't position your crop selection exactly where you want it. Does the edge keep jumping slightly away from where you put it? Like most graphics programs, Elements uses a grid of invisible lines—called the *autogrid*—to help place things exactly (see the box on page 96 for details). Sometimes this grid is a big help, but in situations like this, it's a nuisance. If you hold down Ctrl/æ, you can temporarily disable the autogrid.

You can also get rid of the grid or adjust its spacing. To turn it off, first make the grid visible by going to View \rightarrow Grid. Then choose View \rightarrow Snap To \rightarrow Grid. You can adjust the grid's settings–things like the spacing, color, and whether it uses solid or dotted lines–by going to Edit \rightarrow Preferences \rightarrow Guides & Grid/Adobe Photoshop Elements Editor \rightarrow Preferences \rightarrow Guides & Grid.

 Clear the Crop tool. Occasionally you may find that the Crop tool won't release a setting you entered, even after you clear the Options bar's boxes. For example, if the tool won't let you drag where you want and keeps insisting on creating a particular-sized crop, you need to reset it. Simply click the triangle at the left end of the Options bar, and then choose Reset Tool from the shortcut menu, as shown in Figure 3-10.

Figure 3-10:

If the Crop tool stops cooperating, there's an easy way to make it behave: Click this tiny triangle in the Options bar, and then choose Reset Tool from the menu that appears. If you want all your tools to go back to their original settings, choose Reset All Tools instead.

Cropping an image to an exact size

You don't have to eyeball things when cropping a photo. You can enter any dimensions you want in the Options bar's Width and Height boxes or choose one of the presets from the Aspect Ratio menu, which automatically enters numbers for you. The Aspect Ratio menu includes several standard photo sizes, like $4"\times6"$ and $8"\times10"$. The No Restriction setting means you can drag freely. The Use Photo Ratio option lets you crop your image by using the same width/height proportions (the *aspect ratio*) as the original. Figure 3-11 teaches you a timesaver: how to quickly swap the width and height numbers.

Warning: If you enter a number in the Options bar's Resolution box that's different from your image's current resolution, the Crop tool *resamples* your image to match the new resolution. (Resolution is explained starting on page 114.) See page 121 to understand what resampling is and why it's not always a good thing.

Figure 3-11: To swap the width and height settings, just click these little arrows.

Cropping with the Marquee Tool

The Crop tool is handy, but it wants to make decisions for you about several things you may want to control yourself. For instance, the Crop tool may decide to resample the image (see page 121) whether you want it to or not (and without any warning).

For better control, you may prefer the Marquee tool. It's no harder to use than the Crop tool, but you get to make all the decisions yourself. But there's one other big difference between the two: With the Crop tool, all you can do to the selected area is crop it; the Marquee tool, in contrast, lets you make lots of other changes to the selected area, like adjust its color, which you may want to do before you crop.

To make a basic crop with the Marquee tool:

1. Activate the Marquee tool.

Click the little dotted rectangle in the Tools panel or press M. Figure 3-12 shows you the shape choices you get for the Marquee tool. For cropping, choose the Rectangular Marquee tool.

Figure 3-12:

Click the Marquee tool, and then choose the shape you want from this pop-out menu. The Tools panel icon reflects the shape that's currently selected.

2. Drag the selection marquee across the part of your photo you want to keep.

When you let go of the mouse button, Elements puts dotted lines like the ones shown in Figure 3-13 around the selected area. (Chapter 5 has more about making selections.) These dotted lines are sometimes called "marching ants." (Get it? The dashes look like ants marching around your picture.) The area inside the marching ants is the part that you're keeping. If you make a mistake, press Ctrl+D/\#-D to get rid of the selection and start over.

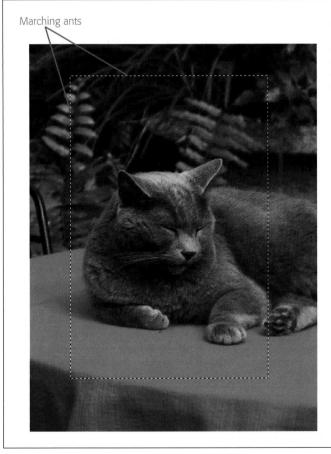

Figure 3-13:

When you let go after making your Marquee selection, you see the "marching ants" around the selection's edge. You can reposition the marquee by dragging it—just put your cursor anywhere inside the selection marquee and then draa it.

3. Crop your photo.

Go to Image \rightarrow Crop. The area outside your selection disappears, and Elements crops your photo to the area you selected in step 2.

If you want to crop your photo to a particular aspect ratio (proportion), you can do that easily. Once the Marquee tool is active but before you drag to make a selection, go to the Options bar. In the Mode menu, choose Fixed Ratio, and then enter the proportions you want in the Width and Height boxes. Finally, drag and crop as described in the previous list, and your photo will end up with the exact proportions you entered. You can also crop to an exact size with the Marquee tool:

1. Check the resolution of your photo.

Go to Image→Resize→Image Size (or press Alt+Ctrl+I/Option- \Re -I) and make sure the Resolution number is somewhere between 150 and 300 if you plan to print your cropped photo (300 is best, for reasons explained on page 119.) If the number looks good, click OK and go to step 2. If the resolution is too low, change the number in the Resolution box to what you want. Make sure that the Resample Image checkbox is turned off, and then click OK.

2. Activate the Marquee tool.

Click the Marquee tool (the little dotted rectangle) in the Tools panel or press M. Make sure you've got the Rectangular Marquee tool, not the Elliptical Marquee tool.

3. Enter your settings in the Options bar.

First, go to the Mode menu and choose Fixed Size. Next, enter the dimensions you want in the Width and Height boxes. (You can also change the unit of measurement from pixels to inches or centimeters if you want; just change "px" to "in" or "cm.")

4. Drag anywhere in your image.

You get a selection the exact size you chose in the Options bar. You can reposition it by dragging or using the arrow keys.

5. Crop your image.

Go to Image \rightarrow Crop.

The Cookie Cutter tool also gives you a way to create really interesting crops, as shown in Figure 3-14.

Tip: If you're doing your own printing, there's no reason to restrict yourself to standard photo sizes like $4'' \times 6''$ —unless, of course, you need the image to fit a frame of that size. But most of the time, your images could just as well be square, or long and skinny, or whatever proportions you want. You can be especially inventive when sizing images for the Web. So don't feel that every photo you take has to be straitjacketed into a standard size.

Zooming and Repositioning Your View

Sometimes, rather than changing the size of your photo, all you want to do is change its appearance in Elements so you can get a better look at it. For example, you may want to zoom in on a particular area, or zoom out so you can see how edits you've made have affected your photo's overall look.

With Elements' Cookie Cutter tool, you don't have to be square. It lets you crop your images to various shapes, from the kind of abstract border you see here, to heart- or starshaped outlines.

There's more on how to use this tool in Chapter 12.

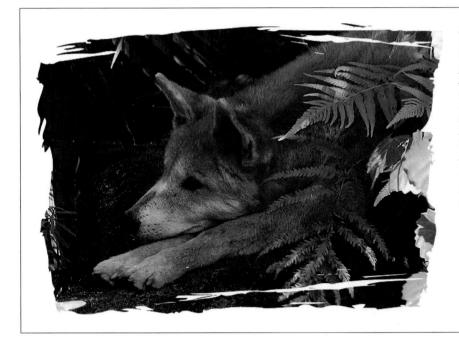

This section is about how to adjust your view of images. Nothing you do with the tools and commands covered in this section changes anything about your actual photo—you're just changing the way you see it. Elements gives you lots of tools and keystroke combinations to help with these views; soon you'll probably find yourself changing perspective without even thinking about it.

Image Views

Before you start changing your view of your photos, it's good to get familiar with the different ways you can position your image. Back in Chapter 1, you learned how to manage panels and bins. This section covers for image windows, which behave a little differently.

You can choose between viewing your images as tabs or in their own floating windows. Elements automatically starts out using tabs, but sometimes you may prefer to work with windows. For instance, if you want to use the Transform commands (page 389), putting your image into a tab gives you plenty of room to pull the handles, while you may find it easier to work with multiple images if each one is in its own window. There are a bunch of options for either view, and even if you're an Elements veteran but haven't quite gotten the hang of this relatively new system, you should read this section in case you accidentally wind up in a view you didn't want. Figure 3-15 shows the difference between tabs and windows.

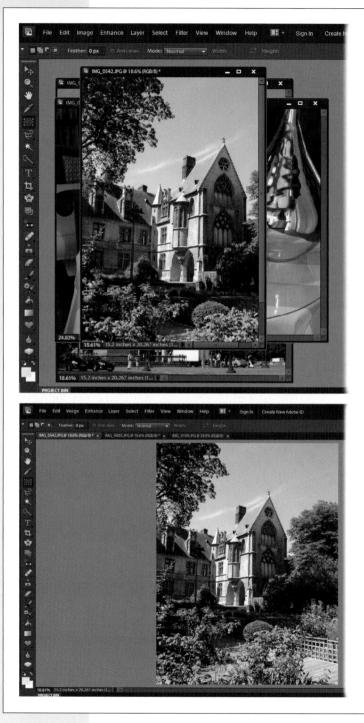

Figure 3-15:

Top: Three floating windows in Cascade view.

Bottom: The same three images as tabs. Notice that you only see one image—the others are tucked away out of sight. You can change which image you see by clicking the tab of the image you want. The tab's background will fill every part of the main Elements window that isn't occupied by bins, however large the area may be. The active image is easy to spot because the text on its tab is white; the other images' tabs have gray text. To give yourself maximum viewing flexibility, go to Edit \rightarrow Preferences \rightarrow General/Adobe Photoshop Elements Editor \rightarrow Preferences \rightarrow General and turn on "Allow Floating Documents in Full Edit Mode." When this setting is turned off, you're stuck with tabs no matter what you choose in the Editor's menus. When it's on, you can quickly switch back and forth between windows, tabs, or even a combination of the two.

Note: There's a bug in Elements that causes floating windows to become tabs after you switch edit modes. So if you have floating windows in Full Edit and then switch to Quick Fix or Guided Edit, when you come back to Full Edit you'll have tabs again. Just pull the tab down to float it, or go to Window—Images—"Float All in Windows" to get your floating windows back again.

Since accurate image viewing is crucial in Elements, you have three main menus to control how the program displays images: the Window and View menus (logically enough), as well as the Arrange menu, which is the gray square to the right of the Help button or the Elements logo (the dark blue square). When you go to Window→Images, you get several choices of how to display your images:

• **Tile.** Your image windows or tabs appear edge to edge so they fill the available desktop space. For example, with two photos open, each one gets half the workspace; with four photos, each one gets a quarter of it, and so on. With tabs, you have a lot of additional options when you use the Arrange menu, described in Figure 3-16.

Figure 3-16:

To arrange your tabs to work with multiple images, just click the thumbnail for the layout you want. The top row shows general arrangements you can apply no matter how many images you have open. The lower section offers arrangements possible for the number of images you have open (four, in this case). The rest are grayed out, since they don't pertain.

If you have floating windows, clicking a thumbnail consolidates them all into tabs in the layout you chose.

• Cascade. Your image windows appear in overlapping stacks (see Figure 3-15).

Most people find cascading windows the most practical view when they want to compare or work with two images. (This option is grayed out if you're working with tabs.)

- Float in Window. If you want to make a single image's tab into a window, click the image's tab to make it the active one, and then choose this option.
- Float All in Windows. If you have a bunch of tabs, choose this to make them all into floating windows.
- **Consolidate All to Tabs.** Got a lot of windows that you want to turn back into tabs? Choosing this option does the trick.
- New Window. Choose this command and you get a separate, duplicate window for your active image. This view is a terrific help when you're working on fine details. You can zoom way in on one view while keeping the other window in a regular view so you don't lose track of where you are in the photo. (Don't worry about version control or remembering which window you're working in—both windows just show different views of the same image.) If you haven't turned on floating windows, this makes a new tab instead, although that's not as useful.
- Minimize (Mac only). If you want to send your current image window to the Dock, choose this or press #-M. Click the image in the Dock to bring it back to Elements. If you have image tabs, then the whole Elements window gets minimized.
- Bring All to Front (Mac only). Use this command to bring all your open Elements image windows to the foreground (very handy if you've got documents from several programs covering each other up).
- Match Zoom. Elements displays all your windows at the same magnification level as the active window (the photo you're currently working on).
- Match Location. Elements makes all your windows match the active window so you see the same part of each image window, like the upper-right corner or the bottom-left edge.

Some of these commands are also in the Arrange menu, but the Arrange menu includes a lot of options found nowhere else, as explained in Figure 3-16.

The bottom section of the Arrange menu contains most of the commands described above, plus a few additional options:

- Fit on Screen. This command makes your photo as large as it can be while still keeping the whole photo visible. You can also press Ctrl+0/#-0 to get this view (that's the number zero, not the letter O).
- Actual Pixels. For the most accurate look at the onscreen size of your photo, go with this option. If you're creating graphics for the Web, this view shows how big your image will be in a web browser. Keyboard shortcut: Ctrl+1/#-1.
- Match Zoom and Location. Select this option to see the same part of each of

your tabs at the same zoom level.

Elements also gives you six handy commands for adjusting the view of your active image window or tab, although three are duplicates of the Arrange menu options. Go to the View menu, and you see:

- New Window for. This is the same as the New Window command in the Window menu, described above.
- Zoom In/Out. Zooming is explained on page 111. These menu commands are an alternative to using the actual Zoom tools.

Tip: Keyboard shortcuts are the fastest way to zoom: press $Ctrl+=/\Re =$ to zoom in and $Ctrl+=/\Re =$ (that's the Ctrl key-or, on a Mac, the \Re key-plus the minus sign) to zoom out. The next section explains the Zoom tool in detail.

- Fit on Screen. This is a duplicate of the Arrange menu command.
- Actual Pixels. Again, the same as in the Arrange menu.
- **Print Size.** This view is really just a guess by Elements because it doesn't know exactly how big a pixel is on your monitor. But it's a rough approximation of the size your image would be if you printed it at its current resolution. (Resolution is explained on page 114 in the section on resizing photos.)

To adjust your view of a particular image, Elements gives you three useful tools: The Zoom tool, the Hand tool, and the Navigator panel, all of which are explained in the following sections. While you may find the whole tab vs. window business a little confusing at first, it gives you lots of ways to stay organized while you work. The box on page 112 has some additional tips for keeping things under control.

The Zoom Tool

Some of Elements' tools require you to get a really close look at your image to see what's going on. Sometimes you need to see the actual pixels as you work, as shown in Figure 3-17. The Zoom tool makes it easy to zoom your view in and out.

The Zoom tool's Tools panel icon is a little magnifying glass. Click it or press Z to activate the tool. Once you do that, circles appear at the left end of the Options bar. If you want to zoom in, click the one with the + sign on it, then click the spot in your photo where you want the zoom to focus. The point you click becomes the center of your view, and the view size increases again each time you click. To zoom out, in the Options bar, click the circle with the – sign on it.

Tip: Holding Alt/Option while you click makes the Zoom tool do the opposite of what it's currently set to do. For instance, if the tool is set to zoom in, pressing this key makes it zoom out.

ORGANIZATION STATION

Window Management Hints

In addition to the various menu commands discussed in this section, there's another way to control whether you have tabs or windows without trekking up to the menu bar: dragging. Here are a few shortcuts:

- Turn a tab into a window. Just grab the tab's title bar and drag down. The tab pops off into a floating window.
- Turn a window into a tab. Drag the window up toward the Options bar till you see a blue outline around the Elements workspace. The blue outline is Elements' way of telling you that, if you let go of the mouse button, it'll consolidate your window with the outlined area, just like it consolidates panels (see page 28).
- Create tabs in a floating window. If you want to
 put two images in one floating window (say you're
 working on combining elements from many different images, and it's getting hard to know which is
 where), just drag one window's title bar onto another
 window's title bar, and let go when you see the blue

outline. You now have a floating window with two tabs. (Repeat this trick as many times as you want for a multitabbed window.)

- Avoid making tabs. When you're working with floating windows, if the tops of the windows move too close together, Elements wants to combine them. If you're dragging windows around and you see the telltale blue outline, just keep going till it disappears.
- Undo accidental tabs. If you create a tab you didn't mean to, just grab the top of the image you want to turn back into a floating window, and then drag it loose from the tab group.

Just remember that in Elements, anytime you're dragging something and a blue outline appears, what you're dragging is going to get consolidated with something if you let go of the mouse. If you don't want that to happen, keep dragging till the outline disappears. (Also, you need to enable floating windows—page 109 tells you how—before any of these tricks will work.)

Figure 3-17:

There will be times when you want to zoom way, way in on your image. You may even need to go pixel by pixel in tricky spots, as shown here. The Zoom tool has several other Options bar settings:

- **Zoom percent.** Enter a number here and the view immediately jumps to that percentage. The maximum is 3200 percent, and the minimum is 1 percent.
- **Resize Windows To Fit.** Turn this checkbox on and your image windows get larger or smaller as you zoom, according to your current view. The image always fills the whole window with no gray space around it.
- Zoom All Windows. If you have more than one image window, turn this option on and the view changes in all the windows simultaneously when you zoom in one window. (This option works with tabs, too, so be careful—you may zoom a hidden image when you don't want to.)

Tip: If you hold down the Shift key while zooming in, all your windows zoom together. You don't need to go to the Options bar to activate this feature.

- Actual Pixels. This button (which is labeled "1:1") has the same effect as choosing Actual Pixels from the Arrange menu. It's explained on page 110.
- Fit Screen. This button does the same thing as the Arrange menu's "Fit on Screen" command—see page 110.
- **Fill Screen.** This makes your photo fill Elements' whole viewing area, even if it doesn't all fit onscreen at once.
- **Print Size.** This is a duplicate of the View menu command. See page 111 for the lowdown.

Tip: You don't need to bother with the Zoom tool at all—you can use your keyboard instead. Press Ctrl+=/ \Re — to zoom in and Ctrl+—/ \Re — (that's the Ctrl key or, for Macs, the Command key, plus the minus sign) to zoom out. Just hold down Ctrl/ \Re and keep tapping the equal or minus sign until you see what you want. (You can zoom to 100 percent by double-clicking the Zoom tool's Tools panel icon.) It doesn't matter which tool you're using—you can always zoom in or out this way. Because you'll do a lot of zooming in Elements, these keyboard shortcuts are ones to remember.

And if you have a mouse with a scroll wheel, you can use that to zoom, too. Go to Edit \rightarrow Preferences \rightarrow General/Adobe Photoshop Elements Editor \rightarrow Preferences \rightarrow General and turn on the "Zoom with Scroll Wheel" checkbox.

The Hand Tool

With all that zooming, sometimes you can't see your whole image at once. The Hand tool lets you change which part of an image appears onscreen. It's super easy to use: Just click the little hand in the Tools panel or press H to activate it. When you do, your cursor turns into the little icon shown in Figure 3-18. Simply drag your photo to move it around in the window. This tool is really helpful when you're zoomed way in or working on a large image.

Figure 3-18:

The easiest way to activate the Hand tool is to press and hold the space bar on your keyboard. You can tell when the Hand tool is active because you see this little white-gloved cursor. No matter what you're doing in Elements, pressing the space bar calls up the Hand tool. When you let go of the space bar, Elements switches back to the tool you were previously usina.

If you find that you can't back out of the Hand tool, just give your space bar a whack—it may be sticking.

The Hand tool gives you the same All Windows option you get with the Zoom tool (page 113), but you don't have to use the Options bar to activate it. Just hold down Shift while using the Hand tool and all your windows scroll in sync. The Hand tool also gives you the same four buttons as the Zoom tool (Actual Pixels, Fit Screen, Fill Screen, and Print Size); they're described on page 113.

Figure 3-19 shows the Hand tool's somewhat more sophisticated assistant, the Navigator panel, which is really useful for working on big photos or when you want to have a slider handy for micromanaging the zoom level. Go to Window→Navigator to call it up.

Figure 3-19:

Meet the Navigator, which is perfect for keeping track of where you are in a large image. You can travel around your image by dragging the little red rectangle—it marks the area of your photo that you see onscreen. You can also enter a percentage for the size you want your photo to display at, move the slider, or click the + and – buttons on either side of the slider to change the view.

Changing the Size of an Image

The previous section explained how to resize your *view* of an image—how it appears on your monitor. But sometimes you need to change the actual size of your image, and that's what this section is about.

Resizing photos brings you up against a pretty tough concept in digital imaging: *resolution*, which measures, in pixels, the amount of detail your image can show. What's confusing is that resolution for printing and for onscreen use (like for email and the Web) are quite different.

You need many more pixels to create a good-looking print of an image than you do to view the image clearly onscreen. A photo that's going to print well almost always has too many pixels in it to display easily onscreen, and as a result, its file is usually pretty hefty for emailing. So you often need two copies of your photo for the two different uses. If you want to know more about the nitty-gritty of resolution, a good place to start is *www.scantips.com*.

This section gives you a brief introduction to both onscreen and print resolution, especially in terms of what decisions you'll need to make when using the Resize Image dialog box. You'll also learn how to add more canvas (more blank space) around your photos, which you'd do to make room for a caption below your image, for instance, or when you want to combine two photos.

To get started, open a photo you want to resize and then go to Image→Resize→Image Size or press Alt+Ctrl+I/Option-ૠ-I. Either way you should see the Image Size dialog box shown in Figure 3-20.

Learn more about: Image !	Size	OK
		Cance
Pixel Dimensions: 28.6M		
Width: 3648 pi	xels	Help
Height: 2736 pi	xels	
Document Size:		

Figure 3-20:

This dialog box gives you two different ways to change the size of your photo. Use the Pixel Dimensions section (shown here) when preparing a photo for onscreen viewing. (The number next to Pixel Dimensions—here, 28.6M—tells you the current size of your file in megabytes or kilobytes.) Before you can make any changes here, you have to turn on the Resample Image checkbox at the bottom of the dialog box (not visible here), since changing pixel dimensions always involves resampling (see page 121).

Resizing Images for Email and the Web

It's important to learn how to size your photos so that they show up easily and clearly onscreen. Have you ever gotten an emailed photo that was so huge you could see only a tiny bit of it on your monitor at once? That happens when someone sends an image that isn't optimized for onscreen viewing. Happily, it's easy to avoid that problem once you know how to correctly size photos for onscreen use.

The Image Size dialog box has two main sections: Pixel Dimensions and Document Size. You'll use the Pixel Dimensions settings when you know your image is only going to be viewed onscreen. (The Document Size settings are for printing, which is covered in the next section.)

A monitor is concerned only with the size of a photo as measured in pixels, known as the *pixel dimensions*. On a monitor, a pixel is always the same size (unlike a printer, which can change the size of the pixels it prints). Your monitor doesn't know any-thing about pixels per inch (ppi), and it can't change the way it displays a photo even if you change the photo's ppi settings, as shown in Figure 3-21. (Graphics programs like Elements can change the size of your onscreen view by, say, zooming in, but most programs can't.) All you have to decide is how many pixels long and how many pixels wide you want your photo to be. You control those measurements in the Pixel Dimensions section of the Image Size dialog box.

Figure 3-21:

This shows that your monitor doesn't care about the ppi settings you enter. One of these apple photos was saved at 3000 ppi, another at 300 ppi, and one at 3 ppi. Can you tell which is which? Nope.

They all look exactly the same on your monitor because they all have exactly the same pixel dimensions, which is the only resolution setting your monitor understands.

What dimensions should you use? That depends on who's going to see your photos, but as a general rule, small monitors today are usually 1024 pixels wide by 768 pixels high, although netbook screens can be quite a bit smaller than that. And some monitors, like the largest Dell and Apple models, have many more pixels than that. Still, if you want to be sure that people who view your photo won't have to scroll to see the whole thing, a good rule of thumb is to choose no more than 650 pixels for the

longer side of your photo, whether that's the width or the height. And if you want people to be able to see more than one image at a time, you may want to make your photos smaller than that. Also, some people still set their monitors to display only 800 pixels wide by 600 pixels high, so you may want to make even smaller images to send to them.

On the other hand, if you send really small pictures to people with deluxe, highresolution monitors where the individual pixels are miniscule, they're likely to complain that the photos are too tiny to see in detail. So if you send to a varied group of folks, you may need to make different copies for different audiences. On the whole, it's better to err on the side of caution-nobody will have trouble receiving and opening an image that's too small, but an overly large attachment can cause problems for people with small mailboxes.

Tip: To get the most accurate look at how your photo displays on a monitor, go to View—Actual Pixels.

Also, although a photo always has the same pixel dimensions, you really can't control the exact inch dimensions at which those pixels display on other people's monitors. A pixel is always the same size on any given monitor (as long as you don't change the monitor's screen resolution), but these days different monitors have different-sized pixels. Figure 3-22 may help clarify this concept.

Both these monitors have a resolution of

Figure 3-22:

1024×768 pixels, and the photo they're displaying takes up exactly the same percentage of each screen. But the picture on the left is larger because the monitor is physically larger-in other words, the individual pixels are bigger.

Note: In the following sections, you'll learn what to do when you want to reduce the size of an image. It's much easier to get good results when making a photo smaller than larger. Elements does let you *increase* the size of your image using a technique called upsampling (page 121), but you often get mediocre results; page 121 explains why.

Resizing Images for Email and the Web

To resize your photos, start by making extra sure you're not resizing the original. You're going to be shedding pixels that you can't get back, so if your photo's not already in the Organizer, resize a copy of it (File→Duplicate) rather than the original. Here's what you do:

1. Call up the Image Size dialog box.

Go to Image→Resize→Image Size or press Alt+Ctrl+I/Option-#-I.

2. Turn on the Resample Image checkbox at the bottom of the dialog box.

You won't be able to make any changes to the pixel dimensions in the top part of the window until you do this.

3. In the Pixel Dimensions area, enter the dimension you want for the longer side of your photo.

Usually you want 650 pixels or fewer, unless you know for sure that your recipients have up-to-date equipment and broadband Internet connections. Be sure to choose pixels as the unit of measurement. You just need to enter a number for one dimension; Elements automatically figures the other dimension as long as the Constrain Proportions checkbox is turned on down near the bottom of the dialog box.

4. Check the settings at the bottom of the dialog box.

Scale Styles doesn't matter, so leave it off. Constrain Proportions and Resample Image should be turned on. (*Resampling* means changing the number of pixels in your image.) The Resample Image menu lists the different resampling methods you can choose from. Adobe recommends Bicubic Sharper when you're making an image smaller, but you may want to experiment with the other options if you don't like the results Bicubic Sharper gives you. (You'll see the suggested use for each method in parentheses after its name in the menu.)

5. Click OK.

Elements resizes your photo, although you may not immediately see a difference onscreen. (Go to View→Actual Pixels before and after you resize and you'll see the difference.) Save your resized photo to make your changes permanent.

Sometimes Elements resizes an image automatically—for example, when you use the Organizer's E-Mail command (see page 564). But the method described here gives you more control than letting Elements make all the decisions for you.

Tip: If you're concerned about file size, use Save For Web (see page 554), which helps you create smaller files.

Resizing for Printing

If you want great prints, you need to think about your photo's resolution quite differently than you do for onscreen images. For printing, as a general rule, the more pixels your photo has, the better. That's the reason camera manufacturers keep packing more megapixels into their new models—the more pixels you have, the larger you can print your photo and still have it look terrific.

Tip: Even before you take photos, you can do a lot toward making them print well if you always choose the largest size and the highest quality setting on your camera (typically Extra Fine, Superfine, or Fine).

When you print, you need to think about two things: the photo's size in inches (or whatever your preferred unit of measurement is) and its resolution in pixels per inch (ppi). These settings work together to control the quality of your print.

Your printer is a virtuoso that plays your pixels like an accordion. It can squeeze the pixels together and make them smaller, or spread them out and make them larger. Generally speaking, the denser the pixels (the higher the ppi), the higher your photo's resolution and the better it looks. If you don't have enough pixels in your photo, the print will look *pixelated*—jagged and blurry. The goal is to have enough pixels in your photo so that they'll be packed fairly densely—ideally about 300 ppi.

You usually don't get a visibly better result if you go over 300 ppi, though—you just have a larger file. And depending on your tastes, you may be content with your results at a lower ppi. For instance, some photos taken with Canon cameras come into Elements at 180 ppi, and you may be happy with how they print. But 200 ppi is usually considered about the lowest density for an acceptable print. Figure 3-23 shows why it's so important to have a high ppi setting.

To set the size of an image for printing:

1. Call up the Image Size dialog box.

Go to Image→Resize→Image Size, or press Alt+Ctrl+I/Option-#-I.

2. Check your image's resolution.

Take a look at the Document Size section of the dialog box (see Figure 3-24). Start by checking the ppi (pixels/inch) setting. If it's too low, like 72 ppi, go to the bottom of the dialog box and turn off the Resample Image checkbox. Then enter the ppi you want in the Document Size area. The dimensions should become smaller to reflect the greater density of the pixels. If they don't, click OK, and then open the dialog box again.

Figure 3-23:

Different resolution settings can dramatically alter the quality of a print. These photos have been printed and then scanned so you can see the results of printing them.

Top: A photo with a resolution of 300 ppi.

Bottom: The same photo with a resolution of 72 ppi. Too few pixels stretched too far causes this kind of blocky, blurry print. When you can see individual pixels like you can here, a photo is said to be pixelated.

Width: 20.267	inches		٦.,
Height: 15.2	inches	-	0
Resolution: 180	pixels/inch	-	
✓ Scale Styles ✓ Constrain Proportions ✓ Resample Image:			
incountry in intrager			

Figure 3-24:

Crop your image to the shape you want (see page 99), and then use this section of the Image Size dialog box to set its size for printing.

3. Check the physical size of your photo.

Look at the Width and Height numbers in the Document Size area. Are they what you want? If so, you're all done. Click OK.

4. If the size numbers aren't right, resize your photo.

If the proportions of your image aren't what you want, crop the photo (page 99) and then come back to the Image Size dialog box. (Don't try to reshape an image using this dialog box.)

Once you've cropped the image and opened the dialog box again, turn on the Resample Image checkbox and choose Bicubic Smoother from the drop-down menu at the bottom of the dialog box, if you're making the photo larger. Use Bicubic Sharper if you're reducing the size. (These settings are Adobe's recommendation, but you may find that you prefer one of the other resampling choices.) Be sure to read the next section, "Resampling," to understand how you're affecting your photo when you do this.

Make sure that Constrain Proportions is turned on, and then enter the size you want for the width or height. (Elements calculates the other dimension for you.) Scale Styles doesn't matter, so leave it off.

5. Click OK.

Elements resizes your photo so it's ready for printing.

Resampling

Resampling is an image-editing term for changing the number of pixels in an image. When you resample, the results are permanent, so you want to avoid resampling an original photo if you can help it. As a rule, it's easier to get good results when you *downsample* (make a photo smaller) than when you *upsample* (make a photo larger).

When you upsample, you're *adding* pixels to the image. Elements has to get them from somewhere, so it makes them up. It's pretty good at doing this, but these pixels are never as good as the ones that were in your photo to begin with, as you can see from Figure 3-25. You can download the figure *russian_box.jpg* from this book's Missing CD page at *www.missingmanuals.com/cds* if you'd like to try this yourself. Zoom in really close so you can see the pixels.

When you enlarge an image to more than 100 percent of its original size, you'll definitely lose some quality. So, for example, if you try to stretch a photo that's $3^{"}$ wide at 180 ppi to an $8^{"}\times10^{"}$ print, don't be surprised if the results look pretty bad.

Elements offers several resampling methods for you to choose from, and they do a really good job when you find the right one for your situation. You select them from the Resample Image menu at the bottom of the Image Size dialog box. Adobe recommends choosing Bicubic Smoother when you're upsampling (enlarging) images and Bicubic Sharper when you're downsampling (reducing) photos, but you may prefer one of the others. It's worth experimenting with them all to see which you like.

Tip: If a whole chapter on Quick Fix is frustratingly slow. you can start off by trying out the ultrafast Auto Smart Fix-a quick-fix tool for the truly impatient. Page 39 tells you everything you need to know. Also, Guided Edit may give you enough help to accomplish what you want to do: page 34 has the full story.

The Quick Fix Window

Getting to the Quick Fix window from the Editor is easy: Just click the Edit tab (if it's not already the active tab) and choose Quick. If you're in the Organizer, click the down-facing arrow on the right side of the Fix tab and choose Quick Photo Edit.

You can also get to Quick Fix from any of the multipage projects in Create mode: Just right-click/Control-click the photo you want to fix and choose Edit Quick; you get sent to the Quick Fix with your photo ready for your adjustments. When you come into the Quick Fix this way, you see a big button at the upper right of the screen that savs "Back to Creation." When you finish, click it to go right back to where you left off in your project.

Tip: You can also apply many quick fixes right from the Organizer, even in Full Screen view. See the box on page 129 for details.

The Quick Fix window looks like a stripped-down version of the Full Edit window (see Figure 4-1). Your tools are neatly arranged on both sides of the image: On the left, there's an eight-item toolbox; on the right, a collection of quick-edit panels (Figure 4-2) in the Panel bin. First, this chapter gives you a quick overview of the tools Quick Fix offers. Then it'll teach you how to actually use them.

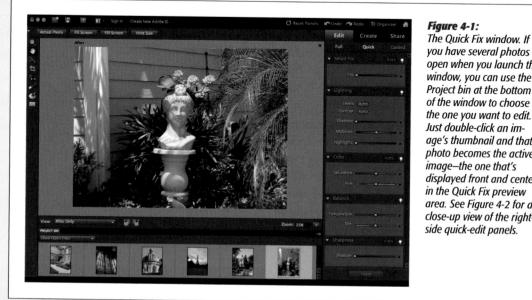

you have several photos open when you launch this window, you can use the Project bin at the bottom of the window to choose the one you want to edit. Just double-click an im-

age's thumbnail and that photo becomes the active image-the one that's displayed front and center in the Quick Fix preview area. See Figure 4-2 for a close-up view of the rightside quick-edit panels.

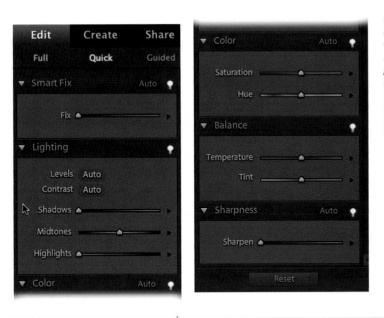

Figure 4-2:

Here are all the ways you can enhance your photos with Quick Fix. The left figure shows the top part of the Panel bin; the right, the bottom part. Besides these handy tools, you can also use most of the Full Edit menu commands if you need something more than the Panel bin provides.

GEM IN THE ROUGH

Quick Fixes in the Organizer

The Organizer gives you several ways to apply Quick Fix's auto fixes without launching the Editor. The Organizer's Fix tab has buttons that let you apply Auto Smart Fix, Auto Color, Auto Levels, Auto Contrast, Auto Sharpen; fix red eye; or crop your photo. For more selective editing, you'll still want the Editor, but if Auto is your thing, you'll be very happy staying in the Organizer. And if you use the Organizer, you get the added benefit of having your fixes automatically made on a copy of your image, which Elements saves in a *version set* (page 75) with your original.

There are two ways to get to the Organizer's auto fixes:

- Just click it. In the main Organizer window, click the Fix tab to start auto-fixing.
- Use Full Screen view. In the Organizer, when you press F11/#-F11 (for Full Screen view), F12/#-F12

(for a side-by-side comparison), or choose either of these views from the Display button in the menu bar, a Quick Edit panel appears on the left side of your screen. (The panel tends to be shy and hide itself by collapsing against the left edge of the screen, so you may need to click it to pop it open). Each of the panel's icons is a button for one of the auto fixes. Just click one to apply that fix while you've got a large view of your photo-very handy for tweaking images as you preview a newly imported batch of photos, for example.

Read on for more about what these tools do. They work the same way in the Organizer as they do in the Editor.

Tip: If you need extra help, check out Guided Edit (page 34), which walks you step by step through a lot of basic editing projects.

The Quick Fix Toolbox

The toolbox holds an easy-to-navigate subset of the Full Edit window's tool collection. All the tools work the same way in both modes, and you can use the same keystrokes to switch tools here. From top to bottom, here's what you get:

- The Zoom tool lets you telescope in and out on your image—perfect for getting a good, close look at details or pulling back to see the whole photo. (See page 111 for more on how this tool works.) You can also zoom by using the Zoom drop-down menu in the lower-right corner of the image preview area.
- The Hand tool helps move your photo around in the image window—just like grabbing it and moving it with your own five fingers. There's more about this tool on page 113.
- The Quick Selection tool lets you apply Quick Fix commands to specific portions of your image. Once you make a selection, the commands you use will change only the selected area, not your entire photo. You can also use the regular Selection brush in Quick Fix. To get to the Selection brush, in the toolbox, just click the Quick Selection tool's icon and hold down your mouse button; then choose the Selection brush from the menu that appears.

What's the difference between the two tools? The Selection brush lets you paint a selection exactly where you want it (or mask out part of your photo to keep it from changing), while the Quick Selection tool makes Elements figure out the boundaries of your selection based on your much less precise marks on the image. Also, the Quick Selection tool is far more automatic than the regular Selection brush. You can read more about these tools beginning on page 154. (To get the most out of them, you need to understand the concept of selections. Chapter 5 tells you everything you need to know.)

• The Crop tool lets you change the size and shape of your photo by cutting off the areas you don't want (see page 100).

Tip: If the contents of your photo need straightening (see page 94), usually it's easier to do that in Full Edit before switching to Quick Fix, since the Quick Fix toolbox doesn't include the Straighten tool. However, there's a sneaky way to straighten with the Crop tool that you can use in Quick Fix, too—see page 100.

 The Red Eye Removal tool lets you darken those demonic-looking red flash reflections in people's eyes. It's explained on page 133. • Unlike the rest of the tools in this list, the **Touch Up tools** aren't available in Full Edit. You won't find these three tools (which live at the bottom of the Quick Fix toolbox) anywhere else in Elements. From top to bottom, these buttons let you whiten teeth, make the sky more blue, or turn part of a photo to black and white. (The keyboard shortcut for switching among these three tools is F.) You'll learn how to use them beginning on page 143.

The Quick Fix Panel Bin

When you switch to Quick Fix, the Task panel presents you with the Quick Fix Panel bin. This is where you make the majority of your adjustments. Elements helpfully arranges everything into five panels—Smart Fix, Lighting, Color,Balance, and Sharpness. In most cases, it makes sense to start with the top panel and work your way down until you get the results you want. (See page 146 for more suggestions on what order to work in.)

Note: There's one exception to this top-to-bottom order of operations: fixing red-eye problems (page 133). You may want to use the Red Eye Removal tool (which is in the toolbox on the left of the window) *before* you do other editing.

The Panel bin always fills the right side of the Quick Fix screen. You can't drag the panels out of the bin as you can in Full Edit mode, but you can expand and collapse the individual panels within the bin, as explained in Figure 4-3.

Figure 4-3:

Clicking any of these flippy triangles collapses or expands that section of the Panel bin. If your Elements window is very small, you may not be able to see the Sharpness section at the bottom of the bin, so you can collapse one of the other sections to bring it into view, or use the slider on the right to scroll through the panels. (The slider only appears when you need it; in other words, if you can see all the panels, you don't see the slider.)

Using presets

Elements has a handy feature to help the undecided: *presets*. However, Adobe makes them tricky to find. To the right of the Panel bin's sliders are small, right-facing triangles. These are actually flippy triangles. If you think you need to use a particular slider but you aren't sure, click its triangle and a grid of nine tiny thumbnails appears below the slider (see Figure 4-4). Each thumbnail represents a different preset for that slider.

If you don't have super-micro vision, these thumbnails are probably too darn small for you to be able to tell the difference—but not to worry: Place your cursor over a thumbnail and Elements previews that setting on your image itself so you can get a view as large as you need. You can even adjust the slider right from the thumbnail as explained in Figure 4-4. Once you like what you see, click the thumbnail to apply that change to your photo. To reset your image back to what it looked like when you began using the current group of presets, click the thumbnail with the curved arrow on it. (If you've already accepted a change from the presets, just use the standard Undo command [Ctrl+Z/#-Z] instead.) To hide the presets, simply click the flippy triangle again.

Figure 4-4:

Put your cursor over any of the thumbnails to see its effect displayed on your photo. To adjust the strength of the effect, click the thumbnail that's closest to what you want, and then drag left or right (this is called scrubbing) and watch as your image changes. If you decide not to make any changes, just click the thumbnail with the curved arrow on it (the center image here) to return your photo to how it looked when you opened that preset group.

Different Views: After vs. Before and After

When you open an image in Quick Fix, your picture appears by itself in the main window with the word "After" above it to let you know that you're in After Only view. Elements keeps the Before view—your original photo—tucked out of sight. But you have three other layout options, which you can choose anytime: Before Only, "Before and After - Horizontal," and "Before and After - Vertical." Both of the before-and-after views are especially helpful when you're trying to figure out whether you're improving your picture, as shown in Figure 4-5. You switch between views by picking the one you want from the View pop-up menu just below your image.

Editing Your Photos

As you'll learn in this section, the Quick Fix window's tools are pretty easy to use. You can try one or all of them—it's up to you. And whenever you're happy with how your photo looks, you can leave Quick Fix and go back to the Full Edit window or the Organizer.

Tip: If you want to rotate your photo, click the Rotate buttons below the image preview area. (See page 91 for more about rotating photos.)

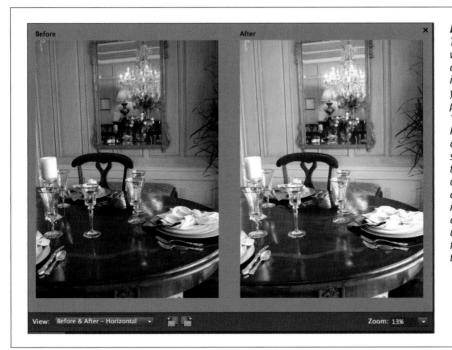

Figure 4-5:

The Ouick Fix window's beforeand-after views make it easy to see how you're changing your photo. Here vou see "Before and After -Horizontal." which displays the views side by side. To see them one above the other, choose "Before and After - Vertical" instead. If you want a more detailed view. use the Zoom tool to focus on just a portion of your picture.

If you're tweaking an image in Quick Fix and decide you don't like how it's turning out, click the Reset button at the bottom right of the Elements window to return your photo to the way it looked *before* you started working in Quick Fix. Keep in mind that this button undoes *all* Quick Fix edits, so don't use it if you want to undo only a single action. For that, just use the regular Undo command: choose Edit→Undo or press Ctrl+Z/#-Z.

Fixing Red Eye

Anyone who's ever taken a flash photo has run into the dreaded problem of *red eye*—those glowing, demonic pupils that make your little cherub look like a character from an Anne Rice novel. Red eye is even more of a problem with digital cameras than with film, but luckily Elements has a simple and terrific tool for fixing it. All you need to do is click the red spots with the Red Eye Removal tool, and your problems are solved.

This tool works the same whether you use it in Quick Fix or Full Edit. Here's what you do:

- 1. Open a photo (page 47).
- 2. Zoom in so you can see where you're clicking.

Use the Zoom tool to magnify the eyes. You can also switch to the Hand tool if you need to drag the photo around so the eyes are front and center.

Editing Your Photos

3. Activate the Red Eye Removal tool.

Click the red eye icon in the toolbox or press Y.

4. Click the red part of the pupil (see Figure 4-6).

That's it! Just one click should fix the problem. If it doesn't, press Ctrl+Z/#-Z to undo it, and then try *dragging* the Red Eye Removal tool over the pupil. Sometimes one method works better than the other. And as explained in a moment, you can also adjust two settings for this tool: Darken Amount and Pupil Size.

5. Click the red part of the other eye.

Repeat the process on the other eye, and you're done.

Figure 4-6:

Zoom in when using the Red Eye Removal tool so you get a good look at the pupils. Don't worry if your photo is so magnified that it loses definition—just make the red area large enough so you can hit it right in the center.

The left eye here has already been fixed. Notice what a good job this tool does of keeping the highlights (called catch lights) in the eye that's been treated.

Tip: You can also apply the Organizer's Auto Red Eye Fix in Quick Fix and Full Edit. In either window, just press Ctrl+R/**#**-R or go to Enhance—Auto Red Eye Fix. (In Full Edit, you can also activate the Red Eye Removal tool, and then click the Auto button in the Options bar.) The only tradeoff to using Auto Red Eye Fix in the Editor is that you don't *automatically* get a version set like you do when using the tool from in the Organizer. But you can create a version set when you save your changes, as explained on page 75.

If you need to adjust how the Red Eye Removal tool works, the Options bar gives you two controls, although 99 percent of the time you can ignore them:

- Darken Amount. If the result is too light, increase the percentage in this box.
- **Pupil Size**. Adjust the number here to tell Elements how large an area to consider part of the pupil.

Tip: You can also fix red eye right in the Raw converter (page 276) if you're dealing with Raw files.

POWER USERS' CLINIC

Another Red Eye Fix

The Red Eye Removal tool does a great job most of the time, but it doesn't always work, and it doesn't work on animals' eyes. Elements gives you a couple of other ways to fix red eye that work in almost any situation. Here's one:

- Zoom way, way in on the eye. You want to be able to see the individual pixels.
- Use the Eyedropper tool (page 257) to sample the color from a good area of the eye, or from another photo. Check the Foreground color square (page 254) to make sure you've got the color you want.
- 3. Get out the Pencil tool (page 408) and set its size to 1 pixel.

 Click the bad or empty pixels of the eye to replace their color with the correct shade. Remember to leave a couple of white pixels for a catch light (the pupil's glinting highlight).

This process works even if the eye is *blown out* (that is, all white with no color info left).

If you're a layers fan, you can also fix red eye by selecting the bad area, creating a Hue/Saturation Adjustment layer (page 218), and then desaturating the red area. However, this method doesn't work so well if the eye is blown out.

Smart Fix

The Quick Fix window's secret weapon is the Smart Fix command, which automatically adjusts a picture's lighting, color, and contrast, all with one click. You don't have to figure anything out—Elements does it all for you.

You'll find the Smart Fix command in the aptly named Smart Fix panel, and it's about as easy to use as hitting the speed-dial button on your phone: Click the Auto button, and if the stars are aligned, your picture will immediately look better. (Figure 4-7 gives you a glimpse of its capabilities. If you want to see for yourself how this fix works, download this photo—*iris.jpg*—from this book's Missing CD page at *www. missingmanuals.com*.)

Tip: You'll find Auto buttons scattered throughout Elements. When you click one, the program makes a best-guess attempt to apply whatever change the Auto button is next to (Smart Fix, Levels, Contrast, and so on). It never hurts to at least try clicking these buttons; if you don't like what you see, you can always perform the magical undo: Edit \rightarrow Undo or Ctrl+Z/æ-Z.

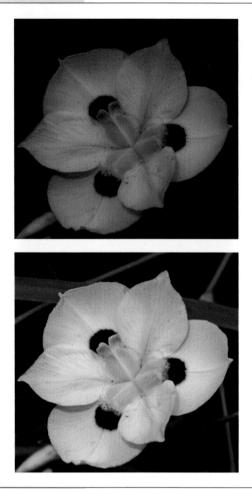

Figure 4-7: Top: This photo, taken in the shade, is pretty dark.

Bottom: The Auto Smart Fix button improved it significantly with just one click. You might want to use the tools in the Balance section (page 140) to really fine-tune the color.

If you're happy with Auto Smart Fix's changes, you can move on to a new photo, or try sharpening your photo a little if the focus appears a bit soft (see page 142). You don't need to do anything to accept the Smart Fix changes, but if you're not thrilled with the results, take a good look at your picture. If you like what Auto Smart Fix did but the effect is too strong or too weak, press Ctrl+Z/I-Z to undo it, and then try playing with the Fix slider instead. Or click the little triangle to the slider's right to try out one of the tool's presets.

The Fix slider does the same thing as the Auto Smart Fix button, only *you* control the degree of change. Watch the image as you move the slider to the right. (If your computer is slow, there's a certain amount of lag, so go slowly to give it a chance to catch up.) If you overdo it, sometimes it's easier to click the Reset button at the bottom of the Panel bin and start again. Use the checkmark and X buttons that appear next to the Smart Fix label (they look like the ones in Figure 4-8) to accept or reject your changes.

Tip: Usually you get better results with a lot of little nudges to the Smart Fix slider than with one big sweeping movement.

Incidentally, these are the same Smart Fix commands you see in the Editor's Enhance menu: Enhance→Auto Smart Fix (Alt+Ctrl+M/Option-ℜ-M), and Enhance→Adjust Smart Fix (Shift+Ctrl+M/Shift-ℜ-M).

Figure 4-8:

When you move a slider in any of the Quick Fix panels, accept and cancel buttons appear in the panel you're using. Clicking the accept (checkmark) button applies the change to your image, while clicking the cancel (X) button undoes the last change you made. If you make several slider adjustments, the cancel button undoes everything you've done since you clicked accept. (Clicking the light bulb icon takes you to the Elements Help Center.)

Sometimes Smart Fix just isn't smart enough to do everything you want, and sometimes it does things you don't want. (It works better on photos that are underexposed [too dark] than overexposed [too bright], for one thing.) Fortunately, you still have several other editing choices, covered in the following sections. (If you don't like what Smart Fix has done to your photo, undo it before making other changes.)

Tip: Auto Smart Fix is one of the commands you can apply from within the Organizer, so there's no need to launch the Editor if you want just this tool. See the box on page 129 for more about making fixes from the Organizer.

Adjusting Lighting and Contrast

The Lighting panel lets you make sophisticated adjustments to the brightness and contrast of your photo. You might be surprised: Sometimes problems you thought stemmed from exposure or even focus can be fixed with these commands.

Levels

If you want to understand how Levels works, you're in for a long, technical ride. But if you just want to know what it can do for your photos, the short answer is that it adjusts the brightness of your image by redistributing its color information. Levels changes (and hopefully fixes!) both brightness and color at the same time.

If you've never used any photo-editing software before, this may sound rather mysterious, but photo-editing pros will tell you that Levels is one of the most powerful commands for fixing and polishing your pictures. To find out if its magic works for you, click the Auto button next to the word "Levels." Figure 4-9 shows what a big difference it can make. Download this photo (*ocean.jpg*) from this book's Missing CD page at *www.missingmanuals.com* if you'd like to give it a try.

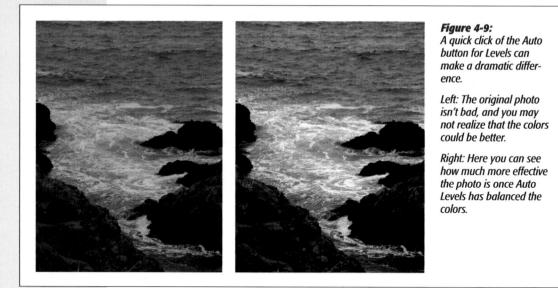

What Levels does is complex. Chapter 7 has loads more details about what's going on behind the scenes and how you can apply this command much more precisely.

Contrast

The main alternative to Auto Levels in Quick Fix is Auto Contrast. Most people find that their images tend to benefit from one or the other of these options. Contrast adjusts the relative darkness and lightness of your image without changing its color, so if Levels made the colors go all goofy, try adjusting the contrast instead. You use Contrast the same way you do the Levels tool: just click the Auto button next to its name.

FREQUENTLY ASKED QUESTION

Calibrating Your Monitor

Why do my photos look awful when I open them in Elements?

You may find that when you open images in Elements, they look really terrible even though they look decent in other programs. Maybe your photos look all washed out, or reddish or greenish, or even black and white. If that's the case, you need to calibrate your monitor, as explained on page 239. It's easy to do and it makes a big difference. The reason for this is that Elements is what's known as a *color-managed* program. You can read all about color management on page 237. For now, you just need to know that color-managed programs pay much more attention to the settings for your monitor than other programs (like word processors) do. Color-managed programs are a little more trouble to set up initially, but the advantage is that you can get truly wonderful results if you invest a little time and effort when you're getting started.

Tip: After you use Auto Contrast, look closely at the edges of the objects in your photo. If your camera's contrast was already high, you may see a halo or a sharp line around the photo's subject. In that case, the contrast is too high; undo Auto Contrast ($Ctrl+Z/\Re-Z$) and try another fix instead.

Shadows and Highlights

The Shadows and Highlights tools do an amazing job of bringing out details that are lost in the shadows or bright areas of your photo. Figure 4-10 shows what a difference these tools can make.

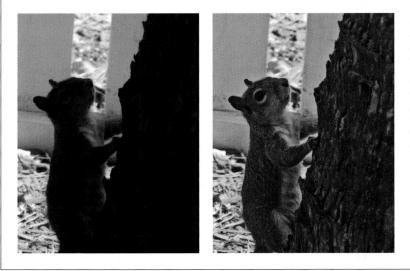

Figure 4-10:

Left: This image has overly bright highlights and shadows that are much too dark.

Right: After a little shadows and highlights adjusting, you can see there's plenty of detail here. (Use the color sliders—described next—to get rid of the orange tone.) The Shadows and Highlights tools are a collection of three sliders, each of which controls a different aspect of your image:

- **Shadows**. Nudge this slider to the right, and you'll see details emerge from murky black shadows as you lighten the dark areas of your photo.
- **Midtones**. After you've adjusted a photo's shadows and highlights, the image may look flat and not have enough contrast between dark and light areas. This slider helps you bring a more realistic look back to your photo. Use it last of the three sliders in this group, *after* you've adjusted the shadows and the highlights.
- Highlights. Use this slider to dim the brightness of overexposed areas.

Tip: You may think you need only lighten shadows in a photo, but sometimes just a smidgen of Highlights may help, too. Don't be afraid to experiment by using this slider even if you've got a relatively dark photo.

Go easy: Getting overenthusiastic with these sliders can give your photos a washedout, flat look.

Color

The Color panel lets you—surprise, surprise—play around with the colors in your image. In many cases, if you've been successful with Auto Levels or Auto Contrast, you won't need to do anything here.

Auto Color

Here's another one-click fix. Actually, in some ways Auto Color should be up in the Lighting section. Like Levels, it simultaneously adjusts color and brightness, but it looks at different information in your photos to decide what to do with them.

When you're first learning to use Quick Fix, you may want to try Auto Levels, Auto Contrast, and Auto Color to see which generally works best for your photos. Undo the changes after you use each one and compare your results. Most people find they prefer one of the three most of the time.

Auto Color may be just the ticket for your photos, but you may also find that it shifts your colors in strange ways. Click it and see what you think. If it makes your photo look worse, just click Reset or press Ctrl+Z/æ-Z to undo it, and go back to Auto Levels or Auto Contrast. If they *all* make your colors look a little wrong, or if you want to tweak the colors in your photo, move on to the Color sliders instead.

Using the Color sliders

If you want to adjust the colors in your photo without changing its brightness, try the Color sliders. For instance, your digital camera may produce colors that don't quite match what you saw when you took the picture; you may have scanned an old print that's faded or discolored; or you may just want to change the colors in a photo for the heck of it. Whatever the case, the sliders below the Auto Color button are for you:

- **Saturation** controls the intensity of your image's color. For example, you can turn a color photo to black and white by moving this slider all the way to the left. Move it too far to the right, and everything glows with so much color that it looks radioactive.
- **Hue** changes the color from, say, red to blue or green. If you aren't aiming for realism, you can have fun using this slider to create funky color changes.

You probably won't use both these sliders on a single photo, but you can if you like. Remember to click the accept checkmark that appears in the Color panel if you want to accept your changes. And don't forget that, as with the other Quick Fixes, Elements gives you presets as starting points if you need some help; just click the triangle to the right of either slider to see them. To fine-tune the color, you may want to move on to the next panel: Balance. In fact, in many cases you'll only need the Balance sliders.

Tip: If you look at the color of the slider's track, it shows what happens when you move in that direction. For example, there's less and less color as you go left in the Saturation track, and more and more to the right. Looking at the tracks can help you figure out where to move the slider.

Balancing color

Photos often have the right amount of saturation, but suppose there's something about the color balance that just isn't right, and moving the Hue slider makes everything look funky. The Balance panel contains two very useful controls for adjusting the overall colors in your image:

- **Temperature** lets you adjust colors from cool (bluish) on the left to warm (orangeish) on the right. Use this slider for things like toning down the warm glow you see in photos taken in tungsten lighting, or just for fine-tuning your color balance.
- Tint adjusts the green/magenta balance of your photo, as shown in Figure 4-11.

There are presets for these adjustments, too, but you may find that they're all much too exaggerated if you're after realistic color, so you're probably better off using the sliders.

Tip: In early versions of Elements, these sliders were grouped with the Color sliders, since you'll often use a combination of adjustments from both groups. Chapter 7 has lots more about how to use the full-blown Editor to really fine-tune your image's colors.

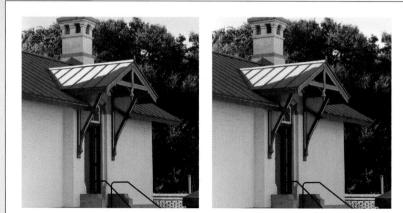

Figure 4-11:

Left: The greenish tint shown here is a common problem with many digital cameras, especially cellphone cameras.

Right: A little adjustment of the Tint slider clears it up in a jiffy. It's not always as obvious as it is here that you need a tint adjustment. If you aren't sure, the sky can be a dead giveaway: Is it robin's egg blue like the left photo here? If so, tint is what you need.

Sharpening

Now that you've finished your other corrections, it's time to sharpen your photo, so move down to the Sharpness panel. Sharpening gives the effect of better focus by improving the edge contrast of objects in your photo. Once again, an Auto button is at your service: Click the Sharpness panel's Auto button to get things started. Figure 4-12 shows what you can expect.

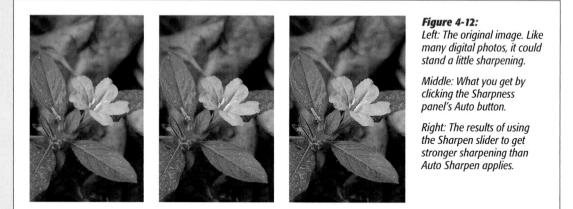

The sad truth is that there really isn't any way to improve the focus of a photo once you click the shutter. Photo-editing programs like Elements sharpen by increasing the contrast where they perceive edges of objects, so sharpening first can have strange effects on other editing tools you apply later. **Tip:** If you see funny halos around objects in your photos, or strange flaky spots (making your photo look like it has eczema), those are a sure sign of oversharpening; reduce the Sharpen settings till they go away. In fact, many modern cameras apply a pretty hefty dose of sharpening right in the camera, so you may decide you like your photo best with no extra sharpening at all.

Always look at the actual pixels (View→Actual Pixels) when you sharpen, because that gives you the clearest idea of what you're doing to your picture. If you don't like what Auto Sharpen does (a distinct possibility), you can undo it (press Ctrl+Z/ \Re -Z) and try the Sharpen slider instead. Zero sharpening is all the way to the left; moving to the right increases the amount of sharpening Elements applies to your photo. As a general rule, you want to sharpen photos you plan to print more than images destined for use online. You can read lots more about sharpening on page 260.

Note: If you've used photo-editing programs before, you may be interested to know that the Auto Sharpen button applies Adjust Sharpness (page 263) to your photo. The difference is that you don't have any control over the settings, as you would if you applied Adjust Sharpness from the Enhance menu. But the good news is that if you want Adjust Sharpness, or if you prefer to use Unsharp Mask (page 261), you can get that control—even from within Quick Fix. Just go to the Enhance menu and choose the sharpener of your choice.

At this point, all that's left to do is crop your photo; page 99 tells you everything you need to know. However, you can also give your photo a bit more punch by using the Touch Up tools explained in the next section.

Tip: If you have a Mac, OS X has some pretty sophisticated sharpening tools built right in. Preview lets you apply Luminance Channel sharpening, a complex technique you might like better than Elements' sharpening options. Open a photo in Preview and give it a try (Tools—Adjust Color—Sharpness) to see whether you prefer it to what Quick Fix can do.

Touch-Ups

At bottom of the Quick Fix toolbox are four special tools to help improve your photos. You've already learned how to use one of them—the Red Eye Removal tool (page 133). Here's what you can do with the other three:

- Whiten Teeth. As you can guess from its name, this tool makes teeth look brighter, as shown in Figure 4-13. What's especially nice is that it doesn't create a fake, overly white look.
- Make Dull Skies Blue. It's a common problem with digital cameras: Your subject is correctly exposed, but the sky looks washed out. Unfortunately, if your sky is really gray or blown out (white-looking), this tool won't help much—it should probably have been called "Make Blue Skies Bluer." It is useful for creating more dramatic skies, though.

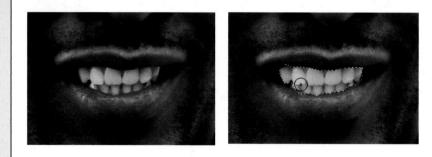

Figure 4-13: Just a quick swipe across these teeth selected and whitened them while keeping a realistic look.

• Black And White – High Contrast. You're probably wondering what the heck this tool's name means. It's Adobe's way of saying, "Transform the area I choose from color to black and white." ("High Contrast" refers to the style of black-and-white conversion this tool uses.) This tool is a great timesaver when you want to create a photo where only part of the picture is in color.

All three tools work pretty much the same way—just draw a line over the area you want to change, and Elements makes a detailed selection of the area and applies the change for you:

1. Open a photo and make your other corrections first.

If you're an old hand at using Elements, use the Touch Up tools before sharpening. But if you're a beginner and not comfortable with layers (see Chapter 6), sharpen first. (See the note on page 145 for more about why.)

2. Click the icon for the tool you want to use.

If you aren't sure which is which, put your cursor over the icons (without clicking) to see pop-up tooltips with their names.

3. Draw a line over the area you want to change.

When you click one of the Touch Up tools, your cursor turns into a circle with crosshairs in it. Just drag that over the area you want to change. Elements automatically expands the area to include the entire object it thinks you want. (It works just like the Quick Selection tool [page 154], only it also applies the changes to your image.) You'll see the marching ants appear (page 105) around the area Elements is changing.

4. If Elements included too much or too little, tweak the selection's size.

In the Options bar, you'll see three little brush icons. Click the left icon to start another new selection, click the middle one and drag to add to the selection, or click the right one and drag over an area you want to remove from the selection. (You don't have to use the Options bar: You can also just drag to extend your selection, or Alt-drag/Option-drag if Elements covered too much area and you need to remove some of it.)

5. Once you're happy with the area covered by the change, you're done.

You can back up by pressing Ctrl+Z/#-Z to undo your changes step by step. Just keep going to eliminate the change completely if you don't like it. (Clicking the Reset button *doesn't* undo the Touch Up tools' changes.)

The Touch Up tools can be very helpful, but they work based on the colors in your photo, so they may not always give you the results you want, as you can see in Figure 4-14. If you want to use the Color sliders (page 140) to adjust things instead, you'll need to switch away from the Touch Up tools and use the Selection brush to re-select the area you're trying to fix. That's because the Saturation and Hue sliders aren't available when the Touch Up tools are active.

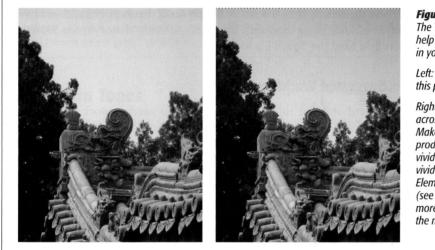

Figure 4-14:

The Touch Up tools can help punch up the sky color in your photos—sometimes.

Left: Smog makes the sky in this photo look really dull.

Right: One quick drag across the sky with the Make Dull Skies Blue tool produces a much more vivid sky-maybe even too vivid (and a tad green). Elements used a gradient (see page 460) to give a more realistic shading to the new color.

Note: The Touch Up tools create a layered file. If you understand layers (Chapter 6), you can go back to Full Edit and make changes after you use these tools and do things like adjust the opacity or blend mode of the layer. You can always discard your Touch Up changes by discarding the layer they're on. And you can even edit the area affected by the changes by editing the layer mask, as explained on page 211, or use the Smart Brush tool (page 156) in Full Edit. (The one exception is the "Black and White – High Contrast" tool: You can't change the settings for the adjustments it makes. If you try to, you just see a weird message telling you that your layer was created in the full version of Photoshop, even though you know it wasn't.)

Also, if there isn't enough color in your photo to begin with, the Touch Up tools may not produce any visible results. For example, Whiten Teeth may not do anything if your subject has super-white dentures, and Make Dull Skies Blue may prove to be a dud if your sky is solid gray or completely overexposed. tones. Blush increases the rosiness of the skin as you move the slider to the right and decreases it as you move it to the left. The Ambient Light slider works just like the Temperature slider in the Quick Fix Panel bin. You may get swell results with your first click, or have to use all the sliders to get a truly realistic result. It simply depends on the photo.

You can preview the changes right in your photo as you work. If you mess up and want to start again, click the dialog box's Reset button. If you decide you'd rather use another tool instead, click Cancel.

4. When you like what you see, click OK.

Elements applies your changes. If you want to undo them, press Ctrl+Z/#-Z.

Learn more about: Adjust (Color for Skin Tone
To Adjust Color for Skin To	nes
1. Click on any person's ski	
	entire photo to improve the color
If you are not satisfied, cl the sliders to achieve the	lick on a different point or move
the shoets to achieve the	results you want.
the singers to achieve the	results you want.
Skin	
Skin	
Skin	
Skin an:	ОК
	OK Cancel Reset
Skin ian: Iush:	OK
Skin an:0	OK Cancel Reset

Figure 4-15:

When this dialog box appears, your cursor turns into a little eyedropper when you move it over your photo. Just click the best-looking area of skin you can find. Clicking different spots gives different results, so you may want to experiment by clicking various places.

You won't see any sliders in the tracks until you click. After Elements adjusts the photo based on your click, sliders appear that you can use to finetune the results.

"Adjust Color for Skin Tone" seems to work best on fair skin, and less well on darker skin tones. It's also better at making fairly subtle adjustments, so you may have to reduce the amount of change from what Elements first did.

Also, notice that not just the skin tones change—Elements adjusts *all* the colors in the photo (Figure 4-16). You may find your image has acquired quite a color cast by the time you've got the skin just right (see page 252). If this bothers you, try a different tool. On the other hand, you can create some very nice late-afternoon light effects with this command.

While "Adjust Color for Skin Tone" is really meant as a kind of alternative fast fix, you may find it's most useful for making small, final adjustments to photos you've already edited using other tools.

Tip: If you understand layers (Chapter 6), you may want to make a duplicate layer and apply this command to the duplicate. That way you can adjust the intensity of the result by adjusting the layer's opacity (see page 197). You can also apply a layer mask (page 211) and mask out the areas you don't want to change.

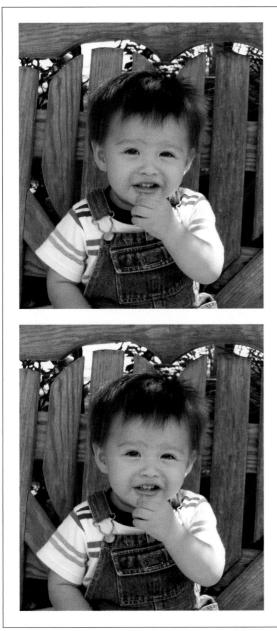

Figure 4-16:

Top: This photo has a slight greenish cast, giving the little boy a somewhat unappealing skin tone.

Bottom: "Adjust Color for Skin Tone" warms up his skin tones and even removes the greenish tinge from the bench he's sitting on.

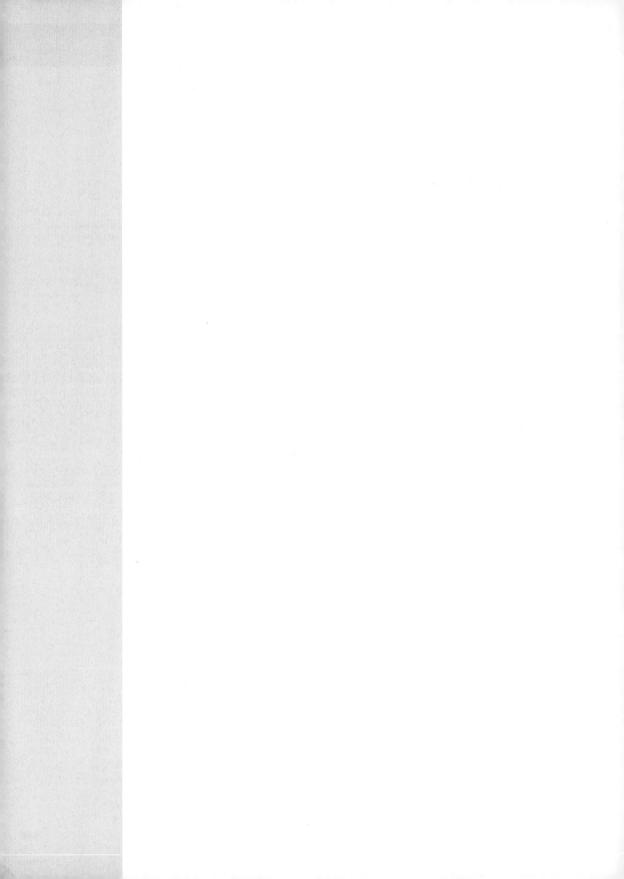

CHAPTER
5

Making Selections

ne of Elements' most impressive talents is its ability to let you select part of your image and make changes only to that area. Selecting something tells Elements, "Hey, *this* is what I want to work on—don't touch the rest of it."

You can select a whole image or any part of it. Using selections, you can fine-tune images in very sophisticated ways: change the color of just one rose in a bouquet, for instance, or change your nephew's festive purple hair back to something his grand-parents would appreciate. Graphics pros will tell you that good selections make the difference between shoddy, amateurish work and a slick professional job.

Elements offers you a whole bunch of different selection tools to work with. You can draw a rectangular or circular selection with the Marquee tools; paint a selection on your photo with the Selection brush; or just draw a line with the Quick Selection tool and let Elements figure out the exact boundaries of your selection. When you're looking to pluck a particular object (a beautiful flower, say) from a photo, the Magic Extractor works wonders. And Transform Selection lets you resize your selections in a snap.

For most jobs, there's no right or wrong tool. With experience, you may find you prefer working with certain tools more than others, and you'll often use more than one tool to create a perfect selection. Once you've read this chapter, you'll understand all the different selection tools and how to use each one.

Tip: It's much easier to select an object that's been photographed against a plain, contrasting background. So if you know you're going to want to select a bicycle, for example, shoot it in front of a blank wall rather than, say, a hedge.

Selecting Everything

Sometimes you just want to select your whole photo, like when you want to copy and paste it. Elements gives you some useful commands that help you easily make basic selections:

• Select All (Select→All or Ctrl+A/#-A) tells Elements to select your whole image. You'll see "marching ants" (Figure 5-1) around the outer edge of the picture.

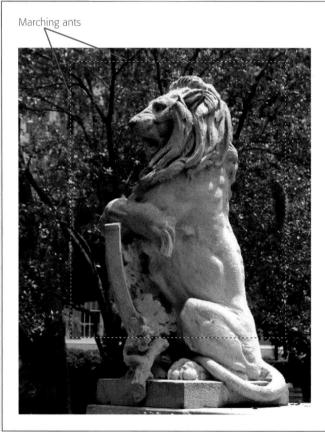

Figure 5-1:

The popular name for these dotted lines is "marching ants" because they march around your selections to show you where the edges lie. When you see the ants, your selection is active, meaning whatever you do next will apply only to the selected area.

If you want to copy your image into another picture or program, Select All is the fastest way to go. If the photo contains layers, which you'll learn about in Chapter 6, you may not be able to get everything you want with the Select All command. In that case, use Edit \rightarrow Copy Merged, or press Shift+Ctrl+C/Shift- \Re -C instead.

Tip: If you're planning on pasting an image into another program like Microsoft Word or Apple's Pages, go to Edit—Preferences—General/Adobe Photoshop Elements Editor—Preferences—General and make sure the Export Clipboard checkbox is turned on.

- **Deselect Everything** (Select→Deselect, Esc, or Ctrl+D/#-D) removes any current selection. Remember this keystroke combination because it's one you'll probably use a lot.
- **Reselect** (Select→Reselect or Shift+Ctrl+D/Shift-#-D) tells Elements to reactivate the selection you just canceled. Use Reselect if you realize you still need a selection you just got rid of, or press Ctrl+Z/#-Z to back up a step.
- Hide/View a Selection (Ctrl+H/#-H) keeps your selection active while hiding its outline. This is handy because sometimes the marching ants are distracting or make it hard to see what you're doing. To bring the ants back, press Ctrl+H/ #-H a second time.

Tip: If a tool acts goofy or won't do anything, start your troubleshooting by pressing Ctrl+H/**#**-H to make sure you don't have a hidden selection you forgot about.

Selecting Rectangular and Elliptical Areas

Selecting your whole picture is all well and good, but many times your reason for making a selection is precisely because you don't want to make changes to the whole image. How do you select just part of the picture?

The easiest way is to use the Marquee tools. You already met the Rectangular Marquee tool back in Chapter 3, in the section on cropping (page 99). If you want to select a block, circle, or oval in your image, the Marquee tools are the way to go. As the winners of the Most Frequently Used Selection Tools award, they get top spot in the Selection area of the Editor's Tools panel. You can modify how they work, like telling them to create a square instead of a rectangle, as explained in Figure 5-2. Here's how to use them:

1. Press M or click the Marquee tool's icon in the Tools panel to activate it.

The Marquee tool is the little dotted rectangle right below the Eyedropper icon in a single-row Tools panel, or below the Hand tool if you have two rows. (You may see a little dotted oval instead if you used the Elliptical Marquee tool last.)

2. Choose the shape you want to draw: a rectangle or an ellipse.

In the Tools panel's pop-out menu for the Marquee tools, choose the rectangle or the ellipse to set the shape, or just tap the M key again to bring up the one you want.

3. Enter a feather value in the Options bar if you want one.

Feathering makes the edges of your selection softer or fuzzier for better blending (when you're trying, say, to replace Brad Pitt's face with yours). The box on page 165 explains how feathering works.

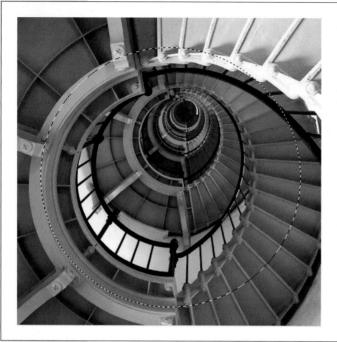

Figure 5-2:

To make a perfectly circular or square selection—rather than an elliptical or rectangular one, respectively—hold down the Shift key while you drag. You can reposition your selection after it's drawn by using the arrow keys or by dragging it. You can also adjust it with Transform Selection, explained on page 177.

4. Drag within your image to make a selection.

Wherever you initially place your mouse becomes one of the corners of your rectangular selection or a point just beyond the outer edge of your ellipse (you can also draw perfectly circular or square selections, as shown in Figure 5-2). The selection's outline expands as you drag your mouse.

If you make a mistake, just press Esc. You can also press either Ctrl+D/#-D to get rid of *all* current selections, or Ctrl+Z/#-Z to remove the most recent selection.

The Mode choices listed in the Options bar give you three ways to control the size of your selection: Normal lets you manually control it; Fixed Ratio lets you enter proportions in the Width and Height boxes; and Fixed Size lets you enter specific dimensions in these boxes. The Anti-alias checkbox is explained in the box on page 165.

Once you've made a selection, you can move the selected area around in the photo by dragging it, or you can use the arrow keys to nudge your selection in the direction you want to move it. And the Transform Selection command lets you drag your selection larger or smaller, or change its shape; page 177 tells you how.

UP TO SPEED

Paste vs. Paste Into Selection

Newcomers to Elements are often confused by the fact that the program has two Paste commands: Paste and Paste Into Selection. Knowing what each one does will help you avoid problems.

- Ninety-nine percent of the time, **Paste** is the one you want. This command simply places your copied object wherever you paste it. Once you've pasted the object, you can move it by moving the selected area.
- Paste Into Selection is a special command for pasting a selection into *another* selection. Your pasted object appears only *within* the bounds of the selection you paste it into. When you use this command, you can still move what you paste, but it won't be visible anywhere outside the edges of the selection you pasted it into.

For example, say you want to put a beautiful mountain view outside a window: First, select and copy the mountain (Ctrl+C/#-C), then select the window, and then choose Edit \rightarrow Paste Into Selection to add the view. Then you can maneuver the mountain photo around till it's properly centered. But if you move it outside the boundary of your window selection, it just disappears. Once you deselect, your material is permanently in place; you can't move it again.

If you understand layers (see Chapter 6), Paste creates a new layer, while Paste Into Selection puts what you paste on the existing layer.

Selecting Irregularly Sized Areas

It would be nice if you could get away with making only simple rectangular and elliptical selections, but life is never that neat. If you want to change the color of one fish in your aquarium picture, for example, selecting a rectangle or square just isn't going to cut it.

Thankfully, Elements gives you other tools that make it easy to create very precise selections—no matter their size or shape. In this section, you'll learn how to use the rest of the selection tools. But first you need to understand the basic controls that they (almost) all share.

Controlling the Selection Tools

If you never make mistakes or change your mind, you can skip this section. If, on the other hand, you're human, you need to know about the mysterious little squares you see in the Options bar when the selection tools are active (see Figure 5-3).

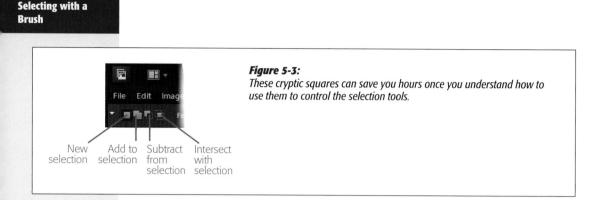

These squares don't look like much, but they tell the selection tools how to do their jobs: whether to start a new selection with each click, to add to what you've already got, or to remove things from your current selection. They're available for all the selection tools except the Selection brush and the Quick Selection tool, which have their own sets of options. From left to right, here's what they do:

- **New selection** is the standard selection mode that you'll probably use most of the time. When you click this button and start a new selection, your previous selection disappears.
- Add to selection tells Elements to add what you select to whatever you've *already* selected. Unless you have an incredibly steady mouse hand, this option is a godsend, because it's not easy to get a perfect selection on the first try. (Holding down the Shift key while you use any selection tool is another way to add to a selection.)
- **Subtract from selection** removes what you select next from any existing selection. (Holding down Alt/Option while selecting the area you want to remove accomplishes the same thing.)
- Intersect with selection is a bit confusing. It lets you take a selected area, make a new selection, and wind up with only the area where the selections overlap, as shown in Figure 5-4. (The keyboard equivalent is Alt+Shift/Option-Shift.) Most people don't need this one much, but it can be useful for things like creating special shapes. If you need a selection shaped like a quarter of a pie, for instance, create a circular selection, and then switch to "Intersect with Selection" and drag a rectangular selection from the circle's center point. You'll wind up with just the arc-shaped area where they intersect.

Selecting with a Brush

Elements gives you two very special brushes for making selections. The Selection brush has been around since Elements 2, so if you've used the program before, you probably know how handy it is. These days it often takes a backseat to the amazing Quick Selection tool, which makes even the trickiest selections as easy as doodling. The Quick Selection tool automatically finds the bounds of the objects you drag it over, while the Selection brush only selects the area directly under the brush cursor.

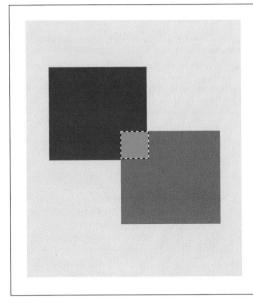

Figure 5-4:

"Intersect with selection" lets you take two separate selections and select only the area where they intersect. If you have an existing selection, when you select again, your new selection includes only the overlapping area. Here, the top blue square is the first selection, and the bottom fuchsia square is the second. The bright green area shows the final selection after you let go of the mouse button.

These two brushes are grouped together in the Tools panel, and they appear in both Full Edit and Quick Fix because they're so useful. You may well find that with these two brushes, you rarely need the other selection tools.

It couldn't be easier to use the Quick Selection tool:

1. Activate the Quick Selection tool.

Click it in the Tools panel, and then choose it from the Tools panel's pop-out menu, or tap the A key until you see its icon. It shares a Tools panel slot with the regular Selection brush. Their icons are very similar, so look carefully—the Quick Selection tool looks like a wand and it points up, while the regular Selection brush points down.

2. Drag within your photo.

As you move the cursor, Elements calculates where it thinks the selection's edges should be, and the selection outline jumps out to surround that area. It's an amazingly good guesser. You don't even need to cover the entire area or go around the edges of the object—Elements does that for you.

This tool has a few Options bar controls, which are explained below, but you mostly won't need to think about them, at least not till you've finished making your selection. Then you'll probably want to try Refine Edge (explained in the next section).

3. Adjust the selection.

Odds are that you won't get a totally perfect selection that includes everything you wanted on the first click. To increase the selection area, drag in the direction where you want to add to the selection. A small move usually does it, and the selection jumps outward to include the area that Elements thinks you want, as shown in Figure 5-5.

To remove an area from the selection, hold Alt/Option and drag or click in the area you don't want.

Once you're happy with your selection, that's it—unless you want to tweak the edges by using Refine Edge (see the next section), and you probably do.

Figure 5-5:

Left: It would be a nuisance to select this water lily by hand because of the many pointy-edged petals. The first drag with the Quick Selection tool produced this partial selection. Notice how well the tool found the edges of the petals.

Right: Another drag across the lily told Elements to select the whole blossom. Creating this selection took less than 5 seconds. (Notice that the tool missed a little bit on the edges in a couple of spots. Reduce the brush size when dragging to add those, or switch to the regular Selection brush to finish up.)

The Quick Selection tool has a few Options bar settings, but you really don't need most of them:

- New selection, Add to selection, Subtract from selection. These three brush icons work just like the equivalent selection squares for selection tools (page 155), but you don't need to use them. The Quick Selection tool automatically adds to your selection if you drag over an unselected area. Shift-drag to select multiple areas that aren't contiguous, or Alt-drag/Option-drag to remove areas from your selection.
- **Brush**. You can make all kinds of adjustments to your brush by clicking this pull-down menu, including choosing from many of the Additional Brush Options palette's choices (see page 403), although you'll rarely need to tweak any of these except maybe the brush size once in a while.

- **Sample All Layers**. Turn this checkbox on, and the Quick Selection tool selects from all visible layers in your image, rather than just the active layer. (Chapter 6 explains all about layers.)
- Auto-Enhance. This setting tells Elements to automatically smooth out the edges of the selection. It's a more automated way to make the same sort of edge adjustments you can make manually with Refine Edge.
- **Refine Edge**. This option lets you tweak the edges of your selection so that you get more realistic results when changing the selected area or copying and pasting it. (Refine Edge is grayed out until you actually make a selection.) It's explained in detail in the next section.

Tip: Depending on what you plan to do with your selection, you may want to check out the Smart Brush tool. It works just like Quick Selection, but it goes further than simply completing your selection for you; it also automatically applies the color correction or special effect you choose from its pull-down menu. See page 234 for more about working with the Smart Brushes.

The Quick Selection tool doesn't work every time for every selection, but it's a wonderful tool that's worth trying first for any irregular selection. You can use the Selection brush or one of the other selection tools to clean up afterward, if needed.

Refine Edge

This is another tremendously helpful Elements feature. It lets you create smooth, feathered, plausible edges on any selection—a must when you want to realistically blend edited sections into the rest of an image. It appears in the Options bar for some of the tools that let you make irregular selections (like Quick Selection), or you can apply it to any active selection by going to Select→Refine Edge. To use it, first make a selection, and then:

1. Call up the Refine Edge dialog box.

If it's not available from the Options bar (like when you're using the Marquee tool, for example), go to Select→Refine Edge.

2. Adjust the edges of your selection.

Use the sliders, explained in the list that follows, to tweak and polish the edges of your selection. The view buttons let you see your selection in five different ways, and you can zoom to 100 percent or more too see exactly how you're changing the selection.

3. When you like what you've done, click OK.

If you decide not to refine your edges, then click Cancel. To start over, Alt-click/ Option-click the Cancel button to turn it into a Reset button. If you play with the sliders and then decide you want to put them back where you started, click Default. The Refine Edge dialog box has three sliders; you may need to use only one, or a combination of them to improve your selection. Your choices are:

- **Smooth**. This removes the jagged edges around your selection. Type a value in pixels or move the slider (to the right for more smoothing, to the left for less). Be careful: You can go as high as 100 pixels, which is almost certainly *much* more smoothing than you need.
- Feather. Feathering (which softens edges) is explained on page 165.
- **Contract/Expand**. This slider adjusts the size of your selection. Move the slider left to contract the selection, or right to expand it.

It's easy to over-refine, so go in small increments and keep checking your selection. Elements lets you to monitor things by giving you a choice of views. The buttons below the Contract/Expand slider give you five different ways to view your selection so you can be sure it's absolutely perfect:

- Standard shows the regular marching ants around your selection.
- **Custom Overlay Color** shows the red mask overlay you get when using the Selection brush in Mask mode (see below). The red area is the *unselected* part of your image. This view is a good way to check for holes and jagged edges.

Tip: Double-click the Custom Overlay Color button to change the overlay's color and opacity. You can also hide the selection altogether by pressing X. Press X again to bring back the mask or the marching ants, or press F to toggle between Standard and Overlay views.

- On Black shows just the selected area against a black background.
- **On White.** If you think you can get a better look at your selection with a light background, choose this view.
- **Mask** shows only the outline of the selection in white against a black background so you aren't distracted by the details in your image.

You also get icons for the Zoom and Hand tools so you can adjust the view to see more or different details.

The Selection Brush

The Selection brush is one of the greatest tools in Elements. It makes creating complex selections *and* cleaning up selections super easy. You can use it on its own or as a complement to the Quick Selection tool, described in the previous section.

The Quick Selection tool is awesome, but sometimes it doesn't stop your selection exactly where you want. The Selection brush gives you total control because it only selects the area you cover with your brushstroke. You simply paint what you want to select by dragging over that area. You can let go of the mouse button, and each time you drag again, Elements automatically adds to your selection. You don't need to change modes in the Options bar or to hold down the Shift key as with other selection tools.

The Selection brush also has a Mask mode, in which Elements highlights what *isn't* part of your selection. Mask mode is great for finding tiny spots you've missed and for checking the accuracy of your selection's outline. In Mask mode, anything you paint over gets *masked* out; in other words, it's protected from being selected. Masking is a little confusing at first, but you'll soon see how useful it is. Figure 5-6 shows the same selection made with and without Mask mode.

Figure 5-6:

Left: This flower was selected by painting with the Selection brush in Selection mode. It looks like a completed selection that you can make using any of the selection tools.

Right: The same selection in Mask mode. The red covers everything that's not part of the selection.

The Selection brush is pretty simple to use:

1. Click the Selection brush in the Tools panel or press A.

The Selection brush lives in the Tools panel with the Quick Selection tool. The Selection brush is the brush that looks like it's painting—its tip points down.

2. In the Options bar, choose either Selection mode or Mask mode and the brush size you want.

Your Options bar choices are explained in the list below.

3. Drag over the area you want to select.

If you're in Selection mode, the area you drag over becomes part of your selection. If you're in Mask mode, the area you drag over is *excluded* from becoming part of your selection.

The Selection brush gives you several choices in the Options bar:

- **Brush thumbnail**. You can choose different brushes here depending on whether you want a hard- or soft-edged selection. (For more about brushes, see page 399.)
- Size. To change the brush cursor's size, type a size in this box or click the arrow and then use the slider. Or, press the close bracket key (]) to enlarge the cursor (keep tapping it until you get the size you want) or the open bracket key ([) to shrink it. You can also put your cursor over the word "Size" and scrub to the left or right to make the brush smaller or larger, respectively. (Don't know how to scrub? For more on this nifty Elements feature, see page 132.)

Tip: The bracket key shortcuts work with any brush, not just the Selection brush.

- **Mode**. Here's where you tell Elements whether you're creating a selection (Selection) or excluding an area from being part of a selection (Mask).
- **Hardness**. This setting controls the sharpness of your brush cursor's edge, which affects your selection (see Figure 5-7).

Figure 5-7:

These two Selection brushstrokes show the way the Hardness setting affects the edges of a selection. Here, two different selections were made in the green rectangle. The top selection was made at 100 percent hardness, and the bottom one at 50 percent. (The selected area was then deleted to show the outline more clearly.)

Switching between Selection and Mask mode is a good way to see how well you've done when you finish making a selection. In Mask mode, the areas of your image that *aren't* part of the selection have a red film over them, so you can clearly see the selected area.

Tip: You don't have to live with a red mask. To change the mask's color, in the Options bar, click the color square to the right of the Overlay setting (the Selection brush has to be active and in Mask mode), and then use the Color Picker to choose a different hue. You can also use the Overlay Opacity setting (labeled simply "Overlay" in the Options bar) to adjust how well your image shows through the mask.

You can temporarily make the Selection brush do the opposite of what it's been doing by holding down Alt/Option while you drag. This can save a lot of time when you're making a tricky selection, since you don't have to keep jumping up to the Options bar to change modes, and you can keep the view (either your selection or the mask) the same. For example, if you're in Selection mode and you've selected too large an area, Alt-drag/Option-drag over the excess to remove it. If you're masking out an area, Alt-drag/Option-drag to add to the selection. This may sound confusing, but it'll make sense once you try it. Some things are easier to learn just by doing them.

Tip: The Selection brush is useful for fine-tuning selections you've made with the other selection tools. Quickly switching to the Selection brush in Mask mode is a great way to check for spots you've missed—the red makes it really easy to spot them.

The Magic Wand

The Magic Wand is a slightly temperamental—and occasionally highly effective tool for selecting an irregularly shaped, but uniformly colored (or nearly so), area of an image. If you have a big area of a particular color, the Magic Wand can find its edges in one click. It's not actually all that magical: All it does is search for pixels with similar color values. But if it works for you, you may decide Adobe should keep "magic" in its name because it's a great timesaver when it cooperates, as Figure 5-8 shows.

Figure 5-8:

Just one click with the Magic Wand created this nearly perfect selection. If there isn't a big difference between the color of the area you want to select and the colors of neighboring areas, this tool won't be as effective as it was here.

You'll find the Magic Wand just below the Lasso tools in a single-column Tools panel, or below the Marquee tool in a double-column panel. (Its keyboard shortcut is W.) Using the Magic Wand is pretty straightforward: Just click anywhere in the area you want to select. Depending on the tool's current *tolerance* setting (explained in the following list), you may nail the selection right away, or it may take several clicks to get everything. If you need to click more than once, remember to hold down Shift so that each click adds to your selection.

The Magic Wand does best when you offer it a good, solid block of color that's clearly defined and doesn't have a lot of different shades in it. But it's frustrating when you try to select colored areas that have any shading or tonal gradations—you have to click and click and click.

Elements gives you some special Options bar settings that you can adjust to help the Wand do a better job:

- **Tolerance** controls how many shades the tool selects. A higher tolerance includes more shades (resulting in a larger selected area), while a lower tolerance gets you fewer shades (and a more precise selection). If you set the tolerance too high, you'll probably select a lot more of your picture than you want.
- Anti-alias is explained in the box on page 165.
- **Contiguous** makes the Magic Wand select only colored areas that actually touch each other. It's on by default, but sometimes you can save a lot of time by turning it off, as Figure 5-9 explains.

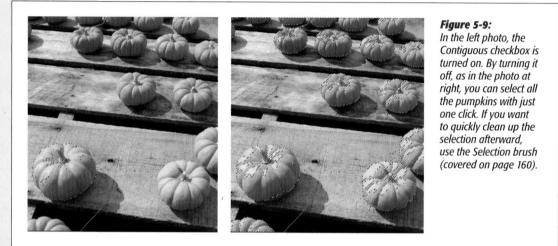

• **Sample All Layers**. If you have a layered file (you'll learn about layers in the next chapter), turn this checkbox on to select the color in *all* the image's layers. If you want to select the color only in the active layer, leave it turned off.

You also get access to the Refine Edge dialog box so you can fix up the edges of your selection, as explained on page 159.

The big disadvantage to the Magic Wand is that it tends to leave you with unselected contrasting areas around the edge of your selection that are a bit of a pain to clean up. You may want to give the Quick Selection tool (page 156) a spin before trying the Magic Wand, especially if you want to select a range of colors. If you put a Magic Wand selection on its own layer (see Chapter 6 to understand how layers work), you can use Refine Edge or the Defringe command (page 175) to help clean up the edges.

UP TO SPEED

Feathering and Anti-Aliasing

If you're old enough to remember what supermarket tabloid covers looked like before Photoshop, you probably had a good laugh at the obviously faked photos. Anyone could see where the art department had physically glued a piece cut from one photo onto another picture.

Nowadays, of course, the pictures of Brangelina's vampire baby from Mars look *much* more believable. That's because with Photoshop (and Elements) you can add *antialiasing* and *feathering* when you make selections.

Anti-aliasing is a way of smoothing the edges of a digital image so they don't look jagged. When you make selections, the Lasso tools and the Magic Wand let you decide whether to use anti-aliasing. It's best to leave anti-aliasing on unless you want a really hard-looking edge on your selection. Feathering, on the other hand, blurs the edges of a selection. When you make a selection that you plan to move to a different photo, a tiny feather can do a lot to make it look like it's always been part of the new photo. Some selection tools, like the Marquee tools, let you set a feather value before using them. And you can feather existing selections by going to Select—Feather or pressing Alt+Ctrl+D/Option- \Re -F. Generally, a 1- or 2-pixel feather gives your selection a natural-looking edge without visible blurring.

A larger feather gives a soft edge to your photos, as you can see in Figure 5-10. If you apply a feather value that's too high for the size of your selection, you see a warning that reads, "No pixels are more than 50% selected." Reduce the feather number to placate Elements.

Figure 5-10:

Old-fashioned vignettes like this one are classic examples of when you'd want a fairly large feather. In this figure, the feather is 15 pixels wide. The higher the feather value, the softer the edge.

The Lasso Tools

The Magic Wand is pretty good, but it works well only when your image has clearly defined areas of color. If you want to select something from a cluttered background, the Magic Wand just won't cut it. In cases like that, the easiest option is to draw around the object you want to select.

Enter the Lasso tool. Elements actually has three Lasso tools: the Lasso, the Polygonal Lasso, and the Magnetic Lasso. Each one lets you select an object by tracing around it.

You activate the Lasso tools by clicking their icon in the Tools panel (it's just below or next to the Marquee tool), and then selecting the particular variation you want in the Tools panel's pop-out menu, or by repeatedly pressing the L key till you see the particular Lasso you want. Then drag around the outline of an object to make your selection. The following sections cover each Lasso tool in detail. All three let you apply feathering and anti-aliasing as you make your selection (see the box on page 165), and the basic Lasso and Polygonal Lasso give you access to Refine Edge (page 159) right in their Options bar settings.

The basic Lasso tool

The theory behind the basic Lasso tool is simple: Activate the tool (your cursor changes to the lasso shape shown in Figure 5-11) and then click your photo and drag around the outline of what you want to select. When the end of your selection gets back around and joins up with the beginning, you've got a selection.

Figure 5-11:

The end of the cursor's "rope," not the lasso's loop, is the selectiondrawing part of the basic Lasso tool. If the cursor's shape bothers you, press the Caps Lock key to change it to crosshairs instead.

It's not always easy to make an accurate selection with the Lasso, especially if you're using a mouse. A graphics tablet (page 599) is a big advantage when using this tool, since tablets let you draw with a pen-shaped pointer. But even if you don't have a graphics tablet lying around, you can make all of Elements' tools work just fine with your mouse once you get used to their quirks.

Note: Or tive layer. (page 193 (see page

The Ma selectio Extracto in paren while yo

Remo

- Foi wai chc
- Ba fro for
- Poi or]
- Ad
- Rei om
- Sm too ma bec
- Zo to a the

It helps to zoom way in and go very slowly when using the Lasso. (See page 111 for more info on changing your view.) Many people use the regular Lasso tool to quickly select an area that roughly surrounds an object (as in Figure 5-11), and then go back with the other selection tools—like the Selection brush or the Magnetic Lasso—to clean things up.

Tip: If you need to draw a straight line for part of your selection border, hold down Alt/Option and click the points where you want the line to start and end. So if you're selecting an arched Palladian window, for instance, once you get around the curve at the top of the window and reach the straight side, press Alt/ Option and click at the bottom of the side to get the whole side all in one go. You need to have already clicked in your image with the tool at least once before you press this key, though, or this trick won't work.

Once you've created a selection, you can click the Refine Edge button in the Options bar to adjust and feather the edges (see page 165). Press Esc or Ctrl+D/#-D to get rid of your selection if you decide you don't want it anymore.

The Magnetic Lasso

The Magnetic Lasso is a very handy tool, especially if you were the kind of kid who never could color inside the lines or cut paper chains out neatly. This tool snaps to the outline of any clearly defined object you're trying to select, so you don't have to follow the edge exactly.

As you might guess, the Magnetic Lasso works best on objects with clearly defined edges, so you won't get much out of it if your subject is a furry animal, for instance. This tool also likes a good strong contrast between the object and the background. (You can change the cursor's shape by pressing the Caps Lock key, just as with the basic Lasso.)

Click to start a selection, and then move your cursor around the perimeter of what you want to select. Then click again back where you began to finish your selection. You can also Ctrl-click at any point, and the Magnetic Lasso will immediately close up whatever area you've surrounded. The Options bar's settings let you adjust how many points the Magnetic Lasso puts down and how sensitive it is to the edge you're tracing, as shown in Figure 5-12. Removing Obje from an Image' Background Removing Objects from an Image's Background

Tip: Some of the fine-tuning tools, like the Smoothing brush, work much better if you zoom in pretty close before using them.

To help you see exactly what you're doing, Elements gives you several ways to adjust the tools and your view of the image. The following settings, which are on the right side of the dialog box, become active only after you click the Preview button:

- **Tool Options**. You can click these color boxes to choose different hues for the Foreground and Background brushes using the Color Picker (page 254). This is also where you can adjust the brush cursor's size, but that's hardly ever necessary unless the brush is bigger than the area you want to select.
- **Preview**. These options let you choose whether to see just the selected area or your entire image. You can also pick what kind of background you want Elements to display your selection against. You can choose None (the standard transparency checkerboard), or a black, gray, or white matte to see a temporary solid-colored background that may make it easier to check the edges of your selection. Selecting Mask gives you the black-and-white view of a layer mask (see page 214); that way, you can paint more of a mask or remove the mask to reveal a larger selection. (Remember that what's masked *isn't* selected.) Rubylith (the brand name of the original red masking film) is just a fancy name for the red mask view as opposed to the black-and-white view you get by choosing Mask.

You also get some very helpful features for making sure your selection is absolutely perfect. These options are on the right side of the dialog box, listed under Touch Up (again, you have to click the Preview button before you can use them):

- **Feather**. Enter the amount, in pixels, you want Elements to feather the edge of your selection. (The box on page 165 explains feathering.) You can actually enter a value here before clicking Preview, if you want, but you won't see the results until you do.
- Fill Holes. If Elements left some gaps in your selection, you may be able to fill them by clicking this button. This tool works only for holes that are completely surrounded by selected material, though. So if the edges of your selection have bites out of them, use the Smoothing brush instead, or give the area an extra click with the Foreground brush.
- **Defringe**. If your selection has a rim of contrasting pixels around it, this button can usually eliminate them. Figure 5-17 shows what a difference defringing can make. You can choose a different number of pixels for Elements to consider when applying this command by entering a value in the Defringe Width box, but the standard setting is usually fine. Elements is pretty good about making clean selections, so you probably won't click this button very often.

Tip: If the edges of your selection are ragged but the same color as the area you want, or if defringing alone doesn't clean things up enough, try the Smoothing brush (page 173). Just run it along the edge of your selection to polish it until it's smooth.

PHOTOSHOP ELEMENTS 10: THE MISSING MANUAL

174

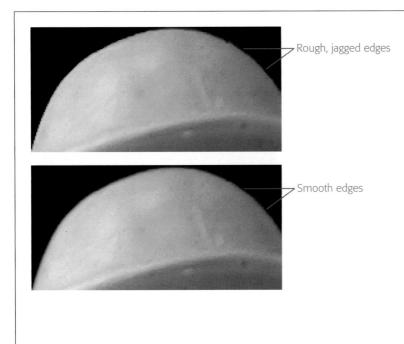

Figure 5-17:

Defringing is a big help in cleaning up the edges of selections.

Top: Here's a close-up of the top of the little mariner's hat. The matte black background makes the ragged edges of the hat stand out. If you place this image into another graphic, it'll look like you cut it out with dull nail scissors.

Bottom: Here you can see how much softer the edges are after applying some defringing. Now you can place the figurine into another file without getting a cut-out effect; the hat will blend in believably. You don't need the Extractor to defringe, though; you can use this command on any layer by going to Enhance→Adjust Color→Defringe Layer.

Changing and Moving Selections

Now that you know all about making selections, it's time to learn some of the finer points of using and manipulating them. Elements gives you several handy options for changing the areas you've selected and for moving images around once they're selected. You can even save a tough selection so you don't have to do *that* again.

Inverting a Selection

One thing you often want to do with a selection is *invert* it. That means telling Elements, "You know the area I've selected? I want you to select everything *except* that area."

Why would you want to do that? Because sometimes it's easier to select what you *don't* want. For example, suppose you have an object with a complicated outline, like the building in Figure 5-18. If you want to use just the building in a scrapbook of your trip to Europe; it's going to be difficult to select. But the sky is just one big block of color, so it's easy to select the sky with the Magic Wand.

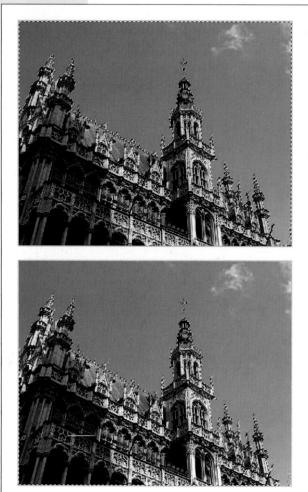

Figure 5-18:

Top: Say you want to make some adjustments to this building. You could spend half an hour meticulously selecting all that Gothic detail, or just select the sky with a couple of clicks of the Magic Wand and then invert your selection to get the building. Here, the marching ants around the sky show that it's the active selection—but that's not what you want.

Bottom: Inverting the selection (Select \rightarrow Inverse) puts the ants around the building instead, without you going to the trouble of tracing over all the elaborate, lacy details of the roofline.

To invert a selection:

1. Make a selection.

You can select with any tool that suits your fancy.

2. Go to Select→Inverse or press Shift+Ctrl+I/Shift-ૠ-I.

Now the part of your image that you *didn't* select is selected. Easy, huh?

Changing and Moving Selections

Making a Selection Larger or Smaller

What if you want to tweak the size of your selection? For example, say you want to move the outline of your selection outward a few pixels to expand it. Elements gives you a really handy way to do that: the Transform Selection command.

With Transform Selection, you can easily drag any selection larger or smaller, rotate it, squish it narrower or shorter, or pull it out longer or wider (imagine smooshing a circular selection into an oval, for instance). As its name implies, Transform Selection does all these things to the *selection*, not to the object you've selected. (If you want to distort an object, you can use the Move tool [page 180] or the Transform commands [page 389] instead.) This is really handy, as you can see in Figure 5-19.

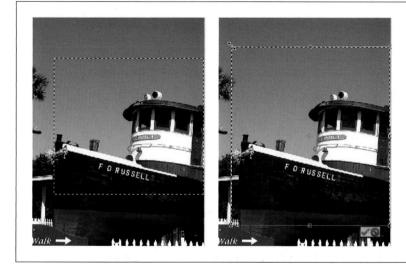

Figure 5-19:

Left: Sometimes it's tough to draw exactly the selection you want. Here, attempting to avoid the sign and the palm fronds led to cutting off part of the rope bumper on the boat's bow.

Right: After you've decided that it would be easier to clone out any small unwanted details (page 315 explains how to clone), Transform Selection makes it easy to resize the selection to include the whole rope.

To use Transform Selection:

1. Make a selection.

Use the selection tool(s) of your choice. Transform Selection is especially handy when you've used one of the Marquee tools and didn't hit the selection quite right, but you can use it on any selection.

2. Go to Select→Transform Selection.

A bounding box with little square handles appears around your image, as shown in Figure 5-19. The Options bar changes to show the settings for this feature, which are the same as those for the Transform tools (page 389). Most of the time you won't need to worry about these settings.

3. Grab a handle and adjust the area covered by your selection.

The different ways you can adjust a selection are explained in the list below.

4. When you get everything just right, click the green checkmark or press Enter/ Return to accept your changes.

If you mess up or change your mind about the whole thing, click Cancel (the red No symbol) to revert to your original selection.

You can change your selection in most of the same ways you learned about back in the section on cropping:

- To make your selection wider or narrower, drag one of the side handles.
- To make your selection taller or shorter, drag a top or bottom handle.
- To make your selection larger or smaller, drag a corner handle. Before you start, take a quick look at the Options bar to be sure the Constrain Proportions checkbox is turned on if you want the selection's shape to stay exactly the same. If you want the shape to change, then turn the checkbox off.
- To rotate your selection, move your mouse near a corner handle till you see the curved arrows, and then click and drag to spin the selection's outline to the angle you want.

Transform Selection is a great feature, but it only expands or contracts your selection in the same ways the Transform tools can change things. In other words, you can change the selection's width and its height as well as its proportions, but you can't change a star-shaped selection into a dog-shaped one, for example. Elements gives you a number of other ways to adjust the size of a selection, which may work better for you in certain situations, although in most cases Transform Selection is probably the easiest.

But what do you do if you just want to enlarge the selection to include surrounding areas of the same color? Elements has you covered. Figuring out which of the following commands to use can be confusing because the two ways to enlarge a selection sound really similar: Grow and Expand. You might think they do the same thing, but there's a slight but important difference between them:

- **Grow** (Select→Grow) moves your selection outward to include more similar, contiguous colors, no matter what shape your original selection was. This command doesn't care about shape; it just finds more matching contiguous pixels.
- Similar (Select→Similar) does the same thing as Grow but looks at all pixels, not just adjacent ones.
- **Contract** (Select→Modify→Contract) shrinks a selection by the number of pixels you specify.

So what's the big distinction between Grow and Expand? Figure 5-20 shows how differently they behave.

Figure 5-20:

Top: In the original selection, the butterfly's wing is selected, but Elements missed some small areas on the edge. (The area outside the selection was deleted to make it easier to see what's selected.)

Bottom left: If you use Grow to enlarge the selection, you also get parts of the background that are similar in tone. As a result, your selection isn't wina-shaped anymore.

Bottom right: If you use Expand instead, the selection still is still shaped like the wing, only now the edges of the selection move outward to include the dark border area you missed the first time. Here the selection is moved out more than you'd want; it took in some of the background, while still preserving the shape of the original selection.

Moving Selected Areas

So far you've learned how to move selections themselves (the marching ants), but often you make selections because you want to move *objects* around—like putting that dreamboat who wouldn't give you the time of day next to you in your class photo. You can move a selected object in several ways. Here's the simplest, tool-free way to move something from one image to another:

1. Select it.

Make sure you've selected everything you want—it's really annoying when you paste a selection from one image to another and then find you missed a spot.

2. Press Ctrl+C/\#-C to copy it.

You can use Ctrl+X/æ-X if you want to cut it out of your original; just remember that Elements leaves a hole if you do that.

3. Decide where to put the selected object.

If you want to dump the object into its very own document, choose File \rightarrow New \rightarrow "Image from Clipboard." Doing so creates a new document with just your selection in it.

If you want to place the object into an existing photo, then use Ctrl+V/\#-V to paste it into another image in Elements.

Once the object is where you want it, you can use the Move tool (explained next) to position it, rotate it, or scale it to fit the rest of the photo. You can even paste it into a document in another program. Just be sure you've turned on Export Clipboard in Edit \rightarrow Preferences \rightarrow General/Adobe Photoshop Elements Editor \rightarrow Preferences \rightarrow General.

Tip: If you copy and paste a selection and then notice it's got partially transparent areas in it, back up and go over your selection with the Selection brush using a hard brush. Then copy and paste again.

POWER USERS' CLINIC

Smoothing and Bordering

Most of the time, you'll probably use Refine Edge (page 159) to fine-tune your selections, but Elements gives you two other ways to tweak the outlines of your selections:

 Smoothing (Select→Modify→Smooth) is a notalways-dependable way to clean up ragged spots in a color-based selection (the kind you'd make with the Magic Wand, for instance). You enter a pixel value in the Smooth Selection dialog box, and Elements evens out your selection based on that number by searching for similarly colored pixels.

For example, if you enter 5, Elements looks at a 5-pixel radius around each pixel in your selection. In areas where most of the pixels are already selected, it adds in the others. In areas where most pixels *aren't* selected, it deselects the ones that were selected to get rid of jagged edges and holes in the selection.

This is handy, but smoothing is sometimes hard to control. Usually it's easier to clean up your selection by hand with the Selection brush.

Bordering (Select→Modify→Border) adds an antialiased, transparent border to your selection. You can think of this command as selecting the selection's outline. You might use it when your selection's edges are too hard and you want to soften them, although you're probably better off using Refine Edge instead. But if you go this route, enter a border size in the Border Selection dialog box and then click OK. Elements selects only the border, so you can also apply a slight Gaussian blur (see page 445) to soften that part of the photo.

The Move tool

You can also move things around within your photo using the Move tool, which lets you cut or copy selected areas. Figure 5-21 shows how to use the Move tool to conceal distracting details.

Changing and Moving Selections

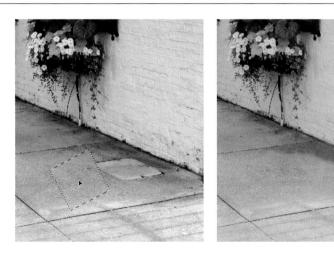

Figure 5-21:

Left: A little home improvement with Elements. Sav you want to aet rid of the meter access hatch in this photo to keep it from drawing the eve away from your lovely flowerboxes. To do that. select a piece of the sidewalk. and then activate the Move tool and hold down the Alt/Option key while dragging to copy the selected area. (If you use the Move tool without holding down the Alt/ Option key, Elements cuts out the selection instead. leaving a hole in your photo.)

Right: After using the Clone Stamp (page 315) to blend in the new piece, you'd never know that slab of sidewalk wasn't solid.

The Move tool lives at the very top of the Full Edit Tools panel. To use it:

1. Make a selection.

Make sure your selection doesn't have anything in it that you don't want to copy.

2. Switch to the Move tool.

Click the Move tool's icon or press V. Your selection stays active but is now surrounded by a rectangle with square handles on it.

3. Move the selection and then press Enter when you're satisfied with its position.

As long as your selection is active, you can work on your photo in other ways and then come back and reactivate the Move tool. (If you're worried about losing a complex selection, save it as described in the next section.) If you're not happy with what you've done, just press Ctrl+Z/æ-Z as many times as needed to back up and start over again.

You can move a selection in several different ways:

- Move it. If you simply move a selection by dragging it, you leave a hole in the background where the selection was because the Move tool *truly* moves your selection. So unless you have something under it that you want to show through, that's probably not what you want to do.
- **Copy it and then move the copy**. If you press the Alt/Option key as you drag with the Move tool, you'll copy your selection so the original stays where it is. But now you have a duplicate to move around and play with, as shown in Figure 5-21.
- **Resize it**. You can drag the Move tool's handles to resize or distort your selected material, which is great when you need to change the size of your selection. The Move tool lets you do the same things as Free Transform (see page 393).
- **Rotate it.** The Move tool lets you rotate your selection the same way you can rotate a picture using Free Rotate (see page 97): Just grab a corner and turn it.

Tip: You can save a trip to the Tools panel and move selections without activating the Move tool. To move a selection without copying it, just place your cursor in the selection, hold down Ctrl/#, and then move the selection. To move a copy of a selection so you don't damage the original, do the same thing, but hold down the Alt/Option key as well. To move *multiple* copies, just let go, press Ctrl+Alt/#-Alt again, and drag once more.

The Move tool is also a great way to manage and move objects that you've put on their own layers (Chapter 6). Page 203 explains how to use the Move tool to arrange layered objects.

Saving Selections

You can tell Elements to remember the outline of your selection so that you can reuse it again later on. This is a wonderful, easy timesaver for particularly intricate selections. It's also very handy if the new Text on Selection tool (page 496) misbehaves, forcing you to restart Elements to get it working again; you can save your selection before you quit Elements and then reload it to pick up where you left off.

Note: Elements' saved selections are the equivalent of Photoshop's *alpha channels*. Keep that in mind if you decide to try tutorials written for the full-featured Photoshop. Incidentally, alpha channels saved in Photoshop show up in Elements as saved selections, and vice versa. You can save a selection, load it again, and save the file with the selection active to have it appear as an alpha channel in a program like Microsoft Word or Apple's Pages.

To save a selection:

- 1. Select something.
- 2. Choose Select \rightarrow Save Selection, name your selection, and then click OK.

When you want to use that selection again, go to Select \rightarrow Load Selection, and there it is waiting for you.

Tip: When you save a feathered selection and then change your mind about how much feather you want, use the Refine Edge command to adjust it. You can also save a hard-edged selection, load it, and then go to Select—Feather to add a feather if you need one. That way you can change the amount each time you use the selection, as long as you remember not to save the *change* to the selection.

Editing a saved selection

It's probably just as easy to start your selection over if you need to tweak a saved selection, but you can make changes if you want. This can save you time if your original selection was really tricky to create.

Say you've got a full-length photo of somebody, and you've created and saved a selection of the person's face (called, naturally enough, Face). Now, imagine that after applying a filter to that selection, you decide it would look silly to change only the face and not the person's hands, too. So you want to add the hands to your saved selection.

You have a couple of ways to do this. The simplest is just to load up Face, activate your selection tool of choice, put the tool in "Add to Selection" mode, select the hands, and then save the selection again with the same name.

But what if you've already selected the hands and you want to add that new selected area to the existing, saved Face selection? Here's what you'd do:

1. Go to Select→Save Selection.

In the Save Selection dialog box, choose your saved Face selection from the Selection drop-down menu. All the radio buttons in the dialog box become active.

2. In the Operation section of the dialog box, turn on the "Add to Selection" radio button and then click OK.

Elements adds what you just selected (the hands) to the saved Face selection and saves it all, so now your Face selection includes the hands, too.

Tip: If you find yourself frequently making changes to saved selections, you might want to check out layer masks (page 211) to see if they'd suit your purpose better. They're much quicker to modify than selections, if they'll work for you.

CHAPTER 6

Layers: The Heart of Elements

f you've been working mostly in the Quick Fix window so far, you've probably noticed that once you close a file, the changes you've made are permanent. You can undo stuff while the file is still open, but once you close it, you're stuck with what you've done.

In Elements, you can keep your changes (most kinds, anyway) and still revert to the original image if you use *layers*, a nifty system of transparent sheets that keeps each component of your image on a separate sliver that you can edit. Layers are one of the greatest image-editing inventions ever: By putting each change you make on its own layer, you can rearrange your image's composition and add or subtract changes whenever you want.

If you use layers, then you can save a file and quit Elements, come back days or weeks later, and *still* undo what you did or change things around some more. There's no statute of limitations for the changes you make using layers.

Some people resist learning about layers because they fear layers are too complicated. But actually, they're really easy to use once you understand how they work. And once you get started with layers, you'll realize that using Elements without them is like driving a Ferrari in first gear. This chapter gives you the info you need to get comfortable working with layers.

Understanding Layers

Imagine that you want to figure out the various ways you can redecorate a room in your house. The first thing you do is create a bare-bones drawing of the room. Now imagine you've also got a bunch of transparent plastic sheets that each contain an image that changes the room's look: a couch, a few different colors of carpeting, a standing lamp, and so on. Your decorating work is now pretty easy, since you can add, remove, and mix and match the transparencies with ease.

Layers in Elements work pretty much the same way: They let you add and remove objects, and make changes to the way your image looks. And you can modify or discard any of these changes later on.

Figure 6-1 shows an Elements file that includes layers. Each object in the flyer is on a different layer, so it's a breeze to remove or rearrange things. (If you want to follow along and work with a layers-heavy file, download *gardenparty.psd* from this book's Missing CD page at *www.missingmanuals.com.*)

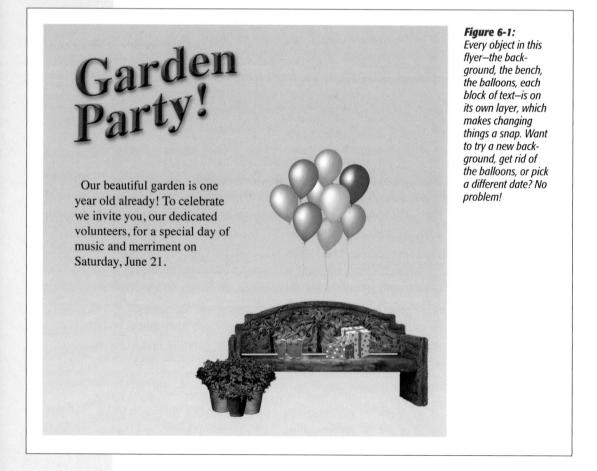

Note: It's important to understand that photos from your camera start out with just one layer. That means if you've got a photo like the one in Figure 6-2 left, all the objects—the two people, the ground they're standing on, and so on—are on the same layer. (Until you select an object and place it on its own layer, that is.)

That said, Elements often generates layers *for* you when you need them. For example, Elements automatically creates layers when you do things like move an object from one photo to another or use the Smart Brush tool (page 234), which thoughtfully puts its changes on their own layer.

You can also use layers for many adjustments to your photos, which lets you tweak or eliminate those changes later on. For instance, say you used Quick Fix's Hue slider, but the next day decide you don't like what you did—you're stuck (unless you can dig out a copy of your original). But if you'd used a *Hue/Saturation Adjustment layer* (page 219) to make the change instead, you could just throw out that layer and keep all your other changes. Pretty neat, huh? You can also use layers to combine parts of different photos, as shown in Figure 6-2.

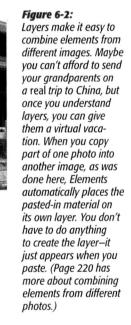

Once you understand how to use layers, you'll feel much more comfortable making radical changes to your images, since any mistakes will be simple to fix. Not only that, but by using layers, you can easily make lots of sophisticated changes that are otherwise very difficult and time-consuming. But the main reason to use layers is for creative freedom: They let you easily add lots of special effects that would be tough to create any other way.

The Layers Panel

The Layers panel is your control center for any layer-related action you want to perform, like adding, deleting, or duplicating layers. Figure 6-3 shows the Layers panel for an image with lots of layers. It includes each layer's name and a little thumbnail of the layer's contents. You can adjust the size of the thumbnails or even turn them off altogether, as explained in Figure 6-4.

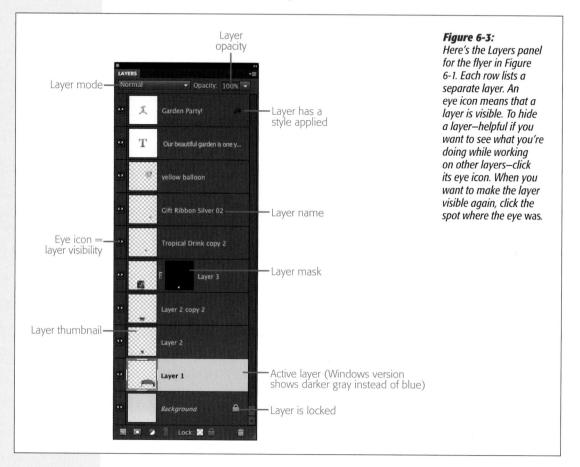

Tip: It helps to keep the Layers panel handy whenever you work with layers, not only for the info it gives you, but also because you can usually manipulate layers more easily in the panel than directly in your image. And many changes, like renaming a layer, you can make *only* in the panel.

Figure 6-4:

If you want to change the size of the thumbnails in the Layers panel, click the little square made up of horizontal lines (in the panel's upper-right corner, above the Opacity setting) to open the panel's pop-out menu. Near the bottom of the menu, choose Panel Options, and this dialog box appears. Here, medium-sized icons are selected.

The Layers panel usually contains one layer that's *active*, meaning that any action you take, like painting, will happen on that layer (and that layer only). You can tell which layer is active by looking at the Layers panel. If you're on a Windows computer, the active one is darker than the others; on a Mac, it's blue (as shown in Figure 6-3).

Note: If you use the layer selection tricks described on page 206, then you can wind up with multiple active layers or none, but you generally want to have only one active layer.

When you look at a layered image, you're looking down on the stack of layers from the top, just as if you were looking at overlays on a drawing. The layers appear in the same order as in the Layers panel—the top layer of your image is at the top of the panel. (Layer order is important because what's on top can obscure what's beneath it.)

Elements lets you do lots of slick maneuvers right in the Layers panel: You can make a layer's contents invisible and then visible again, change the order in which layers are stacked, link layers together, change layers' opacity, add and delete layers—the list goes on and on. The rest of this chapter covers all these options and more.

Tip: The Layers panel is really important, so most people like to keep it around. You can use any of the panel-management techniques described on page 27 to put it where it's easy to get to while you work.

The Background

The bottom layer of any image is a special kind of layer called the *Background*. When you first open an image or photo in Elements, its one existing layer is named Background (assuming nobody has already edited the file in Elements and changed things, that is). The name Background is logical because whatever else you do will happen on top of this layer.

Note: There are two exceptions to the first-layer-is-always-the-Background rule. First, if you create a new image by copying something from another picture, then you just have a layer named Layer 0. Second, Background layers can't be transparent, so if you choose the Transparency option when creating a file from scratch, then you have a Layer 0 instead of a Background layer.

As for content, the Background can be totally plain or busy, busy, busy. A Background layer doesn't literally contain only the background of your photograph your whole photo can be on a Background layer. It's entirely up to you what's on the Background layer, and what you place on other, new layers you add. With photographs, people often keep the original photo on the Background layer, and then perform adjustments and embellishments on other layers.

You can do a lot to Background layers, but there are a few things you *can't* do: Change their blending modes (see page 199), opacity (page 197), or position in the layer stack. If you want to do any of those, then you need to convert the Background into a regular layer first.

To change a Background layer into a regular layer, double-click it in the Layers panel or go to Layer→New→Layer From Background. Or, if you try to make certain kinds of changes to the background (like applying a Layer Style [page 456]), then Elements prompts you to change the Background layer into a regular layer. But Elements often just creates a regular layer when you need it without bothering to ask you about it, like when you use the Transform commands (page 389).

Tip: The Background Eraser and Magic Eraser automatically turn a Background layer into a regular layer when you click a background with them. For example, say you have a picture of an object on a solid background and you want transparency around the object. One click with the Magic Eraser turns the Background layer into a regular layer, eliminates the solid-colored background, and replaces it with transparency. (There's more on the Eraser tools on page 418.)

You can also transform a regular layer into a Background layer if you want, but you need to start with an image that has no Background layer. In real life, it's unlikely that you'd need to do this in Elements 10, but, if you want to try it:

1. In the Layers panel, click the layer you want to convert to a Background layer.

2. Select Layer→New→"Background from Layer."

It may take a few seconds for Elements to finish calculating and to respond. When it's done thinking, the layer you've changed moves down to the bottom of the layer stack in the Layers panel and Elements renames it Background.

Note: If you use a masked layer (page 211) for this, the layer mask gets permanently applied to the image, since Background layers can't be masked.

COMPATIBILITY CORNER

Which File Types Can Use Layers?

You can add layers to any file you can open in Elements, but not every file format lets you *save* layers.

For instance, if your camera shoots JPEGs, you can open those JPEGs in Elements and add layers to them. But when you try to save these files, Elements presents you with the Save As dialog box instead of just saving. If you turn off the dialog box's Save Layers checkbox, a warning tells you that you have to save as a copy. That's Elements' way of telling you that you that you need to save in another format to keep the layers, because you can't have layers in a JPEG file.

You usually want to choose either Photoshop (.psd) or TIFF as your format when saving a layered image because they both let you keep your layers. (PDF files can also have layers.) But if you don't need the layers, then just save your JPEG as a copy, close the original file, and say No when Elements asks if you want to save your changes. If someone using the full-featured Photoshop sends you a layered image, then you see the layers in the Layers panel when you open the file in Elements. Likewise, Photoshop folks can see layers you create in Elements.

If you open a Photoshop file with a layer that says "indicates a set" when you move your cursor over it in the Layers panel, you have what Photoshop calls a *layer group* or layer set (a way of grouping layers into what are essentially folders in the Layers panel), depending on which version of Photoshop created the file. Elements doesn't understand layer sets, so ask the sender to expand the sets and send you the file again. Alternatively, you can use the Layer \rightarrow Simplify command to convert the set to a single layer, which may or may not be editable. Or you can search the Internet for add-on toolsets (page 602) or look for scripts that will let you expand the set in Elements. Elements+ (page 602) is one option.

Creating Layers

As you learned earlier in the chapter, your image doesn't automatically have multiple layers. Lots of newcomers to Elements expect the program to be smart enough to put each object in a photo onto its own layer, which is a lovely dream, but Elements isn't that brainy. To experience the joy of layers, you first need to add at least one layer to your image; you'll learn how in the next few sections.

Tip: It may help you to follow along through the next few sections, so get out a photo of your own or create a new file to use for practice. (See page 52 for details on how to create a new file; if you go that route, choose a white background.) Or, you can download either *gardenparty.psd* or *daisies.com* from this book's Missing CD page at *www.missingmanuals.com*.

Adding a Layer

Elements gives you several ways to add new layers. You can use any of the following methods:

- Choose Layer→New→Layer.
- Press Shift+Ctrl+N/Shift-\%-N.
- In the Layers panel, click the "Create a new layer" icon (the little square shown in Figure 6-5).

When you create a new layer using any of these commands, the layer starts out empty. You won't see anything in your image change until you use the layer for something (you paint on it, for example). In the Layers panel, the new layer is just above the layer that was active when you added the layer. Elements always puts new layers directly above the active layer, so if you want a new layer at the top of the stack, click the current top layer to make it active before creating the new layer.

Tip: The only practical limit to the number of layers your image can have is your computer's processing power. But if you find yourself regularly creating projects with upwards of 100 layers, you may want to upgrade to Photoshop, which has tools that make it easier to manage lots of layers.

Some things you do create new layers automatically. For instance, if you copy and paste an object from another photo (see page 220 for instructions) or add artwork from the Content panel, then the object automatically arrives on its own layer. That's really handy because it lets you put the new item right where you want it without disturbing the rest of your composition.

Sometimes you want to manually create new layers. For example, you'd do that when you want to clone something (explained on page 315). If you don't make a separate layer to clone on, your changes go right onto your existing layer and become part of it; once you save and close the file, you can't undo any of that cloning. But if you put your changes on a separate layer, you can always go back and discard that layer if you change your mind.

Deleting Layers

If you decide you don't want a particular layer anymore, you can easily delete it. Figure 6-6 shows the simplest method, though Elements also gives you a few other ways to delete a layer. You can:

Figure 6-6:

To make a layer go away, either drag it to the trashcan icon on the Layers panel or select the layer and then click the trashcan (circled). Elements asks if you want to delete the active layer; say yes, and it's history. Once you delete a layer, as long as you haven't closed the file, you can get that layer back by using one of the Undo commands. But once you close the file, the layer is gone forever.

- Select Layer→Delete Layer.
- Right-click/Control-click the layer in the Layers panel, and then choose Delete Layer.
- Click the Layers panel's upper-right button (the square made of horizontal lines), and then choose Delete Layer.

Duplicating a Layer

Creating a copy of a layer can be really useful. Many Elements features, like filters and color-modification tools, don't work on brand-new, *empty* layers. But if you apply such changes to your original photo layer, they alter it in ways you can't undo later. The workaround is to create a *duplicate* of the image layer and then make your changes on the copy. That way you can ditch the duplicate later if you change your mind, and your original layer is safely tucked away, unchanged. If you use layer masks (page 211), you'll often duplicate existing layers while working with them.

If all this seems annoyingly theoretical, try going to Enhance \rightarrow Adjust Color \rightarrow Adjust Hue/Saturation, for example, when you're working on a new blank layer. You get the stern dialog box shown in Figure 6-7.

Figure 6-7:

Elements is usually pretty helpful when you try to do something that just won't work, like applying a Hue/Saturation adjustment to an empty layer. The solution here is just to switch the Layers panel's focus to a layer that has something in it. *Tip:* Very rarely, you may encounter the dreaded "no pixels are more than 50% selected" warning. Several things can cause this, but the most common are too large a feather value on a selection (see the box on page 165) or trying to work in the empty part of a layer that contains objects surrounded by transparency.

Elements gives you several ways to duplicate a layer and its content. Select the layer you want to copy to make it the active layer, and then do one of the following:

- Press Ctrl+J/#-J. (Be sure you don't have any active selections when you do this, or Elements copies only the *selection* to the new layer.)
- Choose Layer→Duplicate Layer.
- In the Layers panel, drag the layer you want to copy onto the "Create a new layer" icon.
- In the Layers panel, right-click the Layer, and then, from the pop-up menu, choose Duplicate Layer.
- Click the little four-line square at the upper right of the Layers panel, and then choose Duplicate Layer.

All these methods copy everything in the active layer into the new layer. You can then mess with the duplicate as much as you want without damaging the original. Also, all of them except the keyboard shortcut bring up a dialog box where you can name your new layer, or even choose to use it in a new file or in another image (if you have more than one image open).

Copying and Cutting from Layers

You can also make a new layer that consists of only a *piece* of an existing layer. (This is helpful when you want to do things like apply a Layer style to one object on the layer.) But first you need to decide whether you want to *copy* your selection or *cut* it out and place it on the new layer.

What's the difference? It's pretty much the same as copying versus cutting in your word-processing program. When you use the "New Layer via Copy" command, the area you select appears in the new layer and remains in the old layer, too. "New Layer via Cut," on the other hand, removes the selection from the old layer and places it on the new layer, leaving a corresponding hole in the old layer. Figure 6-8 shows the difference.

GEM IN THE ROUGH

Naming Layers

You may have noticed that Elements isn't terribly creative when it comes to naming layers: You get Layer 1, Layer 2, and so on. Fortunately, you don't have to live with those titles. You can easily rename layers.

Renaming layers may sound like a job for people with way too much time on their hands, but if you're working on a project that has lots of layers, you may find it easier to pick out the layers you want if you give them descriptive names. (Incidentally, you can't rename a Background layer; you have to change it into a regular layer first. Also, Elements helps you out with Text layers by naming them using the first few words of text they contain.) To rename a layer:

- Double-click its name in the Layers panel. The name becomes an active text box.
- Type the new name. You don't even need to highlight the text-Elements does that for you automatically.

As with any other change, you have to save your image afterward if you want to keep the new name.

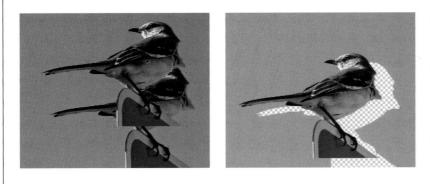

Figure 6-8:

The difference between "New Layer via Copy" and "New Layer via Cut" is obvious when you move the new layer to see what's beneath it.

Left: With "New Layer via Copy," the original bird is still in place in the underlying layer.

Right: When you use "New Layer via Cut," the excised bird leaves a hole behind.

Once you've selected what you want to copy or cut, your new layer is only a couple of keystrokes away:

• New Layer via Copy. To copy your selection to a new layer, press Ctrl+J/ૠ-J or go to Layer→New→"Layer via Copy." (If you don't select anything beforehand, Elements copies your *whole* layer, making this a good shortcut for creating a duplicate layer.)

New Layer via Cut. To cut your selection out of your old layer and put it on a layer by itself, press Shift+Ctrl+J/Shift-ℜ-J or go to Layer→New→"Layer via Cut." Just remember that you leave a hole in your original layer when you do this. (On a Background layer, the hole is filled with the current background color.) If you want to cut and move everything on a layer, press Ctrl+A/ℜ-A before you cut, although usually it's easier just to move the layer instead. To do that, drag it up or down the stack in the Layers panel to put it where you want it.

Tip: If you want to use a layer as the basis for a new document, Elements gives you a quick way to do so. Instead of copying and pasting, you can create a new document by going to Layer \rightarrow Duplicate Layer. You get a dialog box with a Document drop-down menu that lets you place the duplicate layer into your existing image, into any image currently open in the Editor, or into a new document of its own. (This maneuver works only from the Layer menu; pressing Ctrl+J/#-J doesn't bring up the dialog box.) You can also create a new document with only part of a layer by selecting the area you want, pressing Ctrl+C/#-C to copy it. and then going to File \rightarrow New \rightarrow "Image from Clipboard."

Managing Layers

The Layers panel lets you manipulate your layers in all kinds of ways, but first you need to understand a few more of the panel's cryptic icons. Some of the things you can do with layers may seem obscure when you first read about them, but once you actually use layers, you'll quickly see why these options exist. The next few sections explain how to manipulate layers in several different ways: hide them, group them together, change the way you see them, and combine them.

Hiding Layers

You can turn layers' visibility off and on at will, which is tremendously useful. If the image you're working on has a busy background, for example, it's hard to see what you're doing when working on a particular layer. Making the Background layer invisible can help you focus on the layer you're interested in. To turn off a layer's visibility, in the Layers panel, click the eye icon to the layer's left. To make the layer visible again, click the spot where the eye icon was.

Tip: If you have a bunch of hidden layers and decide you don't want them anymore, click the Layers panel's upper-right button (the little four-line square) and choose Delete Hidden Layers to get rid of them all at once.

Adjusting Layer Opacity

Your choices for layer visibility aren't limited to on and off. You can create immensely cool effects by adjusting the *opacity* of your layers. In other words, you can make a layer partially transparent so that what's underneath it shows through.

To adjust a layer's opacity, click the layer in the Layers panel, and then either:

- Double-click the Opacity box, and then type in the percentage of opacity you want.
- Click the triangle to the right of the Opacity box and then drag the pop-out slider, or put your cursor on the word "Opacity" and *scrub* (drag) left for less opacity or right for more. (Figure 6-9 explains the advantage of scrubbing.) If you'd like to experiment with creating Fill and Adjustment layers (page 217) and changing their modes and opacity, download *daisies.jpg* from this book's Missing CD page at *www.missingmanuals.com*.

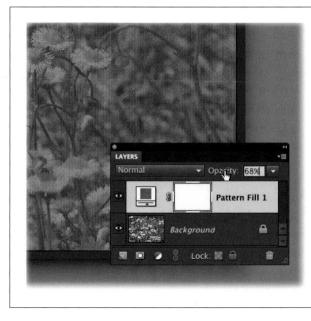

Figure 6-9:

You can watch the opacity of your layer change on the fly if you drag your cursor back and forth over the word "Opacity." Blend modes (page 198) often give the best effect if you adjust the opacity of their layers.

When you create a layer by pressing $Shift+Ctrl+N/Shift+\Re+N$ or choosing Layer \rightarrow New \rightarrow Layer, you can set the new layer's opacity in the New Layer dialog box that appears. If you create a new layer by clicking the Layers panel's New Layer icon, then you need to Alt-click/Option-click that icon to bring up the New Layer dialog box so you can set the opacity.

Note: You can't change a Background layer's opacity. You first have to convert it to a regular layer; page 190 explains how.

Locking Layers

If you've gotten a layer just perfect and you don't want to accidentally change it, you can *lock* that layer to protect you from yourself. Locking keeps you from changing a layer's contents.

To lock *everything* on a layer so you can't make any changes to it, make sure the layer is active and then click the "Lock all" icon (the dark gray padlock at the bottom of the Layers panel). A dark gray padlock appears in the Layers panel to the right of the layer's name, and the "Lock all" icon shows a dark gray outline around it. Now if you try to paint on that layer or use any other tools on it, your cursor turns into a No symbol (a red circle with a diagonal line through it) to remind you that you can't edit that layer. To unlock the layer, just click the "Lock all" icon at the bottom of the panel again.

Note: Locking a layer only keeps you from *editing* that layer. It doesn't stop you from flattening it or merging it into another layer, or from cropping your image.

If you want, you can also lock only the transparent parts of a layer—helpful when you want to modify an object that sits atop a transparent layer, like the seashell in Figure 6-10. When you do that, the transparent parts of your layer stay transparent no matter what you do to the rest of it.

Figure 6-10:

After you've isolated an object on its own layer, you may want to paint only on that object—and not on the transparent portion of the layer. Elements lets you lock the transparent part of a layer, making it easy to paint just the object.

Left: On a regular layer, paint goes wherever your brush does.

Right: With the layer's transparency locked, the brushstroke stops at the edge of the seashell, even though the brush cursor (the circle) is now on the transparent part of the layer. To lock the transparent parts of a layer, select the layer, and then, at the bottom of the Layers panel, click the little "Lock transparent pixels" checkerboard. (It's grayed out if your image doesn't have any transparent parts.) When you do this, a light gray padlock appears in the Layers panel to the right of the layer's name, and the checkerboard icon displays a tiny border, but you have to look very hard to see it. To unlock the layer, just click the checkerboard again.

Blend Mode

At the top of the Layers panel is a drop-down menu that usually says "Normal" (or, in the New Layer dialog box, "Mode: Normal"). This is your *blend mode* setting. When used with layers, blend modes control how the objects on a layer combine, or *blend*, with the objects on the layer beneath it. By using different blend modes, you can make your image lighter or darker, or even make it look like a poster, with just a few bold colors in it. Blend modes can also control how some tools—those with Blend Mode settings—change your image. Tweaking a tool's blend mode can sometimes dramatically change your results.

Blend modes are an awful lot of fun once you understand how to use them. They can help you fix under- or overexposed photos and create all kinds of special visual effects. You can also use some tools, like the Brush tool, in different blend modes to achieve different effects. The most common blend mode is Normal, in which every-thing you do behaves just the way you'd expect: An object shows its regular colors, and paint acts just like, well, paint.

Page 413 has lots more about how to use blend modes. For now, take a look at Figure 6-11, which shows how you can totally change the way a layer looks just by changing its blend mode.

Not every blend mode makes a visible change to every image. Some of them may seem to do nothing; that's to be expected. It just means that you don't have a condition in your image that responds to that particular mode change. See page 265 for one example of a situation where a mode change makes an enormous difference.

POWER USERS' CLINIC

Fading in Elements

One great thing you get in the full-featured Photoshop that Elements lacks is the ability to *fade* special effects and filters. Fading gives you fine control over how much these tools change an image. For example, filters often generate harsh-looking results, so Photoshop's Fade command lets you adjust a filter's effect until it's what you intended. Happily, you can approximate the Fade command in Elements: First, apply filters, effects, or layer styles to a duplicate layer. Then, reduce the layer's opacity till it blends in with what's below (and change the blend mode if necessary) to get exactly the result you want.

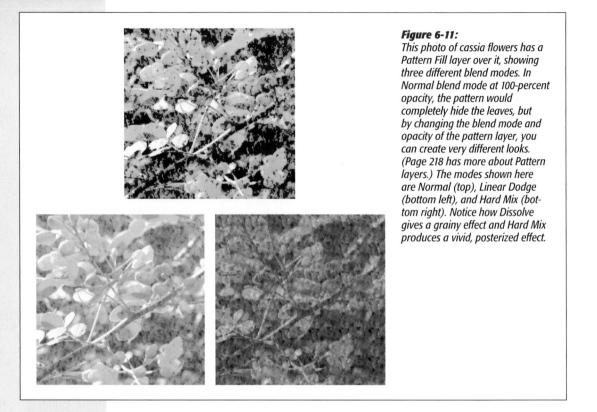

Rearranging Layers

One of the truly amazing things you can do with Elements is move layers around. You can change the order in which layers are stacked so that different objects appear in front of or behind each other. For example, you can position one object behind another if they're both on their own layers. In the Layers panel, just grab a layer and drag it to where you want it.

Tip: Remember, you're always looking down onto the layer stack when you view your image, so moving something up in the Layers panel's list moves it toward the front of the picture.

Figure 6-12 shows the early stages of the garden party invitation from Figure 6-1. The potted plants are already in place, and the bench was brought in from another image. But the bench came in at the top of the layer stack, in front of the flowers. To put the bench behind the plants, simply drag the bench layer below the plants layer in the Layers panel.

Figure 6-12:

Top: When you bring a new element into an image, it comes in on top of the active layer. In this case, that made the bench the front object.

Bottom: Move the new layer down in the stack, and it appears behind the objects on layers above it. In this example, the bench moves behind the plants.

Note: Background layers are the only kind of layer you can't move. If you want to put Background layer in another spot in the layer stack, first convert it to a regular layer (page 190), and *then* move it.

You can also move layers by going to Layer \rightarrow Arrange, and then choosing one of these commands:

- Bring to Front (Shift+Ctrl+]/Shift-\"-]) sends the selected layer to the top of the stack so the layer's contents appear in your image's foreground.
- **Bring Forward** (Ctrl+]/#-]) moves the layer up one level in the Layers panel, so it appears one step closer to the front of your image.
- Send Backward (Ctrl+[/\#-[) moves the layer down one level so it's one step farther back in the image.
- Send to Back (Shift+Ctrl+[/Shift-\colored-c]) puts the layer directly above the Background layer so it appears as far back as possible.

If you want to unlink layers, then simply click one of the linked layers in the Layers panel, and then click the same chain icon you used to link them.

You can also merge the layers (covered in the next section) into one layer if you want. Or you can use the layer selection choices described in the box below and skip linking altogether; as long as your layers all stay selected, they travel as a group. But the advantage of linking is that your layers stay associated until you unlink them—you don't need to worry about accidentally clicking somewhere else in the panel and losing your selection group.

ORGANIZATION STATION

Selecting Layers

You can quickly choose multiple layers when you want to do things like link, move, or delete layers. For your quickselection pleasure, Elements gives you a whole group of layer-selection commands, which you'll find in the Select menu. Here's what they do:

- All Layers. Choose this command and Elements selects every layer except the Background layer. Even if you've turned off a layer's visibility (page 196), it still gets selected.
- Deselect Layers. When you're done working with layers as a group, pick this command and you won't have any layers selected until you click one.
- Similar Layers. This command is the most useful in the group. Choose it and every layer that's the same type as the active one gets selected, no matter

where it is in the stack. So, for example, if you have a Text layer active when you choose Similar Layers, Elements selects *all* your Text layers. Or if you have an Adjustment layer active, it selects all the Adjustment layers. You can use this command to quickly select a stack of Adjustment layers you want to drag to another image, for instance, using the technique described on page 222.

You can also Shift-click to select multiple layers that are next to each other in the Layers panel, or Ctrl-click/æ-click to select layers that are separated. That way, you can avoid the Select menu altogether. Once you're done, you can either use the Deselect Layers command or just click another layer to make it the active layer.

Grouping layers by clipping

An even more powerful way to combine layers is to group them together using a *clipping mask*. This technique sounds complex, but it's actually quite easy and very powerful. With this kind of grouping, one layer (the clipping mask layer) influences the other layers it's grouped with.

Note: This technique used to be called "grouping," but starting with Elements 8 Adobe changed it to "clipping," which is what it's called is in Photoshop. The behavior is exactly the same as the old grouped layers—only the name is different.

Clipping layers isn't anything like linking them. You can probably understand the process most easily by looking at Figure 6-16, which shows how to crop an image on one layer using the shape of an object on another layer.

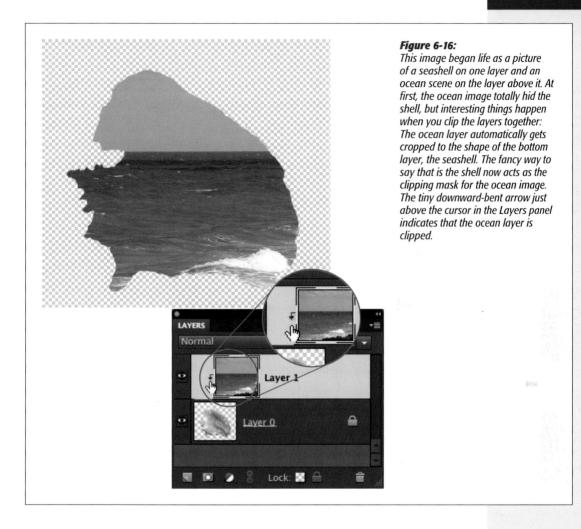

Note: If you clip two layers together, the bottom layer determines the opacity of both layers.

Once the layers are clipped together, you can still slide the top layer around with the Move tool to reposition it so that you see exactly the part of it that you want. So in Figure 6-16, for example, the ocean layer was positioned so the breaking wave showed in the bottom of the shell shape.

To clip two layers together, position the two layers one above the other in the Layers panel by dragging. (Put the one you want to act as the mask *below* the other image.) Then choose Layer \rightarrow Create Clipping Mask or press Ctrl+G/#-G. Then make the top layer (of the two you want to group) the active layer.

You can also clip right in the Layers panel: Hold down Alt/Option, and then, in the panel, move your cursor over the dividing line between the layers. When two linked circles appear by your cursor, click once and Elements groups your layers together with a clipping mask.

If you get tired of the layer grouping or you want to delete or change one of the layers, then select Layer→Release Clipping Mask or press Ctrl+G/ #-G again to undo the grouping.

Tip: You have an even easier way to group layers: The New Layer dialog box has a "Use Previous Layer to Create Clipping Mask" checkbox. Turn it on, and Elements pre-clips your new layer with the layer below it.

Merging and Flattening Layers

By now, you probably have some sense of how useful layers are. But there's a downside to having layers in your image: They take up a lot of storage space, especially if you have lots of duplicate layers. (In other words, layers make files bigger.) Fortunately, you don't have to keep layers in your files forever. You can reduce a file's size quite a bit—and sometimes also make things easier to manage—by merging layers or flattening the image.

Merging layers

Sometimes you may have two or more separate layers that really could be treated as one layer, like the plants in Figure 6-17. You aren't limited to just linking those layers together; once you've got everything arranged just right, you can *merge* them together into one layer. Also, if you want to copy and paste your image, standard copy and paste commands typically copy only the top layer, so it helps to get everything into one layer, at least temporarily. You'll probably merge layers quite often when you're working with multilayer files (for example, when you've got multiple objects that you want to edit simultaneously).

You have a couple of different ways to merge layers, depending on what's active in your image. You can get to either of the following commands by heading up to the Layers menu, clicking the Layers panel's upper-right button (the four-lined square), or by using keyboard shortcuts:

- Merge Down (Ctrl+E/#-E) combines the active layer with the layer immediately beneath it. If the layer just below the active layer is hidden, then you don't see this option in the list of choices.
- Merge Visible (Shift+Ctrl+E/Shift-\#-E) combines all the visible layers into one layer. If you want to combine layers that are far apart, then just temporarily turn off the visibility of the ones in between (and any other layers that you don't want to merge) by clicking their eye icons.

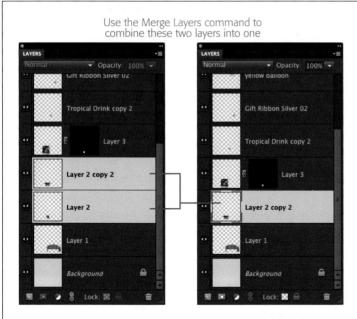

Figure 6-17:

Those potted plants again. If you no longer need two separate plant layers, then you can merge the layers together.

Left: The Layers panel with the two separate layers for the red flowering plants.

Right: The plant layers merged into one layer.

It's important to understand that once you merge layers and then save and close your file, you can't just unmerge them. While your file is still open, you can use any of the undo commands, but once you exceed the undo limit you've set in Preferences (page 37), you're stuck with your merged layers.

Tip: The box below explains another way to combine all your layers while still keeping separate copies of the individual layers.

Sometimes, when your layer contains text or shapes drawn with the Shape tool, you can't merge the layer right away; Elements asks you to *simplify* the layer first. Simplifying means converting its contents to a *raster object*—a bunch of pixels, subject to the same resizing limitations as any photo. So, for example, after you rasterize a Text layer, then you can apply filters to the text or paint on it, but you can't edit the words anymore. (See page 426 for more about simplifying and working with shapes, and Chapter 14 to learn about working with text.)

POWER USERS' CLINIC

Stamp Visible

Sometimes you want to perform an action on all your image's visible layers without permanently merging them together. You can do this easily and quickly—even if you have dozens of layers in your file—with the Stamp Visible command, which combines the contents of all your layers into a new layer at the top of the stack.

Stamp Visible is great because it lets you work away on the new combined layer while leaving your existing layers untouched, in case you want them back later. Just press Ctrl+Shift+Alt+E/#-Shift-Option-E or hold down Alt/Option while selecting the Merge Visible command from the Layers menu or from the Layers panel's menu, which you open by clicking the square made of four horizontal lines. However you run the command, Elements creates a new top layer for you and fills it with the combined contents of all your other layers.

If you want to keep a layer or two from being included in this new layer, then just turn off the visibility of the layers you don't want to include before using Stamp Visible.

Flattening an image

While layers are simply swell when you're working on an image, they're a headache when you want to share your image, especially if you're sending it to a photo-printing service (their machines usually don't understand layered files). Even if you're printing at home, the large size of a multilayer file can make it take forever to print. And if you plan to use your image in other programs, very few non-Adobe programs are totally comfortable with layered files, so you may get some odd results.

In these cases, you can squash everything in your picture into a single layer. You do this by *flattening* your image: Go to Layer \rightarrow Flatten Image or, in the Layers panel, click the four-lined-square and choose Flatten Image. Or, to keep your original intact, go to File \rightarrow Save As, and in the Save As dialog box, turn *off* the Layers checkbox and turn *on* the "As a Copy" checkbox before clicking the Save button.

Tip: Saving your image as a JPEG file automatically gets rid of layers, too.

There's no keyboard shortcut for flattening because it's something you don't want to do by accident. Like merging, flattening is a permanent change. Cautious Elements veterans always do a Save As (instead of a plain Save) before flattening. That way you have a flattened copy *and* a working copy with the layers intact, just in case. Organizer version sets (page 75) can help you here, too, because they let you save different states of your image, so you can have both a layered and a flattened version.

Note: Flattening creates a Background layer out of the existing layers in your image, which means that you lose transparency, just as with a regular Background layer. If you want to create a single layer with transparency, then use the Merge Visible command (page 208) instead.

Layer Masks

Elements gives you an incredibly powerful tool for getting the most out of your layers: *layer masks*. What are they and why is this such a big deal?

As their name implies, layer masks let you hide (or "mask") parts of layers. Back in Chapter 5, you learned about selecting parts of photos and using the Magic Extractor to cut objects out of the background, and earlier in this chapter you learned how to cut or copy something to a new layer. Those are all fine techniques, but if next week you change your mind about exactly what you want to include, you have to start all over again. Wouldn't it be cool if you could just make the parts of your photo that you don't want vanish, and then make them reappear later on if you change your mind?

Layer masks let you do exactly that: They're like a cloak of invisibility for your layer, and it's totally up to you how much shows. When you mask part of a layer, the visible part looks just like an object that's been cut out and surrounded by transparency, but the rest of the layer is all still there—it's just hidden away. What's more, showing or hiding more of what's on the layer is as easy as painting on it, and there's no statute of limitations-you can come back to the layer and adjust things whenever you want. Figure 6-18 helps explain why this is such a great way to work.

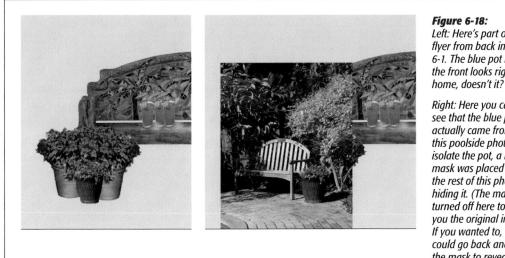

Figure 6-18: Left: Here's part of that flyer from back in Figure 6-1. The blue pot in the front looks right at

Right: Here you can see that the blue pot actually came from this poolside photo. To isolate the pot, a layer mask was placed over the rest of this photo, hiding it. (The mask was turned off here to show *you the original image.*) If you wanted to, you could go back and edit the mask to reveal more of the photo or change what the mask covers if, for instance, you decide you'd rather use one of the bushes behind the pot in your flyer instead.

Managing Layers

In full Photoshop, layer masks have been *de rigueur* for all sorts of changes for years now because they're incredibly powerful and easy to use. The only downside to layer masks is that the extra content makes your file somewhat larger, but that's a small price to pay for so much flexibility.

Note: Adjustment and Fill layers (which you'll learn about in the next section) come with layer masks already attached to them; you don't have to do anything to add them.

Layer masks are a tad confusing at first, but you'll quickly get the hang of them and learn how much they can do for you. The easy way to remember what they do is to think of them as Halloween masks for your layers: Whatever is behind the mask is hidden, while you can see everything that's not covered by the mask.

You can add a layer mask to any layer except a Background layer. Here's how:

1. Make sure the layer you want to mask is active.

If it's not, click it in the Layers panel.

2. Add a layer mask.

You have several choices for how your mask should start off:

- Empty, showing all the layer's contents. To create a "blank" layer mask (in other words, one that starts out not covering anything in your layer), just click the "Add layer mask" button at the bottom of the Layers panel (it looks like a circle within a square; you can see it back in Figure 6-5) or choose Layer→Layer Mask→Reveal All. When you do, a pure white mask thumbnail appears in your Layers panel to the right of the layer's thumbnail.
- Filled, completely hiding the layer. To create a "full" layer mask that covers everything in your layer, Alt-click/Option-click the "Add layer mask" button or choose Layer→Layer Mask→Hide All. Elements add a black mask thumbnail to your Layers panel. You'd use this option if you wanted to hide most of the layer. That way, you can just reveal ("unmask") the areas you want to keep visible, like the eyes and lips of a portrait, for example. That's faster than painting over everything else in the layer. (You'll learn how to edit layer masks in a moment so you can hide exactly what you want.)
- With only a selection visible. To hide all but certain areas of your layer, select the parts you want to keep visible and then click the "Add layer mask" button or go to Layer→Layer Mask→Reveal Selection. Elements masks everything but your selection, leaving only the selected area(s) visible. The result looks exactly like you used the Magic Extractor on your layer; the difference is that everything else is *still there*—it's just hidden.
- With only a selection hidden. If you only want to hide a few bits of your layer, select those parts and then Alt-click/Option-click the "Add layer mask" button or go to Layer→Layer Mask→Hide Selection and Elements hides the selected area(s).

You'll learn how to edit the area covered by a mask in a moment, but first here are a few other useful things you can do with a layer mask:

• Disable it. If you want to see your layer without the mask, in the Layers panel, just right-click/Control-click its thumbnail and choose Disable Layer Mask, or go to Layer→Layer Mask→Disable. Everything that the mask was hiding reappears and Elements puts a big red X over the mask's thumbnail to remind you that it's disabled.

Note: When you disable a layer mask, your menu choice changes to read "Enable" instead. Just choose it to toggle the mask back on.

- Merge it into the layer. If you decide that you really, really don't need to edit a layer mask anymore, right-click/Control-click its thumbnail in the Layers panel and choose Apply, or go to Layer→Layer Mask→Apply, and the mask becomes a permanent, uneditable part of the layer it's attached to. Basically, doing this puts you in the same situation you'd be in if you used the "Layer via Copy" command or if you'd selected something and then deleted the rest of the layer (meaning you lose all the flexibility you get by using a layer mask), so this isn't something you'll do often.
- Unlink it. When you add a layer mask, a little chain appears in the Layers panel between the layer's thumbnail and the mask's thumbnail to indicate that they work as a unit. But if you unlink them, you can move the mask separately from the layer itself. This is handy when you've got a mask the size and shape of the area you want to see perfectly masked out, only it's not quite over the right part of the image, for example. In that case, unlink the mask from the layer so you can drag the mask without moving the layer's contents. To do that, just click the chain icon or go to Layer→Layer Mask→Unlink. The chain disappears and you can now use the Move tool to rearrange things. To relink them, click the spot where the chain icon was or choose the menu item again (which now says "Link").
- Delete it. To get rid of a layer mask and return the layer to its unmasked state, in the Layers panel, right-click/Control-click the mask's thumbnail and choose Delete Layer Mask, or go to Layer→Layer Mask→Delete.

Editing a layer mask

Now that you have a mask, it's time to learn how to change the area it covers. You do this by simply painting on it with black or white. Painting with black increases the masked area; painting with white increases the visible area. "Black conceals and white reveals" is an old Photoshop saw that can help you remembering what each color does.

You can work on the mask by painting directly in the main image window, or make the layer mask visible and work in either of two special mask views, which are sometimes helpful when the objects in your image have tricky edges, or if you need to check for missed spots. Here's the simplest way to make changes to the area covered by a layer mask:

1. Make sure the masked layer is the active layer.

If it isn't, click it in the Layers panel. This step is important: If the masked layer isn't active, you'll add paint to the actual image.

2. In the Layers panel, click the layer mask's thumbnail.

You tell Elements whether you want to work directly on the layer or on the layer *mask* by clicking the Layers panel thumbnail of the one you want. (You can tell which one is active because Elements puts an extra little outline around its thumbnail.) The Foreground and Background color squares change to black and white, respectively, as soon as you click the thumbnail. If for some reason they don't, just press D.

3. Paint directly on your image.

Use the Brush tool to paint on the image. Paint an area black to hide it, or white to show it. Remember: black conceals and white reveals. (An easy way to switch between your Foreground and Background colors is to press X.)

You can also use the Selection tools the same way you would on any other selection to change the mask's area. (See Chapter 5 if you need help making selections.) If you watch the layer mask's thumbnail in the Layers panel, you'll see that it changes to show where you've painted.

To make a layer mask visible in the main image window (rather than just as a thumbnail in the Layers panel), you simply click it in the Layers panel while holding down a key or two. Elements gives you a choice of two different ways to see the masked area, as shown in Figure 6-19. If you Alt-click/Option-click the mask's thumbnail, you see the black layer mask (instead of your photo) in the image window. Add the Shift key when you click to see a red overlay on the photo instead of the black-andwhite view. Press the same keys again while clicking the thumbnail to get back to a regular view of your image.

The black mask view shows only the mask itself, not your photo beneath it. This is a good choice when you want to check how clean the edges of your selection are. But if you're adding or subtracting areas of your photo, choose the red-overlay view instead so you can see the objects in your photo as you paint over them. You can use the method described earlier to paint in either view.

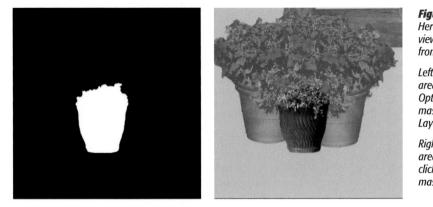

Figure 6-19:

Here are two different views of the layer mask from Figure 6-18.

Left: To see the masked area in black, Alt-click/ Option-click the layer mask's thumbnail in the Layers panel.

Right: To see the masked area in red, Alt+Shiftclick/Option-Shift-click the mask's thumbnail instead.

Tip: You can use shades of gray to adjust a layer mask's transparency. Simply paint on your mask with gray to change the opacity of the area revealed on the layer. Paint with dark gray, for example, for a faint, ghosted effect, the sort of thing you might use to create a background for stationery. The darker the gray, the less shows through; the lighter the gray, the more what you're painting shows through the mask.

Layer masks are incredibly powerful and this section has just covered the very basics, but there are literally *thousands* of different uses for them. You can paint the edges of your photo with grunge brushes, for instance, to created interesting image borders, or apply a black-to-white gradient to a layer mask to make the layer fade on one edge. There are entire books written about masking techniques, and once you get started you'll want to explore more ways you can use this powerful tool to help your creativity soar. If you want to learn how to mask a particular object (like hair, say), just Google "mask hair photoshop" and you'll get more tutorials than you could work through in a lifetime. Katrin Eismann's *Photoshop Masking & Compositing* (New Riders Press) is one of the most complete books on the subject, although a fair amount of the book (like the parts about using the Pen tool) pertains only to Photoshop.

Tip: Full Photoshop also has another kind of mask, called the Quick Mask. If you try a tutorial written for Photoshop that calls for Quick Mask, just use the Selection brush in Mask mode instead.

Adjustment and Fill Layers

Adjustment layers and *Fill layers* are special types of layers. Adjustment layers let you manipulate the lighting, color, or exposure of the layers beneath them. If you're mainly interested in using Elements to spruce up your photos, then you'll probably use Adjustment layers more than any other kind of layer. They're great because they let you undo or change your edits later on.

You can also use Adjustment layers to take the changes you've made to one photo and apply those same changes to another photo (see the Note on page 305). And after you've created an Adjustment layer, you can limit future edits so they change only the area of your photo affected by the Adjustment layer. You'll find out about all the things you can do with Adjustment layers in the next few chapters. For now, you just need to learn how to create and manipulate them, which the next section explains.

Fill layers are exactly what they sound like: layers filled with a color, pattern, or *gradient* (a rainbow-like range of colors—see page 460). Fill layers are great when you've cut an object out of its background and you want to put some color behind it, for example.

One cool thing about both Adjustment and Fill layers is that they automatically come with layer masks, as shown in Figure 6-20.

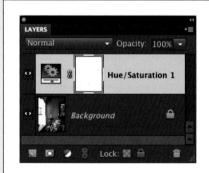

Figure 6-20:

Adjustment and Fill layers, like the Hue/Saturation layer shown here, always display two things in the Layers panel: an icon on the left and a thumbnail on the right. The thumbnail represents the layer's layer mask, which you can use to control the area that's affected by the adjustment. As for the icons, all Adjustment layers display the little gear icon you see here, while each type of Fill layer has its own unique icon, which you can double-click to bring up a dialog box that lets you make changes to the layer's settings. With Adjustment layers, just click the layer you want to change to make it the active layer, and then go to the Adjustments panel to tweak things.

Tip: Digital photographers should check out Photo Filter Adjustment layers, which let you make the sort of adjustments to photos that used to require you to put a colored piece of glass over your camera's lens. Page 297 has more about photo filters.

GEM IN THE ROUGH

Adjustment Layers for Batch Processing

Page 303 shows you how to perform *batch* commands that is, simultaneously applying adjustments to groups of photos by using the Process Multiple Files command. The drawback of Process Multiple Files is that it only gives you access to some of the auto commands, so your editing options are really limited.

So what if you're a fussy photographer who's got 17 shots that are all pretty much the same and you'd like to apply the same fixes to all of them—do you have to edit each one from scratch? Nope. You can open the photos you want to fix, and then drag an Adjustment layer from the first photo onto each of the other photos. (Page 221 shows you how to drag layers between images.) The new photo gets the same adjustments at the same settings. It's not as fast as true batch processing, but it takes a lot less time than editing each photo from scratch.

Adding Fill and Adjustment Layers

Creating an Adjustment or Fill layer is easy: In the Layers panel, just click the halfblack/half-white circle to display the menu shown in Figure 6-21. The menu includes all your Adjustment and Fill layer options (the first three items are Fill layers; the rest are Adjustment layers).

Figure 6-21:

To create a new Adjustment or Fill layer, click the half-black/half-white circle to see this menu, and then pick the type of Adjustment or Fill layer you want. If you'd rather work from the menu bar, then go to Layer \rightarrow New Adjustment Layer (or Layer \rightarrow New Fill Layer) and choose the layer type you want.

Fill layers

Elements can create three types of Fill layers: Solid Color, Gradient (a rainbow-like range of colors), and Pattern. (See page 320 for more about patterns, or page 460 for the lowdown on gradients.) When you create a Fill layer, you get a dialog box that lets you tweak the layer's settings. After you make your choices, click OK, and the new layer appears.

You can change a Fill layer's settings by selecting the layer in the Layers panel, and then going to Layer \rightarrow Layer Content Options, or, in the Layers panel, double-clicking the layer's left-hand icon. Either way, the layer's dialog box reappears so you can adjust its settings.

Adjustment layers

When you create an Adjustment layer, the layer automatically appears in your image, and the Adjustments panel appears in the Panel bin so you can adjust the layer's settings (Figure 6-22). (The exception is the Invert Adjustment layer—if you create one of those, you see the Adjustments panel, but it doesn't give you any settings to change.)

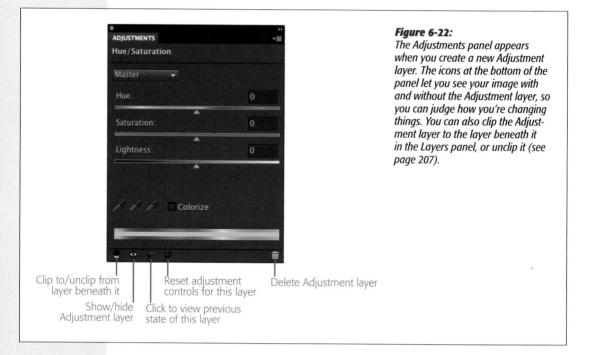

The Adjustments panel is really handy because it lets you see the settings for any Adjustment layer anytime. In the Layers panel, just click the gear icon for the layer you want to change, and Elements displays the Adjustments panel showing the settings for that layer. Click on a different Adjustment layer to see its settings instead.

You can select from the following kinds of Adjustment layers:

- Levels. This is a much more sophisticated way to apply Levels than using the Auto Levels button in Quick Fix or the Enhance menu's Auto Level command. For most people, Levels is *the* most important Adjustment layer. Page 244 has more about using Levels.
- **Brightness/Contrast.** This does pretty much the same things as the Quick Fix adjustment (covered on page 138).
- **Hue/Saturation**. Again, this is much like the Quick Fix command (page 140), only with slightly different controls.
- **Gradient Map.** This one is tricky to understand and is explained in detail on page 470. It maps each tone in your image to a new tone based on the gradient you select. That means you can apply a gradient so that the colors aren't just distributed in a straight line across your image.
- **Photo Filter.** Use this type of layer to adjust the color balance of your photos by adding warming, cooling, or special effects filters, just like you might attach to the lens of a film camera. See page 297 for more info.
- **Invert**. This reverses the colors in your image to their opposite values, for an effect similar to a film negative; page 342 has details.
- **Threshold**. Use this kind of layer to make everything in your photo pure black or white (with no shades of gray). See page 342.
- **Posterize**. This one reduces the numbers of colors in your image to create a poster-like effect, as explained on page 342.

You can edit an Adjustment layer's layer mask the same way you edit any layer mask (page 213). The only difference is what happens when you edit the mask: Instead of showing or hiding the objects in your photo, you show and hide the *effects* of the adjustment, since this kind of a layer contains the adjustment instead of physical objects.

Deleting Adjustment and Fill layers

Deleting Fill and Adjustment layers is a tad different from deleting regular layers, as explained in Figure 6-23.

Figure 6-23:

Deleting Adjustment and Fill layers is a two-step process. When you select an Adjustment or Fill layer and then click the Layers panel's "Delete layer" icon (the trashcan), Elements asks if you want to "Delete layer mask?" Click Delete, and then click the trashcan icon again to fully delete the layer. If you want to get rid of an Adjustment or Fill layer in one step, go to the Layer menu, right-click the layer in the Layers panel, or click the Layers panel's upper-right menu button (the square made of four horizontal lines). All these routes give you a Delete Layer option.

Moving Objects Between Images

Layers let you easily combine parts of different photos. If you're using tabs, the simplest way to do this is by copying and pasting: Select what you want to move (press Ctrl+A/\mathbf{H}-A if you want to move the whole photo), and then press Ctrl+C/\mathbf{H}-C to copy it. Next, make the destination image the active image by double-clicking it in the Project bin, and then press Ctrl+V/\mathbf{H}-V to paste. The pasted material comes in on its own layer, and you can use the Move tool to rearrange it in its new home.

You can also move objects between images by dragging. To do this, you need to choose one of the tiled views if you're using tabs (page 109), or Tile or Cascade (Window→Images→Tile or Cascade) if you're using floating windows (page 109). Just put what you want from photo A into its own layer, and then drag it onto photo B. You can use the Move tool to move the object from one image to another, or you can just drag it. The trick is that you have to drag the layer from photo A's *Layers panel*. If you try to drop one photo directly onto another photo's window, then you'll just wind up with a lot of windows stacked on top of each other. Figure 6-24 shows you how to execute this maneuver.

Tip: You can also drag a photo directly from the Project bin onto another image. This is really useful for projects like scrapbooking where you have many objects, each in its own file, to add to a page in Elements.

But what if, rather than moving a whole layer, you just want to move a particular object—say, a person—to another photo? Just follow these steps:

1. Open both photos in Full Edit.

You can pull off this maneuver by using a tabbed view, but most people find it easier to use floating windows when working with several images. To create floating windows, first go to Edit—Preferences—General/Adobe Photoshop Elements Editor—Preferences—General and make sure that "Allow Floating Documents in Full Edit Mode" is turned on. Next, head to the Arrange menu (page 109) and choose "Float All in Windows," and then go to Window—Images and choose Tile or Cascade. If you want to use tabs instead, go to the Arrange menu and choose a layout that gives you a view of all your images.

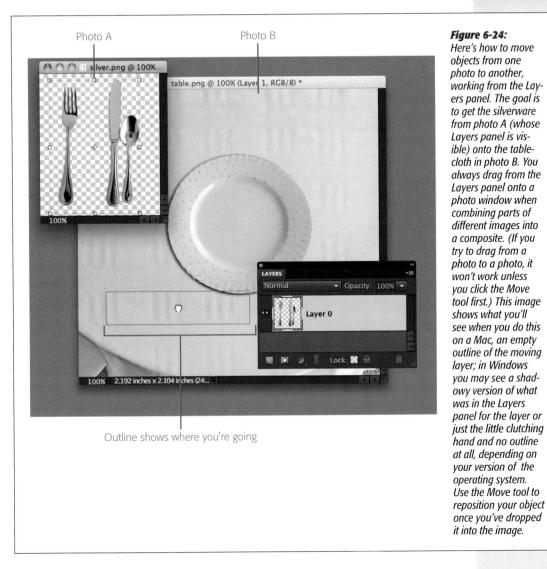

2. Prepare both photos for combining.

Go to Image \rightarrow Resize \rightarrow Image Size, and then make sure both photos have the same Resolution (ppi) setting before you start (see page 114 if you need a refresher on resizing and resolution). Why? If one photo is way bigger than the other, then the moved object could easily blanket the entire target image.

You don't absolutely have to do this size balancing, but it'll make your life a lot easier, since it helps avoid having an enormous or tiny pasted object. (Keep reading for more advice about resolution when moving objects and layers.)

3. Select what you want to move.

Use the selection tools of your choice (see Chapter 5 if you need help making selections). Add a 1- or 2-pixel feather to your selection to avoid a hard, cut-out-looking edge.

4. Move the object.

There are several ways to move what you selected to the other image:

- Copy and paste. Press Ctrl+C/\u00e3-C to copy the object from the first photo. Next, click the second photo to make it active, and then press Ctrl+V/\u00e3-V to paste what you copied.
- Use the Move tool. Activate the Move tool, and then drag your selection from one photo to the other. As you're moving, you may see a hole in the original where the selection was, but as long as you don't let go till you get over the second photo, this fills back in after you let go. (If seeing this bothers you, just Alt-drag/Option-drag to move a *copy* of the selection instead.)
- **Drag the layer**. If the object you want to move is already on its own layer, surrounded by transparency, then you can just drag the layer from the first photo's Layers panel into the destination photo's main image window or tab.

It doesn't matter which method you use—Elements puts whatever you moved on its own layer in the combined image.

5. If necessary, use the Move tool to position or scale the transported object, as shown in Figure 6-25.

See page 180 for more about using the Move tool.

6. Save your work.

If you may want to make further adjustments to the object you moved, then save your image as a TIFF or Photoshop (.psd) file to keep the layers. (Remember that if you save your file as a JPEG, then you lose the layers and you can't easily change or move the new object anymore.)

Here are a few things to keep in mind when copying from one image to another:

• Watch out for conflicting resolution settings (see page 119). The destination image (that is, the one receiving the moved layer or object) controls the resolution. So if you bring in a layer that's set to 300 pixels per inch (ppi) and place it on an image that's set to 72 ppi, then Elements sets the object you're moving to 72 ppi; its overall apparent size will increase proportionately as the pixels get spread out more.

Tip: It's tricky to work with multiple images in tabs. Instead, try creating floating windows (Arrange menu—"Float All in Windows"), and then go to Window—Images and choose Tile or Cascade. Cascade gives you the most flexibility for positioning your photos. (You'll need to turn on floating windows in the Editor's preferences before you can do this; see page 109.)

Figure 6-25:

If you forget to balance out the relative sizes and resolutions of the photos you're combining, then you can wind up with a giant object in your photo, like these flowers. The solution is simple: Just Shift-drag a corner of the oversized item's resizing box (circled). (You may need to drag the new object around a bit in order to expose a corner.) Don't forget that you can use all the Move tool's features on your new object.

- Lighting matters. Objects that are lit differently stand out if you try to combine them. If possible, plan ahead and use similar lighting for photos you're thinking about combining.
- Center your moved layer. If you're dragging a layer and want Elements to center it in the new image, then Shift-drag the layer.
- Feather with care. A little feathering goes a long way toward creating a realistic combined image.

Tip: If you'd like more practice using layers and moving objects between photos, visit this book's Missing CD page at *www.missingmanuals.com* and download the table tutorial, which walks you through most of the basic layer functions.

Figure 7-1:

In photography terms, each Multiply layer you add is roughly equivalent to stopping your camera down one f-stop, at least as far as the dark areas are concerned.

Top: This photo is totally overexposed, and it looks like there's no detail there at all.

Bottom: Multiply layers darken things enough to bring back a lot of the washed-out areas and bring out quite a bit of detail. But as you can see here, even Elements can't do much in areas where there's no detail at all, like the sky and the white framing around the windows.

3. Adjust the opacity of the layer if needed.

If the effect of the new layer is too strong, in the Layers panel, move the Opacity slider to the left to reduce the new layer's opacity.

4. If you decide that part of your image was actually better exposed before you added the new layer, mask out the areas where the exposure was okay.

Apply a mask to the duplicate layer, and then paint out the areas where the original image was properly exposed, so that the background layer shows through (page 213 explains how). Remember that you can also paint with shades of gray to control how much of the original shows through. That can be very helpful in getting the most realistic results from this technique.

5. Repeat as necessary.

You may have to use as many as five or six layers if your photo is in really bad shape. If you need extra layers, you'll probably want them at 100 percent opacity, so you can just keep pressing Ctrl+J/ૠ-J to duplicate the current top layer, including the layer mask (if you applied one). You're more likely to need several layers to fix overexposure than underexposure. And, of course, there are limits to what even Elements can do for a blindingly overexposed image. Overexposure is usually tougher to fix than underexposure, especially if the area is blown out, as explained in the box on page 228.

IN THE FIELD

Avoiding Blowouts

An area of a photo is *blown out* when it's so overexposed that it appears plain white—in other words, your camera didn't record any data at all for that area. (Elements isn't great with total black, either, but that doesn't happen quite as often. Most underexposed photos have some tonal gradations in them, even if you can't see them very well.)

A blowout is as disastrous in photography as it is when you're driving. Even Elements can't fix blowouts, because there's no data for it to work with. So, you're stuck with the fixes discussed in this chapter, which are never as good as a properly exposed original.

When you're taking pictures and choosing camera settings, remember that it's generally easier to correct underexposure

than overexposure. So if you live where there's really bright sunlight most of the time, you may want to make a habit of backing your exposure compensation down a hair. Depending on your camera, your subject, and the average ambient glare, you should try starting by setting the exposure compensation at -.3 and adjusting from there.

You can also try *bracketing* your shots—taking multiple photos of exactly the same subject with different exposure settings. Then you can combine the two exposures for maximum effect using Elements' Exposure Merge feature (page 290).

The Shadows/Highlights Command

The Shadows/Highlights command is one of Elements' best features. It's an incredibly powerful tool for adjusting only the dark or light areas of your photo without messing up the rest of it. Figure 7-2 shows what a great help it can be.

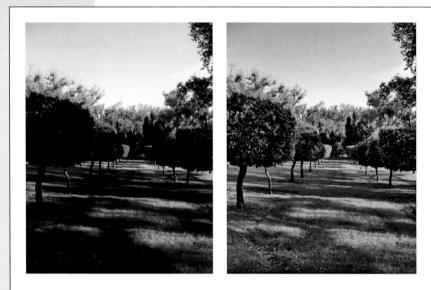

Figure 7-2:

The Shadows/Highlights command can bring back details in photos where you were sure there was no information at all—but sometimes at a cost.

Left: The sky and the grass aren't bad, but you'd never know there were oranges on these trees.

Right: A dose of Shadows/Highlights unearths plenty of details, although the overall effect is a bit flat when you push the tool this far. This photo needs lots more work, but at least now you can see what kind of trees they are.

The Shadows/Highlights command in Full Edit works pretty much the same way it does in Quick Fix (page 139). The single flaw in this great tool is that you can't apply it as an Adjustment layer (page 216), so you may want to apply Shadows/Highlights to a duplicate layer. Then, later on, you can discard the changes if you want to take another whack at adjusting the photo. In any case, it's easy to make amazing changes to your photos with Shadows/Highlights. Here's how:

1. Open your photo and duplicate the layer (Ctrl+J/#-J) if you want to.

If you haven't edited your photo before, this is usually the Background layer, but you can use this command on any layer. Duplicating the layer makes it easier to undo Shadows/Highlights later if you change your mind.

2. Go to Enhance→Adjust Lighting→Shadows/Highlights.

Elements opens the Shadows/Highlights dialog box and makes your photo about 30 shades lighter. Don't panic. As soon as you select this command, the Lighten Shadows setting automatically jumps to 25 percent, which is way too much for most photos. Just shove the slider back to 0 to undo this change before you start making your corrections. 3. Move the sliders in the Shadows/Highlights dialog box around until you like what you see.

The sliders do exactly what they say: Lighten Shadows makes the dark areas of your photo lighter, and Darken Highlights makes the light areas darker. (Mid-tone Contrast is discussed in a moment.) Dragging the sliders to the right increases their effect.

4. Click OK when you're happy.

Tip: If you're applying Shadows/Highlights on a duplicate layer, you can use a layer mask (page 211) to restrict your changes to only certain areas of your image.

The Shadows/Highlights dialog box is a cinch to use, because you just make decisions based on what you're seeing. When you're using it, keep these tips in mind:

- You may want to add a smidgen of the opposite tool to balance things out a little. In other words, if you're lightening shadows, you may get better results by giving the Darken Highlights slider a teeny nudge, too.
- Midtone Contrast is there because your photo may look kind of flat after you're done with Shadows/Highlights, especially if you've made big adjustments. Move the Midtone Contrast slider to the right to increase the photo's contrast. It usually adds a bit of a darkening effect, so you may need to go back to one of the other sliders to tweak your photo after you use it.
- You can overdo the Shadows/Highlights tool. When you see halos around the objects in your photo, you've pushed the settings too far.

Tip: If the Shadows/Highlights tool washes out your photo's colors—making everyone look like they've been through the laundry too many times—adjust the color intensity with one of the Saturation commands, either in Quick Fix or Full Edit (as described on page 331). Watch people's skin tones when increasing the saturation—if the subjects in your photo start looking like sunless-tanning-lotion disaster victims, you've gone too far. Also check out the Vibrance slider in the Raw Converter (page 281), or try adjusting colors with Elements' Color Curves feature (page 327).

Correcting Part of an Image

Shadows/Highlights is great if you want to adjust *all* the light or dark areas of a photo, but what if you want to tweak the exposure only in certain areas? Or what if you like the photo's background just fine, but you want to tweak the subject a little? You can use a layer mask on a duplicate layer and make adjustments there, or make a selection in your photo (see Chapter 5 for more about selecting), copy the selected area to a new layer, and then make adjustments to that layer. But Elements gives you a super simple way to apply a correction to just the area you want: the Smart Brush tools.

Correcting color with a brush

The Smart Brush is actually two different tools (the Smart Brush and the Detail Smart Brush) that work just like the Quick Selection tool and the regular Selection brush, respectively. Only instead of merely selecting part of your photo, they also edit it as you brush. So you may be able to make targeted adjustments to different areas of your photo just by drawing a line over them. (The Smart Brushes don't always work, but they're truly amazing when they do.)

In this section you'll learn how to use the Smart Brush to correct exposure, but you have a whole menu of different things you can do with the Smart Brush: Change the color of someone's jacket, apply different special effects, put a little lipstick on people, convert an area to black and white—the list goes on and on. As a matter of fact, if you've been using Quick Fix, you may well have met the Smart Brush already, although it doesn't go by that name there: The Touch Up tools in Quick Fix all use the Smart Brush to apply their effects.

Here's how to put this nifty pair of tools to work:

1. Open a photo in Full Edit, and then activate the Smart Brush.

Click its icon in the Tools panel (it's the brush with the gear next to it) or press F. Use the pop-out menu to be sure you have the regular Smart Brush. It shares its Tools panel slot with the Detail Smart Brush, which works like the Selection brush in that it changes only the area directly under the brush instead of automatically expanding your selection to include the whole object you brush over. For now, see if the regular Smart Brush is smart enough to select the area you want.

2. Choose the correction you want to apply.

Go to the Options bar, and then choose from the rightmost drop-down menu. (Both Smart Brushes have the same Options bar settings, discussed below. The important one is explained in Figure 7-3.) Adobe calls these choices Smart Paint.

Figure 7-3:

Your Smart Paint options (the things you can do with the Smart Brush) are grouped into the categories listed in this drop-down menu. Each thumbnail image shows that option applied to a photo.

For exposure issues, start by looking at the choices in the Lighting section (choose Lighting from the drop-down menu at the top of the list). You can choose to make the area darker, brighter, make the contrast low or high, or even put a spotlight effect on it. Just scroll through the list to find the effect you want, click it, and then click somewhere outside your photo to hide the menu. You can also drag the menu loose from the Options bar and put it where you want, if you'd like to keep it available and out of the way of your photo.

3. Drag over the area you want to change.

This step is just like using the Quick Selection tool (page 154). You don't need to make a careful selection, since Elements calculates the area it thinks you want to include and creates the selection for you. A simple line should do it.

4. Tweak the selection, if necessary.

If Elements didn't quite select everything you want, then add to the selection by brushing again. If you still need to modify the selection, then use the selection editing tools explained in Figure 7-4. If you're really unhappy with the Smart Brush's selection talents, then head back to the Tools panel and try the Detail Smart Brush instead.

Figure 7-4:

Once you've used the Smart Brush, a little icon called a pin (circled, bottom) appears in your photo to let you know that the selected region is now under the power of the Smart Brush. Click the pin and you see a trio of icons (circled, top) that let you edit the selected area. From left to right, the icons mean New Selection, "Add to Selection," and "Remove from Selection."

If you're pressed for time, there's an even quicker way to modify your selection: Just drag again to add to the area affected by the Smart Brush (or to use the same adjustment on another part of your photo), or Alt-drag to remove changes from an area.

You'll see the pin anytime the Smart Brush is activated again, even after you've closed and saved your photo.

You can invert a selection by turning on the Options bar's Inverse checkbox. Then what you select with the brush is *excluded* from your selection, and everything else is included. You can turn on the checkbox before or after using the Smart Brush, as long as it's still the active tool. If you come back to the Smart Brush after using another tool, then you need to reactivate your Smart Brush selection by clicking the pin shown in Figure 7-4 before you can invert the selection, thus inverting the area covered by the effect.

Fixing Exposure Problems

5. Once you like the selection, adjust the effect (if you want).

The Smart Brush gives you several ways to change what it's done:

- Change what happens to the selected area. While the selection is active, just head to the Options bar and choose a different Smart Paint adjustment. Elements automatically updates your image.
- Add a different kind of Smart Paint. At the left end of the Options bar, click the tiny triangle and choose Reset Tool. Then the Smart Brush puts down an *additional* adjustment when you use it, instead of just changing what you've already done. You can also use this to double-up an effect—to add Lipstick twice, for instance, if you thought the first pass was too faint. Each Smart Brush adjustment gets its own pin, so if you have two Smart Brush adjustments in your photo, then you'll have two pins in it, too. (Each pin is a different color.)
- Change the settings for Smart Paint you've already applied. Rather than adding another Smart Paint layer to increase the effect, you can adjust the settings for the changes you've already made. Right-click (or Control-click with a one-button mouse) the pin in your image, and then choose Change Adjustment Settings. The Layers panel changes to show the settings so you can adjust the effect you're brushing on. The Smart Brush uses Adjustment layers to make its changes, so the available settings are the same as they would be if you created a regular Adjustment layer. For example, if you're using the Brighter option, as shown in Figure 7-3, then you get the settings for a Brightness/Contrast Adjustment layer.

Note: If you're using certain of the black-and-white adjustments, you may not be able to edit them afterwards, just as when you use the Black and White tool in Quick Fix (see page 144).

6. When you're happy with what you have, you're done.

You can always go back to your Smart Paint changes again. Just activate the Smart Brush (click it in the Tools panel or press F) and the pin(s) appear again to let you easily change what you've done. You can eliminate Smart Brush changes by right-clicking (Control-clicking with a one-button mouse) the adjusted area and then choosing Delete Adjustment (the Smart Brush needs to be active), or by going to the Layers panel and discarding their layers (you can do this anytime, whether the Smart Brush is active or not). You can also edit a Smart Brush adjustment's layer mask the way you'd edit any other layer mask, as described on page 213. But usually it's easier just to click the pin and then adjust your selection.

The Smart Brush is especially handy for projects like creating images that are part color and part black-and-white, or even for silly special effects like making one object from your photo look like it's been isolated on a '60s-style psychedelic background.

Tip: Check out the new textures available for the Smart Brushes in Elements 10. They're very handy for creating backgrounds for isolated subjects. You'll find them in their own category in the Options bar's presets drop-down menu.

The Smart Brush has several Options bar settings, but you usually don't need to use them:

- New selection. Click the left brush icon to add the same effect elsewhere in your photo. (Just clicking someplace else with the brush does the same thing. Be careful, though: The brush may think that the new area is a continuation of your previous selection, so it may combine the two. If that happens, try using a smaller brush.)
- Add to selection. Click this next brush icon to put the Smart Brush in add-toselection mode (the brush enters this mode automatically even if you don't click this icon).
- Subtract from selection. Did the Smart Brush take in more area than you wanted? Click this final brush icon before brushing away what you don't want, or just Alt-drag/Option-drag.
- **Brush Picker**. You can change the brush's size, hardness, spacing, angle, or roundness here.
- **Inverse**. If you want to apply the correction to the area you *didn't* select with the Smart Brush, then turn on this checkbox.
- **Refine Edge**. Use this if you want to make the edges of your effect sleeker. See page 159 for details.
- Smart Paint. Click this thumbnail image for a pop-out menu of all the possible Smart Brush adjustments, grouped into categories. (If you hover your cursor over the thumbnail, the tooltip that appears says "Choose A Preset," but Adobe calls these settings Smart Paint in the Help files and elsewhere.)

If you like the idea of the Smart Brush but never seem to find exactly the adjustments you want, or if you always want to change the settings you apply, then you can create your own Smart Paint options, as described in the box on page 237.

Controlling the Colors You See

You want your photos to look as good as possible and to have beautiful, breathtaking color, right? That's probably why you bought Elements. But now that you've got the program, you're having a little trouble getting things to look the way you want. Does the following sound familiar?

- Your photos look great onscreen, but your prints are washed out, too dark, or the colors are all a little wrong.
- Your photos look fine in programs like Word or Windows Explorer, but they look awful in Elements.

POWER USERS' CLINIC

Making Smart Paint

While the Smart Brush offers a lot of different Smart Paint choices, you may find it slightly frustrating that Elements doesn't have a setting for the particular corrections you use most frequently. No problem—as long as you can use Adjustment layers (page 216) to achieve the effect you want, you can create your own Smart Paint presets, and they'll appear in the menus right along with the ones from Adobe.

To get started in Windows 7 or Vista, go to C:\Program-Data\Adobe\Photoshop Elements10.0\Photo Creations\ adjustment lavers. (In XP, it's C:\Documents and Settinas) All Users \Application Data \Adobe \Photoshop Elements \10.0 \ Photo Creations\adjustment lavers.) These files are hidden. so you need to turn on hidden files to see them (the Tip on page 604 tells you how). On a Mac, go to [your hard drive]→Library→Application Support→ Adobe→Photoshop Elements→10.0→Photo Creations→ adjustment lavers. (If you use OS X 10.7 [Lion], see page 11.) For the App Store version, go to Applications, right-click/ Control-click Adobe Photoshop Elements 10 Editor, and then choose Show Package Contents-Contents-Application Data→Photoshop Elements→10.0→Photo Creations→ adjustment layers. No matter what your operating system, you see three files for each Smart Paint preset:

- A PSD file containing the preset's actual settings.
- A thumbnail file, which you need if you want to have a little preview in the menu.
- An XML file that tells Elements where in the menus to display the preset, like whether to show it in "Black and White" or in Lighting, for instance. These files all have the word "metadata" in their names.

Basically, you need to edit *copies* of these files to make new ones for each preset you want to add. Here's how:

- Open one of the PSD files in the Editor. Pick the one that's the closest to what you want. Notice that the file is a 160-pixel square PSD file with an Adjustment layer on it. Save the file with a new name so you don't mess up the original.
- Change the settings. In the Layers panel, click once on the Adjustment layer to select it, and then—in the Adjustments panel—tweak the settings. Then save the file.

- Create a new thumbnail. You can just save the original thumbnail with a new name. (Thumbnails are 74-pixel square JPEGs, in case you want to make a new one from scratch.)
- 4. Create a new XML file. Open the XML file and do a Save As, changing the name to that of the new Smart Paint choice you just created. (In Windows, you can open XML files with Windows' Notepad text editor. In the "Save As" dialog box, choose All Files in the "Save as type" menu. On a Mac, use TextEdit, but be sure you save as plain text (.txt). Then look through the contents of the file for a line like this:

<name value="\$\$\$/content/adjustmentlayers/
ContrastHigh=Contrast High" />

In this example, you'd be adapting the Contrast High preset, so you just find the two instances of the name (note that there's no space in the first one), and then change them to the name of your new preset. You can also edit the preset's tooltip (the text that appears when you point to its thumbnail) and the category (you can use an existing category or create a new one).

When you're finished making changes, save the file. Name it [my effect].metadata (replace "my effect" with the actual name you gave your new preset). Make sure all three files are in the Adjustment Layers folder. Next, in Windows 7/ Vista, go to C:\ProgramData\Adobe\Photoshop Elements\ 10.0\Locale\en US (this path is different if you aren't in the United States), and delete MediaDatabase.db3 to refresh the list of presets. In XP, it's in C:\Documents and Settings\All Users\ Application Data\Adobe\Photoshop Elements\10.0\ Locale\ en_us (or your location). In Mac OS X, it's [your hard drive]-Library-ApplicationSupport-Adobe-Photoshop Elements→10.0→Locale→en_US (or your location). If you use OS X 10.7 (Lion), see page 11. For the App Store version, go to Applications, right-click/Control-click Adobe Photoshop Elements 10 Editor, and choose Show Package Contents→ Contents→Application Data→Photoshop Elements→10.0→ Locale→en_US (or your location). (Note that deleting this file will also delete all items in your Favorites panel [page 524].) The next time you start Elements, you should see your new Smart Paint there along with the ones that came with Elements. What's going on? The answer has to do with the fact that Elements is a *color-managed* program. That means Elements uses information about your monitor when deciding how to display images. Color management is the science of making sure that the color in your images is always exactly the same, no matter who opens your file or what kind of hardware they're viewing it on or printing it with. If you think of all the different monitor and printer models out there, you get an idea of what a big job this is.

Graphics pros spend their whole lives grappling with color management, and you can find plenty of books about the finer points of it. At its most sophisticated, color management is complicated enough to make you curl up in the fetal position and swear never to create another picture. Luckily, Elements makes color management easy. Most of the time, you have only two things to deal with: your monitor calibration and your color space. The following pages cover both.

Note: There are a couple of other color-related settings for printing, too, but you can deal with those when you're ready to print. Chapter 16 explains them.

Calibrating Your Monitor

Most programs pay no attention to your monitor's color settings, but color-managed applications like Elements rely on the *profile*—the information your computer stores about your monitor's settings—when it decides how to print or display a photo onscreen. If that profile isn't accurate, the color in Elements won't be either.

So, you may need to *calibrate* your monitor, which is a way of adjusting its settings. A properly calibrated monitor makes all the difference in the world in getting great-looking results. If your photos look bad only in Elements or if your printed pictures don't look anything like they do onscreen, calibrating is a good way to start fixing the problem.

Getting started with calibrating

Calibrating a monitor sounds intimidating, but it's actually not that difficult—some people think it's even kind of fun. And it's worth it, because afterward your monitor may look about a thousand times better than you thought it could. Calibrating may even make it easier to read text in Word, for instance, because the contrast is better. Your calibrating options, from best to only okay, are:

• Use a colorimeter. This method may sound disturbingly scientific, but it's actually the easiest. A *colorimeter* is just a device with special software that does the calibration for you. Using such a device is much more accurate than calibrating by eye. For a long time, only pros could afford colorimeters, but these days if you shop around, you can find the Pantone Huey or the Spyder2Express for about \$70 or less. More professional calibrators like the i1 Display Pro or the ColorMunki Display aren't that much more expensive. If you're serious about controlling your colors in Elements, this is by far your best option.

Note: Your calibration software probably asks you to set the brightness and contrast before you begin, even though most LCD monitors don't have adjustable dials for these settings. If you're happy with your monitor's current brightness and contrast, you can safely ignore this step. Unless you have a reason to use different settings, for an LCD monitor, you usually want to set the white point to 6500 (Kelvin) and your gamma to 2.2.

- **Software**. Whether you have a Windows computer or a Mac, you likely have some kind of software that can help you improve what you see.
 - Windows: There's a good chance that the drivers (software) for your graphics card include some kind of calibration tool. Go to Control Panel→Appearance and Personalization→Display→Calibrate Color to use the Windows calibrator (in Windows XP: Display→Properties→Settings→ Advanced) to see what you have.
 - Mac: If you go to System Preferences→Displays→Color→Calibrate, you can use Apple's Display Calibrator Assistant to calibrate your monitor—sort of (see Figure 7-5). You can also find lots of calibration programs online, but most of them aren't much, if any, better than the Assistant.
- Adobe Gamma. If you have an older Windows version of Elements (Elements 5 or earlier), you may have this program, which used to come with Elements. It's pretty ancient, was never meant to work with anything but old CRT monitors (the big, fat ones like old-fashioned televisions), and doesn't work in Windows 7 or Vista. If you happen to have Adobe Gamma, it's better than nothing, but it's probably less useful than any other program you might have for adjusting your display.

If your photos still look a little odd even after you've calibrated your monitor, you may need to turn on the Ignore EXIF setting in the Editor's preferences; see Figure 7-6.

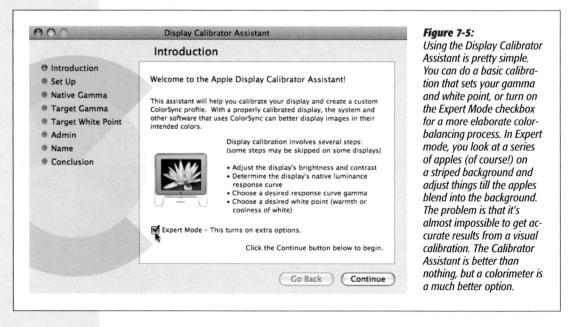

Fiaure 7-6:

If all the images from your diaital camera have a color cast (usually red or vellow), ao to Edit→Preferences→ Savina Files/ Adobe Photoshop Elements Editor→ Preferences→Savina Files, and turn on "Ianore Camera Data (EXIF) profiles." Some cameras embed nonstandard color information in their files, so this setting tells Elements to pay no attention to it. which should make vour photos display and print properly.

Choosing a Color Space

The other thing you may need to do to get good color from Elements is to check which *color space* the program is using. Color spaces are standards that Elements uses to define your colors. That may sound pretty abstruse, but they're simply ways of defining what colors mean. For example, when someone says "green," what do you envision: a lush emerald color, a deep forest green, a bright lime, or something else?

Choosing a color space helps make sure that everything that handles a digital file— Elements, your monitor, your printer, and so on—sees colors the same way. Over the years, the graphics industry has agreed on standards so that everyone has the same understanding of what you mean when you say "red" or "green"—as long as you specify which color space (set of standards) you're using.

Elements gives you only two color spaces to pick from: *sRGB* (also called *sRGB IEC61966-2.1* if you want to impress your geek friends) and *Adobe RGB*. When you choose one, you're telling Elements which set of standards you want it to apply to your photos.

If you're happy with the colors you see on your monitor in Elements and you like the prints you're getting, you don't need to make any changes. If, on the other hand, you aren't satisfied with what Elements is showing you, you'll probably want to modify your color space, which you can do in the Color Settings dialog box (Figure 7-7). Go to Edit→Color Settings or press Shift+Ctrl+K/Shift-æ-K. Here are your choices:

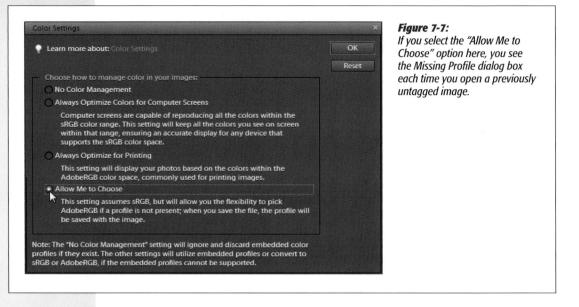

- No Color Management. Elements ignores any information that your file already contains, like color space data from your camera, and doesn't attempt to add any color info to the file. (When you do a Save As, there's a checkbox that offers you the option of embedding your monitor profile. Don't turn on this checkbox, since your monitor profile is best left for the monitor's own use, and putting the profile into your file can make trouble if you ever send it someplace else for printing.)
- Always Optimize Colors for Computer Screens. This option selects the sRGB color space, which is what most web browsers use; this is a good choice when you're preparing graphics for the Web. Many online printing services also prefer sRGB files. (If you've used an early version of Elements, this is the same as the old Limited Color Management option.)
- Always Optimize for Printing. This option uses the Adobe RGB color space, which is wider than sRGB, meaning it allows more color gradations than sRGB. This is sometimes your best choice for printing—but not always. So despite the Color Settings dialog box's note about how this option is "commonly used for printing," don't be afraid to try one of the other settings instead. Many home inkjet printers actually cope better with sRGB or no color management than with Adobe RGB. (For Elements veterans, this setting used to be called Full Color Management.)

• Allow Me to Choose. This option assumes that you're using the sRGB color space, but lets you assign either an Adobe RGB tag, an sRGB tag, or no tag at all (color tags are explained in a moment). After you select this option, each time you open a file that isn't sRGB, you see the dialog box shown in Figure 7-7 which you can use to assign a different profile to a photo. Just save the image once without a profile (turn off the ICC [International Color Consortium] Profile checkbox in the Save As dialog box), and then reopen it and choose the profile you want from this dialog box. Or, the box on page 244 explains an easier way to convert a color profile if you need to make a change.

So what's your best option? Once again, if everything looks good, leave it alone. Otherwise, for general use, you're probably best off starting with No Color Management, then trying the others if that doesn't work.

If you choose one of the other three options, when you save your file, Elements attempts to embed the file with a *color tag*, info about the file's color space—either Adobe RGB or sRGB. (This kind of tag isn't related to the Organizer tags you read about in Chapter 2.) If you don't want a color tag—also known as an *ICC Profile*—in your file, just turn off the checkbox before you save the file. Figure 7-8 shows where to find the profile information in the Save As dialog box, and how to turn the whole process off.

	File name:	field_goalpsd			Save
	Format:	Photoshop (*.PSD;*	.PDD)	<u> </u>	Cancel
Save Options Organize:		he Elements Organizer	Save in Version Se	t with Origina	al
Save:	Layers		🕼 As a Copy		
Color:	ICC Profile:	sRGB IEC61966-2.1			
🕖 Thumbnai	1	🕼 Use Lower Cas	e Extension		
A File mu	ist be saved as a	copy with this selectio	n.		

Figure 7-8:

When vou save a file. Elements offers to embed a color taa in it. You can safely turn off the ICC Profile checkbox and leave the file untagaed. Assigning a profile is helpful because then any proaram that sees the file knows what color standards vou're workina with. But if you're new to Elements, you'll usually have an easier time if vou don't start embedding profiles in files without a good reason.)

Note: Elements automatically opens files tagged with a color space other than the one you're working in without letting you know what it's just done, so you won't know that there's a mismatch between the file's ICC profile and the color space you're using in Elements. (If, on the other hand, you try to open a file in a color *mode* that Elements can't handle, like CMYK, then Elements offers to convert it to a mode you can use.) So, if you have an Adobe RGB file and you're working in "Always Optimize Colors for Computer Screens," Elements doesn't warn you about the profile mismatch the way early versions of the program did—it just opens the file. If you consistently get strange color shifts when you open your Elements-edited files in other programs, check to be sure there isn't a profile mismatch between your images and Elements.

POWER USERS' CLINIC

Converting Profiles in Elements

If you're a color-management maven, Elements gives you a feature you'll really appreciate—the ability to easily convert an image's ICC profile from one color space to another. If you've been working in, say, sRGB and now you want your photo to have the Adobe RGB profile, you can convert it by going to Image→Convert Color Profile and choosing "Convert to Adobe RGB Profile" from the pop-out menu. You can choose to remove the current profile or convert to sRGB or Adobe RGB; your current color profile choice is grayed out.

This is a true conversion: It correctly maps out the colors of your image for the new profile, so they don't shift the way they might if you were just to tag a photo with a different profile. Why would you want to do such a conversion? If, for example, you use Adobe RGB when editing your photos, but you're sending your pictures to an online printing service that wants sRGB instead, then you may want to think about converting.

Using Levels

People who've used Elements for a while will tell you that the Levels command is one of the program's most essential tools. You can fix an amazing array of problems simply by adjusting the level of each *color channel*. (On your monitor, each color you see is composed of three channels: red, green, and blue. In Elements, you can make very precise adjustments to your images by adjusting these channels separately.)

Just as its name suggests, Levels adjusts the amount, or level, of each color in an image. You can make several different adjustments with Levels, from generally brightening your colors to fixing a color cast (page 251 has more about color casts). Many digital photo enthusiasts treat almost every picture they take to a dose of Levels because there's no better way to polish up the color in a photo.

The way Levels works is fairly complex. Start by thinking of the possible ranges of brightness in any photo on a scale from 0 (black) to 255 (white). Some photos may have pixels in them that fall at both those extremes, but most photos don't. Even the ones that do may not have the full range of brightness in each individual color channel. Most of the time, you'll find some empty space at one or both ends of the scale.

When you use Levels, you tell Elements to consider the range of colors available in *your* photo as the *total* tonal range it has to work with, and Elements redistributes your colors accordingly. Basically, you just get rid of the empty space at the ends of the scale of possibilities. This can dramatically change the color distribution in your photo, as you can see in Figure 7-9.

Fortunately, it's much, much easier to *use* Levels than to understand it, as you know if you've tried Auto Levels in Quick Fix (page 138). That command is great for, well, quick fixes. But if you really need to massage your image, Levels has a lot more under the hood than you can access in Quick Fix. The next section shows you how to get at these settings.

Using Levels

Figure 7-9:

A simple Levels adjustment can make a huge difference in the way your photos look.

Left: The gray-green cast to this photo makes everything look dull.

Right: Levels not only gets rid of the color cast, but also helps give the photo better contrast and sharpness.

Understanding the Histogram

Before you get started adjusting Levels, you need to understand the heart, soul, and brain of the Levels dialog box: the Histogram, shown in Figure 7-10. (You can call up this dialog box by pressing Ctrl+L/#-L.)

evels		and the second	
Learn more	about: Levels		ОК
			Reset
Channel: RGI	B -		<u>R</u> eset
Input Levels:			
			<u>A</u> uto
		E STATICEST	
			2 2
	L		Preview
Plastic strates and			<i>¶ ¶</i> <u>▼</u> Preview
•	A		₽ Preview
		255	Preview
•	A	255	<i>P</i> Preview
0	A	255	P P ■ <u>P</u> review

Figure 7-10:

One of the scariest sights in Elements, the Levels dialog box is actually your friend. If it frightens you, take comfort in knowing that you can always click the Auto button here, which is the same Auto Levels command as in Quick Fix. But it's worth persevering: The other options here give you much better control over the end results. The Histogram is the black bumpy mound in the middle of the dialog box. It's really nothing more than a bar graph indicating the distribution of the colors in your photo—there's just no space between the bars, which is why it looks like mountains.

From left to right, the Histogram shows the brightness range from dark to light (the 0 to 255 mentioned earlier in this section). The height of the "mountain" at any given point shows how many pixels in your photo have that particular brightness. You can tell a lot about your photo by where the mound is before you adjust it, as explained in Figure 7-11.

Above the Histogram is a Channel menu that says "RGB." If you click it, you can choose to see a separate Histogram for each individual color. You can adjust all three channels at once with the RGB setting, or change each channel separately for maximum control.

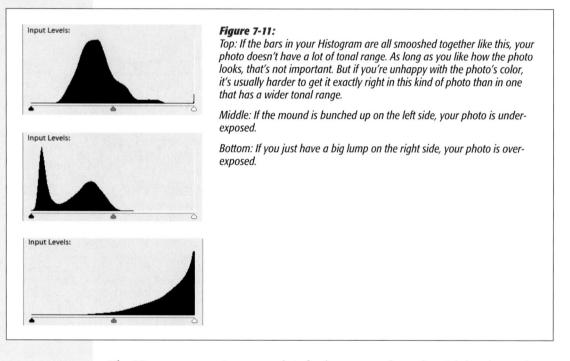

The Histogram contains so much info about your photo that Adobe also makes it available in the Full Editor in its own panel (Figure 7-12), so you can always see it and use it to monitor how you're changing the colors in an image. Once you get fluent in reading Histogramese, you'll probably want to keep this panel around.

The Histogram is just a graph, and you don't do anything to it directly. When you use Levels, you use the Histogram as a guide so that you can tell Elements what to consider the black and white points—that is, the darkest and lightest points—in your photo. (Remember, you're thinking in terms of brightness values, not shades of color, for these settings.)

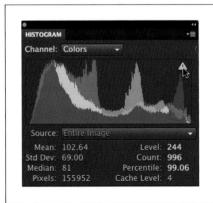

Figure 7-12:

If you keep the Histogram on your desktop, you can always see what effect your changes are having on the photo's color distribution. To get this nifty Technicolor view, go to Window \rightarrow Histogram and then choose Colors from the panel's drop-down menu. To update the Histogram, click the triangle in its upper right as shown here.

If you're really into statistics, there are a bunch of them at the bottom of this panel, but if you're not a pro, you can safely ignore these numbers.

Once you've set these end points (you'll learn how in a moment), you can adjust the *midtones*—the tones in between that would appear gray in a black-and-white photo. If that seems complicated, it's not—at least, not when you're actually doing it. Once you've made a Levels adjustment, the next time you open the Levels dialog box, you'll see that your Histogram now runs the whole length of the scale because you've told Elements to redistribute your colors so that they cover the full dark-tolight range.

The next two sections show you—finally!—how to actually adjust your image's Levels.

Tip: Once you learn how to interpret the histograms in Elements, you can try your hand with your camera's histogram (if it has one). It's really hard to judge how well your picture turned out when all you have to go by is your camera's tiny LCD screen, so your camera's histogram can be a big help in figuring out how well exposed your shot was.

Adjusting Levels: The Eyedropper Method

One way to adjust Levels is to set the image's black, white, and/or gray points by using the eyedroppers in the Levels Adjustments panel. It's quite simple—just follow these steps:

1. Bring up the Levels Adjustments panel by selecting Layer→New Adjustment Layer→Levels.

If you like, you can name the layer in the New Layer dialog box that appears, or just click OK to get on with it and create your layer. If you don't want a separate layer for your Levels adjustment, go to Enhance \rightarrow Adjust Lighting \rightarrow Levels or press Ctrl+L/#-L instead. (You'll get a dialog box instead of the panel, but it works exactly the same way.) But making the Levels changes on an Adjustment layer gives you more flexibility for making future changes.

2. If necessary, move the Adjustments panel or the Levels dialog box out of the way so you have a good view of your photo.

The dialog box loves to plunk itself down smack in the middle of the most important part of your image. Just grab it by the top bar and drag it somewhere else.

3. In the Adjustments panel or Levels dialog box, click the black eyedropper.

In the Adjustments panel, from top to bottom, the eyedroppers are black, gray, and white. In the dialog box they're arranged from left to right instead.

4. Move your cursor over your photo and click an area that should be black.

Should be, not *is*. That's a mistake lots of people make the first time they use the Levels eyedroppers: They click a spot that's the same color as the eyedropper rather than one that *ought to be* that color. For instance, if your photo includes a wood carving that looks black but you know it *should* be dark brown, that's a bad place to click. Try clicking a black coffee mug or belt, instead. This is called "setting a black point."

5. Repeat with the other eyedroppers for their respective colors.

Now find a spot that should be white (like maybe a cloud that's a little off-white now) and one that should be gray to set your white and gray points. That's the way it's supposed to work, but you can't always use all the eyedroppers in a given photo. Experiment to see what gives you the best-looking results.

Tip: You don't always need to set a gray point. If you try to set it and think your photo looked better without it, just skip that step.

6. If you're using the dialog box, when you're happy with what you see, click OK.

If you're working with the Adjustments panel, you don't have to do anything: Elements has already applied your changes, so you're done.

See, it's not so hard. If you mess up, just click the dialog box's Reset button to start over again. (In the Adjustments panel, click the square made of four horizontal lines at the panel's upper right, and then choose Reset Levels from the drop-down menu.)

Adjusting Levels: The Slider Controls

The eyedropper method works fine if your photo has spots that should be black, white, or gray, but sometimes your pictures won't have any of these colors. Fortunately, the Levels sliders give you yet another way to apply Levels, and it's by far the most popular method, giving you maximum control over your colors.

Right below the Histogram are three little triangles called *Input sliders*. The left slider sets the black point in your photo, the right slider sets the white point, and the middle slider adjusts the midtones (gray). You just drag them to make changes to the color levels in your photo, as shown in Figure 7-13.

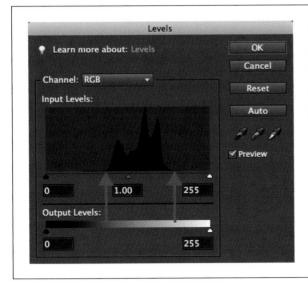

Figure 7-13:

To use the Levels Input sliders, simply drag the left and right sliders from the ends of the track until they're under the outer edges of the color data in the graph. The red arrows in this figure show where you'd position the left and right sliders for this particular photo. If there's empty space on the end of the graph, just move the slider until it's under the first mound of data.

When you move the left Input slider, you tell Levels, "Take all the pixels from this point down and consider them black." With the right slider, you're saying, "Make this pixel and all higher values white." The middle slider adjusts the brightness values that are considered medium gray. All three adjustments improve the contrast of your image.

Tip: If there are small amounts of color data (flat lines) at the ends of the Histogram, or if all the data is clumped in the middle of the graph—watch your photo as you move the left and right sliders to decide how far in you should bring them. Moving them all the way in may be too drastic. Your own taste should always be the deciding factor when you're adjusting a photo.

FREQUENTLY ASKED QUESTION

Levels Before Curves

I never know where to start adjusting the colors in my photos. Some photo mavens talk about using Levels, others about Curves. Which should I use?

Elements includes a much-requested feature from Photoshop—*Color Curves*. Despite the name, the Curves tool isn't some kind of arc-drawing tool; it's a sophisticated way of adjusting the colors in your photos. Curves works something like Levels, but with many more points of correction.

In Elements, you get a simplified version of Photoshop's Curves dialog box, with a few preset settings. Because this version doesn't have quite as many adjustment points, you get much of the advanced color control of Curves without all the complexity.

Generally speaking, a quick Levels adjustment is usually all you need to achieve good, realistic color. If you still aren't satisfied with the contrast in your image or you want to create funky artistic effects, check out page 327, which explains Color Curves in detail. The easiest way to use the Levels sliders is to:

1. Bring up the Levels dialog box or the Levels Adjustments panel.

Use one of the methods described in step 1 of the eyedropper method (page 247). If necessary, move the dialog box or Adjustments panel so you've got a clear view of your photo.

2. Grab the black Input slider.

That's the one below the left end of the Histogram.

3. Slide it to the right, if necessary.

Move it over until it's under the farthest left part of the Histogram that has a mound in it. If you glance back at Figure 7-13, you'd move the left slider just a tiny bit, to where the left red arrow is. (Incidentally, although you're adjusting your image's colors, the Levels Histogram is always black and white no matter what you do—you don't see any color in the dialog box itself.)

You may not need to move the slider at all if there's already a good bit of data at the left end of the Histogram. It's not mandatory to adjust all the sliders for every photo.

4. Grab the white slider (the one on the right side) and move it left if necessary.

Bring it under the farthest right area of the Histogram that has a mound in it.

5. Now adjust the gray slider.

This is the *midtones* slider, and it adjusts the midtones of your image. Move it back and forth while watching your photo until you like what you see. This slider has the most impact on the overall result, so take some time to play with it.

6. If you're using the dialog box, click OK.

You can adjust your whole image at once or each color channel individually. The most accurate way is to open the Levels dialog box and to choose each color channel separately from the Channel drop-down menu. Adjust the end points for each channel, and then choose RGB from the menu and tweak just the midtones (gray) slider.

Tip: If you know the numerical value of the pixels you want to designate for any of these settings, you can type that information into the unlabeled Input Levels boxes below the Histogram. You can set the gray value from .10 to 9.99 (it's set at 1.00 automatically), and the other two boxes anywhere from 0 to 255.

The last control you may want to use in the Levels dialog box or Levels Adjustments panel is the Output Levels slider, which works roughly the same way as the brightness and contrast controls on your TV. Moving this slider makes the darkest pixels darker and the lightest pixels lighter. Image pros call this "adjusting the tonal range of a photo."

Adjusting Levels can improve almost every photo you take, but if your image has a bad *color cast*—if it's too orange or too blue, say—you may need something else. The next section explains how to get rid of color like that.

Removing Unwanted Color

It's not uncommon for an otherwise good photo to have a *color cast*—that is, to have all its tonal values shifted so it's too blue, like Figure 7-14, or too orange.

Fiaure 7-14:

Left: You may wind up with photos like this every once in a while if you forget to change your camera's white balancea special setting for the type of lighting conditions you're shooting in (common settings are daylight, fluorescent, and so on). This is an outdoor photo taken with the camera set for tungsten indoor lighting.

Right: Elements fixes that wicked color cast in a jiffy. The photo still needs other adjustments, but the color is back in the right ballpark.

Elements gives you several ways to correct color-cast problems:

- Auto Color Correction doesn't give you any control over the changes, but it often does a good job. To use it, go to Enhance→Auto Color Correction or press Shift+Ctrl+B/Shift-æ-B.
- **The Raw Converter** (page 270) may be the easiest way to fix problems, though it works only on Raw, JPEG, and TIFF files. Just run your photo through the Raw Converter and adjust its white balance there.
- Levels gives you the finest control of all. You can often eliminate a color cast by adjusting the individual color channels (as explained in the previous section) till the extra color is gone. The drawbacks are that Levels can be very fiddly for this sort of work; sometimes this method doesn't work if the problem is severe; and it can take much longer than the other methods.
- **Remove Color Cast** is a command designed specially for correcting a color cast with one click. The next section explains how to use it.
- The Color Variations dialog box can help you figure out which colors you need more or less of, but it has some limitations. It's covered on page 253.

- The Photo Filter command gives you much more control than the Remove Color Cast command, and you can apply Photo Filters as Adjustment layers, too. Photo Filters are covered on page 297.
- **The Average Blur Filter**, used with a blend mode, lets you fix a color cast. As you'll read on page 448, it's something like creating a custom photo filter.
- Adjust Color for Skin Tone makes Elements adjust your photo based on the skin colors in the image. In practice, this adjustment is often more likely to introduce a color cast than to correct one, but if your photo has a slight bluish cast that's visible in the subject's skin (as explained on page 147), it may do the trick. This option works best for slight, annoying casts that are too subtle for the other methods in this list.

You can use any of these methods, but typically you'd start with Levels and then move on to the Remove Color Cast or Photo Filter command. To practice any of the fixes you're about to learn, download the photo *duneflowers.jpg* from this book's Missing CD page at *www.missingmanuals.com*.

The Remove Color Cast Command

This command uses an eyedropper to adjust the colors in your photo based on the pixels you click. With this method, you show Elements where a neutral color should be. As you saw with the flowers in Figure 7-14, Remove Color Cast can make a big difference with just one click. To use it:

1. Go to Enhance→Adjust Color→Remove Color Cast.

Your cursor should change to an eyedropper when you move it over your photo. If it doesn't, go to the dialog box and click the eyedropper icon.

2. Click an area that should be gray, white, or black.

You only have to click once in your photo for this feature to work. As with the Levels eyedropper tool, click an area that *should be* gray, white, or black (as opposed to looking for an area that's *currently* one of these colors). If the image has several of these, you can try clicking different spots in your photo. Just click Reset in between each sample until you find the spot that gives you the most natural-looking color.

3. Click OK.

Remove Color Cast works pretty well if your image has areas that should be black, white, or gray, even if they're tiny. The tricky thing is when you have an image that doesn't have any areas that should be one of those colors to sample. If that's the case, consider using the Photo Filter command (page 297) instead.

Tip: If you generally like what Auto Levels does for your photos but feel like it leaves behind a slight color cast, a click with the Color Cast tool may be just the right finishing touch.

Using Color Variations

The Color Variations dialog box (Figure 7-15) appeals to many Elements beginners because it gives you visual clues about how to fix the color in your photo. You just click the little preview thumbnail that shows the color balance you like best and Elements applies the necessary change to make your photo look like that thumbnail.

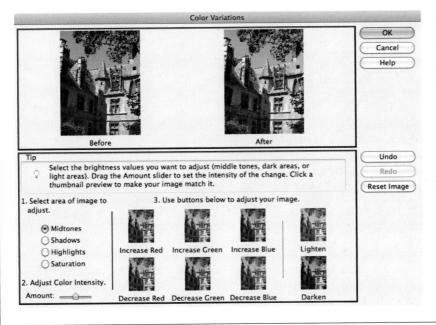

Figure 7-15:

You'll often do better using the Ouick Fix window to make the same kinds of changes vou can make with Color Variations, but Color Variations is handv because vou can see exactly what your photo needs-in this case, a little less red and a bit more lightness. The after photo is bluer than you'd probably want it to be. In that case, click Reset Image and move the slider in the lower-left corner of the dialoa box to the left a bit and then try again.

But Color Variations has some pretty severe limitations, most notably the microscopic size of the thumbnails. Because of that, it's hard to see what you're doing, so even newcomers can usually get better results in Quick Fix (page 127).

Still, Color Variations is useful when you know something isn't right with your photo's color, but you can't quite figure out what to do about it. And because it's adjustable, Color Variations is good for when you do know what you want, but want to make only a tiny change to your photo's color. To use Color Variations:

1. Open a photo and create a duplicate layer.

You probably want to make a duplicate layer for the adjustments (Ctrl+J/#-J) so that you'll have the option of discarding the changes if you're not happy with them. If you decide not to work on a duplicate, remember that you won't be able to undo these changes after you close the file.

2. Go to Enhance→Adjust Color→Color Variations.

Elements displays the dialog box pictured in Figure 7-15.

3. Under "Select area of image to adjust," click a radio button to choose whether to adjust midtones, shadows, highlights, or saturation.

Color Variations automatically selects Midtones, which is usually what you want. But experiment with the other settings to see what they do. The Saturation button works just like Saturation in Quick Fix (page 141).

4. Use the slider at the bottom of the dialog box to control how drastic the change should be.

The farther right you drag the slider, the more dramatic the change. Usually, just a smidgen is enough to make a noticeable change.

5. Below where it says "Use buttons below to adjust your image," click one of the thumbnails to make your photo look like it.

You can always click the Undo or Redo buttons on the right side of the window, or click Reset Image to put your photo back to where it was when you started.

6. When you're happy with the result, click OK.

Choosing Colors

So far, the color corrections you've read about in this chapter have all done most of the color assigning for you. But a lot of the time, you want to *tell* Elements what colors to work with—like when you're selecting the color for a Background or Fill layer, or when you want to paint on an image.

Although you can use any of the millions of colors your screen can display, Elements loads only two colors at a time. You choose these colors using the Foreground and Background color squares at the bottom of the Tools panel (see Figure 7-16).

Click to set default colors-

Foreground color-

-Switch Foreground and Background colors

-Background color

Figure 7-16:

The top square displays the Foreground color (here, that's blue); the bottom square displays the Background color (yellow). To quickly switch to the standard colors—black and white—either click the two tiny squares labeled here or press D. Click the curved double-headed arrow or press X to swap the Foreground and Background colors.

Foreground and Background mean just what they sound like—use the Foreground color with tools like the Brush or the Paint Bucket, and the Background color to fill in backgrounds. You can use as many colors in your images as you want, of course, but you can only use two at any given time.

Choosing Colors

The color-picking tools at the bottom of the Tools panel let you control the color you're using in a number of different ways:

- **Reset default colors**. Click the tiny black and white squares above the upper left of the Foreground square in a single column Toolbox (or below and to the left of the Foreground square if you have two columns) to return to the standard settings: black for the Foreground color and white for the Background color. Pressing the D key does the same thing.
- Switch Foreground and Background colors. Click the little curved two-headed arrow above and to the right of the squares, and the Background color becomes the Foreground color, and vice versa. This is helpful when you've inadvertently made your color selection in the wrong box. (Say you set the Foreground color to yellow, but you actually meant to make the *Background* color yellow; just click these arrows and you're all set.) You can also press X instead.
- Change either the Foreground or Background color to whatever color you want. Click either square to call up the Color Picker (explained on page 254) to make your new choice. There's no limit on the number of colors you can select in Elements. (Well, technically there is, but it's in the millions, so you should find enough choices for anything you want to do.)

You have a few different ways to select your Foreground and Background colors. The next few sections show you how to use the Color Picker, the Eyedropper tool (to pick a color from an existing image), and the Color Swatches panel.

When working with some of Elements' tools, like the Type tool, you can choose a color in the tool's Options bar. Adobe knows that, given a choice, most people prefer to work with either Color Swatches or the Color Picker, so they've come up with a clever way to accommodate both camps, as shown in Figure 7-17.

Tip: If you have an iPad, you have another way to create colors for Elements. Adobe's Color Lava app lets you use your fingers to blend colors and then send them to Elements so you can use them there. Head to *www.photoshop.com/products/mobile/colorlava* for more info about this app.

The Color Picker

Figure 7-18 shows the Color Picker, which has an intimidating number of options, but, most of the time, you don't need them all. Choosing a color is as simple as clicking wherever you see the color you want. Here's how to use the Color Picker:

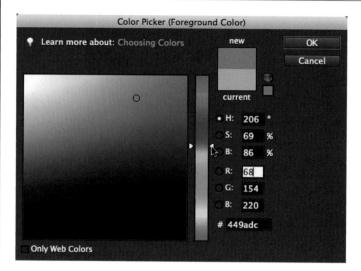

Figure 7-18:

For many beginners, the most important parts of Elements' Color Picker are the vertical rectangular slider in the middle (called, appropriately enough, the Color Slider) and the big square box, called the Color Field. Use the slider to get the general color you want, and then click in the field to pick the exact shade.

1. Click the Foreground or Background color square in the Tools panel.

Elements launches the Color Picker. Some tools—like the Paint Bucket (page 409) and the Selection brush's mask color option—also use the Color Picker. It works the same way no matter how you get to it.

2. Choose the color range you want to select from.

Use the vertical Color Slider in the middle of the dialog box to slide through the spectrum until you see the color you want in the big, square Color Field.

3. Click the spot in the Color Field where you see the exact shade you want.

You can keep clicking around and watch the color in the window's top box change to reflect what you click. The bottom box shows your original color for comparison.

4. Click OK.

The color you selected now appears in the Foreground or Background square in the Tools panel (depending on which one you clicked in step 1).

That's the basic way to use the Color Picker. The box on page 257 explains how to enter a numeric value for your color if you know it, or how to change the shades the Color Picker offers you.

Note: You're not limited to Elements' Color Picker. You can use your operating system's Color Picker instead, if you prefer (maybe you're used to working with the Windows Picker, for example).

Windows: To change the Color Picker, in the Elements Editor, go to Edit—Preferences—General. At the top of the dialog box, choose Windows from the Color Picker menu. Now when you click a color square, the Windows Color Picker opens up looking pretty feeble, with just a few colored squares and some white ones. But if you click Define Custom Colors, it expands, giving you access to most of the same features as in the Adobe picker. (The plain white squares are like little pigeonholes where you can save your color choices.)

Mac: Go to Adobe Photoshop Elements Editor→Preferences→General and select Apple from the Color Picker menu at the top of the dialog box. You might prefer Apple's color picker if you like to choose colors from a color wheel. There's even a fun view where you choose from a box of crayons. You can save colors in Apple's color picker by dragging them from the color field at the top of the window into the squares at the bottom. Then click a square to choose that color the next time you want it.

POWER USERS' CLINIC

Paint by Number

Elements' Color Picker includes some sophisticated controls that most folks can ignore. But in case you're curious, here's what the rest of the Color Picker does:

- H, S, and B buttons. These numbers determine the hue, saturation, and brightness of your color, respectively. They control pretty much the same values as the Hue/Saturation adjustment (page 331).
- **R**, **G**, **and B buttons**. These numbers let you specify the amount of red, green, and blue you want in the color you're picking. Each field can have a numerical value anywhere from 0 to 255. A lower number means less of the color, a higher number means more. For example, 128 R, 128 G, 128 B is neutral gray. By changing the numbers, you change the blend of the color.
- # (Hex number). Below the radio buttons is a box where you can enter a special six-character *hexadecimal* code that you'd use when creating web graphics. These codes tell web browsers which colors to display. You can also click a color in the window to see the Hex number for that shade.
- Only Web Colors checkbox. Turning on this box ensures that the colors you see in the main Color Field are drawn only from the 216 colors that antique web browsers can display. For example, if you're creating a website and you're really worried about color compatibility with Netscape 4.0, this box is for you. If you see a tiny cube just to the right of the color sample box (as in Figure 7-18), the color you're using isn't deemed web safe.

The Eyedropper Tool

If you've ever repainted your house, you've probably had the frustrating experience of spotting the *exact* color you want somewhere, but you had no way of capturing that color. That's one problem you'll never run into in Elements, thanks to the handy Eyedropper tool. It lets you sample any color on your monitor and make it the Foreground color in Elements. If you can get a color onto your computer, Elements can grab it. *Sampling* a color (that is, snagging it for your own use) couldn't be simpler with the Eyedropper: Just move your cursor over the color you want and click. It even works on colors that aren't in Elements, as explained in Figure 7-19. Sampling is perfect for projects like scrapbook pages where you want to use, say, the color from an event program cover as a theme color for the project. Just scan the program and sample the color with the Eyedropper.

By now, you may think that Elements has more eyedroppers than your medicine cabinet. But this is the *official* Elements Eyedropper tool that has its own place in the Tools panel. It's one of the easiest tools to use:

1. Click the Eyedropper in the Tools panel or press I.

Your cursor changes into a tiny eyedropper.

2. Move the Eyedropper over the color you want to sample.

If you want to watch the color in the Foreground color square change as you move the Eyedropper around, hold the mouse button down as you go.

3. Click when you see the color you want.

Elements loads your color choice as the Foreground color so it's ready to use. (To set the Background color instead, Alt-click/Option-click the color you want.)

If you want to keep your new color around so you can use it later without having to get the Eyedropper out again, save it in the Swatches panel. The next section teaches you how.

Figure 7-19:

To use the Eyedropper tool to sample colors outside of Elements, start by clicking anywhere in your Elements file. Then, while still holding your mouse button down, move your cursor over to the non-Elements object (a web page, for instance), until it's over the area you want to sample. When you let go, the new color appears in Elements' Foreground color square. (If you let go before you get to the non-Elements object, this trick won't work.)

Here, the Eyedropper (circled) is sampling the aqua color from a photo in Windows 7's Windows Photo Viewer. If you don't have a big monitor, it can take a bit of maneuvering to get the program windows positioned so that you can perform this procedure.

Tip: Since there may be some slight pixel-to-pixel variation in a color, you can set the Eyedropper to sample a little block of pixels and average them. In the Eyedropper's Sample Size setting in the Options bar, you can choose between the exact pixel you click (Point Sample), a 3-pixel square average, or a 5-pixel square average. Oddly enough, this Eyedropper setting also applies to the Magic Wand (page 163). Change it here and you change it for the wand, too.

The Color Swatches Panel

The Color Swatches panel holds several preloaded groups of sample colors for you to choose from. Go to Window→Color Swatches to call it up. You can park it in the Panel bin just like any other panel or leave it floating on your desktop. When you're ready to choose a color, just click the swatch you want in the panel, and it appears in the Tools panel's Foreground color square or in the color box of the tool you're using.

The Color Swatches panel is really handy when you want to keep certain colors at your fingertips. For instance, you can put your logo colors into it, and then you always have them available for any graphics or ads you create in Elements.

Elements starts you off with several different libraries (groups) of color swatches; click the pull-down menu in the Swatches panel to see them all. Any swatch you create appears at the bottom of the current library; you can save it there or create your own swatch libraries.

Using the Color Swatches to select your Foreground or Background color is as easy as using the Eyedropper tool. Figure 7-20 shows you how.

Figure 7-20:

When you move your cursor over the Color Swatches panel, it changes to an eyedropper. Simply click to select a Foreground color, or Ctrl-click/ #-click to pick a Background color. If you're using a preloaded color library, you'll see labels appear as you move over each square.

You can change the way the Color Swatches panel displays swatch information, as explained in Figure 7-21.

Figure 7-21:

To see swatch information displayed like this, click the four-line square at the top right of the panel and select Small List. (When using some Elements tools, like the Type tools, you bring up these display options by clicking the Options button below the swatch samples instead.) Depending on the library you're using, you'll see the names or hex numbers of each color in addition to a small thumbnail of it.

Saving colors in the Swatches panel

You can save any colors you've picked using the Color Picker or Eyedropper tool as swatches. (If you don't save them, you lose them as soon as you select a different library or close the panel.) To save a swatch, you can do one of two things:

- Click the New Swatch icon at the bottom of the Color Swatches panel. (It's the same square that stands for "new" in the Layers panel.)
- Click the little square made up of four lines at the panel's upper right and then choose New Swatch.

Either way, you get a chance to name and save the new swatch. The name shows up as a pop-up label when you hover your cursor over that swatch in the panel. (When you save the swatch, Elements picks a spot to save it; don't change that location if you want Elements to recognize what you're saving as a swatch.) Your swatch appears at the bottom of the current swatch library. To delete a swatch that you've saved, Alt-click/Option-click it or drag it to the Trash icon in the Color Swatches panel.

You can create your own swatch libraries if you want to keep your swatches separate from the ones Elements gives you. To do that, click the four-line square at the Color Swatches panel's upper right and pick Save Swatches. Then give the new library a name and save it.

Note: When you save a new swatch library, it doesn't show up in the list of libraries until the next time you start Elements.

Sharpening Images

Digital cameras are wonderful, but it's often hard to tell how well-focused your photos are until you download them to your computer. And because of the way cameras' digital sensors process information, most digital image data needs to be *sharpened*. Sharpening is an image-editing trick that makes your pictures look more clearly focused. Elements includes some almost miraculous tools for sharpening your images. (It's pretty darned good at blurring them, too, if that's what you want; see page 445.)

Unsharp Mask

Although it sounds like the last thing you'd ever want to use on a photo, Unsharp Mask reigned as the Supreme Sharpener for many generations of image correction, despite having the most counterintuitive name in all of Elements.

To be fair, it's not Adobe's fault. *Unsharp Mask* is an old darkroom term, and it actually does make sense if you know how our film ancestors used to improve a picture's focus. It refers to a complicated darkroom technique that involved making a blurred copy of the photo at one point in the process.

For several versions of Elements, Unsharp Mask ranked right up there with Levels as a contender for most useful tool in Elements, and some people still think it's the best way to sharpen a photo. Figure 7-22 shows how much a little Unsharp Mask can do for your pictures.

Figure 7-22: Left: The photo as it came from the camera.

Right: The same photo treated with a dose of Unsharp Mask. Notice how much clearer the individual hairs in the dog's coat are and how much better defined the eyes and mouth are.

To use Unsharp Mask, first finish all your other corrections and changes. A good rule of thumb for sharpening is "last and once." Unsharp Mask (or any sharpening tool) can undermine other adjustments you make later on, so always make sharpening your last step. Repeatedly applying sharpening can degrade your image's quality.

Tip: An exception to the rule about sharpening only once is when you're converting Raw images (page 270): You can usually sharpen both in the Raw Converter and then again as a last step without causing problems.

If you're sharpening an image that has layers, be sure the active layer has something in it. (Applying sharpening to a Levels Adjustment layer, for example, won't do anything.) Also, perform any format conversions before applying sharpening. Finally, you may want to sharpen a duplicate layer just in case you want to undo your changes later. Press Ctrl+J/æ-J to create the duplicate layer.

Note: It's helpful to understand just exactly what Elements does when it "sharpens" your photo. It doesn't magically correct the focus. As a matter of fact, it doesn't really sharpen anything. What it does is increase the contrast where colors meet, giving the *impression* of crisper focus. So while Elements can dramatically improve a shot that's a little soft, it can't fix that old double exposure or a shot where the subject is just a blur of motion.

When you're ready to apply Unsharp Mask:

1. Go to Enhance→Unsharp Mask.

You can use Unsharp Mask in either Full Edit or Quick Fix.

2. Adjust the settings in the Unsharp Mask dialog box until you like what you see.

Move the sliders until you're happy with the sharpness of your photo. (The following list explains what each slider does.) In the preview part of the dialog box, you can zoom in and out and grab the photo to adjust which part you see. It's also a good idea to drag the dialog box off to the side so that you can watch your actual image for a more global view of the changes you're making. You get the most accurate look at how you're affecting the image if you set the view to 100% or Actual Pixels.

3. When you're satisfied, click OK.

The Unsharp Mask sliders work much like other tools' sliders:

- Amount tells Elements how much to sharpen, in percent terms. A higher number means more sharpening.
- **Radius** lets Elements know how far from an edge it should look when increasing the contrast.
- Threshold controls how different a pixel needs to be from the surrounding pixels before Elements considers it an edge and sharpens it. If you leave this setting at zero—which is the standard setting—Elements sharpens *all* the image's pixels.

There are many, many different schools of thought about where to move the sliders or which values to plug into each box. Whatever works for you is fine. The one thing you want to watch out for is *oversharpening*. Figure 7-23 explains how to know if you've gone too far.

Figure 7-23: The perils of oversharpenina.

This is just a normal pumpkin. not a diseased one, but oversharpenina aives it a flaky appearance and makes the straw in the backaround look sketched in rather than real. The presence of halos *(like those alona the* edae of the pumpkin) is often vour best clue that you've oversharpened an imaae.

You'll probably need to experiment a bit to find out which settings work best for you. Photos you plan to print usually need to be sharpened to an extent that makes them look oversharpened on your monitor. So you may want to create two separate versions of your photo: one for onscreen viewing and one for printing. Version sets in the Organizer are great for keeping track of multiple copies like this.

Adjust Sharpness

Unsharp Mask has been around since long before digital imaging. A lot of people (including the folks at Adobe) have been thinking that, in the computer age, there's got to be a better way to sharpen, and now there is. The latest tool in the war on poor focus is Adjust Sharpness.

The Unsharp Mask tool helps boost a photo's sharpness by a process something like reducing Gaussian blur (page 445). Problem is, Gaussian blurring is rarely the cause of your picture's poor focus, so there's only so much Unsharp Mask can do. In real life, blurry photos are usually caused by one of two things:

- Lens blur. Your camera's prime focal point isn't directly over your subject. Or perhaps your lens isn't quite as sharp as you'd like it to be.
- Motion blur. You moved the camera—or your subject moved—while you pressed the shutter.

Adjust Sharpness is as easy to use as Unsharp Mask, and it gives you settings to correct all three kinds of blur—Gaussian, lens, and motion. When you first open the Adjust Sharpness dialog box, its settings are almost identical to those of Unsharp Mask. It's the extra things Adjust Sharpness can do that make it a more versatile tool. Here's how to use it:

1. Make sure the layer you want to sharpen is the active layer.

See Chapter 6 if you need a refresher on layers.

2. Go to Enhance→Adjust Sharpness.

You can reach this menu item from either Full Edit or Quick Fix.

3. Make your changes in the Adjust Sharpness dialog box.

As shown in Figure 7-24, the dialog box gives you a nice big preview. It's usually best to stick with 50 or 100 percent zoom (use the plus and minus buttons below the preview to zoom) for the most accurate view. The settings are explained in detail after this list.

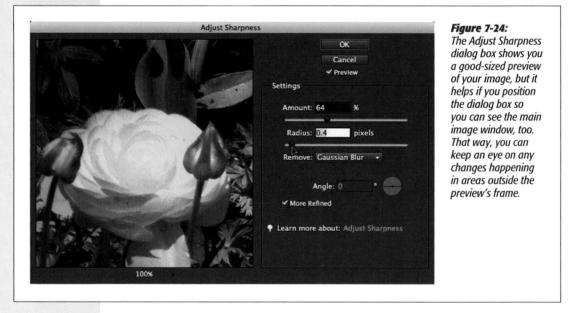

4. When you like the way your photo looks, click OK.

The first two settings in the Adjust Sharpness dialog box, Amount and Radius, work exactly the same way they do in Unsharp Mask (page 261). Here's what the other settings do:

• **Remove**. This is where you choose what kind of fuzziness to fix: Gaussian, lens, or motion blur, as explained on page 263. If you aren't sure which you want, try all three and see which works best.

- **Angle.** In a motion blur, you can improve your results by telling Elements the angle of the motion. For example, if your grip on the camera slipped, the direction of motion would be downward. Move the line in the little circle or type a number in degrees to approximate the angle. (It's awfully tricky to get the angle exactly right, so you may find it easier to sharpen without messing with this setting.)
- More Refined. Turn on this checkbox and Elements takes a tad longer to apply sharpening since it sharpens more details. Generally you'll want to leave this setting off for photos with lots of little details, like leaves or fur (and people's faces, unless you like to look at pores). But you might want it on for bold desert landscapes, for example, or other subjects without lots of fiddly small parts. Noise, artifacts, and dust become much more prominent when you turn on this box, since they get sharpened along with the details of your photo. Experiment and watch the main image window as well as the preview to see how this setting affects your photo.

Tip: Although Amount and Radius mean the same things as they do in Unsharp Mask, that doesn't necessarily mean that you can just plug your favorite Unsharp Mask settings into the Adjust Sharpness dialog box and get the same results. You may prefer very different numbers for these settings for the two tools.

Some people who've used Smart Sharpening in the full-featured Photoshop swear they'll never go back to plain Unsharp Mask. Try out Adjust Sharpness—Elements' version of Smart Sharpening—and see if you, too, like it better than Unsharp Mask. To give you an idea of the difference between the two methods, Figure 7-25 shows the dog from Figure 7-22 again, only this time with a dose of Adjust Sharpness instead of Unsharp Mask. Some people consider Adjust Sharpness just too darned fiddly to use, so feel free to go back to Unsharp Mask if it works better for you. (And Mac folks, don't forget that you also have the option of sharpening in Preview [page 143]).

The High-Pass Filter

Unsharp Mask is definitely the traditional favorite, and Adjust Sharpness is the latest thing in sharpening, but there's an alternative method that many people prefer because you apply it on a dedicated layer and can lessen the effect later by adjusting the layer's opacity. Moreover, you can use this method to punch up the colors in your photo as you sharpen. It's called *high-pass sharpening*.

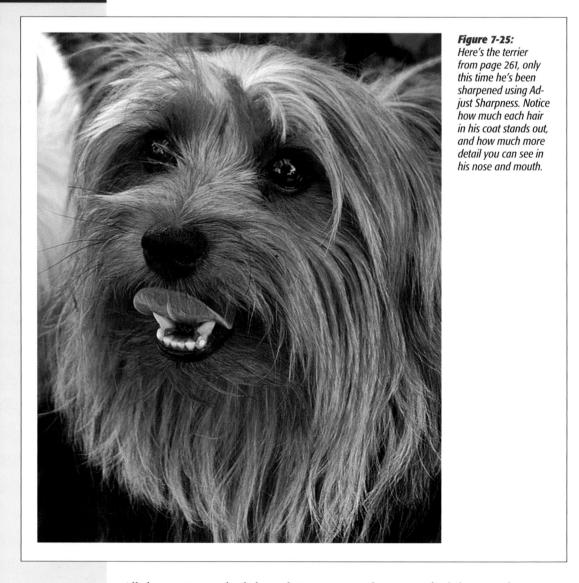

All sharpening methods have their virtues, and you may find that you choose your technique according to the content of your photo. Try the following procedure by downloading the photo *tiles.jpg* from this book's Missing CD page at *www.missing-manuals.com/cds*:

1. Open your photo and make sure the layer you want to sharpen is the active layer.

2. Duplicate the layer by pressing Ctrl+J/\#-J.

If you have a multilayered image and you want to sharpen all the layers, first flatten the image or use the Stamp Visible command (see the box on page 210) so everything is on one layer.

3. Go to Filter→Other→High Pass.

Your photo now looks like the victim of a mudslide, buried in featureless gray. Don't panic—that's what's supposed to happen.

4. In the High Pass dialog box, move the slider until you can barely see the outline of your subject.

Usually that means picking a setting roughly between 1.5 and 3.5. If you can see colors, your setting is probably too high. (If you can't quite eliminate every trace of color without totally losing the outline, a tiny bit of color is OK.) Keep in mind that the edges you see through the gray are the ones that will get sharpened the most. Use that as your guide for how much detail to include.

5. Click OK.

6. In the Layers panel, set the blend mode for the new layer to Overlay.

Ta-da! Your subject is back again in glowing, sharper color, as shown in Figure 7-26.

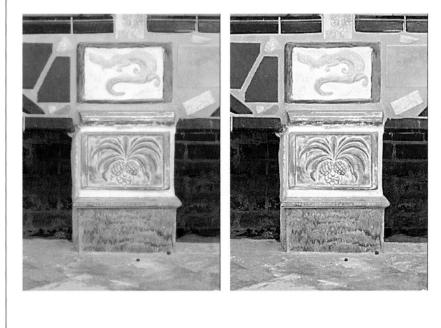

Figure 7-26: Left: A close-up look at the original photo.

Right: High-pass sharpenina usina the Vivid Light blend mode makes the colors stand out more. but it also makes all the tiles a bit coarser and rougher looking than they were in the oriainal. For hiahpass sharpening, you can use any of the blend modes in the group with Overlay, except Hard Mix and Pin Light. Vivid Light can make your colors pop, but watch out for sharpening artifacts (page 263), since they'll be more vivid. too. Overlay gives you a softer effect.

Tip: There's yet another way to create "pop" in your photos: the Clarity setting in the Raw Converter (page 281), which sharpens and enhances contrast at the same time. (If you know what "local contrast enhancement" means, this setting does something similar.) You can use it on Raw, JPEG, and TIFF files. It's especially useful for clearing haze from your shots.

The Sharpen Tool

Elements also gives you a dedicated Sharpen tool for working on specific areas in your photo rather than the entire image. It's a special brush that sharpens the areas you drag it over; Figure 7-27 shows it in action. To get to it, go to the Blur tool or press R, and then choose the Sharpen tool from the pop-out menu.

Figure 7-27:

The Sharpen tool isn't meant for sharpening whole photos, but it's great for sharpening details. Here, it's being used to touch up the details in the middle statue. (The red arrow helps you find the circular cursor.)

Approach this tool with caution: it's super easy to overdo it. One pass too many or too high a setting and you start seeing artifacts right away.

The Sharpen tool has some of the same Options bar settings as the Brush tool (see page 399 for more about brush settings). It also has a few settings all its own:

- **Mode** lets you increase the visibility of an object's edge by choosing from several different blend modes; Normal typically gives the most predictable results.
- **Strength** controls how much the brush sharpens what it passes over. A higher number means more sharpening.
- **Sample All Layers** makes the Sharpen tool work on all the visible layers in your image. Leave it off if you want to sharpen only the active layer.

CHAPTER 8

Elements for Digital Photographers

f you're a fairly serious digital photographer, you'll be delighted to know that Adobe hasn't just loaded Elements with easy-to-use features. The program also includes a collection of pretty advanced tools pulled straight from the fullfeatured Photoshop.

Number one on the list is the Adobe Camera Raw Converter, which takes Raw files—a format some cameras use to give you maximum editing control—and lets you convert and edit them in Elements. In this chapter, you'll learn lots more about the Raw format and why you may (or may not) want to use it for your photos. Don't skip to the next chapter if your camera shoots only JPEGs, though: You can use the Raw Converter to edit JPEG and TIFF images as well as Raw files, which can come in really handy, as you'll see shortly.

Note: Whereas JPEG and TIFF are acronyms for technical photographic terms, the word Raw–which you may occasionally see in all caps (RAW)–actually refers to the pristine, unprocessed quality of these files.

And you'll learn about Exposure Merge, which lets you combine different versions of a photo to create a single image with a higher dynamic range (a wider range of correctly exposed areas) than you can get from a single shot.

You'll also get to know the Photo Filter command, which helps adjust colors by replicating the old-school effect of placing filters over camera lenses. And Elements has some truly useful batch-processing tools that let you do things like rename groups of files, convert them to different formats, and even apply basic retouching to multiple photos. Read on to learn about all these features.

The Raw Converter

Probably the most useful thing Adobe has done for photography buffs is to include the Adobe Camera Raw Converter in Elements. For many people, this feature alone is well worth the price of the program, since you just can't beat the convenience of being able to perform conversions in the same program you use for editing.

If you don't know what Raw is, it's just a file format (a group of formats, really, since every camera maker has its own Raw format with its own file extension). But it's a very special one. Your digital camera actually contains a little computer that does a certain amount of processing to your photos right inside the camera itself. If you shoot in JPEG format, for instance, your camera makes some decisions about things like sharpness, color saturation, and contrast before it saves the JPEG files to its memory card.

But if your camera lets you shoot Raw files, then you get the unprocessed data straight from the camera. Shooting in Raw lets you make your own decisions about how your photos should look, to a much greater degree than with any other format. It's something like getting a negative from your digital camera—what you do to it in your digital darkroom is up to you.

That's Raw's big advantage—total control. The downside is that every camera manufacturer has its own proprietary Raw format, and the format varies even among models from the same manufacturer. No regular graphics program can edit these files, and very few programs can even view them. Instead, you need special software to convert Raw files to a format you can work with. In the past, that usually meant you needed software from the manufacturer before you could move your photo into an editing program like Elements.

Enter Adobe Camera Raw, which lets you convert your files right in Elements. Not only that, but the Adobe Camera Raw plug-in that comes with Elements lets you make sophisticated corrections to your photos before you even open them. Many times, you can do everything you need right in the Converter, so that you're done as soon as you open the converted file. (You can, of course, still use any of Elements' regular tools once you've opened a Raw file.) Using Adobe Camera Raw saves you a ton of time, and it's compatible with most cameras' Raw files.

Note: Adobe regularly updates the Raw Converter to work with new proprietary Raw formats produced by different cameras and to include updated profiles for existing cameras. So if your camera's Raw files don't open, check for a newer version of the Converter by going to Help—Updates in the Editor. If you aren't sure which version of the Raw Converter you have, go to Help—About Plug-In—Camera Raw/ Photoshop Elements—About Plug-In—Camera Raw to check. (Normally, when you install Elements, it's set to periodically check for updates automatically, but you can also check manually.) If you have the Mac App Store version, updates appear in the App Store instead.

Using the Raw Converter

For all the options it gives you, the Raw Converter is really easy to use. Adobe designed it to *automatically* calculate and apply what it thinks are the correct settings for exposure, shadows, brightness, and contrast. You can accept the Converter's decisions or override them and do everything yourself—it's your call.

While you may find all the Converter's various settings, tools, and tabs a little overwhelming at first, it's really laid out quite logically. Here's a quick overview of how to use it (you'll get details in a moment):

1. Open your file in the Raw Converter.

You can call up the Raw Converter from either the Organizer or Full Edit just by opening a Raw file.

2. Adjust your view and do any necessary rotating, straightening, or cropping.

The Raw Converter has its own tools for all these tasks, so you don't need to go into the Editor for any of them.

3. Adjust the image's settings.

This is the best part of shooting Raw format images: You can tweak settings for things like lighting and color. The Converter also lets you apply final touchups like noise reduction, sharpening, and so on.

4. Leave the Converter, go to the Editor.

The Raw Converter is a powerhouse for improving your photo's fundamental appearance, but to perform all the other adjustments Elements lets you make—applying filters, adding effects, and so on—you need to move your image to the Editor, which is also where you save the file in the standard graphics format of your choice (like TIFF, PSD, or JPEG).

If you'd like some practice with the Converter, you can find a sample image (*Raw_ practice.mrw*) on this book's Missing CD page at *www.missingmanuals.com/cds*, but be warned: It's a big file (7.2 MB).

Note: If you run Elements on a screen that's less than 800 pixels high (like on a netbook, say, or if you've reduced your monitor's resolution to less than that), the Raw Converter window won't appear. Elements just automatically converts your file and opens it straight into the Editor without giving you a chance to tweak anything.

To start converting a Raw file, in the Organizer, highlight the file, and then click Fix \rightarrow Full Photo Edit (or press Ctrl+I/ \Re -I) to bring up the Converter window. (If you select multiple files in the Organizer and the Converter doesn't open automatically, then find your files in the Project bin by choosing "Show Files selected in Organizer." Select them all, and then double-click one thumbnail to display them in the Converter.) If you're starting from the Editor, just go to File \rightarrow Open. Figure 8-1 explains how to work with multiple files in the Raw Converter.

Figure 8-1:

When you open several files in the Raw Converter at once, you get this handy filmstrip view down the left side of the window. You can select a single image from the group by clicking it, and then your changes apply only to that file. Shift-click or Ctrl-click to select multiple images (or use the Select All button at the top of the list), and all the selected files get changed along with the one in the main preview area.

When you finish your tweaks and click Open, all the selected files appear in the Project bin. If you want to save a group of them in another format, then use the Process Multiple Files command (page 298).

Note: In Windows, you may not be able to open Raw files by double-clicking them outside Elements (from the Windows desktop, for instance). If you try that, you'll probably see a message to the effect that your computer has no idea what program to use to open that file. To make sure that your computer always uses Elements to open Raw files, follow the steps on page 49. (Windows may also offer to take you to a website where you can download the files necessary to let Windows display your Raw photos.) On a Mac, you can usually open Raw files in Preview using the built-in Raw support in OS X, unless you have a very new camera or one of the few models that Apple doesn't support.

One important point to remember about Raw files: Elements never overwrites your original file. As a matter of fact, Elements *can't* modify the original Raw file in any way. So your original is always there if you want to try converting it again later using different settings. It's something like having a negative from which you can always get more prints. This also applies to any image you edit in the Raw Converter, not just Raw files. You can crop a JPEG file here, for instance, and your original JPEG doesn't get cropped—only the copy you open from the Converter. (There's more on working with non-Raw files in the Converter on page 286.)

Tip: If you shoot Raw+JPEG (where your camera takes one photo and saves it as both a Raw file and a JPEG file), you may find that the Photo Downloader (page 20) gets very confused by this scenario. If you have problems importing these files to the Organizer, try using one of the other methods discussed on page 47 to get your photos onto your computer, then use File→Get Photos→"From Files and Folders" to bring them into the Organizer.

Adjusting the view

When the Raw Converter opens, you see something like Figure 8-2. Before you decide whether to accept the automatic settings that Elements offers or to do your own tweaking, you need to get a good close look at the image. The Converter makes it easy to do this by giving you a large preview of the image, and a handful of tools to help adjust what you see:

- Zoom and Hand tools. These are in the toolbox in the top left of the Converter window. You use them here exactly the same way as elsewhere in Elements. (You'll find more about the Zoom tool on page 111; the Hand tool is described on page 113. The keyboard shortcuts for adjusting the view and scrolling also work in the Raw Converter.)
- View percentage. Below the lower-left corner of the preview window is a popup menu with preset sizes. Just choose the size you want, or click the + or – buttons to zoom in or out.

Note: Some adjustments and some of the special views, like the mask views for sharpening, aren't available unless you zoom to 100 percent or more.

- **Full Screen**. Just to the right of the Preview checkbox above the image area is an icon that looks like a page with a double-headed arrow on it. Click it to put the Raw Converter window into full-screen mode. Click it again to toggle back to the normal view.
- **Histogram**. In the upper-right corner of the Converter is a histogram that helps you keep track of how your changes affect the colors in the photo. (Flip back to page 245 for more on the fine art of reading histograms.)

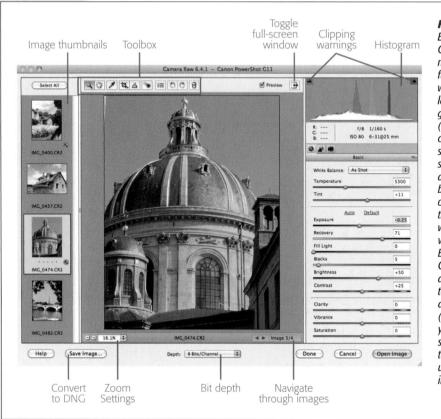

Figure 8-2: Elements' Raw Converter packs a number of powerful tools into one window. Besides the larae preview, vou aet a small toolbox (in the upper-left corner) containina some old friends, a specialized tool for adjusting the white balance (explained on page 276), and the panel on the right where vou tweak various settinas. Below your photo, the Converter aives vou a few view-adjusting tools, including a drop-down menu (lower-left) where vou can choose zoom settings. If you need to rotate the image. use the curled arrows in the toolbox.

Tip: Another handy feature in the Raw Converter is the panel just below the Histogram, where you can see important shooting information about your photo, like the aperture and ISO speed (*ISO* is a digital camera's version of film speed). If you hover your cursor over a pixel in the image, the RGB values (page 244) for that pixel appear here as well.

Once you've gotten a good close look at the photo, you have a decision to make: Did Elements do a good enough job of choosing the settings for you? If so, you're done. Just click the Open Image button in the Converter's lower right corner and Elements opens your photo in the Editor, ready for any artistic changes or cropping. If you prefer to make adjustments to the photo in the Converter, read on. (If you're happy with Elements' conversion, but you want to sharpen the picture, then skip ahead to page 283.)

Note: Everyone gets confused by the Save Image button. That button is actually the DNG Converter (see page 288), and all you can do when you click it is create a DNG file. To save your edited Raw file, click Done if you want to save your changes without actually opening the file, or click Open Image and then save it in the format of your choice in the Editor.

FREQUENTLY ASKED QUESTION

To Shoot in the Raw or Not

Should I shoot all my pictures in Raw format?

It depends. Using Raw format has its pros and cons. You may be surprised to learn that some professional photographers choose not to use Raw. For example, many journalists don't use it, and it's not common with sports photographers, either.

Here's a quick look at the advantages and disadvantages, to help you decide if you want to get involved with Raw. On the plus side, you get:

- More control. With Raw, you have a lot of extra chances to tweak your photos, and you get to call the shots, instead of your camera making the processing choices.
- More fixes. If you're not a perfect photographer, Raw is more forgiving than other formats, so you can fix a lot of mistakes (though even Raw can't make a bad photo great).
- No need to constantly fuss with white balance while shooting. However, you'll have better quality data to work with if your camera's white-balance settings are correct.
- Nondestructive editing. The edits you make in the Raw Converter don't change your original image one jot. It's always there if you need to make a fresh start.

But Raw also has some significant drawbacks. For one thing, you can't just open a Raw file and start editing it the way you do with JPEGs. You always have to convert it first, whether you use the Elements Converter or one supplied by the company that made your camera. Other disadvantages include:

 Larger file size. Raw files are smaller than TIFFs, but they're usually much bigger than the highest quality JPEGs. Consequently, you need bigger (or more) memory cards if you regularly shoot Raw.

- Slower speed. It generally takes your camera longer to save Raw files than JPEGs-something to keep in mind when you're taking action shots. Most cameras these days have a buffer that holds several shots and lets you keep shooting while the camera is working, but you may hit the wall pretty quickly if you're using burst (rapid-advance) mode, especially with a pocketsized point-and-shoot camera that uses Raw. In that case, you just have to wait. (Most digital single-lens reflex cameras are pretty fast with Raw these days, but they're generally even faster with JPEG.)
- Worse in-camera preview. For older cameras, you have some pretty significant limitations for digitally zooming the view in the viewfinder when using Raw, and Windows may not be able to show previews of your Raw files, either, without a special browser. Macs usually can, unless the camera model is new since the last time Apple updated OS X's Raw support, but there are a couple of cameras that never seem to get included. Also, Apple sometimes drops old camera models.

You may want to try a few shots of the same subject in both Raw and JPEG to see whether you notice a difference in your results. Generally speaking, Raw offers the most leeway if you want to make significant edits, but you need to understand what you're doing. JPEG is easier if you're a beginner.

The bottom line: It's your call. Some excellent photographers wouldn't think of shooting in anything but Raw, while others think it's too time-consuming.

Rotating, straightening, and cropping

Before tweaking your settings, you can make the following basic adjustments to your photo right in the Raw Converter:

- Rotate it. Click one of the rotation arrows above the image preview.
- Straighten it. The Raw Converter has its own Straighten tool (page 94), which you use just like the one in the Editor's Tools panel, although it has a different icon and cursor. (It's just to the right of the Crop tool in the Raw Converter's toolbox.) However, you don't see your photo actually straighten out in the Converter—Elements just shows you the outline of where the edges of your straightened photo will be. Open the photo in the Editor to make Elements apply the straightening.
- **Crop it**. The Raw Converter has the same Crop tool as the Editor (page 100). You can crop to a particular aspect ratio here if you want. Just click the Crop tool's icon for a pop-out menu of presets to choose from, or right-click the image itself when the Crop tool is active. If you want to crop to a particular size, choose Custom from the pop-out menu, and then, in the dialog box that appears, enter your numbers. (You also need to select inches, centimeters, or pixels, or enter a custom aspect ratio.) Your cropping info gets saved along with the Raw file, so the next time you open the file in the Converter, you see the cropped version.

As with straightening, Elements just draws a mask over the cropped area in the Converter; you can still see the outline of the whole photo. To adjust your crop, in the Raw Converter's toolbox, click the Crop tool again, and then drag one of the handles that appear around the cropped area. To revert to the uncropped original later, click the Raw Converter's Crop tool, then right-click/ Control-click inside the crop boundaries in the preview area, and then choose Clear Crop.

Tip: You can also fix red eye in the Raw Converter. The Red Eye Removal tool is in the toolbox just to the right of the Straighten tool, and it works the same way it does everywhere else in Elements (see page 133).

Adjusting White Balance

The long strip down the right side of the Raw Converter gives you lots of ways to tweak and correct your photo's color, exposure, sharpness, brightness, and noise level. The strip is divided into three tabs. Start with the one labeled "Basic," which contains, well, the *basic* settings for the major adjustments.

First, check your White Balance setting, which is at the top of the Basic tab. Adjusting white balance is often the most important change when it comes to making your photos look their best. The White Balance control adjusts all the colors in your photo by creating a neutral white tone. If that sounds a little strange, stop and think about it for a minute: The color you think of as *white* actually changes depending on the lighting conditions. At noon there's no warmth (no orange/yellow) to the light because the sun is high in the sky. Later in the day when the sun's rays are lower, whites are warmer. Indoors, tungsten lighting is much warmer than fluorescent lighting, which makes whites rather bluish or greenish. Your eyes and brain easily compensate for these changes, but sometimes your camera may not, or may overcompensate, giving your photos a color cast. The Raw Converter's White Balance setting lets you create more accurate color by neutralizing the white tones.

Most digital cameras have their own collections of white-balance settings. Typical choices include Auto, Daylight, Cloudy, Tungsten, Fluorescent, and Custom. When you shoot JPEGs, picking the correct setting really matters, because it's tough to readjust white balance, even in a program like Elements. (Unless you tweak the JPEG with the Raw Converter as explained in the box on page 286, and even then the results may not be what you want.) With Raw photos, you can afford to be a little sloppier about setting your camera's white balance, because you can easily fix things in the Raw Converter.

Getting the white balance right can make a huge difference in how your photo looks, as you can see in Figure 8-3.

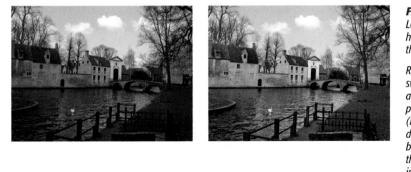

Figure 8-3:

Left: The lighting in this shot has a bluish cast that makes the scene look chilly.

Right: A single click on the swan with the White Balance tool makes the whole photo appear warmer. (It could stand a little additional tweaking, but the better white balance makes the photo more vivid and improves its contrast.)

The Raw Converter gives you several ways to adjust your image's white balance:

- **Pull-down menu**. The White Balance menu just below the Histogram starts out set to As Shot, which means Elements is showing your camera's settings. You can use this menu to choosing from Auto, Daylight, Cloudy, and other options. It's worth giving Auto a try because it picks the correct settings surprisingly often.
- **Temperature**. Use this slider to make your photo warmer (more orange) or cooler (more blue). Moving the slider to the left cools your photo; moving it to the right warms it. You can also type a temperature in the box in degrees Kelvin

(the official measurement for color temperature), if you're experienced in doing this by the numbers. Use the Temperature slider and the Tint slider (described next) together for a perfect white balance.

- **Tint**. This slider controls the green/magenta balance of your photo, pretty much the way it does in Quick Fix. Move it to the left to increase the green in your photo, and to the right for more magenta.
- White Balance tool. The Raw window has its own special Eyedropper tool up in the toolbox: the White Balance tool. Activate it and then click any white or light-gray spot in your photo, and Elements calculates the white balance based on those pixels. This is the most accurate method in this list, but you may have a hard time finding neutral pixels on which to use it.

If you're a good photographer, then much of the time a good white balance and a little sharpening may be all your photo needs before it's ready to go out into the world.

Adjusting Tone

The next group of six sliders—from Exposure down through Contrast—helps you improve your image's exposure and lighting (also known as "tone"). If you like Elements to make decisions for you, click the word "Auto" above these sliders, and the program selects what it thinks are the best positions for each of the six sliders. If you don't click anything, then Elements starts you off with the Default settings. Here's the difference between Auto and Default:

• Auto. Elements automatically adjusts your photo, using the same softwarepowered guesswork behind the other Auto buttons throughout the program, as explained in Figure 8-4.

General		ОК	If you want the Raw Converter to always open your photos with
Save image settings in:	Sidecar ",xmp" files	Cancel	the Auto settings applied, you contain the total
Apply sharpening to:	All images	•	verter Preferences dialog box (in the Raw Converter's toolbox, cli
- Default Image Settings -			the three-line icon or press Ctrl+
Apply auto tone adju	<u>istments</u> ic to camera serial number		ℜ-K). In the dialog box, turn on the "Apply auto tone adjustmen checkbox, as shown here, and
	ic to camera serial number ic to camera ISO setting		from now on, the Raw Converter is in Auto mode-at least for the
DNC File Meedline			tone settings.
DNG File Handling)" files		
🕅 Update embedded J	PEG previews: Medium Size 👻		

• **Default.** The Raw Converter has a database of basic tone settings for each camera model. If you choose Default, then you see the baseline settings for your camera, and it's up to you to make further adjustments to the photo. If you want, you can set your own camera *defaults* (where the sliders are when your photo opens), too, as explained on page 282. If you don't like what you got with Auto, then just click Default to send your photo back to how it was when you opened it.

After you've clicked Auto or Default, you can override any setting by moving its slider yourself. If you go to the trouble of shooting Raw, then you may well prefer to do so, as Figure 8-5 demonstrates.

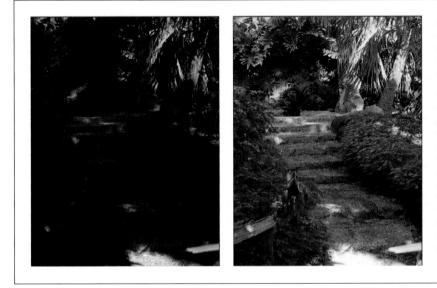

Figure 8-5:

Left: The Raw Converter's default settings make this photo look like a lost cause.

Right: With a little bit of manual adjustment, the photo reveals that the camera actually captured plenty of details. (Note that the one properly exposed bit of foreground in the left image is now quite blown out. This image is a great candidate for the Exposure Merge feature, discussed on page 290.)

Here's a blow-by-blow of each of the six settings:

• **Exposure**. A properly exposed photo shows the largest possible range of detail shadows contain enough light to reveal details, and highlights aren't so bright that all you see is white. Move this slider to the left to decrease exposure and to the right to increase it. (Note to photo veterans: The values on the scale are equivalent to f-stops.) Too high a choice here will *clip* some of your highlights (meaning they'll be so bright that you won't see any detail in them). Figure 8-6 explains more about clipping.

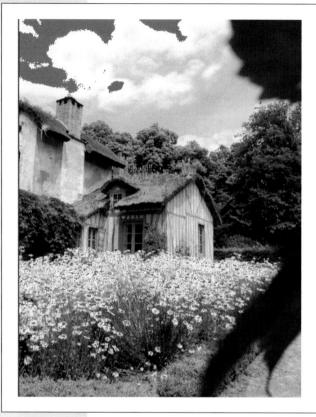

Figure 8-6:

To help you get the tone settings right, Elements includes two triangles above the ends of the Histogram. Click them to turn on "clipping warnings" that reveal where your highlights (in red) or your shadows (in blue) lose detail at your current settings. If the photo isn't clipped, then the triangle for that end of the Histogram is dark. If the triangle is white or colored, then you have a problem; click the triangle to turn the mask on to see the clipping. As you adjust the tone settings, the mask changes accordingly. In this photo, you can see that the red and blue speckled areas will be clipped when you open the photo unless you adjust your settings.

- **Recovery.** This clever slider brings down overexposed highlights, recovering the details that were lost, without underexposing the rest of the photo. Be careful when using it, though—a little goes a long way.
- **Fill Light.** If your subject appears backlit, move this slider to the right to lighten up the shadowed areas, just the way a photographer's fill light does. Elements' Fill Light is clever enough to bring up the shadowed areas in your photos without clipping the highlights.
- Blacks. This slider increases the shadow values in your photo and determines which pixels become black. Increasing this setting may help improve the contrast in the image. Move the slider to the right to increase shadows or to the left to decrease them. A small change here has a big impact: Move this slider too far to the right, and you'll clip your image's shadows (meaning they turn pure black, with no details, and your colors may become funky, too).
- **Brightness**. This is similar to Exposure in that moving the slider to the right lightens your image, and moving it to the left darkens it. But this setting doesn't clip your photo the way the Exposure setting may. Use this slider to set the overall brightness of the image after you've used the Exposure, Recovery, and Blacks sliders to set the photo's brightness value limits.

• **Contrast**. This slider adjusts your image's midtones; move it to the right for greater contrast in those tones, and to the left for less. People usually use this slider last, because things can shift pretty dramatically if you use other sliders after you've increased the contrast.

Most of the time, you'll use several of these sliders to get a perfectly exposed photo. Once you have things adjusted the way you want, you can go on to the lower group of settings and adjust your photo's clarity, vibrance, and saturation. You can also save your current settings for use with other photos, or undo all the changes you've made, as explained on page 282.

Adjusting Vibrance and Saturation

The final group of settings on the right side of the Raw Converter controls the vividness of your image's colors. Most Raw files have lower saturation to start with than you'd see in the same photo shot as a JPEG, so people often want to boost the saturation of their Raw images a bit. Move the sliders to the right for more intense color, and to the left for more muted color. If you know you'll *always* want to change the intensity of the color, then you can change the standard setting by moving the slider until you have the intensity you want, and then creating a new camera default setting, as described on page 282.

Here's what each of the three sliders does:

- **Clarity**. This slider is a bit different from the next two. Clarity isn't strictly a color tool, although it's an absolutely amazing feature. If you're an experienced Elements sharpener, you may have heard of the technique called *local contrast enhancement*, where you use the Unsharp Mask with a low Amount setting and a high Radius setting to eliminate haze and bring out details. That's sort of what this slider does: Through some incredibly sophisticated computing, it creates an edge mask for your photo that it uses to increase detail. It can do wonderful things for many—maybe even most—of your photos by improving contrast and adding punch. Give it a try, but be sure you're viewing your photo at 100 percent magnification (or more) so you can see how you're changing things. With some cameras, you may find that the details in the converted photos look rather blocky when viewed at that size. If that happens, open the file in the Raw Converter again and choose a lower Clarity setting.
- Vibrance. While Saturation (explained next) adjusts all colors equally, the Vibrance slider is much smarter: It increases the intensity of the duller colors, while holding back on colors that are already so vivid they may over-saturate. If you want to adjust saturation to make your photo pop, then try this slider first; it's one of the handiest features in the Raw Converter.
- **Saturation**. This slider controls how vivid your colors are by changing the intensity of *all* the colors in the photo by the same amount.

Saving your settings

Most of the time, you'll only want to use the current Raw Converter settings on the specific photo(s) you're editing right now. But Elements gives you a bunch of ways to save time by saving your settings for future use. Just below the Histogram, to the right of the word "Basic," are three tiny lines with a minute arrow at their bottom right. Click that icon to see a drop-down menu. Whatever you choose in this menu determines how Elements converts your photo. Here's what the choices mean:

- **Image Settings**. This is the "undo all my changes" option. In other words, if you've made some changes to your photo in the Converter but you want to revert to the settings Elements originally presented you with, then choose this option.
- **Camera Raw Defaults**. The Raw Converter contains a profile of normal Raw settings for your camera model that it uses as its baseline for the adjustments it makes. That's what you get when you pick this option. You may have several profiles to choose from here (see the box on page 288).
- **Previous Conversion**. If you've already processed a photo and want to apply the same settings to the photo you're currently working on, then choosing this setting applies the settings from the last Raw image you opened (but only if it's from the same camera).
- **Custom Settings**. Once you start changing the Raw Converter's settings, this becomes the active choice. You don't need to select it—Elements turns it on automatically as soon as you start making adjustments.

Since individual cameras—even if they're the same model—may vary a bit (as a result of the manufacturing process), the Camera Raw Defaults settings may not be the best ones for your camera. You can override the default settings and create your own set of defaults for any camera. Here's how:

- To change your camera's settings: If you know that you *always* want a different setting for one of the sliders—like maybe your Shadows setting should be at 13 instead of the factory setting of 9—move any or all of the sliders to where you want them, and then choose Save New Camera Raw Defaults from the menu discussed above. From now on, Elements opens your photos with these settings as your starting point.
- To revert to the original Elements settings for your camera: If you want to go back to the way things were originally, then click the Settings button (the one with the three lines on it), and choose Reset Camera Raw Defaults.

Tip: You can apply the same changes to multiple photos at once. Page 272 explains how.

The Raw Converter's preferences include a couple of special settings that may interest you. To bring up the Camera Raw Preferences dialog box, in the Raw Converter's toolbox, click the icon with three lines. These preferences can be really useful, especially if you have more than one camera:

- Make defaults specific to camera serial number. Turn this on if you have more than one of a particular camera model; for instance, if you carry two bodies of the same model with different lenses when you shoot, or if both you and your spouse have the same camera model. This setting lets you have a different default for each camera body.
- Make defaults specific to camera ISO setting. Since you may shoot very differently at different ISO settings (ISO is the digital equivalent of film speed), you can use this setting to create a default that Elements applies only to photos shot at ISO 100, or at ISO 1600, and so on.

Tip: If you regularly share photos with people using other programs, you'll be pleased to know that the Raw Converter's preferences let you choose whether your settings get saved in the Camera Raw database or in a sidecar XMP file that goes along with the image. If you choose the XMP option, then your settings become portable along with your photo—so if you send the file to someone else, the settings travel along with the photo, as long as you send the XMP file, too.

You don't have to create default settings to save the changes you make to a particular photo. If you just want to save the settings for the photo or group of photos you're working on right now without having to open them all in the Editor and save them in another format, make your changes, and then click the Raw Converter's Done button to update the settings for the image file(s).

Tip: You can also choose a different profile for your camera for the Raw Converter to use as a basis for adjusting your photos. Page 288 explains how.

Adjusting Sharpness and Reducing Noise

Once you've got your exposure and white balance right, you may be almost done with your photo. But in most cases, you'll want to click over to the Raw Converter's Detail tab to do a little sharpening (on the right side of the Raw Converter, above the word "Basic," click the icon that looks like two triangles).

This tab also includes two other important adjustments: *Luminance* and *Color* (both described in a moment), which help reduce noise in your photos. None of the adjustments on this tab have Auto settings, although you can change the standard settings by moving their sliders where you want them and then creating a new camera default (page 282).

The Raw Converter

Sharpening increases the edge contrast in your photo, which makes it appear more crisply focused. The sharpening tools in the Raw Converter are a bit different from those in the Editor, but some of the sliders should look familiar if you've sharpened before, since they're similar to the settings for Unsharp Mask and Adjust Sharpness:

- **Amount** controls how much you want Elements to sharpen. The scale here goes from zero (no sharpening) to 150 (way too much sharpening).
- **Radius** governs how wide an area Elements considers an edge. Its scale goes from .5 pixels to 3 pixels.
- **Detail** controls how Elements applies the sharpening to your image. At 100 the right end of the scale—the effect is most similar to Unsharp Mask (in other words, you can overdo it if you aren't careful). At zero, you shouldn't see any sharpening halos at all.
- **Masking** is a very cool feature that reduces the area where sharpening takes place so that only edges get sharpened. If you find that you're sharpening more details than you like, then use this slider to create an Edge Mask that keeps Elements from sharpening areas inside the edges. The farther you move this slider to the right, the more area you protect from sharpening. While you adjust this slider, Elements does some amazing behind-the-scenes calculations, so don't be surprised if there's a little lag in the preview when you move this slider.

Masking and Detail work together to perform really accurate sharpening, which is why the sliders go so high—you won't like the effect from just one of them set all the way up, but by experimenting with using both sliders, you can create excellent sharpening in your photo.

You can get an extremely helpful view of your image if you hold the Alt/Option key as you move the sliders, as explained in Figure 8-7 (but only if the view is set to at least 100%).

If you're not planning on making any further edits to your photo when you leave the Raw Converter, then go ahead and sharpen your image here. On the other hand, some people prefer to wait and sharpen only after they finish all their other adjustments in Full Edit mode, so they skip these sliders. But you can usually sharpen here and then sharpen again later (outside the Converter) without any problems.

The final two settings on this tab (under Noise Reduction) work together to reduce *noise* (graininess) in your photos. Noise is a big problem in digital photos, especially with 5-plus megapixel cameras that don't have the large sensors found in single-lens reflex cameras, and with cellphone cameras. Here's how these two adjustments can help:

• Luminance. This setting reduces grayscale noise, which gives your photo an overall grainy appearance—something like what you see in old newspaper photos. The slider always starts at zero, since you don't want to use more than you need—moving it to the right reduces noise but also softens the image's details.

• **Color**. If areas of your photo that should be evenly colored contain obvious clumps of different-colored pixels, this setting can help smooth things out. Drag this slider to the right to reduce the amount of color noise.

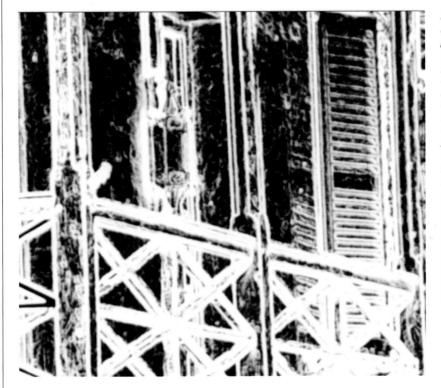

Figure 8-7:

If you've tried highpass sharpenina (page 265), then vou won't have any trouble understanding this helpful view of your image. Set the view to 100% or higher, and then Alt-drag/Option-drag anv of the sharpening sliders to see this black-and-white view of vour image. The lack of color makes it easy to focus on what vou're doina to the edae sharpness in your photo, so you aet a hiahly accurate view of the effect each slider is havina.

In most cases, it may take a fair amount of fiddling with these sliders to come up with the best compromise between sharpness and smoothness. It helps if you zoom in to 100% or more when using these sliders.

Choosing bit depth: 8 or 16?

Once you've got your photo looking good, you have one more important choice to make: Do you want to open it as an 8-bit file or a 16-bit file? *Bit depth* refers to how many pieces of color data, or *bits*, each pixel in your image can hold. A single pixel of an 8-bit image can have 24 pieces of information in it—8 for each of the three color channels (red, green, and blue). A 16-bit image holds far more color info than an 8-bit photo. How much more? An 8-bit image can hold up to 16 million colors, which may sound like a lot, but a 16-bit image can hold up to 281 *trillion* colors.

HIDDEN FEATURE ALERT

Non-Raw Files in the Raw Converter

If your camera shoots JPEGs and you've always been curious about what this Raw business is all about, you can find out for yourself—sort of. You can open JPEG, PSD, and TIFF files with the Raw Converter, and then process them there. (If you want to try another kind of file, save it as a TIFF and *then* open it with the Raw Converter. That way you can take advantage of the Converter's special tools, like Vibrance or Clarity, for any photo.)

To open non-Raw files from the Editor, just use File—Open As, and then choose Camera Raw (*not* Photoshop Raw) as the format. (If you're on a Mac, Go to File—Open, select the image, and then choose Camera Raw from the Format menu.) The image opens in the Converter, and you can work on it just like a real Raw file—well, almost. The thing about using other formats in the Converter is this: When your camera processed the JPEG file that it wrote to its memory card, it tossed out the info it didn't need for the JPEG, so Elements doesn't have the same amount of info to work with as it does for a true Raw file. The Converter even

lets you create a DNG-digital negative-file (page 288) from a JPEG if you want, but it can't put back the info that wasn't included in the JPEG, so this feature isn't really very useful for most people.

Because non-Raw files don't have as much info as Raw files, working with them in the Raw Converter can lead to some iffy results. You may find that the Converter does a bang-up job on your photo, or you may decide you liked it better before you started messing with it. There are so many variables involved that it's really hard to predict the results you'll get. But it's definitely worth giving it a try.

If you find you like using the Raw Converter for JPEGs, then you might want to experiment with reducing your camera's saturation, contrast, and sharpening settings, if possible. That's because you're more likely to get good results from the Raw Converter if your image is fairly neutral to start with.

Tip: You can adjust 16-bit images with microscopic precision, but your home printer only prints in 8-bit color anyway. If you want to do all your editing (or at least 90 percent of it) in 16-bit color, then consider upgrading to Photoshop.

Most digital cameras produce Raw files with 10 or 12 bits per channel, although a few can shoot 16-bit files. You'd think it would be a good idea to save your digital files at the largest possible bit depth. But you'll find quite a few restrictions on how much you can do with 16-bit files in Elements. You can open them, make some corrections, and save them, but that's about all. You can't work with layers or apply the more artistic filters to 16-bit files, but you can use many of Elements' Auto commands. If you want to work with layers on 16-bit files, then you need to upgrade to Photoshop.

Note: Your scanner may say it handles 24-bit color, but this is actually the same as what Elements calls 8-bit. Elements goes by the number of bits per color channel, whereas some scanner manufacturers try to impress you by giving you the total for all three channels ($8 \times 3 = 24$). So when you see really high bit numbers on scanners—assuming they're not machines from commercial print shops—you can usually get the Elements equivalent by dividing by three.

Once you've decided between 8- and 16-bit color, just make your selection in the Depth drop-down menu at the bottom of the Raw Converter window. This setting is "sticky," so if you change it, all your images open in that color depth until you change it. If you ever forget what bit depth you've chosen, your image's title bar or tab tells you, as shown in Figure 8-8.

○ ○ ○ ○ ☐ hameau.jpg.@ 20.1% (RGB/8)	Figure 8-8: You can always tell an image's bit depth by looking at the top bar or tab of its image window in the Editor. The 8 at the end of this title tells you that this is an 8-bit image.
--------------------------------------	--

Tip: If you decide to create a 16-bit image and later become frustrated by your lack of editing choices, then you can convert your image to 8-bit by choosing Image \rightarrow Mode \rightarrow 8 Bits/Channel in the Editor. (You can't convert an 8-bit image to 16 bits, however.)

If you want to take advantage of any 16-bit files you have, you may want to use either Save As or the Organizer's version set option for the copy you plan to convert to 8-bit. That way, you'll still have the 16-bit file for future reference. Incidentally, your Save options are different for the two bit depths: JPEG, for instance, is available only for 8-bit files, because JPEGs are *always* 8-bit.

A popular choice when you're thinking about your order of operations (*workflow*, in photo industry–speak) is to first convert your Raw file as a 16-bit image to take advantage of the increased color information and make basic corrections, and then convert to 8-bit for the fancy stuff like adding artistic filters or layers.

Finishing Up

Now that you've got your photo all tweaked, sleeked, and groomed to look exactly the way you want, it's time to get it out of the Raw Converter. To do that, click the Open Image button in the Converter's lower-right corner, which sends the image to Full Edit, where you can save it in the format of your choice, like TIFF or JPEG. (Why not click the Raw Converter's Save Image button? Adobe should probably rename this button, which confuses everyone. The Save Image button is actually a link to the DNG Converter, discussed in the next section.) If you just want to save your changes without opening the file, then you don't need to do anything: The next time you open the Raw file, the Raw Converter will remember where you left off. Just click Done to close the Converter.

POWER USERS' CLINIC

Working with Profiles

The Raw Converter has another trick up its sleeve. (You can safely ignore this feature if you're a beginner, but it's pretty handy for Raw experts.) In addition to Basic and Detail, the Raw Converter has a third tab: Camera Calibration. If you click it, you see a Name drop-down menu. Your choices there depend on your particular camera model, but the list typically includes a group of profiles with names like Adobe Standard, Camera Portrait, Camera Neutral, and so on; some numbered profiles that seem to imply you're using an older version of Adobe Camera Raw; or a combination of both kinds of profiles.

What's the point of this cryptic tab? It lets you choose from the different *profiles* for your camera (basically, sets of parameters that the Raw Converter uses to convert the Raw file from cameras into recognizable photos). Just click through the profiles in the list and choose the one you like best. (In Photoshop, you can edit profiles here, but not in Elements.) Go through the different choices and watch how the preview of your image changes. If you're wondering why the list shows older ACR (Adobe Camera Raw) versions like 4.2, that's because the list shows the version numbers for when the built-in Adobe Camera Raw profiles were last updated. (Not all camera models list these older profiles.) So if you've been thinking, "You know, I think I prefer the way my Raw files looked a couple of versions ago," no problem. Just pick the older profile version for your camera from the list and use that instead of the newest one.

Converting to DNG

A few years ago, there was a lot of buzz about Adobe's DNG (digital negative) format, and if you shoot Raw, you should know what it is. As you learned at the beginning of this chapter, every camera manufacturer uses a different format for Raw files. Even the formats for different cameras from the same manufacturer differ. It's a recipe for an industry-wide headache.

Adobe's solution is the DNG format, which the company envisions as a more standardized alternative to Raw files. Here's how it works: If you convert your Raw file to a DNG file, then it still behaves like a Raw file—you can still tweak its settings in the Raw Converter, and you still have to save it in standard image formats like TIFF or JPEG to use it in a project. But the idea behind DNG is that if you keep your Raw files in this format, then you don't have to worry about whether Elements version 35 can open them. Adobe clearly hopes that all camera manufacturers will adopt this standard, putting an end to the mishmash of different formats that make Raw files such a nuisance to deal with. If all cameras used DNG, then when you bought a new camera you wouldn't have to worry whether your programs could view the camera's images. You can create DNG files from your Raw files right in the Raw Converter. At the bottom left of the window, just click the Save Image button, and up pops the DNG Converter shown in Figure 8-9. Choose a destination (where you want to save the file), and then select how you want to name the DNG file. You get the same naming options as with Process Multiple Files (page 301), but since you convert only one file at a time here, you may as well keep the photo's current name and just add the .dng extension to the end of it.

				ents' DNG
Destination: Save	in Same Location			erter. The
Select Folder	/Users/Barbara/Desktop/paris/10304/		Cancel	m section of vindow lets y
				se whether t
File Naming				ress the file,
Example: IMG_0203	Ldng			o handle the
Document Name	+	+		e preview, al her to embed
	+	•		original Raw
Begin Numbering:			in the	new one. G
File Extension:	.dng 🛟			, you're bes
				ng the setting ection the w
- Format: Digital Neo				ire here.
Compatibility:	amera Raw 5.4 and later 🛟			
JPEG Preview:	ledium Size			
	Raw File			

The jury is still out on whether DNG is going to become the industry standard. But people have had other good ideas over the years like the JPEG 2000 format (see page 80) that never really took off, and DNG hasn't proved to be quite as universal as Adobe had hoped, so a fair number of people are becoming a bit skeptical about the ultimate fate of DNG, and it's not nearly as popular now as it was a few years ago. Whether you create DNG files from your Raw files is up to you, but for now, it's probably prudent to hang onto the original Raw files as well, even if you decide in favor of DNG.

Tip: If you want to convert a group of Raw files to DNG in one batch, the easiest way is to go to Adobe's website (*www.adobe.com/downloads*), search for "DNG", and then download the stand-alone DNG Converter, which you can leave on your desktop. Then just drop a folder of Raw images onto its icon, and the DNG Converter processes the whole folder at once. You can also batch-save images in the Raw Converter by highlighting them in the list on the left side of the window, and then clicking Save Images.

Blending Exposures

If you've been using a digital camera for any length of time, you know what a juggling act it can be to get a photo that's properly exposed everywhere, from its deepest shadows to its brightest highlights. With most digital cameras, you're likely to hit the clipping point (page 280) in an image much sooner than you want to: If you up the exposure so the shadows are nice and detailed, then about half the time you blow out the highlights. On the other hand, if you adjust the exposure settings down to favor the highlights, then your shadows are murkier than an old Enron annual report. Figure 8-10 shows the problem.

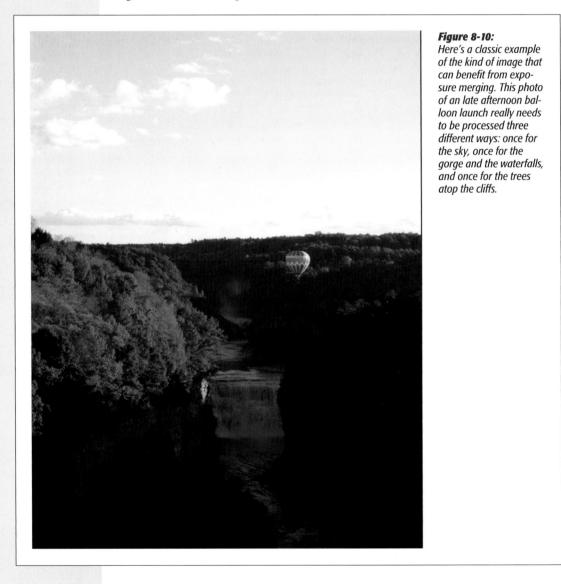

Digital blending is a technique photographers use to get around these limitations. To use it, you *bracket* your shots, meaning you take two or more identical photos of your subject at different settings—one exposed for shadows and one for highlights— and then combine them, choosing the best bits of each one. People who are fanatical about getting their images truly perfect may combine several different exposures.

That technique is great for landscapes, but if you're shooting hummingbirds, rollerskating chimps, or toddlers, you know it's just about impossible to get two identical shots of a moving subject. And if you're like many people, you may not realize you didn't capture what you wanted until you see the shot on your computer at home. But even if you only have one photo of that perfect moment, you can sometimes cheat a bit and get a similar result from processing your photo twice in the Raw Converter (once to favor the shadow areas, and once for the highlights) so you wind up with two exposures. The problem is figuring out how to combine them into one great image.

Happily, Elements gives you a super simple way to do this. It's called Photomerge Exposure, and it's as easy to use as any of the program's other photomerge features (see Chapter 11 for more about those). It can even be a one-click fix, if you want. Elements offers you several ways to blend your photos. Your main choice is between an automatic merge, where Elements makes most of the decisions for you, and a manual merge, which gives you more control but requires a little more effort.

Note: Exposure merging isn't meant for blending two totally different photos together, like replacing the blown out sky in your photo of the Taj Mahal with a good sky from a photo of your dude-ranch trip. To use Photomerge Exposure, your photos should be pretty much identical except for their exposures. So use images you took with your camera's exposure bracketing feature, or even one shot you've processed twice or more to get one good version with properly exposed highlights, one with good shadows, and so on. Sadly, Elements actually does a better job with a single photo processed two ways than it does with multiple shots, so if you don't like what you get by blending two actual exposures, take the best one, process it two ways, and then use those files as the basis of your merge.

Automatic Merges

It's incredibly easy to combine your photos using the Automatic Merge option. Elements makes most of the decisions for you. (If that's not for you, you can opt for a manual merge, where you call the shots, as explained in the next section.) Here's what you do:

1. Prepare, open, and select your images.

You can start with two or more photos where you used exposure bracketing on your camera, or with one image that you processed in two (or more) different ways in the Raw Converter (page 270), for example, once favoring the shadows and once the highlights.

Elements lets you combine up to 10 photos, so you can create as many different versions as you need to make sure every part of the image is properly exposed. Then select the photos you want to work with in the Project bin, and you're ready for the next step.

2. Call up the Photomerge Exposure window.

In Full Edit, go to File \rightarrow New \rightarrow Photomerge Exposure, or Guided Edit \rightarrow Photomerge \rightarrow Exposure. Either way, the Photomerge Exposure window opens. It's a lot like the windows for Group Shot, Faces, and Scene Cleaner, if you've used any of those before, and it works much the same way.

3. Tell Elements you want to make an automatic merge.

Most of the time, you'll already see the final automatically merged image, but if the Exposure Merge window doesn't open with the Automatic tab active, simply click that tab. (It's easy to tell which tab is active without even looking at the right side of the window: in Automatic mode you see only one image in the preview area on the left of the screen, while in Manual mode you see two.)

4. Select a merge option and make any adjustments you want.

On the right side of the Exposure Merge window are two radio buttons that let you choose the type of automatic merge:

- Simple Blending. Elements does everything—all you have to do is click Done.
- Smart Blending. If you pick this option, you can use the three sliders on the right side of the window to adjust the merge. (The sliders are explained below.) Elements uses a different kind of analysis on your photo here than it does if you opt for the Simple Blending merge, so don't be surprised if the values in your image shift a bit when you click this radio button.

You can't use the sliders if you have Simple Blending selected; they only become active when you choose Smart Blending.

5. When you're happy with what you see, click Done.

Elements blends the photos as a separate file so that your originals are preserved. Don't forget to save the blended image.

That's all there is to it. Elements does a pretty good job, as shown in Figure 8-11 (depending on your photos, of course). But you can help the program by nudging the Smart Blending sliders if you aren't quite satisfied with what Elements proposes for your image. Here's what each slider does:

- Highlight Details controls the way Elements blends the bright areas of the images.
- Shadows adjusts the blend for the darker areas.

Tip: If you've used Shadows/Highlights (page 231), you already know everything you need to about these two sliders.

• **Saturation** adjusts the color intensity, which is handy if the blend made your photo look a little drab or oversaturated. It's similar to the Saturation slider in Quick Fix (page 141).

If you prefer to have more control over what Elements does, you can combine your photos manually instead, as explained next.

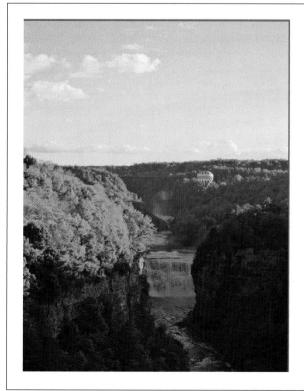

Figure 8-11:

Here's what Elements proposes as a Simple Merge for the photo shown in Figure 8-10. You'd probably want to tweak it some in the Editor, but overall, Photomerge Exposure did a pretty good job. You can do even better by making a manual merge, where you have more control over how the images blend together. The sky is still a tad light in this version, for instance.

Manual Merges

Automatic merges are super easy to do, even for a beginner, but sometimes Elements just doesn't get it right. Or maybe you just like telling Elements what to do rather than accepting its judgment about your images. Either way, manual merges are what you want.

You begin a manual merge the same way as an automatic one (follow steps 1 and 2 on page 291). Then, once you have the Photomerge Exposure window open:

1. Choose to make a manual merge.

On the right side of the Photomerge Exposure window, click the Manual tab if it's not already active. When you do, Elements changes the window to display spaces for two photos, just like it does for Photomerge Faces, Group Shot, and Scene Cleaner (all described in Chapter 11).

2. Choose a background photo.

This is the photo that's going to be the basis of your merge—the one you'll blend bits of other photos into. Usually, you'll want to pick the photo with the largest area of correct exposure, though the Tip below describes an exception to this rule. (You can use up to ten photos in a manual merge, but you only work with two at a time.) Drag your background photo of choice into the right-hand slot.

Tip: If you're blending several exposures, you may get the best results if you choose the photo with the best midtones as your background photo, even if that's not the photo with the largest properly exposed area. That's because Elements likes to start from the middle and work out when blending several images (in other words, it works better if you let it figure out the midtones first before making it blend the shadows and highlights).

3. Choose a foreground photo.

This is the photo you'll copy bits from to put in the background photo. Doubleclick it to tell Elements it's the one you want to use. It appears in the left-hand slot. (Elements sometimes picks a foreground image for you, but it's not always a good guesser and you may want to override the choice it made.)

4. Tell Elements what to copy.

Click the Selection Tool button on the right side of the window (the pencil icon) and drag over the areas in the foreground photo that you want to move to the background photo. This tool works like the Quick Selection tool in that it automatically expands the selection from the line or dot you make. If it selects too much or if you drag over something by mistake, use the Eraser tool to remove some of your marks (see Figure 8-12).

5. If you need to, align the photos.

If your copied material is slightly out of alignment with the background photo (a common problem if you used exposure bracketing for live subjects), scroll down in the Manual tab until you see the Advanced Option header; click it, and then click the Alignment Tool button. When you do, three little target marks appear in each preview when you move your cursor over the photo. Drag the marks so they're in the same spot in each photo (like over a tiger's eyes and mouth in bracketed wildlife photos), and then click the Align Photos button. Elements figures out the difference in perspective between the two images and corrects for it.

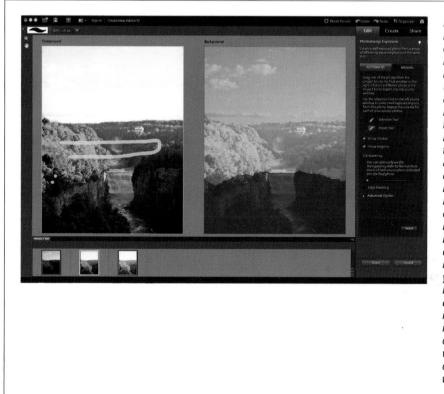

Figure 8-12:

Here's the midpoint of creating a manual merae of the imaae in Figure 8-10. (The Show Regions checkbox is turned on here to make it easier to see what Elements is doing.) Here, the trees on the cliffs are being brought over from the left image, as indicated by the vellow mask on the riaht-hand image. However, the balloon itself is a tad overexposed in spots in the left image, so vou miaht want to ao back with the eraser and remove the marks over it so that it doesn't aet copied over. or else zoom the view way in to erase only the blown-out white parts.

6. Tweak the blending.

You may be horrified by how crudely Elements blends the images at first, but that's okay. There are two settings in the Manual tab that you can use to fix things:

- **Transparency**. Use this slider to adjust the foreground image's opacity for a more realistic effect.
- Edge Blending. Turn on this checkbox and Elements automatically refines the edges of the blend to avoid a cut-and-pasted look. (This one appears second in the list, but try it first.)
- 7. Repeat with other images, if you wish.

If you want to add details from another image that you preselected, drag it to the foreground image slot and repeat the process. You can keep doing this to combine a total of 10 images. Each additional photo gets a different colored marker to help you keep track of what came from which photo.

8. When you like what you see, click Done.

As with an automatic merge, Elements creates a new layered file for the blended image so your originals are untouched.

If you need to adjust the view while you're working on a merge, Elements gives you some help:

- Zoom and Hand tools. Your old friends the Zoom and Hand tools live in the little toolbox to the left of the images. They work the same way here as everywhere else in Elements.
- Show Strokes. This checkbox in the Merge tab lets you show or hide the marks you make with the Selection tool.
- Show Regions. Turn this on and Elements displays a yellow mask over the background photo, with blue over the areas where it's blending in material from the foreground photo, as you can see in Figure 8-12. The window area is yellow because that's what's coming over from the foreground photo. (If you add more photos, each gets a mask colored to match its marker color.)

Tip: Photomerge Exposure is fun, but you may find you want something a bit more powerful. In that case, you should explore HDR (High Dynamic Range) programs and plug-ins. Regardless of whether you have a Windows computer or a Mac, a good place to start is *www.hdrlabs.com*. Mac folks should also check out Bracketeer from Pangeasoft (*www.pangeasoft.net*), an excellent exposure-blending program that produces wonderful results.

WORKAROUND WORKSHOP

Manually Blending Exposures

Elements' Photomerge Exposure tool makes it pretty easy to blend exposures, but you may not care for the final result, no matter how much effort you put into it. In that case, you can just blend the images yourself by stacking them up, and it's not too hard to do:

- Open both exposures. You can only work with two images at once when you do it this way.
- Pick the photo with the largest amount of properly exposed area. That's going to be the top layer of your combined image.
- Turn that photo into a regular layer. Double click it in the Layers panel to unlock it. You can give it a name, if you want, or just click OK to accept the one Elements gives it.

- Apply a layer mask to it. Click the layer mask icon at the bottom of the Layers panel (it looks like a circle within a square).
- Combine the images. In the Project bin, drag the masked photo's layer thumbnail onto the other image's thumbnail.
- 6. Edit the layer mask to combine the images. On the layer mask, paint out the badly exposed areas of the masked photo to let the well-exposed parts of the other image show through. See page 213 for the details of how to do this.

If you want to add additional exposures, merge the two existing layers first, and then repeat the process with another image.

Photo Filter

Elements Photo Filter feature gives you a host of nifty filters to work with. These filters are the digital equivalent of the lens-mounted filters used in traditional film photography. They can help you correct problems with your image's white balance, and perform a bunch of other fixes from the seriously photographic to the downright silly. For example, you can correct bad skin tone or dig out an old photo of your fifth-grade nemesis and make him green. Figure 8-13 shows the Photo Filter in action.

Figure 8-13:

You can use the Photo Filter to correct the color casts caused by artificial lighting or reflected light.

Left: This photo had a strong warm cast from nearby incandescent lighting.

Right: The filter named "Cooling Filter (LBB)" took care of it. (Conversely, you'd use one of the warming filters to counteract a blue cast caused by fluorescent lighting.)

Elements comes with 20 photo filters, but for most people, the top six are the most important: three warming filters and three cooling filters, which you use to get rid of color casts caused by poor white balance (see page 251).

The filters sometimes work better than the Color Cast eyedropper (page 262) because you can control the strength with which you apply them (using the Density slider, explained in a moment). You can also apply them as Adjustment layers, so you can tweak them later on.

To apply a photo filter:

1. Open the Photo Filter dialog box, or create a new Adjustment layer.

Go to Layer \rightarrow New Adjustment Layer \rightarrow Photo Filter, or Filter \rightarrow Adjustments \rightarrow Photo Filter. Either way, you see the Photo Filter adjustment controls. If you go the Adjustment-layer route, the controls appear in the Adjustments panel after you click OK. If you're applying the Photo Filter directly to your image, you get a dialog box instead, but both offer exactly the same controls.

2. Choose a filter from the drop-down list or click the Color radio button.

The drop-down list gives you a choice of filters in preset colors. (The numbers following the names of some filters correspond to the numbers of the glass filters you'd use on a film camera.) If you want to pick your own custom color, then click the Color button instead.

3. If you turned on the Color button, then click the color square next to it to bring up the "Select filter color" dialog box—which is really just the Color Picker (page 254)—and choose the shade you want.

Pick a color for the filter, and that color appears in the dialog box's color square. Elements applies the color to your image so you can decide whether you like it. When you've got the color you want, click OK to close the Color Picker.

4. In the Adjustments panel or the dialog box, move the Density slider to adjust the intensity of the filter.

Moving the slider to the right increases the filter's effect; moving it to the left decreases it. If you leave the Preserve Luminosity checkbox turned on, then the filter doesn't darken your image. Turn off the checkbox and your photo gets darker when you apply the filter. Watch your image to see the effect.

5. When your photo looks good, save it.

Processing Multiple Files

If you're addicted to batch-processing photos, then you'll love Elements' Process Multiple Files feature. In addition to renaming your files and changing their formats, you can do a lot of other very useful things with this tool, like adding copyright information or captions to multiple files, or even using some of Quick Fix's Auto commands.

To call up the batch-processing window, in Full Edit, go to File \rightarrow Process Multiple Files. You see yet another headache-inducing, giant Elements dialog box. Fear not—this one is actually pretty easy to understand. If you look closely, you see that it's divided into sections, each with a different specialty (see Figure 8-14).

Tip: Process *Multiple* Files is the name of the command, but you can run it on just one photo if you want, although you'll usually find it easier to do a regular Save As (see Chapter 2 for more about saving files). Just open your photo, go to File—Process Multiple Files, and then, in the Process Files From drop-down menu, choose Opened Files. You can even opt to save the new version to the desktop so you don't overwrite the original.

Processing Multiple Files

Process Multiple Files		
Learn more about: Process Multiple Files		
Process Files From: Folder Source: HD:Users:Barbara:Desktop:tournament photos: Browse Include All Subfolders Destination: op:tournament photos:tournament processed: Browse Same as Source File Naming Rename Files Dasketball_tournament + 3 Digit Serial Number Example: basketball_tournam Starting serial#: 1 Compatibility: Windows Mac OS Unix Image Size Resize Images	Quick Fix Auto Leve Auto Cole Auto Cole Sharpen Labels Caption File Name Description Position: Fonts: T	e on
Width: pixels ▼ Resolution: 150 ▼ dpi Height: pixels ↓ <t< td=""><td>Opacity: Color:</td><td>100 -</td></t<>	Opacity: Color:	100 -
File Type I Convert Files to: PSD V		
Log errors that result from processing files		

Figure 8-14:

You could call Process Multiple Files "Computer, Earn Your Keep," because it can make so many chanaes at once.

Here. the dialog box is set up to apply the following changes: Rename every file (from thinas like PICT8983 to basketball tournament001. basketball tournament002, and so on). chanae the imaaes to PSD format. apply Auto Levels and Auto Contrast, and add the filename as a caption. You make all that happen just by clicking the OK button.

The following sections cover each part of the Process Multiple Files dialog box. You *have* to use the first section (which tells Elements which files to process), but you'll probably want to use only one or two of the other sections at any given time (though you can use them all, as shown in Figure 8-14).

Tip: If you're working in the Windows Organizer, then you can do some batch-processing without opening the Editor. Select the files you want, and then go to File \rightarrow Export As New File(s) (or press Ctrl+E). You get a dialog box that lets you change the files' format, pick a new size from a list of presets, set a destination for the new images, and choose a new "common base name" (if you want). If you choose this last option, then your files get the new name plus a sequential number. (By the way, this export feature is a great way to create a folder of JPEGs to send to an online photo service.) Unfortunately, the Export command isn't available in the Mac Organizer.

Choosing Files

The upper-left section of the dialog box is where you identify the files you want to convert, and then tell Elements where to put them once it has processed them. You have several options here, which you select from the Process Files From drop-down menu: the contents of a folder, files you import, or the currently open files. Choosing Import brings up the same options you get when you select File→Import; use this option to convert files as you bring them into Elements—from a camera or scanner, for example.

Tip: If you want to include files scattered around in different locations on your hard drive, then speed things up by opening the files first or gathering them into one folder. If you have a couple of folders' worth of photos to convert, save time by putting all those folders into one containing folder and using the Include All Subfolders option explained in a moment. That way, all the files get converted at once.

Here's a step-by-step tour of the process:

1. Choose the files you want to convert.

Use the Process Files From drop-down menu to select which kind of files you want: a folder, files imported from your camera or scanner, or files that are currently open.

2. If you chose Folder, then tell Elements which folder you want.

Click the Browse button and, in the dialog box that appears, choose a folder. (Files you want to process have to be in a folder if they aren't already open.)

If you have folders *within* a folder and you want to operate on all those files, then turn on the Include All Subfolders checkbox. Otherwise, Elements changes only the files in the top-level folder.

3. Pick a destination.

This field tells Elements where to put the files after it processes them. Most of the time, you'll want a new folder for this, so click Browse, and then, in the window that opens, click New Folder. Or you can choose an existing folder in the Browse window, but a word of warning if you go this route: Be careful about choosing "Same as Source;" Figure 8-15 explains why.

be overwritten.	lles wil
OK	

Figure 8-15:

If you turn on the "Same as Source" checkbox, then Elements warns you that it's going to replace your originals with the new versions. That can be a timesaver, but it's dangerous, too—if something goes wrong, then your originals are toast. Bottom line: Don't turn on "Same as Source" unless you have backup copies someplace else.

Processing Multiple Files

The following sections explain the various things Process Multiple Files can do to the files you've selected.

Renaming Files

Being able to rename a group of files in one fell swoop is a very cool feature, but it has a few limitations. If you think it means you can give each photo a unique name like "Keisha and Gram at the Park," followed by "Fred's New Newt," and so on, you're going to be disappointed. Instead, what Elements offers is a quick way of applying a similar name to a group of files. That means you can easily transform a folder filled with files named *DSCF001.jpg*, *DSCF0002.jpg*, and so on, into the slightly friendlier *Keisha and Gram001.jpg*, *Keisha and Gram002.jpg*.

To rename files, turn on the Process Multiple Files dialog box's Rename Files checkbox. Below it are two text boxes with drop-down menus next to them (a + signseparates the menus). You can enter anything you like in these boxes, and it replaces every filename in the group. Or you can choose any of the options in the menus (both menus are the same).

The menus offer you a choice of the document name (in three different capitalization styles), serial numbers, serial letters, dates, extensions, or nothing at all (which gives you just numbers without any kind of prefix). Figure 8-16 shows the many options you get.

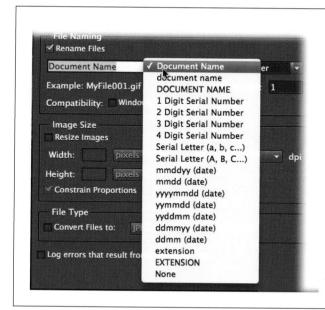

Figure 8-16:

Elements offers loads of naming options. If you select Document Name, for example, your photos retain their original names plus whatever you choose from the right-side drop-down menu. DOCUMENT NAME gets you the same filenames in all capital letters, "1 Digit Serial Number" starts you off with the number 1, and so on. **Tip:** If you want to add serial numbers to your filenames, you can designate the starting number in the "Starting serial#" box. Elements always starts out by suggesting 1. However, you can type over the 1 to change it to any number you please. Once you make a choice, just below the Document Name area, you can see an example of how the filename will look. So if you type *tongue_piercing_day* into the first text box and choose 3 Digit Serial Number in the second, then Elements names your photos *tongue_piercing_day002.jpg*, and so on.

Tip: If you turn on the "Same as Source" checkbox, then Elements grays out the Rename Files option. So if you want to put your renamed files in the same folder as the originals, leave "Same as Source" turned off, but select the same folder as the destination in the top part of the dialog box. That way Elements, places your renamed files in the same folder as the originals without *replacing* the originals.

You also get to tell Elements which operating systems' naming conventions it should use when assigning the new names, as explained in Figure 8-17. If you send files to people or servers that run other operating systems, then you know how important this is. Your best bet is to play it safe and turn on all three checkboxes; you never know when you may need to send a photo to your nephew who uses Linux.

Figure 8-17:

The Compatibility checkboxes tell Elements to watch out for any characters that would violate the naming conventions of the operating systems you select. This is handy if, say, your website is hosted on a Unix server and you want to be sure your filenames don't create problems for it. The checkbox for your own operating system is always turned on, and you can choose to be compatible with either or neither of the other operating systems.

Changing Image Size and File Type

The Image Size and File Type sections of the Process Multiple Files dialog box let you resize photos and change their file formats. The Image Size settings work best when you're trying to reduce file sizes (say you've got a folder of images that you've converted for Web use but found are still too big).

Note: Before you make any big changes to a group of files, it's important to understand how changes to an image's resolution and file size affect its appearance. See page 114 for a refresher.

To apply image-size changes, turn on the Resize Images checkbox, and then adjust the Width, Height, and Resolution settings, all of which work the same way as those described on page 119. You'll get better results with this command if you make sure all the images you run it on in one batch are in the same orientation. In other words, use it first on your landscape-oriented files and then on your portrait-oriented images.

In the File Type section, you can convert files from one format to another. This is probably the most popular batch-processing activity. If, for example, your camera creates JPEGs and you want to edit TIFFs, then you can change a whole folder at once. From the drop-down menu, just select the type of files you want to create.

The final setting on the left side of the dialog box is a checkbox that makes Elements log any errors it runs into while processing your files. It's a good idea to turn this checkbox on, as explained in Figure 8-18.

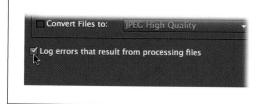

Figure 8-18:

If you turn on this checkbox, then Elements lets you know if it runs into any problems while converting the files. You'll find a little text log file in the folder with your completed images, whether there were problems or not. (If nothing went awry, it's blank.)

Applying Quick Fix Commands

In the upper-right corner of the Process Multiple Files dialog box are some of the same Quick Fix commands you find in the regular Quick Fix window. If you consistently get good results with the Auto commands there, then you can use these checkboxes to run them on a whole folder at once.

You can run Auto Levels, Auto Contrast, Auto Color, Auto Sharpen, or any combination of those commands that you like on all the files in the folder you're processing. If you need a refresher on what each one does, see Chapter 4, beginning on page 138.

Unfortunately, you can't batch-run the Auto Smart Fix command from this dialog box. If that's what you want to do, or if your only reason for bringing up the Process Multiple Files dialog box is to use any of the editing options (without renaming, resizing, or using any of the other features in Process Multiple Files), then you can save time by selecting your photos in the Organizer and running those commands right from the Organizer's Fix tab, as explained on page 129.

Tip: Don't forget that you can also batch-process corrections in the Raw Converter (see page 272). Then open the files in the Editor and use Process Multiple Files to save all the changed files at once.

Attaching Labels

The tools in the Labels section let you add captions and copyright notices, which Elements calls *watermarks*, to your images (see Figure 8-19). Watermarks and captions get imprinted right onto the photo itself. The process is the same for creating both; only the content differs. A watermark contains any text you choose, while a caption is limited to your choices from a group of checkboxes.

First, you need to choose between a watermark and a caption (select from the dropdown menu right below the Labels heading). You can't do both at once, so if you want both, add one, run Process Multiple Files, and then add the other and run Process Multiple Files again on the resulting images. You can download *fall.jpg* from this book's Missing CD page at *www.missingmanuals.com* to practice adding your own watermarks and captions.

Watermarks

To create a watermark, you enter some text in the Custom Text box, and then choose where you want the text to go and what it should look like, as explained in a moment. Text you enter here gets applied to every photo in the batch, so this is a great way to add copyright or contact info that you want on every photo, as shown in Figure 8-19. (If you want different text on each photo, check out the Description option for captions, as shown in Figure 8-20.)

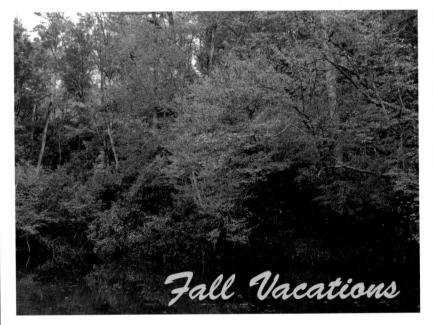

Figure 8-19:

The text "Fall Vacations" in this image is what Adobe calls a watermark. Elements is very flexible about the fonts and sizes you can choose for a watermark or caption, but you don't get much say in where it goes on your photo if vou use Process Multiple Files. For maximum flexibility, use the Type tool, as explained on page 474. The drawback: You can't batchprocess using that method.

Tip: If you're on a Windows computer and want to include the copyright symbol (O), hold the Alt key while typing *0169* on the number pad (not the top row of the keyboard), or use the Character Map (choose Start—All Programs—Accessories—System Tools—Character Map). On a Windows laptop without a number pad, turn on Number Lock (you may need to press the Fn key to do this) and then hold down the Alt key while typing *0169* on the embedded number pad (those are the numbers on the letter keys, not at the top of the keyboard). On a Mac, just press Option-G.

Once you've decided what you want the custom text to say, you need to make some choices about its position and size. These options are the same whether you're adding a watermark or a caption, and if you switch from one to the other before actually running Process Multiple Files, then your previous choices appear:

- **Position**. This tells Elements where to put your caption. Your options are Bottom Left, Bottom Right, or Centered. Careful: Centered doesn't mean "bottom center"—it puts the text smack in the middle of your image.
- **Font**. From the drop-down menu, choose any font on your computer. (Chapter 14 has tons of info about fonts.)
- **Size**. This setting (whose icon is two Ts) determines the how big your text is. Click the menu next to the two Ts to choose from several preset sizes, up to 72 point.
- **Opacity**. Use this to adjust how solidly your text prints. Choose 100 percent for maximum readability, or click the down arrow and move the slider to the left for watermark text that lets the image underneath it show through.
- **Color.** Use this setting to select your text's color. Click the box to bring up the Color Picker (page 254) and make your choice.

Tip: If you want to use a logo as a watermark, the Process Multiple Files dialog box can't help you. But there *is* a way to apply a logo to a bunch of images in Elements: First, create the logo on a new layer in one of the images. Adjust the opacity with the slider in the Layers panel until you like the results, and then save the file. Now you can drag that layer from the Layers panel onto the image window for each photo where you need it. (If you Shift-drag the layer, then it goes to exactly the same spot on each image, assuming they're all the same size.) You can also do this with Adjustment layers, which give you a sort of batch-processing capability for applying the same adjustments to multiple files. Another option is to create a custom brush from your logo (page 407) and use that, and then adjust the opacity or apply a Layer style (page 456) for a truly custom look.

Adding captions

For a caption, you can select any of the following, separately or in combination:

• File Name. You can choose to show the file's name as the caption. If you decide to run the rename option at the same time, then you get the new name you're assigning.

- Description. Turn this checkbox on to use any text you've entered in the Description section of the File Info dialog box (File→File Info) as your caption. This option is your most flexible one for entering text, and the only way to add different text to each photo you're batch-processing (see Figure 8-20). Just enter the text for each photo in the Description field of the File Info dialog box before you use Process Multiple Files.
- Date Modified. This is the date your file was last changed. In practice, that means today's date, because you're modifying your file by running Process Multiple Files on it.

Your choices for how and where your caption will appear are the same as those listed above for watermarks.

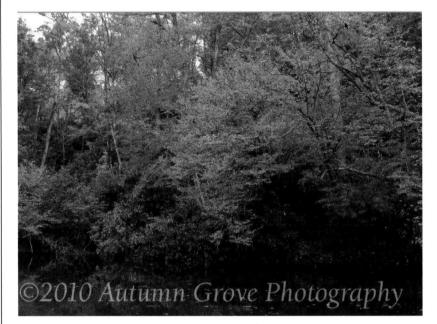

Figure 8-20: You just can't beat Process Multiple Files for quickly adding copyright info to your photos, although some other methods create a more sophisticated look, as described in the Tip on page 305.

CHAPTER

Retouching: Fine-Tuning Images

B asic edits like exposure fixes and sharpening are fine if all you want to make are simple adjustments. But Elements also gives you tools to make sophisticated changes that aren't hard to apply, and that can make the difference between a ho-hum photo and a fabulous one. This chapter introduces you to some advanced editing maneuvers that can help you rescue damaged photos or give good ones a little extra zing.

The first part of the chapter shows how to get rid of blemishes—not only those that affect skin, but also dust, scratches, stains, and other photographic imperfections. You'll also learn some powerful color-improving techniques, including using the Color Curves tool, which is a great way to enhance your image's contrast and color.

Then you'll learn to use the exciting Recompose tool, which lets you change the size and shape of your photos, eliminate empty areas between subjects in an image, and even get rid of unwanted elements in your pictures, all without distorting the parts you want to keep. This amazing feature works so well that nobody seeing the results would ever suspect the photo wasn't originally shot that way.

Fixing Blemishes

It's an imperfect world, but in your photos, it doesn't have to be. Elements gives you powerful tools for fixing your subject's flaws: You can erase crow's feet and blemishes, eliminate power lines in an otherwise perfect view, or even hide objects you wish weren't in your photo. Not only that, but these same tools are great for fixing problems like tears, folds, and stains—the great foes of photoscanning veterans. With a little effort, you can bring back photos that seem beyond help. Two of the most important ways to do this are cloning and healing. Cloning lets you patch bad areas by hiding them with material from elsewhere in a photo. Healing is similar, but when you use this method Elements also evaluates the area around the spot you're fixing and then blends your repair into what's already there. You'll need to use both methods to fix badly damaged photos. Figure 9-1 shows an example of the kind of restoration you can accomplish with Elements (and a little persistence).

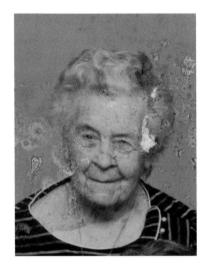

Figure 9-1:

Top: Here's a section of a water-damaged family portrait. The grandmother's face is almost obliterated.

Bottom: The same image after repairing it with Elements. It took a lot of cloning and healing to get this result, but if you keep at it, you can do the kind of work that would have required professional help before Elements.

If you're interested in restoring old photos, check out Katrin Eismann's books on the subject (Photoshop Restoration and Retouching [New Riders, 2006] is a good one to start with). They cover full-featured Photoshop, but you can adapt most of the techniques for Elements. You might also want to read Matt Kloskowski's The Photoshop Elements 5 Restoration and Retouching Book (Peachpit, 2007). (Although it's for Elements 5 for Windows, you can still use the techniques in later versions of Elements for Mac or PC.)

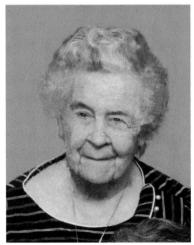

Elements gives you three main tools for this kind of work:

- The Spot Healing brush is the easiest way to repair photos. Just drag over the spot you want to fix, and Elements searches the surrounding area and blends that info into the trouble spot, making it indistinguishable from the background. What's more, you get a Content-Aware option, bringing over one of the most popular features from Photoshop (although the Elements version is much more limited; see page 311). When you use the Content Aware feature, Elements analyzes your photo so it can create new material that looks like part of the original image. This makes the Spot Healing Brush a truly versatile tool for making seamless fixes.
- The Healing brush works much like the Spot Healing brush, only you tell the Healing brush which part of your photo to use as a source for the material you want to blend in. This tool is better suited to large areas, because you don't have to worry about inadvertently dragging in unwanted details.
- The Clone Stamp works like the Healing brush in that you sample a good area and apply it to the spot you want to fix. But instead of blending the repair in, the Clone Stamp actually covers the bad area with the replacement. This tool is best for situations when you want to *completely* hide the underlying area, as opposed to letting any of what's already there blend into your repair (which is how things work with the Healing brushes). The Clone Stamp is also your best option for creating a realistic copy of details that are elsewhere in your photo. You can clone some leaves to fill in a bare branch, for instance, or replace a knothole in a fence board with good wood.

All three tools work similarly: You drag each one over the area you want to change. It's as simple as using a paintbrush. In fact, each of these tools requires you to choose a brush like the ones you'll learn about in Chapter 12. Brush selection is pretty straightforward; you'll learn the basics in this chapter.

Tip: To smooth out blotchy or blemished skin, check out the Surface Blur filter, explained on page 449. It's good to try for minor touch-ups that affect large areas. In contrast, the tools described in this section are better for fixing individual imperfections, like pimples or scars.

The Spot Healing Brush: Fixing Small Areas

The Spot Healing brush is great at fixing minor blemishes like pimples, lipstick smudges, stray lint, and so on. Simply paint over the area you want to repair, and Elements searches the surrounding regions and blends them into the spot you're brushing. Figure 9-2 shows what a great job this tool can do. (If you'd like to experiment with this tool, download the file *borage.jpg* from this book's Missing CD page at *www.missingmanuals.com.*)

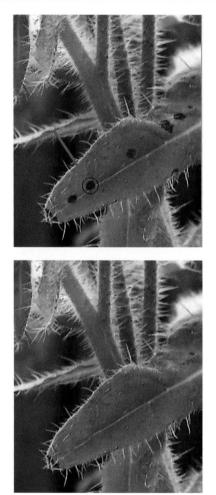

Figure 9-2:

The trick to using the Spot Healing brush is to work on tiny areas. If you choose too large a brush or drag over too large an area, you're more likely to pick up undesired shades and details from the surrounding area.

Top: Say you want to show off your fine crop of borage, but something's been attacking the leaves. Simply grab a brush that's just barely bigger than the blemish, like the one shown here.

Bottom: One click with the Spot Healing brush and you have a truly invisible fix. It only took a few clicks to repair all the brown spots on this leaf.

The Spot Healing brush's ability to borrow information from surrounding areas is great in some situations, but a drawback in others. The larger the area you drag the brush over, the wider Elements searches for replacement material. So if there's contrasting material close to the area you're trying to fix, it can get pulled into the repair. For instance, if you're trying to fix a spot on an eyelid, you may wind up with some of the color from the eye itself mixed in with your repair.

You get the best results from this brush when you choose a brush size that barely covers the spot you're trying to fix. If you need to drag to fix an oblong area, for instance, use the smallest brush width that covers the flaw. The Spot Healing brush also works much better when there's a large surrounding area that looks the way you want your repaired spot to look.

Tip: Sometimes you can help Elements out by making a selection first, to limit the area where the brush can search for replacement material.

You won't believe how easy it is to fix problem areas with this tool. All you do is:

1. Activate the Spot Healing brush.

Click the Healing brush icon (the Band-Aid) in the Tools panel or press J, and then choose the Spot Healing brush—the one with the dotted selection lines extending from it—from the pop-out menu.

2. Choose a brush just barely bigger than the flaw you're trying to fix.

You can adjust your brush size using the Options bar's Size slider or by pressing] (the close bracket key) for a larger brush or [(the open bracket key) for a smaller brush.

The Spot Healing brush is set to use Content-Aware (explained in a sec), and that's the best setting to try first.

3. Click the bad spot.

If the brush doesn't quite cover the flaw, drag over the blemished area.

4. When you release the mouse button, Elements repairs the blemish.

You may see a weird dark gray area as you drag. Don't worry—it's just there to show you where you're brushing and it disappears when Elements fixes the photo after you let go.

The Spot Healing brush has four Options bar settings:

- **Brush**. You can use this pull-down menu to choose a different brush style (see Chapter 12 for more about brushes), but you're usually best off sticking to the standard brush that Elements starts with and just changing the size, if necessary.
- **Size.** Use this box to set the brush's size. You want a brush just barely wide enough to cover the blemish you're healing.
- **Type**. These radio buttons let you adjust how the brush works. **Proximity Match** tells Elements to search the surrounding area for replacement pixels, and **Create Texture** tells it to blend only from the area you drag it over. Choosing **Content-Aware** tells the program to do some fancy figuring to invent new material to blend in with the existing photo (see Figure 9-3).

Your best bet will usually be to try Content-Aware first. If that doesn't do a good job, undo what you did and try Proximity Match instead. Generally speaking, if Proximity Match doesn't work well, you'll get better results by switching to the regular Healing brush than by choosing Create Texture, though Adobe suggests that you may like the results you get from Create Texture better if you drag over a spot more than once.

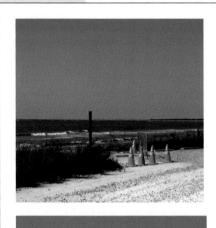

Figure 9-3:

The Content-Aware option for the Healing Brushes can give you amazing results with some photos, but it can also result in cases of "so near and yet so far," as you can see here.

Top: The only day you could get to the beach with your camera, there were traffic cones everywhere.

Bottom: The Content-Aware option did a great job of zapping the big wooden post, but large areas like all those cones make it confused about what to use as replacement material. You could keep trying the Spot Healing brush over and over, but at this point it would be faster to use the Clone Stamp (page 315) for that area instead.

• Sample All Layers. Turn this checkbox on if you want the brush to look for replacement material in all your photo's visible layers. If you leave it off, Elements only uses material from the active layer. (Another reason to turn this on: if you created a new, blank layer to heal on so you can blend your work in later by adjusting the healed area's opacity.)

Sometimes you get great results with the Spot Healing brush on a larger area if it's surrounded by a field that's similar in tone to the spot you're trying to fix, especially if you use the Content-Aware option, but you may find that you need to do extra work for a perfect result (see Figure 9-3). Sometimes you can switch to Proximity Match and finish up, or you may need the regular Healing Brush (explained next) or the Clone Stamp (page 315) to get things just perfect.

The Healing Brush: Fixing Larger Areas

The Healing brush lets you fix much bigger areas than you can usually manage with the Spot Healing brush. The main difference between the two tools is that with the regular Healing brush, *you* choose the area that gets blended into the repair. The blending makes your repair look natural, as Figure 9-4 shows.

Fixing Blemishes

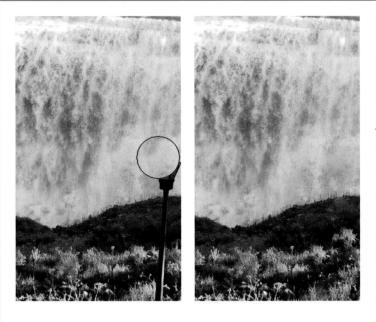

Figure 9-4:

Left: After you Alt-click/Option-click to choose your repair source, the brush's cursor shows you the area it plans to blend. Here, for instance, inside the cursor's circle you can see the part of the waterfall you'll be blending in, rather than the lamppost you'll be covering up. (If this bothers you, see page 315 to learn how to aet a reaular. empty cursor.)

Right: It took three brushstrokes to eliminate this lamppost (one for the water, one for the grass, and one for where they intersect), but you can see how quickly this method gets you 99% of the way to a naturallooking fix. There's a little bit of haze in the grass right along the edge of the cliff that might benefit from a little touching up with the Clone Stamp (page 315), but that only requires another click or two.

Tip: You may want to give the Spot Healing brush's Content-Aware option a try for larger areas, too. If it fails, then go with the regular Healing brush instead. And sometimes you'll want to use both brushes. For example, in Figure 9-4, the regular Healing brush does a good job hiding the lamppost where it was in front of the water and the ground, but you might want to try the Spot Healing brush's Content-Aware option to get a good transition line between the two.

The basic procedure for using the Healing brush is similar to that for the Spot Healing brush: Drag over the flaw you want to fix. The difference is that with the Healing brush, you first Alt-click/Option-click where you want Elements to look for replacement pixels. The repair material (which Elements calls your "source") doesn't have to be nearby; in fact, you can sample from a totally different photo if you like (to do that, just arrange both photos in your workspace so you can easily move the cursor from one to the other).

It's almost as simple to use the Healing brush as it is to use the Spot Healing brush:

1. Activate the Healing brush.

Click the Healing brush's icon (the Band-Aid) in the Tools panel or press J and choose it from the pop-out menu.

2. Find a good spot to use in the repair and Alt-click/Option-click it.

When you Alt-click/Option-click the good spot, your cursor temporarily turns into a circle with crosshairs in it to indicate that this is the point from which Elements will retrieve your repair material. (If you want to use material from a different photo, both the source photo and the one you're repairing have to be in the same *color mode*—see page 54.)

3. Drag over the area you want to repair.

You can see where Elements is sampling the repair material from because it puts a + in that spot. As with the Spot Healing brush, the area you drag over turns dark until you release the mouse button.

4. When you let go of your mouse, Elements blends the sampled area into the problem area.

You often won't know how effective you were until Elements is through working its magic (it may take a few seconds for the program to finish its calculations and blend in the repair). If you don't like the result, press Ctrl+Z/:Z to undo it and try again.

The Healing brush offers you quite a few choices in the Options bar:

- **Brush.** Click the brush thumbnail for a pop-out palette that lets you customize the size, shape, and hardness of your brush cursor (see page 399). The standard brush generally works well, so you'll probably just need to adjust its size. If you have a graphics tablet, you can use the menu at the bottom of the palette to tell Elements you want to control the brush size by how hard you press on the stylus or the stylus's scroll wheel.
- Mode. You can choose from various blend modes (page 199) here, but most of the time, you want one of the top two options: Normal and Replace. Normal is usually your best choice, but if the replacement pixels give the area you working on a visibly different texture than the surrounding area, choose Replace instead, which preserves the grain of your photo.
- **Source.** You can sample an area to use as a replacement (by leaving the Sampled radio button turned on), or you can blend in a pattern (by turning on the Pattern radio button). Using the Healing brush with patterns is explained on page 321.
- **Pattern thumbnail**. If you turn on the Pattern radio button, Elements activates this box. Click it to select a pattern.
- Aligned. If you leave this checkbox turned off, all the material Elements uses comes from the area that you first defined as your source point. Turn on this checkbox, and Elements keeps sampling new material in your source as you use the tool; the sampling follows the direction of your brush. Even if you let go of the mouse button, Elements continues to sample new material as long as you continue brushing.

Generally, for both the Healing brush and the Clone Stamp (see below), it's easier to leave this setting turned off. You can still change your source point by Alt-clicking/Option-clicking another spot, but you often get better results if *you* make the decision about when to move on to another location rather than letting Elements decide.

- **Sample All Layers**. This checkbox tells Elements to sample from all the visible layers in the area where you set your source point. Leave it turned off and Elements samples only the active layer. You would turn it on if you wanted to heal on a new, blank layer.
- Overlay Options. Click this icon (the overlapping gray squares) for a pop-out menu where you can turn off or adjust the visible overlay for your photo (the filled cursor). The menu lets you see a floating, ghostly overlay of the source area where you're sampling in relation to your original, so you can tell exactly how things line up for accurate healing. You can also adjust the overlay's opacity or invert it (make the light areas dark and the dark areas light so that you can see details more clearly) for a better view. The Clipped option pins the overlay to your brush so you see only a brush-sized piece of overlay rather than one that covers the entire image. Turning on the Auto Hide checkbox makes the overlay disappear when you click so it's not in your way as you work. When you first use the Healing brush, it's set to use a Clipped overlay. Just turn off all the settings in this menu if you want an empty circle for your cursor.

Note: The Clone Stamp (explained next) has the same Overlay Options settings as the Healing brush, and the settings you choose for one tool also apply when you switch to the other tool.

You can also heal on a separate layer. The advantage of doing this is that if you find the end result is a little too much—your granny suddenly looks like a Stepford wife, say—you can back things off a bit by reducing the opacity of the healed layer to let the original show through. This is also a good plan when using the Clone Stamp (explained next). Just press Ctrl+Shift+N/\#-Shift-N to create a new layer and then, in the Options bar, turn on the Sample All Layers checkbox.

The Clone Stamp

The Clone Stamp is like the Healing brush in that you add material from a source point that you select, but the Clone Stamp doesn't *blend in* the new material—it just covers up the underlying area. This makes the Clone Stamp great for when you don't want to leave any trace of what you're repairing. Figure 9-5 shows an example of when cloning is a better choice than healing.

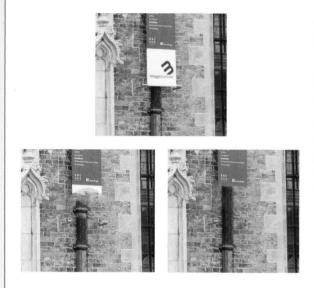

Figure 9-5:

Here's an example of when you'd choose cloning over healing.

Top: Say you want to get rid of the distracting white part of this banner.

Bottom left: Using content-aware healing (page 311) gets you started, but it also heals away part of the drainpipe and duplicates the strap holding it to the building.

Bottom right: By using the Clone Stamp in concert with the Spot Healing Brush, you can remove the white part of the banner and extend the pipe.

GEM IN THE ROUGH

Fixing Dust and Scratches

Scratched, dusty prints can create giant headaches when you scan them. Cleaning your scanner's glass helps, but lots of photos come with dust marks already in the print, or in the file itself if the lens or sensor of your digital camera was dusty.

A similar problem is caused by *artifacts*, blobbish areas of color caused by JPEG compression. If you take a close look at the sky in a JPEG photo, for instance, you may see that instead of a smooth swath of blue, there are lots of little distinct clumps of each shade of blue.

The Healing brushes are usually your best first line of defense for fixing these problems, but if the specks are widespread, Elements offers a couple other options.

The first is the Reduce Noise filter's JPEG artifacts option (page 442). If you're lucky, that will take care of things.

If it doesn't, another possible solution is the Despeckle filter (Filter \rightarrow Noise \rightarrow Despeckle). And if *that* doesn't get everything, undo it and try the Dust & Scratches filter (Filter \rightarrow Noise \rightarrow Dust & Scratches) or the Median filter (Filter \rightarrow Noise \rightarrow Median). The Radius setting for these last two filters tells Elements how far to search for pixels to use in its calculations; keep that number as low as possible. The downside to using the filters in this group is that they smooth things out in a way that can make your image look blurred, so you'll probably want to make a selection first to confine their effects to the areas that need repair. Generally, Despeckle is the filter that blurs your image the least.

One final option: Try creating a duplicate layer (Layer \rightarrow Duplicate), running the Surface Blur filter (page 449) on it and then, in the Layers panel, reducing the opacity of the filtered layer.

Using the Clone Stamp is much like using the Healing brush, but you get different results:

1. Activate the Clone Stamp.

Click its icon (the rubber stamp) in the Tools panel or press S, and then choose it from the pop-out menu.

Tip: You can clone on a separate layer, just as you can use the Healing tool on a dedicated layer. It's a good idea to clone on a separate layer, since cloning is so much more opaque than healing, plus it lets you adjust the opacity of your repair afterwards. So before you start cloning, press Shift+Ctrl+N/Shift-**#**-N to create a new layer and then turn on Sample All Layers in the Options bar.

2. Find the spot you want to repair.

You may need to zoom way, way in to get a good enough look at what you're doing. (Page 111 tells you how to adjust your view.)

3. Find a good spot to sample as a replacement for the bad area.

You want an area that has the same tone as the spot you're fixing. The Clone Stamp doesn't do any blending the way the Healing brush does, so any tone difference will be pretty obvious.

4. Alt-click/Option-click the spot you want to clone from.

When you click, the cursor turns to a circle with crosshairs in it, indicating the source point for the repair. (Once you're actually working with the Clone Stamp, you see a + marking the sampling point.)

5. Click the spot you want to cover.

Elements puts whatever you just selected on top of your image, concealing the original. You can drag with the Clone Stamp, but that makes it act like it's in Aligned mode (described in the previous list), so it's often preferable to click several times for areas that are larger than your sample. (The only difference between real Aligned mode and what you get from dragging is that with dragging, when you let go of the mouse, your source point snaps back to where you started. If you turn on the Aligned checkbox, your source point stays where you stopped.)

6. Continue until you've covered the area.

With the Clone Stamp, unlike the Healing brush, what you see as you click is what you get—Elements doesn't do any further blending or smoothing.

The choices you make in the Clone Stamp's Options bar are important in getting the best results:

• **Brush**. You can use this pull-down menu to select a different brush style (see Chapter 12 for more about brushes), but the standard style usually works pretty well. If the soft edges of the cloned areas bother you, you may be tempted to switch to a harder brush, but that will likely make your photo look like you threw confetti on it, because hard edges won't blend with what's already there.

- Size. Choose a brush that's just big enough to select your sample without picking up other details that you don't want in your repair. It can be tempting to clone huge chunks to speed things up, but most of the time you'll do better using the smallest brush that gets the sample you want.
- **Mode.** You can choose any blend mode (page 199) for cloning, but Normal is usually your best bet. Other modes can create interesting special effects.
- **Opacity.** Elements automatically uses 100-percent opacity for cloning, but you can reduce this setting to let some details of the original show through.

Tip: You gain more control by placing your cloned material on another layer than by adjusting the Clone Stamp's opacity.

• Aligned. This setting works exactly the way it does for the Healing brush (page 314). Turn it on and Elements keeps sampling at a uniform distance from your cursor as you clone; turn it off and it keeps putting down the same source material. Figure 9-6 shows an example of when you'd turn on Aligned. (If you drag rather than click with the Clone Stamp, Elements turns on the Aligned checkbox automatically.)

Figure 9-6:

One way to get rid of the power line in this photo is to use the Clone Stamp's Aligned option. (The thick power line originally entered this photo at the upper left, above the smaller lines you can still see in the background.) By choosing a brush barely larger than the thick power line and sampling just above the line, you can replace the entire thing in one long sweep, despite the many changes in the background behind it.

- **Sample All Layers**. When you turn on this checkbox, Elements takes its replacement material from all the visible layers in the area where you set your source point. When it's off, Elements samples only the active layer.
- **Overlay Options**. The Clone Stamp starts out using a clipped overlay, the same way the Healing brush does. Your options for adjusting the overlay are the same, too (page 315). If you want an empty cursor, just turn off all the options in this drop-down menu. The settings you choose here apply when you use the Healing brush and vice versa.

The Clone Stamp shares its spot in the Tools panel with the Pattern Stamp, which is explained on page 322. (You can tell which is which because the Pattern Stamp's icon has a blue checkerboard to its left.)

The Clone Stamp is a powerful tool, but it's crotchety, too. See the box below for some suggestions on how to make it behave.

TROUBLESHOOTING MOMENT

Keeping the Clone Stamp Under Control

The Clone Stamp is a great tool, but it sometimes has a mind of its own.

If you suddenly see spots of a different shade appearing as you clone, take a look at the Options bar's Aligned checkbox. It has a tendency to insist on staying turned on; even if you turn it off, it can turn itself back on when you aren't looking.

Once in a great while, the Clone Stamp just won't reset itself when you try to select a new sampling point. In that case, try clicking the tiny down arrow at the left end of the Options bar and choosing the Reset Tool option, as shown in Figure 9-7. If that doesn't do it, quit Elements and then relaunch it and delete Elements' preferences file. Here's how: Hold down Ctrl+Alt+Shift/æ-Option-Shift immediately after you launch Elements. Keep these keys down till you see a dialog box asking if you want to delete the program's settings; click Yes. This returns all your Elements settings to where they were the first time you launched the program, and usually cures about 80 percent of the problems you may run into in Elements.

Figure 9-7:

Left: You can reset the Clone Stamp (or, for that matter, any Elements tool) by clicking the tiny arrow at the left end of the Options bar (circled).

Right: From the pop-up menu, choose Reset Tool. (If you want to reset the whole Tools panel, choose Reset All Tools instead.) This clears up a lot of the little problems you may have when trying to make a tool behave.

WORKAROUND WORKSHOP

Repairing Tears and Stains

With Elements, you can do a lot to bring damaged photos back to life. The Healing brush and the Clone Stamp are major players when it comes to restoring pictures. It's fiddly work that takes some persistence, but you can achieve wonders if you have the patience.

If you're lucky enough to have large parts of your photo that are in good shape, you can use the Move tool to copy the good bits into the problem area. First, select the part you want to copy. Then press V to activate the Move tool and Alt-drag/Option-drag the good piece where you want it.

If you need a mirror image of something, you can use the Rotate commands to flip your selection. For example, if the left leg of a chair is fine but the right one is missing, try selecting and Alt-dragging/Option-dragging the left leg with the Move tool. When it's where you want it, go to Image \rightarrow Rotate \rightarrow Flip Selection Horizontal to turn the copied left leg into a new right leg.

If you don't need to rotate an object, sometimes you can just increase the Clone Stamp's brush size and clone the object where you need a duplicate. However, this technique works well only when the background is the same in both areas.

Applying Patterns

In addition to solid colors, Elements also lets you add patterns to your images. The program comes with quite a few patterns, and you can download more (see page 602) or create your own. Patterns let you add interesting designs to your images or give more realistic textures to certain repairs.

You can use the Healing brush or the Pattern Stamp to apply patterns. The Healing brush has a pattern option in the Options bar. The Pattern Stamp shares a Tools panel slot with the Clone Stamp, and it works much like the Clone Stamp, but puts down a preselected pattern instead of a sampled area. The tool you use to apply the pattern makes a big difference, as you can see from Figure 9-8. The next two sections explain how to use both tools.

Tip: Elements gives you lots of ways to use patterns, including creating a Fill layer that's covered with the pattern you choose. Fill layers are covered on page 218.

The Smart brushes (page 234) also let you apply patterned effects to your images, although Adobe officially calls these effects "textures" rather than "patterns." They're particularly nice for creating interest in a flat or empty background area. In the Options bar, just choose Textures from the thumbnails pop-out menu.

Figure 9-8:

The same pattern applied with the Healing brush (left) and the Pattern Stamp (right). The Healing brush blends the pattern in with the underlying color (and texture, when there is any), while the Pattern Stamp just plunks down the pattern exactly as it appears in the pop-out palette.

To get a softer edge on the Healing Brush's pattern, choose a softer brush from the pop-out palette.

The Healing Brush

The Healing brush's Pattern mode is great for things like improving the texture of someone's skin by applying skin texture from another photo.

Using patterns with the Healing brush is just as easy and works the same way as using it in normal healing mode: Just drag across the area you want to fix. The only difference is that you don't have to choose a sampling point, since the *pattern* is your source: When you drag, Elements blends the pattern you selected into your photo.

After activating the Healing brush (keyboard shortcut: J), click the Pattern radio button in the Options bar and then choose a pattern from the pop-out palette. You can see more patterns by clicking the two arrows in the palette's upper-right corner, or you can create and save your own patterns. Figure 9-9 explains how to make custom patterns.

Tip: Changing the blend mode (page 199) when using patterns can result in some interesting effects.

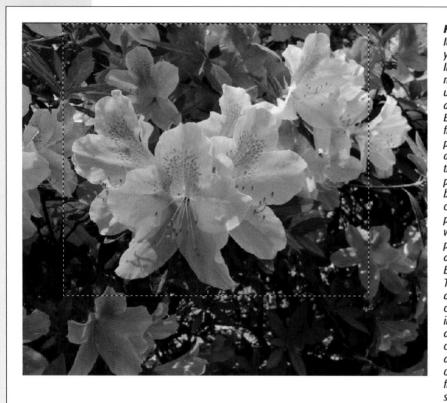

Figure 9-9: It's easy to create your own patterns. In any image, simply make a rectanaular. unfeathered selection, and then choose Edit→"Define Pattern from Selection." Your pattern appears at the bottom of the current pattern palette, and a dialog box pops up so you can name the new pattern. To use a whole image as a pattern, don't make a selection-just go to Edit→Define Pattern. To rename or delete a pattern later, rightclick/Control-click it in the Pattern palette and make your choice. You can also download hundreds of different patterns from various online sources (see page 602).

The Pattern Stamp

This tool is like the Clone Stamp, but instead of copying sampled areas, it puts down a predefined pattern that you select from the Pattern palette. The Pattern Stamp is useful when you want to apply a pattern to your image without mixing it with what's already there. For instance, if you want to see what your patio would look like if it were a garden, you could use the Pattern Stamp to paint a lawn and a flower border on a photo of your patio.

To get started, click the Clone Stamp in the Tools panel, and then choose the Pattern Stamp from the pop-out menu. Then click the pattern thumbnail in the Options bar to open the Pattern palette so you can make your selection. Other options for this brush (like the size, hardness, and so on) are the same as for the Clone Stamp. The one extra option is the Impressionist checkbox demonstrated in Figure 9-10, which is mostly useful for creating special effects.

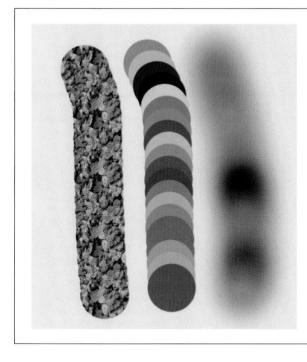

Figure 9-10:

If you turn on the Impressionist checkbox in the Options bar, Elements blurs your pattern, creating an effect vaguely like an Impressionist painting, but only if you use a soft brush. Here you see a pattern put down with the Pattern Stamp using different settings: with the Impressionist setting turned off (left) and with the Impressionist checkbox turned on using a hard brush (middle) and a very soft brush (right).

Once you've selected a pattern, simply drag in your photo where you want Elements to put that pattern.

Recomposing Photos

The previous sections taught you how to remove flaws and objects you don't want in your photos by manually covering them up bit by bit. But maybe you're thinking, "It seems so last-century to have to drudge away like that. There's got to be an easier way!" You're right—there is.

The Recompose tool is one of the coolest features in Elements. It lets you eliminate unwanted objects and people from your photos by just scribbling a line over them, and then moving the edges of your photo to reshape it. Amazingly, Elements can keep the rest of the photo undistorted as it makes the unwanted objects vanish. Take a look at Figure 9-11 to see what this tool can do. Want to get rid of your daughter's ex-boyfriend in that group shot? Just draw a line on him in the photo, push the image's edges closer together, and he's history. Couldn't get your feuding coworkers to stand close together in the holiday party photo? No problem—you can easily remove the empty space between them.

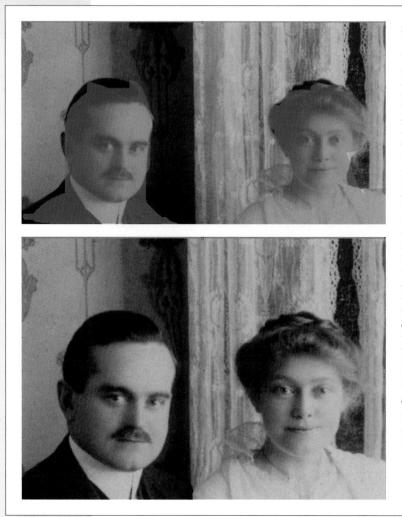

Figure 9-11:

Top: What do you do if you only have a wide photo of vour areat arandparents, but you want to put it in a narrow frame? You could shrink it down till it fits, but then the image would be too small. Instead, just make a few marks on it with the Recompose tool (the areen marks mean "Keep this"). To turn on the tool's Quick Highlight feature-shown here (it automatically covers the whole area you drag over, the way the Ouick Selection tool's selection expands to cover the whole object with one drag-just right-click/Controlclick your photo and choose it from the menu. The Normal Hiahliaht (Elements' startina setting for this brush) usually produces fairly similar results. but Quick Highlight makes it easier to see exactly what you're choosing. To recompose the image, just drag one of its edges toward the middle of the photo.

Bottom: The end result. Your ancestors will now fit nicely into their new frame.

You can also use the Recompose tool to alter the shape of your photo without cropping it. Have a landscape-oriented photo that you wish were portrait-oriented instead? Recompose can fix that. There are limits to what it can do, but with a suitable photo, you can just shove it into the proportions you want, and Elements will keep everything looking perfectly normal and not at all distorted. It takes an awesome amount of computer intelligence to make this tool work, but it's actually one of the easier Elements tools to use:

1. Open a photo and activate the Recompose tool.

There are two ways to call it up:

- From the Tools panel. In Full Edit, the Recompose tool shares a slot with the Crop tool. Their keyboard shortcut is C.
- From the Image menu. Go to Image→Recompose, or press Alt+Ctrl+R/ Option-%-R.
- 2. Tell Elements which parts of the photo you *don't* want to change.

You use the Recompose tool's Protection brush to indicate which areas you want preserved. To select this brush, click the leftmost icon in the Options bar—the green paintbrush and lock—and then drag over the areas you want to keep. This is something like using the Quick Selection tool in that you don't have to select *everything;* just make enough marks so that Elements knows which objects you mean. This tool is more literal-minded than the Quick Selection tool, so you may need more marks when using it.

Tip: The Recompose tool has a hidden menu to speed things up: Right-click/Control-click your photo when the tool is active and you can choose Quick Highlight (shown in Figure 9-11), which makes the whole process of telling Elements what to keep and what to eliminate go much faster. You tend to get better results with this method, too.

To automatically select the people in your photo, in the Options bar, click the "Highlight Skin tones" icon (the little green man). However, this feature doesn't work on sepia images like the one in Figure 9-11.

3. Tell Elements what you want to get rid of.

To delete specific objects or areas, drag over them with the Removal brush (click the Options bar icon that looks like a red paintbrush and an X).

Tip: You don't always need to use both of the Recompose tool's brushes. You can even try not marking anything at all, but you'll likely get better results if you give Elements a little guidance. If you make a mistake with either brush, use the corresponding eraser (the icon just to the brush's right) to remove the stray marks.

4. Recompose your photo.

Once you're through marking up your photo, you can use the familiar bounding box around the image to resize it. It works just like the Move tool's bounding box: Grab a handle or a corner and drag to change the shape of your image. There are several Options bar settings that can help you out if you need to make the photo a specific size; they're explained in a moment.

Watch as the unwanted areas disappear as you drag the edges closer together.

Tip: If you want to make your image wider or taller than it is now (to make a portrait-oriented photo into a landscape one, for example), you first need to add canvas (page 122) to give the new width or height someplace to go. Just keep in mind that Elements isn't as good at removing objects when you're making the image larger as it is when you're shrinking it down.

5. Finish up.

When you're happy with your image, click the Commit button (the green checkmark) or press Enter/Return. If you decide you don't want to recompose after all, or if you need to go back and adjust the marks you made on the picture, click the red Cancel button. When you're done, crop off any extra blank space on the edges of your photo. (Cropping is explained on page 99.)

Tip: You may find that some remnants of removed objects reappear after you press Enter/Return. Just use the Clone Stamp or the Healing Brush to get rid of them.

The Recompose tool has several Options bar settings to make your job easier:

- **Brushes.** There are four brushes at the left end of the Options bar. From left to right they are: the "Mark for Protection" brush, "Erase highlights marked for protection" (for erasing Protection brush marks you don't want), the "Mark for Removal" brush, and "Erase highlights marked for removal" (for erasing Removal marks you made by mistake).
- **Size**. This is just like the size setting for any brush tool: Enter a size in pixels, scrub on the Options bar (page 132), or use the bracket key shortcuts to change the size (page 400). Chapter 12 covers brushes in detail.
- **Highlight Skin tones.** Click this icon and, if you're lucky, Elements selects the people in your photo. It's kind of dicey, though—you may find Elements prefers other objects to the folks in your pictures, but it's worth a click, since you can always undo Elements' selection.
- **Preset.** Normally this option is set to No Restriction, which lets you drag any way you like, but you can also choose to recompose to the photo's current aspect ratio to one of several popular photo-paper sizes or the 16:9 aspect ratio popular for images used in high-definition videos. If you make a choice here or in the width and height boxes (explained next), Elements recomposes your photo to that size.
- W (width) and H (height). If you want to enter a custom size, do that here. Click the arrows between the boxes to swap the numbers, just as you can with the Crop tool.
- Amount. This tells Elements how much you want to protect the details from distortion. For best results, leave it at 100%.

What's most amazing about this tool is the way your background still looks real when you're done. Someone seeing your Recomposed photo would never guess that it didn't start out looking just like it does now. Recomposing doesn't work for every photo, but when it does, the results are almost magical.

Color Curves: Enhancing Tone and Contrast

If you hang around photo-editing veterans, you'll hear how useful Photoshop's Curves tool is. Contrary to what you might expect, Curves isn't a drawing tool. Instead, it works much like Levels (page 244), but with many more points of correction. Adobe includes a simplified version of this tool in Elements, and calls it *Color Curves* to remind you what it's for.

Unlike Levels, which lets you adjust your entire photo's white point, black point, and midtone settings, the Color Curves tool lets you target specific tonal regions. For instance, it lets you make only your shadows lighter or only your highlights darker. Maybe that's why some pros say that Color Curves is Levels on steroids. (The box on page 249 has advice on when to use Levels and when to use Color Curves.)

Since Curves, in its original-strength Photoshop version, is a pretty complicated tool, Adobe makes it easier to use in Elements. Elements starts you with a group of preset adjustments to choose from (see Figure 9-12). These presets are shortcuts to the types of basic enhancements you'll use most often; just click one to try it. If you like what it does, you're done. But if you aren't satisfied with any of the presets, you can easily make changes using the Adjust Color Curves dialog box's Adjust sliders.

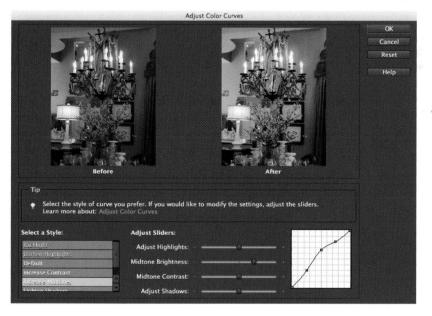

Figure 9-12:

The Adjust Color Curves dialog box gives you a good look at what you're doing to your photo with large before and after previews. Start by clicking around in the list of preset styles in the lower left of the dialog box, and then use the Adjust sliders to fine-tune the effect. Here's how to improve a photo's appearance with Color Curves:

1. Open your photo and make a duplicate layer.

Press Ctrl+J/æ-J or go to Layer→Duplicate Layer. Elements doesn't let you use Color Curves as an Adjustment layer, so you're safer applying it to a duplicate layer in case you want to change something later.

If you decide you'd like to restrict your adjustment to a particular area, you can apply a layer mask (page 211) to the duplicate layer and edit the mask so your adjustment changes only part of the photo. For instance, if you're happy with everything in your shot of Junior's Little League game except the catcher in the foreground, do a Color Curves adjustment on a duplicate layer and then mask out everything but him.

2. Go to Enhance→Adjust Color→Adjust Color Curves.

Elements opens the Adjust Color Curves dialog box, where you see your original image on the left.

3. Choose a Color Curves preset.

Scroll through the "Select a Style" list and click the preset that seems closest to what you want. Feel free to experiment by clicking different presets. (As long as you're just clicking in the list, you don't need to click Reset between each one, since Elements starts from your original each time you click.)

The dialog box gives you a decent-sized look at how you're changing your image, but for important photos, you can also preview the effect right in your image. To do that, drag the dialog box out of the way and check your actual photo to see how you're changing things before you commit.

4. Apply the changes, or tweak them some more.

If you're satisfied, click OK. If not, go to the next step.

5. Make any further adjustments.

If you think your photo still doesn't look quite right, use the Adjust sliders shown in Figure 9-13 to tweak your photo. (The sliders are explained in a moment.) Click Reset if you want to undo any of the changes you make with the sliders. Notice how subtle the preset curves are—a tiny nudge makes a big difference, so be gentle.

6. When you're happy with your photo's new look, click OK.

Don't forget to save your changes. If you used a duplicate layer, you can always change your mind later on and start over on a fresh layer.

Tip: If you've used Curves add-ons in an old version of Elements—like those from Richard Lynch or Grant Dixon, for example—or if you've used Photoshop's Curves Adjustment layers (you power user, you!), the Color Curves tool may take a bit of getting used to, since you can't adjust the curve by dragging it. If not being able to drag dives you nuts, SmartCurve (*http://free.pages.at/easyfilter/curves.html*) is a popular, free, Windows-only add-on that lets you drag to your heart's content (unfortunately, there's no Mac equivalent). Also, some of the add-on toolsets for Elements let you make corrections on a graph rather than with the sliders. (See page 602 for more about add-ons.)

Color Curves: Enhancing Tone and Contrast

Select a Style:	Adjust Sliders:	Figure 9-13: The graph on the
Backlight	Adjust Highlights:	right is where the Color Curves feature
Darken Highlights Default	Midtone Brightness:	gets its name. When
Incresse Contract	Midtone Contrast:	you first open the
Increase Midtones	Adjust Shadows:	Adjust Color Curves
		dialog box, the grap is a straight diagon line. Any changes you make cause the points on the graph to move, resulting in
		a curve like the one
		shown here. To go back to the straigh line, click Reset (no

Once you have some Color Curves experience under your belt, you probably won't be satisfied with the presets, so don't hesitate to use the sliders to adjust different tonal regions in your photo:

- Adjust Highlights. Move this slider to the left to darken your photo's highlights, or to the right to lighten them.
- **Midtone Brightness.** If you'd like the middle range of colors to be darker, move this slider to the left. Move it to the right to make the midtones brighter.
- Midtone Contrast. This slider works just like the one in Elements' Shadows/ Highlights feature (page 231): Move it to the right to increase your photo's contrast, or to the left to decrease it.
- Adjust Shadows. If you want to lighten shadowy areas, move this slider to the right. To darken them, move it to the left.

As you move the sliders, you can see the point you're adjusting move on the graph and watch the curve change shape. Although it's fun to see what's going on in the graph, you should pay more attention to what's happening in your photo.

Color Curves is such a potent tool that it can change your photo in ways you don't intend. So rather than using Color Curves to make huge adjustments, try another tool first, and then use Color Curves for the final, subtle tweaks. But if you *want* to create some wild special effects, then Color Curves may be just the ticket; see Figure 9-14 for an example.

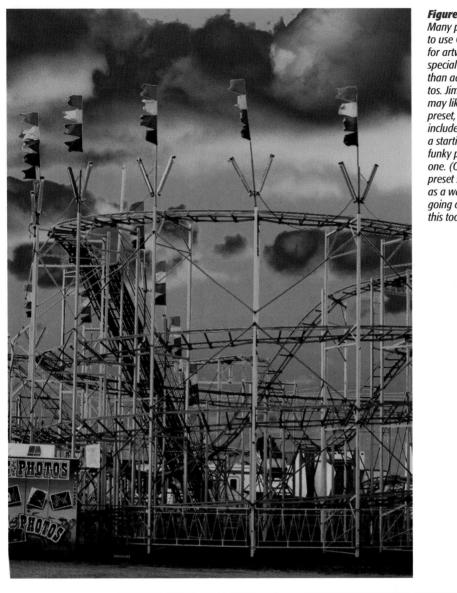

Figure 9-14: Many people prefer to use Color Curves for artwork and special effects rather than adjusting photos. Jimi Hendrix fans may like the Solarize preset, which Adobe includes to give you a starting point for funky pictures like this one. (Others say this preset should serve as a warning about going overboard with this tool.)

Tip: You can also apply the Solarize adjustment to part of your photo with the Smart Brush tool (page 234). But if you use the brush method, you can't edit the settings afterward, so you may prefer to apply Solarize using Color Curves on a duplicate layer.

Making Colors More Vibrant

Do you drool over the luscious photos in travel magazines, the ones of vivid destinations that make regular life seem drab in comparison? What *is* it about those photos that makes them so dramatic? Often the answer is the *saturation*, or intensity, of the colors. Supersaturated color makes for darned appealing landscape and object photos, regardless of how the real thing may rate on the vividness scale.

There are various ways to adjust the saturation of your photos. Some cameras have features that help control it, but Elements lets you go even further. For example, by increasing or decreasing a photo's saturation, you can shift the perceived focal point, change the image's mood, or just make your photo more eye-catching.

By increasing your subject's saturation and decreasing it in the rest of the photo, you can focus your viewer's attention, even in a crowded photo. Figure 9-15 shows an example of this technique. (You can download the photo *skipper.jpg* from this book's Missing CD page at *www.missingmanuals.com* to try it yourself.)

It's easy to change saturation. You might want to start with the Raw Converter's Vibrance slider (remember that you can open other image formats there besides Raw files—see page 286). If that doesn't work well, try using either of the more traditional methods: the Hue/Saturation dialog box or the Sponge tool, which are explained in the following sections. For big areas or when you want a lot of control, go with the Hue/Saturation dialog box. If you just want to quickly paint a different saturation level (either more or less saturation) on a small spot in your photo, the Sponge tool is faster.

Tip: Many consumer-grade digital cameras are set to crank the saturation of your JPEG photos into the stratosphere. That's great if you love all the color, but if you prefer not to live in a Technicolor universe, you can desaturate your photos in Elements to remove some of the excess color.

The Hue/Saturation Dialog Box

Hue/Saturation is one of the most popular commands in Elements. If you aren't satisfied with the results of a simple Levels adjustment, you may want to work on the hue or saturation as the next step toward getting eye-catching color.

Hue simply means the color of your image—whether it's blue or brown or purple or green. Most people use the saturation adjustments more than the hue controls, but both hue and saturation are controlled by the same dialog box. In Elements, you can use the Hue slider to actually change the color of objects in your photos, but you'll probably want to adjust saturation far more often than you'll want to shift an image's hue.

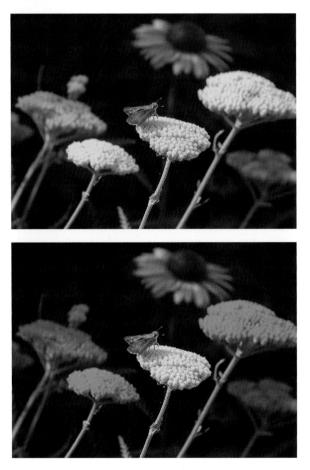

Figure 9-15:

Top: All the yellow flowers in this image are equally bright, including those in the background, so you might miss the butterfly on the front blossom.

Bottom: To make the butterfly and its flower stand out from the crowd, desaturate the rest of the image.

When you use Hue/Saturation, it's a good idea to first make most of your other corrections—like Levels or exposure changes. When you're ready to use the Hue/ Saturation command, just follow these steps:

1. If you want to adjust only part of your photo, select the area you want to change.

Use whatever Selection tool(s) you prefer. (See Chapter 5 for a refresher on selections.)

2. Call up the Hue/Saturation dialog box.

Go to Enhance→Adjust Color→Adjust Hue/Saturation, or to Layer→New Adjustment Layer→Hue/Saturation. As always, if you want to make changes that you can easily reverse, use an Adjustment layer instead of working directly on your photo. (If you go the Adjustment layer route, you'll make your changes in the Adjustments panel rather than a dialog box, but your options are exactly the same.)

Tip: Using an Adjustment layer gives you more flexibility because you can always come back and edit the layer's mask later on if you change your mind about what you want to include. See page 213 for more info.

3. Move the sliders until you like what you see.

To adjust only saturation, ignore the Hue slider. Move the Saturation slider to the right to increase the amount of saturation (more color) or to the left to decrease it. If necessary, move the Lightness slider to the left to make the color darker, or to the right to make it lighter. If you're using an Adjustment layer, that's all you have to do. (If you use the dialog box, click OK when you're satisfied.)

Incidentally, you don't have to change all the colors in your photo equally; Figure 9-16 explains how to focus on individual color channels.

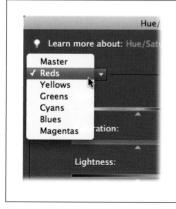

Figure 9-16:

The Hue/Saturation controls include a pull-down menu that lets you adjust specific color channels. For example, if only the reds are excessive (a common problem with digital cameras), you can lower the saturation of just the reds without changing the other channels.

Tip: Generally speaking, if you want to change a pastel to a more intense color, you'll need to increase the saturation *and* reduce the lightness (by moving the Lightness slider to the left) if you don't want the color to look radioactive.

Adjusting Saturation with the Sponge Tool

The Sponge tool gives you another way to adjust saturation. Even though it's called a sponge, this tool works like any other brush tool in Elements; the process of choosing the size and hardness is the same as choosing them for a brush (see page 399).

Tip: Although the Sponge tool is handy for working on small areas, all the dragging required gets old when you're working on a large chunk of your image. For those situations, use Hue/Saturation (page 331) instead.

To use the Sponge tool, just drag over the area you want to change. Figure 9-17 shows the kind of work the Sponge does.

Figure 9-17:

The Sponge tool was applied to the upper-right part of this wall, increasing the color saturation and making the paint redder. Approach the Sponge tool with caution: It doesn't take much to degrade in your image, especially if you've made lots of other adjustments to it. So if you start to see noise (graininess), undo your sponging and try again at a reduced Flow setting.

You may want to press Ctrl+J/#-J to create a duplicate layer before using the Sponge. That way you can throw out the duplicate layer later if you don't like the changes, or add a layer mask to restrict the area they affect (page 211). Here's how to use this tool:

1. Activate the Sponge tool.

Press O (that's the letter o, not the number zero) or click its icon in the Tools panel, and then choose the Sponge from the pop-out menu. Then choose the brush size and the settings you want in the Options bar.

2. Drag in the area you want to change.

If you aren't seeing enough of a difference, increase the Flow setting (explained in a moment) a little. If the effect is too strong, reduce the Flow number.

Tip: If you have a hard time coloring (or decoloring) inside the lines, select the area you want before sponging. That way the tool won't have any effect outside the selection, so you can be as sloppy as you like.

The Sponge tool's Options bar has a couple of unique settings:

- Mode. Here's where you choose whether to saturate (add color) or desaturate (remove color).
- Flow. This setting governs how intense the effect is; a higher number means more intensity.

Changing an Object's Color

In Chapter 4, you saw one way to change the color of an object: Select it and then use Quick Fix's Hue and Saturation sliders. Elements also gives you other ways to achieve the same result: You can use an Adjustment layer, the Replace Color command, or the Color Replacement tool. (The Smart Brush tools offer a whole menu of color changes, too; see the Tip below for the lowdown.)

The method you should choose depends on your photo and personal preference. Using an Adjustment layer gives you the most flexibility if you want to make changes later. Replace Color is the fastest way to change one color that's widely scattered throughout your whole image. And the Color Replacement tool lets you quickly brush a replacement color over the color you want to change. Figure 9-18 shows the kind of complex color change you can make in a jiffy using any one of these methods.

Tip: The Smart Brush, which you learned about back on page 234, also lets you target the area you want to change and make a quick color adjustment, so you might think that sounds like a good tool for changing color. It can be, but its color presets are pretty limited (and pretty ugly). Also, the Smart Brush doesn't just apply a single color—it uses gradient maps (page 470) instead. If you can get the effect you like using the Smart Brush, go for it. But it's tough to adjust color with this tool, since you have to either pick a different gradient or edit the gradient the Smart Brush used (page 465 tells you how). On the whole, the methods described in the following pages are much simpler to control.

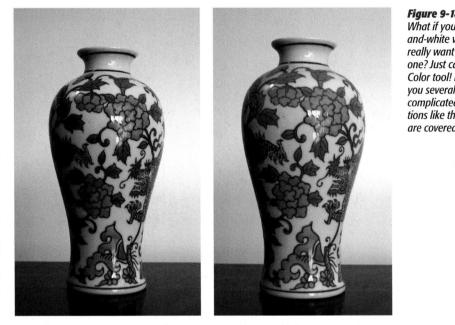

Figure 9-18:

What if you have a greenand-white vase but vou really want a red-and-white one? Just call up the Replace Color tool! Elements gives you several ways to make complicated color substitutions like this, all of which are covered in this section.

Using an Adjustment Layer

You can use a Hue/Saturation Adjustment layer to make the kind of color changes you saw in Figure 9-18. The advantage of this method is that you can go back later and change the settings you used or change the area affected by the layer (as opposed to changing your whole image). The process is the same as the one described on page 331, only this time you start by selecting what you want to change:

1. Select the object whose color you want to change.

Use any of the Selection tools (see Chapter 5). If you don't make a selection before creating the Adjustment layer, you'll change your whole photo.

2. Create a new Hue/Saturation Adjustment layer.

Go to Layer→New Adjustment Layer→Hue/Saturation. The new layer affects only the area you selected.

3. Use the Adjustments panel's sliders to tweak the color until it looks good, and then click OK.

Use the Hue slider first to pick the color you want. When it's close to the right color, use the Saturation slider to adjust the color's vividness and the Lightness slider to adjust its darkness.

This method is fine if it's easy to select the area you want to change. But what if you have a bunch of widely scattered areas of color to change, or you want to change one shade everywhere it appears in your photo? For that, Elements offers the Replace Color command, explained next.

Replacing Specific Colors

Take a look at the green-and-white vase in Figure 9-18 again. Do you have to tediously select each green area if you want to make it a red-and-white vase? You *can* do it that way, but it's far easier to use the Replace Color command. When you use this command, you'll see one of those Elements dialog boxes that looks a bit intimidating, but it's a snap to use once you understand how it works. Replace Color changes every instance of the color you select, no matter where it appears in your image.

You don't need to start by making a selection when you use this command but as usual, if you want to keep your options for future changes open, use it on a duplicate layer (Ctrl+J/#-J). And before you start, be sure your active layer isn't an Adjustment layer, or Replace Color won't work. Then:

1. Open the Replace Color dialog box.

Go to Enhance \rightarrow Adjust Color \rightarrow Replace Color. The Replace Color dialog box in Figure 9-19 appears. You may need to drag it out of the way so you can see your whole photo.

Tip: To protect a particular area of your chosen color from being changed, paint a mask on it by using the Selection brush in Mask mode before you start.

2. Move your cursor over your photo.

The cursor changes to an eyedropper. Make sure that the left eyedropper in the Replace Color dialog box (the one without a plus or minus sign by it) is the active one, as in Figure 9-19.

3. Click an area of the color you want to replace.

Elements selects all the areas that match the particular shade you selected, but you won't see the marching ants in your image the way you do with the Selection tools. If you click more than once, you *change* your selection instead of adding to it, the way you would with any of the regular Selection tools. To add to your selection (that is, to select additional shades), Shift-click in your photo.

Another way to add more shades is to select the middle eyedropper (the one with the + sign next to it) and click in your photo again. To remove a color, select the right eyedropper (with the – sign) and click, or Alt-click/Option-click with the leftmost eyedropper. If you want to start selecting all over again, Alt-click/Option-click the Cancel button to turn it into a Reset button.

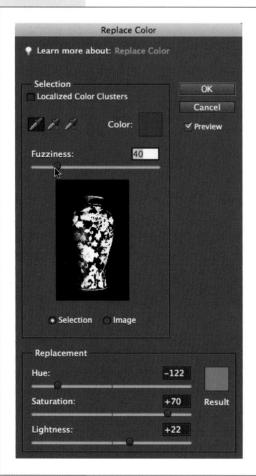

Figure 9-19:

The area of the Replace Color dialog box that looks like a negative shows you where the sliders will affect the color. The lighter areas are where Elements plans to substitute your new color.

Use the Hue and Saturation sliders to adjust the replacement color (shown in the Result box) the way you would with a regular Hue/Saturation adjustment. The Fuzziness setting (explained in Figure 9-20) works a little like the Magic Wand's Tolerance setting and the Localized Color Clusters checkbox is something like the Magic Wand's Contiguous setting—it restricts the selection to colors near where you click.

4. When you've selected everything you want to change, move the sliders to change the color.

The Hue, Saturation, and Lightness sliders work exactly the way they do in the Hue/Saturation dialog box (page 331). Move them and watch the Result box in the Replace Color dialog box to see what color you're concocting. You can also click the Result box to bring up the Color Picker and choose a shade there. If you need to tweak the area you're changing, use the Fuzziness slider to adjust the range of colors that Color Replacement affects, as shown in Figure 9-20.

Look at your photo after you've chosen your replacement color. If the preview doesn't show that color in all the areas you want, click the missing spots with the dialog box's middle eyedropper to fix them.

5. Click OK.

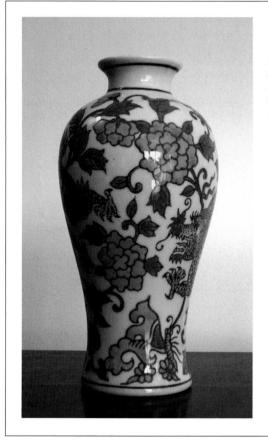

Figure 9-20:

Fuzziness is similar to the Magic Wand's Tolerance setting (page 164). Take a close look at the red parts of this vase there's still a lot of green in the center of some of them. To change more pixels, set the Fuzziness higher by moving the slider to the right (in this image, that change would make all the green spots turn red). If you find you're changing areas you don't want to, move the Fuzziness slider to the left instead.

The Color Replacement Tool

You can also brush on a color change. The Color Replacement tool lets you brush a different color onto the area you want to change without changing any colors besides the one you target.

You can use pretty much any color you want with this tool, so you'd think it would be pretty versatile for changing colors, but these days there are more useful tools in Elements. That's partly because the Color Replacement tool doesn't do everything it used to do in early versions of the program. Now it works best when you simply want to change a color to another hue of similar intensity; you're likely to get poor results if you want to replace a light color with a darker one, for example. Figure 9-21 shows the virtues and limitations of this tool.

Figure 9-21:

If you'd like to put some zip into this photo by coloring the hat, the Color Replacement tool is one way to do it. Although the sampled color used was a dark teal green, the Color Replacement tool in Hue mode brushes on a pale, vivid aqua instead. If you wanted to make the hat the intense dark teal of the sampled color, you should use a different method instead, like adding a Hue/Saturation Adjustment layer (page 336).

Using the Color Replacement tool is straightforward:

1. Pick the color to use as a replacement.

Elements uses the current Foreground color as the replacement color. To change colors, click the Foreground color square in the Tools panel and then choose a new hue from the Color Picker.

2. Activate the Color Replacement tool and pick a brush size.

Click the Brush tool in the Tools panel or press B and then choose the Color Replacement tool from the pop-out menu. For this tool, you usually want a fairly large brush, as shown in Figure 9-21. (See Chapter 12 to learn all about brushes.)

3. Click or drag in your photo to change the color.

Elements targets the color that's under the crosshairs in the center of the brush cursor. So in Figure 9-21, for example, keeping the crosshairs inside the hat ensures that only the hat changes.

Tip: You may want to use the Color Replacement tool on a duplicate layer (Ctrl+J/æ-J) so you can adjust the layer's opacity to control the effect.

The Options bar settings make a big difference in the way this tool works:

• **Brush options**. These settings (size, hardness, angle, and so on) are the same as for any brush. See Chapter 12 for more about brushes.

Special Effects

- Mode. This controls the tool's blend mode (page 199). Generally you'll want to choose Color or Hue, although you can get some funky special effects with Saturation.
- Limits. This setting tells Elements which areas of your photo to look at when it searches for color. Contiguous means it only targets areas that touch each other. Discontiguous means the tool changes *all* the places it finds a color—regardless of whether they're touching.
- **Tolerance.** This is like the Magic Wand's Tolerance setting: The higher the number, the more shades of color Elements changes. This setting is the key to getting good results with this tool.
- Anti-alias. This setting smoothes the edges of the replacement color; it's best to leave it turned on.

Special Effects

Elements gives you some other useful ways of drastically changing the look of your image. You can apply these effects as Adjustment layers (Layer \rightarrow New Adjustment Layer) or by going to Filter \rightarrow Adjustments (there's much more about filters in Chapter 13). Either route gives you the same options (except for Equalize, which is only available as a filter); you can see them in action in Figure 9-22.

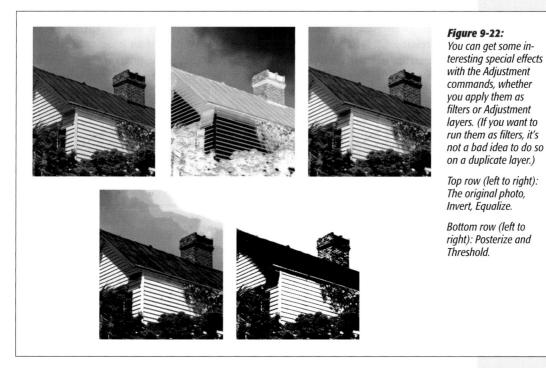

CHAPTER 10

Removing and Adding Color

A stunning black-and-white image is so much more than just a color photo without color. If you love classic black-and-white photography, or if you yearn to be the next Ansel Adams, you'll be over the moon with the highquality black-and-white conversions Elements can do. If, on the other hand, you can't imagine why anyone would willingly abandon color, consider that in a world crammed with eye-popping colors, black and white really stands out. Or say you need to have something printed where you can't use color illustrations. And for artistic photography, there's nothing like black and white, where tone and contrast make or break the photo, without colors to distract you from its underlying structure.

In this chapter, you'll learn how to turn a color photo black and white, and how to create images that are partly in color and partly black and white. You'll also learn how to reverse the process and colorize black-and-white images.

Method One: Making Color Photos Black and White

Generally, just removing the color from a photo produces a flat-looking, uninteresting image. A good black-and-white photo usually needs more contrast than you'll get if you simply zap the color. You can create different effects and moods in your photo, depending on what you decide to emphasize in the black-and-white version.

Black-and-white conversion has traditionally been a pretty complicated process. If you do a Google search, you'll find dozens of recipes for doing conversions. Fortunately for you, Elements makes it easy to perform this task, and even do sophisticated tweaking of the different color channels. Just follow these steps:

1. Open the photo you want to convert.

If the file has multiple layers, flatten it (Layer \rightarrow Flatten Image) or make sure the layer you want to convert is the active layer (click it in the Layers panel). To convert only a part of your photo, select the area you want to make black and white or create a duplicate layer (Ctrl+J/ \Re -J) and then use a layer mask to adjust the visible black and white area after you do the conversion. (As always, it's best to do this on a copy, not on your original photo.)

2. Go to Enhance→"Convert to Black and White," or press Alt+Ctrl+B/Option-#-B.

The "Convert to Black and White" dialog box appears. It includes helpful before and after previews of your image, and the controls shown in Figure 10-1.

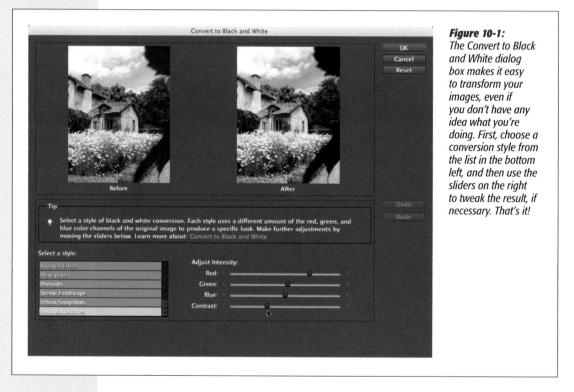

3. Choose a conversion style.

Elements gives you various preset styles for the conversion. Click a style in the list to apply it to your photo. Try each one to find your favorite.

4. Tweak the conversion, if necessary.

Use the Adjust Intensity sliders below the preview area (Red, Green, and so on) to increase or decrease the prominence of each color channel (page 244). You don't need to understand color channels to do this; just move the sliders around and see what they do (the After image shows how you're changing things). Go gently—it doesn't take much to make a big difference.

Once you move a slider, the Undo and Redo buttons on the right side of the dialog box become clickable. Use them to step backward and forward through your changes. To start from scratch, click Reset.

5. When you're satisfied with how your photo looks, click OK.

Be sure to carefully examine your actual image. Don't just rely on the smallish preview window—move the dialog box around your screen so you can see your whole photo before you accept the conversion. If you decide against creating a black-and-white image, click Cancel.

If you used a duplicate layer and you decide you only want a partially black-andwhite image, after you click OK, apply a layer mask (page 211) and paint away the areas you want to leave in color (see page 213 for how to edit the mask). Just remember: "black conceals, white reveals."

Tip: You may want to emphasize certain details in your photo without making additional changes to the overall tonality. To do that, use the Dodge and Burn tools (page 410) once you've completed your conversion.

While the different conversion styles have descriptive names, like Portraits and Scenic Landscape, don't put too much stock in those names. They're simply less intimidating ways of describing preset collections of color-channel settings. Be sure to test out the various styles to see which works best on your photo. For instance, you may prefer the way Uncle Julio looks when you choose the Newspaper style instead of the Portraits style.

But wait a minute: Changes to the color channels? That's right. Back in Chapter 7, you read about how your photo consists of three separate color channels: red, blue, and green. In your camera's original file, each of these channels is recorded as variations of light and dark tones—in other words, as a black-and-white image. Your image file tells the computer or printer to render a particular channel as all red, blue, or green, and the blending of the three monotone channels makes all the colors you see.

When you convert your photo back to black and white, each of these channels contains varying amounts of details from your photo, depending on the color of your original subject. So, the green channel might have more detail from your subject's eyelashes, while the red channel may have more detail from the bark on the tree she's standing under. (Remember, the color channels themselves don't necessarily correspond to the color of the objects you see in your final photo. Or, put another way: Your camera uses a mixture of red, blue, and green to create what looks like bark to us humans.) And there's often more noise (graininess) in one channel than the others.

The "Convert to Black and White" dialog box's Red, Green, and Blue sliders let you increase or decrease the presence of each color channel so you can adjust how prominent various details in your photo are by changing the importance of the color channels. These adjustments can greatly change the appearance of the final conversion. The Contrast slider, not surprisingly, adjusts the contrast (page 138) of the combined channels.

That's the theory behind those color channel sliders, but fortunately, you don't have to understand it to use them effectively. Just be sure you have a good view of your photo (zoom in and, if necessary, move the dialog box) and then move the sliders till you're happy with what you see. If you plan to print your converted photo, the Note on page 350 has some tips on how to get a good black-and-white print from a color inkjet printer.

Tip: Elements gives you an even easier way to convert your photo to black and white (but it's an all-ornothing scenario—you can't adjust the tones in your image): the Effects panel's black-and-white tint effect. Go to the Effects panel (choose Window—Effects if it's not already visible), and then choose Photo Effects by clicking the third icon from the left at the top of the panel. From the panel's drop-down menu, choose Monotone Color, and then double-click the black-and-white apple to apply the effect. Also, some frames in the Frames section of the Content panel (page 522)—like a few of the Color Tint frames—automatically convert your photo to black and white when you place it in the frame. Page 510 explains how to use these frames.

Method Two: Removing Color from a Photo

Because one size never fits all, Elements gives you a few other, totally different ways to remove the color from your images. The instructions in the preceding section are usually your best bet when you want to convert your whole photo to black and white. But if you're in a hurry or you're looking to do something artistic, like change a color photo into a drawing or painting, you can try one of these three methods:

• Convert Mode. You may remember from page 54 that you need to choose a color mode for your photos: RGB, Bitmap, or Grayscale. You can remove the color from a photo simply by changing its mode to Grayscale: Go to Image→Mode→Grayscale. This method is quick, but it's also a bit destructive, since you can't apply it to a layer: Your whole photo is either grayscale or not, and once you save and close the photo, your color info is gone for good.

• Remove Color. You can keep your photo as an RGB file and drain its color by going to Enhance→Adjust Color→Remove Color, or pressing Shift+Ctrl+U/ Shift-æ-U. This command removes the color only from the active layer, so if your photo has more than one layer, you need to flatten it first (Layer→Flatten Image) or the other layers will keep their color.

The Remove Color command is really just another way to completely desaturate your photo—like you might do when using the Hue/Saturation command (described next). Remove Color is faster but you don't get as much control as with the Hue/Saturation command. Figure 10-2 shows the difference between applying the Remove Color command and converting your entire image to grayscale.

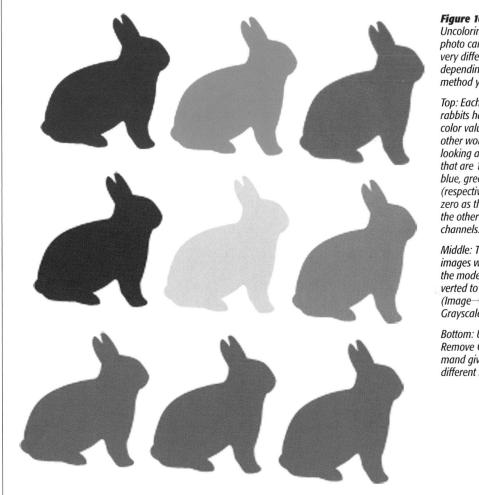

Figure 10-2: Uncoloring your photo can generate very different results depending on the method you use.

Top: Each of these rabbits has a pure color value of 255. In other words, you're looking at rabbits that are 100 percent blue, green, and red (respectively), with zero as the value for the other two color channels.

Middle: The same images with the mode converted to grayscale (Image→Mode→ Grayscale).

Bottom: Using the Remove Color command gives you quite different results. • **Hue/Saturation**. You can also call up the Hue/Saturation dialog box (page 331) by going to Enhance→Adjust Color→Adjust Hue/Saturation, and then moving the Saturation slider all the way to the left or typing *-100* into the Saturation box. The advantage of this method is that, if you don't care for the shade of gray you get, you can desaturate each color channel separately by using the dialog box's pull-down menu. This method also lets you tweak the settings a bit to eliminate any color cast you may get from your printer.

Tip: If you're planning to print the results of your black-and-white conversion, the paper you use can make a *big* difference in the gray tones you get. If you don't like the results you get with your usual paper, try a different weight or brand. You'll need to experiment because the inks for various printer models interact differently with various brands of paper. And if you plan on printing lots of black-and-white photos, you may want to look into buying a photo printer that lets you substitute several shades of gray for your color cartridges.

Creating Spot Color

Removing almost all the color from a photo but leaving one or two objects in vivid tones, called *spot color*, is an effective artistic device that's long been popular in the print industry. (In the commercial printing business, "spot color" means something else—it refers to the use of special inks for a particular color in a multicolor image.) Figure 10-3 shows an example. To practice the maneuvers you're about to learn, download the file *caboose.jpg* from this book's Missing CD page at *www.missing-manuals.com*.

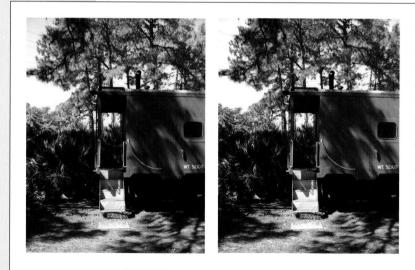

Figure 10-3:

With Elements, you can easily remove the color from part of an image.

Left: Here's the original photo.

Right: Now the color is gone from everything except the caboose. You'll learn three easy ways to create this effect in this section. This section walks you through three of the easiest methods for creating spot color. (The method explained earlier in this chapter [page 345] is the most flexible and gives you the best results, since you have more control over the black-and-white conversion settings, but that doesn't mean you shouldn't learn other ways of achieving the same effect.)

Tip: Check your camera's special effects settings for a spot or accent color option. Many cameras can now create black-and-white images with only one shade left in color.

Brushing Away Color

Creating black-and-white areas in a color photo is super easy in Elements. One way is to use the Smart Brush to convert an area to black and white while making your selection (see Figure 10-4). In other words, you paint the object you want to make black and white, and Elements selects and converts it—while preserving the color in the rest of your photo. If you want to keep most of your image in color while converting only small portions of it to black and white, or vice versa, definitely try this method first.

To paint away color with the Smart Brush:

1. Open a photo in Full Edit mode, and then activate the Smart Brush.

Press F or click its icon in the Tools panel, and then choose the brush from the pop-out menu. The Smart Brush puts its changes on their own layer, so you don't need to create a duplicate layer before using it.

You can also do this in Quick Fix, but you don't get a choice of styles, so skip step 2 if you do it there. (If you do the conversion in Quick Fix, you also can't edit the settings later; if you try to, Elements displays an error message.)

2. Choose the style of black-and-white conversion you want.

Find the thumbnail at the right end of the Smart Brush's Options bar settings. This is actually the pop-out menu for the Smart Brush's presets. Click the thumbnail and then, in the palette that appears, click the drop-down menu and choose "Black and White." Finally, click the thumbnail that looks most like what you want (if you don't like it once it's applied, you can change it). Elements has a number of different conversion styles, and the names don't mean much, so it's best to go by the thumbnail preview when choosing one.

3. Drag over the object in your photo that you want to make black and white.

The Smart Brush should select the object and convert it, all in one go. If you have a hard time getting a good selection, go back to Elements' main Tools panel and use the Detail Smart Brush (page 234) instead. (It works like the regular Selection brush, changing only the area directly under the cursor, so you'll have more work to do, but you'll get a more accurate selection.)

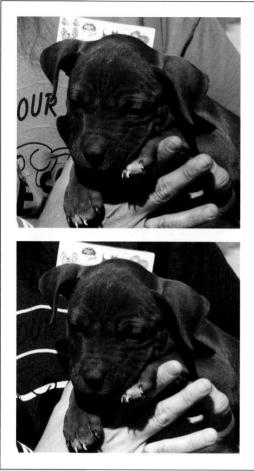

Figure 10-4:

With the Smart Brush, converting part of your photo to black and white is as simple as making a selection.

Top: The puppy is really cute, but the bright blue shirt draws your eye away from him.

Bottom: Drag over the puppy with the Smart Brush with the Inverse option turned on, and he stays in color while the rest of the photo turns black and white.

That's all there is to it. If you don't like the conversion style you chose or want to change the area the brush affects, click the pin that appears when the Smart Brush is active and then make your changes. (See page 235 for more about how to fine-tune Smart Brush edits.) You can also adjust the affected area by editing the Smart Brush's layer mask, as explained on page 213.

The Smart Brush is great when you want a photo that's mostly in color with only a small area of black and white. If you want the opposite—a photo that's mostly black and white with only a small area of color—then turn on the Options bar's Inverse checkbox, which reverses the area changed by the effect, and then brush over the area you want to keep in color. That way, the part of your image you brush stays in color, while the rest of the photo turns black and white as soon as you start brushing. You can also use one of the methods listed in the following sections.

Tip: The Smart Brush's black-and-white conversion settings aren't always editable. Instead, you may see a confusing message that claims the Adjustment layer was created in Photoshop, even though you just created it in Elements. That's because Adobe uses the Smart Brush to make some Photoshop-only conversion styles available in Elements so you can *apply* them but not tweak them once you're done.

Erasing Colors from a Duplicate Layer

If you don't want to use a layer mask (page 211), you can easily remove colors from parts of your image with the Eraser tool. (See page 418 for more about Elements' different erasers.) With this method, you place a color-free layer over your colored original, and then erase bits of the top layer to let the color below show through. Here's how:

1. Open a photo and then create a duplicate layer.

Press Ctrl+J/ૠ-J or go to Layer→Duplicate Layer. This layer will become the black-and-white version.

2. Remove the color from the new top layer.

Make sure the top layer (the new one you just created) is the active layer, and then go to Enhance—"Convert to Black and White," or to Enhance—Adjust Color—Remove Color. You should now see a black-and-white version of your image.

3. Erase the areas on the top layer where you want to see color.

Use the Eraser tool (page 418) to remove parts of the top layer so the colored layer underneath it shows through. Usually you'll get the best results with a fairly soft brush.

If you want an image that's mostly colored with only a few black-and-white areas, reverse this technique: Remove the color from the bottom layer and leave the top layer in color; then erase as described above.

When you're finished, you can flatten the layers if you want. But by keeping them separate, you give yourself the option of going back and erasing more of the top layer later on. You can also start over by trashing the layer you erased and making a new duplicate of the bottom layer.

Removing Color from Selections

If you don't want your image to have multiple layers, you can make a selection and then use the Enhance menu's "Convert to Black and White" option or Remove Color command. Just make sure you perform this technique on a copy, *not* the original—you don't want to risk wrecking your original photo.

Creating Spot Color

While the Smart Brush is the handiest tool for uncoloring small areas, as explained above, the method described here is best if you don't like any of the Smart Brush's presets or if you're dead set against adding a new layer. Here's what you do:

1. Mask out the area of your image where you want to keep the color.

Use the Selection brush in Mask mode (see page 161) and paint a mask over the area where you want to *keep* the color, to protect it from being changed in step 2. In other words, you'll make everything black and white *except* where you paint with the Selection brush.

If you want to keep the color in most of your photo and remove the color from only one or two objects, then paint over them with the brush in Selection mode instead, or use the Quick Selection tool.

2. Remove the color from the selected area.

Go to Enhance—"Convert to Black and White," or to Enhance—Adjust Color—Remove Color. Elements removes the color from the areas not protected by the mask, but leaves the area under the mask untouched. (You can also do this by going to Enhance—Adjust Color—Adjust Hue/Saturation, and then moving the Saturation slider all the way to the left.) If you have trouble seeing what you've got, temporarily switch from Mask mode to Selection mode, or just click another tool and then click back to the Selection brush to make any changes.

You should now see color only in the areas that you didn't select. This method is the least flexible of all the ones described in this chapter because, once you close your image, the change is permanent. That's why you definitely don't want to use this method on your original photo.

Using an Adjustment Layer and the Saturation Slider

Finally, you can remove color using a Hue/Saturation Adjustment layer. This method doesn't offer you the tone adjustments you can make when using the Enhance menu's "Convert to Black and White" option, but using an Adjustment layer lets you both add and subtract areas of color later on. Here's what you do:

1. Select the area where you want to remove the color.

Use any Selection tool you like (see Chapter 5 for a refresher). If it's easier to select the area where you want to keep the color, do that, and then press Shift+Ctrl+I/Shift-ૠ-I to invert your selection so the area that will lose its color is selected instead.

2. Create a Hue/Saturation Adjustment layer.

Go to Layer \rightarrow New Adjustment Layer \rightarrow Hue/Saturation, or click the Layers panel's New Adjustment Layer icon (the half-black, half-white circle) and choose Hue/Saturation.

3. In Adjustments panel, use the Hue/Saturation controls to remove the color.

Move the Saturation slider all the way to the left to get rid of the color.

With this method, you can go back and edit the Hue/Saturation Adjustment layer's layer mask to change the amount of colored area, including letting only partial color show, as you can see in Figure 10-5. But most of the time you'll get a better looking black-and-white conversion with the duplicate layer technique described on page 353.

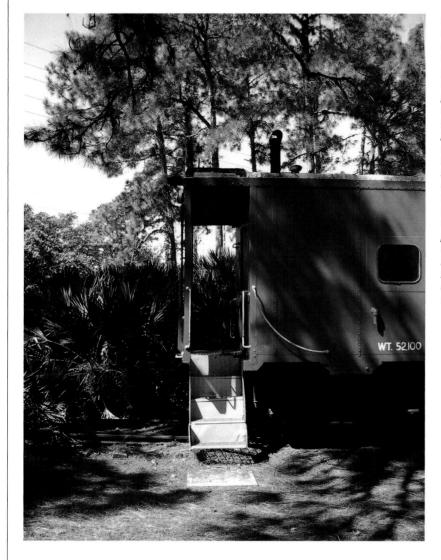

Figure 10-5:

By painting with different shades of arav on the laver mask. vou can make the adjustment's effect partially transparent. Here, a fairly light arav was used to paint over the trees and ground on the left side of the image so that a little areen and brown shows through, but it's not the bright, saturated color of the original photo. (Only part of the left side of the image was painted so you can see the contrast with what was there before.)

Colorizing Black-and-White Photos

So far, you've read about ways to make color photos black and white. But what about when you want to add color to a black-and-white image? Elements lets you do that, too. For instance, you can give an old photo the sort of hand-tinted effect you sometimes see in antique prints, as shown in Figure 10-6.

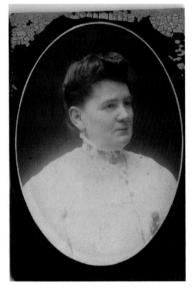

Figure 10-6:

Left: If you decide to color an old black-and-white or sepia photo, put each color on its own layer. That way you can adjust the transparency or change the hue or saturation of one color without changing the other colors, too.

Right: A very low opacity is enough for old photos like this one if you want to give the impression of a print that was hand-colored.

You can easily color things in Elements. But before you start tinting a photo, first make any needed repairs. (See page 320 for repair strategies, or page 228 for exposure fixes.) When your image is in good shape, here's how to color it:

1. Make sure the photo is in RGB mode.

Go to Image \rightarrow Mode \rightarrow RGB Color. If your photo is in any other mode, you won't be able to color it.

2. Create a new layer in Color blend mode.

Go to Layer \rightarrow New \rightarrow Layer and, in the New Layer dialog box that appears, select Color from the Mode menu. With the layer in Color mode, you can paint on the layer and the image's details will still show through.

3. Paint on the layer.

Use the Brush tool (page 399) and choose a color for the Tools panel's Foreground color square. Keep changing the Foreground color as needed. If the color goes on too heavy, reduce the brush's opacity in the Options bar.

Tip: You'll probably want to create a separate layer for each color, to make it easier to go back later and fix just one thing without risking the rest of your hard work.

You can also paint directly on the original layer (if you do, try switching the brush's blend mode to Color). But if you do that, you'll find it far more difficult to fix things if you make a mistake when you're well into your project. Working on the original layer also doesn't give you much of an out if you decide later that, say, the lip color you painted first doesn't look so great with the skin color you just chose.

The methods just described are handy when you want to use many different colors on a photo, but if you want to add only a single color to part of the photo, the easiest way is to use the Smart Brush:

1. Be sure your photo is in RGB mode.

Go to Image \rightarrow Mode \rightarrow RGB Color. If your photo isn't in RGB mode, the Smart Brush will paint only in shades of gray rather than the color you select.

2. Activate the Smart Brush, and then choose a color to paint with.

Press F or click the Smart Brush's icon in the Tools panel. Then head to the Options bar and click the thumbnail to the right of the Refine Edge button. On the palette that appears, choose Color from the pull-down menu. From the menu thumbnails, select the color you want.

3. Drag over what you want to color.

The Smart Brush automatically creates your selection and colors it.

Tip: If you don't get a good selection with the regular Smart Brush, try the Detail Smart Brush instead.

4. Tweak the effect.

The brush tends to apply color pretty heavily, so you may prefer to go to the Layers panel and reduce the Smart Brush layer's opacity (see page 197 for more about layer opacity).

The Smart Brush works well if you happen to like one of its available color choices. But if you don't, use the new-layer method described earlier in this section, which is much more flexible, since you can choose any color you want.

SPECIAL EFFECTS

Hints for Coloring Old Photographs

If you want to add some color to an antique black-andwhite image, it's easier to put each part of a face you're going to color—lips, eyes, cheeks, skin—on a separate layer than to try to control different shades on one layer. That way, you can easily change just one color later on. (You can always merge the layers—by choosing Layer→Merge Visible or Merge Down—when you're done working on the photo.)

Here are some other tips for when you're aiming for that 19th-century look:

 To create a photo that looks like it was hand-colored a century ago, paint at less than 100-percent opacity the tinting on old photos is very transparent.

- If you select an area before you paint, you don't have to worry about getting color where you don't want it, because your paint is confined to your selection.
- Skin colors are really hard to create in the Color Picker. Instead, try sampling skin tones from another photo. If it's a family photo, the odds are good that the current generation's skin tones are reasonably close to great-granddad's. (If you're comfortable using Elements' more advanced features, a gradient map [page 470] can be an excellent way to create realistic skin shading, although it usually takes lots of gradient editing to get things just right. The face in Figure 10-6 was colored using a low-opacity gradient map based on the copper gradient that comes with Elements.)

Tinting a Whole Photo

You can give an entire photo a single color tint all over, even if the original is a grayscale photo. Tinting is a great way to create a variety of different moods.

Elements gives you two basic ways to tint photos. (There are actually a lot more than two, but these should get you started.) The first method described in this section (Layer style) is faster, but the second (Colorize) lets you tweak your settings more. Figure 10-7 shows the results of using the Layer-style method on a color photo.

Tip: For a more subtle effect, you can use Photo Filters, described on page 297. Photo Effects (page 450) also has some terrific monotone tint effects.

For either method, if you want to keep the original color (or lack thereof) in part of your photo, use the Selection brush in Mask mode to mask out the area you don't want to change.

Tip: Some of the Content panel's frame effects automatically add a tint to your photo when you apply them.

Figure 10-7:

You can most easily create a monochrome color scheme for your photo with the Photographic Effects Layer styles, which are explained in Chapter 13. This image had the Red Tone style applied to the original color photo. Elements removed the existing color and recolored the image in one click. The downside is that you can't edit the color once you're done if you later decide you'd rather have, say, blue.

Using a Layer style

Although many people never dig down far enough to find them, Adobe gives you some Photographic Effects Layer styles that make tinting a photo as easy as doubleclicking. You'll learn more about Layer styles on page 456, but this section tells you all you need to know to use the Photographic styles. It's a simple process:

1. Create a duplicate layer.

Go to Layer \rightarrow Duplicate Layer or press Ctrl+J/#-J. (If you don't create a duplicate layer and your original has only a Background layer, Elements asks if you want to convert it to a layer when you apply the style; click OK.)

2. If necessary, change the image's mode to RGB.

Go to Image \rightarrow Mode \rightarrow RGB Color. With this method, it doesn't matter whether your original is in color; the Layer style gets rid of the original color and tints the photo all at the same time.

3. Choose a Layer style.

Go to the Effects panel and, at the top of the panel, click the Layer Styles icon, which looks like two overlapping rectangles. Then, from the panel's drop-down menu, choose Photographic Effects. Double-click the color square you like, drag it onto the photo, or click it once in the panel and then click the Apply button. You can click around and try different colors to see which you prefer. Undo (Ctrl+Z/#-Z) after each style you try, since sometimes an existing layer style can change the way a new one affects your photo.

4. When you like what you see, you're done.

The drawback to this method is that you can't easily go back and edit the color you get from the Layer style. Even if you call up the Style Settings dialog box (see page 458), you don't get any active checkboxes, because these styles don't use those settings. Instead, you need to use a Hue/Saturation adjustment (see page 331) or Color Variations (page 253) to go back later and change the Layer style's tint color.

The Content panel's tint effects

The Content panel includes some frames that automatically apply a tint to your photo, as shown in Figure 10-8. (Go to Window→Content to display the panel if it's not already visible.) These range from simple all-over colors like Sepia to fading gradients. (See page 460 for more about gradients.)

You can read more about using the Content panel's frames on page 510. To tint a photo, choose By Type in the panel's left drop-down menu, and Frames in its right one, and then scroll down the list of thumbnails. If there's a color like blue, red, or sepia inside the frame instead of gray, it means your photo will be tinted that color when you apply the frame to it.

Tip: The Photo Effects section of the Effects panel also has some very effective color tints. Page 450 explains how to apply Effects.

Using Colorize

If you want to add a color tint to a grayscale photo or to change the color of a photo that already has color in it, you can use the Colorize checkbox in either the Hue/ Saturation dialog box or the Adjustments panel. With this method, you can choose any color you like, as opposed to the limited color choices of the Layer styles explained in the previous section. You can also adjust the intensity of the color with the Saturation slider once you've selected the shade you want. Figure 10-9 explains how the Colorize setting changes the way the Hue/Saturation command works.

Using the Content panel, you can apply elaborate effects—like this fading gradient, drop shadow, and frame—with just a double-click. The effect used here is the Color Tint Blue Fadeout 20px.

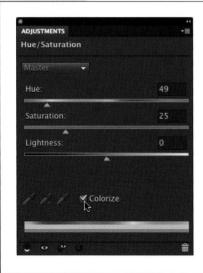

Figure 10-9:

To color something that doesn't have any color info in it, like a white shirt or a grayscale image, in the Adjustments panel, turn on the Colorize checkbox. (If you don't use an Adjustment layer, you get the same checkbox in the Hue/Saturation dialog box.) If you don't turn on this checkbox, you can adjust the hue, saturation, and lightness of white all day long, but all it'll do is go from white to gray to black because there's no color info there for Elements to work with. Also, if something is pure white (that is, contains no color data at all), you may need to darken it by moving the Lightness slider to the left before any color shows up.

Here's how to work with the Colorize checkbox:

1. Make sure your photo is in RGB mode.

Go to Image→Mode→RGB Color.

2. Remove the photo's color, if necessary.

Press Shift+Ctrl+U/Shift-\"-U to remove the color. Do this if the photo has become yellowed or discolored from age, for example. If your whites are really dingy, you might want to make a Levels adjustment (page 244) to brighten them before removing the color.

3. Colorize your photo on a new layer.

Go to Layer \rightarrow New Adjustment Layer \rightarrow Hue/Saturation, and then in the Adjustments panel, turn on the Colorize checkbox. When you do that, Elements fills your image with the current Foreground color. If you don't like it, that's okay—you're going to change it in the next step.

4. Adjust the color until it looks the way you want it to.

Move the Hue, Saturation, and Lightness sliders until you get the look you want, and then click OK. Figure 10-10 shows the results. (If you selected and masked an area, that part should still show the original color.)

Tip: Want to turn a full-color photo to a monotone image in a hurry? Just turn on the Colorize checkbox– you don't need to remove your photo's color first—and Elements reduces your photo to just one color. The advantage to using this method rather than a layer style is that you can use the sliders to select any color you want.

Figure 10-10:

This photo was tinted purple by turning on the Colorize checkbox in the Hue/Saturation dialog box. (The gold ornaments were masked out so they stayed in full color.)

You can change your mind about the colorizing by double-clicking the layer's gear icon in the Layers panel. That brings up the controls for the Hue/Saturation adjustment again so you can change your settings. You can also edit the layer mask, as described on page 213, if you want to change the area that's affected by the Adjustment layer.

When you're done, if you merge layers (or press Ctrl+Alt+Shift+E/#-Option-Shift-E to produce a new merged layer above the existing layers), you can use Levels, Color Variations, and Elements' other color-editing tools to tweak the tint effect.

CHAPTER **11**

Photomerge: Creating Panoramas, Group Shots, and More

E veryone's had the frustrating experience of trying to photograph an awesome view—like a city skyline or a mountain range—only to find that it's too wide to fit into one picture. Elements, once again, comes to the rescue. With the Photomerge command, you can stitch together a group of photos you shot while panning across the horizon to create a panorama that's much larger than any single photo your camera can take. Panoramas can become addictive once you've tried them, and they're a great way to get those wide, wide shots that are beyond the capability of your camera lens.

Elements includes the same great Photomerge feature that's part of Photoshop, which makes it incredibly easy to create super panoramas. Not only that, but Adobe also gives you a few fun twists on Photomerge that are unique to Elements: Faces, which lets you easily move features from one face to another; Group Shot so you can replace folks in group photos; and Scene Cleaner, for those times when your almost-perfect vacation shot is spoiled by strangers walking into the frame. You also get Style Match, which lets you copy the overall look of one photo into another. Like the Ansel Adams-ish look you came up with for one of your images? With Style Match, you can just tell Elements to copy that onto a different photo.

Note: Elements includes one more kind of merge: Photomerge Exposure, which lets you blend differently exposed versions of the same scene (like photos taken using your camera's exposure bracketing feature) to create one image that's perfectly exposed from the deepest shadows to the brightest highlights. You can learn all about it on page 290.

Finally, if you're into photographing buildings (especially tall ones), you know that you often need to do some perspective correcting because the building can appear to lean backward or sideways as a result of distortion caused by your camera's lens. This chapter shows you how to use the Correct Camera Distortion filter to straighten things back up. You'll also learn how to use the Transform commands to adjust or warp your images.

Creating Panoramas

It's incredibly simple to make panoramas in Elements. You just tell the program which photos to use, and Elements automatically stitches them together. Figure 11-1 shows what a great job it does.

Figure 11-1: With subjects like the Smoky Mountains, you can never capture the entire scene in one shot. Here's a four-photo panorama made with Photomerge. The individual photos had big variations in exposure and were taken without a tripod. But Elements still managed to take the images-straight from the camera with no adjusting-and blend them seamlessly.

Elements can merge as many photos as you want to include in a panorama. The only real size limitation comes when you want to print your compositions. If you create a five-photo horizontal panorama but your paper is letter size, for example, your printout will only be a couple of inches high, even if you rotate the panorama to print lengthwise. However, if you're a panorama addict, you can buy a special printer with attachments that let you print on rolls of paper, so that there's no limit to the longest dimension of your panorama. You can also use an online printing service, like the Kodak Gallery, to get larger prints than you can make at home. (See page 526 for more about ordering prints online.)

You'll get the best panoramas if you plan ahead when shooting your photos. The pictures should be side by side, of course, and they should overlap each other by at least 30 percent. Also, you'll minimize the biggest panorama problem—matching the color in your photos—if you make sure they all have identical exposures. While Elements can do a lot to blend exposures that don't match well, for the best results, adjust your photos *before* you start creating a panorama. It helps to keep them side

by side so you can compare them as you work. (See page 107 to learn how to arrange your photos on the Elements desktop.) The box on page 370 has more tips for taking merge-ready shots. However, Elements has gotten pretty good at blending photos together even if they have somewhat different exposures, as you can see in Figure 11-2.

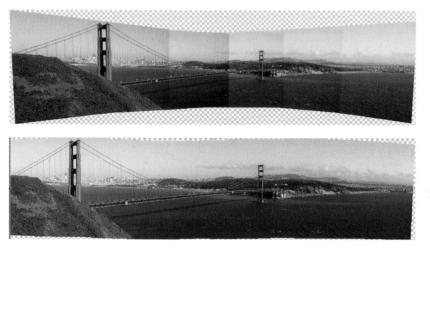

Figure 11-2:

Even if there's quite a difference in the color and exposures of your images, Elements can often do a fine job of combining them, as long as you turn on the Blend Images Together setting.

Top: Here's what you get with all the checkboxes in the Photomerge dialog box turned off. Not bad, but clearly stitched together.

Bottom: With Blend Images Together turned on, Elements does a fine job of smoothing the transitions between the photos. This image also shows what happens to your image's perspective if you turn on Geometric Distortion Correction (page 383).

When the photos you want to combine look good, you're ready to create a panorama. Just follow these steps:

1. Start your merge.

Go to File→New→Photomerge Panorama. The Photomerge dialog box appears.

2. Choose your photos.

If the images you want to include are already open, click the Add Open Files button. Otherwise, in the Use drop-down menu, choose Files or Folder, and then click the Browse button to navigate to the photos you want. As you click them in the window that appears, Elements adds them to the list in the Photomerge dialog box. Add more files by clicking Browse again. To remove a file, click it in the dialog box's list, and then click Remove. **Tip:** You can merge directly from Raw files, although you don't get any controls for adjusting the file conversions (but you may get a pretty good merge anyway). Photomerge works only with 8-bit files (page 285), so if you have 16-bit files, Elements asks if you want to convert them when it begins merging. For faster Raw merges, set the Raw converter to 8 bits before you start.

3. From the Layout list on the left side of the dialog box, choose a merge style.

Ninety-nine percent of the time you'll want to choose Auto, which works great in most cases; Elements takes care of everything, and usually produces a nice panorama. You also get some other choices for special situations:

- **Perspective.** When you select this option, Elements adjusts the rest of the images to match the middle one (Elements figures out which image this is; you don't need to do anything to indicate it) by using skewing and other Transform commands to create a realistic view.
- **Cylindrical.** Sometimes when you adjust perspective, you create a panorama shaped like a giant bow tie (as in Figure 11-2, top). Cylindrical mapping (the method Elements uses to plan out the panorama) corrects this distortion. (It's called "cylindrical" because it's like looking at the label on a bottle: the middle part seems the largest, and the image gets smaller as it fades into the distance, like a label wrapping around the sides of a bottle.) You may want to use this style for really wide panoramas.

Note: If you choose Auto, Elements may use either Perspective or Cylindrical mapping when it creates your panorama, depending on what it thinks will work best for your photos.

- **Spherical.** Spherical aligns and transforms your images as if you were standing inside a globe and pasting them on the wall. This is a good choice if your source images cover more than 180° along the horizon. It's similar to Cylindrical but also corrects distortion on the vertical axis, not just side to side.
- **Collage.** If you choose this option, Elements rotates your photos, if needed, to get them to align perfectly, but doesn't make any perspective changes to them. If you want to combine your photos exactly as they are, this is your best bet. Elements usually crops the completed panorama, though.
- **Reposition.** Elements overlaps your photos and blends the exposures, but doesn't make any changes to the perspective.
- **Interactive Layout.** This option lets you position your images manually in a window that's similar to the Photomerge window that was in early versions of Elements; the next section explains it in detail.

4. Choose how you want Elements to combine the images.

At the bottom of the Photomerge dialog box are three checkboxes that can make a big difference in the final panorama, as you can see from Figure 11-2. You can choose:

- Blend Images Together. This tells Elements to smooth the transitions between your photos and blend the colors in the images. Leave this setting on unless you have a good reason to turn it off.
- Vignette Removal. If you want to merge photos that have some *vignetting* (shadowy corners caused by things like your camera's lens hood or the lens itself), turn this on and Elements will fix it while it merges the photos.
- Geometric Distortion Correction. If you look at the first photo in Figure 11-2, it's shaped like a big bow tie, a common outcome when stitching lots of images together. Turn this setting on, and Elements squares things up a bit, as you can see in the bottom image of Figure 11-2. However, you may not like the result; it's totally up to you whether to turn this checkbox on.

Note: You can't turn on Vignette Removal or Geometric Distortion Correction if you choose the Collage, Reposition, or Interactive Layout merge style.

5. Click OK to create your panorama.

Elements whirls into action, combining, adjusting, and looking for the most invisible places to put the seams until it whips up a completed panorama for you. That's all there is to it.

Note: Elements has a lot of complex calculations to make when creating a panorama, especially if you're combining lots of images or there are big exposure differences between the photos, so this step may take awhile. Don't assume that Elements is stuck; it may just need a few minutes to finish working.

6. Tell Elements whether or not to fill in any empty edges in the completed panorama.

When Elements finishes combining your images, you see a dialog box asking if you'd like the program to automatically fill in the edges of the panorama to make it rectangular. Elements uses Content-Aware filling (page 309) to do this, and sometimes you can get pretty amazing results.

However, this requires Elements to do a lot of serious thinking, and if there's a lot of empty space in your panorama, you can expect your computer to slow to a crawl while Elements works. If your panorama is large, Elements may take many minutes to ponder it—and then announce that your computer doesn't have enough memory, anyway. You'll find that this feature works best if you also turn on Geometric Distortion Correction or use the Collage merge style so there's less empty space to fill.

Note: Edge-filling creates a merged layer of all the photos and works on that, so your file size will be much larger if you use it.

You'll probably want to crop your panorama, but otherwise, you're all done (except for saving the completed file). You can do anything to your panorama that you can do to any other photo. The Recompose tool (page 323) is especially useful for adjusting proportions in panoramas, if you need to do that.

Tip: Elements creates layered panoramas, and if you look at the Layers panel you can see layer masks showing how much of each photo it used. Since you know how to edit layer masks (page 213), you can go back afterwards and manually make changes, if you want.

IN THE FIELD

Shooting Tips for Good Merges

The most important part of creating an impressive and plausible panorama starts before you even launch Elements. You can save yourself a lot of grief by planning ahead when shooting photos.

Most of the time, you know *before* you shoot that you'll want to merge your photos. You don't often say, "Wow, I have seven photos of the Captain Jack Sparrow balloon at the Thanksgiving Day parade that just happen to be exactly in line and have a 30-percent overlap between each one! Guess I'll try a merge."

So before you take pictures for a panorama, set your camera to be as much in manual mode as possible. The biggest headache in panorama making is trying to get the exposure, color, brightness, and so on to blend seamlessly (but Elements is darned good at blending the outlines of the physical objects in your photos). So lock your camera's settings so that the exposure of each image is as identical as possible. Even small digital cameras that don't have much in the way of manual controls may have some kind of panorama setting—like Canon's Stitch Assist mode—that does the same thing. (Your camera may actually be able to make merges that are at least as good as what Elements can do, because the camera does the image-blending internally. Check whether your model has a panorama feature.)

The more your photos overlap, the better. Elements does what it can with what you give it, but it's really happy if about a third of each image overlaps with the next.

Use a tripod if you have one, and *pan heads* (tripod heads that let you swivel your camera in an absolutely straight line). As long as your shots aren't wildly out of line, Elements can usually cope. But you may have to do quite a bit of cropping to get even edges on the finished result if you don't use a tripod.

Whether or not you use a tripod, keep the camera—rather than the horizon—level to avoid distortion. In other words, focus your attention more on leveling the body of the camera than what you see through the viewfinder. Use the same focal length for each image, and try not to use the zoom, unless it's manual, so you can keep it exactly the same for every image.

Tip: Elements always creates layered panoramas. So before you send your panorama out for printing, flatten it (Layer—Flatten Image), since most commercial printers don't accept layered files. Also, if you enlarge the view of your layered panorama and zoom in on the seams, you may see what look like hairline cracks. Merging or flattening the layers gets rid of these cracks.

Manual Positioning with Interactive Layout

If you want to position your photos by hand, choose Interactive Layout from the Photomerge dialog box's Layout list. When you click OK, Elements does its best to combine your photos, and then presents them to you in the window shown in Figure 11-3.

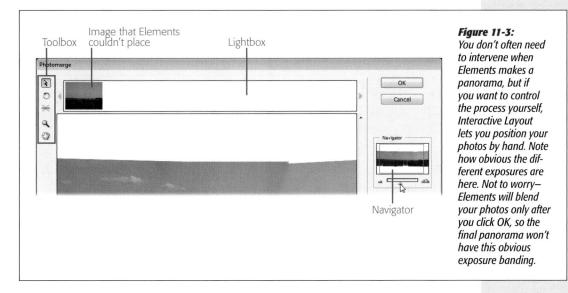

Your panorama in its current state appears in the large preview area, surrounded by special tools to help you get a better merge. On the window's left side is a toolbox, and there are special controls down the right side. The lightbox across the top of the window contains any photos that Elements couldn't figure out how to place.

You can use any combination of these features to improve your panorama. For example, you can manually drag files from the lightbox into the merged photos, and reposition photos already in your panorama. Just grab them with the Select Image tool (explained below), and then drag them to the correct spot in the merge.

If you try to nudge a photo into position and it keeps jumping away from where you place it, turn off the "Snap to Image" checkbox on the right side of the window. Then you should be able to put your photo exactly where you want it. Just remember that Elements isn't doing the figuring for you anymore, so use the Zoom tool to get a good look at how you're aligning things. You may need to micro-adjust the photo's exact position.

Some of its tools at the top left of the window are familiar, and others are just for panoramas. From top to bottom they are:

• Select Image. Use this tool to move individual photos into or out of your merged photo or to reposition them. When this tool is active, you can drag photos into or out of the lightbox. Press A or click the tool's icon to activate it.

- Rotate Image. Elements usually rotates images automatically when it merges them, but if it doesn't or if it guesses wrong, press R to activate this tool, and then click the photo you want to rotate. Handles appear on the image, just like the ones you get with the regular Rotate commands. Simply grab a corner and turn the photo until it fits in properly. Usually, you don't need to drastically change a photo's orientation, but this tool helps you make small changes to line things up better.
- Set Vanishing Point. To understand what this tool does, think of standing on a long, straight, country road and looking off into the distance. The point at which the two parallel lines of the road seem to converge and meet the horizon is called the *vanishing point*. This tool tells Elements where you want that point to be in your finished panorama. Knowing the vanishing point helps Elements figure out the correct perspective; Figure 11-4 shows how it can change your results. Press V to activate this tool.

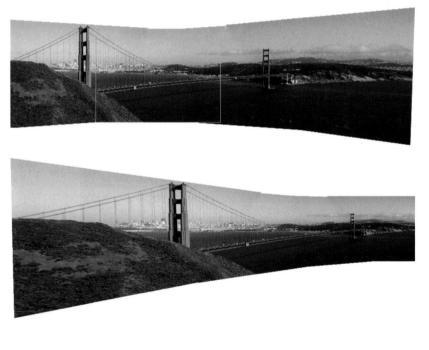

Figure 11-4:

You can radically alter the perspective of your panorama by selecting a vanishing point.

Top: The result of clicking the center photo with the Set Vanishing Point tool.

Bottom: The result of clicking the righthand image. Note that the tool selects a whole *image*, not a specific point within a photo. You can click any photo to put your vanishing point there, but if you then try to tweak things by clicking a higher or lower point in the same photo, nothing happens. To change the vanishing point you've set, just click a different photo.

- Zoom. This is the same Zoom tool you meet everywhere else in Elements. Click the magnifying glass icon in the toolbox or press Z to activate it.
- **Move View.** You use this tool the way you use the Hand tool when you need to scoot your *entire* merged image around to see a different part of it. Click the hand icon in the toolbox or press H to activate it. (If you want to move just one photo within your panorama, use the Select Image tool instead.)

To control your onscreen view of the panorama, use the Navigator on the right side of the Photomerge window. It works just like the regular Navigator described on page 114. Move the slider to resize the view of your panorama; drag it to the right to zoom in on an area, or to the left to shrink the view so you can see the whole thing at once. To target a particular spot in your merge, drag the red rectangle to control the area that's onscreen.

Also, on the bottom and right side of the preview window are scroll bars and two arrows. Click an arrow to move in the direction the arrow points (so, for example, click the right-facing arrow at the bottom of the window to slide your image to the right). At certain view sizes you'll also see a square (something like a checkbox) at the bottom and/or right side of the image. You can drag that like a handle to manipulate the view, too.

Below the Navigator box are two radio buttons that adjust the viewing angle of your panorama:

- **Reposition Only**. This setting tells Elements to simply overlap the edges of your photos without changing the perspective. But if you don't like the way the angles in your panorama look, try clicking Perspective instead. (Elements always blends the exposures of your images to make the transitions smooth; there's no way to turn that off.)
- **Perspective.** If you click this button, Elements tries to apply perspective to your panorama to make it look more realistic. Sometimes the program does a bang-up job, but usually you get better results if you help it out by setting a vanishing point. If you still get a weird result, go ahead and create the merge anyway, and then correct the perspective afterward using one of the Transform commands covered in the next section.

Once you like how your photos are arranged, click OK, and Elements creates your final panorama.

Merging Different Faces

Merging isn't just for making panoramas. One of the Elements-only tools that Adobe gives you is Faces, a fun (okay, let's be honest—silly) feature that lets you merge parts of one person's face with another person's face. You can use it to create caricature-like photos, or to paste your new sweetie's face over your old sweetie's face in last year's holiday photo. Figure 11-5 shows an example of what Faces can do.

Figure 11-5:

Faces is really just for fun. You can create composite images like this one, and then use Elements' other tools to make your photo even sillier, if you like.

Although you'd be hard put to think of a serious use for Faces (it *may* work for something like copying a smile from one photo to another image of the same person with a more serious expression, but the result may not be top quality), it's fun to play with and simple to use:

1. Choose the photos you want to combine.

You need to have at least two photos open in the Project bin before you start. You can Ctrl-click/#-click to preselect the photos you want to include.

2. Call up the Faces window.

You can get to it either from File \rightarrow New \rightarrow Photomerge Faces, or from Guided Edit \rightarrow Photomerge \rightarrow Faces.

If you didn't preselect images, a dialog box asks you to choose the photos you want to include. In the Project bin, Ctrl-click/#-click to select the photos you want to use, or click Open All in the dialog box. Elements then opens the Faces window, which has a preview area on the left and an instruction pane on the right.

3. Pick a Final photo.

This is the photo into which you'll paste parts of a face from one or more other photos. Drag a photo from the bin into the Final area (the right-hand preview).

4. Choose another Source photo if you don't like the one Elements selected.

This is the photo from which you'll copy part of a face to move to the Final image. Double-click an image in the Project bin, and it appears in the left-hand preview area. You can copy from many different photos, but you can work only with one Source photo at a time. (When you're done working with a Source photo, just double-click the next one you want. That way, you can use the ears from one photo, the nose from another, and so on.)

Merging Different Faces

5. Align your photos.

This step is really important, because otherwise Elements can't adjust for any differences in size or angle between the two shots. Click the Alignment Tool button in the Photomerge Faces pane, and the three little targets shown in Figure 11-6 appear in each image. (You may need to move your cursor over a photo to see them.)

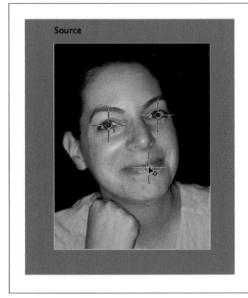

Figure 11-6:

To tell Elements how to align your photos, drag one of these three targets over each eye and the mouth in each photo.

Position the markers over the eyes and mouth in each photo. (If you need help seeing what you're doing, there's a little toolbox on the left with your old friends, the Zoom and Hand tools, so you can reposition the photo for the best view.) Then click the Align Photos button, and Elements adjusts the photos so they're the same size and sit at the same angle.

6. Tell Elements what features to move from the Source image to the Final image.

Click the Pencil tool in the Photomerge Faces pane and, in the Source photo, draw over the area you want to move. In a few seconds you should see the selected area appear in the Final photo. You only need to draw a quick line—don't try to color over all the material you want to move. In the Options bar, you can adjust the size of the Pencil tool if it's hard to see what you're doing, or if it's grabbing too much of the surrounding area.

If Elements moves too much stuff from the Source photo, use the Photomerge Faces pane's Eraser tool to remove part of your line. Watch the preview in the Final image to see how you're changing the selection. If you want to start over, click the Reset button at the bottom of the pane (you may have to scroll down to see it).

7. When you're happy, click Done.

Elements creates your merge as a layered file. Now you can edit it using any tool to do things like clean up the edges or to manually clone (page 315) a little more material than Elements moved. And you can make your image even sillier using the Transform commands (page 389), the Liquify filter (page 487), and so on.

You can adjust two settings in the Photomerge pane:

- Show Strokes. If you want to see what you're selecting with the Pencil tool, leave this checkbox on.
- Show Regions. Turn this on to see a translucent overlay on the Final image, which makes it easier to tell which parts you're copying over from your Source photo. This is just like the regions options for Exposure Merge, which you can see on page 295.

It would be nice if you could use this feature to merge things besides faces, but it doesn't do a very good job of that. Even for faces, if you're doing something important, like repairing an old photo with parts from another picture of the same person, you may prefer to do your own selections and then manually move and adjust things (see page 220). But the Faces feature's alignment tools can simplify the process enough that it's worth giving it a try to see if it can do what you want.

Arranging a Group Shot

Have you ever tried taking photos of a bunch of people? Almost every time, you get a photo where everything is perfect—except for that one guy with his eyes shut. In another shot, that guy is fine, but other people are yawning or looking away from the camera. You probably thought, "Dang, I wish I could move Ed from that photo to this one. Then I'd have a perfect shot." Adobe heard you, and Group Shot is the result. It's designed for moving one person in a group from one photo to another, similar photo.

You launch Group Shot by going to File \rightarrow New \rightarrow Photomerge Group Shot, or Guided Edit \rightarrow Photomerge \rightarrow Group Shot. The steps for using Group Shot are the same as for Faces, except that you don't normally need to align the photos, since Group Shot is intended for situations where you were saying, "Just one more, everybody!" as opposed to moving people from photos taken at different times with different angles and lighting.

If you do need to align your photos, you can do that with the advanced options (click the flippy triangle next to Advanced Options in the Photomerge Group Shot pane to get to them). Just place the markers the same way you do in Faces (see Figure 11-6). Another advanced option is Pixel Blending, which adjusts the moved material to make it closer in tone to the rest of the Final image.

Tidying Up with Scene Cleaner

Note: It would be great if you could use Group Shot for things like creating a photo showing several generations of your family by combining images from photos taken over many years. But Group Shot moves someone from the Source photo and pastes that person into the same spot in the Final photo, and then creates a composite layer in the completed merge. That means the relocated person is merged into the Background image, and isn't left as an extracted object, so you can't put that person in a different spot. So you need to tackle your generational-photo project the old-fashioned way: by moving each person onto a separate layer and then repositioning everybody where you want them.

Tidying Up with Scene Cleaner

You've probably had this experience when showing your vacation photos: "Here's a shot of Jodi and Taylor at the rim of the Grand Canyon. Those other people? No idea who they are; they just walked into the shot." Scene Cleaner was made to fix photos like that. It lets you eliminate unwanted people or elements in your images to help you create photos like the ones you see in travel magazines that show famous sights in their lonely glory, without any tourists cluttering up the scene.

Scene Cleaner is quite easy to use, but you'll get better results if you can plan ahead when taking your photos. In order to get a people-less landscape (or one with only people you know), you need to shoot multiple photos from nearly the same angle. All the areas you want to feature should be uninhabited in at least one photo. So, for instance, if you can get one shot of the Statue of Liberty where all the tourists are on the left side of her crown and one where they're on the right side, you're all set. Then you can use Scene Cleaner to create a more perfect world:

1. Open the photos you want to combine.

In addition to being taken from nearly the same vantage point, the images should have similar exposures. If a cloud was passing overhead, for instance, so that one photo is bright and one is shadowy, you'll have to do some fancy touchups afterward to blend the tones. In fact, it's usually easier to do this beforehand. Chapter 7 has the full story on correcting exposures.

2. Call up Scene Cleaner.

In Full Edit, go to File \rightarrow New \rightarrow Photomerge Scene Cleaner, or go to Guided Edit \rightarrow Photomerge \rightarrow Scene Cleaner. Either way, you wind up in Guided Edit to create your merged image. Elements automatically aligns your photos, so there may be a slight delay before you see the Scene Cleaner window.

3. Choose a Final image.

This is the base image into which you'll put parts of your other photo(s). Drag the photo you want from the Project bin into the Final preview area (the right-hand slot).

4. Choose a Source image if you want to use a different photo than the one Elements picked.

Look through your photos to find one that has an empty area where the people or objects you want to remove from the Final photo are. Click that photo in the Project bin, and it appears in the Source preview area (the left-hand slot). (As with Faces, you can use many Source images, but you work with only one at a time; just click the next Source photo when you're ready for it.)

5. If necessary, align your photos manually.

Usually you don't need to do this, but if Elements didn't do a good job of automatically aligning your photos, in the Photomerge Scene Cleaner pane, click the flippy triangle next to Advanced Options (you may have to scroll down to see it), and then click the Alignment tool. You see the three markers described in the section on Faces (page 375). This time, instead of eyes and mouth, place them over three similar locations in each photo, and then click the Align Photos button.

6. Tell Elements what you want to move.

If the Pencil tool isn't active, click it in the Photomerge Scene Cleaner pane. Then, in the Source image, draw over the area you want to move to the Final photo. Just draw a quick line—Elements figures out the exactly what move. (You can also go to the Final preview and draw over the area you want to cover—Elements can figure it out either way.)

7. Adjust the areas if needed.

Use the Pencil tool again to add more areas, or the Eraser tool to remove bits if you moved too much. You can use the Eraser in either preview, Source or Final. If you have more than two photos to work with, in the Project bin, click another photo to display it in the Source slot, and then select the area you want. If you need to see the edges of the areas that Elements is moving, turn on the Show Regions checkbox, explained in Figure 11-7. If the exposures don't blend well, go to the Advanced Options and turn on Pixel Blending for a smoother merge.

8. When you're happy, click Done.

Don't forget to save your work. If you want to start over, click Reset. If you decide to give up on the merge, click Cancel.

Most of the time, you only need to use Scene Cleaner's Pencil and Eraser tools, but Adobe gives you some additional options to help you out when necessary:

- Show Strokes. Leave this checkbox turned on or you can't see where you're drawing with the tools.
- Show Regions. Scene Cleaner actually brings over chunks of the Source image. If you turn this checkbox on, you can see a blue-and-yellow overlay showing the exact size of the material you're moving (see Figure 11-7).
- Alignment Tool. This advanced option lets you manually set the comparison points in case you don't like Elements' automatic choices. Step 5 above explains how to do so.

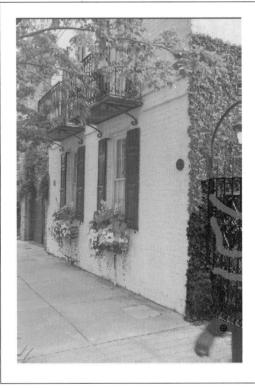

Figure 11-7:

When you turn on the Show Regions checkbox, Elements covers your photo with this mask. Here the yellow shows the original area from the Final photo, and the blue shows the section (without the lady's purse and arm) brought over from the Source photo. If you look closely at the bottom-right corner of the image, you can see that the hand hasn't been deleted yet, but another drag with the pencil will do it. The mask is helpful if you have a hard time getting exactly the amount of source material you want. The overlay gives you a better idea of where to erase or add material if you need to.

• **Pixel Blending.** Just as with Faces, you can turn on this setting when there's a discrepancy in the color or exposure of your photos so that they combine more seamlessly.

It's not always easy to get enough clear areas to blend, even with multiple photos. But when you have the right kind of Source photos, you can create the impression that you and your pals had a private tour of your favorite places.

Merging Styles

Style Match is the latest addition to Adobe's ever-growing list of ways to merge images. Think about all the great photographers; each one has a distinctive style, and a lot of that comes from the way their images were treated in the darkroom or processed digitally. Style Match lets you create and duplicate your own style, or imitate one of your favorite photographer's styles. It gives you a way to say to Elements, "See this photo? I really like the way it looks. Do what you can to make my other photo look just like that." You can produce a number of fun effects this way. And if you happen to be the executor of Ansel Adams's estate, don't worry: Not even a computer running Elements can take a casual snapshot and turn it into a serious work of art. In fact, what you actually get from using Style Match may be wildly different from what you expected, but that's part of the fun. You aren't just limited to using photos as sources, either; you can try blending effects from any kind of image. So if you did a digital painting and you'd like to try to copy that, you can use it as your source, although you're not going to get all the brushstrokes and textures.

Style Match is super easy to use. And if you don't have any carefully styled photos to use as sources, Adobe gives you some sample styles to use. Here's what you do:

1. Open a photo and then go to File→New→Photomerge Style Match, or Guided Edit→Photomerge→Style Match.

This should be the photo to which you're going to apply the style. Your photo appears in the "After" slot in the Style Match window.

2. Choose a style to copy.

The Style Match window includes a new bin—the Style bin—that appears on top of the Project bin. (To get back to the Project bin, click its tab.) In this new bin are some sample images to get you started, but you can use any image as your source. To use one of your own images, click the green + button at the bin's upper left, and then choose between using a photo from the Organizer or one from your hard disk. If you choose your hard disk, in the window that opens, navigate to the image you want and then click Open. In either case, the image(s) you choose get added to the Style bin. If you want to remove an image from the bin, click it and then click the trashcan to get it out of your way.

3. Apply the style.

Just drag the image you want to copy from the Style bin to the Style Image slot on the left, and Elements automatically applies that image's style to your After photo. The result probably looks pretty bad (see Figure 11-8), but that's okay, because you're going to tweak things in the next step.

4. Try other styles, if you want.

If you think you might like the style from another image better than the one you used, just drag the new image to the Style Image slot and Elements uses its style instead. (Each time you add a new style, it *replaces* the previous one; the effect isn't cumulative.) To go back to your original image, click the Reset button at the bottom of the Photomerge Style Match pane.

5. Make any adjustments to the way Elements applied the style.

The Photomerge Style Match pane includes a number of sliders you can use to tweak the effect on your image (they're explained in a moment). You can also use the Style Eraser to remove the style from part of your photo (if you want to apply it only to the background, for example), and the Style Painter to put back areas if you decide you took away too much. They work just like the regular Eraser and Brush tools, but they only apply (or remove) styles.

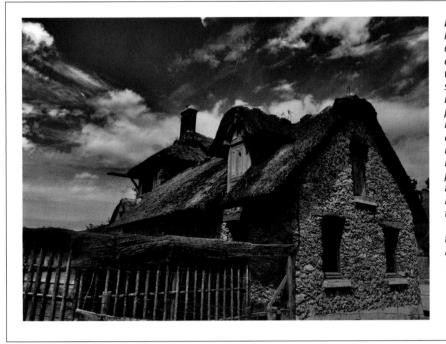

Figure 11-8:

Here's an example of what happens to a reaular RGB photo when you copy the style from an old black-and-white photo to it. The RGB imaae's colors have an interestina. dramatic effect to them. but if you want to duplicate the colorina of the Silver Hotel image in addition to its style. turn on the Transfer Tones checkbox in the Photomerge Style Match pane. Figure 11-9 shows the result.

Tip: You can change the blend mode in the Options bar when using either the Style Eraser or the Style Painter, which can make for some interesting special effects. You can create very painting-like effects with Style Match by using blend modes and a graphics tablet (which lets you make more painterly brushstrokes).

6. When you like what you see, click Done.

It may take a few seconds for Elements to apply the style. When it's finished, it creates a layered file, so you can remove the style later by discarding the layer it's on.

As mentioned above, the first version of your photo that you see after applying a style may be pretty gnarly, but Elements gives you a whole panel full of ways to adjust things. Once the program applies the initial style, you can use any of these settings to tweak it, in addition to the Style Eraser and Style Painter tools (explained in step 4 above):

- **Style Intensity.** This slider always starts off at 100%, so the style is as strong as Elements can make it. Move the slider to the left if you want to reduce the effect.
- **Style Clarity.** This is a little like a contrast slider. Move it to the right for more intense contrast or to the left for a more blended look.

- Enhance Details. If you want a more posterized look (page 342), move this slider to the right. Moving it all the way to the left reduces the applied style to a kind of haze over your image.
- **Soften Stroke Edges.** The further you move this slider to the right, the less sharp-edged your Style Painter or Style Eraser strokes will be.
- **Transfer Tones.** As mentioned earlier, this is probably the setting you'll want to go for first. Turn on this checkbox to also apply the *coloration* of the Style Image to your photo, not just its style. For example, if you use the sepia-toned Style Image on a color photo, your image will still be in color, just oddly darkened in spots. To convert your photo to a sepia image, turn this setting on. Figure 11-9 shows what it can do.

Note: If your Style Image is colored, you might get some pretty strange effects by turning on Transfer Tones.

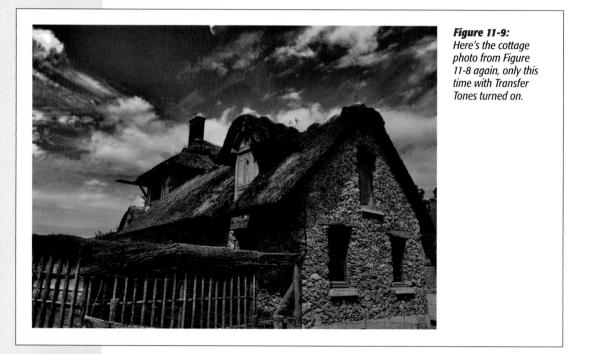

Style Match is fun, but it's not meant for doing serious retouching like getting the same adjustments onto a stack of photos. It works best on subjects like landscapes, although you can get some pretty funny results by first using Faces (page 373) and then running Style Match on the resulting image.

Correcting Lens Distortion

Correcting Lens Distortion

If you ever photograph buildings, you know that it can be tough getting good shots with a fixed-lens digital camera. When you get too close to the building, your lens causes distortion, as shown in Figure 11-10. You can buy special perspective-correcting lenses, but they're expensive (and if you have a pocket camera, they aren't even an option). Fortunately, you can use Elements' Correct Camera Distortion filter to fix photos after you take them. This is another popular Photoshop tool that Adobe transferred over to Elements, minus a couple of advanced options.

Figure 11-10:

Here's a classic candidate for Elements' Correct Camera Distortion filter. See how the buildings appear to lean back and to the right? This type of distortion is common when you're using a pointand-shoot camera in a narrow space that doesn't let you get far enough away from your subject. You can fix such problems in a jiffy with the help of this filter. Correct Camera Distortion is a terrifically helpful filter, and not just for buildings. You can also use it to correct the slight balloon effect you sometimes see in close-ups of people's faces (especially in shots taken with a wide-angle setting). You can even deploy the filter for creative purposes, like producing the effect of a fish-eye lens by pushing the filter's settings to their extremes.

Here are some telltale signs that it's time to summon Correct Camera Distortion:

- You've used the Straighten tool on your image but things still don't look right.
- Your horizon is straight, but your photo has no true right angles. In other words, the objects in your photo lean in misleading ways. For instance, buildings lean in from the edges of the frame, or lean back away from you.
- Every time you straighten to a new reference line, something else gets out of whack. For example, say you keep choosing different lines in your photo that ought to be level, but no matter which one you choose, something else in the photo goes out of plumb.
- Your image has a dark, shadowy effect in its corners (this is called *vignetting*). You can also use this filter to *create* vignetting for special effects.

Adobe has made this filter extremely easy to use. Just follow these steps:

1. Open a photo, and then go to Filter→Correct Camera Distortion.

The dialog box shown in Figure 11-11 appears. Elements automatically places a grid over your image to help you align things.

Note: Even though Correct Camera Distortion is in the Filter menu, you can't reapply it using the Ctrl+F/ #-F keyboard shortcut the way you can with most other filters—you always have to select it from the Filter menu.

2. If necessary, use the Hand tool to adjust your photo in the window.

You want a clear view of a reference line—something you know you want to correct, like the edge of a building. If the distortion is really bad, finding a really true reference line may be impossible, but try to find at least one line that's pret-ty closely aligned to the grid, so you have a reference for changing the photo. You can also use the usual view controls (including zoom in and out buttons) in the dialog box's lower-left corner. The Hand tool adjusts both your photo and the grid, so you can't use it to position your photo *relative* to the grid. However, the Hand tool doesn't do anything unless you set your view to more than 100 percent.

The Show Grid checkbox below the image window lets you turn the grid on and off, but since you're going to be aligning your image, you'll almost always want to keep it on. To change the grid's color, click the Color box next to the Show Grid checkbox.

Correcting Lens Distortion

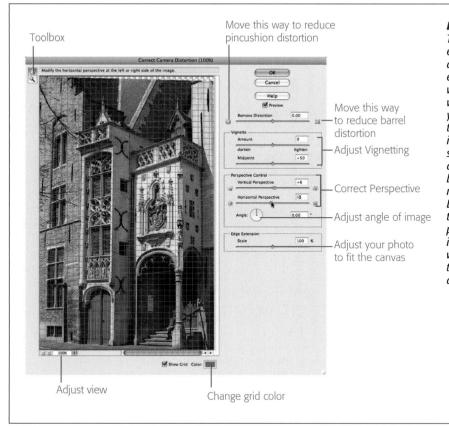

Figure 11-11: To use Correct Camera Distortion. look at the icons on either end of each slider. which show you what happens when vou move the slider toward the icon. For instance, if your photo suffers from barrel distortion (everything bows outwards). move the Remove Distortion slider toward the pinched-in pincushion. The icon illustrates exactly what you want to do to vour photo-slim it down.

3. Make your adjustments.

This filter lets you fix three different kinds of problems: barrel/pincushion distortion, vignetting, and perspective problems. These errors are the ones you're most likely to run into, and correcting them is as easy as dragging sliders around. The small icons on each side of the Perspective Control sliders show you how your photo will change if you drag the slider in that direction. You may need to make only one adjustment, or you may need many (the bulleted list that follows helps you decide which controls to use).

As you tweak these settings, watch the grid carefully to see how things are lining up. When everything is straightened to your satisfaction, you're done. If you want to start over, Alt-click/Option-click the Cancel button to change it to a Reset button and return your photo to the state it was in when you summoned this filter.

4. Scale your photo, if you wish.

As you make adjustments, you'll probably notice some empty space appearing on either side of your canvas (the background area of your file). This often happens when Elements pinches and stretches your photo to correct distortion. To make things right, you have two options: click OK and then crop the photo yourself using any of the methods you learned about starting on page 99, or use the Correct Camera Distortion dialog box's Edge Extension slider to enlarge your photo so that it fills the image window. If you use the second method, Elements crops some of the photo, and you have little control over what it chops off. After all the effort you've put into using this filter, you may as well do your own cropping to get the best possible results.

5. Click OK to apply your changes.

If you don't like the way things are turning out, reset your photo by Alt-clicking/ Option-clicking the Cancel button. If you just want a quick look at where you started (without undoing your work), toggle the Preview checkbox on and off.

The Correct Camera Distortion filter gives you a few different ways to adjust your image. Your choices are divided into sections according to the kinds of distortion they fix:

• **Remove Distortion**. Use this slider to fix *barrel distortion* (objects in your photo balloon out, like the sides of a barrel, as shown in Figure 11-12) and its opposite, *pincushion distortion* (your photo has a pinched look, with the edges of objects pushing in toward the center). Move the slider to the right to fix barrel distortion, and to the left to fix pincushion distortion.

Tip: Barrel distortion is usually worst when you use wide-angle lens settings, while pincushion distortion generally happens when a telephoto lens is fully extended. Barreling is more common than pincushioning, especially when you use a small point-and-shoot camera. You can often reduce barrel distortion in a small camera by simply avoiding your lens's widest setting. For instance, if you change the aperture setting from f2.8 to f5.6 or just zoom in a tad, you may see significantly less distortion.

• Vignette. If your photo has dark corners (usually caused by shadows from the lens or lens hood), you need to spend time with these sliders. Vignetting typically afflicts owners of digital single-lens reflex cameras, or people who use add-on lenses with fixed-lens cameras. Move the Amount slider to the right to lighten the corners or to the left to darken them. The Midpoint slider controls how much of your photo is affected by the Amount slider. Move it to the left to increase the area (to bring it toward the center of the photo), or to the right to keep the vignette correction near the corners. Consider turning off the Show Grid checkbox while you're working with these sliders so that you have an unobstructed view of how you're changing the lightness values in your photo. (Turn it back on again if you have other adjustments to make afterward.)

Figure 11-12:

A classic case of barrel distortion. This photo was already straiahtened with the Straighten tool, but things are still out of plumb: notice how the columns and walls lean in toward the top of the photo. You can even see a bit of a curve in the pillar on the far right. Barrel distortion is the most common kind of lens distortion, and vou can easily fix it with the Correct Camera Distortion filter.

• **Perspective Control.** Use these sliders to correct objects like buildings that appear to be tilting or leaning forward or backward. It's easiest to understand these sliders by looking at the icons at their ends, which show the effect you'll get by moving the slider in that direction. The Vertical Perspective slider spreads the top of your photo wider as you move the slider to the left, and makes the bottom wider as you move it to the right. (If buildings seem like they're leaning

backward, move it to the left.) The Horizontal Perspective slider is for when your subject doesn't seem to be straight on in relation to the lens (for example, if it appears rotated a few degrees to the right or left). Move the slider to the left to bring the left side of the photo toward you, and to the right to bring the right side closer.

You can rotate your entire photo by moving the line in the Angle circle to the position you want, or by typing a number into the box. A small change here has a huge effect. Here's how it works: There are 360 degrees in a circle. Your photo's starting point is 0.00 degrees. To rotate your photo counterclockwise, start from 0.01, and then go up in small increments to increase the rotation. To go clockwise, start with 359.99, and then reduce the number.

Tip: Each of the adjustment sliders is accompanied by a box where you can type a number instead of moving the slider. If you want to make the same adjustments to several photos, take note of the numbers you used to fix your first photo, and then plug those numbers into the boxes for the other photos.

• Edge Extension. As explained in step 4 above, when you're done fixing your photo, you're likely to end up with some blank areas along the edge of your canvas. Move the Scale slider to the right to enlarge your photo and get rid of those blank areas. (Moving the slider to the left shrinks your photo and enlarges the blank areas, but you'll rarely want to do that.)

One important thing to keep in mind: Unlike the Zoom tool, the Scale slider changes your *actual* photo, not just your view of it. So when you click the Correct Camera Distortion dialog box's OK button after using this slider, Elements resizes and crops your photo. So if you want the objects in your photo to stay the same size, don't use this slider. Instead, just click OK, and then crop using any of the methods discussed starting on page 99.

The most important thing to remember when using Correct Camera Distortion is that a little goes a long way. For most photos, the best method is to start small and work in tiny increments. These distortions can be subtle, and you often need to make only subtle adjustments to correct them.

Tip: The Correct Camera Distortion filter isn't just for corrections. You can use it to make your sour-tempered boss look truly prune-y, for example, by pincushioning him. (Just make sure you do it at home.) Or, you can add vignettes to photos for special effects, and use the filter on shapes (simplify them first; see page 426), artwork, or anything else that strikes your fancy.

Transforming Images

You'll probably end up using the Correct Camera Distortion filter for most of your straightening and warp-correcting. But Elements also includes a set of Transform commands, demonstrated in Figure 11-13, that come in handy when you want to make a change to just *one* side of a photo, or for making final tweaks to a correction you made with Correct Camera Distortion. You can also apply these commands just for fun to create wacky photos or text effects. The following pages explain all your options.

Figure 11-13:

Left: While you could use Correct Camera Distortion (page 383) to straighten a slanting building like this one, sometimes it's easier to make straightforward corrections like this by switching to the Transform commands and just giving the object a yank to pull it where you want it.

Right: Here, it took only a dose of Skew and a bit of Distort to pull the building straight and make it tall again.

Skew, Distort, and Perspective

Elements gives you four Transform commands, including three specialized ones— Skew, Distort, and Perspective—to help straighten out objects in your photos. They all move your photo in different directions, but the way you use them is the same. When you choose the Transform command you want, the same box-like handles appear around your photo that you see when using the Move tool. Just drag a handle in the direction you want your photo to move. Figure 11-14 shows how to use these commands.

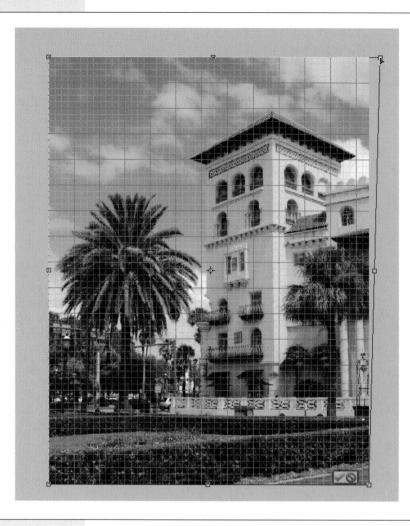

Figure 11-14:

Here's an example of how you'd use the Skew command to pull a building upright. To apply the Transform commands, make sure you can reach the handles on the image's corners; it helps to enlarge your image window far beyond the size of the actual image to give yourself room to pull.

(If you're using tabbed windows, you don't need to do this because you already have plenty of space around your image. But if you're working with floating windows, just drag the lower-right corner to enlarge the window.)

To see the list of Transform commands, go to Image→Transform. The first one, Free Transform, is the most powerful because it includes all the others—you'll learn about it in the next section. (Although Free Transform is the most capable command, it can also be the trickiest to use. You may find it easier to use one of the specialized Transform commands so you don't have to worry about inadvertently moving a photo in an unwanted direction.)

Note: Transform commands work only on layers or active selections. So if you have only a Background layer, Elements turns it into a regular layer when you use Transform commands.

Here's what the other Transform commands do:

- **Skew** slants an image. If you have a building that looks like it's leaning to one side, for example, you can use this command to straighten it back up again.
- **Distort** stretches your photo in the direction you pull it. Use it to make buildings (or people) taller and skinnier, or shorter and squatter.
- **Perspective** stretches your photo to make it look like parts are nearer or farther away. For example, if a building in your photo looks like it's leaning away from you, you can use this command to pull the top back toward you.

Tip: If you have an active selection, then you can apply the Transform commands to just that selection (as long as you aren't working on a Background layer).

All the Transform commands—including Free Transform—have the same Options bar settings, shown in Figure 11-15.

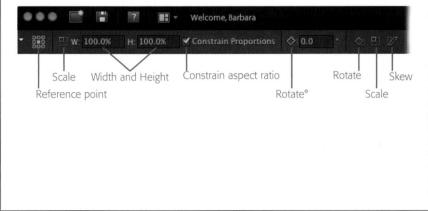

Figure 11-15:

The Options bar for the Transform commands. The W (width) and H (height) boxes let you specify dimensions when you're resizing an image. To scale by dragging instead, click the Scale button labeled here, and then drag any of the scaling handles (not shown) that appear on the bounding box around your image.

From left to right, the Options bar settings control:

• **Reference point location**. This strange little doodad (shown in Figure 11-16) lets you tell Elements where the fixed point should be when you transform something; it's a miniature cousin of the Canvas Size dialog box's placement grid (page 122). The reference point starts out in the image's center, but you can tell Elements to move everything using the upper-left corner or the bottom-right corner as the reference point instead. To do that, click the square you want it to use as the reference.

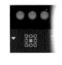

Figure 11-16:

This nine-box icon in the Options bar is where you set the reference point for transformations, which tells Elements the central point to rotate around. For example, if you want your photo to spin around its lowerleft corner instead of its center, click the lower-left square here. For the Transform commands, this also tells Elements to use that corner as the pivot point for the rotation.

- Scale, W, H, Constrain Proportions. You can resize your image by dragging, or by entering a percentage in the W or H box. Turn on the Constrain Proportions checkbox to preserve your image's original proportions.
- **Rotate**. Confusingly, there are two different Rotate commands next to each other in the Options bar. The box next just to the right of Constrain Proportions lets you enter the number of degrees you want Elements to rotate your image or selection. Or, click the *next* pair of rotated squares and you can grab a corner of your image to make a free rotation (see page 97).

Tip: If you Shift-drag while rotating your image, it turns in 15-degree increments.

- Scale. Yup, this is yet another Options bar setting for controlling scale. Click here if you want to resize your image by dragging it rather than entering numbers in the W and H boxes.
- **Skew**. Click this icon, and then pull a corner of your image to the left or right, the way you do with the Skew command.

In most cases, you can transform an object without paying much attention to these settings—just grab a handle and drag. Here's what you do:

1. Position your image to give yourself room to work.

Position your photo so that you have room to drag the handles far beyond its edges (Figure 11-14 explains how). If you're using tabbed windows, you probably have plenty of room.

2. Choose how to transform your image.

Go to Image \rightarrow Transform, and then select the command you want. It's not always easy to tell which will work best for a given photo, so you may want to try all three in turn. You can always change your mind and undo your changes by pressing Esc before you accept a change, or by pressing Ctrl+Z/#-Z after you've made the change.

You can use Transform commands only on regular layers, so if your image just has a Background layer, the first thing Elements does is convert that layer to a regular layer. (You can apply Transform commands to a *selection* on a Background layer without converting it to a regular layer, though.) Once the Transform command is active, handles appear around your image.

3. Transform your image.

Grab a handle and pull in the direction you want the image to move. You can switch to another handle to pull in a different direction. If you decide you made a mistake, press Esc to return to your original photo.

4. When you're happy with how your photo looks, accept the change.

Click the Commit button (the green checkmark) below your photo or press Return. If you decide not to apply the transformation after all, click the Cancel button (the red No symbol) instead.

Tip: Before clicking the Commit button, you can switch to another Transform command and add that transformation to your image, too.

Free Transform

Free Transform combines all the other Transform commands into one, and lets you warp your image in many different ways. If you aren't sure what you need to do, Free Transform is a good choice.

You use Free Transform exactly the way you use the other Transform tools, following the steps in the previous section. The difference is that with Free Transform, you can pull in *any* direction, using keystroke-drag combinations to tell Elements which kind of transformation you want to apply. Each of the following transformations does exactly the same thing it would if you selected it from the Image \rightarrow Transform menu:

- **Distort.** To make your photo taller or shorter, Ctrl-drag/#-drag any handle. Your cursor turns into a gray arrowhead.
- Skew. To make your photo lean to the left or right, Ctrl+Shift-drag/#-Shiftdrag a handle in the middle of a side. Your cursor turns into a gray arrowhead with a tiny double-arrow next to it.
- **Perspective**. To correct an object that appears to lean away from or toward you, press Ctrl+Alt+Shift/#-Option-Shift and drag a corner handle. You see the same gray arrowhead cursor as when you're distorting.

Free Transform is the most powerful of all the Transform commands, but when you're pulling in several different directions, it's easy to distort your photo. That's why some people prefer to use the simpler Transform commands and apply multiple transformations instead.

Tip: To transform only a selected area, try the Transform Selection command (page 177), which lets you make any of these changes to a selection's outline without calling up Free Transform. To change the *contents* of a selection, use the tools covered in this chapter.

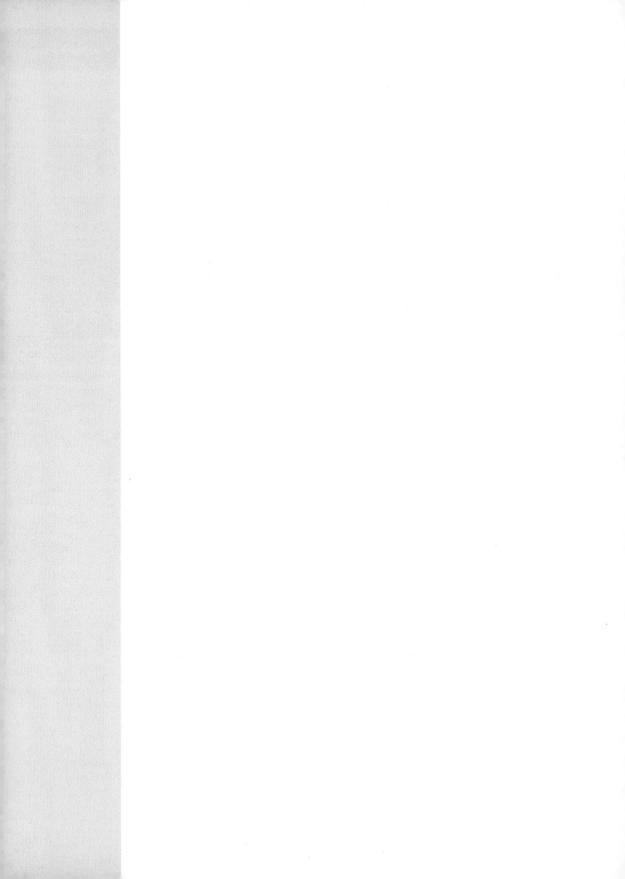

Part Four: Artistic Elements

Chapter 12: Drawing with Brushes, Shapes, and Other Tools Chapter 13: Filters, Effects, Layer Styles, and Gradients Chapter 14: Text in Elements

CHAPTER 12

Drawing with Brushes, Shapes, and Other Tools

f you're not artistically inclined, you may feel tempted to skip this chapter. After all, you probably just want to fix and enhance your photos—why should you care about brush technique? Surprisingly enough, you should care quite a lot.

In Elements, brushes aren't just for painting a moustache and horns on a picture of someone you don't like, or for blackening your sister's teeth in that old school photo. Lots of Elements' tools use brushes to apply their effects. So far, you've already run into the Selection brush, the Clone Stamp, and the Color Replacement brush, to name just a few. And even with the Brush tool, you can paint with lots of things besides color—like light or shadows, for example. In Elements, when you want to apply an effect in a precise manner, you often use some sort of brush to do it.

If you're used to working with real brushes, their digital cousins can take some getting used to, but there are many serious artists now who paint primarily in Photoshop. With Elements, you get most of the same tools as in the full Photoshop, if not quite all the settings for each tool. Figure 12-1 shows an example of the detailed work you can do with Elements and some artistic ability.

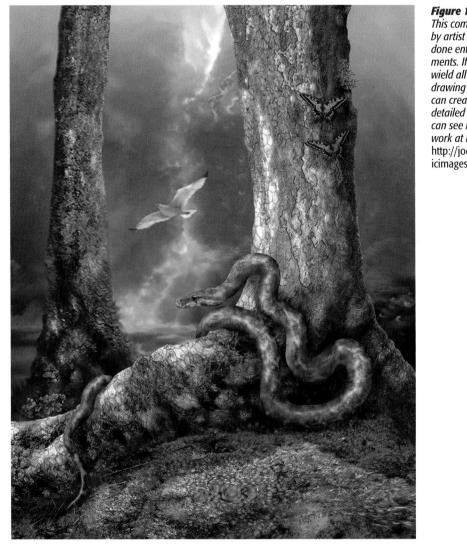

Figure 12-1:

This complex drawing by artist Jodi Frye was done entirely in Elements. If you learn to wield all of Elements' drawina power, vou can create amazinaly detailed artwork. You can see more of Jodi's work at her website, http://jodifrvesgraphicimages.weebly.com.

This chapter explains how to use the Brush tool, some of the other brush-like tools (such as the Erasers), and how to draw shapes even if you can't hold a pencil steady. You'll also learn some practical applications for your new skills, like dodging and burning photos to enhance them, and a super easy method of cropping your photos in sophisticated, artistic ways-a technique scrapbookers love.

Tip: If you have an iPad and like to fingerpaint, you can create drawings on your iPad in Adobe's Eazel app and send them directly to Elements to use in your projects. To learn more, head to *www.photoshop. com/products/mobile/eazel*.

Picking and Using a Basic Brush

If you look at the Tools panel, you'll see the Brush tool's icon below the Eraser (in a single-column Tools panel) or below the Clone Stamp (in a two-column Tools panel). Don't confuse it with the Selection brushes, which are up above the Crop or Type tool, or the Smart Brush (page 234), which is below the regular Brush tool or to the right of it, depending on whether you have one column or two. To activate the Brush tool, click its icon or press B.

The Brush is one of the tools that includes a pop-out menu in the Tools panel you can choose between the Brush, the Impressionist Brush, the Color Replacement tool, and the Pencil tool. You can read about the Impressionist Brush and the Pencil tool later in this chapter, and about the Color Replacement tool on page 339. This section is about the regular ol' Brush tool.

The Options bar (Figure 12-2) gives you lots of ways to customize the Brush tool. Here's a quick rundown of these settings (from left to right):

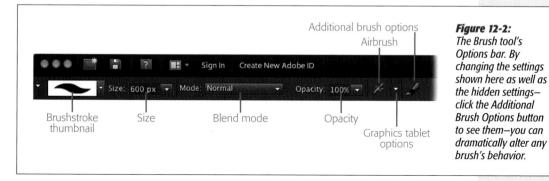

• **Brushstroke thumbnail.** This squiggle shows the stroke you'd get with the current settings. Click it to display the Brush palette. Elements gives you a bunch of basic brush collections, called *libraries*, which you can view and select here. You can also download many more from various websites (see page 602).

If you click the palette's drop-down menu, you'll see that you get more than just hard and soft brushes of various sizes (see Figure 12-3). You also get special brushes for drop shadows, brushes that are sensitive to pen pressure if you're using a graphics tablet—which you can also use with a mouse, but you don't have as many options—and brushes that paint shapes and designs.

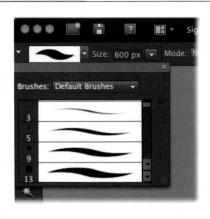

Figure 12-3:

Elements gives you a pretty good list of different brushes to choose from, and you can add your own. Here you see just one of the many brush libraries included with Elements, the Default Brushes. (Page 407 explains how to make your own brushes.)

Elements starts off displaying the brushes in the palette as black thumbnails on a dark gray background, but that's hard to see. Fortunately, you can click the double arrows in the palette's upper-right corner and choose Stroke Thumbnail for this black-on-white view.

Note: One very cool feature of Elements' brushes is that any changes you make to a brush are reflected in the little brushstroke thumbnail that appears in the Brush palette.

• Size. This slider lets you adjust the size of your brush cursor—anywhere from 1 pixel up to sizes that may be too big to fit on your monitor (2500 pixels is the maximum). You can also just type a size in the box. Figure 12-4 shows yet another way to adjust settings like brush size using your mouse. Or, as you're working, you can press the close bracket key (]) to quickly increase brush size, or the open bracket key ([) to decrease it.

Figure 12-4:

You don't need to open drop-down menus like the one shown here that says "94%." Just move your cursor over the word "Size," and the cursor changes into a pointing hand with a double-headed arrow. Now you can "scrub" (click and drag) back and forth right on the Options bar to make changes—left for smaller or less, right for larger or more. This trick works anywhere you see a numerical pop-out slider (such as in the Layers panel's Opacity menu).

- **Mode.** Here's where you choose the brush's blend mode. The mode you choose determines how the brush's color interacts with what's in your image. For example, Normal simply paints the current Foreground color (you'll learn more about all the mode choices later in this chapter).
- **Opacity.** This lets you to control how thoroughly your brushstrokes cover what's beneath them. You can use the drop-down menu's slider or type in any percentage you like, from 1 to 100. The maximum—100 percent—gets you total coverage (at least in Normal mode). Or you can scrub, as shown in Figure 12-4.

• **Airbrush.** Clicking this little pen-like brush icon just to the right of the Opacity setting lets you use the Brush tool as an airbrush. Figure 12-5 shows how this works.

Figure 12-5:

As with real airbrushes, Elements' airbrush continues to "spray" paint as long as you hold down the mouse button, regardless of whether the mouse is moving.

Top: Here's what you get with one click with the Brush tool in Regular (non-airbrush) mode.

Bottom: Here's the effect of one click with the same brush in Airbrush mode. See how far the color spread beyond the cursor (the circle)? Not every brush offers the airbrush option.

- **Brush Tablet Options**. Click the tiny arrow to the right of the airbrush icon to see a bunch of checkboxes. If you use a graphics tablet, you can use these settings to tell Elements which brush characteristics should respond to the pressure of your stroke. (Page 599 has more about graphics tablets.)
- Additional Brush Options. Clicking this icon (which looks just like the Brush tool's icon) brings up the Additional Brush Options palette, which offers oodles of ways to customize your brush, all of which are covered in the next section. If you're using the Brush tool for artistic purposes, it pays to familiarize yourself with these settings, since this is where you can set a chiseled stroke or a fade, for example.

Tip: If you ever want to return a brush to its original settings, click the Reset button (the tiny black arrow) on the left end of the Options bar, and then choose Reset Tool from the pop-up menu.

To actually use the Brush tool, enter your settings—make sure you've selected the color you want in the Foreground color square—and then simply drag across your image wherever you want to paint.

Tip: If you're used to painting with long, sweeping strokes, keep in mind that in Elements, that technique can be frustrating. That's because when you undo a mistake (by pressing Ctrl+Z/æ-Z), Elements undoes *everything* you've done while you've been holding down the mouse button. In tricky spots, you can save yourself some aggravation by using shorter strokes so you don't have to lose that whole long curve you painstakingly worked on just because you wobbled a bit at the end. (The Eraser tool [page 418] is handy for tidying up in these situations, too.)

One of the biggest differences between drawing with a mouse and drawing with a real brush is that, on a computer, it doesn't matter how hard you press the mouse. But if you've got a *graphics tablet*, an electronic pad that causes your pen movements to appear onscreen instantly, you can replicate real-world brushing, including pressure effects. Page 599 tells you all about using a tablet.

Tip: To draw or paint a straight line, hold down the Shift key while moving your cursor. If you click where you want the line to start, press and hold Shift, and then click at the end point, Elements draws a straight line between those two points. Remember to click first and *then* press Shift, or you may draw lines where you don't want them.

TROUBLESHOOTING MOMENT

What Happened to My Cursor?

One thing that drives newcomers to Elements nuts is having the Brush cursor change from a circle to little crosshairs, seemingly spontaneously. This is one of those "It's not a bug, it's a feature" situations. Many tools in Elements offer you the option of what's called the *precise cursor*, shown in Figure 12-6. There are situations where you may prefer to see those little crosshairs so that you can tell *exactly* where you're working.

You toggle the precise cursor on and off by pressing the Caps Lock key. So if you press that key by accident, you may find yourself in precise-cursor mode with no idea how you got there. Just press Caps Lock again to turn it off.

There's one other way you may wind up with the precise cursor, and this time you have no choice in the matter. It happens when your image is so small in proportion to the cursor that Elements *has to* display the crosshairs to show the brush in the right scale for your image. Zooming in usually gets your regular cursor back, unless you're working with a 1-pixel brush, which always uses crosshairs.

You can also elect to always see the crosshairs within the regular cursor circle if you want. In the Preferences dialog box (Edit→Preferences→Display & Cursors/Adobe Photoshop Elements Editor→Preferences→Display & Cursors), in the Painting Cursors box, turn on "Show Crosshair in Brush Tip" and you'll always have a mark for the exact center of your brush.

Figure 12-6:

Adobe calls these crosshairs the precise cursor. Elements sometimes makes your cursor look like this when you're zoomed way out on an image. To get the normal cursor back, you can zoom in some, and read the box above for further advice.

Modifying Your Brush

When you click the Additional Brush Options icon on the right side of the Options bar, Elements displays a palette that lets you customize your brush. You'll run into a version of this palette for some of the other brush-like tools, too, like the Healing brush. The palette lets you change how your brush behaves in a number of sophisticated and fun ways. Mastering these settings goes a long way toward getting artistic results in Elements:

• Fade controls how fast the brushstroke fades out—just the way a real brush does when it runs out of paint. A lower number means it fades out quickly (very few steps), while a higher one means the fade happens slowly (more steps). Counterintuitively, leaving this setting at 0 means no fading at all—the stroke is the same at the end as it is at the beginning.

You can pick any number up to 9,999, so with a little fiddling, you should be able to get just the effect you want. If the brush isn't fading fast enough, decrease the number; if it fades too fast, increase it. A smaller brush usually needs a higher number than a larger brush does. And you may find that you need to set the brush spacing (explained in a sec) in the 20s or higher to make fading show any visible effect.

Tip: Watch the Options bar's brush thumbnail as you tweak the additional brush options; the thumbnail changes to reflect your new settings.

- **Hue Jitter.** Some brushes, especially the ones you can use to paint objects like leaves, automatically vary the color for a more interesting or realistic effect. This setting controls how fast the brush switches between the Background and Fore-ground colors. The higher the number (percentage) here, the faster the color varies; a lower number makes the brush take longer to get from one color to the other. Brushes that use hue jitter don't put down only the two colors, but a range of hues in between. Not all brushes respond to this setting, but for the ones that do, it's a pretty cool feature. Figure 12-7 shows how it works.
- Scatter means just what it sounds like: how far the marks get distributed in your brushstroke. When you paint with a brush in Elements, you're actually putting down many repetitions of the brush shape rather than a simple line. So if you set scatter to a low percentage, you get a dense, line-like stroke, whereas a higher value creates an effect more like random spots.
- **Spacing** controls how far apart the brush marks get laid down when you paint. A lower number makes them close together, a higher number farther apart, as shown in Figure 12-8. Scatter controls randomness, including how far the marks appear above and below the stroke itself, while Spacing just determines how frequently the brush makes a mark along the path of the stroke.

Figure 12-7: Top: A brushstroke with no hue jitter.

Middle: The same brushstroke with a medium hue jitter value.

Bottom: The same brushstroke with a high hue jitter value. The colors used here are red and blue. It takes a fairly high number to get all the way to blue in a stroke this short. Some brushes, like this one, automatically do a little color shading, even without jitter turned on.

Figure 12-8:

The same brushstroke with the spacing set at 5 percent, 75 percent, and 150 percent (respectively, from top to bottom).

You may have wondered why some of the brushstroke thumbnails look like long caterpillars, when the brush should paint an object, like a star or leaf. The reason? Cramped spacing. The thumbnail shows the spacing as Elements originally sets it. Widen the spacing to see separate objects instead of a clump.

- **Hardness** controls whether the brush's edge is sharp or fuzzy. This setting isn't available for all brushes, but when it is, you can choose any value between zero (the fuzziest) and 100 percent (the most defined edge).
- Angle and Roundness. Painters don't use only round brushes, and you don't have to in Elements, either. If you've ever painted with a real brush, you'll understand these settings right away. They let you create a more chiseled edge to your brush and then rotate it so that it's not always painting with the edge facing the same direction.

There are some brushes in Elements' libraries that aren't round, like the calligraphic and chalk brushes. But you can adjust the roundness of any brush to make it more suitable for chiseled strokes, as shown in Figure 12-9.

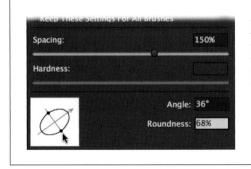

Figure 12-9:

Here's the bottom of the Additional Brush Options palette. To adjust a brush's angle and roundness, drag the black dots to make the brush rounder or narrower, and then grab the arrow and spin it to the angle you want. You can also type a number directly into either the Angle or Roundness box (or both).

The palette also includes a checkbox labeled Keep These Settings For All Brushes; turn it on if you want to make all your brushes behave exactly the same way. The checkbox only keeps the settings listed *above* it in the palette, though, not the ones below it.

Saving Modified Brush Settings

If you modify a brush and like your creation, you can save it as a custom brush. Elements lets you alter any of the existing brushes and save the result—a great feature if you're working on a project that's going to last awhile and you don't want to keep modifying the settings. (Don't worry: When you modify an existing brush, Elements preserves a copy of the original.) To create your own brush, just:

1. Choose a brush to modify.

Select any brush in the Brush palette.

2. Make the changes you want.

Change the brush's settings until you get what you're after. The brush thumbnail in the Options bar reflects your new settings.

3. Tell Elements you want to keep the new brush.

Click the brush thumbnail to open the Brush palette, and then click the black double arrows on the right side of the palette and choose Save Brush. Elements asks you to name it; you don't *have* to, but named brushes are easier to keep track of. The name will appear as pop-up text when you hover over the brush's thumbnail in the Brush palette.

4. Click OK.

The brush shows up at the bottom of your current list of brushes. If you make lots of custom brushes, you may want to create a special set for them. The Preset Manager (page 604) can help you do that.

Deleting a brush is pretty straightforward: Select it in the Brush palette, and then click the double arrows on the palette's right side and choose Delete Brush. Or you can Alt-click/Option-click the brush's thumbnail in the palette. (The cursor changes into a pair of scissors when you hold down the Alt/Option key; simply clicking with the scissors deletes the brush.)

You can also make a selection from an image and save it as a brush (the next section explains how). Just remember, though, that brushes by definition aren't any specific color, so you save only the *shape* of the selection, not the color of it. The color you get when you use the brush is whichever color you choose to apply. If you want to save a colored sample, try saving your selection as a pattern (page 322) instead, or using the Clone Stamp (page 315) repeatedly.

The Specialty Brushes

So far you've learned about brushes that behave pretty much as brushes do in the real world—they paint a stripe of something, whether that's color, light, or even transparency. But in the digital world, a brush doesn't have to be just a brush. With some of Elements' brushes, you can paint stars, flowers, disembodied eyeballs, gravel, or even rubber ducks with just one stroke, as shown in Figure 12-10.

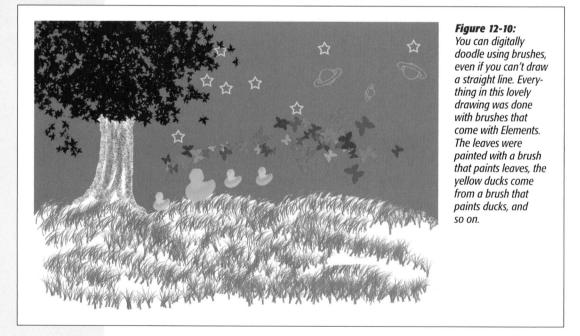

If you click the arrow next to a brush's thumbnail in the Options bar, you'll see the list of brushes in the current category and a drop-down menu that lets you investigate Elements' other brush sets. The brushes used in Figure 12-10, for example, came from several different categories.

The Specialty brushes respond readily to changes in the Additional Brush Options palette's settings (covered earlier in this chapter). Your choices there can make a huge difference in the effect you get—whether you're painting swaths of smooth grass like a lawn, or scattered sprigs of dune grass, for instance. And if you're using a graphics tablet, many brushes are sensitive to pen pressure.

Tip: If you've tried some of the special-effects brushes and found the results rather anemic, you can always go back once you've painted with them and punch up their color using a Multiply layer, just as you would with an overexposed photo (see page 229).

Making a Custom Brush

You can turn any picture, or selection within a picture, into a brush that paints the shape you've selected. Figure 12-11 shows what a cluster of flowers looks—and behaves like—when it's been turned into a brush. It's surprisingly easy to create a custom brush from any object you have a picture of:

1. Open the photo or drawing that includes what you want to use as a brush.

You can choose an area as large as 2500 pixels square. (Remember, you can resize your selection once it's a brush, just the way you can resize any other brush, so don't worry if it's a big area. That said, if you use a super-detailed brush at a tiny size setting, it may lose some definition.)

2. Select the object or region you want.

Use any of the Selection tools to do this. It's a good idea to inspect your selection with the Selection brush in Mask mode, because any stray areas you included by mistake get painted with each stroke—just as if you wanted them there.

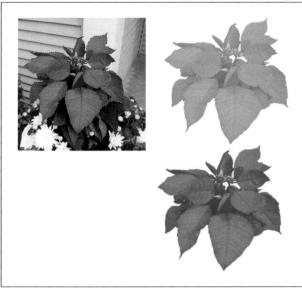

Figure 12-11:

Left: If you want to make a brush that draws poinsettias, just select one in a photo and save it as a brush.

Right: You can paint better than you thought! And with this brush, your poinsettias can be any color you like.

3. Create your brush.

Go to Edit→"Define Brush from Selection." A dialog box appears showing the selection's shape and asking you to name the new brush. Check the thumbnail to be sure it's exactly what you had in mind. If it is, click OK; if not, click Cancel and try again.

The new brush shows up at the bottom of your currently active list of brushes. If you want to get rid of it, Alt-click/Option-click the brush's thumbnail, or highlight the thumbnail, click the double arrows on the right side of the palette, and then choose Delete Brush.

The Impressionist Brush

When you paint with the Impressionist Brush, you blur and blend the edges of the objects in your photo, just like in an Impressionist painting. At least that's what's *supposed* to happen. This brush is very tricky to control, but you can get some really interesting effects with it, especially if you paint on a duplicate layer and play with the duplicate layer's Opacity setting. Usually, you'll want a really low opacity with this brush, or some of the curlier styles will make your image look like it's made from poodle hair. Changing the brush's Mode setting (page 413) can also help control the effect.

To activate the Impressionist Brush, press B or click the Brush tool's Tools panel icon, and then select it from the pop-out menu. This brush has most of the same Options bar settings as the regular Brush, but if you click the More Options button (the icon to the right of the Opacity setting), you'll see three new settings:

- Style determines what kind of brushstroke effect the brush will create.
- Area tells Elements the diameter of the painting area, meaning how much area the actual stroke should cover. This is usually much larger than the size of the cursor itself.
- **Tolerance** controls how similar in color the pixels the brush passes over have to be before they're affected by the brush.

If you really want to create a hand-painted look, you may prefer the brushstroke filters (Filter→Brush Strokes); page 435 explains how to use them. The Impressionist Brush isn't really the best tool for creating true Impressionist effects, although its blurring qualities can sometimes be useful because it covers large areas faster than the Blur tool. The Smudge tool (page 416) is another excellent—though time-consuming—way to create a painted effect.

The Pencil Tool

Basically just another brush, the Pencil tool shares the Brush tool's slot in the Tools panel. Choose the Pencil from the pop-out menu or press N to activate it.

The Pencil has many of the same settings as the Brush—like size, mode, and opacity—but it offers only hard-edged brushes. In other words, you can't draw fuzzy lines with the Pencil tool, not even the kind of lines you'd sketch with a soft pencil; the Pencil's lines are *always* well defined. This tool is especially useful when you want to work on a pixel-by-pixel basis.

You use the Pencil tool the same way you use any other brush. The big difference is the Auto Erase checkbox in the Options bar. Turning on this setting makes the Pencil paint with the Background color over areas that contain the Foreground color. But if you start dragging in an area that doesn't include the Foreground color, it paints with the Foreground color instead. This is really confusing until you try it. Take a look at Figure 12-12 for some help understanding this setting, or better yet, create a blank file and try it yourself.

Figure 12-12:

The slightly confusing Auto Erase option was used to create two lines here: a horizontal one of the Foreground color (purple) and a vertical one of the Background color (light green). The horizontal line was drawn by starting with the cursor outside the purple circle (so the Pencil erased the green, leaving a purple line across the circle). The vertical line was drawn by starting inside the purple circle, causing the Background color to be exposed.

The Paint Bucket

When you want to fill a large area with color in a hurry, the Paint Bucket is the tool for you. It's right below the Brush in the Tools panel if you have two columns of tools, or below the Smart brush if you have one column. If you click it or press its keyboard shortcut (K) and then click in your image, all the available area (either your whole image or the current selection) gets flooded with the current Foreground color. It works something like the Magic Wand: Just as the Magic Wand *selects* only the color you click, the Paint Bucket *fills* only the color you click.

Note: Make any Options bar setting adjustments, discussed next, *before* clicking in your photo with the Paint Bucket.

Most of the Paint Bucket's Options bar settings are probably familiar:

- **Pattern**. Normally, the Paint Bucket fills the area with the Foreground color, but turn on this checkbox to make it use a pattern instead. Choose an existing pattern from the Pattern drop-down menu in the Options bar, or create your own, just as you would with the Pattern Stamp (page 322).
- Mode. You can use the Paint Bucket in any blend mode, as explained later in this chapter (page 413).
- **Opacity.** One hundred percent opacity gives you total coverage: nothing shows through the paint you put down. Lower the percentage for a more transparent effect.
- **Tolerance.** This setting works the same way it does for the Magic Wand (page 164): The higher the number, the more shades the paint fills.
- Anti-alias. This setting smoothes the edges of the fill. Leave it turned on unless you have a specific reason not to.
- **Contiguous.** This is another option that should be familiar from the Magic Wand (page 164). If you leave this checkbox on, you change only areas of the chosen color that touch each other. Turn it off, and *all* areas of the color you click get changed, whether they're contiguous or not.
- All Layers. Fills any pixels that meet your criteria (determined by the tool's other Options bar settings), no matter what layer they're on. (The Paint Bucket actually paints on the active layer, but with this checkbox turned on, it looks for pixels to change based on all the layers in your image.) To exclude a layer, click that layer's eye icon in the Layers panel to hide it. Don't forget that you can lock the transparent and translucent parts of layers in the Layers panel (see page 198).

You can undo a Paint Bucket fill with the usual Ctrl+Z/#-Z.

Tip: You can sometimes improve blown-out skies by using the Eyedropper to select an appropriate shade of blue from another photo and then filling the blown-out areas of your sky using the Paint Bucket at a very low opacity.

Dodging and Burning

Like Unsharp Mask, dodging and burning are old darkroom techniques used to enhance photos and emphasize particular areas. Dodging *lightens* your image and brings out hidden details in the range you specify (midtones, shadows, or highlights), and burning *darkens* your photos and brings out details in a given range. Both tools live with the Sponge tool in the Tools panel.

You may think that, given the Shadows/Highlights command, you don't need these tools. But they still serve a useful purpose because they let you make *selective* changes, rather than affecting the whole image or requiring tedious selections the way Shadows/Highlights does. When you dodge or burn, you just paint your changes.

Figure 12-13 shows an example of when you might need to work on a particular area. Of course, you can also make a selection and then use Shadows/Highlights on just that, which you may want to try in addition to dodging and burning.

Figure 12-13:

Although the overall shadow/highlight balance of this photo is about right, the strong sideways lighting creates quite an imbalance over this little guy's face. Careful dodging and burning can really help with these problems, as you can see in Figure 12-14.

Skillful use of dodging and burning can greatly improve your photos, although it helps to have an artistic eye to spot what to emphasize and what to play down. Use these tools along with the black-and-white conversion feature (page 345) to emphasize certain areas of your photos. Masters of black-and-white photography, like Ansel Adams, relied heavily on dodging and burning (in the darkroom, in those days) to create their greatest images.

Both the Dodge and Burn tools are really just variants of the Brush tool, except they don't apply color—they just *affect* the colors and tones that are already present in your photo. Adobe refers to them as the "toning tools."

One word of warning about these tools: Unless you use them on a duplicate layer, you can't undo their effects once you close your photo, so be careful how you use them. Many people prefer to dodge and burn using the method described in the box on page 415 rather than with the actual Dodge and Burn tools, unless they're working on black-and-white photos.

Tip: You may also want to try some of the Smart Brush's lighting settings (page 234) for making selective adjustments to just part of your photo. A little experimenting will give you a sense for which tools you prefer to use in different situations. Also, if you're aiming to copy a specific look from an already corrected photo, try the Style Merge feature (page 379). It may not work, but it's worth a shot.

Dodging

You can use the Dodge tool to lighten areas of your image and to bring out details hidden in shadows. It's a good idea to create a separate layer (Layer \rightarrow Duplicate Layer or Ctrl+J/#-J) when using this tool to preserve your image if you go overboard. (Be sure you apply the Dodge tool to a layer that has something in it, or nothing will happen.) Here's how to use it:

1. Activate the Dodge tool.

Click the Sponge tool in the Tools panel or press O, and then choose the Dodge tool (the lollipop-like paddle) from the pop-out menu. You'll see some of the usual brush options in the Options bar, but with two differences: a Range setting that determines whether the tool works on highlights, midtones, or shadows; and an Exposure setting that determines the strength of the effect.

2. Adjust the tools settings and then drag over the area you want to change.

Choose a low Exposure setting and drag more than once to get a more realistic result (that's true for the Burn tool, as well), as shown in Figure 12-14. After you're done, if you think the tool's effect is still too strong, you can always reduce the layer's opacity (as long as you're working on a duplicate layer).

Figure 12-14:

Figure 12-13 after a dose of the Dodge and Burn tools. The shadowed side of his face is easier to see, but the contrast is pretty flat there, while it's much too dramatic on the sunny side of his face. (The effects are deliberately too strong here to show you the perils of getting overzealous with either tool.) See page 415 to learn a different method for selectively adjusting highlights and shadows. Both methods have advantages and disadvantages.

Burning

The Burn tool works just like the Dodge tool, but does exactly the opposite: It darkens. Use the Burn tool to uncover details in your images' highlights. (Of course, there have to be some details there for the tool to work.) If your photo's highlights are blown out, you won't get any results, no matter how much you apply the tool. The Burn tool is grouped with the Sponge and Dodge tools in the Tools panel; its icon is a curled hand.

Most of the time, you'll probably want to use the Dodge and Burn tools in combination. They can help draw attention to specific parts of your photo, but they work best for subtle changes. Applying them too vigorously—especially on color photos—creates an obviously faked look. Black-and-white photos (or color images converted to black and white) can generally stand much stronger contrasts.

Blending and Smudging

You can control how Elements blends the color you add to an image with the colors that are already there. This section takes a look at two different blending methods: using *blend modes* to determine how the colors you paint change what's already in your image, and using the Smudge tool to mix parts of your image together.

Blend Modes

Blend modes are almost limitless in the ways they can manipulate images. They control how the color you add when painting reacts with the existing pixels in an image—whether you just add color (Normal mode), make the existing color darker (Multiply mode), or change the saturation (Saturation mode).

Image-editing experts have found plenty of clever ways to use blend modes for some really sophisticated techniques. Thorough coverage of these techniques would turn this into a book the size of the Yellow Pages, but Figure 12-15 shows a few examples of how simply changing a brush's blend mode can radically alter your results.

Elements groups the blend modes according to the effects they have. You won't always see every group or all the choices, but generally speaking, in Elements menus (such as the Options bar's Mode menu for the Brush tool) the top group includes what you might call "painting modes," followed by modes for darkening, lightening, adjusting light, applying special effects, and adjusting color.

Keep in mind that the modes sometimes work quite differently with layers than with tools. In other words, painting with a brush in Dissolve mode may produce an effect quite different than creating a layer in Dissolve mode and painting on it.

There are so many ways to combine blend modes that even Elements pros can't always predict the results, so experimenting is the best way to learn about them. They're really cool and useful once you get used to them, but if you're just starting out in Elements, there's no need to worry about them right away.

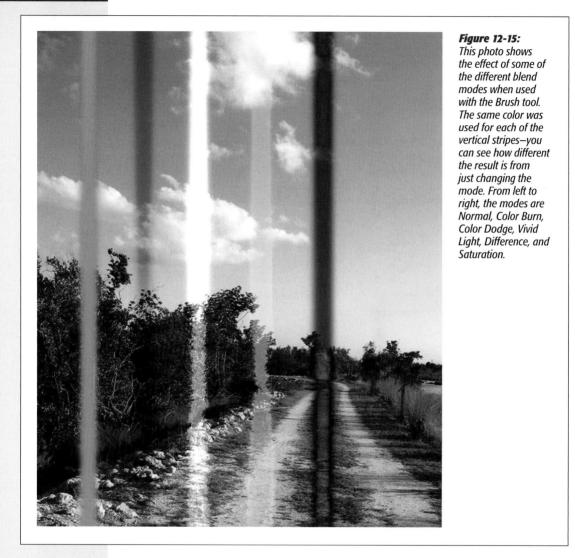

Tip: If you'd like to learn more about how each mode works, you can find a lot of useful tutorials on the Web. A good place to start is *www.photoshopgurus.com/tutorials/t010.html*. (Ignore the section "Additional blend mode information"—that's only for Photoshop folks.)

POWER USERS' CLINIC

Blend Modes Instead of Dodge and Burn

You can do a lot in Elements without ever touching blend modes. But if you take time to familiarize yourself with them, you might find they become a regular part of your image-editing toolkit. For instance, you may prefer the effect you get using a layer in Overlay mode to that of the Dodge and Burn tools.

To adjust a photo using a layer in Overlay blend mode, first make basic adjustments like Levels or Shadows/Highlights. Then, when you're ready to fine-tune your photo by painting over the details you want to enhance, here's what you do:

- Create a new layer. Go to Layer→New→Layer or press Shift+Ctrl+N/Shift-æ-N.
- Before dismissing the New Layer dialog box, choose the Overlay blend mode. Select Overlay from the Mode menu, turn on the "Fill with Overlayneutral color (50% gray)" checkbox, and then click OK. You won't see anything happen to your photo just yet.

- Set the Foreground and Background colors to black and white, respectively. Press D to set the Foreground and Background squares to black and white.
- 4. Activate the Brush tool. Choose a brush (set to Normal mode) and set its opacity very low, maybe 17 percent or less. (You'll need to experiment a bit to see how low a setting is low enough.)
- 5. Paint on the areas you want to adjust. Paint with white to bring up the detail in dark areas and with black to darken overly light areas. (Remember that you can switch from one to the other by pressing X.) The detail on your photo comes up just like magic.

Figure 12-16 shows the results of using Overlay mode on the image from Figure 12-13 so you can compare the results. This method has the added advantage of being adjustable—simply change the opacity of the Overlay layer to tweak the effect. You can carry this technique to extremes for really interesting effects when you want an artistic (rather than realistic) result.

Figure 12-16:

Here's the little boy from Figure 12-13 again, this time after a dose of Overlay blending, as described in the box above. Unlike the results of using the Dodge and Burn tools (Figure 12-14), the color isn't grayish, but the contrast where shadowed areas meet bright ones still needs some work.

The Smudge Tool

The Smudge tool does just what you'd think: You can use it to smear the colors in your image as if you were rubbing them with your finger. You can even "finger paint" with it, if you feel the call of your inner preschooler. Adobe describes the effect of the Smudge tool as being "like a finger dragged through wet paint." It's sort of like a cousin to the Liquify filter (page 487), but with fewer options.

If you want to turn your photos into paintings (as in Figure 12-17), the humble Smudge tool is your most valuable resource. For really artistic smudging, you need a graphics tablet so you can vary the stroke pressure. (You can use this tool without a tablet, but you won't get nearly as good an effect.) To learn more about this kind of smudging, you can find some excellent tutorials in the Retouching forum at Digital Photography Review (*www.dpreview.com*; search for *smudging*). The forums at *www. retouchpro.com* are also a favorite hangout of expert smudgers.

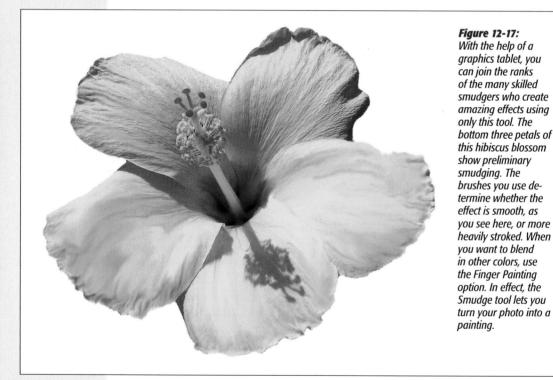

Tip: Scott Deardorff is one of the most talented smudgers out there. If you're serious about smudging, check out his DVDs and online training at *http://deardorfftraining.com*. His blog there includes a lot of great free tips on smudging techniques, too. Visit his website at *www.scottdeardorffportraits.com* to see some outstanding examples of what skilled hands can accomplish with the humble Smudge tool.

A warning: If you have a slow computer, there will be quite a bit of lag between when you apply the Smudge tool and when you see its effect onscreen. This delay makes the tool tricky to control, because you have to resist the temptation to keep going over an area until you see results.

You'll find the Smudge tool hidden under the Blur tool in the Tools panel. Click the Blur tool or press R and, from the pop-out menu, choose the Smudge tool (its icon, not surprisingly, is a finger that looks like it's painting).

The Smudge tool has mostly the same Options bar settings as a regular brush, but it also includes the Sample All Layers checkbox, just like the Healing brush and the Clone Stamp, as well as two additional settings:

- **Strength.** This setting means just what it says—it controls how much the tool smudges the colors together. A higher number results in more blending.
- **Finger Painting**. Turning on this checkbox makes the Smudge tool smear in the Foreground color at the start of each stroke. When this box is turned off, the tool uses the color that's under the cursor at the start of each stroke. (Figure 12-18 shows the difference.) This option is useful for creating artistic smudges. If you want a bit of a contrasting color to help your strokes stand out more, choose a Foreground color and turn this checkbox on.

Figure 12-18:

The strokes on the left were done with the Smudge tool's Finger Painting checkbox turned on, which lets you introduce a bit of the Foreground color (orange, in this case) into the beginning of each stroke. This technique is really useful for shading and when you need to mix in just a touch of another color.

The smudging on the right was done with Finger Painting turned off, so it uses only the colors that are already in the image.

Tip: Use the Eyedropper (page 257) to sample parts of your image to add Finger Painting colors that harmonize well with the area you're smudging.

Once you've chosen your settings, smudge away.

Note: When using the Smudge tool, you only see results where two colors come together because it blends together the pixel colors where edges meet. So if you use Smudge in the middle of an area of solid color, nothing happens unless you've turned on Finger Painting.

The Eraser Tool

Everyone makes mistakes. That's why Adobe has thoughtfully included three different mistake-fixers in Elements. If you click and hold the Eraser icon in the Tools panel, you'll see the Eraser, the Magic Eraser, and the Background Eraser. You'll probably use all three tools at one time or another. This section explains what each one does.

Using the Eraser

The Eraser is basically just another kind of brush tool, only it removes color instead of adding it. How it works varies a little depending on where you use it. If you use it on a regular layer, it replaces the color with transparency. On a Background layer or one in which transparency is locked, it replaces whatever color is there with the Background color (see Chapter 6 for more about how layers work).

The Eraser's settings are pretty much the same as for any other brush—including brush style, size, and opacity—but a couple of them work differently:

• Mode. For this tool, Mode doesn't have anything to do with blend modes (page 413); instead, this setting tells Elements the shape of the eraser you want to work with. Your choices are Brush, Pencil, and Block.

You can see the difference in how the Eraser is going to work by watching the brush-style preview in the Options bar as you change modes. Picking Brush or Pencil mode lets you use the Eraser as you would those tools—in other words, you can choose any brush you like. The Brush option lets you make soft-edged erasures, while Pencil mode makes only hard-edged erasures. Choosing Block mode changes the cursor to a square, so that you can use it as you would an artist's erasing block—sort of.

• **Opacity** determines how much color gets removed; at 100 percent, it's all gone (or all replaced with the background color).

Here's how to use this tool:

1. Activate the Eraser.

Press E or click the Eraser tool in the Tools panel. Its icon is a pink eraser, so it's easy to find.

2. Choose your settings.

In the Options bar, select a size, mode, and opacity. (As noted earlier, the mode and opacity settings work differently here than they do for regular brushes.)

3. Drag anywhere in your image to remove what you don't want.

You may need to change the size of the Eraser a few times. It's usually easiest to use a small Eraser (or the Background Eraser—page 420) to accurately clear around the edges of the object you want to keep, as shown in Figure 12-19. Then you can use a larger brush size to get rid of the remaining chunks, once you don't have to worry about accidentally going into the area you want to keep.

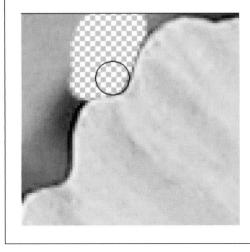

Tip: You can use a selection (see Chapter 5) to limit where the Eraser operates.

Because it's tedious to erase around a long outline or to remove entire backgrounds, Elements has two other kinds of Erasers for those situations.

The Magic Eraser

Once you try the Magic Eraser, you're likely to wonder why the heck Adobe gave this pedestrian tool such an intriguing name. What's so magic about it? Not much, really. It's called "magic" because it works a lot like the Magic Wand tool in that you can use it to select pixels in a single color or range (depending on the tolerance settings). Its icon even has the same little sparkle as the Magic Wand's icon to remind you of the relationship.

The problem, as Figure 12-20 shows, is that the Magic Eraser doesn't do as clean a job as the other erasers. Still, it can be a big help in eliminating large chunks of solid color. Moreover, if you're lucky, you may be able to clean the edges right up with Refine Edge (page 159) or the Defringe Layer command (page 175). To use Refine Edge, you'll need to select the layer's contents, or click in the empty background area with the Magic Wand, and then choose Select→Invert.

It's typically best to use the Magic Eraser in combination with at least one of the other erasers if you're looking to achieve really clean results. One sometimes-use-ful side effect of the Magic Eraser is that, when you click your photo with it, Elements automatically turns your Background layer into a regular layer, just the way the Background Eraser (explained next) does. So if you want to do something to the remaining object that requires a regular layer—like applying a Layer style (page 456)—this tool saves you a step.

Figure 12-20:

This figure gives you a closeup look at the Maaic Eraser at work on the background behind a cluster of berries. A couple of clicks with this tool aot rid of a chunk of the background, and setting the tolerance higher would've gotten even more. But if you look closely, you can see the disadvantage of this tool: The edges of the berries are fringed with dark, ragged areas it didn't eliminate. You may be able to clean up the edges with the Defringe Layer command (page 175) or Refine Edge (page 159), but those methods aren't always 100 percent successful.

The Background Eraser

Lots of people think *this* eraser deserves the name "Magic" much more than the Magic Eraser tool. This tool is a tremendous help when you want to remove all the background around an object.

The Background Eraser erases all the pixels under your cursor (but outside the edges of the object) and renders the area it's used on transparent, even if it's a Background layer. (If you click with it on a Background layer, your computer may hesitate for a sec because it's busy transforming your Background to a regular layer.) Here's how to use it:

1. Activate the Background Eraser.

Press E or, in the Tools panel, click the Eraser icon, and then choose the Background Eraser from the pop-out menu. (Its icon is an eraser with a pair of scissors next to it.)

2. In the Options bar, choose a brush size.

The cursor turns into a circle with crosshairs in it. These crosshairs are important: They're the Background Eraser's "hot spot." Elements turns any color that you drag them over into transparency. The size of the cursor (the circle) changes depending on how large a brush you choose, but the crosshairs stay the same size. As you can see in Figure 12-21, with a large brush, there may be a lot of space around the crosshairs. That makes it easy to remove big chunks of the background at once, since everything in the circle gets eliminated.

Figure 12-21:

The Background Eraser does a very careful job of separating these berries from their background. Just be sure to keep the little crosshairs away from the color you want to keep. Here, because the crosshairs are outside the red, only the background is getting removed. But if you moved the crosshairs over a berry, the Background Eraser would bite chunks out of it.

Note: If *all* your brush tools start using crosshairs as their cursors (not just the Background Eraser), the box on page 402 tells you how to get back to your regular cursor.

3. Drag in your photo.

Move around the edge of the object you want to keep, being careful not to let the crosshairs touch the object itself, or else you'll start erasing that, too. If you make a mistake, just press Ctrl+Z/#-Z.

The Background Eraser has three Options bar settings to help refine how it works (you may not need to change any of these settings to get the results you want):

- **Brush.** If you want to use a different brush style, choose it from this pull-down menu.
- Limits. Do you want the Background Eraser to remove only contiguous color, or all the patches of a certain color? This works exactly like the Contiguous setting for the Magic Wand (page 164).
- **Tolerance**. This setting tells the Background Eraser how similar colors have to be for it to remove them. Again, it's just like the Magic Wand's setting.

If you want to remove the background around an object, you may find it most effective to start by using the Background Eraser around the object's edges, and then switching to the other Erasers to clean up. The advantage of this method is that you don't have to clean up junk left over from the Magic Eraser. Plus it's easier to maneuver the Background Eraser than the regular Eraser, especially if you don't have a graphics tablet.

Drawing with Shapes

Wow, so many brush options and Adobe still isn't done—there's yet another way to draw things in Elements. The program includes the Shape tool (which is actually a group of tools that share one slot in the Tools panel), which lets you draw geometrically perfect shapes, regardless of your artistic ability. And not just simple shapes like circles and rectangles: You can draw animals, plants, starbursts, picture frames—all sorts of things, as shown in Figure 12-22. This tool should appeal to anyone whose grade-school "masterpieces" always got put up on the wall...behind the piano.

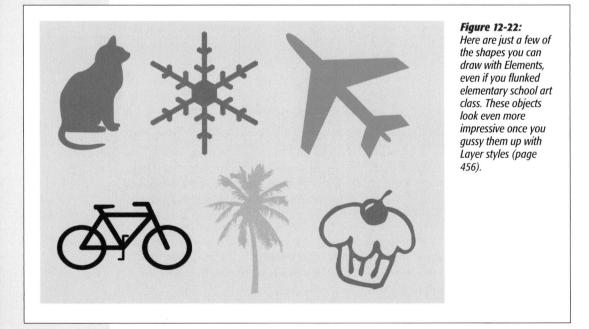

Note: If you want to create text that follows the outline of a shape—to put words around the outside of a trombone, say—don't use the Shape tool to create the path for the text. Use the Text on Shape tool (page 496) instead.

Turning yourself into an artist by using Elements' Shape tool is easy. Just follow these steps:

1. Open an image or create a new one.

You can add shapes to any file you can open in Elements.

2. Activate the Shape tool.

Click the Shape tool in the Tools panel or press U. The Shape tool is sometimes a little confusing to Elements newcomers because its Tools panel icon reflects the shape that's currently active—so you may see a rectangle, a polygon, or a line, for instance. (You'll see a blue heart if you haven't used this tool before.)

3. Select the shape you want to draw.

Use the Tools panel menu to choose a rectangle, a rounded rectangle, an ellipse, a polygon, a line, or a custom shape. (If you select the custom shape, you have *lots* of shapes to choose from; click the Shape pull-down menu in the Options bar to pick one.) All the shapes, and their accompanying options, are described in the following sections.

Tip: You can also add custom shapes by choosing them in the Content panel (page 522). There, just double-click the shape you want, or click the shape's thumbnail and then click Apply.

4. Adjust your settings in the Options bar.

Choose a color by clicking the color square in the Options bar or just use the Foreground color, which automatically appears in the Options bar when you switch to the Shape tool. Clicking the Options bar's color square brings up the Color Picker. If you click the arrow to the right of the square instead, you get the Color Swatches panel (page 259).

If you have special requirements, like a rectangle that's exactly $1"\times2"$, click the down arrow just to the right of the tool's icon to open the Custom Shape Options panel, where you can enter a size for your shape.

There's also an Options bar setting that lets you apply a Layer style (see page 456) as you draw your shape. Just click the down arrow on the right side of the Style box, and then choose the style you want from the pop-out panel. To go back to drawing without applying a style, choose the square with the diagonal red line through it.

5. Drag in your image to draw the shape.

Notice that *how* you drag affects the final appearance of the shape. For example, the way you drag determines its proportions. If you're drawing a fish, you can drag so that it's long and skinny or short and fat. Even with practice, it can take a couple of tries to get exactly the proportions you want.

Tip: If you're trying to create exact copies of a particular shape you've already drawn, use the Shape Selection tool (page 429) to create the duplicates.

The Shape tool automatically puts each shape on its own layer. If you don't want it to do that, or need to control how shapes interact, use the squares in the middle of the Options bar. They're the same as the ones for managing selections (page 156). Use them to add more than one shape to a layer, subtract one shape from another, keep only the area where shapes intersect, or exclude the areas where they intersect.

Tip: If you want to draw multiple shapes on one layer, click the Options bar's "Add to shape area (+)" button. That way, all the shapes you add end up on the same layer. (Shapes don't have to touch or overlap to use this option.)

Clicking the Simplify button in the Options bar turns any shape from a vector image (which is infinitely resizable) into a raster image (one that's drawn pixel by pixel). The box on page 426 tells you everything you need to know about the difference between these types of images, including why and when you'd want to make this change.

The following sections describe all the main shape categories and their special settings.

Rectangle and Rounded Rectangle

The Rectangle and Rounded Rectangle tools work pretty much the same way, and they're both really popular for creating web-page buttons. With either tool active (select them from the Tools panel or press U repeatedly until one of their icons appears in the Tools panel), in the Options bar, you can click down arrow to the right of the blue version of the shape to display a menu. (Adobe calls this the Geometry Options menu.) There, you'll find the following settings:

- **Unconstrained.** Elements selects this option automatically unless you change it. It lets you draw a rectangle with whatever dimensions you want; how you drag determines the proportions.
- **Square.** To draw a square instead of a rectangle, click this radio button before you start, or just hold down the Shift key as you drag.

- **Fixed Size.** This setting makes Elements draw your shape the size you specify. Just enter the dimensions you want in inches, pixels, or centimeters.
- **Proportional.** Use this setting if you know the proportions you want your rectangle to have, but not the exact size. For example, if you enter a width of 2 and a height of 1, no matter where you drag, the shape will always be twice as long as it is high.
- From Center. This setting lets you draw your shape from its center instead of from a corner. It's useful when you know where you want the shape but aren't sure how big it needs to be.
- **Snap to Pixels.** This checkbox tells Elements to make sure that the edges of your rectangle fall exactly on the edge of a pixel to help create crisper-looking edges. It's available only for the Rectangle and Rounded Rectangle tools.

Most of the Shape tools have similar options, though the Rounded Rectangle has one Options bar setting of its own: *Radius*, which is the amount (in pixels) that the corners are rounded off; a higher number means more rounding.

Tip: Looking to add a simple, empty rectangle, square, circle, or ellipse rather than one filled with color? See the box on page 430 to learn how.

Ellipse

The Ellipse tool has the same Geometry Options settings as the Rectangle tool. The only difference is that you can opt for a circle instead of a square. You can also draw a circle by pressing the Shift key while you drag.

Polygon

You can draw many kinds of regular polygons with this tool. Use the Options bar's Sides setting to choose the number of sides. The Geometry Options settings for this tool are a bit different than for the other Shape tools:

- **Radius.** This setting controls the distance from the center of the polygon to its outermost points.
- **Smooth Corners**. If you don't want sharp edges at the shape's corners, turn on this checkbox.
- **Star**. This setting inverts the polygon's angles to create a star-like shape, as shown in Figure 12-23.
- **Indent Sides By**. If you're drawing a star, enter a percentage here to set how much of the sides to indent.
- **Smooth Indents**. Turn this checkbox on if you don't want sharp interior angles on your star.

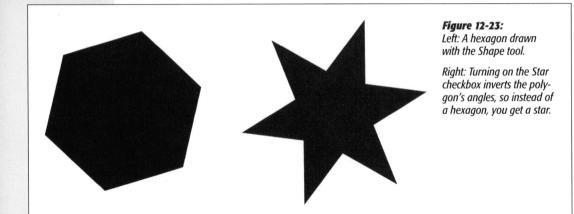

UP TO SPEED

Rasterizing Vector Shapes

Back in Chapter 3, you read about how the majority of your images (definitely your photos) are just a bunch of pixels to Elements. These types of images are known as *raster* images. The shapes you draw with the Shape tools work a little differently; they're what's called *vector* images.

A vector image is made up of a set of directions specifying what kind of geometric shapes your computer should draw. The advantage of vector images is that you can size them way up or down without producing the kind of pixelation (blockiness) you get when you resize a raster image too much.

Shapes keep their vector characteristics until you *simplify* the layers they're on. Simplifying (which is also called *rasterizing*) just means that Elements turns your shape into regular pixels (in other words, into a raster image). Once you simplify vector images, you have the same limitations on resizing them as you do for a regular photo. For example, afterwards you can make your former vector image smaller without running into trouble, but you can't make it larger than 100 percent without losing quality, just as with a photo.

Sooner or later, you may want to transform your vector image to a regular raster image so that you can do certain things to it, like apply filters or effects. If you try to do something to a vector image that requires simplifying (rasterizing) a layer, Elements generally asks you to do so via a dialog box. To rasterize your shape, just click OK, or click the Simplify button in the Options bar. Remember that once you've rasterized a shape, if you try to resize, you won't get the clean, unpixelated results that you got back when it was a vector image. If you need to resize a shape, it's easiest to start over with a new shape—if that's feasible. (This kind of situation is yet another good argument for to using layers!)

Also, before you simplified the layer, you could change the shape's color by clicking the Options bar's color box, and the active shape would automatically change to the new color. After you simplify the layer, the shape totally ignores what you do in the Options bar. Simplifying always affects the *whole* layer—everything on it gets simplified. Once you simplify a shape, you have to select it and change its color the way you would with any detail in a photo.

The Content panel brings yet another wrinkle to the raster/ vector situation—Smart Objects (page 514). The items in the Content panel (the frames, backgrounds, and other doodads) act as vector objects, except that they may also seek out a particular place in the layer stack. Choose a background from this panel, for instance, and it knows to zip down and replace your former Background layer.

Line Tool

Not surprisingly, you use this tool to draw straight lines and arrows. Specify the weight (width) of the line in pixels in the Options bar. If you want your line to have an arrowhead on it, the Geometry Options menu lets you control what it looks like:

- **Start/End.** Do you want the arrowhead at the start or the end of the line you draw? Tell Elements your preference by turning on the appropriate checkbox.
- Width and Length. These settings determine how wide and long the arrowhead is. The unit of measurement here is the percentage of the line's width, so if you enter a number lower than 100, your arrowhead will be narrower than the line it's attached to. You can pick values between 10 and 5,000 percent. If your length setting is too low, you'll get a shape that looks more like a T than an arrow.
- **Concavity.** Use this setting if you want Elements to indent the side of the arrowhead where it meets the line. This number determines the amount of curvature on the widest part of the arrowhead (see Figure 12-24). You can pick a setting between –50 percent and +50 percent.

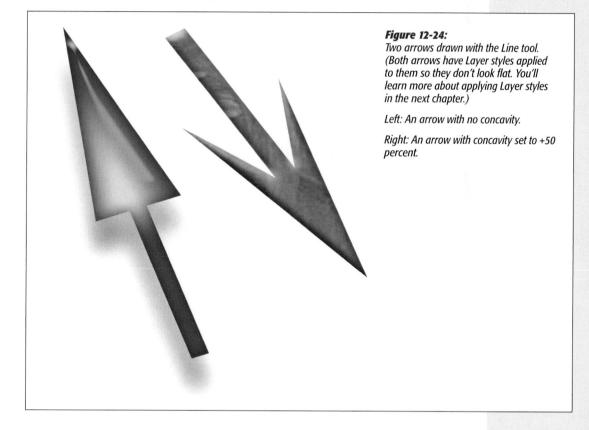

Tip: If you prefer fancier arrows, you'll find some in the Custom Shape tool, explained next.

The Custom Shape Tool

This tool lets you draw a huge variety of different objects, as you can see in Figure 12-25. Its Tools panel icon is the little blue heart. Click it or press U and then choose the Custom Shape tool from the pop-out menu.

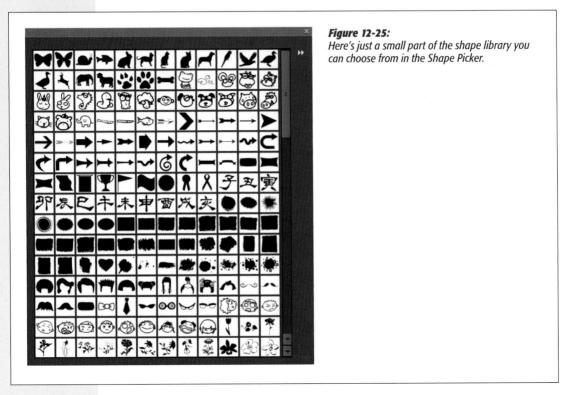

Once the Custom Shape tool is active, the Options bar displays a little thumbnail labeled "Shape" with a down arrow next to it; click this arrow to bring up the Shape Picker. Various shapes automatically appear, but if you click the double arrows in the upper-right corner of the window, you see a menu with lots more choices. To scroll through them all, choose All Elements Shapes.

Tip: The Shape Picker includes a copyright symbol you can use if you want something official-looking that's easy to enlarge and use as a watermark on your photos.

The Custom Shape tool also has a few Geometry Options settings:

- **Unconstrained.** This setting lets you control the proportions of your shape by dragging.
- Defined Proportions. Makes the shape keep its original proportions.
- **Defined Size.** The shape is always the size it was originally created to be dragging won't make it bigger or smaller. It just plinks down at a fixed size you can't control (except by resizing it after the fact).
- Fixed Size. Enter the dimensions you want in inches, pixels, or centimeters.
- From Center. Lets you start drawing in the center of the object.

Note: You can add shapes to Elements (the file posted on this book's Missing CD page for Chapter 19 explains how). Depending on where you put them, they may appear in either the Content panel or the Shape Picker. Look for files that end in *.csh* when you're downloading new shapes.

The Shape Selection Tool

The gray, up-arrow icon you see in the Options bar when you have any of the Shape tools active (it's just to the left of any Shape tool's icon) is the Shape Selection tool. This is a special kind of Move tool that works only on shapes that haven't been simplified yet (page 426), as explained in Figure 12-26. (You can also activate the Shape Selection tool from the Tools panel, where it shares a slot with all the shape tools.)

Figure 12-26:

The Shape Selection tool gives you the same kind of bounding box as the Move tool, and it works the same way, but only on shapes that haven't been simplified. You can also apply transformations like skewing and rotating (page 389) when the Shape Selection tool is active.

Once you simplify a shape's layer, you have to use the regular Move tool to move it around. (You can always use the Move tool, even on shapes that haven't been simplified, where you could use the Shape Selection tool instead.)

Just click the Shape Selection tool and then move your shape. (The shape doesn't even have to be on the active layer.) This may seem like an unnecessary tool, but it's very handy for some tasks, like making exact duplicates of shapes (Alt-drag/Optiondrag a shape to copy it). You can also use this tool to combine multiple shapes into one by clicking the Options bar's Combine button. The Options bar also includes the choices you have when using any of the shape tools: add, subtract, intersect, and exclude.

The Shape Selection tool works just like the Move tool: You can drag to move a shape, hold down Alt/Option while you drag to copy (instead of move) the original shape, drag the handles to resize the shape, and so on. Unfortunately, you can't align and distribute shapes with this tool the way you can with the Move tool. If you need to line things up, use the regular Move tool instead.

WORKAROUND WORKSHOP

Drawing Outlines and Borders

If you've played around with the Shape tool, you may have noticed that you can't draw shapes that are just outlines (that is, ones that aren't filled with color). No matter what you do, your shape is always solid (except for the frame shapes). Even if you haven't ever touched the Shape tool, you may be wondering how the heck to get a simple, plaincolored border around a photo.

The easiest way to create an outline is to make a selection using the Marquee tool or another selection tool and then select Edit—Stroke (Outline) Selection. The Stroke dialog box pops up and lets you enter a width for the line in pixels and choose a color. You'll also see choices for Location, which tell Elements where you want the line: around the inside edge of the selection, centered on the edge of the selection, or around the outside. (If you're bordering an entire photo, don't choose Outside, or the border won't show up because it'll be off the edge of your image.) You can also choose a blend mode (page 413) for the outline and set its opacity. Using a mode can give you a more subtle edge than a normal stroke does. The Preserve Transparency checkbox ensures that any transparent areas in your layer *stay* transparent. When you're finished adjusting the dialog box's settings, click OK and then deselect (press Ctrl+D/#-D or just click someplace else in the image) to turn off your Marquee, and you've got yourself an outlined shape.

Be sure to also check out some of the simple frame designs in the Content panel (page 522). They let you apply a border with just a double-click.

The Cookie Cutter Tool

At first glance, you may think the Cookie Cutter is a pretty silly tool. But actually, it's so handy that you may use it all the time once you understand it. The Cookie Cutter creates the same shapes as the Custom Shape tool, but you use it to crop a photo to the shape you chose. Want a heart-shaped portrait of your sweetie? The Cookie Cutter is the tool for you. If you're a scrapbooker, just a couple of clicks can get you results that would have taken ages and a bunch of special scissors to create with paper.

The Cookie Cutter Tool

If you're not into that sort of thing, don't go away, because hidden in the shapes library are some of the most sophisticated, artistic crop shapes you can find. You can use them to get the kinds of effects that people pay commercial artists big bucks to create—like abstract crops that give a jagged or worn edge to your photo (great for contemporary effects).

You can also combine the result with a stroked edge, as explained in the box above, and maybe a Layer style (page 456), too. Even without any additional frills, your photo's shape will be more interesting, as shown in Figure 12-27.

Tip: Elements also gives you a couple of other ways to create cutouts and fancy edge effects. In Windows, if you plan to print your cropped photo for use in a scrapbooking project, for example, check out the Picture Package feature (page 545). The frames there include some shape crops, and you can do everything right in the Organizer's Print dialog box, if those shapes work for you. (Despite the name, you can make a Picture Package with only one photo.) And the Content panel's Frames section (page 522) includes a bunch of crops, ranging from simple shapes like stars to elaborate edges that make your photo look like a half-completed jigsaw puzzle. And for an ultra-fancy effect, check out the Out of Bounds action in Guided Edit (page 34), which makes your subject look like it's stepping or flying out of the edges of the photo, and the Picture Stack Guided Edit, which makes your photo look like it's made from many photos piled together.

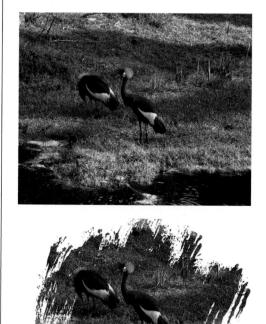

Figure 12-27:

A quick drag with the Cookie Cutter is all it took to create the bottom graphic from the top photo. If you want to create custom album or scrapbook pages, you can rotate or skew your crops before you commit them. (Page 389 explains how to rotate and skew images.) You use the Cookie Cutter just like the Custom Shape tool, but you cut a shape from a photo, instead of drawing a shape:

1. Activate the Cookie Cutter tool.

Click the Cookie Cutter in the Tools panel (its icon is a star) or press Q.

2. Select the shape you want your photo to be.

Choose a shape from the Shape Picker by clicking the down arrow next to the shape displayed in the Options bar. You have access to all the Custom Shapes, but pay special attention to the Crop Shapes category. Click the double arrows on right side of the Shape Picker to select a specific category of shapes, or choose All Elements Shapes.

3. Adjust your settings, if necessary.

You have the same Geometry Options described earlier for the Custom Shapes (page 424)—only here they're called Shape Options instead—so you can set a fixed size or constrain proportions, if you want. Click the Shape Options button to see your choices.

You can feather the edge of your shape, too. Just enter the amount (in pixels) in the Options bar's Feather box. (See page 165 for more about feathering.) The Crop option crops the edges of your photo so they're just large enough to contain the shape.

4. Drag in your photo.

Elements puts a mask over your photo, and you see only the area that will still be there once you crop, surrounded by transparency.

5. If necessary, adjust your crop.

You can reposition the shape mask or drag its corners to resize it. Although the cropped areas disappear, they'll reappear as you reposition the mask if you move it so that they're included again.

Once you've created the shape, you'll see the Transform options (page 389) in the Options bar (which means that you can skew or distort the shape, if you want) until you *commit* your shape, as explained in the next step. You can drag the mask around to reposition it, or Shift-drag a corner to resize it without altering its proportions. It may take a little maneuvering to get exactly the parts of your photo that you want inside the crop.

6. When you've got everything lined up just right, click the Commit button (the green checkmark) in the image window or press Enter.

If you don't like the results, click the Cancel button (the red circle) or press Esc. Once you've made your crop, you can use Ctrl+Z/#-Z if you want to undo it and try something else.

Tip: The Cookie Cutter replaces the areas it removes with transparency. If the transparency checkerboard makes it too hard for you to get a clear look at what you've done, temporarily create a new white or colored Fill layer beneath the cropped layer. Then simply delete the Fill layer once you're happy with your crop.

CHAPTER 13

Filters, Effects, Layer Styles, and Gradients

There's a common saying among artistic types who use software in their studios: *Tools don't equal talent*. And it's true: No mere computer program is going to turn a klutz into a Klimt. But Elements has some special tools—*filters, effects,* and *Layer styles*—that can sure help you fool a lot of people. It's amazing what a difference you can make in the appearance of an image with only a couple of clicks.

Filters are a jaw-droppingly easy way to change how photos look. You can use certain filters for enhancing and correcting images, but Elements also gives you a bunch of other filters that are great for unleashing all your artistic impulses, as shown in Figure 13-1. (You can find the original photos—*rooftops.jpg* and *bauhinia.jpg*—on this book's Missing CD page at *www.missingmanuals.com/cds* if you want to play around with them yourself.)

Most filters have settings you can adjust to control how the filter changes your photo. Elements comes with more than a hundred different filters, so there isn't room in this chapter to cover each filter individually, but you'll learn the basics of applying filters and get in-depth coverage of some of the ones you're most likely to use.

Effects, on the other hand, are like little macros or scripts designed to make elaborate changes to your image, like creating a three-dimensional frame around it or making it look like a pencil sketch or an oil pastel. (Adobe calls them Photo Effects, but you can apply them to any kind of image, not just photos.) They're easy to apply—you just double-click a button—but you can't tweak their settings as easily as you can with filters, since effects are programmed to make specific changes.

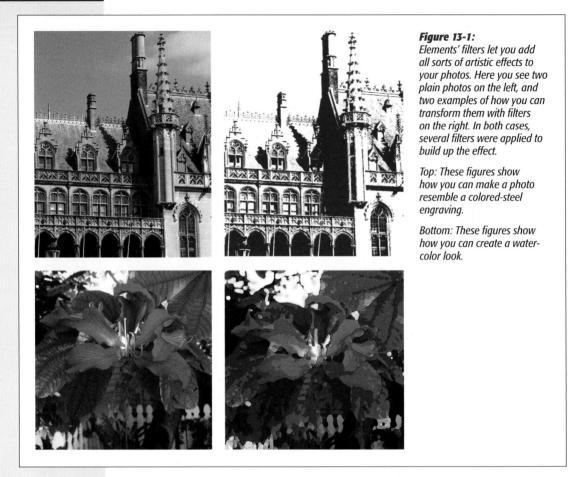

Note: If you've used Elements before, you may know that the effects are also called *actions*. Full-featured Photoshop lets you record and save your own actions and install actions created by others. Elements has an actions player so you can use certain Photoshop actions in Elements, but you can't *create* actions in Elements.

Elements also gives you some spiffy new special effects in Guided Edit. If you've been using Elements for a while, you may think Guided Edit is just for beginners, but now there's plenty there even if you're an old pro. You can use it to create elaborate effects like the Apple-style reflections you see in so many ads these days, make your image look like it's made from a pile of separate photos, create fancy glamour-style portraits, or make a pop-art image à la Warhol. Page 454 has the lowdown. *Layer styles* change the appearance of only one layer of your photo (see Chapter 6 for more about layers). They're great for creating impressive-looking text, but you also can apply them to objects and shapes. Most Layer styles include settings you can easily modify.

If you want to get really creative, you can combine filters, effects, and Layer styles on the same image. You may end up spending hours trying different groupings, because it's addicting to watch the often unpredictable results you get when mixing them up.

The last section of this chapter focuses on *gradients*. A gradient is a rainbow-like range of color that you can use to color in an object or a background. You can also use gradients and *gradient maps*—gradients that are distributed according to the brightness values in your photo—for precise retouching effects.

Using Filters

Filters let you change the look of photos in complex ways, but applying them is as easy as double-clicking. Elements gives you a ton of filters, grouped into categories to help you choose one that does what you want. This section offers a quick tour through the filter categories and some info about using a few of the most popular filters, like Noise and Blur.

To make it easy to work with filters, Elements lets you apply them from two different places: the Filter menu and the Effects panel. (The menu is the only place where you can see *every* filter; some filters, like the Adjustment filters, don't appear in the panel.) Elements also includes the Filter Gallery, a great feature that helps you get an idea of how your photo will look when you apply the artistic filters. Keep reading to learn about all three methods.

Applying Filters

In the Filter menu, you choose a filter from the list by category and then by name. In the Effects panel, thumbnail images give you a preview of what the filters do by showing how they affect a picture of an apple.

The cool thing about the Filter Gallery is that it shows you a preview of what a filter looks like when applied to *your* image. Some filters automatically open the Filter Gallery when you choose them from the menu or the panel, though you can call up the Gallery without first choosing a filter by going to Filter→Filter Gallery. You can't apply every filter from the Gallery—only some of the ones with adjustable settings.

Tip: You can easily apply the same filter repeatedly: Press Ctrl+F/**#**-F and Elements applies the last filter you used, with whatever settings you last used. The top item in the Filter menu also lists the name of this filter (selecting it has the same effect as the keyboard shortcut: Elements applies that filter with the same settings you last used).

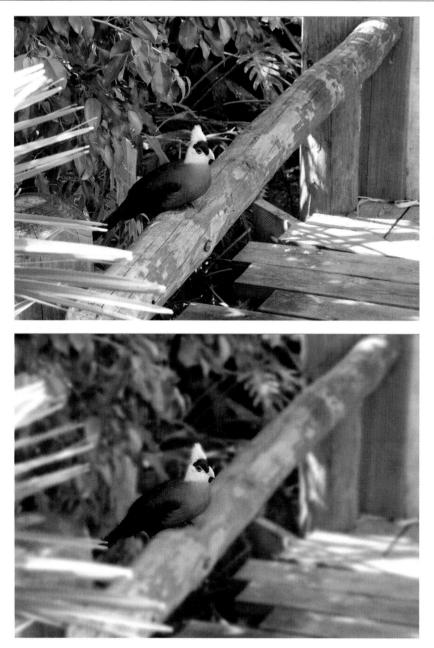

Figure 13-7:

Top: This little guy felt hidden enough to let the camera get pretty close, and he was almost right: It's hard to focus on him with all the stuff in the background. Blurring the background will center the focus on the bird rather than the distracting details.

Bottom: Applying the Gaussian Blur filter to the background makes the bird the clear focal point.

Radial Blur: Producing a sense of motion

As you can see in Figure 13-8, the Radial Blur filter creates a sense of motion. It has two styles: Zoom, which is designed to create the effect of a camera zooming in, and Spin, which produces a circular effect around a center point you designate.

The Radial Blur dialog box looks complicated, but it's really not. (Call it up by going to Filter \rightarrow Blur \rightarrow Radial Blur.) Unfortunately, Elements doesn't give you a preview with this filter, because applying it requires so much processing power. But the dialog box gives you a choice between Draft, Good, and Best quality. You can use Draft for a quick look at roughly what you'll get. Then, undo it and choose Good for the final version. (Good and Best aren't very different except on large images, so don't feel you have to choose Best for the final version. However, with an up-to-date computer, you probably don't need to bother with Draft because your machine can whip up a final version a lot faster than computers could when this filter was first created.)

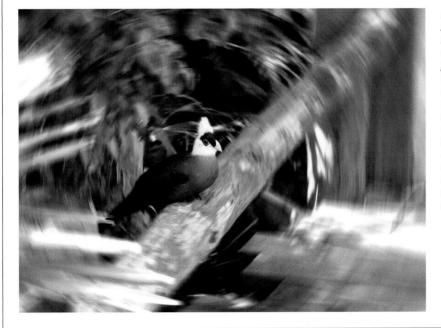

Figure 13-8:

A Radial Blur applied in Spin mode. As you can see, this filter can produce an almost vertiginous sense of motion. If you don't want to give people motion sickness, go easy on the Amount setting. A setting of 5 was used here, but unless you're looking for a psychedelic '60s effect, 1 or 2 is usuallv plentv.

After choosing your blur method (Zoom or Spin), adjust the Amount slider, which controls how intense a blur Elements applies. Next, click in the Blur Center box to tell Elements where you want the blur centered, as shown in Figure 13-9. Click OK when you're finished.

Using Filters

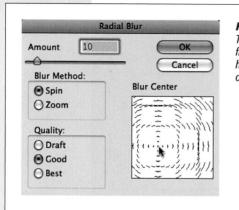

Figure 13-9:

The Blur Center box lets you pick a center point for the Radial Blur filter's effect. Drag the ripple drawing inside the box in any direction; here, the center point was moved just to the left and down from its original position in the center of the box.

Color correcting with the Average Blur filter

If you've already given the Average Blur filter a whirl, you may be wondering what on earth Adobe was thinking when they created it. If you use it on a whole photo, the image disappears under a monochromatic soup, something like what you'd get by pureeing all the colors in the photo together.

Oddly enough, this effect makes this filter a great tool for getting rid of color casts (page 251). You can use the Average Blur filter to create a sort of custom Photo Filter (page 297) toned specially for the image you use it on. The secret is using blend modes (page 199). Here's how:

1. Open your image and make a duplicate layer.

Press Ctrl+J/æ-J or go to Layer→Duplicate Layer.

2. Apply the Average Blur filter.

Make sure the duplicate layer is the active layer (click it in the Layers panel if it isn't), and then go to Filter \rightarrow Blur \rightarrow Average. Your photo disappears under a layer of (probably) unpleasing solid color, but you'll fix that next.

3. Change the blur layer's blend mode.

In the Layers panel, set the Mode drop-down menu to Color. Already things are starting to look better.

4. Invert the blur layer.

Press Ctrl+I/#-I to invert the layer's colors.

5. Reduce the blur layer's opacity and do any other necessary tweaking.

Use the Layers panel's opacity slider; start at 50 percent. By now, the color should look right—no more color cast. Tweak if necessary, and then save your work.

Tip: You may want to add a Hue/Saturation layer if you find that, no matter how you adjust the blur layer's Opacity setting, the photo still looks a little flat.

The Average Blur filter is a particularly good way to color-correct underwater photos, where it's hard to get a realistic white balance using your camera's built-in settings.

Improving skin texture with the Surface Blur filter

The Surface Blur filter is yet another way to blur images. At this point you may be thinking that you already have enough ways to eliminate details in your photos, but Surface Blur is actually really handy, especially on pictures of people. This filter is smart enough to avoid blurring details and areas of high contrast, which makes it great for fixing skin. If you want to eliminate pores, for instance, or reduce the visibility of freckles, this is your tool. And it's simple to use, too:

1. Open your image and make a duplicate layer.

Press Ctrl+J/ಱ-J or go to Layer→Duplicate Layer.

Tip: For best results, start by selecting the area you want to blur (see Chapter 5 for help with selections). Then make your duplicate layer from the selection so you can keep the details in the areas you *aren't* trying to fix. For example, select only the skin of your subject's face, leaving out the mouth and eyes so they won't be affected by the blur. Or, better yet, adjust the whole duplicate layer and then use a layer mask (page 211) to mask out the areas where you want to keep the details, or just erase those areas.

2. Apply the Surface Blur filter.

Make sure your duplicate layer is the active layer (click it in the Layers panel if it isn't), and then go to Filter \rightarrow Blur \rightarrow Surface Blur. If necessary, move the dialog box out of the way so you can watch what you're doing in the main image window and in the dialog box's preview area.

3. Tweak the filter's settings till you like the effect.

The dialog box's sliders are explained below. Be cautious—it doesn't take much to make your photo look like a painting. Click OK when the flaws are concealed as much as possible without losing important details like eyelashes.

4. If you want, change the duplicate layer's blend mode and/or opacity.

Use the Layers panel's controls for this step. If you want to eliminate blemishes, for example, try the Lighten blend mode.

The Surface Blur filter isn't hard to understand, but you usually have to do a fair amount of fiddling with its sliders to get the best balance between softening and preserving detail for a natural-looking effect. Here's what the sliders do:

• **Radius.** As with other filters, this setting controls how far Elements should blur your image. Move this slider to the left for a smaller blur, or to the right for a wider blur.

• **Threshold.** This slider controls how different in tone the pixels have to be for Elements to blur them. A low setting means less blurring (fewer tones will be blurred); a higher setting means more blurring.

If you want to do a lot of experimenting, instead of dragging the sliders, try highlighting the number in each setting's box and then using the up and down arrow keys to adjust the effect.

Note: Elements includes a whole tutorial specially for fixing portrait photos (although it uses the Smart Blur rather than Surface Blur). To try it out, go to Edit tab—Guided—Advanced Edits—Perfect Portrait.

Adding Effects

Like filters, Elements effects give you loads of ways to modify your photo's appearance—from adding lizard-skin textures to surrounding it with a classy frame. Although you apply effects with a simple double-click, these clicks trigger a series of changes. Some effects involve many complex steps, but Elements works so quickly you might not notice all the changes it makes.

Note: You usually can't customize or change an effect's settings—they're all or nothing. For example, if you use one of the Frame effects, you either take the frame size as Elements applies it to your image, or you don't; you can't adjust its scale relative to your photo. This issue is why most of the frames are now Smart Objects (page 514) that you apply from the Content panel, rather than effects—you have more control over Smart Objects.

You'll find effects in a few different spots in Elements:

- The Effects panel is home to most photo effects—like tinting (Figure 13-10)— and a few frames. The panel is explained after this list.
- The Content panel houses some effects, but they only work on text. Page 522 has the scoop.
- **Guided Edit**. The past few versions of Elements have included a couple of fairly rudimentary special effects in this let-us-show-you-how section. Page 34 tells you more about using Guided Edit.

To apply an effect from the Effects panel, choose Window \rightarrow Effects, and then click the Photo Effects button at the top of the panel (its icon is a rectangle with little sparkles around it). Just as with filters, use the panel's drop-down menu to see all your choices or pick from only one category. The thumbnail images give you a preview of how each effect will change your image.

To apply an effect, double-click its thumbnail in the Effects panel; click the thumbnail once, and then click the Apply button; or drag the thumbnail onto your photo. That's all there is to it. If you don't like the result, press Ctrl+Z/æ-Z to undo it, since you can't do much to tweak it. Here are a couple effects-related tips to help you get the most out of these nifty-butquirky features:

- A few effects flatten or simplify your image, so it's usually best to make a copy of your image, or wait until you're done making all your other edits, before applying an effect.
- Many effects create new layers; check the Layers panel once you're done applying them. You may want to flatten your image to reduce the file size before printing or storing it. (See Chapter 6 if you need a refresher on layers.)

Figure 13-10:

The Effects panel's Photo Effects section lets you age a photo by applying an antique look to it, as shown here. This was a color photo that had the Vintage Photo effect applied to it. **Tip:** If you want to apply an effect to only part of an image, check out some of the Smart Brush tool's new options (page 234). Some of these are quite different under the hood from the effects described in this section, but the end result may be just what you're after.

Using Actions

If you hang around people who use Photoshop, you'll hear talk about *actions* and how useful they are. An action is a little script—similar to a macro in a program like Word—that automates the steps for doing something, which can save tons of time. For example, imagine an action that applies your favorite filter and crops a photo to a certain size, or one that creates a complicated artistic effect, like a colorful watercolor look that would take many steps to do manually. Wouldn't it be great if you could use actions in Elements?

Well, in a way, Elements has always been able to use actions—under the hood, effects are really actions. And you've always been able to add some Photoshop actions to Elements, although the process used to be complicated. But not anymore: Recent versions of Elements include the Action Player, which lets you run many Photoshop actions in Elements.

Adobe gives you a few useful actions to get you started, and you can add your own, as explained later in this section. To run an action:

1. Open a photo and then go to the Action Player.

Click the Edit tab→Guided→Automated Actions→Action Player.

2. From the first drop-down menu, choose the Action set you want.

Action sets are groups of related actions. Elements comes with sets that let you add captions (and canvas to display the captions), trim weight from your subjects, resize and crop your photos, and apply special effects to them.

3. From the second drop-down menu, choose a specific action.

You can choose how much thinner to make someone with the Lose Weight actions, for example, or what color canvas (white, gray, or black) to add for a caption.

4. Run the action.

Click the Play Action button and Elements does its thing. The built-in actions happen pretty much instantly, but if you add actions from other sources, you may see pop-up dialog boxes that let you adjust settings for some steps. Just make any changes, click OK, and the action resumes and finishes up. If you don't like the results, click the Reset button or press Ctrl+Z/#-Z to undo the action, and then try another one instead. (You can't step backward in the Elements Action Player.)

5. When you like the results, click Done.

If you decide you don't want to use an action after all, click Cancel instead.

One of the best things about the Action Player is that you can easily add more actions to it. You can't create actions in Elements—you need Photoshop for that—but there are thousands of free actions on the Internet that you can download and add to Elements. Page 602 suggests some places to look for them.

Once you download an action, if you're using Windows 7 or Vista, just save it in C:\ProgramData\Adobe\Photoshop Elements\10.0\Locale\en US\Workflow Panels\ Actions (the "en US" part is different if you aren't in the United States). For Windows XP, it's C:\Documents and Settings\All Users\Application Data\Adobe\Photoshop Elements/10.0/Locale/en us/Workflow Panels/Actions (ditto on the en US info). (You need to turn on hidden folder viewing for Windows operating systems, since these are hidden files; the Tip on page 604 tells vou how.) On a Mac, it's Hard Drive \rightarrow Library \rightarrow Application Support \rightarrow Adobe \rightarrow Photoshop Elements \rightarrow 10.0 \rightarrow Locale \rightarrow en US→Workflow Panels→Actions (as in Windows, the "en_US" part is different if you aren't in the U.S.). If you use OS X 10.7 (Lion), see page 11. If you have the Mac App Store version, go to Applications and right-click/Control-click Adobe Photoshop Elements Editor, then choose Show Package Contents-Contents-Application Data→Photoshop Elements→10.0→Locale→en_US (or your location)→Workflow Panels \rightarrow Actions. (You'll see a message that the Actions folder can't be modified; click Authenticate and enter your OS X password when asked, and then you can put the action there.)

The next time you start Elements, you'll see your action in the drop-down menu shown in Figure 13-11.

Figure 13-11:

If you add an action that isn't part of an action set, you still have to make a choice in both Guided Edit panel menus. Just choose its name from both menus, as shown here.

Redsteel is the action used to create the building image in Figure 13-1. You can download it from this book's Missing CD page at www.missingmanuals. com if you want to try installing actions. It works best on photos with lots of detail. On images with large blocks of color, the effect is more like pop art than a colored-steel engraving.

It's important to understand a few differences between actions in Photoshop and in Elements. Photoshop can run an action on a whole folder of images at once. In Elements, you're restricted to one photo at a time. Also, Elements can't fully perform actions that invoke Photoshop-only commands. For example, if you run an action that includes creating a history snapshot, you see the dialog box shown in Figure 13-12. If you like to play it safe, find actions written specifically for Elements. Page 602 tells you where to look for them.

Figure 13-12:

When you run an action in Elements, you may see dialog boxes asking for your input as the action works through its steps. If you see this dialog box, you're trying to run an action that includes a step that Elements can't perform. You don't have to stop the action, but be aware that you won't get the same results as you would in Photoshop.

Tip: While the Action Player is great, there's one disadvantage to having it in Guided Edit: You can't access the Layers panel, which is annoying if you're running an action that requires you to choose a layer midaction, because you can't select a particular layer without the Layers panel. The good news is that you can install actions in the Effects panel. This lets you use actions in Full Edit, where you can get to the Layers panel anytime an action requires it. By installing actions in the Effects panel, you can still use the add-on tools for Elements that are actually actions that use or create layers, like the various free toolsets available online. You'll find much more about downloading and installing these in Chapter 19.

Special Effects in Guided Edit

In addition to the special effects in the Actions Player, Elements 10 includes two categories in Guided Edit that contain lots of interesting special effects for your images. In each of these, Elements carefully walks you through some fairly complex photo work in these edits, which can give you some pretty impressive results, as you can see in Figure 13-13.

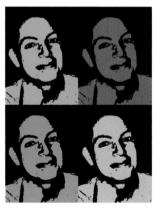

Figure 13-13:

Both of these images began with a simple color photo. Two clicks created this distinctive Lomostyle image (left), and creating the pop art portrait (right) was only a tad more complicated. To get started, go to Edit tab \rightarrow Guided \rightarrow Photography Effects. Here's are your choices:

- Line Drawing. If you've tried the Pencil Sketch filter and weren't happy with your results, this guided edit gives you some help with additional tweaks to get a (somewhat) more realistic looking drawn effect.
- Lomo Camera Effect. The name of this effect may not mean anything to you, but if you click it in the Guided Edit panel, the example image's style should be familiar. Lomo was a brand of camera that produced photos that, technically speaking, weren't the greatest: They were oversaturated, had shadowy vignetted corners, and the registration (alignment) of the color channels was sometimes off, to name a few flaws. But people loved the strong personality of these images, and in recent years, making a photo look like it was taken with a Lomo has become popular. Figure 13-13 (left) shows an example of what Elements creates with this effect.
- Old Fashioned Photo. Use this to create a sepia-toned photo with an aged texture.
- **Orton Effect.** As explained on page 445, this edit uses a very soft focus to create a dreamlike mood.
- **Saturated Slide Film Effect.** You may be old enough to remember the ultrasaturated colors you could get by shooting certain types of slide film. This guided edit walks you through creating a similar effect digitally.

In addition, there are several fun effects in Guided Edit's Photo Play section, which is directly beneath the Photography Effects section. Some of these are a bit complex, but once you've been through the process once or twice, it becomes very easy to create any of them:

• **Out Of Bounds.** This effect makes part of your subject looks like it's moving out of the framed image, giving your photo a sort of 3-D look.

Tip: Good candidates for the Out Of Bounds effect are photos where there's a fairly strong color contrast between your subject and the background. For example, your daughter will be easier to select if she's playing soccer on a grass field than if she's running on a track amidst her classmates.

- **Picture Stack.** This makes your photo look like you took several shots of different bits of your subject and then arranged the pictures on a table so you could see the whole thing at once. You can choose whether there should be four, eight, or 12 pictures in the stack; adjust the size of the photos' borders; and change the background color, although you really don't see very much of it.
- **Pop Art.** This guided edit helps you create that '60s Andy Warhol look (like the one in Figure 13-13, right) with just a couple of clicks. It works best on photos of people or of objects with fairly simple lines rather than super-detailed subjects.

Tip: To see what your image looks like without the styles you've applied to it, go to Layer \rightarrow Layer Style \rightarrow Hide All Effects.

You can download hundreds of additional Layer styles from the Web (see page 602 for tips on where to look and how to install them). It's easy to get addicted to collecting Layer styles because they're so much fun to use. You've been warned!

Applying Gradients

You may have noticed that a few of Elements Layer styles and effects apply a color tint that fades away at the edges of your layer or image. You can fade and blend colors in almost any way imaginable by using *gradients*, which let you create anything from a multicolored rainbow extravaganza to a single color that fades away into transparency. Figure 13-17 shows a few examples of what you can do with gradients. The only limit is your imagination.

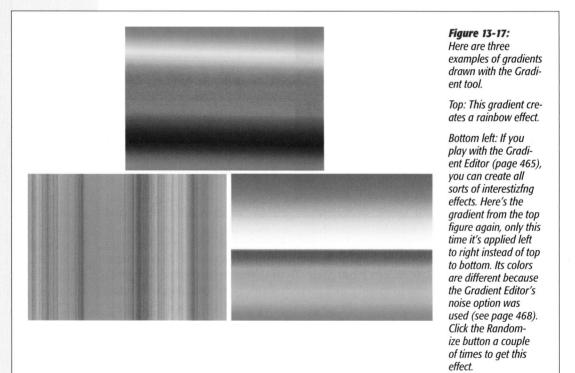

Bottom right: This figure shows the kind of gradient you can create if you want a landscape background for artwork. You can apply gradients directly to your image using the Gradient tool, or create *Gradient Fill layers*, which are whole layers filled with—you guessed it—gradients. You can even edit gradients and create new ones using the Gradient Editor. Finally, there's a special kind of gradient called a *gradient map* that lets you replace the colors in your image with the colors from a gradient. This section covers the basics of using all these tools and methods.

The Gradient Tool

If you want to apply a gradient to an object in your image, the Gradient tool is the fastest way to go. This tool seems complicated at first, but it's actually easy to use. Start by activating it in the Tools panel (its icon is a yellow-and-blue rectangle) or by pressing G. Figure 13-18 shows your Options bar choices for this tool.

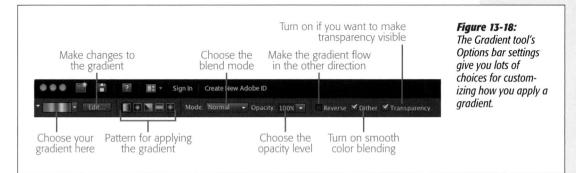

Using the Gradient tool is as easy as dragging: Click where you want the gradient to begin, and then drag to the point where you want it to stop (you'll see a line connecting the beginning and ending points). When you release your mouse button, the gradient covers the available space.

For example, say you're using a yellow-to-white gradient. If you click to end the gradient one-third of the way into your photo, the yellow stops transitioning at that point, since you told Elements to stop the gradient there, and the remaining two-thirds of your photo get covered with white. In other words, something put down by the tool covers the entire space—your whole photo, in this case. Clicking stops the color *transition*—no more yellow beyond that point—but the gradient's end color fills in everyplace else. (Don't worry: This is much easier to understand once you try it.) Drag the gradient within a selection to confine it to that area so the entire photo or layer isn't affected by the gradient's colors.

Tip: The Gradient tool puts the gradient on the same layer as the image you apply it to, which means that it's hard to change anything about a gradient after you apply it. If you think you might want to alter a gradient, use a Gradient Fill layer instead.

Some of Elements' gradients use your Foreground and Background colors, but Elements also offers a number of preset gradients with different color schemes. Click the arrow to the right of the gradient thumbnail in the Options bar to see a panel of different gradients, some of which use your selected colors, and others that have their own color schemes. The gradients are grouped into categories. In the upperright corner of the gradient thumbnails panel, click the double arrow to see all the gradient categories, and then choose one to see what it contains. (You can work only with the gradients in one category at a time.)

You can download gradients from the Web and add them to your library using the Preset Manager (page 604); page 602 has suggestions of where to look online. You can also create your own gradients from scratch. Creating and editing gradients is explained later in this chapter, in the section about the Gradient Editor.

To apply a gradient with the Gradient tool, first make a selection if you don't want to see the gradient applied to your whole image. Then:

1. Choose the colors you want to use for your gradient.

Click the Foreground and Background color squares to choose colors. (Remember, some gradients ignore these colors and use their own preset colors instead.)

2. Activate the Gradient tool.

Click its icon in the Tools panel or press G.

3. Select a gradient.

Go to the Options bar, click the gradient thumbnail, and then choose the one you want. Then make any other necessary changes to the Options bar settings (your options are explained in a moment), like reversing the gradient.

4. Apply the gradient.

Drag in your image to mark where the gradient should run. If you're using a linear gradient, you can make it run vertically by dragging up or down, or make it go horizontally by dragging sideways. For Radial, Reflection, and Diamond gradients, try dragging from the center of your image to an edge. If you don't like the result, press $Ctrl+Z/\Re-Z$ to undo it and try again. Once you like the way the gradient looks, you don't need to do anything special to accept it; just save your image before you close it.

You can customize gradients in several ways without even using the Gradient Editor. When the Gradient tool is active, the Options bar offers the following settings:

- **Gradient.** Click the arrow to the right of the gradient thumbnail to choose a different gradient.
- Edit. Click this button to bring up the Gradient Editor (page 465).
- **Gradient types**. These five buttons determine the way the colors flow in your gradient. From left to right, your choices are: Linear (in a straight line), Radial (a sunburst effect), Angle (a counterclockwise sweep around the starting point), Reflected (from the center out to each edge in a mirror image), and Diamond. Figure 13-19 shows what each one looks like.

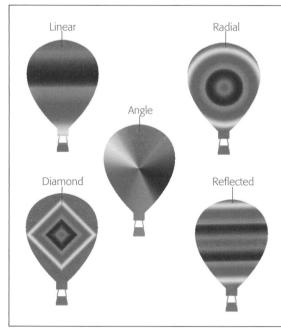

Fiaure 13-19:

The same gradient pattern applied using the different gradient types: Linear, Radial, Angle, Diamond, and Reflected.

- Mode. You can apply a gradient in any blend mode (see page 199).
- **Opacity.** If you want your image to be visible through the gradient, reduce this setting.
- **Reverse.** This setting changes the direction in which Elements applies the colors so that, for example, instead of yellow to blue (from left to right, say), you get blue to yellow instead.
- **Dither.** Turn on this checkbox and Elements uses fewer colors but simulates the full color range using a noise pattern. This can help to prevent banding of your colors, making smoother transitions between them.
- **Transparency**. If you want to fade to transparency anywhere in your gradient, turn on this checkbox. Otherwise, the gradient can't show transparent regions.

Gradient Fill Layers

You can also apply a gradient using a special kind of Fill layer (page 218). Most of the time, this method is better than using the Gradient tool, especially if you want to be able to make changes to the gradient after you apply it.

Applying Gradients

To create a Gradient Fill layer, go to Layer \rightarrow New Fill Layer \rightarrow Gradient. The New Layer dialog box appears so you can set the layer's blend mode (page 199) and opacity. Once you click OK, Elements fills the new layer with the currently selected gradient, and the dialog box shown in Figure 13-20 pops up. You can change many of the gradient's settings here, or choose a different gradient altogether. The dialog box's settings are much the same as those in the Options bar for the Gradient tool:

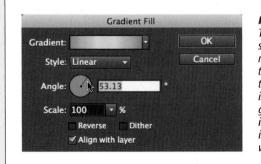

Figure 13-20:

The Gradient Fill dialog box gives you access to most of the same settings you find in the Options bar for the Gradient tool. The major difference is that with a Fill layer, you set the direction of the gradient by typing in a number for the angle or by changing the direction of the line in the circle as shown here (the cursor is pointing to the line you drag to change the angle). You don't get a chance to set the direction by dragging directly in your image as you do with the Gradient tool, but while this dialog box is onscreen, you can drag the gradient in your image to change where it transitions.

- **Gradient.** To choose a different gradient, click the arrow next to the thumbnail to see the gradient thumbnails panel. To choose from a different gradient category, click the double arrow in the panel's upper right, and then choose the category you want.
- **Style.** You have the same choices here as for the Gradient tool (Linear, Diamond, and so on). Choose a different style and Elements previews it in the layer.
- **Angle.** This setting controls the direction the colors will run. To change the direction of the flow, enter a number in degrees or spin the line in the circle by dragging it.
- Scale. This setting determines how large your gradient is relative to the layer. One hundred percent means they're the same size; at 150 percent, the gradient is bigger than your layer, so you see only a portion of the gradient in the layer. (For example, if you had a black-to-white gradient, you might see only shades of gray in your image.) If you turn off the "Align with layer" checkbox (explained in a sec), you can adjust the location of the gradient relative to your image by dragging the gradient.
- Reverse. Turn on this checkbox to make colors flow in the opposite direction.
- Dither. Use this setting to avoid banding and create smooth color transitions.
- Align with layer. This setting keeps the gradient in line with the layer. Turn it off and you can pull the gradient around in your image to place it exactly where you want it. At least, that's how it's *supposed* to work; you can usually drag while the dialog box is visible but not after you click OK.

Applying Gradients

When the gradient looks good, click OK to create the layer. You can edit it later by heading to the Layers panel and double-clicking the layer's leftmost icon (the one with the gradient on it). That brings up the Gradient Fill dialog box again, so you can change its settings or choose a different gradient.

Editing Gradients

Elements' Gradient Editor lets you create gradients that include any colors you like. You can even make ones in which the color fades to transparency, or modify existing gradient presets. Alas, the Gradient Editor isn't the easiest tool in the world to use. This section tells you the basics you need to get started. Then, as is the case with so many of Elements' features, playing around with the Gradient Editor is the best way to understand how it works.

You have to activate the Gradient tool to launch the Gradient Editor. After you activate the tool, in the Options bar, click the Edit button to see the Gradient Editor (see Figure 13-21).

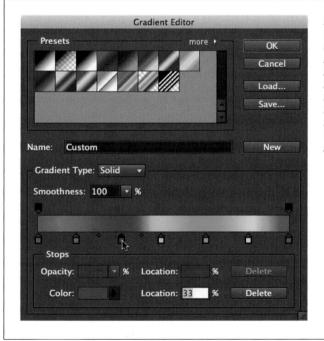

Figure 13-21:

The powerful and complex Gradient Editor. Here, the blue stop (where the cursor is) was clicked to make it active. (The black triangle above the stop is Elements' way of telling you it's the active stop. In Windows, the triangle turns the same color as the stop.) The two tiny diamonds on either side of the active stop mark the midpoints of the transitions between the selected color and its neighbors. You can move these diamonds to change the midpoints.

The Gradient Editor opens showing the current gradient. You can choose a different gradient by picking from the thumbnails at the top of the Gradient Editor window, or by clicking the word "more" in the window's upper right and choosing a new category from the list. (You'll learn how to save your custom gradients later in this chapter.)

To get started using the Gradient Editor, first choose your gradient's type and smoothness settings:

- **Gradient Type.** Your choices are Solid or Noise. Solid gradients are the most common; they let you create transitions between solid blocks of color. Noise gradients, which are covered later in this section, produce bands of color, as you might see in a spectrometer.
- Smoothness. This setting controls how even the transitions between colors are.

You do most of your work in the Gradient Editor's *Gradient bar*, the long colored bar where Elements displays the current gradient. The little boxes (called *stops*) and diamonds surrounding the Gradient bar let you control the color and transparency of your gradient.

Note: The directions in this section are for editing regular gradients. Noise gradients work a little differently, as explained on page 468.

For now, you only care about the stops *below* the Gradient bar (the ones above it are explained in the next section). Each one is a *color stop*; it represents where a particular color falls in the gradient. (You need at least two color stops in a gradient.) If you click a stop, the pointed end turns black or the same color as the stop, letting you know that it's the active stop. Anything you do at this point will affect the area governed by that stop. You can slide the stops around to change where the colors transition.

The color stops let you customize your gradient in lots of different ways. Using them, you can:

- Change where the color transitions. Click a color stop and you see a tiny diamond appear under the bar. (If the stop isn't at the end of the gradient, you get two diamonds, one on either side of it.)The diamond is the midpoint of the color change. Diamonds always appear between two color stops. You can drag the diamond in either direction to skew the color range between two color stops so that it more heavily represents one color over another. (You know you've successfully grabbed the diamond when it turns black or the color of the adjoining stop.) Wherever you place the diamond tells Elements that's where the color change should be half completed.
- Change one of the colors in the gradient. Click any color stop, and then click the Color square at the bottom of the Gradient Editor, in the Stops section, to bring up the Color Picker. Choose a new color, and the gradient automatically reflects your change. You can also pick a new color by moving your cursor over the Gradient bar; the cursor turns into an eyedropper that lets you sample a color. If you click the arrow to the right of the Color square, you can select the current Foreground or Background color. (The User Color option just means the Gradient Editor behaves normally, meaning that moving your cursor over the Gradient bar brings up the eyedropper.)

- Add a color to the gradient. Click anywhere just beneath the bar to indicate where you want the new color to appear. Elements adds a new color stop where you clicked. Next, click the Color square at the bottom of the window to bring up the Color Picker so you can choose the color to add. The new color appears in the gradient at the new stop. Repeat as many times as you want, adding a new color each time. To precisely position the new stop, enter numbers (indicating percentage) in the Location box below the Gradient bar. For example, 50 percent positions a stop at the bar's midpoint. To duplicate an existing color from your gradient, click its stop, and then click below the bar where you want to use that color again.
- **Remove a color from a gradient.** If a gradient is *almost* what you want but you don't like one of the colors, you don't have to live with it. You can remove a color by clicking its stop to make it the active color. Then click the Delete button at the bottom right of the Gradient Editor, or just drag the stop downward off the bar. (The Delete button is grayed out if no color stop is active.)

Transparency in gradients

You can also use the Gradient Editor to adjust the transparency in a gradient. Elements gives you nearly unlimited control over transparency in gradients, and the opacity of any color at any point in the gradient. Adjusting opacity in the Gradient Editor is much like using the color stops to edit the colors, but instead of color stops you use *opacity stops*.

Note: Transparency is particularly nice in images for Web use, but remember that you need to save in a format that preserves transparency, like GIF, or you lose the transparency. If you save your file as a JPEG, the transparent areas become opaque white. See page 553 for more about file formats for the Web.

The opacity stops are the little boxes *above* the Gradient bar. You can move an opacity stop to wherever you want, and then adjust the transparency using the settings in the Gradient Editor's Stops section. Click above the Gradient bar wherever you want to add an opacity stop. The more opacity stops in the Gradient bar, the more points where you can adjust your gradient's opacity.

Here's how to add an opacity stop and adjust its opacity setting:

1. Click one of the existing opacity stops.

If the little square on the stop is black, the stop is completely opaque. A white square represents a spot that's totally transparent. The new stop you're about to create will have the same opacity as the stop you click in this step, but you can adjust the new stop once you create it. (You can actually skip this step, but it lets you predetermine the opacity of your new stop.)

2. Add a stop.

Click just above the Gradient bar where you want to add a stop. If you want your stop to be precisely positioned, then you can enter numbers (indicating percentage) in the Location box below the Gradient bar. For example, 50 percent positions a stop at the bar's midpoint.

3. Adjust the new stop's opacity.

THE CASTLETON

LITTLE THEATRE

Go to the Opacity box below the Gradient bar and either enter a percentage or click the arrow to the right of the number and then move the slider. To get rid of a stop, click it and then click Delete or drag the stop upward, away from the bar.

By adding stops, you can make your gradient fade in and out, as shown in the background of Figure 13-22, which has a simple, vertical blue-to-transparent linear gradient that's been edited so that it fades in and out a few times.

You can make a gradient fade in and out like this background by adding opacity stops and reducing the opacity of each stop.

PRESENTS:

Creating noise gradients

Elements also lets you create what Adobe calls *noise gradients*, which aren't speckled as you might expect if you're thinking of camera noise. Instead, noise gradients randomly distribute their colors within the range you specify, giving them a banded or spectrometer-like look. The effect is interesting, but noise gradients can be unpredictable. The noisier a gradient is, the more stripes of color you see, and the greater the number of random colors. With the Gradient tool active, you can create a noise gradient by tweaking one of the sample ones that comes with Elements. First, go to the Options bar and click the down arrow to the right of the gradient's thumbnail; this opens the gradient thumbnail panel. Next, click the double arrow at the panel's upper right and then, in the pop-out list of categories, select Noise Samples. Click to select one you like. You can then edit it by clicking the gradient thumbnail in the Options bar to bring up the Gradient Editor.

Tip: If you want to create a noise gradient without basing it on one of Elements Noise Sample presets, you can click the Option bar's Edit button to bring up the Gradient Editor, and then choose Noise from the Gradient Type menu.

Noise gradients have some special Gradient Editor settings of their own:

• **Roughness** controls how gradually the gradient transitions from color to color (see Figure 13-23 for details). A higher number not only means less smooth transitions, but also more shades of color in the gradient.

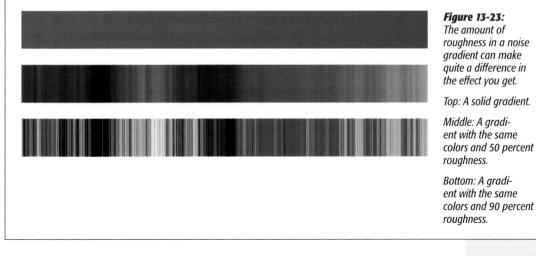

- **Color Model** determines which color mode you work in—RGB or HSB. RGB gives you red, green, and blue color sliders, while HSB lets you set hue, saturation, and brightness (see page 257 for more about these settings).
- Restrict Colors keeps your colors from getting too saturated.
- Add Transparency puts random amounts of transparency into your gradient.
- **Randomize** adds random colors (and transparency, too, if you turned on that checkbox). Keep clicking the Randomize button until you see an effect you like.

Applying Gradients

Saving Gradients

After all that work, you probably want to save your gradient so you can use it again. You have two ways to save a gradient from the Gradient Editor:

• **Click the New button**. In the Name box to the left of the New button, type a name for your gradient. Elements adds your gradient to the current category, and adds a thumbnail of your gradient to the gradient thumbnails panel in the currently visible set.

Tip: If you forget and click the New button before naming your gradient (or if you just want to change its name), in the Gradient Editor, right-click/Control-click the gradient's thumbnail, and then choose Rename Gradient.

• **Click Save.** The Save dialog box appears and Elements asks you to name the gradient. You'll save it in a special Gradients folder, which Elements automatically takes you to in the Save dialog box. This method resaves the entire set of presets that's visible when you create your gradient. When you want to use the gradient again, click the Gradient Editor's Load button, and then select it from the list of gradients that appears. The new set appears at the bottom of the list of gradient libraries you see when you click the double arrows in the palette's upper right.

Tip: You can also save and load gradients by calling up the Options bar's gradient thumbnail panel (click the arrow to the right of the gradient thumbnail) and then clicking the double arrows in the panel's upper right.

Gradient Maps

Gradient maps let you use gradients in nonlinear ways. So instead of a rainbow that shades from one direction to another, with a gradient map, Elements substitutes the gradient's colors for the image's existing colors. You can use gradient maps for funky special effects as well as serious photo corrections.

When you create a gradient map, Elements plots out the brightness values in your image and applies those values to a gradient (light to dark). Then Elements replaces the existing colors with the gradient you choose, using the lightness values as a guide to determine which color goes where. That sounds complicated, and it is; but if you try it, you'll quickly see what's going on. Take a look at Figure 13-24, where applying a gradient map dramatically livens up a dull photo. But that's not all gradient maps are good for. They can also be valuable tools for straight retouching. See the box on page 472 to learn how to use gradients to fix the color in photos.

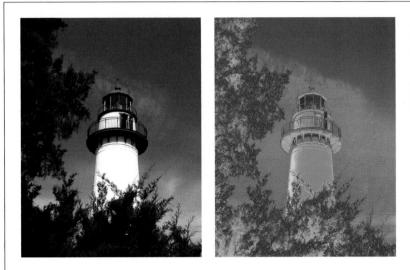

Figure 13-24: Left: An ordinary shot of a liahthouse.

Right: The image becomes altogether different when you apply a gradient map adjustment.

You can apply a gradient map directly to your image by going to Filter \rightarrow Adjustments \rightarrow Gradient Map or using the Smart Brush [page 234] (in the Options bar's Smart Paint setting, choose Special Effects \rightarrow Rainbow Map.) But most times, you'll want to use a Gradient Map Adjustment layer, because it's easier to edit after you've created the layer. Here's how:

1. Create a Gradient Map Adjustment layer.

Go to Layer \rightarrow New Adjustment Layer \rightarrow Gradient Map. The New Layer dialog box appears so you can choose the blend mode and opacity for your new layer, and name it if you want. Click OK, and Elements adds a gradient map to your photo, but don't worry if it's not what you had in mind. You can modify it by going to the Adjustments panel, shown in Figure 13-25.

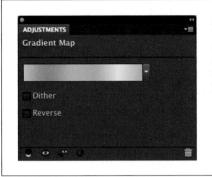

Figure 13-25:

The Gradient Map Adjustments panel. Clicking the tiny arrow to the right of the thumbnail (where the cursor is here) displays a drop-down menu showing the available gradient patterns. Click in the pattern preview area to bring up the Gradient Editor (page 465) if you want to make changes to the gradient you chose.

2. Select a gradient.

In the Adjustments panel, you see a gradient whose colors are based on your current Foreground and Background colors. That gradient is the map that Elements made of the lightness/darkness values in your image. If you want your image to show color, choose a color gradient rather than a black- or gray-to-white one. At the right of the gradient thumbnail, click the arrow, and then choose a color gradient. Elements automatically replaces the colors in your image with the equivalent values from the gradient you chose, so you can click around in the gradient libraries and watch your image change.

The Dither checkbox adds a little random noise to make the gradient's transitions smoother. The Reverse checkbox switches the direction in which Elements applies the gradient to the map. For example, if you chose a red-to-green gradient, reversing it would put green where it would have previously been red, and vice versa. It's worth giving this setting a try—you can get some interesting effects.

3. Keep editing until you're satisfied with the result.

When you like what you see, save your image. You can also edit the gradient map layer by clicking it in the Layers panel, as explained in Figure 13-25.

Remember that you don't have to use your gradient in Normal blend mode—you can select any layer blend mode. You can spend hours playing around with gradient maps. Try adding other filters and adjustments to produce all sorts of strange results.

Tip: Try equalizing your image (Filter—Adjustments—Equalize) after applying a gradient map adjustment—the colors can shift dramatically. Equalizing is a good thing to try if your gradient map makes your image look dull or dingy. You may need to merge the image's layers to get this command to work, since you can't equalize an Adjustment layer. (See page 342 for more about the Equalize command.)

POWER USERS' CLINIC

Using Gradients for Color Correction

If you just want to use Elements to enhance and correct photos, you may think that all this gradient business is a big waste of time. But gradients and gradient maps aren't just for introducing lurid colors into your photos—they're also powerful tools for correcting images.

For instance, say you have a photo where one side is darker than the other and you want to apply an Adjustment layer so it affects only the dark side of the image. You can pull this off by bringing up the Adjustment layer's layer mask (see page 211), and then applying a gradient directly to the mask. You can also use Gradient Map Adjustment layers in different blend modes to help balance out the colors in your photos, although you may need to use the Gradient Editor to play with the distribution of light and dark values to get the best effect.

Gradient maps are also useful for colorizing skin in blackand-white photos. Set up a gradient based on three or more skin tones, and you can get a more realistic distribution of color tones than you can by painting.

CHAPTER 14

Text in Elements

E lements makes it easy to add text to your images. You can quickly create all kinds of fancy text to use in greeting cards, as newsletter headlines, or as graphics for web pages.

Elements gives you lots of ways to jazz up your text: you can apply Layer styles, effects, and gradients to it, or warp it into psychedelic shapes. And the Type Mask tools let you fill individual letters with the contents of a photo. Best of all, most Type tools let you change your text with just a few clicks (see Figure 14-1). By the time you finish this chapter, you'll know all the ways that Elements can add pizzazz to your text.

Elements 10 brings three exciting new tools for making artistic text: Text on Selection, Text on Shape, and Text on Custom Path. With these tools, you can create text that swoops and turns, or make text run around the edge of an object in your photo. You can create very dramatic text effects with these tools. They're covered beginning on page 495.

Happy Figure 14-1: With Elements, vou can take basic text and turn it into the kind of snazzy headlines vou see on areeting cards and Anniversary manazine covers It took only a couple of clicks-a couple of Laver styles (Analed Spectrum and a bevel) and some warpina-to turn these plain black letters (top) into an extravaaanza (bottom). Happy Anniversary

Adding Text to an Image

It's a cinch to add text to an image in Elements. Just activate the Type tool, choose a font from the Options bar, and type away. The Type tool's icon in the Tools panel is easy to recognize: It's a capital T. (It lives just above the Crop tool or to the left of the Crop tool, depending on whether you have one or two columns of tools.) Elements actually gives you *seven* different Type tools, all of which you can see in the Type tool icon's pop-out menu: the Horizontal Type tool, the Vertical Type tool, the Horizontal Type Mask tool, the Vertical Type Mask tool, Text on Shape, and Text on Custom Path.

You'll learn about the Type Mask and "Text on…" tools later in this chapter (see page 490); this section focuses on the regular Horizontal and Vertical Type tools. As their names imply, the Horizontal Type tool lets you enter text that runs left to right, while the Vertical Type tool is for creating text that runs down the page.

When you use the Type tools, Elements automatically puts your text on its own layer, which makes it easy to throw out what you've typed and start over again. When the Type tool is active, Elements creates a new Text layer each time you click in your image.

TROUBLESHOOTING MOMENT

Why Does the Type Tool Turn My Photo Red?

If your image gets covered with an ugly reddish film every time you click it with the Type tool, that means you've activated one of the Type *Mask* tools rather than one of the regular Type tools. (Type masks, covered later in this chapter, are useful when you want to create text that's cut from an image.) To switch over to the regular Type tools, just click the Type tool icon in the Tools panel and use the pop-out menu to select either of the regular Type tools (horizontal or vertical). The red mask may also appear if you try to add type to an image that's in Indexed Color mode, like a GIF. If you want to add text to a GIF, first go to Image \rightarrow Mode \rightarrow RGB and then type away. If you still need a GIF when you're done, then use "Save for Web" (page 554) to save your finished file.

Text Options

Activate either the Horizontal or Vertical Type tool, and then take a look at the many Options bar settings (Figure 14-2) These choices let you control pretty much every aspect of your text, including its font, color, and alignment. Your choices from left to right are:

• Font Family. Choose your font here. Elements lists all the fonts installed on your computer.

Tip: The font family menu displays the word "Sample" in the actual fonts to make it easier for you to find the one you want. To see all your choices, in the Options bar, click the down arrow to the right of the font name box. You can adjust the size of these previews by going to Edit—Preferences—Type/Adobe Photoshop Elements Editor—Preferences—Type.

- Font Style. Here's where you select the styles available for your font, like bold or italic.
- **Size.** This is where you choose how big the text should be. Text is traditionally measured in *points*—that's what the "pt" here stands for. (The box on page 479 explains the relationship between points and actual size in Elements.) You can choose a preset sizes from the drop-down menu, or just type in the size you want. You aren't limited to the sizes shown in the menu—you can enter any number you want.

Tip: If points make you nervous, you can change the Type measurement unit to millimeters or pixels by going to Edit \rightarrow Preferences \rightarrow Units & Rulers/Adobe Photoshop Elements Editor \rightarrow Preferences \rightarrow Units & Rulers.

- Anti-aliasing. This setting smoothes the edges of your text. Turn it on or off by clicking the little square with the two *A*s on it. Anti-aliasing is explained on page 165, but usually you want it turned on.
- **Faux Styles**. Yup, faux as in "fake." If your chosen font doesn't have a bold, italic, underline, or strikethrough version, you can tell Elements to simulate that style by clicking the appropriate icon here. (This option isn't available for some fonts.)
- **Justification**. This drop-down menu tells Elements how to align your text, just like in a word-processing program. If you enter multiple lines of text, this is where you tell Elements whether you want it lined up left, right, or centered (for horizontal text). If you select the Vertical Type tool, you can align along the top, bottom, or middle instead.

Tip: If you're using the Vertical Type tool, each time you start a new column, Elements puts it to the left of the previous one, so your columns run from right to left. If you want vertical text columns that run left to right instead, you need to put each column on its own layer and position them manually. You can use the Move tool's Distribute option to space them evenly (page 203).

• Leading (rhymes with "bedding"). This setting controls the spacing (measured in points) between the lines of text. For horizontal text, leading is the difference between the baselines (the bottom of the letters) of each line. For vertical text, leading is the distance from the center of one column to the center of the column next to it. Figure 14-3 shows what a difference leading can make. Elements automatically sets the leading to Auto, which is the program's guess about what looks best. You can change the leading by choosing a number from the list or by entering the amount you want (in points, unless you changed the measurement unit in Elements' preferences).

- HeliskiingParasailing
- Cave Diving
- On-Site Medical Facility
- Heliskiing
- Parasailing
- Cave Diving
- On-Site Medical Facility
- Color. Click this square to bring up the Color Picker and set the color of your . text. Or, click the arrow to the right of this square to bring up Color Swatches. When you make a selection, the Foreground color square changes to reflect your choice.

Tip: When the Type tool's cursor is active in your image (so you see a blinking line showing where letters will appear if you type), you can't use the standard keyboard commands to reset your Foreground and Background colors to black and white (X) or to switch them (D). (If you try to use the shortcuts, you'll simply type those letters in your image.) Instead, you have to click the relevant buttons in the Tools panel (page 254).

Warp. The little T-above-a-curved-line icon hides a bunch of options for distorting your text in lots of interesting ways. There's more about this option on page 482. (The Warp Text command is also available from Layer→Type→Warp Text.) This button is grayed out until you actually type something.

Figure 14-3:

Leading is the space between lines of text.

Top: A list of four items with Auto leadina.

Bottom: The same list with the leading set to a higher number to make more space between the rows.

If you adjust the leading of vertical text, you change the space between the columns, rather than between letters within each column. The box on page 482 explains how to tighten up the space between letters that are stacked vertically.

- Orientation. This button, which has a T and two arrows on it, changes your text from horizontal to vertical, or vice versa. You can also change text's orientation by going to Layer→Type→Horizontal or Vertical. You can't change the orientation of text that doesn't exist yet, so this setting is grayed out until you add some.
- Style. You can add funky visual effects to text with Layer styles (page 456). First, add some text to your image, and then, in the Options bar, click the Commit button (the green checkmark). Next, click the Style box and choose a Layer style from the pop-out palette. (If you want to remove a style that you've just applied, click the double arrows in the upper-right corner of the palette and choose Remove Style from the pop-out menu, or go to Layer→Layer Style→Clear Layer Style.)

These two choices don't show up in the Options bar until you've typed something:

- **Cancel.** When you add text to your image, Elements automatically places the text on its own layer. Click this button (the red circle with a slash) to delete this newly created Text layer. This button works only if you click it *before* you click the Commit button (described next). To delete text after you've committed it, head to the Layers panel and drag the Text layer onto the trashcan icon.
- **Commit.** Click this green checkmark after you type on your image to tell Elements that yes, you want the text to stay the way it is.

If you see either of these buttons in the Options bar, that means you haven't committed your text, and many menu selections and other tools won't be available until you do. When you see these buttons, you're in what Elements calls *Edit mode*, where you can make changes to the text, but most of the rest of Elements features aren't available to you. Just click Commit or Cancel to get the rest of the program's options back.

Creating Text

Now that you're familiar with the choices in the Options bar, you're ready to start putting text in your image. You can add text to an existing image or start by creating a new file (if you want to create text to use as a graphic by itself, say). To use either the Horizontal or Vertical Type tools, just follow these steps:

1. Activate the Type tool.

Click it in the Tools panel or press T, and then select the Horizontal Type tool or the Vertical Type tool from the pop-out menu.

2. Modify any settings you want to change on the Options bar.

See the list in the previous section for a rundown of your choices. You can make changes after you enter the text, too, so your choices aren't set in stone yet. Elements lets you edit text until you simplify the Text layer. (Page 426 explains what simplifying is.)

TROUBLESHOOTING MOMENT

How Resolution Affects Font Size

It's easy enough to pick a font size in the Text tool's Options bar. But you may find that what you thought would be big, bold, headline-size text is so tiny in your image that you can hardly see it. What gives?

In Elements, the actual size of text in your image is tied to the image's resolution. So, if you thought that choosing 72-point text would give you a headline that's an inch high, it will—but only if the *resolution* of your file is 72 pixels per inch (ppi). The higher the resolution, the smaller that same text is going to be. So if the resolution is 144 ppi instead, your 72-point text will print half an inch high. In a 216 ppi image, it'll be one-third of an inch high, and so on.

If you're working with high-resolution images, you have to increase the size of your fonts to allow for the extra pixel packing that comes from increased resolution. It's not uncommon to have to choose sizes that are *much* higher than

anything listed in the Options bar's size menu. Don't be afraid of using really big sizes if you need them—just keep entering larger numbers in the Size box until the text looks right in proportion to your image.

Another confusing thing about text in Elements is that the program creates text based on the *actual* size of your image, not your view size. So if you're zoomed way in on an image and you add some text that looks like it's a reasonable size, it may be much smaller when you print the image or see it at actual size. People often try to put very small text on a very big image and wonder why it's so hard to read. If you aren't sure about the actual size of your document, try going to View→Print Size before typing. This view offers only an approximation, but it helps you get a better idea of what your text will look like.

3. Enter your text.

Click in the image where you'd like the text to go and then start typing. Elements automatically creates a new layer for the text. If you're using the Horizontal Type tool, the horizontal line you see is the baseline the letters sit on. If you're typing vertically, the vertical part of the cursor is the centerline of the characters.

Type the way you would in a word processor, pressing Enter/Return to create new lines. If you want Elements to *wrap* the text (adjust it to fit a given space), drag in your image with the Type tool to create a text box before you start typing. Otherwise, you need to insert returns manually. If you create a text box, you can resize it to adjust the text's flow by dragging the box's handles after you finish typing. (You won't be able to do this anymore after you simplify the layer.)

As noted earlier, if you want to use the Vertical Type tool, you can't make the columns of text run left to right. So if you need several vertical columns of English text, enter one column and then click the Commit button. Then start over again for the next column, so that each column is on its own layer.

Tip: Be careful about clicking when the Type tool is active—each click creates a new Text layer. That's great if you're creating lots of separate text boxes to position individually, but it's easy to create a layer without meaning to. If you accidentally make a new layer, just delete it in the Layers panel, or merge it with your existing Text layer.

4. Move the text if you don't like where it is.

Sometimes the text doesn't end up exactly where you want it. As long as you haven't committed the text yet, you can move it with the Type tool—just put the cursor below the text and drag. (You'll know when you've found the right spot because the cursor changes from the I-beam text-insertion cursor to one that looks like the Move tool's cursor.) If you have trouble moving your text, try the Move tool, but note that switching tools automatically commits your text (see step 5). So if you need to move vertical columns of text, wait until *after* you've committed the text to do that.

5. If you like what you see, click the checkmark in the Options bar to commit the text.

When you commit text, you tell Elements that you accept what you've created. The Type tool's cursor is no longer active in your photo once you commit.

If, on the other hand, you don't like what you typed, click the Cancel button in the Options bar, and the whole Text layer goes away.

Once you've entered text, you can modify it using most of Elements' editing tools. You can add Layer styles to it (page 456), move it with the Move tool, rotate it, change its color, and so on.

Note: If you try to paste text into Elements by copying it from your word processor, the results can be unpredictable. Sometimes it works fine, but you may find the text comes in as one endlessly long line of words. If that happens, it's often easier to type your text into Elements from scratch than to reformat it.

Editing Text

In Elements, you can change text after you enter it, just like in a word processor. Elements lets you change not only the letters, but the font and size, too, even if you've applied lots of Layer styles. You modify text by highlighting it and making the correction or by changing your settings in the Options bar. Figure 14-4 shows you the easy way to highlight text for editing.

Figure 14-4:

If you change your mind about what you want to say, no problem. Here, the text is highlighted so that the words can be edited. The best part is that you can change the text to say anything, and all the formatting stays exactly the same. (You can't do this after you simplify a Text layer, though.) If you find it hard to highlight text by dragging, go to the Layers panel and double-click the layer's text icon (the white rectangle with the T in it). When you do, Elements highlights all the text on that layer so you can make your changes. **Tip:** As mentioned earlier, you can see the word "Sample" in the Font Family menu (page 475) displayed in the actual fonts themselves. Even better, Elements gives you a quick way to preview what your actual text will look like in various fonts. First, highlight the text, and then click in the Options bar's Font box. Then use the up and down or left and right arrow keys to move around in the font list. Elements changes the words in your image so they appear in each font you choose as you go through the list.

You can make all these changes as long as you don't *simplify* your text. Simplifying is the process of changing text from a vector shape that's easy to edit to a rasterized graphic (see the box on page 426 for details). In this respect, text works just like the shapes you learned about in Chapter 12: Once you simplify text, Elements doesn't see it as text anymore, just as a bunch of regular pixels.

You can either simplify text yourself (by selecting Layer \rightarrow Simplify Layer), or wait for Elements to prompt you to simplify, which it'll do when you try to do things to the text like apply a filter or add an effect. It's usually best not to simplify until you must.

Tip: While the text effects that come with Elements don't simplify text, if you download effects, they may automatically simplify text without asking first. So make sure you've made all the edits you want to your text before using any effects you've downloaded.

Smoothing text: anti-aliasing

You read about anti-aliasing for graphics in Chapter 5 (page 165). Anti-aliasing has a similar effect on text: It gets rid of any jaggedness by blending the edge pixels on letters to make the outline look smooth, as shown in Figure 14-5.

Figure 14-5:

An extremely close look at two versions of the same A. The left one has antialiasing turned on, making its edges smooth (well, smoother). The edges on the right one are much more jagged and rough looking.

Elements always starts you off with anti-aliasing turned on, and 99 percent of the time you'll want to keep it on. The main reason to turn it off is to avoid *fringing*—a line of unwanted pixels that make text look like it was cut out of an image with a colored background.

Tip: If your text looks really jagged even with anti-aliasing turned on, check your resolution: Text often looks poor at low resolution settings, just as photos do. See page 114 for more about resolution.

You turn anti-aliasing on and off by clicking the Options bar's Anti-aliased button (the two *As*). The button has a dark outline when anti-aliasing is on. You can also apply this setting by going to Laver \rightarrow Type \rightarrow Anti-Alias Off or Anti-Alias On.

Note: Once you simplify text, you can't change its anti-aliasing setting.

WORKAROUND WORKSHOP

Using Asian Text Options to Control Spacing

Spacing letters correctly when you're using the Vertical Type tool can be tough. Elements lets you adjust the leading (page 476), but with vertical text, that setting affects the spacing between *columns* of letters, not between the letters within a column. Also, sometimes you may want to adjust the spacing between letters written in horizontal text. Elements lets you make either of these fixes, but you need to enlist the help of the program's Asian Text Options—even if you're writing in English.

To get started, go to Edit—Preferences—Type/Adobe Photoshop Elements Editor—Preferences—Type, turn on the Show Asian Text Options checkbox, and then click OK. Now, the next time you click in an image with the Type tool, you'll see an Asian character in the Options bar just to the right of the Text Orientation button (page 478). Click this character to see a pop-out menu with three options: *Tate-Chuu-Yoko*, *Mojikumi*, and a drop-down menu with percentages on it. You want the drop-down menu, which is for *Tsume*, a setting that reduces the amount of space around the characters you apply it to.

To apply Tsume, just highlight the characters you want to change in your image, and then select a percentage from the drop-down menu. (The higher the percentage, the tighter the spacing.) You can select a single letter or a whole word when using Tsume. Since it reduces the space all the way around each letter you apply it to, you can use it for either vertical or horizontal text, although for horizontal text, you'll probably use it to tidy up the spacing of just one or two letters. For vertical text, Tsume is a great way to tighten up the spacing of all the characters.

Warping Text

Elements lets you warp the shape of your text in all sorts of fun ways. You can make it wave like a flag, bulge out, twist like a fish, or arc up or down, among other things. These complex effects are really easy, too, and best of all, you can still edit the text once you've applied them. Figure 14-6 shows just a few examples of what you can do. If you add a Layer style (explained on page 456) too, warping is even more effective.

Note: Warping text is easy to do, but it's also a bit limited. You can control the amount of warp for the style you choose, but you can't just create a freeform style of your own. The section "Artistic Text" (page 495) has information about new Elements text tools that give you much more flexibility than warping does.

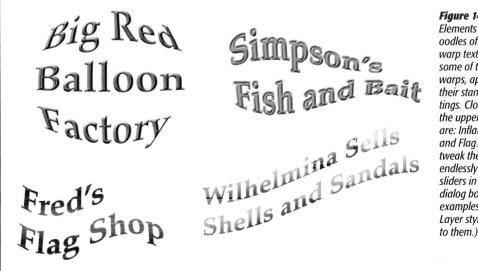

Figure 14-6:

Elements aives vou oodles of wavs to warp text. Here are some of the basic warps, applied usina their standard settinas. Clockwise from the upper left, they are: Inflate, Fish, Rise, and Flaa. You can tweak these effects endlessly using the sliders in the Warp dialoa box. (These examples also have Laver styles applied to them.)

To warp text, follow these steps:

1. Enter some text.

Use the Move tool to reposition the text, if necessary.

2. Select the text you want to warp.

Make sure the Text laver is the active laver, or you won't be able to select what you typed. Click the Text layer in the Layers panel if it's not already highlighted there.

3. Click the Options bar's Create Warped Text button.

Make sure the Type tool is active or you won't see this button (the T with a curved line under it). When you click it, the Warp Text dialog box, shown in Figure 14-7, appears.

4. Tell Elements how to warp the text.

Select a warp from the Style drop-down list. Next, make any changes you want to the sliders or the horizontal/vertical orientation of the warp (your options are described in more detail in a moment). Tweaking these settings can radically alter the warp's effect. Drag the sliders around to experiment, and watch your image to see the results.

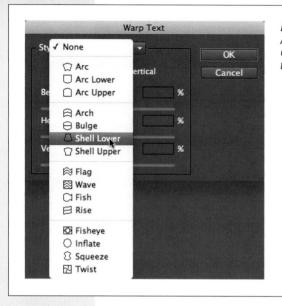

Figure 14-7:

As you can see, you have lots of ways to warp your text. Once you choose a warp style, Elements displays sliders in the dialog box that let you customize the effect.

5. When you come up with something you like, click OK.

Note: You can't warp text that has the Faux Bold style applied to it (you can warp all the other styles to your heart's content). If you forget and try to do so, Elements politely reminds you. The program even offers to remove the style and continue with your warp.

Elements gives you lots of different warp styles to choose from, and you can customize each one using the settings in the Warp Text dialog box. The settings are pretty straightforward:

- **Style.** This is where you choose from among all the warping patterns, like Arc, Flag, and so on. To help you select, Elements includes thumbnails in the list that show the general shape of each warp.
- Horizontal/Vertical. These radio buttons control the orientation of the warp. Most of the time, you'll want to leave the button the same as the text's orientation, but you can get interesting effects by warping the opposite way. A vertical warp on horizontal text gives more of a perspective effect, like the text is moving toward you or away from you. And you can get some really funky effects by putting a horizontal warp on vertical text.
- **Bend.** This is where you tell Elements how much of an arc you want, if you'd like to change it from Element's standard setting. Just type a percentage in the box or move the slider.

• **Horizontal/Vertical Distortion**. These settings control how much the text warps in the horizontal or vertical plane. They give you precise control over just how and where the text warps. They work pretty much the same way as the Bend setting: type in a negative or positive percentage or move the sliders.

The best way to find the look you want is to experiment. It's lots of fun, especially if you apply a Layer style first to give your text a 3-D look before warping it.

Tip: Many of the warps look best on two lines of text, so that the lines bend in opposite directions. However, you can also get really interesting effects by putting two lines of text on separate layers and applying different warps to each.

To edit a warp after you apply it, double-click the Text layer's Warp icon in the Layers panel (it's a T with a curved line under it). Doing that automatically makes the Text layer active and highlights the text on it. Then, in the Options bar, click the Create Warped Text button to open the Warp Text dialog box showing your current settings. Make any changes you want or set the style to None to unwarp the text.

Adding Special Effects

Besides warping text, you can apply all kinds of Layer styles, filters, and special *text effects* to it to make it look more elaborate. You can change the color of the text, make the letters look 3-D, add brushstrokes for a painted effect, and so on. (There's more about Layer styles, filters, and effects in Chapter 13.)

Elements gives you lots of different ways to add special effects to text. The following sections explain three of the most interesting: applying text effects, using a gradient to make rainbow-colored text, and using the Liquify filter to warp text in truly odd ways.

Text Effects

The Content panel (page 522) has a whole category dedicated to effects for text (Figure 14-8). You apply text effects just the way you apply any other effect: Select the Text layer in the Layers panel and then double-click the effect you want in the Content panel.

If you already have Layer styles on your text, it's hard to predict how much these effects will respect the existing Layer styles. Some effects build on the changes you've previously made with Layer styles, but most undo anything you've done before. Experimenting is the best way to find out what happens when you combine Layer styles and effects.

Figure 14-8:

The Content panel includes a whole section of text effects. Most–like Animal Fur Zebra and Denim–are unique to this section. Others, like Bevel, are just shortcuts for effects you could also achieve using Layer styles, gradients, or other Elements tools.

Text Gradients

As you learned in Chapter 13, gradients fill your text with a spectrum of color. The simplest way to get these rainbow effects is to apply one of the Layer styles or text effects that include a gradient. But those methods don't give you any control over the colors or direction of the gradient, so if you have a specific look in mind, you may have to start from scratch and do it yourself. The easiest way is to start with a type mask, as explained on page 490. But if you already have some text in your image, as long as you haven't simplified it, you can easily fill it with a gradient.

Tip: Heavier, chunkier fonts show off gradients better than thin, spidery ones. Fonts with names that end in Extended, Black, or Extra Bold are good choices, like Arial Black or Rockwell Extra Bold.

First, make sure you've got some text in your image, and then follow these steps:

1. Create a new layer for your gradient directly above the Text layer.

You're going to clip these two layers (page 206), which is why they need to be next to each other. To create the new layer, press Ctrl+Shift+N/ૠ-Shift-N or go to Layer→New→Layer. In the New Layer dialog box, turn on the "Use Previous Layer to Create Clipping Mask" checkbox.

Look at the Layers panel to be sure the new layer is the active layer and that it's right above the Text layer. If it isn't active, give it a click in the Layers panel to highlight it.

2. Activate the Gradient tool.

Click the Gradient tool in the Tools panel (or press G), and then choose a gradient style in the Options bar. (See page 460 for more about how to select, modify, and apply gradients.)

3. Drag across your new layer in the direction you want the gradient to run.

Because this layer is grouped with the Text layer, the gradient appears only in your text. If you don't like the result, press Ctrl+Z/#-Z and drag again until you like what you see.

That's all you have to do, except of course save your work if you want to keep it. You can also activate the Move tool and drag the gradient layer around till your text shows the color range you want. You won't see the gradient layer itself as you move it, but the colors of the text will change.

Note: You may have noticed that the Smart Brush tool (page 234) includes Rainbow Map as one of the adjustments you can brush onto your image. Sounds like it might be just the ticket for avoiding all this layer-creation business, doesn't it? Unfortunately, it applies a gradient *map* (see page 470), not a regular gradient, to your image. Because text is all the same tonal level, if you brush the Smart Brush's Rainbow Map onto some text, you'll just get a one-color result, not a rainbow at all.

However, there are a couple of gradients in the Content panel's text effects, so you might want to check those out before trying the steps above. If you find an effect that's exactly what you want, you'll save yourself some effort.

Applying the Liquify Filter to Text

The Options bar's Create Warped Text button (explained on page 482) gives you lots of ways to reshape your text. But there's an even more powerful way to warp text: the Liquify filter (see Figure 14-9).

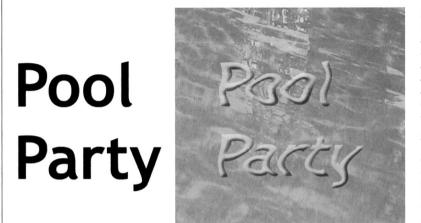

Figure 14-9:

The Liquify filter can reshape text in many different ways, including making it undulate like it's underwater (as shown here), making letters twirl around on themselves, or adding a flame-like effect.

Left: Plain black text.

Right: After adding a Wow Plastic Layer style, you can use the Liquify filter's Turbulence tool to make the letters look like they're swimming. If you like what you see in the dialog box's preview, click OK and wait a few seconds while Elements applies your transformations; you're done. If you don't like what you see, you can always have another go at it. Click the Liquify dialog box's Revert button, which returns your image to the condition it was in before you started using the filter. Another option is Alt-clicking/Option-clicking the Cancel button to turn it to a Reset button that resets the tool options *and* your image.

Type Masks: Setting an Image in Text

So far in this chapter, you've learned how to create regular text and glam it up by applying Layer styles and effects. But in Elements, you can also create text by filling letters with the contents of a photo, as shown in Figure 14-11. (You'll find *sunset.jpg*, the photo used as the basis for Figure 14-11 and Figure 14-12, on this book's Missing CD page at *www.missingmanuals.com*.)

The Type Mask tools work by making a selection in the shape of your letters. Essentially, they create a kind of stencil that you can then place on top of an image.

Once you've used these tools to create text-shaped selections, you can perform all sorts of neat tricks: emboss the text into an image (so that it looks like it's been stamped there); apply a stroke to the text's outline (useful if the font doesn't have a built-in outline option); or copy and move the text to another document entirely.

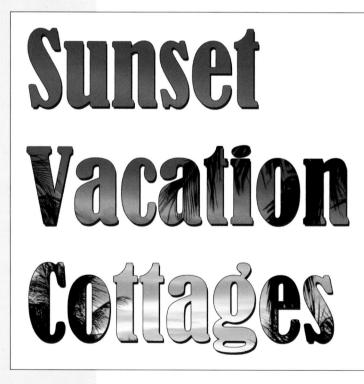

Figure 14-11:

Using the Type Mask tools, you can create text that's made from an image. These tools also let you emboss text into a photo (see Figure 14-13).

Using the Type Mask Tools

Here's how to create a type mask and lay it over an image so that the letters are filled with whatever's in the image:

- 1. Open the image that you want to use as your source for creating the text.
- 2. Activate one of the Type Mask tools.

Click the Type tool in the Tools panel or press T. Then select the Type Mask tool you want—horizontal or vertical—from the pop-out menu. The Type Mask tools behave just like the regular Type tools: A horizontal mask goes across the page, a vertical mask goes up and down. The Type Mask tools also have the same Options bar settings as the regular Type tools, except for Color and Style. It's important to choose a really blocky font for the type mask, since you can't see much of the image if you use thin text.

3. Click your image and start typing.

When you click, a red film covers the image. The red indicates the area that *won't* be part of your letters. By typing, you cut a selection through the red area (see Chapter 5 if you need a refresher on selections). In other words, instead of creating regular text, you're creating a text-shaped selection. You can see the shape of the selection as you type.

It's hard to reposition the words once you've committed them, so take a good look at what you've got. While the mask is active, you can move it by dragging it, as explained in Figure 14-12.

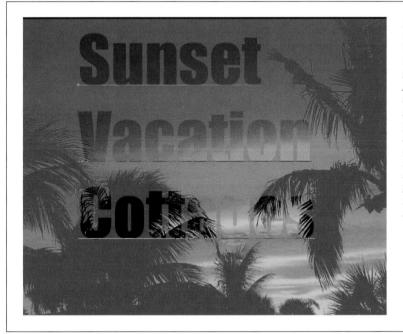

Figure 14-12:

Once you've activated the Type Mask tool and clicked in the image, you'll see this red mask appear over the picture. As you type, the text appears, as shown here. As long as you haven't committed the text yet, you can easily move it around by holding down Ctrl/ℜ and dragging it. You can also rotate the letters by grabbing a corner of the bounding box and turning it. When you commit the text, Elements turns the text into a text-shaped selection.

4. Don't click the Commit button until you're satisfied with what you have.

Once you click the Commit button (the green checkmark on the right side of the Options bar), you can't alter the text as easily as you can with the regular Type tool. That's because the regular tools create their own layers, while the Type Mask tools just create selections. Once you commit, the text is just like any other selection—Elements doesn't see it as text anymore, so you can no longer change its size by highlighting it and picking a different size in the Options bar, for example.

5. When you're happy with the selection, click the Commit button.

When you click this button, Elements turns the outline of the text into an active selection. You can move the selection's outline by nudging it with the arrow keys, and use the Transform Selection command (page 177) to scoot it around in your image or to resize, transform, or rotate it. (This can make the letters look a little strange, though, so watch the effects carefully.)

6. Remove the non-text portion of your image.

Go to Select \rightarrow Inverse and then press Backspace/Delete to remove the rest of the image if you want to create letters filled with the image. (If you don't perform this step, you'll just have a text-shaped selection to admire.) Or you can copy and paste the selection into another document.

If you want a transparent background, double-click the Background layer in the Layers panel to turn it to a regular layer before you perform this step. Otherwise, the area outside the letters will be filled with the current Background color.

Figure 14-13 shows the effect of pressing Ctrl+J/\#-J to place a type mask selection onto a duplicate layer of its own, and then adding Layer styles to the new layer.

Creating Outlined Text

If the font you're using doesn't come with a built-in outline style (if it had one, it would appear in the Font Style menu, but very few font families have such a style), Elements gives you three ways to create outlined text. The Content panel's text effects (page 522) include an outline effect that you can apply with just a double-click. If you don't like what you get with that, you can also use the Stroke Layer styles or the Type Mask tools to outline text. Both of these methods (which are explained in this section) are easy, but they require a bit more time than using the Content panel. On the plus side, you have more control over the result. Use the Layer styles method if you want the text's outline to be filled in; the type mask method gives you an empty outline.

To add an outline to text with the Stroke Layer style:

1. Open an image or create a new one, and then activate the Type tool.

Click the Type tool's icon in the Tools panel or press T until you get either the Horizontal or Vertical Type tool (not the Type *Mask* tool).

Figure 14-13:

By copying text to another laver, vou can bevel or emboss it into your photo. This image shows something vou need to watch out for-text that's kind of hard to see because it blends into the image. You may need to place vour text a few times , before vou aet it positioned so that it's leaible. or vou can add a colored outline to make it stand out more, as described in the next section.

2. Adjust the Options bar settings.

Select the font, size, style, and so on.

3. Enter some text and commit it.

After you type the text, click the green checkmark in the Options bar.

4. Apply a Stroke Layer style.

Go to the Effects panel \rightarrow Layer styles \rightarrow Strokes, and then double-click the style you want. Even if you don't like any of the Stroke styles, go ahead and pick one; you can edit the results in the next step.

5. Edit the outline if you wish.

In the Layers panel, double-click the Text layer's Layer style icon (the little *fx* to the right of the layer's name) to bring up the Style Settings dialog box, where you can change the width and color of the stroke (see page 458).

Your other option is to use the Type Mask tool to create a text outline like the one shown in Figure 14-14. Here's how:

1. Open an image or create a new one (if you just want the text by itself), and then activate the Type Mask tool of your choice.

Click the Type tool's icon in the Tools panel or press T, and then select either of the Type *Mask* tools.

2. Choose a font and size.

Use the Options bar's settings to pick a font you like, adjust its size, and so on. Outlined text works better with a fairly heavy font rather than a slender one, and bold fonts work better than regular ones.

Figure 14-14:

The Type Mask tools let you create outlined text almost as quickly as ordinary text.

3. Enter some text.

Click in the image where you want the text to go, and then type away. If you want to warp the text (page 482), do that now, before you commit it.

4. Click the Options bar's Commit button (the green checkmark).

Be sure you like what you've got before you do this, because once you commit the text, it changes into a selection that's hard to edit. If you'd rather start over, click the Cancel button (the red circle with a slash) instead.

5. Add a stroke to the text.

Be sure the text selection is active, and then go to Edit \rightarrow Stroke (Outline) Selection. Choose a line width in pixels and the color you want, and then click OK. (Page 430 has details about your other choices in the Stroke dialog box.) Your selection turns into an outline of the text you typed.

Tip: You can also create a hollow outline using the Stroke Layer styles: Type some text, and then simplify the Text layer (Layer—Simplify). Next, go to the Effects panel and choose a stroke Layer style in a contrasting color. Then select the color of the text itself (as opposed to the outline) with the Magic Wand (page 163; be sure to turn off the tool's Contiguous setting), and delete that color. The downside to this approach is that you can't edit the text once you simplify it.

Artistic Text

Since the early days of Elements, one of the biggest complaints about it has been that, for all the amazing things you can do with other parts of the program, its text-related features were pretty prosaic. You could glam up text with special effects, but it mostly ran left to right or straight up and down.

Elements 10 brings you three new tools for adding really fancy text to your images: Text on Selection, Text on Shape, and Text on a Custom Path. With these tools, you can make your text curve, swoop, and turn, or even run around a circle. They really bump things up when it comes to adding text to your images.

All the tools use a concept that, until now, only existed in full Photoshop: *paths*. A path is just what it sounds like. In the same way that your feet follow a path in the park, a path in Elements is a guideline for where text should go. The path is visible when you're creating it, adding text to it, or editing the Text layer, but it won't appear in the finished image. All folks will see is the cool ways you've made text snake around in your image.

Adding Text to a Selection

Text on Selection is the first of the new text tools. It's pretty simple to use: just select the object where you want the text and then type away. Here's how to get started:

1. Open a photo into the Editor.

This tool doesn't work well on blank or solid-colored files. If you want to use one of those, use Text on Custom Path (explained on page 500) instead. There's no need to make a separate layer for this; the tool will put the text on its own layer.

2. Select the object where you want the text.

When you first click the photo, you see a cursor that looks like the Quick Selection tool's cursor—a circle with a crosshair inside it—and it works the same way. Drag over the area you want to select, and Elements finds the object's edges for you. Keep dragging to add to the area, or Alt-drag/Option-drag to remove part of the selection.

3. Adjust the size of the selection and accept it.

You can use the Options bar's Offset slider to make the selection larger or smaller: Drag it left to reduce the size or right to increase it. When you like the selection, click the green-checkmark Commit button in your image (it may be hard to find) or press Enter/Return to accept the selection. If you want to start over, click the red Cancel button instead or press Esc.

4. Choose your Options bar settings.

Pick a font, style (regular, bold, or whatever), and size, just as you would with the regular Type tool.

5. Enter some text.

When you committed your selection in step 3, the outline changed from marching ants to a solid line. That's the path for your text, and it's only visible when this tool is active; click over to another tool and the line disappears. It's just a working guideline and it won't print, either.

When you move your cursor close to the line, it changes to the text-insertion I-beam shown in Figure 14-15 to let you know that you can start typing. You can start anywhere on the path and type as much or as little as you want. Just be careful not to overrun the starting point if you type all the way around the selection, or you may lose some of the text.

6. When you're through typing, in the Options bar, click the green Commit button.

As with the regular Type tools, you can't use Enter/Return to commit your text. If you decide you don't like the way the text looks, click Cancel instead.

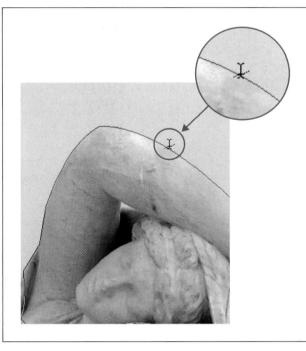

Figure 14-15:

When your cursor changes to this shape, you're ready to start typing. If you don't like where the text is going (say it's inside the selection and you want it outside, or vice versa), press and hold $Ctrl/\Re$ so that a little black arrow appears next to the cursor. Drag so that it's inside or outside the path and your text will follow it.

Tip: Watch out that you don't overrun the beginning of your typing when you're working your way around the selection. If you do that, parts of your text will disappear. You may be able to backspace your way out of it, but if that doesn't work, you'll have to start over.

That's the basic way to use Text on Selection, but there are a few tricks that make this tool much more useful than it first appears:

- Use any kind of selection. Although this tool only gives you the Quick Selection tool, you can actually create a selection with any tool, which is handy if your image doesn't give this tool much to work with. Just make your selection *before* you use Text on Selection; that way, when you activate Text on Selection, you should see the Commit and Cancel buttons in the image. (Click once inside the selection if you don't see them.) Click Commit and you've got yourself a path.
- Move the text inside or outside the path. Figure 14-15 explains how to change where the text appears.

• Move the text's starting point. If you start typing, and then wish you'd started someplace else on the path, go ahead and commit your text anyway. Then, make sure the Text layer is the active layer (click in the Layers panel if it isn't), and you should see an X at the beginning of the text's baseline. Grab that and drag it to move the text where you want it. (If you have trouble doing this, you can also click over to the Shape Selection tool [page 429] and grab with that instead.)

Tip: The X marks the start of your text, and there's a tiny, almost invisible circle that marks the end of it. If you type so much that the text circles back past your starting point, or you drag the beginning of the text so it's past the circle, some of your letters will disappear or the text will bunch up in weird places on the path. Find the circle and drag it farther away from the starting point and things should return to normal.

- **Resize the text**. If you decide later that you wish you'd made the text larger or smaller or that you'd used a different font, that's easy to fix. With any of the Text tools active, head over to the Layers panel and double-click the Text layer's icon to select all the text. Then change the font or size till you like what you see. (You can also use the Move and Transform tools on the text, but if you want to change only the letters and not the overall size of the selection itself, this is the best way to do it.)
- Transform your selection. Any time after you create the selection but before you commit the text, you can hold down Ctrl+T/#-T and you'll see Transform Selection handles appear in your image. Drag one, and the text will follow the new shape. Or, after you commit the text, you can use the Move tool to drag a handle. Both methods resize the selection as well as the letters. Just don't try to make the text a *lot* bigger this way, or it may start to look pixelated.

The one thing you can't do is adjust the spacing of individual letters, unfortunately. Despite this, Text on Selection is a great way to add text to your images in ways that are much more interesting than boring straight lines.

Tip: This tool is really fun, but it's quite crotchety and easily tired. If it begins to sulk and become unresponsive, save your selection (page 182), and then quit and restart the Editor. Sometimes that's the only thing that brings it back to its senses. If even that fails, try resetting the Editor's preferences, as described on page 617.

Making Text Outline a Shape

You can also make text in the shape of a heart or butterfly, for example. This is very popular for scrapbooking or for projects like greeting cards. It works pretty much the same way as Text on Selection, except you can start with a blank file, if you want. Figure 14-16 shows an example of what you can create.

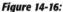

Here's a basic example of what you can do with the Text on Shape tool. With a pointy shape like this, when you reach the tricky spots, adding a few extra spaces can help keep the letters from piling up in the narrow areas of the shape.

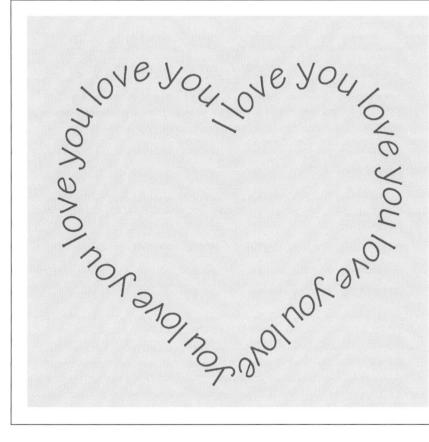

To get started, just choose Text on Shape in the Tools panel, or press T until you see its icon, which is a capital T with a star next to it. Then:

1. Choose the shape you want from the drop-down menu.

You don't get to choose from all of Elements' shapes. Your only options are rectangle, rounded rectangle, ellipse, polygon, heart, speech bubble, and butterfly.

2. Drag in the image to draw the shape.

Once you let go, the shape turns into a path, meaning it won't be visible as a shape in your finished image. It's only a guideline for entering text.

3. Make your font choices in the Options bar, click the path where you want the text to start, and then start typing.

They're the same options you have for the Text on Selection tool, described above.

4. When you're done, click the green Commit button in the Options bar.

If you decide to forget the whole thing, click Cancel instead.

Some of the shapes put the text inside their paths and some put it outside, but you can use the technique explained back in Figure 14-15 to override this and put the text wherever you want it.

You can also use any shape you want, not just the ones available in Text on Shape. Simply use the Custom Shape tool (page 428) to draw any shape you like. Next, create a new layer, get out the Magic Wand, and turn on the Sample All Layers checkbox. Then use the Wand to select the shape. Once you have a selection, switch to the Text on Selection tool and use it as explained above. You can delete the shape layer when you're done if you don't want it to appear in your completed image.

Creating Your Own Path

There's yet another way to make text loop and curve, and it's the most flexible of all: creating a custom path for the text to follow. You can draw a path that's any shape you like. Here's how:

1. Select the Text on Custom Path tool.

It's the bottom item in the Text tools group, and its icon is a T with a pencil next to it. Choose it from the pop-out menu, or keep tapping the T key till you see it.

2. Draw a path.

When you activate the tool, your cursor changes to an old-fashioned fountain pen nib. (If it doesn't, head to the left end of the Options bar and click the pencil icon.) Simply drag to draw a path for the text. You can follow the outline of an object in a photo, or just draw freehand. Like the paths you can create with the Text on Selection and Text on Shape tools, what you draw here is a non-printing guideline for entering your text. If you like the path you draw, in the Options bar, click the green Commit button and skip to step 4. If you think your work is imperfect but salvageable, continue with step 3. If you want to start your path over from scratch, in the Options bar, click the Red Cancel button.

3. Refine the path.

If you aren't thrilled with how your path looks, that's okay, because it's easy to fix. In the Options bar, click the Refine Path icon to the right of the Pencil. It looks like the Move tool icon, but it works a little differently, as explained in Figure 14-17. Once you've got the anchor points adjusted to your liking, in the Options bar, click the green Commit checkmark. If you decide it would be easier to start over, click the red Cancel button instead.

4. Add some text.

After you commit the path, the anchor points disappear and it seems like there's nothing else you can do, but if you move the cursor near the path, you see the I-shaped text-entry cursor appear. Before you start typing, go up to the Options bar and chose a font, style, size, and color. Then click where you want the text to start and type away.

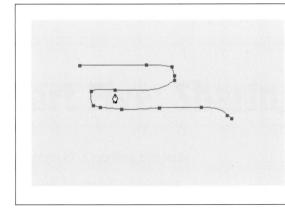

Figure 14-17:

When you activate the Refine Path option, you see these little square anchor points, which are something like the ones from the Magnetic Lasso tool (page 168). Drag a point to move it; Alt-click/Option-click a point to remove it; and Alt-Shift-click/Option-Shift-click to add a new one. By manipulating the points, you can greatly smooth out a rather bumpy line like this one.

5. Commit the text.

When you're through typing, go to the Options bar and click the green Commit button. (Click the red Cancel button to make the text go away.)

One of the really great things about Text on Custom Path is that you can go back anytime and edit any aspect of your work, as long as you don't simplify it (page 426). Just make sure the Text layer is active and then click this tool's Refine Path icon in the Options bar and you can drag the path all over the place. To edit the text, double-click the T icon in the Layers panel to select it. You can also use all the techniques for moving and resizing listed in the Text on Selection section (page 497). This is a great, useful tool for adding dramatic text effects to your images.

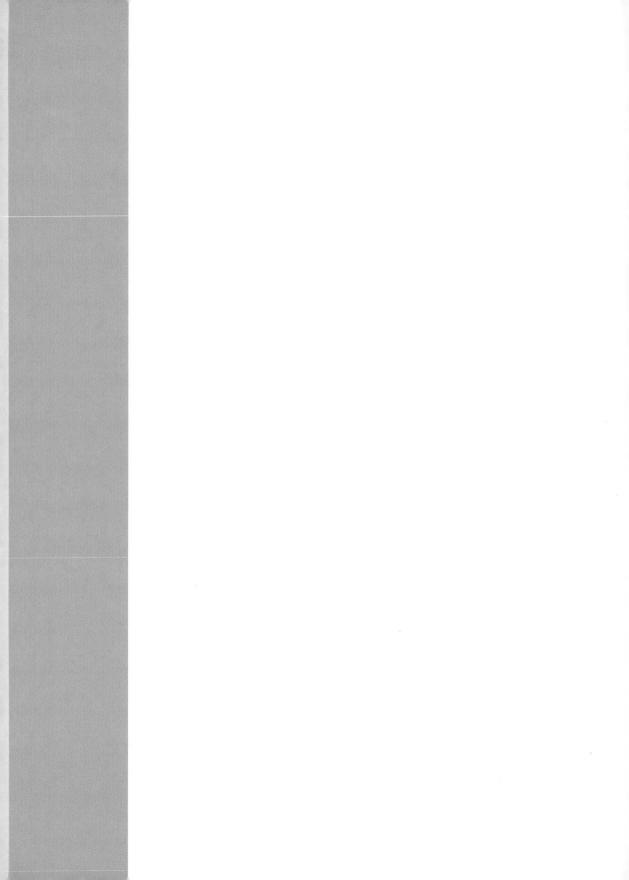

CHAPTER 15

Creating Projects

I fyou're into making scrapbooks, greeting cards, or other photo concoctions, Elements is perfect for you. You can dress up your pictures in all sorts of creative ways without any other software. Elements is crammed with add-on graphics, frames, and other special effects; it even lets you create multipage documents.

This chapter kicks off with an in-depth look at how to create a photo collage. Once you've got those steps under your belt, all the other projects (summarized starting on page 517) use the same basic method. You'll also learn how to create photo books and calendars using Kodak Gallery and Shutterfly, Adobe's online photo-printing partners.

Note: To learn how to create online albums (photo-filled web pages) and slideshows with Elements, flip to Chapter 18.

Photo Collages

The Create tab (in both the Editor and the Organizer) helps you make fancy pages featuring your photos, which you can then share as either printouts or digital files. Although Elements gives you lots of preset layouts to start from, you can customize every aspect of them to create projects that are totally your own.

Photo Collages

One type of page you can create is a *photo collage*, which displays one or more photos, with or without a themed background. (Take a look at Figure 15-1 to get a glimpse of what you can do.) All the collage styles begin with one or more suggested photo placeholders, but you can add or remove photos at will, as well as change the background, frame styles, and other details.

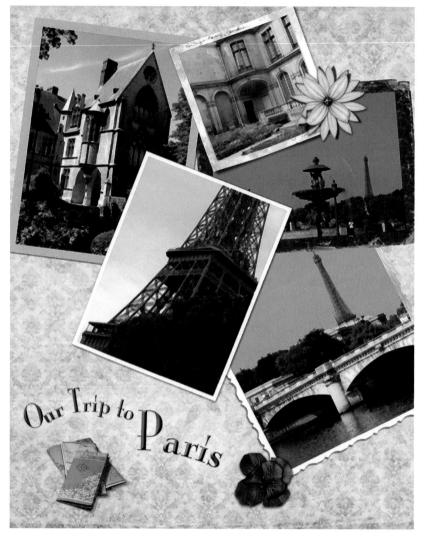

Figure 15-1:

This composition was created as a photo collage. All the artwork except for the photos came from the Content panel. The photos were added first, their layers merged together, and then several filters were applied to aive it a painted effect (see Chapter 13 for more about filters). The curvy text was created using the new Text on Custom Path tool (page 500), and layer styles applied to it. Finally, the remaining graphics (the flowers and the maps) were added to make them look like they're lying on a painted page.

To create a photo collage:

1. Open some photos in the Editor or select them in the Organizer.

This step is optional, but if you preselect photos, Elements can automatically place them into the collage for you.

2. Go to Create \rightarrow Photo Collage.

If you start from the Organizer, Elements bounces you over to the Editor to create the collage. Don't be dismayed by the relatively small size of the window that appears when you start the project. Once you make choices here and then click OK, you'll be back to working in the main Editor window.

Note: If you've edited any photos and haven't saved the changes, Elements automatically saves everything when you choose a project, whether or not the images will be included in the project. So if you've been playing around with wild effects, be sure to close those images without saving them before you start a Create project (unless you want to keep them as they are). Elements will usually warn you before it saves your changes, but it's good practice to get into the habit of doing this yourself each time.

3. Choose a page size from the list on the left side of the Photo Collage window.

If you're confused about why it says "Print locally" above the size choices, it's to indicate that this is a project designed for you to print at home. (Some of the other projects, like photo books [page 517], offer online printing, and for those projects you'll see "Kodak" or "Shutterfly" before the list of items you can order from them.)

Tip: You can't easily rotate the collage sizes to change them from portrait orientation to landscape or vice versa, so if you start a collage and don't like the orientation for the size you choose (8 $1/2 \times 11$ is always portrait, for example), you may find it simpler just to create your collage starting with a blank file in Full Edit. You can do everything there that you can here—you just don't start out with a pre-designed project, so you simply add all the items you want to include instead of modifying things that are already there.

4. Select a theme from the middle section of the window.

Themes add coordinated backgrounds and frames for your photos, and in some cases, coordinated text styles as well. Click a theme's thumbnail to select it, and the right side of the window gives you a closer look at your choice.

If you don't like any of the existing themes, it doesn't really matter, since you can change every detail once you get to the main Create window. So just pick the theme you dislike the least.

Note: You may not see any choices other than the cluttered Basic one when you start your first collage.

5. Tell Elements whether to automatically place your images in the collage.

If you leave the "Autofill with Selected Images" checkbox at the bottom of the window turned on, the pictures you chose in the Organizer or Project bin automatically appear in the collage when Elements creates it. (If you don't preselect any photos, the currently active photo in the Editor gets added, if you have any photos open there.) If you want to determine which photos go into which slots yourself, turn off this checkbox.

Note: Unlike some earlier versions of Elements, the Create projects in Elements 10 start with a fixed number of pages. If you've selected more photos than will fit in your current layout choice, Elements just doesn't place them, rather than automatically increasing the page count to accommodate the extra photos the way, say, Elements 8 did. In Elements 10, a collage can only be one page long. So if you want more pages, create a separate file for each one.

6. When you've made your choices, click OK.

Elements sends you back to the main Create window and gets to work creating the collage. When it's done thinking, it displays the collage in the editing area.

If you preselected photos and left the Autofill checkbox turned on, Elements puts the photos into frames for you. (It puts each image in the collage on its own layer.) If you didn't select any photos (or if you didn't select enough to fill all the slots), you see "Click here to add photo or Drag photo here" inside each empty frame. That's fine, because you can add photos in step 8.

At this point, you're working in what Adobe calls Basic mode, explained in Figure 15-2.

7. Choose a layout.

After Elements creates the collage, the Create panel displays new options. At the top left of the panel you see the word "Pages." A collage only has one page, so when you click this word, your page's thumbnail is displayed in its lonely glory. (For projects like photo books that have multiple pages, this is where you'd navigate among thumbnails of the project's different pages.)

Tip: If you want to make a multipage collage, save your file as a layered Tiff or .PSD file. Then you can add pages to it in Full Edit using the method described on page 515.

If you like the preview that Elements shows you, there's no need to change anything. But if you click the word "Layouts" in the Create panel, you see a bunch of alternative designs, grouped by the number of photos per page. To audition a different layout, either double-click its thumbnail or drag it onto the collage in the preview area. If you don't like it, undo it (Ctrl+ Z/\Re -Z) and try another one.

Figure 15-2: When you first return to the main Create workspace after choosina a project. Elements puts vou in Basic mode. That means that everything listed in the Artwork panel is intended to harmonize with your chosen theme. You can add araphics and text here, but if you want access to all of Elements' araphics. vou'll need to click the button circled here to switch to Advanced mode

Tip: If you only plan to use a couple of photos, one fast way to get rid of the extra photo slots in the Basic layout is to head to the Create panel and scroll down the Layouts section till you see a layout with only one or two photos. Double-click the layout you want and the extra frames go away.

8. Adjust the photos.

If you haven't already picked photos for this project, drag a photo from the Project bin into a frame, or click an empty frame in the collage and then choose a photo from the dialog box that appears.

Regardless of how you get photos into the collage, you can make a number of adjustments to them once they're there. The next section explains everything you can do with photos in a Create project.

You can change a frame's style by choosing a new one from the Create panel's Artwork section (page 522). To change to the new frame, double-click the new style, or drag it onto the photo. The following section describes all the ways you can tweak photos and frames.

9. Customize the collage.

This is the fun part. Click a photo in your collage, and drag it into a different position. Or drag art over from the Artwork section (these graphics are vector images [page 426], so they'll look great no matter how big or small you make them). You can also add text to the collage (you'll learn how on page 512), or click the word "Artwork" in the Create panel to add graphics or change the background; just drag what you want into the preview area.

If you switch to Advanced mode (page 514), you can even flatten your image and use filters on the entire page. Figure 15-1 shows an example of what you can create with a photo collage.

10. Finish up your collage.

When you're done, you have a couple of choices of what to do next.

Click Done and Elements asks if you want to save your changes. Click Yes/Save to bring up the Save As window so you can name the project and save it. You can save it in any standard file format if it's a one-page collage, but for projects with more than one page (like calendars), you have to save it as a PSE file—which is a special format just for multipage Elements documents (see the box on page 517 for details)—or as a PDF file. (If you decide you want to get rid of your collage, click No/Don't Save instead.)

You can also print your collage right from Create. Just click Print to bring up the Editor's print window, described on page 530.

Note: Once you save a Create project, what happens the next time you open the file varies depending on what type of project it is. If you save and close a collage, for instances, the next time you open it, it will open in Full Edit rather than Create. That's okay, because you can do anything you want to the collage in the Editor. This is also true for the other projects, like CD and DVD labels, that you can only print at home. On the other hand, projects you can order online, like photo books and greeting cards, always open back up in Create.

Customizing Your Project

There's almost no limit to what you can do in a photo collage. Anything you've read in the other chapters of this book works here, too. Plus you can do a few special things with photos in a collage. This section explains your options.

Adjusting photos and frames

Elements gives you a ton of ways to tweak the photos in a collage:

• Rotate a photo in its frame. Right-click/Control-click a photo and choose Rotate 90 Right or Rotate 90 Left to turn your photo 90° clockwise or counterclockwise. • Adjust the way a photo appears in its frame. Right-click/Control-click a photo and choose "Position Photo in Frame" (or just double-click it) to bring up the controls explained in Figure 15-3.

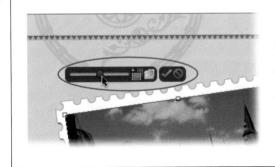

Figure 15-3:

When you double-click a photo in a Create project, you get these controls for adjusting it. You can resize the picture with the slider, rotate the photo by clicking the blue rectangles (next to the slider), or search for a new photo by clicking the folder icon. You can also drag a handle of the photo's bounding box to resize the photo or rotate it, just the way you'd use the Move tool. When it looks good, click the green checkmark to accept your changes.

- **Remove a photo from the collage**. Right-click/Control-click the photo and then choose Clear Photo. To remove the photo's placeholder and frame as well, just click the photo to select it and then press Backspace/Delete.
- **Remove a frame from a photo.** Right-click/Control-click and then choose Clear Frame.
- **Resize a frame.** You can resize a frame eitherbefore or after you put a photo into it. Click the frame once to bring up resizing handles, and then drag a corner handle to make the frame larger or smaller. You can also rotate a framed photo using these handles.
- **Resize a frame to fit a photo**. If you want to make a frame fit a photo, instead of the other way around, right-click/Control-click the photo and then choose "Fit Frame to Photo."
- Add another photo. Just drag a frame from the Create panel's Artwork section to a blank area of the collage, and then click within the frame to add a photo. (If you get too close to an existing frame, the new frame may replace the existing one. If that happens, just press Ctrl+Z/%-Z to undo it and then drag again, more carefully, to the blank spot.) You can also drag a photo into the collage from the Project bin.
- Edit a frame's Layer style. Most of the Create panel's frames have a Layer style applied to them. Right-click/Control-click a frame in your collage and choose Edit Layer Style to change things like the size of the frame's drop shadow. You can also edit the styles from the Layers panel in Advanced Mode the same way you'd edit any Layer style (see page 456).
- Add a filter to a photo. If you click over to Advanced mode (see page 514), you get access to all the Effects panel's filters (page 435) so you can quickly create a brushed look or rubber-stamp effect, for example. However, you have to simplify the photo's layer before you can use filters on it (page 426 explains simplifying).

Adding graphics and text

It's really easy to add all sorts of embellishments to a collage. Click the word "Artwork" at the top of the Create panel to see a long list of stuff designed to harmonize with your current theme. The list is divided into three categories:

• **Backgrounds.** If you don't like the look of the page's background, just drag in a new one. Drop it anywhere in the preview area and Elements replaces the existing background with it, or just double-click the one you want. (Backgrounds are Smart Objects, which are explained in the box on page 514.)

Note: If you're in Basic mode, you may not see some of the options described here. To see all the artwork the Create panel has to offer, switch to Advanced mode. (Both modes are described in the next section.) Also, remember that once you save and close a collage, you won't be in Create the next time you open it (you'll be in Full Edit instead), but you can still add all these items from the Content panel there.

- Frames. Elements includes some very fancy frames. Some of them tint your photo; you can tell which ones will do this by looking at the part of a frame's thumbnail where the picture will go—if it's colored red or blue, for example, the photo will get tinted that color. Others cut your photo into various shapes. There are all kinds of interesting ways to frame your photos here, so try a few to see which ones you like. Just drop one onto a photo to use it.
- **Graphics.** You can add all sorts of clip art to your Create projects. The great thing about these graphics is that they're vector objects (page 426), which means you can resize them as much as you want without having them go all pixely, as long as you don't simplify them (page 426). The thumbnails may look a little funny and so may the graphics after you drag their handles to make them bigger, but once you press Enter/Return, they should settle down into perfect detail.

Tip: If you don't like scrolling through all the Create tab's artwork, use the flippy triangle to the left of a category's name to collapse that section and bring the next one up into view.

The text feature is one of the niftiest parts of the Create panel. Click the word "Text" at the top of the panel to see the handy text tool shown in Figure 15-4, which explains how to use it. Once you create a text block but before you start typing, you can choose a font, size, color, and style (bold, italic, underlined, and so on) for the text. Use the Style drop-down menu to choose real styles like bold or italic, or the buttons beneath it for faux styles (page 476). You can even apply warping to your text, but the Warp Text button is grayed out until you enter some text. (Chapter 14 explains all the things you can do with text in Elements.) If you want to change anything about the text after you enter it, just highlight it and make your changes in the Text tab.

Figure 15-4:

To add text to a project, first adjust the settings for the font, size, and so on (see Chapter 14 to learn about these settings), and then either click the words "Add Text Block" or just click where you want the text to go and start typing. If the project has placeholder text (explained in the Note below), just drag over it and then type the words you want to use.

Note: Some of the Create templates include placeholder text so you can see where your message will go. A lot of these placeholders are what looks like a foreign language, beginning with the words, "Lorem Ip-sum." This is actually a kind of nonsense Latin used for centuries in layouts so that people could evaluate a design without being distracted by what the words said. So don't worry—Elements won't translate your text into Italian or Spanish. Just drag over the placeholder text to highlight it and then type what you want.

Beneath the Settings section of the Create panel's Text tab is a large section confusingly labeled Styles. This section gives you lots of other ways to customize text, using the same Text Effects you read about in Chapter 14. After you've typed what you want, highlight it and then drag a style onto it or double-click a style to apply it. If you click the Move tool in the little toolbox to the left of the preview area, you can rotate the text to any angle you like.

If you switch to Advanced mode (which you'll read about in a sec), you can use Elements' regular Type tools, described in Chapter 14, and all of the fonts on your computer. When you're in Advanced mode, the Create window's Text section gets replaced by the Effects section (which gives you access to the Effects panel's filters and Layer styles.)

Create modes: Basic and Advanced

When you first start working on a Create project in the main Elements window, you're automatically in Basic mode. That means the Create panel only shows you options (like artwork and text) that Adobe thinks would work well in your particular project. And the only tools available to you on the left side of the screen are the Move, Zoom, and Hand tools.

You can put together a pretty impressive project working in Basic mode, but Adobe knows that you may want to do a lot more with your project, so they created Advanced mode. To use this mode, click the "Switch to Advanced Mode" button below the left side of the preview area. When you do, you get a whole different set of options. The regular Elements toolbox appears on the left side of the screen, along with the Layers panel on the right side. And when you click the word "Artwork" in the Create panel, you see *all* of Elements' content for your chosen category, not just its suggested choices.)

You can toggle back and forth between the two modes as much as you like. Simply click the button below the main preview area to change modes.

Note: When you switch to Advanced mode, the word "Text" at the top of the Create panel changes to read "Effects." That's because you can use Elements' regular Type tools (page 474) in Advanced mode, so Elements replaces the limited text options you get in Basic mode with the contents of the Effects panel.

POWER USERS' CLINIC

Smart Objects

Smart Objects are one of the ways Adobe makes Elements projects so fun and easy. Like their big-shot cousins in the full version of Photoshop, these objects seem to know where they are and what you're trying to do—and behave accordingly. Here are some examples of Smart Objects and what makes them so smart:

- When you apply a new background from the Artwork section of the Create panel or from the Content panel, it automatically zooms down to the bottom of the layer stack to replace the existing background.
- The Content panel's frames automatically target your photos. Want to frame an image? Just go to the Content panel and double-click a frame. It automatically appears in your image, though you may need to adjust its size or the area that it frames once it's in your photo.
- You can resize, transform, and distort objects from the Content panel's Graphics section as much as you want without affecting their quality. This behavior is something like how vector art works, but what's going on under the hood is quite different. (The preview may appear pixelated, but the actual object should be okay once you click the green checkmark Commit button.)

Anything you put into an Elements file in Full Edit by choosing File—Place becomes a Smart Object, so you can do things like resize it to any size. Also, anything you drag into one of the Create projects (photos, graphics, whatever) becomes a Smart Object. However, there are a few things you can do to Smart Objects only if you simplify them (page 426). For example, if you try to paint on a Smart Object, you just get the dialog box shown in Figure 15-5.

Figure 15-5:

You can enlarge, shrink, transform, and distort Smart Objects no problem, but if you try to paint on them or apply filters or effects to them, you get this message. It's fine to click OK, but once you do, your formerly smart object will behave like any other object. You won't be able to enlarge it to more than 100 percent, for instance, or it'll go all pixely on you.

Creating Multipage Documents in the Editor

Photo books are the only Create projects where you can add additional pages (see page 507), but you can always add pages to files in the Editor. You'd want to do that if you decide you need to create a scrapbook file, for instance, in a size that's not available in Create, or if you want to make something like a Create photo collage, but with more than one page. Since you have access to all the Create artwork in Full Edit via the Content panel (page 522), there's no reason not to build your own project from scratch in the Editor if you prefer.

Tip: While you're limited as to the formats you can use for saving a Create project, you can export a Create project as a PDF or as a series of individual JPEG or TIFF files (one per page). Just go to File → Export <type of project>, and then choose a format and where you want to save it.

In the Editor, the size and resolution of your existing page determines the size and resolution of pages you add. In other words, if your current file is a single 3"×5" photo and you add a page to it, you get a new 3"×5" page. If you want to add a letter-size page to a small photo file, you first have to add canvas to the photo (page 122) or resize it—but check out page 121 to learn why resizing a small photo to letter size probably won't work well.

To add a new page to a document in the Editor, go to the Edit menu and choose one of the following commands:

- Add Blank Page (Alt+Ctrl+G/Option-\mathcal{B}-G). This command creates a new, totally empty page with the same dimensions and resolution as your existing page.
- Add Page Using Current Layout (Alt+Shift+Ctrl+G/Option-Shift+#-G). This command tells Elements to create a page that's exactly like the current state of your existing page (including any changes you've made), except that instead of photos, there are placeholders for you to fill in. So, for example, if you've added frames from the Content panel and dragged a photo to another position in your file, the new frame and positioning appear in your new page, just without the photo. Any graphics you've added from the Content panel show up as well. This command is a big help when you're making your own projects in the Editor rather than using Create mode.

If you decide you've got too many pages, go to Edit→Delete Current Page, and the currently active page is history.

You can navigate through all the pages in a project using the Project bin, as shown in Figure 15-6. You can also add and delete pages directly from the Project bin by right-clicking and choosing what you want to do from the pop-out menu—a big help when you're editing a multipage project. (If you have a Create project with more than one page, you can't expand it in the Project bin. Instead you need to open it when you do, Elements automatically takes you to Create—and use the Pages tab to navigate through your project.)

Figure 15-6: Multipage files display a distinctive icon in the Project bin so you can easily recognize them.

Top: Here's a file which had pages added in Full Edit (left) and a photo book Create project (right). (These are Mac files; their Windows equivalents have icons that look more like a stack of pages, but they work the same way.)

Bottom: You can expand and contract the Full Edit file by clicking the arrow (circled), but Create projects won't expand in the Project bin. Instead, you enter Create to choose a page to work on.

No matter what kind of file you start with—whether it's a Create project or just a regular JPEG—you have to save it in PSE or PDF format if you add pages to it. Elements reminds you of this by displaying the dialog box in Figure 15-7 when you add a second page to a project. While it's really nice to be able to create multipage documents in Elements, the PSE format has some drawbacks, as explained in the box on page 517. Elements is smart enough to tell the difference between a PSE file created in the Full Edit and one created in Create, so your Editor-created PSE file will always open in the Editor while your PSE Create project file will always open in Create mode.

0	Adding a page requires that you save this file as a Photo Creation Project (PSE). This will create a project folder which includes the .PSD files for each page, and a .PSE project file.
	ОК
Don'	t show again

Figure 15-7:

You can't save a document with multiple pages in common file formats like TIFF or PSD. Your only option is PSE, as this dialog box reminds you whenever you add a second page to a document. (The box below explains why PSE format is a mixed blessing.) But actually, this dialog box's message isn't totally true—you can also save your project as a PDF file, but your options for editing a PDF are limited, so save it for last, after you're done making any changes.)

TROUBLESHOOTING MOMENT

About PSE Files

Any time you create a multipage document in Elements, you get only one editable file format choice when it's time to save: PSE. This special format has both advantages and disadvantages.

When you create a PSE file, you actually create a *folder* containing a separate .psd file for each page (or for each double-page spread if you're creating a photo book), and a PSE *project file* that contains all the info Elements needs to reassemble the document the next time you open it. That's handy when you're working in Elements, but the drawback is that hardly any other program can read these files. However, PSE files work just fine if you print at home or use Kodak Gallery for online printing; you can send them to Kodak Gallery as easily as you send JPEGs.

The rub comes when you want to use a different printing service. If you make, say, a book that you want to print at Lulu.com or MyPublisher.com, they don't accept PSE files at least not as of this writing. Most printing services require PDF files instead. Fortunately, Elements can save your multipage PSE file as a multipage PDF that you can upload to your printing service of choice. (Be aware, though, that Elements creates *huge* PDF files.) Usually, you'll want to wait till you're through editing your project to create a PDF. So keep the file in PSE format as long as you still have work to do.

Photo Books

Elements lets you create several sizes of pages to use in bound books of photos, which are a popular gift item. To get started, go to Create—Photo Book, and you'll see several different sizes to choose from. When you click a size on the left side of the Photo Book window, the right side changes to show details about it, as you can see in Figure 15-8. Most photo books are meant to be ordered online, but there's an $8.5"\times11"$ size (well, technically $11"\times8.5"$) that you can print at home. And in fact, you can actually print *any* Create project on your home printer, if you like.

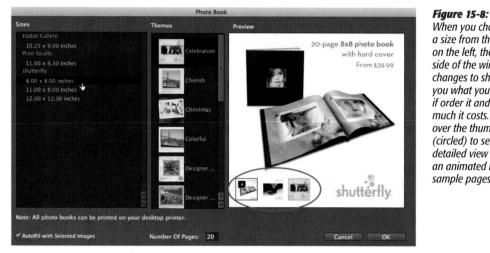

When vou choose a size from the list on the left, the right side of the window changes to show you what you'll get if order it and how much it costs. Hover over the thumbnails (circled) to see a detailed view or aet an animated look at sample pages.

At the bottom center of the Photo Book window (Figure 15-8) is a box where you can enter the number of pages you want, if you know how long you want the book to be. However, the photo books from Shutterfly and Kodak automatically start out with 20 pages, since that's the minimum number you need to order from them (Kodak's maximum is 80 pages, and Shutterfly's is 100 pages plus the title page), so you can't delete pages to bring the total below 20. If you want to make a 4- or 10-page book, then choose the $11" \times 8.5"$ "print locally" option.

Note: The minimum number of pages required for the online books is subject to change, so don't be surprised if one day you see a different number in that window. It just means the online services were updated to reflect a new minimum.

Creating a photo book is almost exactly like creating a collage (page 505). The only difference is that you have lots of pages to navigate through in the Content panel's Pages tab. Just click a different two-page layout to work on those pages. (Elements shows you the double-page spreads you'll see when the book is open.) You can also use the controls below the preview area (shown in Figure 15-9) to step through pages or type in the number of the page you want to view. The Show Safe Zone checkbox displays aqua-colored guides that indicate the printable boundaries of the page. If they bother you, turn them off while you're working, but you should turn them on at least once for each page to check that everything you've added will fit before you send the book off for printing.

Note: Photo books usually have a cutout front cover, so the first page is the Title page (which Elements calls page number T).

Figure 15-9: When you click Create, Elements aives vou a helpful double-page view of your book so you can edit the pictures or change the layout. The control strip below the book lets vou move through the pages to see each double-page spread and turn auides on or off. Here you also see the controls for adiusting the left photo and frame so they match up better.

To add pages to a photo book, in the Pages tab, click the thumbnail of the doublepage spread you want to duplicate and then click the green + sign at the top of the Content panel. To remove a double-page spread (you can't remove just one page), click its thumbnail and then click the red – button. (Keep in mind that Elements won't let you go below the minimum number of pages for the Kodak or Shutterfly books.) And now in Elements 10, you can change the order of pages in a photo book by dragging them in the Pages tab.

Tip: If you decide that a photo needs a little touching up to look right in your magnum opus, just rightclick/Control-click it and choose Edit Quick to go to Quick Fix (Chapter 4 explains all the things you can do there to spiff up your photos). When you enter Quick Fix from Create, you see a button at the top that says "Back to Creation;" click it to return to your collage. This is available for any multipage creation, including greeting cards and calendars, but not for single page projects like collages or CD/DVD inserts.

When you finish creating the book, you can click Done or Print as with a collage, and there's also an Order button that zips you over to Shutterfly or Kodak (depending on whose template you're using) so you can order the book from them. If you want to order a book from another company, click Done and then save the file in PDF format, which is accepted almost everywhere.

Tip: You can also create a book of photos without using Elements' Photo Book feature at all. Just connect to the Kodak Gallery or Shutterfly website, upload your photos (as explained on page 526), and then have the company print them in its own style of photo book. (You don't get any page decorations or layout choices when you use the Kodak wizard, though.)

Greeting Cards

For greeting cards, Elements lets you choose from several different layouts: some single-page options, and several folded styles. And although they're all templates for cards from either Shutterfly or Kodak, you can also print them at home. The process for creating a card is the same as for a collage (page 505) or photo book. If you save your card to print it or work on it later, you have to save it as a PSE or PDF file, even if it's only a single page.

Photo Calendars

You can make very nice wall calendars in Create. You start by picking a month and year for the calendar's starting point, and then choose whether to print it at home or have Kodak do that for you. Then you choose a theme for it. As with the other Create projects, the Photo Calendar window shows Kodak's starting price (if you click the small thumbnail at the lower left of the Preview pane) and you get a nice animated view of the style you choose.

After you click OK, you can customize each month in all the usual ways (add or remove photos, change the background, add artwork, and so on). There's also a special way to customize specific dates, as Figure 15-10 explains.

Figure 15-10:

You can add a photo to any date on the calendar. Just draa it in from the Project bin and Elements resizes it to fit the slot for that date. You can also jump over to Advanced mode and reduce the photo layer's opacity, as you see here, so that vou can see what vou write on that date sauare. If vou like. vou can also add text blocks to mark your red-letter days, exactly the same ways you add text to any Create project (page 512).

Tip: Elements' calendars are designed to use a different photo or group of photos for each month, but if you want to see the same photo of your honey every month, you can do that, too. Just keep dragging it into the layout for each month where you want it to appear.

CD/DVD Jackets

Elements lets you create CD jewel case inserts and DVD inserts, which appear on the front and back of the case. To make a CD insert in either the Editor or the Organizer, just go to Create \rightarrow More Options \rightarrow CD Jacket. You get a variety of different templates, all the right size to fit in a CD case.

The steps for creating a CD jacket are the same as for a photo collage (page 505), but the layout choices are, of course, different. Pay special attention to photo placement when choosing a layout; remember that the right side of the layout is the front cover. Turn the "Autofill with Selected Images" checkbox off or on to suit you.

Unfortunately, only the "2 Centered" layout even approximately marks out the general spine area, where most CDs display their titles. If you decide to enter text that you want to appear on the spine, add a text block as described on page 512, and then either rotate the completed text into position with the Move tool, or switch to Advanced mode (page 514) and use the Rotate commands (page 94).

The DVD Jacket wizard (Create \rightarrow More Options \rightarrow DVD Jacket) is identical except for the layout choices.

CD/DVD Labels

You can create stick-on labels for CDs and DVDs with Elements and print them on blank label sheets from any office supply store. To get started, go to Create \rightarrow More Options \rightarrow CD/DVD Label. Elements gives you templates that create a single label. When you're done, you need to place your work into the template that goes with your specific brand of labels. (Most CD or DVD labels print two to a page.) The major brands, like Avery (*www.avery.com*) and Neato (*www.neato.com*), have free downloadable templates on their websites to help you position the labels properly on the page.

Tip: While labels make your discs look great, it's risky to put a stick-on label on any disc you'll use in a computer because, if the label gets stuck in the disk drive, you may have to replace the drive. Consider using a marker to label discs instead, or buying printable discs if your printer can print on them.

Photo Stamps

If you're in the U. S., you can order photo stamps—real, legitimate postage that features the photo of your choice. If you've always wanted to be immortalized on a stamp, here's your chance. You create stamps from the Organizer, so select one or more photos there, and then go to Create→PhotoStamps. (You can technically start from the Editor, but Elements will send you over to the Organizer to begin your order.) Elements automatically uploads your photos to Stamps.com, where you can create an account and then order away.

Note: Before you spend a lot of time preparing photos for stamps, check the price list at Stamps.com (go to *http://tinyurl.com/3j4hdg3* to hop straight to that list) to see whether you think the stamps will be worth the cost. They're a bit more expensive than regular postage stamps, but they're very popular for special occasions, like sending wedding announcements. (FYI, image files you use on stamps have to be less than 5 megabytes in size.)

Working with the Content and Favorites Panels

If you like all the graphics, frames, and other artistic goodies you can use in Create, you'll be happy to know you have access to all that stuff for *any* image, not just ones in Create projects. It all lives in the Content panel, which you can call up anytime in Full Edit. You also get a Favorites panel, where you can keep the Content- and Effects-panel items you use most often. This section gives you a guided tour of both these panels.

The Content Panel

At first glance, the Content panel may seem a little confusing, but it works something like the Effects panel, with menus and a row of little icons for each of its major categories (see Figure 15-11). Here's how it to use it to glam up your images:

1. In Full Edit, make sure the panel is visible.

If it's not already in the Panel bin, go to Window \rightarrow Content.

2. Choose how you want to search for fun additions to your image.

At the top of the panel are two drop-down menus. In the left-hand menu, choose what you want to search by (like activity, word, or mood), or choose Show All to see everything in the panel.

3. Refine your search.

In the right-hand drop-down menu, choose what you specifically want. What's in this menu changes depending on what you selected in the left-hand menu. So if you choose By Type on the left, you see Backgrounds, Frames, Graphics, and so on in this menu. If you choose By Mood on the left instead, the righthand menu offers you choices like Active, Adventurous, Fun, Romantic, and Thoughtful.

Figure 15-11:

Once you've winnowed down your choices by selecting from the panel's two drop-down menus, use the category buttons (labeled) to further control which thumbnails appear in the Content panel.

Elements starts you off by including all the categories (a gray outline around a button means it's active and that its category is included in your search). Click any of the buttons to turn them off and exclude that category from your search.

Here you see the results of searching By $Event \rightarrow Celebration$. And since the Graphics button is turned off, no graphics appear in the thumbnail area.

4. If you like, filter your results.

You may get an awful lot of results from some of your menu choices, so you can use the category buttons below the menus (they're labeled in Figure 15-11) to filter out items you don't want. From left to right the buttons are Backgrounds, Frames, Graphics, Shapes, and Text Effects. So if you chose By Seasons and Winter in the menus, respectively, but don't want to see frames, just turn off the Frames button (click it to get rid of the dark highlight around it), and Elements shows you everything except frames. To bring something you've excluded back into your search results, simply click its button again to turn it back on. You can turn as many buttons as you want on or off to include or exclude various kinds of content.

Note: If you're like a lot of people, most of the time you'll want to stick with By Type in the left-hand drop-down menu and choose the category you want from the right-hand menu. If you do that, Elements grays out the category buttons, since you've already selected a category from the menu.

5. Add your choice to your image.

To use anything in the Content panel, double-click its thumbnail or drag it onto your image. You can also click your selection once and then click the panel's Apply button. Every item you add comes in on its own layer.

To remove what you've added, press Ctrl+Z/#-Z if you just added it, or click the object with the Move tool and then press Backspace/Delete. If you use the Backspace/Delete key, Elements asks if you want to "Delete the Layer"—you do, so click OK. (Chapter 6 is all about layers.)

Warning: Don't use the Content panel's trashcan icon to delete an object from your project. That seems like a logical thing to do–after all, that's how it works in the Layers panel. But with the Content panel, the trashcan deletes the graphic, frame, or whatever from the *panel*, not just from your image. So only use the trashcan for Content panel items you never want to use again. For example, if you've downloaded and installed a frame (see this book's Missing CD page) and know you won't use it again, then it's time to use the trashcan.

If that seems like a lot of navigation, check out the Favorites panel (described next) for a faster way to reach Content panel items you use a lot.

Tip: One advantage of signing up for a Photoshop.com account (page 21) is that, when you do, the Content panel displays some extra items you can download. Free downloads display a blue banner across the corner of their panel thumbnails, while items only available for those with paid accounts display a gold banner.

The Favorites Panel

If you use the same effects, graphics, and styles over and over, you may find it tedious to keep navigating to them in the Content or Effects panels. Simplify things by saving your Content and Effects standbys in the Favorites panel. That way, you can get to them with just a click or two. To see the Favorites panel, go to Window→Favorites.

To add an item to this panel, right-click/Control-click its thumbnail in the Content or Effects panel, and then choose "Add to Favorites," or just drag its thumbnail to the Favorites panel. To delete a favorite, right-click/Control-click its thumbnail and then choose "Remove from Favorites," or click it once to highlight it, and then click the trashcan icon at the bottom of the panel. (Unlike with the Content panel, trashing something here just removes it from the Favorites panel, not from Elements altogether.) If you forget what a thumbnail is for, right-click it and choose Details to see a description of it.

Tip: While you can't bring up the Content panel in Create (only the appropriate items from it), when you're in Advanced mode (page 514), you can go to Window—Favorites to make the Favorites panel appear as a floating panel. This is an easy way to bring your favorite graphics into Create projects without a lot of hunting around. (You need to add favorites in Full Edit. Once you're in Create, you can see the panel and add content *from* it, but you can't add anything *to* it there.)

CHAPTER 16

Printing Photos

Now that you've gone to so much trouble to make your photos look terrific, you no doubt want to share your masterpieces with other people. This chapter and the next two look at the many different options Elements gives you for sharing photos with the world at large.

This chapter covers the traditional method: printing photos. You can print them at home on an inkjet printer, take them to a kiosk at a local store, or order prints online. Elements makes it especially simple to use Shutterfly and Kodak Gallery, Adobe's online printing partners. You also get an easy connection to several other popular online photo services (page 594). The best thing about ordering prints online is that you're not limited to just ordinary prints: You can create hardcover books, calendars, embarrassing t-shirts—you name it.

Note: If you create online albums at Photoshop.com (page 572), you can let friends order prints directly from your personal Photoshop.com web page. (Those prints come from Shutterfly.)

It's worth noting that while the basics of printing are the same whether you're using a Windows computer or a Mac, some things are a bit different between the two platforms. As you go through this chapter, you'll see the differences noted as they come up.

Getting Ready to Print

Whether you're printing at home or sending photos to a printing service, you need to make sure your image files are set up to give you good-looking prints.

The first thing to check is the photo's resolution, which controls the number of pixels per inch (ppi) in the image. If the photo doesn't have enough pixels, then the print will look grainy and pixelated. Most photo aficionados consider 300 ppi ideal; a quality print needs a resolution of at least 150 ppi to avoid the grainy look you see in low-resolution photos. See page 114 to learn how to check and—if necessary—tweak a photo's resolution.

Tip: Be sure to set the resolution to a whole number—using decimals may make some printers print black lines on photos. For example, 247 ppi is fine, but 247.35 ppi may cause problems. (Older printers are most likely to have trouble with decimals.)

If you're printing on photo paper or sending photos out for printing, make sure the images are cropped to fit a standard photo paper size. (Cropping is covered starting on page 99.) And if you're printing at home, the paper and ink you use make a big difference in the color and quality of the prints. It may seem like just a marketing scam, but you really *will* get the best results by using your printer manufacturer's recommended paper and ink.

Ordering Prints

You don't need to own a printer to print photos, because there's no shortage of companies hoping you'll give them the privilege of doing it for you. You can order prints online or use a print kiosk at a local store. Elements makes it really easy to prepare photos for printing either way. Just save the photos in a compatible file format (see page 75 for more about picking a file format). JPEG format is usually your best bet, but always check with the service you plan to use to see if it has any special requirements.

If you're going to physically take your photos somewhere for printing (as opposed to ordering them online), in Windows you can burn the photos to a CD to take in. Use the Organizer to export the photos to the desktop, as explained in Figure 16-1. Then use your computer's CD-creation program to burn the exported photos to a disc, or just copy them to a memory card or portable USB drive. If you're using the Mac Organizer, use the Copy/Move command (File→"Copy/Move to Removable Drive") to copy the photos to a media card or thumb drive and take that in, but going that route doesn't give you the same options for renaming, resizing, and changing the file format that you get with the Windows Export command.

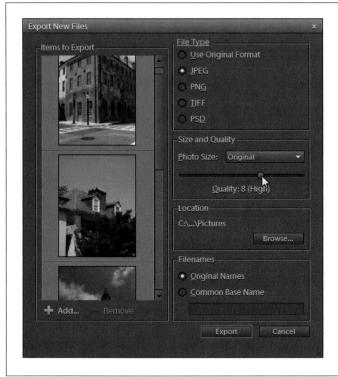

Figure 16-1:

In Windows, use the Export New Files dialog box to get images ready for in-store printing (at a kiosk, for example).

First, in the Organizer, select the photos. Then choose File \rightarrow Export As New File(s) to send them to your desktop so you can burn them to a CD. In the dialog box that appears (shown here), pick a new file format in the File Type section, if necessary (say you have TIFFs and the store wants JPEGs, for example). For printing, always choose maximum quality (the Quality slider becomes active when you choose JPEG as the file type). In the Location section, click the Browse button to choose the desktop.

If you want to rename the files, type something in the Common Base Name field and Elements gives each exported file that new name followed by -1,-2, -3, and so on. When everything looks aood, click Export to do just that.

Tip: On both PCs and Macs, you can also burn a CD from within Elements. In the Editor, go to Share→ More Options→CD/DVD.

Adobe has partnered with the popular online photo-printing services Shutterfly and Kodak Gallery to make it simple to upload photos directly from Elements. You can order prints, books, or any of the other photo-bearing items that they would love to sell you. Of course, you're free to use any *other* online printing service (see page 594 for some suggestions), but ordering from them isn't integrated right into Elements the way it is with these two.

Note: If you've ordered online from an early version of Elements but haven't done so recently, Kodak Gallery is the current name for what used to be Ofoto.com. So if you have an Ofoto account, then you can still use it with Kodak Gallery. (There are a couple of places in Elements where Kodak Gallery is referred to as Kodak EasyShare Gallery, another former name, but it's all the same service.)

Once you've edited your photos and are ready to place an order, just follow these steps (they're the same for both Macs and PCs):

1. Select the photos you want to have printed.

Open them in the Editor, or select them in the Organizer. (Your photos don't have to be in the Organizer if you start from the Editor, and they aren't added to the Organizer automatically when you order prints.)

2. Connect to the service you want to use and sign in.

You can order prints from Shutterfly or Kodak Gallery from either the Editor or the Organizer:

- File menu. Go to File→Order Prints, and then select the service you want to use.
- Create tab. Go to Create→Photo Prints, and then choose Shutterfly or Kodak from the list of options that appears.

Regardless of where you start, Elements sends you to the Organizer (if you're not already there), prepares your photos, and connects to the service you picked.

The online prints window opens. The details differ slightly depending on whether you're using Kodak or Shutterfly, but the general process is the same. You need to log in before you can order, or to create an account if it's the first time you're using either service. An easy-to-follow series of guided question screens appears to help you set up an account and complete your order. Figure 16-2 shows the Shutterfly version.

3. Order your prints.

The service lets you add or subtract photos, choose how many of each and which size, the finish you want, and so on. Then you enter info about the recipients (their names and addresses). Both companies remember whom you've sent photos to with previous orders, so you don't have to reenter Aunt Suzie's address each time. When your order is all set, enter your payment information, and in a few days you'll receive an envelope of prints in the mail.

Tip: Elements automatically checks for updates to these services, and automatically notifies you about special promotions the sites are offering. You can stop it from doing either by heading to the Organizer and choosing Edit—Preferences—Adobe Partner Services and turning off the appropriate checkboxes in the "Check for Services" section.

Even though Elements makes ordering prints from Kodak or Shutterfly really convenient, you can use either service without going through Elements or use other online print services like Snapfish (*www.snapfish.com*). The real advantage of ordering from Elements is the convenience of being able to work right in the Organizer.

utterfly	Or i					1
otterny.	Welcome Bar	bara (Not Barbar	a?)			
0	elect sizes and	0	Upload	Confirmation		
Order optio		quantitios				Next →
4x6	Changing the f	inish will apply to a 8x10	Wallet			Select Recipient
●Glossy ○Matte	0 Contraction of the second s	0 Colossy Matte	0 Construction of the second		Add more pictures Cancel order	
11x14 and larger are only available in matte finish. Save as my default setting for future orders.					Print pricing	
					Size	Print prices
5 Pictures					4x6	\$0.15 0.10
					5x7	\$0.99 0.66
Enter desire	d quantities for a	ach picture siz	e		8x10	\$3.99 2.67
States and	1	4x6	0 A 11x	14	Wallet(4)	\$1.79 1.20
a dall					11×14	\$7.99 5.35
	0	5x7	0 16x	20	16x20	\$17.99 12.0
	0	8x10	0 🐥 20x3	30	20x30	\$22.99 15.4
Remove	0	Wallet (4)				
	IMG_0002	int message 1.psd 2010-07-14 message to all prin	<u>ts</u>			
	1	4x6	0 <u>*</u> 11x	14		
Man Land	0	5x7	0 🗍 16x	20		
COLUMN THE REAL	1000					

Figure 16-2:

You can choose from many different sizes, and order as many of each photo as you like. As you can see here, you can even add the name of the image or a text message to the back of each print. This is Shutterfly's upload window; the one for Kodak Gallery is very similar.

Tip: If you use Shutterfly, you can start an order right from Full Screen view (page 60). The Quick Edit panel there has a "Mark for Printing" button. Click it when you see photos you want to print. Then, when you return to the Media Browser from Full Screen view, a pop-up window offers you the choice of printing the photos at home or ordering prints. Click Order Prints, and Elements prepares your photos and opens the Shutterfly window for you.

If you're using Adobe's Photoshop.com service (page 21), then you can connect to many popular online print services right from the personal web page you get as part of a Photoshop.com account. And when you share an album online there, you can let friends order prints of your photos right from your web page. See page 574 for more info.

Printing at Home

If you prefer to print photos at home, Elements has you covered. It's quite easy to print from Elements, but this is one of the areas where your operating system makes a little bit of a difference. In Windows, you can print from either the Editor or the Organizer, and the process is pretty much the same from either, although you can only print groups of photos on a single page from the Organizer. On a Mac, all printing takes place from the Editor, no matter where you start.

Before you print, it's really important to be sure the resolution (ppi) of your photo is what you want (see page 119 for more about resolution). It's also a good idea to do any cropping (page 99) before you call up the Print window. You can start from either the Editor or the Organizer, and once you're in the Print window, you can choose to create individual prints, a contact sheet of small thumbnails of all your photos, or a picture package of several sizes of prints. The following sections explain all your options.

Making Individual Prints

The basic process of printing from Elements is the same no matter where you start or what you're printing. You'll see a few differences between PCs and Macs if you're printing contact sheets or picture packages, which are covered later in this chapter, and there are a couple of minor ones, noted here, between how Windows and OS X handle all printing projects.

This section is about printing one photo per page from the Editor, since that method offers the most options. (To learn about the minor differences between printing from the Editor and from the *Windows* Organizer, see the box on page 536.) Once you understand how to make single prints from the Editor, you won't have any trouble with other kinds of printing. Both Windows and OS X require pretty much the same steps, but the order is slightly different.

Printing in Windows

1. Choose the photo(s) you want to print.

In the Project bin, select the photos you want to print. If you don't select any, Elements prints all your open photos. (You can add or remove photos once you're in the Print window, too—*if* the photos are already in the Organizer, as explained in Figure 16-3.)

2. Go to File \rightarrow Print.

The Print window appears. It's divided into three main sections: On the left is a filmstrip-like view where you can add or remove photo you want to print (Figure 16-3). In the middle is a preview area where you see the image(s) you're going to print and some controls for rotating and adjusting the image(s) (there's a blue outline around the area that's going to print). And on the right is a group of numbered settings, listed in the order you need to adjust them.

Figure 16-3:

On the left side of the Print window (shown here), you can add more photos to print, but only if they're already in the Organizer. Click the green + button, and a window opens that lets you browse through all your Organizer photos to choose ones to add.

If you want to print photos that aren't in the Organizer, open them in Elements and then select them in the Project bin before you start the print process. If you decide not to print one of the photos in the Print window, click its thumbnail, and then click the red – button (which is graved out here, because no photos are selected).

3. Choose the printer you want to use.

Select it from the drop-down menu on the right side of the window (Step 1 listed there).

4. Choose your printer settings.

On the right side of the Print window under Step 2 (Printer Settings), check to see what Elements proposes for the type of paper and the print quality. If you don't like its choices, click Change Settings. In the Change Settings window that appears, adjust the settings to your liking. The window includes a setting to change the print size, but you don't need to use it—you'll choose a size in the main Print window in the next step. Depending on your printer, you may have additional options here, like which paper tray you want the printer to use. If your printer can make borderless prints, you see a checkbox for that, too. Turn it on, and you'll only see borderless choices in the next step. When everything looks good, click OK.

5. Select a paper size.

Click the Select Paper Size menu (Step 3 in Elements' Print window) for a list of the sizes available for your printer. What's listed is determined by the printer you chose in Step 1, and by whether you turned on the Borderless checkbox in the Change Settings window. If you want to change the page's orientation, click the button showing the orientation you want.

6. Choose what kind of prints you want to make.

In the Print window's Step 4, choose whether to make individual prints, a contact sheet, or a picture package. In this example, you're making individual prints (one photo per page), so choose that. (If you want to make a contact sheet or picture package, flip to page 543.)

7. Select a print size.

Use the aptly named Select Print Size drop-down menu (Step 5). If you don't want any of the preset sizes, choose Actual Size or Custom. If you choose Custom, the More Options dialog box appears showing the Custom Print Size settings, which are explained on page 538. Enter your choices and then click OK.

If you turn off the "Crop to Fit" checkbox in the Print window, Elements prints your whole image as large as it can be within the print size you chose, even if that means leaving empty space at some of the edges. If you want to make the image fill the available space, leave "Crop to Fit" turned on and Elements trims the image to fit the print size you chose. Figure 16-4 shows the difference this setting makes.

Figure 16-4:

Left: Here's how this photo will print with "Crop to Fit" turned off. Notice the white space at the top and bottom of the blue bounding box.

Right: Leave "Crop to Fit" turned on, and Elements enlarges the photo enough to fill all the space before cropping off the excess (here, it cropped the right and left edges).

8. Choose how many copies of each page you want to print.

If you want to make more than one copy of each print, enter a number in the box below the "Crop to Fit" checkbox. (Keep in mind that Elements prints this many copies of *every* print in this batch—you can't make three copies of one photo and two of another, for example.)

9. Print your photos.

Click Print and Elements prints the photos. If you change your mind, click Cancel or close the Print dialog box.

Printing in OS X

1. Choose the photo(s) you want to print.

In the Project bin, select the photos you want to print. (If you don't select any, Elements prints all your open photos.) Just as in Windows, you can add photos once you're in the Print window, as explained in Figure 16-3, but they have to be in Organizer.

2. Go to File→Print.

The Print window appears. It's divided into three main sections: On the left is a filmstrip-like view where you can add or remove photos you want to print (Figure 16-3). In the middle is a preview area where you see the image(s) you're going to print and some controls for rotating and adjusting the image(s) (there's a blue outline around the area that's going to print). And on the right is a group of numbered settings, listed in the order you need to adjust them.

3. Choose the printer you want to use.

Select it from the pull-down menu on the right side of the window (it's labeled "Step 1").

4. Select a paper size.

In Step 2 in Elements' Print window, click the Select Paper Size menu for a list of the sizes available for your printer. What's listed is determined by the printer you chose in Step 1. If you want to change the page's orientation, click the button showing the orientation you want.

5. Select a print size.

Use the aptly named Select Print Size drop-down menu (Step 3). If you don't want any of the preset print sizes, choose Actual Size or Custom. If you choose Custom, the More Options dialog box appears showing the Custom Print Size options, which are explained on page 538. Enter your choices and then click OK.

If you turn off the "Crop to Fit" checkbox, Elements prints your whole image as large as it can be within the print size you chose, even if that means leaving empty space at some of the edges. If you want to make your image fill the available space, leave "Crop to Fit" turned on and Elements trims the image to fit the print size you chose. Turn back to Figure 16-4 to see the difference this setting makes.

6. Choose how many copies of each page you want to print.

If you want to make more than one copy of each print, enter a number in the box below the "Crop to Fit" checkbox. (Keep in mind that Elements prints this many copies of *every* image in this batch—you can't make three copies of one photo and two of another, for example.)

7. Print your photos.

After you adjust Elements' Print window's settings and click the Print button, you see OS X's Print dialog box, where you make your final print setting choices—like paper profile and color management. Figure 16-5 explains how it works.

First, choose the printer you want to use from the top pull-down menu. Next, click Show Details (if you're using Mac OS X 10.7 [Lion]) or the blue downarrow button to the right of the printer's name (if you're using Mac OS X 10.6 [Snow Leopard] or earlier) to expand the dialog box, and then choose paper and color options from the pull-down menu that starts out set to Layout.

Your paper and color options vary depending on the kind of printer you have. Selecting a paper profile may sound complicated, but it's usually as simple as selecting the kind of paper you plan to use (Photo Paper Plus Glossy, say) from a list of choices. Setting color options can be as easy as choosing "high-quality photo" from a list of quality settings, and usually you'll have someplace to specify Printer Color Management, although probably not in the same menu item.

When everything is set, click Print and Elements prints your photo(s).

That's the basic process for printing from Elements. If you're in a hurry or not fussy, you can use it to get a handful of prints in short order. But odds are that you're using Elements precisely because you *are* fussy about your photos, and you may want to tweak several other settings. The next sections cover all the ways you can customize things like how the photo sits on the page, its color management, and so forth.

Note: Elements' Print window isn't *color managed* (page 239), which means that what you see in the window isn't necessarily the same as the colors you'll get when you print; the preview is just meant to show you where on the page the photo is going to print (which is the subject of the next section).

Printing at Home

Printer	Canon i9100	÷
Copies	: 1	
Pages		
? PDF •	Show Details C	ancel
	Print	
Printer	Canon i9100	•
Presets	: Standard	
? (PD	F Preview Can	cel Print
	Print	
Printer	Canon i9100	
Presets	Layout	
Copies	Color Matching	
Pages	Paper Handling Cover Page	
rages	Scheduler	
	✓ Quality & Media	
M	Color Options	•
Pap	Borderless Printing Supply Levels	÷
	Summary	
Prir	t Quality: Standard	•
	Grayscale Printing	

Use the OS X Print dialog box to choose paper and printquality settings.

Top: In OS X 10.7 (Lion), click the Show Details button circled here to expand the window so you can see all your options.

Middle: In older versions of OS X, click the arrow (circled) to do the same thing.

Bottom: In any version of OS X, you then use this pulldown menu in the middle of the dialog box to make your choices.

THE SIMPLE LIFE

Printing from the Windows Organizer

In Windows, if you want to make individual prints in the Organizer, start by selecting the photo(s) in the Organizer's Media Browser rather than in the Editor's Project bin. Other than that, the process for printing individual images is exactly the same whether you start in the Editor or the Organizer except for three details, which all involve clicking the Prints window's More Options button:

- Image positioning. The Editor always prints one photo per page, regardless of the relative sizes of the photos and your paper, while the Organizer may place more than one photo on a page if there's room. If you want to restrict the Organizer to placing only one image on a sheet, click the More Options button, make sure Printing Choices is selected on the left side of the window, and then turn on "One Photo Per Page." Also, if you print from the Editor, you can turn off the Print window's Center Image checkbox to reposition your photo. (This checkbox isn't available if you start from the Organizer—Elements is totally in charge of positioning your photos.)
- Max Print Resolution. If you start the printing process from the Organizer, when you're in the Print

window and go to More Options—Custom Print Size, you'll see a box labeled Max Print Resolution. (The Editor's Print window just lists your image's print resolution in pixels per inch.) If you don't make a change here, anything you print from the Organizer will print at 350 ppi or less (see page 119 for more about resolution and why this may matter). Normally, that's just fine.

 Color Management. Instead of the many options you find if you open the Print window from the Editor when you go to More Options→Color Management (see page 540), if you start in the Organizer, the More Options dialog box just presents you with the current color space for your image and a drop-down menu set to "Same as Source." Leave that setting as is.

Another handy Organizer feature is that you can mark photos for printing in Full Screen view (page 60). When you return to the Media Browser, a pop-up window gives you the option of printing your photos or ordering prints online (page 526).

Positioning Your Image

In both the Windows and Mac versions of Elements, there are two main ways to adjust the relationship between an image and the paper you print it on. Elements' Print window has some controls for rotating and sizing the image, which are normally all you'll need. You can even scoot the photo around within the preview area to determine which part of it is going to print if you don't want to print the entire image. And if you like, you can also call up the Page Setup dialog box, which is the same for all programs on your computer. The following sections explain your options. (Quick reminder: In Windows, Elements only lets you position your image if you start from the Editor; if you print from the Organizer, Elements decides where to put the image.)

Print window settings

When you open Elements' Print window, you see your photo in a white preview area surrounded by a blue outline (called a *bounding box*). The white area represents the paper, and the blue box shows the printing boundaries of the photo. (The blue outline doesn't get printed. Incidentally, Adobe's official name for the area surrounded by the blue outline is the Print Well, in case you run into it in any tutorials.) Your first impulse may be to grab the photo and try to adjust its placement on the page. But if you do this, rather than moving the blue box, you just move your image *within* the box. You need to pay attention to your cursor to see just what you're going to move, as Figure 16-6 explains.

Figure 16-6:

It's easy to move a photo around on the paper, but you have to be a little careful.

Left: If you grab the photo itself, you get the hand cursor (circled) and you'll simply move the image within the print outline and change what part of the image will print.

Right: To move the photo to another spot on the page, turn off the Center Image checkbox below the preview, and then move the cursor close to the edge of the photo till it turns into the crossed arrows shown here (circled). These arrows indicate that you can drag the photo to wherever you want it.

To reposition a photo on the page (to print a small photo on the upper-left corner of a large piece of paper, for example), just turn off the Center Image checkbox and then drag the bounding box wherever you want it, or enter the amount of distance from the top and left edges of the page in inches, centimeters, millimeters, points, or picas.

In addition to moving the bounding box itself, there are several ways to change how your image appears within it. You can:

• Rotate the photo. Below the preview area are the same rotation icons you see elsewhere in Elements. Click one to rotate your photo within the bounding box. (If you want to rotate the box on the page, use the buttons under Select Paper Size.) If you turn on the Image Only checkbox to the right of the rotation icons, then the bounding box stays put and your image rotates within it.

- **Resize the photo.** If you don't want to print the whole image, you can zoom in on part of it by using the slider below the preview to control which part of it appears in the box. Be careful with this feature: You can easily enlarge your image beyond a reasonable pixel density. (When you click Print, Elements will warn you if the image is going to print at less than 220 ppi, but as a general rule it's best to take care of any resizing *before* you open the Print window.)
- **Reposition the photo in the box.** As mentioned above, you can drag the image around in the preview area to determine which part of it will print. (You can also accidentally drag the image almost out of view. If that happens, just choose a different print size in the right part of the window, and then switch back to the original size. Elements recenters your image in the bounding box each time you change this setting.)

Tip: If you turn on the "Crop to Fit" checkbox on the right side of the Print window, Elements crops based on the *original* position of your image; it doesn't take into account any dragging that you do. In other words, you can't control the part of your photo that gets printed if you use "Crop to Fit."

- Make the image and print size the same. If you decide to make a 4" ×6" print of an image that's the right aspect ratio (shape) for a 5" ×7" print, you'll end up with some empty space on the edges because the print size and the aspect ratio aren't equivalent. There are two ways around this. You can turn on "Crop to Fit," and Elements will chop off the edges of the photo. Or, if you've already cropped your image to a photo-paper size, head to the Select Paper Size drop-down menu and choose Actual Size. You can also use a Custom size, as explained next.
- Pick a custom print size. Either choose Custom from the Print window's Select Print Size menu, or click the More Options button and then click Custom Print Size; either way, you see the More Options dialog box's Custom Print Size options. There, you can type in the exact height and width you want to print in inches, centimeters, millimeters, points, or picas.
- Make the image fill the paper. If you click the Print Window's More Options button and then click Custom Print Size, you can turn on the "Scale to Fit Media" checkbox, and Elements makes your image larger or smaller so that all of it fits into your desired page size. (You may need to use your operating system's Page Setup dialog box—described next—to change the page orientation after choosing this option.)

The Page Setup dialog box

In the lower-left corner of Elements' Print window, there's a Page Setup button. Click it to bring up your operating system's Page Setup dialog box. Normally, you don't need to use this dialog box at all in Elements—choosing your printer in the Print window's Step 1 area takes care of things. But once you've got everything set up in Elements' Print window, you can use Page Setup to override Elements' settings. You can also select a printer here, but normally choosing a printer in Elements' Print window changes the Page Setup dialog box to match.

Additional Print Options

Elements includes a number of other useful ways to tweak a photo, like putting a border around it, printing crop marks as guides for trimming the printed photo, or even flipping it for printing as an iron-on transfer. You'll find these by clicking the Print window's More Options button and then, on the left side of the dialog box that appears, clicking Printing Choices:

- Photo Details. You can print the image's shot or creation date, filename, and/ or caption on the page with the photo by turning on the relevant checkbox(es) here. (When you click Apply, the Print Window's image preview area changes to show where the text will get printed, so if the More Options dialog box is in the way, move it over so you can see what happens as you check these boxes.) Caption text is what you entered in the Organizer, or you can go to File→Info in the Editor to add a caption in the relevant field.
- **Border.** If you want to add a border to the photo, turn on the Thickness checkbox, and then enter a size for your border (in inches, millimeters, or points). Elements shrinks the photo to accommodate the border, even if there's plenty of empty space around the picture, so you may need to enlarge the photo a bit before printing to get the size you originally chose. Click the white square that appears to bring up the Color Picker so you can choose a border color. If the page has empty space you want to fill with a background color, then turn on the Background checkbox and click its color square to bring up the Color Picker.
- **Iron-on Transfer.** Turn on the Flip Image checkbox to reverse your image horizontally. You'd use this when printing transfers for projects like t-shirts.
- **Trim Guidelines.** The Print Crop Marks checkbox lets you print guidelines in the margins of the photo to make it easier to trim exactly. These marks are useful mainly for trimming bordered photos so that the borders are exactly even.

The easiest way to set up color management, and a good way to start, is to choose Printer Manages Color. This means that Elements hands the photo over to your printer and lets the printer take care of the color-management duties. Then all you need to do is select the proper paper profile and settings for your printer. Selecting a paper profile may sound kind of technical, but actually, you've probably already done it.

In Windows, you picked a paper profile back in Printer Settings→Change Settings (step 4 on page 531). It's usually as simple as choosing, say, Photo Paper Plus Glossy from the list of options there. If you already chose a paper type and print quality in Elements' Print window, your printer preferences should have changed to reflect them. However, your printer may offer some additional choices that are worth exploring. In the More Options dialog box's Color Management section, just click the Printer Preferences button to get to these settings, or, in Elements' Change Settings dialog box (page 531), click the Advanced Settings button. The exact wording in the dialog box that appears differs depending on what kind of printer you have, but Figure 16-8 shows a typical printer's settings.

dvanced Printing Shortcuts Features Color		how to set up color
Color Options	Show preview before printing	management in your printer's settings, it's easy. Here, just leavin this particular HP printer's menu set to ColorSmart/sRGB is of it takes. If you plan to let Elements manage color, you'd choose "Application Manage Colors" instead. Diffe ent brands of printer. have different names for their color-manag ment systems, so you have to hunt around
		in the window a bit, but it's usually pretty simple to figure out which option you wa

On a Mac, you make your paper profile choices in the OS X Print window, as explained back on page 534. Your options are similar to the ones in Windows, you just get to them in a different place.

Tip: If your camera takes photos in sRGB, and you've been editing them using Elements' No Color Management or "Always Optimize Colors for Computer Screens" setting, then don't choose Adobe RGB for the printer profile, as your colors may shift drastically. If for some reason you want to change the color space for the printer, first go to Image→Convert Color Profile, and then apply the Adobe RGB profile to the photo. If you aren't absolutely sure that your printer understands Adobe RGB (many inkjets don't) and you don't have a compelling reason for changing this setting, then it's best to leave things alone.

You can configure Elements' color settings in a zillion different ways, and you may need to experiment a bit to find what works best. (See the box below for advice on how to cheaply test out a bunch of different print settings.) If you go looking around for more info, you'll find that this subject is very controversial—everyone has a different approach that's the "right" one. But in fact, you have many options that can lead to good results.

UNDER THE HOOD

What's Your Intent?

For most people, the Rendering Intent setting in Elements' More Options dialog box is the most confusing of the color-management options. Here are the basics you need to know to choose a setting:

Sometimes a photo may contain colors that fall outside the color boundaries of the print space you're using; in other words, the print space can't properly display those colors. The Rendering Intent setting tells Elements what to do if it runs into colors like that. You have four choices:

• **Perceptual** tells Elements to preserve the relationship between the colors in your image—even if that means it has to visibly shift some colors to make them all fit.

- **Saturation** makes colors very vivid—but not necessarily very accurate. This setting is more for special effects than for regular photo printing.
- **Relative Colorimetric** tries to preserve the colors in both the source and the output color spaces by shifting things to the closest matching color in the printer profile's space. This is Elements' standard setting, and it's usually what you want because it keeps colors as close as possible to what you see onscreen.
- Absolute Colorimetric lets you simulate another printer and paper. This setting is for specialized proofing situations

Printing Multiple Images (Windows)

Elements also lets you print from the Windows Organizer, which gives you many more output options than the Editor, including the ability to print several photos on one page. You can create *contact sheets* of thumbnails and *picture packages* (like you'd order from a professional photographer), and easily add all kinds of fancy borders to the photos (by choosing a frame in the Print window's settings) in the Organizer. (You can *begin* creating a contact sheet or a picture package in the Editor, but Elements bounces you over to the Organizer for the actual printing.)

Note: To learn how to print a bunch of images on a Mac, skip to page 546.

Contact Sheets

Contact sheets show thumbnail views of multiple images on a single page. They're great for creating a visual reference guide to the photos you've archived on a CD, for instance. Or you may want to print a contact sheet of all the photos on a memory card as soon as you download the photos to your computer, even before you edit them (see Figure 16-9).

To print a contact sheet, in Elements' Print window (File \rightarrow Print), go to the "Select Type of Print" menu and choose Contact Sheet. (If you start from the Editor, Elements asks if you want to go to the Organizer, which is where you print Contact Sheets.) The window changes to show a "Select a Layout" section, and you can use the following settings to customize your contact sheet:

- **Columns.** Here's where you decide how many columns of photos to have on a page (up to nine). The more columns, the smaller the thumbnails. Even if you have only one image currently chosen, increasing the number of columns shrinks the thumbnail.
- Show Print Options. Turn on this checkbox and you can decide whether to have Elements print the image's date, caption (any text in the image's caption field), and/or filename below each thumbnail. You can also add page numbers if you're printing multiple pages. (If all your photos fit on one page, the Page Numbers checkbox is grayed out.)

You can add and remove images as explained earlier (page 531), and you can click a photo in the layout and use the slider to zoom, just as with individual prints. When you like the layout, click Print.

Picture Packages

Elements' Picture Package tool lets you print several images on one sheet. You can print a package that's one photo printed repeatedly, or one that includes multiple photos.

To get started, in the Organizer, press Ctrl+P to call up the Prints window. Then go to "Select Type of Print" and choose Picture Package. Next, under "Select a Layout," pick which composition style you want (choices include four $3" \times 5"$ photos, two $5" \times 7"$ photos, and so on). Then choose a frame, if you want one, from the "Select a Frame" menu. Add photos to your package by clicking the Add button in the lower-left corner of the window.

Tip: You can also start a picture package in either the Editor or the Organizer by going to the Create tab—Photo Prints—Print Picture Package. The only real advantage to going that route is that the Print window opens with "Picture Package" preselected in Step 4.

Figure 16-10 shows you how to change the layout of the photos once they're on the page. If you turn on the Fill Page With First Photo checkbox, then you get an whole page dedicated to each photo showing multiple sizes of the image, instead of various photos on each page.

Reorganizing a picture package is dragand-drop easy. If you have empty space in your layout and want to fill it, or you want to chanae the photo in a particular slot, just drag a thumbnail from the filmstrip on the left into the slot where you want to use the photo. (You can't drag images between slots, only from the thumbnails on the left.) To remove a photo from the package, click it on the left side of the main window and then click the red Remove button.

If you turn on the "Crop to Fit" checkbox, Elements crops your photos to fit their slots, but you're probably better off doing any cropping yourself in the Editor instead. You can select a photo in the layout and then use the rotation buttons and the zoom slider to tweak it. When you've got the photos arranged the way you want, click Print.

Printing Multiple Images (Mac)

The Mac version of Elements gives you even better options for printing multiple images, because you can save your completed projects for future use. This section teaches you how to create contact sheets and picture packages.

WORKAROUND WORKSHOP

Creating Your Own Package

You may find that you want a layout for your picture package that's different from any of the choices Elements offers. Fortunately, you can easily make your own picture package from scratch:

- Save all the photos you want to use at the same resolution. See page 119 for more about setting a file's resolution.
- In the Editor, create a new document (Ctrl+N/ ℜ-N or File→New). Make sure it's the size you want your finished package to be, and that it has the same resolution as your photos. You can save time by choosing the Letter preset size from the New dialog box's Size menu; that size is already set to 300 ppi.
- 3. Bring each photo into your new file. Drag the photos from the Project bin and then position them as you wish, or just copy (Ctrl+C/#-C) and paste (Ctrl+V/#-V) them. Each photo comes in on its own layer, so it's easy to reposition them individually. Once the photos are in the new document, you can use the Move tool or Scale command (page 392) to resize them.

When you have all the photos positioned and sized, save the combined file, and then print it. You can make the file smaller by flattening it first (Layer—Flatten Image), but only flatten it if you don't think you'll want to tweak the layout later.

In Windows, you can also create new layouts in the Organizer. Go to C:\Program Files[Program Files(x86) for 64-bit operating systems]\Adobe\Elements 10 Organizer \Assets\locale\en_US \layouts (the "en_US" part will be different if you aren't in the United States) and choose the layout that's closest to what you want. (You might want to audition the different layouts in Elements first and make note of the one that's most like what you want, so you'll know which file to open.) Open the file in the text editor of your choice, save it with a new name, and then make your changes. When you're done, save the changes, and then put the new file into the same folder as the original. If you're not sure about what to change, the layouts folder has a helpful ReadMe file that explains what to do.

Contact Sheets

Contact sheets show a bunch of thumbnails of different photos. You can use them to keep track of the photos on a CD or as a record of all the photos you took in one shooting session, for example. The plug-in that comes with Elements makes it a snap to create a contact sheet that's laid out the way you want. To create a contact sheet:

1. Collect your photos.

You can make a contact sheet of all your open photos or all the photos in a folder. So decide which photos you want to use and open them in the Editor, or put them together in a folder.

2. Call up the Contact Sheet dialog box (Figure 16-11).

Press Option-#-P, or go to File→Contact Sheet II. (Confusingly, there's no Contact Sheet I option—it was replaced by this one several versions of Elements ago.) You can also go to Create→Photo Prints→Print Contact Sheet in either the Editor or the Organizer, although you'll get bounced over to the Editor to actually create the contact sheet, and you can't preselect photos in the Organizer.

Contact Sheet	Figure 16-11:
Source Images Use: Folder : Choose Include All Subfolders	OK You can customize a contact sheet Cancel by adjusting things like the amound Help As you tweak these settings, the Iayout thumbnail on the right side of the dialog box changes to reflect
Document Units: inches Width: 8 Height: 10 Resolution: 300 pixels/inch Mode: RGB Color Flatten All Layers	Page 1 of 1 0 of 0 Images W: 16 in H: 14 in Press the
Thumbnails Place: across fi Use Auto-Spacing Columns: 5 Vertical: 0.014 in Rows: 6 Horizontal: 0.014 in Rotate For Best Fit Use Filename As Caption Font: Minion Pro Font Size: 12 pt	ESC key to Cancel processing images

3. Choose your settings.

You have lots of options:

- **Source Images.** This is where you pick which photos to include. You can select the files currently open in the Editor or files in a certain folder.
- **Document.** Here's where you select the overall page settings. Set the page size in inches, centimeters, or pixels. Then enter a resolution and choose between RGB and grayscale color mode (see page 54). The Flatten All Layers checkbox doesn't affect your originals—it just creates a contact sheet where text and images are on the same layer—so you can leave it turned on to keep the file smaller.

- Thumbnails. These settings control how the thumbnails are laid out. Choose whether you want the pictures to go across the page or down (as they're being laid out), how many columns and rows you'd like, and whether you want Elements to figure out the spacing between images or to set the spacing yourself. Turn on the Rotate For Best Fit checkbox to make Elements rotate the thumbnails so they fit on the paper most efficiently. (If you don't like having photos improperly oriented, leave this setting off.)
- Use Filename As Caption. Turn on this setting if you want the name of each photo to appear as a caption. Your font choices are Myriad Pro, Minion Pro, or Lucida Grande. Getting a font size you like may take some experimenting.

4. Click OK to create the contact sheet.

Elements goes to work and you see your images flash back and forth. The contact sheet thumbnail in the Project bin updates to show each photo as Elements places it.

Tip: If you change your mind about making a contact sheet while Elements is working, press the Esc key.

5. Save or print your contact sheet.

Your finished contact sheet is just like any other file: You can save it in the format of your choice, print it out, burn it to disc along with the photos it contains (see page 86)—whatever. If you included so many photos that they don't all fit on one page, then Elements creates a separate file for each page.

Picture Packages

You can also print a group of pictures, called a picture package, on one page. You can make packages that feature one photo printed in several different sizes, or packages that include more than one photo. Here's how:

1. Start your package.

You start a picture package in the Editor by going to File \rightarrow Picture Package. (You can also start from either the Editor or Organizer by going to Create \rightarrow Photo Prints \rightarrow Print Picture Package, though you end up in the same Picture Package window in the Editor.) You don't need to select any photos first, but you may want to open photos in the Editor before starting, since the Picture Package, like the Contact Sheet, ignores the Organizer. So it's often simplest to open the photos or collect them into a folder to make them easy to find before you start this process.

2. Choose your photo(s).

The Picture Package dialog box's Use drop-down menu is where you select the pictures you want in the package. If you choose lots of files, Elements adds as many pages as necessary to fit them all in. You can use a single file, a folder of photos, the frontmost open photo, or all open photos. Elements starts by filling the entire layout with copies of one photo, but you can change that in step 4 if you want more than one image per page.

3. Choose your page size and layout settings.

Elements gives you lots of options:

- **Document.** This is where you pick the overall settings for your package. You can set the page size $(12" \times 18", 8" \times 10", 10" \times 16", \text{ or } 7.5" \times 10.9")$, layout (how many photos appear on one page and their sizes), resolution, and whether to use RGB or grayscale color mode (see page 54). The Flatten All Layers setting works the same way as it does for contact sheets (see step 3 on page 548). The page size options are all photo paper sizes, but you can print the $8" \times 10"$ layout on standard $8.5" \times 11"$ paper.
- Label. This is where you can tell Elements to put text on the photos. If you don't want any text, leave the Content menu set to None. If you want text, you can use the filename, copyright, description, credit, or title from the file's metadata (see page 70), or enter custom text. The other options are for the text itself: font, size, color, opacity, and position. If you don't want black text, click the Color box to bring up the Color Picker. The Rotate menu lets you tell Elements to rotate the text so that, if your photos print sideways, say, the text still prints right side up on the photo. And you can use the Opacity and Position settings to create a watermark.

If all these options aren't enough for you, check out the next section, which explains how to customize a picture package even further.

4. Adjust the placement of the photos.

Figure 16-12 explains how to change the contents of a particular placeholder (Adobe calls them *zones*). Keep clicking zones to put as many different shots on a page as you have zones to hold them.

5. When everything's arranged to your liking, click OK to create the package.

If your settings required more than one page to fit the photos, each page is a separate file. You can print them or save them in any format that suits you, just like a single photo.

Figure 16-12:

To add a new photo or replace an existing one click any box in the Lavout section of this dialog box and then choose the new photo in the "Select an Image File" dialog box that appears. (You can't rearrange photos by dragaina them from one zone to another.) An even easier way to slot in a new photo is to drag it in from the Finder, and then drop it in the right zone: Elements opens the image and replaces the existing photo

Customizing a picture package

You're not limited to the picture-package layouts Elements offers. You can customize a layout in all sorts of ways and then save it to use again. Start by choosing the built-in layout that's closest to what you want. Then click the Edit Layout button in the Picture Package window's bottom right to call up the dialog box shown in Figure 16-13.

You can choose a preset page size or type in a custom size in inches, centimeters, millimeters, or pixels. And as Figure 16-13 explains, you can also change the size and location of the images in the package. (The boxes for typing in custom sizes are grayed out until you select a zone.)

If you click a zone and then click Add Zone, Elements creates an additional zone instead of replacing the one you clicked. If there's no space that's big enough for the new zone, Elements just dumps the new zone on top of the existing layout and leaves you to sort things out. Simply delete an existing zone to make room for the new one. The Snap To checkbox in the dialog box's Grid section helps you line up the zones.

Printing Multiple Images (Mac)

Layout	1		Elements gives you
Name: (1)5×7 (2)3.5×5		Save	lots of ways to cus-
Page Size: 8.0 x 10.0 in 🛟	· 不是是不是你的问题。	Cancel	tomize a picture pe age's layout. Enter
Width: 8 in			numbers on the lea
Height: 10 in			side of this dialog
Units: inches			or just click a zone to bring up resizing
Image Zones Size: Width: 3.5 in Height: 2.4 in Position: X: 0 in Y: 5.06 in Crid: Snap To Size: 0.5 in			handles. Resizing works just like usir the Move tool—you can drag or resize zone, or Option-ch it to see a pop-up menu that include some standard siz To delete a zone, c it and then click th Delete Zone buttou To start from scrat click Delete All

When you're happy with your custom layout, name it by typing something in the Name box, and then click Save. (Be sure to give your layout a new name so you don't overwrite the built-in layout you started with.) Make sure you save it in Applications—Adobe Photoshop Elements 10—Support Files—Presets—Layouts. That way, your new layout will show up in the list of preset layouts.

If this method of customizing a picture package doesn't meet your needs, the box on page 547 explains another way to create a custom package.

CHAPTER 17

Email and the Web

Printing photos is great, but it costs money, takes time, and doesn't do much to instantly impress your faraway friends. And to many people, printing is just so 20th century. Fortunately, Elements comes packed with tools that make it easy to prep your photos for onscreen viewing and to email them in a variety of crowd-pleasing ways.

Image Formats and the Web

Back in the Web's early days, making graphic files small was important because most Internet connections were as slow as snails. Nowadays, file size isn't as crucial; your main obligation when creating graphics for the Web is ensuring they're compatible with the web browsers people use to view them. That means you'll probably want to use either of the two most popular image formats, JPEG or GIF, though PNG is also an option:

• **JPEG** (Joint Photographic Experts' Group) is the most popular choice for images with lots of detail, and where you need smooth color transitions. Photos are almost always posted on the Web as JPEGs.

Tip: JPEGs can't have transparent areas, although there's a workaround for that: Fill the background around the image with the same color as the web page you want to post it on. That way, the background blends into the web page, giving the impression that the object is surrounded by transparency. See Figure 17-4 (page 558) for details on this trick.

- **GIF** (Graphics Interchange Format) files are great for images with limited numbers of colors, like corporate logos and headlines. Text looks much sharper in GIF format than it does as a JPEG. GIFs also let you keep transparency as part of the image.
- **PNG** (Portable Network Graphic) is a web graphics format that was created to overcome some of the disadvantages of JPEGs and GIFs. There's a lot to like about PNG files: They can include transparent areas, and the format reduces the file size of photographs without losing data, as happens with JPEG files (see page 80 for more about that). PNG files' big drawback is that only newer web browsers handle them well. Old versions of Internet Explorer are notorious for not supporting the PNG format, so if you've potentially got viewers with ancient computers, then you probably don't want to use PNGs.

Elements makes it a breeze to save images in any of these formats using the Save For Web dialog box, explained next.

Saving Images for the Web or Email

If you plan to email your photos or put them up on your website, Save For Web is a terrific feature that takes any open image and saves it in a web-friendly format. It also gives you lots of options to help maintain maximum image quality while keeping file size to a minimum. Save For Web aims to create as small a file as possible without compromising the image's onscreen quality.

Save For Web creates smaller JPEG files than you can get by using the Save As command because it strips out the image's EXIF data, the information about your camera's settings (see page 71). To get started with Save For Web, in the Editor, go to File→"Save for Web" or press Alt+Shift+Ctrl+S/Option-Shift-æ-S. The dialog box shown in Figure 17-1 appears.

The most important point to remember when saving images for the Web is that the resolution (measured in pixels per inch, or ppi) is completely irrelevant. You only care about the image's pixel dimensions, such as 400×600 . If you're working with a photo that you've optimized for print, you almost certainly want to downsize it; Save For Web makes that a snap.

Elements gives you lots of useful tools in the Save For Web dialog box, like the Hand and Zoom tools for adjusting the view. But the main attraction is the before-andafter image preview in the two main preview panes. On the left is your original and on the right is what the image will look like after you save it. The file size is listed below each image preview.

Below the right preview, you see an estimate of how long it will take to download the image at that size. You can adjust the download time by modifying your assumptions about your recipient's Internet connection speed, as shown in Figure 17-2. You can also change the zoom percentage (using the Zoom menu in the dialog box's bottom left), but you should usually stick with 100 percent because that's the size your image will be on the Web.

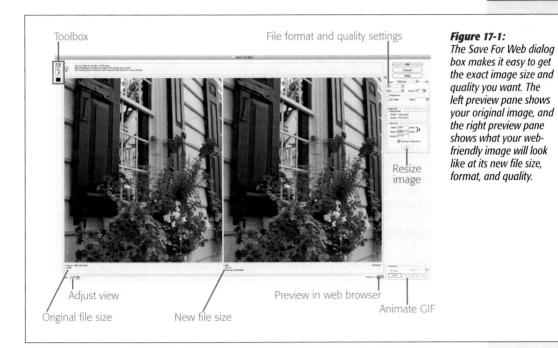

Figure 17-2:

Below the right-hand preview pane, the Save For Web dialog box displays an estimate of how long it'll take to download your image.

To change the download settings (for example, the speed of the Internet connection), go to the upper-right corner of the dialog box and click the arrow button to call up this list. (The items at the top of this list are explained later in this chapter on page 559.) If you turn on the Progressive checkbox, then your JPEG loads from the top down. This option was popular for large files when everyone had slow dial-up connections, but it makes for a slightly larger file, so it's not as popular today. If you turn on the ICC Profile checkbox, Elements embeds a color space profile in the image. (See page 241 for more about color spaces.)

The Matte menu lets you set the color of any area that's transparent in the original (see Figure 17-4). If you don't set a matte color, Elements uses white. By choosing a color that matches the background of your web page, you can make it *look* like the image is surrounded by transparency. You have three ways to select a color: Click the arrow to the right of the Matte box and then choose from the drop-down menu; click the arrow to the right of the Matte box and then sample a color from your image with the Eyedropper tool; or click the Matte box's color square to call up the Color Picker.

Tip: Elements' Color Picker lets you limit your choices to web-safe colors by turning on the Only Web Colors checkbox in its lower-left corner. But do you *have* to stick to this limited color palette for web graphics? Not really. You need to be seriously concerned about keeping to web-safe colors only if you know the majority of people looking at your image will be using *very* old web browsers. All modern browsers can cope with a normal color range. Getting colors to display consistently in all browsers is another kettle of fish entirely, as the next section explains.

example, the purple matte around this hibiscus blossom will blend into the purple background of the page it's bound for.

Figure 17-4: When you save an image in JPEG format, the transparent areas aren't preserved. But Elements helps you simulate transparency by letting you choose a matte color, which replaces the transparency. By choosing a matte color that's identical to your web page's background, vou can simulate transparency. For

• **GIF.** The fewer colors a GIF contains, the smaller the file. You can use the Colors box to set the number of colors. Use the arrows on the left edge of the box to scroll to the number you want, or just type it in the box.

If you turn on the Interlaced checkbox, then your image downloads in multiple passes (sort of like an image that's slowly coming into focus). With today's computers, interlacing isn't as useful as it used to be on slower machines. If you want to keep transparent areas transparent, then leave the Transparency checkbox turned on. If you don't want transparency, then choose a matte color the way you do for a JPEG (see the previous bullet point). If you're creating a GIF that you plan to animate, turn on the Animate checkbox. (You need a layered file to make an animated GIF; page 561 has the details.)

Dither is an important setting because the GIF format works by compressing and flattening large areas of colors. When you use dithering, Elements blends existing colors to make the image look like it has more colors than it actually does. For instance, Elements may mix red and blue pixels in an area to create purple. You can choose how much dither you want by entering a percentage. Depending on your image, you may not want any dithering; in that case, set the Dither field to 0%. (Dithering makes for a larger file, but in these days of large files and fast connections, the difference in size is miniscule, so you'll usually want to use it.)

• **PNG-8.** This option, the more basic of your PNG choices in Elements, gives you pretty much the same options you get with GIF.

With both PNG-8 and GIF, you get advanced options for how to display colors (specifically, to have Elements generate the color lookup table, which probably doesn't mean anything to you unless you're a web-design maven). The menu below the file-format menu lists your options. You can safely ignore this menu (Elements chooses Selective unless you change it), but if you're curious, here are your choices: Selective favors broad areas of color and keeps to web-safe colors; Perceptual favors colors to which the human eye is more sensitive; Adaptive samples colors from the spectrum appearing most commonly in the image; and Restrictive keeps everything within the old 216-color web palette.

• **PNG-24.** This is the more advanced level of PNG. Technically, both PNG formats let you use transparency, but more web browsers understand transparent areas in PNG-24 files than in PNG-8 files. Your other save options with this format are the same as some of those for JPEGs.

Previewing Images and Adjusting Color

Elements gives you a few different ways to preview how an image will look in a web browser. You can start by looking at your image in any browser you have on your computer (see Figure 17-5).

Figure 17-5:

To preview an image in a web browser, click the Preview In button in the bottom right of the Save For Web dialog box to launch your computer's standard web browser. (On Macs, this button doesn't have a graphic on it, as you see here. In Windows, the button displays your preferred browser's icon, or the one for the last browser you used for previewing in Elements.) Or you can click the arrow and choose a browser from the list. The first time you click this arrow, you may need to pick Edit List and then click Find All to use the browser you want. Elements sniffs out every browser on your computer and adds what it finds to this menu. (Sometimes the Windows version of Elements only finds Internet Explorer, so you have to add other browsers, like Firefox, manually via the Add button in the Browsers window. On Macs, Elements is pretty good about finding them all.)

To add a new browser, in the Save For Web dialog box, click the Preview In dropdown list, and then choose Edit List. In the Browsers dialog box that appears, click the Add button and navigate to the one you want. If you want to have *all* your browsers listed, then click Find All. From now on, you can pick any browser in the list to make Elements launch the browser with your image in it.

If you want to get a rough idea of how your image will look on other people's monitors, click the arrow next to the upper-right corner of the right-hand preview window (see Figure 17-2). The list that appears includes the following options:

- **Browser Dither.** If an image contains more colors than a web browser can display, the browser uses dithering (see page 559) to create the additional colors. Select this option to get an idea of how your image will look if a browser has to do this.
- Uncompensated Color. This option shows colors the way they normally appear on your monitor, so it doesn't adjust the color—it just displays what you usually see.
- **Standard Windows Color**. Displays colors the way they should look on an typical Windows monitor.
- Standard Macintosh Color. Shows colors the way they should look on an average Mac monitor.
- Use Document Color Profile. If you kept the image's ICC profile (page 241), then this setting tries to show how your image will look as a result.

Select one of these options and Elements displays the result in the right-hand preview pane. Keep in mind that these are all only rough approximations; you need only take a stroll down the monitor aisle at your local electronics store to see what a wacky bunch of color variations are possible. You really can't control how other people will see your image without going to their homes and adjusting their monitors for them. **Note:** Changing any of these color options affects only the way the image displays on your monitor in Save For Web; it doesn't change anything in the image itself or the way it displays in other parts of Elements.

Creating Animated GIFs

With Elements, it's easy to create *animated GIFs*, those little illustrations that make web pages look annoyingly jumbled or delightfully active, depending on your taste. If you've ever seen a strip of movie film or the cels for a cartoon, Elements creates a similar series of frames with these specialized GIFs.

Animated GIFs are made up of layers, with a separate layer for each frame. Save For Web creates the actual animation, which you can preview in a web browser.

Note: It's a shame that you can't easily animate a JPEG the way you can a GIF. Most elaborate web animations involving photographs are done with Flash, which is another program altogether. (You can learn a little more about Flash on page 571; if you want the full story, pick up a copy of *Flash CS5.5: The Missing Manual.*) But Elements offers another option if you want to make a standalone animation as opposed to an animated graphic for a web page: *flipbooks* (page 591), cartoon-like Windows Media format animations. (Unfortunately, you can only make flipbooks in the Windows version of Elements.)

The best way to learn about animated GIFs is to create one. Here's how to make twinkling stars:

1. In the Editor, set the Foreground color to some shade of yellow and the Background color to black.

See page 254 if you need help setting these colors.

2. Create a new document.

Press Ctrl+N/#-N. In the New dialog box, set the size to 200 pixels \times 200 pixels, choose RGB for the color mode, and then choose Background Color for the background contents. Finally, set the resolution to 72 ppi and then click OK.

3. Activate the Custom Shape tool (page 428) and choose a star shape.

In the Options bar, click the down arrow to the right of the Shape field to open the Shapes palette. Then click the double arrow in the palette's upper right and, from the menu, select Nature. Double-click the Sun 2 shape, which is in the top row, second from the left.

4. Draw some stars.

Drag to draw one yellow star, and then, in the Options bar, click the "Add to shape area" button (page 424) before drawing four or five more stars. (This step puts all the stars on the same layer, which is important, since that way you won't have a bunch of layers to merge.)

5. Merge the star layer and the Background layer.

Choose Layer \rightarrow Merge Down. You now have one layer containing yellow stars on a black background, like the bottom layer in Figure 17-6.

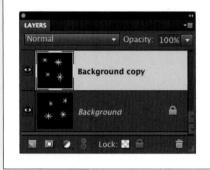

Figure 17-6:

This animated GIF has only two frames, which makes for a pretty crude animation. The more frames you have, the smoother the animation, but the bigger the file, too. On a tiny image like this one, size doesn't matter, but with a larger image, your file can get huge pretty fast.

6. Duplicate the layer.

Choose Layer→Duplicate Layer and then click OK. You now have two identical layers.

7. Rotate the top layer 90 degrees.

Click any tool in the Tools panel besides the Custom Shape tool, and then go to Image→Rotate→Layer 90° Left (not the regular "90° Left" command). You should now have two layers with stars in different places on each one.

8. Animate your GIF.

Go to File—Save For Web, and in the dialog box that appears, turn on the Animate checkbox. (If you don't see the Animate checkbox, make sure GIF is listed in the box below the word "Preset;" if it isn't, select it from the drop-down menu.) In the Animation section of the dialog box, adjust the time between frames, if you want. Leave the Loop checkbox turned on so the animation repeats over and over (if you turn it off, your animation plays just once and then stops).

9. Preview the animation.

You can use the arrows in the Animation section to step through your animation one frame at a time, but for a more realistic preview, view the image in a web browser as explained in the previous section. The stars should twinkle. Well, okay, they flash off and on—think of twinkle lights.

10. Save your animation, if you like, by clicking OK in the Save For Web dialog box.

Note: Unfortunately Elements 10 isn't very useful for editing animated GIFs once you've created them. The program can only see one layer when you open an existing animated GIF, and it displays a warning to let you know you'll lose the other layers if you try to save over the existing file. So if you want to work with GIFs a lot, you're probably better off using a different program for this.

ON THE WEB

Creating Web Buttons

Elements makes it a snap to create buttons to use on web pages. Here's how:

- Create a new blank file (File→New→Blank File). In the New dialog box's Preset menu, choose Web and then pick a size you like. In the Background Contents menu, choose Transparent. Then click OK.
- Set the Foreground color square to the color you want to use for the button, and use the Shape tool to draw the shape you want. (It helps to choose Actual Pixels for your view size when doing web work, because that shows you the same size you'll see in a web browser.)
- Apply one or more Layer styles (page 456) to make your button look more 3-D. Bevels, some of the Complex Layer styles, and the Wow Layer styles are all popular choices.
- Add any necessary text using the Type tool (page 474). You may want to apply a Layer style to the text, too.
- 5. Save the file as a GIF.

Emailing Photos

Elements makes emailing your photos a piece of cake. With just a few clicks, the program preps the image(s), fires up your email program, and attaches the image(s) to an outgoing email. (Of course, you can also email images without Elements' help, and you may prefer that method since you get more freedom to specify settings like file size.)

Note: Elements can prep your image and automatically launch your email program only if you're using Windows Live Mail (in Windows 7), Vista's Windows Mail, Outlook Express or Outlook (in Windows XP), or Adobe's own mail server in any version of Windows. (It's a bit annoying that you can't use Windows Live Mail anywhere but in Windows 7, but that's how Adobe set things up.) On a Mac, your choices are OS X's Mail, Entourage, or Outlook 2011. The first time you use one of Elements' email features, you get a pop-up window asking you to choose one of these programs. If you want to change the program later, in the Organizer, go to Edit—Preferences—Sharing.

Elements' email features don't work with other email programs like Yahoo Mail or Thunderbird, so if you want to use a program like that, just use that program's Attach button instead. (In Windows, you can export an image from the Organizer to your desktop to make it easier to find.)

If you use Windows, the Share tab gives you an almost bewildering array of formatting choices for emailing photos: You can send simple attachments or prearranged groups of photos, frame the photos, change their background color, and so on. On a Mac, not so much, unfortunately. Here are your main choices:

• Email Attachments (Mac and Windows). This is the most traditional option, where you send each photo as a standard attachment.

Photo Mail (Windows only). Elements lets you send emails formatted in *HTML*, the programming language used to create web pages. This option gives you all kinds of fancy design choices, and your photo gets embedded in the body of the email—it's basically like emailing someone a custom-built web page featuring your image.

The catch is that the recipient has to be using a mail program that understands HTML. Most newer email programs fit the bill, but if you're emailing someone who uses ancient software like AOL 4, then your email formatting won't appear correctly. An even larger problem, though, is that if your recipient has her email program's HTML option turned off, then your email doesn't appear with all its formatting intact. Page 566 has more info about Elements' Photo Mail options.

• **PDF Slide Show (Mac and Windows).** This option creates a basic PDF-format slideshow of all your images. All you have to do is name the slideshow (see page 568).

You need to choose the kind of email you want to send before you start. To pick, click the one you want in the Share tab. (You can start from either the Editor or the Organizer, although you get sent over to the Organizer to actually create your email.) The basic process is pretty similar for all the different types and is explained in detail below. There's one really annoying aspect of sending images from Elements, though: The messages you send include an ad for Elements.

Individual Attachments (Mac and Windows)

To send photos as regular email attachments, just follow these steps:

Note: If you want to email photos that aren't already in the Organizer, open them in the Editor before you start, and then choose Share—E-Mail Attachments.

1. In the Organizer, select some photos, and then go to Share→Email Attachments.

You can preselect photos before you start, or add or change them once the Email Attachments panel appears; Figure 17-7 explains how. (You can also start from the Editor, if you want. If you do, Elements includes your open photos when it whisks you off to the Organizer to create the email, so you can email images not already in the Organizer. Once you get to the Email Attachments panel, you can only add Organizer photos.)

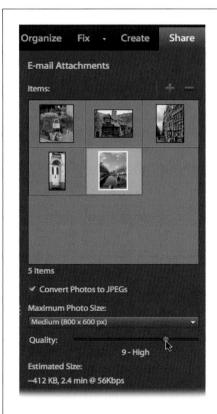

Figure 17-7:

The Organizer's Email Attachments panel is pretty easy to use. You can start with one photo or a group, as shown here. To send more photos, just drag the images' thumbnails from the Media Browser into the Email panel. You can also highlight photos in the Media Browser, and then, at the top of the Email Attachments panel, click the Add button (the green + sign, which is grayed out here). Remove photos you don't want by highlighting them, and then clicking Delete (the red – sign). Drag your photos in the panel to change their order. (The first photo here shows the red band with a lock on it because it's open in the Editor, but it'll get emailed just fine in spite of that.)

In the Email Attachments panel, below the image thumbnails, is some info that can help you decide how many photos to send and how large to make them:

- Number of Items. Indicates how many photos you've selected to send.
- **Convert Photos to JPEGs.** JPEG is the best format for emailing photos, so you can turn on this checkbox to have Elements make JPEG versions of the images you've selected. (If the photos are already JPEGs, then the option is grayed out.) If you just want to convert just some of your photos to JPEGs, select their thumbnails before you turn on this checkbox.
- **Maximum Photo Size.** This tells Elements how large you want the emailed photos to be. Remember that it can take a really long time to download a large image with a dial-up Internet connection, and many email providers have a 10 MB limit per mailbox. If you need to change the size, then use this drop-down menu to choose a new one.
- **Quality.** If you're just emailing photos for viewing onscreen, then you can get away with a lower Quality setting than you can for photos that the recipient is going to print.

Below these settings is Elements' calculation of how large the attachment will be and how long it'll take to download with a dial-up connection (a useful warning if you're sending to people with slow Internet connections). When you're satisfied with the attachment, click Next.

2. Type in a message (optional).

In this panel, you can change or remove the message that automatically appears in the body of the email, which says, "Here are the files that I want to share with you."

3. Address the email (optional).

Decide whether you want to enter the recipient's email address now. You can:

- **Do nothing.** Wait until Elements is through, and then type the address in the completed email before you send it.
- Select Recipients. Elements keeps a Contact Book—a list of people you regularly email—so you can simply select names from the list. (The box on page 567 has more about this feature.) If you haven't used Elements' email feature before, then start by clicking the Edit Contacts button (the little silhouette just above the Select Recipients section) and entering your recipient's contact info.
- Edit Contacts. If you want to enter a new recipient or change the information for someone in your list, then click the Edit Contacts button (the silhouette), and enter the new info in the Contact Book.
- 4. To finish, click Next.

Elements launches your email program, creates a new message, and attaches the files for you. You can then make any changes to the message or recipient in your email program. (If your files are pretty big for emailing, then Elements displays a warning and suggests burning a CD instead. Since the warning appears for files of 1MB or larger, use your own judgment here. Unless your friends have dial-up connections, a 1MB attachment is no big deal these days, but some Internet Service Providers still limit attachment sizes to 5MB or less.)

Photo Mail (Windows only)

Elements also gives you a ton of options for gussying up your photos if you choose Photo Mail in the Share tab. As mentioned earlier, Photo Mail is actually HTML mail. When you send HTML mail, your message gets formatted using a *template*, a stationery design in which your photo appears.

Note: Mac folks, there's no need to fret because you don't have Photo Mail. If you use OS X's Mail, you've got some pretty fine templates right there. Just start a new message and then click Show Stationery at the upper right of the new message window to see a bunch of Apple-designed formatting choices.

ORGANIZATION STATION

Elements' Contact Book

The Organizer makes it easy to call up the addresses of people you regularly email by keeping a Contact Book. Any time you send email to a new recipient, you first have to add the address to the Contact Book by clicking the Edit Contacts button (the silhouette) in the Email Attachments panel. (You can also get to the Contact Book by choosing Edit—Contact Book in the main Organizer window.)

Once you've got the Contact Book open, click the New Contact button to add an address. Then you can type in a name, email address, phone number, and other contact info. To edit or delete a contact, just highlight it in the list and then click the relevant button.

You can also create groups of names in the Contact Book, for times when you want to send the same photo to several people at once. To do this, click New Group, enter a name for the group, select entries in the Contact Book, and then click Add. The people's names go into the Members list. To remove a name from the group, highlight it in the Members list and then click Remove. In Windows, Elements makes it easy to coordinate the Contact Book with your existing address book. You can choose to import addresses from Vista's Windows Mail, Microsoft Outlook, or Outlook Express, as well as any that you've saved as V-cards (a digital business card format) in other programs. Just click Import and choose your source. You can also export your Contact Book addresses as V-cards to use them in other programs. This is another feature that isn't in the Mac version yet, although OS X's Address Book can import and export V-cards for you.

If you have a Photoshop.com account, then your Contact Book is stored online, so Elements nags you to connect to Photoshop.com if you try to use it when you aren't connected to the Internet. If you don't use Photoshop.com, then your Contact Book is stored on your computer and should always be available to you.

The process for sending Photo Mail is pretty much the same as for regular attachments (page 564), but in the first panel you can choose whether to display captions along with the photos, and you don't get the option of converting the photos to JPEGs; Elements controls that.

After you've chosen your photos and (optionally) your recipients, the Stationery & Layouts wizard (a series of guided question screens) presents a long list of stationery theme categories with several choices in each. The preview window updates to show each one as you click it. You can add a caption to any photo in this window by highlighting the text below the photo and typing what you want. When you find a style you like, click Next Step.

In the next window, you have a choice of several different page layouts. Below the layouts, you can choose a typeface from a list of five common fonts. Click the box to the right of the font's name to choose a color for the text. You can also customize the frame or border around your photos, as shown in Figure 17-8. Each time you make a change in the left pane of the window, Elements updates the preview so you can see just what you're getting.

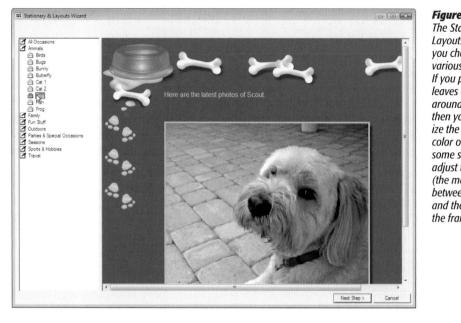

Figure 17-8: The Stationerv & Lavouts wizard lets you choose from various frame styles. If you pick a style that leaves empty space around the photo, then you can customize the background color of the email. For some styles, you can adjust the padding (the matte-like space between the photo and the frame) and the frame's size.

When you've adjusted everything to your liking, click Next. (Click Cancel if you don't want to send the email after all, or Previous Step if you want to go back and choose a different theme.) Elements creates your ready-to-send email. You can make any changes to the message and address just as you would to any other email—and send it off like any other email, too.

PDF Slideshows (Mac and Windows)

You can also email a group of photos as a slideshow. Elements uses the popular PDF format, which lets your recipients page through each slide using the free, ubiquitous Adobe Reader program (or, on a Mac, in OS X Preview, if they prefer). They just open the PDF and view the photos one by one. You can create a PDF slideshow from the Share tab in either the Editor or the Organizer if you don't want to deal with the Slide Show Editor (covered in more detail on page 580).

Emailing Photos

To create a slideshow, select your photos as described earlier, and then in either the Editor or the Organizer, go to Share \rightarrow More Options \rightarrow PDF Slide Show. (If you start from the Editor, Elements sends you over to the Organizer to create your slideshow.) In the PDF Slideshow panel that appears, Elements offers you a choice of sizes and quality, just as you have for sending regular email attachments. Name the slideshow, and then click Next. In the next panel, enter a message or recipients if you like, and then click Next. Elements tells you the size of your slideshow and suggests that if it's going to be larger than a megabyte, you should consider another route, like burning a CD or using Photoshop.com. Click OK, and Elements generates a standard email message with the slideshow attached.

Note: Although this is the only kind of slideshow you can create in Elements if you have a Mac, don't forget that you can also make slideshows in iMovie, iPhoto, and iDVD if you want something more deluxe.

CHAPTER 18

Online Albums and Slideshows

In the last chapter, you learned how to email photos. But what if you've got legions of friends—do you have to email your pictures to everyone individually? Not with Elements, which makes it incredibly simple to post images online, thanks to Photoshop.com, a one-stop shop where you can share your photos *and* back them up. You can create fancy online albums complete with professional-looking effects, courtesy of *Flash*, the ubiquitous Adobe program that's responsible for zillions of nifty online animations.

If you have Windows, Elements can also help you put together elaborate slideshows, complete with slick between-photo transitions like wipes and dissolves, clip art, and even audio. And for the perfect combination of high-tech wizardry and old-school charm, you can make digital *flipbooks*, simple slideshows that are easy to share with friends. Like the paper flipbooks of yore, these little shows can make a series of still photos appear to move, like a cartoon. In this chapter, you'll learn the ins and outs of all these ways of sharing photos.

Note: Alas, the fancy slideshows and flipbooks didn't make it into the Mac Organizer, but Apple fans can still make online albums and PDF slideshows. And if you have the App Store version of Elements, you can't create any of the projects described in this chapter, since you don't have the Organizer.

Online Albums

Adobe calls these "albums," but the online albums you create from Elements aren't just boring, grid-like rows of photos like you see on most photo websites. Instead they're elaborate, Flash-based displays in which your photos do things like appear in an animation of old-fashioned slides dropped onto a table, and your friends can sift through the pile and click the slides they want for a close-up view. And you get to choose whether to share your album with the whole world or to limit viewing to just your family and friends.

Sharing a New Album

If you use Photoshop.com (page 21), Adobe makes it super easy to share your albums there, right as you create them. Follow the steps on page 66 for creating and naming an album, and then, before you click Done:

1. In the Organize bin's Album Details panel, click the Sharing tab.

On the left side of the window is a preview of your slideshow, and on the right side is a list of options for sharing to Photoshop.com. (If you decide you want to change the order of the photos or add or delete images, you can click back to the Content tab to rearrange them at any time.)

Note: This section describes using the Organizer's Album Details panel, but you can also start a new online album from the Share tab in either the Organizer or the Editor, as explained later in this chapter (page 575). The process is very similar; the only difference is that you choose a sharing method when you start, and then click Next to go to the Album Details panel.

2. If you wish, change the template.

Elements starts you off by displaying your photos in a slideshow on the left side of the window. If you want something different, go to the "Select a Template" menu above the preview area and choose a template category, and then doubleclick the various template thumbnails that appear below the menu. Use the slider below the thumbnails to move back and forth through the category's available slideshows. The left side of the window displays a large preview of what your photos will look like in the selected template, and there's also a description of the template below the thumbnails.

Note: In the template list, you see the same little blue and gold banners on some thumbnails that appear in the Content panel (page 522). They mean the same thing here: If a template has a blue banner, you can download it for free (if you have a Photoshop.com account). If the banner is gold, you need a Plus account (the paid version) to download it. Once you download a template, you won't see the banner on it anymore.

Some templates play as a slideshow automatically, and others are interactive, as explained in Figure 18-1. (When you create the album, Elements applies the last template style you clicked.)

Figure 18-1:

Some of the album styles automatically start playing their slideshows, while others, like the Scrapbook template shown here, are interactive. Your friends "turn" the pages of the book to move backward and forward through your album.

Note: If you're looking for the Yahoo maps in the Elements 10 Organizer, Adobe has removed this feature (no great loss, since it was pretty quirky and often didn't work well). However, you can still share photos on a map by using the World Travel album template, which works for both Macs and Windows computers.

3. Change any settings for the album.

Some albums have "ghosted" settings panels that come into focus when you move your cursor over them. Others have tabs you can click within the preview to make changes. The settings you can change depend on the template: You may only be able to tweak the title that appears, or to do things like change the number of burning candles on a cake.

Tip: Some templates have a checkbox for sound effects. Sound effects are fun, but remember that before viewers can start watching the album, the audio files have to load. So if your friends have slow Internet connections, you may want to leave sounds turned off.

4. Choose the album options you want in the Sharing pane.

Your choices are explained in detail below, but this is where you choose who gets to see your album and, if you want to, personalize the notification message they receive when the album appears on Photoshop.com.

5. Click Done.

If you aren't signed into Photoshop.com, the login window appears. Once you log in, Elements uploads your album to the site, and the people you specified in Step 4 receive an email with a link to your album. (If you decide not to create an online album after all, click Cancel instead.)

The Sharing pane gives you several choices for who gets to see your albums and what they can do with the photos:

- Share to Photoshop.com. Turn on this checkbox to make the options below it available.
- **Display in My Gallery.** If you turn this on, your album becomes public. Anyone browsing Photoshop.com can see it (and comment on it, if you don't change that setting on your Photoshop.com account page).
- **Message.** If you want to include a personal message in the album notification email, type it here.
- Send Email To. Click the Contacts button (the one with the head and shoulders on it) to choose your recipients. You can select all your contacts, none, or open the Contact Book (page 567) to add people. The names appear in a list; just turn off the checkboxes next to the names of people who *shouldn't* receive a notification.

Tip: If you don't want to hassle with creating contacts every time you invite different people to view an album, just send the invitation to yourself, copy the link in the email you receive, and then paste that into a regular email and send it to your recipients. Or, once the album is posted on Photoshop.com, just copy the address from your web browser's address bar.

- Allow Viewers to. Here's where you can choose to let your friends download your photos or order prints of them (or both), if you like.
- View Online. Click this button to see your completed album at Photoshop.com.

You can go back to the Sharing pane at any time to add new recipients or to change your album's content or template. To do that, click the Edit Album button at the top of the Albums panel in the main Organize bin, or just click the Share button to the right of the album's name. To stop sharing an album and remove it from Photoshop.com, click the Stop Sharing button (the red circle with a slash).

But your sharing isn't limited to Photoshop.com. If you don't want to use Photoshop.com, you can start an album from the main Share tab by clicking the Online Album button, which lets you choose between exporting your album to your hard drive or sending to Photoshop.com. Alternatively, if you're using the process described in the above list, just don't turn on the Sharing pane's "Share to Photoshop. com" checkbox when you create your album; click Done, and then skip to the next section of this chapter and follow the instructions there for sharing existing albums. **Note:** If you aren't in the United States, then when you create an online album, you do so at Adobe's Photoshop Showcase website (page 21) rather than on Photoshop.com. The process is exactly the same, and so are the templates available. However, your options for downloading and sharing the photos in the completed album may be different.

There are a few drawbacks to posting an album to Photoshop.com. For one thing, as you probably know, a disadvantage of Flash is that you can't view Flash animations on iPhones, iPads, and many other mobile devices. So your gadget-toting friends can use the link in the email you send them to view your photos in their devices' web browsers, but only as a very basic kind of slideshow, not in the fancy templates available in Elements. And if you have friends with dial-up Internet connections, it'll take them forever to load the online albums. Fortunately, Adobe gives you other ways to share albums, as the next section explains.

Other Ways to Share

You don't have to decide whether to share an album while you're creating it. Even if you don't sign up for a Photoshop.com account, you can still create the same kinds of albums and impress friends with them, since you can save them to your computer and then upload them to your own website via FTP (File Transfer Protocol, the way you'd send any other files to your site) or burn them to a CD or DVD.

Note: While you can upload your Elements albums via FTP, you'll need a separate program to do this. FTP isn't built into Elements anymore, so upload your albums the same way you upload other files to your site.

It's also easy to share existing albums, either from the Share tab or from the Organize tab's Albums panel:

- Share tab. In either the Organizer or the Editor, click the Share tab and select Online Album. Elements sends you over to the Organizer, where you can create a new album or choose an existing album from the list, and then select how you want to share it. The rest of the process is the same as the one for sharing a new album (page 572).
- Edit Album. In the Organizer's Albums panel, select an album, and then click the Edit Album button (the pencil at the top of the panel). This method offers you only the same Photoshop.com options you get when creating a new album, though you can't export to your hard drive or to CD/DVD this way.
- Album name. In the Organizer's Albums panel, right-click an album's name or the little Share icon to the right of the name, and then choose whether to have Elements export to your hard disk or, in Windows, to a CD or DVD. (Photoshop.com isn't an option here.)

The process for any of these options is similar to the one described in the previous section. You can change templates, rearrange the photos, add or remove photos, and so on, exactly the way you can when creating a new album. The main difference is your sharing options:

• Export to CD/DVD (Windows Only). The Sharing tab gives you the same options for renaming and changing the template that it does for an FTP export, but instead of entering server information, you choose the drive to use to burn the disc, and enter a name for the CD or DVD. When you click Done, Elements asks you to insert a disc. Put one in, and then click OK. Elements burns the disc, and then asks if you want to verify it; you do. Finally, it reminds you to label the completed disc before it ejects it.

Discs made this way play on computers, not DVD players. If your friends use Windows, the disc should play automatically when they put it into their computers. If that doesn't work (sometimes the loading animation loops endlessly and the slideshow never runs), or if they're using Macs, tell them to open the disc, navigate to the Root folder, and then double-click the *index.html* file inside that. The slideshow will then play in their web browser.

Tip: If you have a Mac, you can still burn an album to a disc. Just export it to the hard disk and then burn it to a disc using the Finder.

• Export to Hard Disk. Elements saves your album to a folder on your hard drive. In the Album Details panel's Sharing tab, click the Browse button to choose a location for the album and then click Done. This way, you can create an "online" album that plays right on your computer, even when you aren't connected to the Internet. To play the slideshow, open the folder and double-click the file named *index.html.* Your web browser opens and the slideshow runs in it. If you want to upload the album to your website, choose this option, then use an FTP program to upload the album, the same way you would send any other file to your site.

You can share albums by exporting them even if you've also uploaded them to Photoshop.com. It's a really handy way to make a fancy slideshow.

Slideshows

Online albums are about the easiest way to make fancy slideshows to share with people in other places, but maybe you want more control than they give you, or perhaps you want to add features like music or panning and zooming over the photos à la Ken Burns. Elements makes it easy to create very slick little slideshows—even some with music and transitions between the images—that you can play on your PC or send to your friends. By using Elements' Slide Show feature, you can make really elaborate slideshows, but the Slide Show Editor is still only available in the Windows version of the program. If you have a Mac or if you prefer the simple life, you can quickly create a plain-vanilla PDF slideshow in about as much time as it takes to email a photo.

PDF slideshows are really straightforward to create, but you can't add audio to them or control how the photos transition. On the plus side, you can send PDF slideshows to anyone, regardless of what operating system they use. As long as your recipients have Adobe Reader (which is free) or another PDF-viewing program, they can watch your show.

The Slide Show Editor, on the other hand, lets you indulge your creativity big time. You can add all sorts of snazzy transitions, mix in sound (background music or narration), add clip art, pan around your photos, and so on. It's a bit more complex to work with the Slide Show Editor than to make a PDF, but the real drawback to the Slide Show Editor comes in your choices for the final output: The slideshow file you create isn't as universally compatible as PDF slideshows, as explained later in this chapter.

The easiest slideshow of all, though, is the one you make in the Organizer's Full Screen view, where it's a snap to create a full-featured slideshow with just a couple of quick settings adjustments. But you can only show this kind of slideshow to people who can see your computer monitor—you can't save it and email it or post it on the Web.

Tip: If you plan to create a simple PDF slideshow, then you need to do all your photo editing beforehand. The Full Screen view and Slide Show Editor methods, on the other hand, let you edit as much as you like before you finalize the slideshow.

Full Screen View

Elements gives you a really easy way to create impressive little slideshows to play on your computer, which could come in handy if you want to play a retrospective of Mom and Dad's life together during their 50th wedding anniversary party, for example. Whether you're using a Mac or a Windows machine, you do this via the Organizer's Full Screen view, and you have all kinds of options for music and fancy transitions between the images. To get started:

1. In the Organizer, select the photos and videos you want to use in the slideshow, and then go to Full Screen view.

Press F11/#-F11 or click the Full Screen button (the little blue rectangle icon with arrows pointing out from its corners; it's between the thumbnail size slider and the view order menu). If you want the photos displayed in a particular order, put them into an album (page 66) and rearrange them there.

2. In Full Screen view, adjust the slideshow's settings.

Use the control strip across the bottom of the screen (shown in Figure 18-2) to control how Elements presents your slideshow. (Your options are explained below.) You can't change the background color in these slideshows—it's always black (unless you choose the 3D Pixelate transition, in which case it's white).

3. Run the slideshow.

Press the Play button or tap the space bar to start the slideshow. To pause it, click the Pause button or press the space bar again. To exit Full Screen view and get back to the Organizer, click the X button at the right end of the control strip or press Esc.

You probably won't use all the options in the control strip (Figure 18-2). For instance, it's unlikely that you'd want to see the Quick Edit or Organizer panels while showing off your photos to your friends. The two most important buttons are the ones just to the right of the playback controls:

• Settings. Click this button to add music to your slideshow (or choose None if you don't want any). Elements comes with a few built-in songs, but you can use any compatible audio file that's on your computer. If you don't see the audio file you're looking for, click the Browse button to find it. You can opt to play audio captions you've recorded in the Slide Show Editor (Windows only [page 588]), display captions, or allow Elements to resize your photos and videos so they fit onscreen (yes, videos play here, too, if you include them in the show).

You can also choose to display a filmstrip of thumbnails of all your photos down the right edge of the screen (the control strip button does the same thing), or to have the show start automatically when you enter Full Screen view. Use the Page Duration box to determine how long each photo stays on the screen.

• **Transitions.** You can choose from among four kinds of transitions between slides: Classic (one photo simply gives way to the next), Fade In/Out, Pan & Zoom (Elements pans across each photo), or 3D Pixelate, which puts an elaborate glittery dissolve between each one. Move your cursor over each transition thumbnail to see a demo of it, and then click the radio button under the one you want.

It hardly takes any time to set up a slideshow this way, and all you have to do once you get it going is to stand back and accept compliments for your impressive display. The disadvantage to this kind of slideshow, obviously, is that you can't share it with anyone who doesn't have access to your computer. But Elements gives you a bunch of ways to make slideshows to send to other folks, as explained in the rest of this chapter.

Tip: If you want a fancier slideshow than you can create in Full Screen view, create an online album (see page 572) and export it to your hard disk. To play it there, open the folder and double-click the file named *index.html*.

PDF Slideshows

Elements gives you two ways to create PDF slideshows. The first, the Simple PDF slideshow, is very basic—just a quick run-through of the photos you choose. But if you make a PDF in the Slide Show Editor (which you can only do on a PC), you can create something slightly more elaborate.

Simple PDF slideshow

You can start a PDF slideshow from either the Editor or Organizer, although you always create the show in the Organizer. In either place, go to the Share tab→More Options→PDF Slide Show. Once you find the command, creating the slideshow is as easy as sending an email. You can read more about it on page 568. This slideshow has no transitions, no clip art, and no custom type, but it's the most compatible kind of slideshow you can make in Elements, which means that almost anyone you send it to will be able to view it. And you can easily create a reasonable-sized file so anybody can watch it, no matter how underpowered their computer.

Making a PDF in the Slide Show Editor (Windows only)

The other way to create a PDF slideshow isn't as intuitive as the method just described. When you create a show in the Slide Show Editor as explained in the next section, you can choose between saving it as a Windows Media Video (WMV) file or a PDF. If you want to preserve the show's multimedia bells and whistles, then you need to choose WMV. But then there's that tantalizing PDF option.

You may think this PDF slideshow sounds like the best of both worlds—a very compatible format and all the fancy effects you created with the Slide Show Editor. Unfortunately, that's not quite how it works. When you create a PDF this way, you lose the pan-and-zoom feature (page 588), the audio, and the transitions you selected. You do keep any custom slides, text, and clip art that you added, though. On the whole, it's best to use this feature when you've created a full-scale slideshow but one or two of the people you want to send it to can't open Windows Media files. The people who get the PDF can't see everything the WMV recipients do, but it's faster than trying to recreate a separate version for the WMV-challenged. To create a PDF using the Slide Show Editor, just follow the instructions in the following section. When you're ready to create your PDF, click Output, and on the left side of the Slide Show Output dialog box that opens, choose "Save As a File." On the right side of the dialog box, click the PDF File button. This displays a series of settings just for your PDF:

- Slide Size. This setting starts out at Small. If you're going to burn a CD, then you can choose a larger size. But if you want to email the final file, then choose Small or Very Small. You also have a Custom choice for when you want to create a size that's different from the presets.
- Loop. Turn this on, and the slideshow repeats over and over until your viewer stops it by pressing Esc.
- Manual Advance. If you want recipients to be able to click their way through the slideshow instead of having each slide automatically advance to the next one, turn this on.
- View Slide Show after Saving. Turn this on, and as soon as Elements is through creating your slideshow, it launches Adobe Reader so you can watch the results of your work.

Tip: To make a PDF from an existing slideshow project file, in the Media Browser, right-click the slideshow's thumbnail, and then choose Edit. Once the Slide Show Editor opens, click Output \rightarrow "Save As a File."

When you've got everything set the way you want it, click OK to bring up the Save As dialog box. Simply name your file and then save it.

The Slide Show Editor (Windows only)

The Slide Show Editor lets you add audio, clip art, and nifty slide-to-slide transitions to your slideshows. You also get several different ways to share the completed slideshow, including making a Video CD (VCD) or—if you also have Premiere Elements—a DVD that your friends can watch using a regular DVD player.

To get started, in the Organizer, select the images you want to include. You may want to set up an album (page 66), which lets you control the order of the images. (You can change the order once they're in the Slide Show Editor, but for large shows, you save time if you have things arranged in pretty much the correct order when you start.) You can also start with a single photo and, once you're in the Slide Show Editor, click the Add Media button to add more images. In any case, once you've got the photos selected, go to Create→Slide Show.

DECISIONS, DECISIONS

Choosing a Slideshow

A couple of versions ago, people sometimes slammed Elements for not offering much in the way of slideshows. Now the program gives you so many slideshow options you might get overwhelmed trying to decide on one. Here are some suggestions to help you out:

- Slideshows on your computer. The fastest way to create a slideshow to display on your computer screen is to use the Organizer's Full Screen view, as explained on page 577.
- Slideshows for the Web. If you want to share the slideshow on the Internet, create an online album (page 572).
- Slideshows with audio. If you use a Windows computer and you want the slideshow to have a narrated soundtrack, use the Slide Show Editor to create the show, and then burn it to a disc to share with friends, who can watch the show on their computers using Windows Media Player. On a Mac, you can use iMovie to do this.
- Slideshows for people who aren't comfortable with technology. You've got two options here, neither of which is guaranteed to prevent Uncle

Joe from complaining that he can't see pictures of his new grandniece. You can create an online album (page 572) and then send him a disc or email him a link, but recipients need a web browser with Flash installed. The simple PDF slideshow (page 568) is also pretty straightforward, but your recipients need to have Adobe Reader or another PDF viewer to watch it. If you know they have Windows and don't have Reader (and don't know how to install it), try a flipbook [page 591] at the slowest setting. For the *severely* techno-challenged, consider a printed photo book, described on page 517.

Finally, if you still don't think Elements offers enough choices, ProShow Gold from Photodex (*www.photodex.com*) is probably the most popular slideshow program for Windows. On a Mac, if iMovie, iPhoto, and iDVD don't work for you, Fotomagico (*www.boinx.com*) is the next step up. And if you don't like Elements' photo albums, JAlbum (*www. jalbum.net*) is a popular free alternative for both Mac and Windows, although these days many people just use one of the photo-sharing services mentioned on page 594 to create online slideshows.

Slide Show Preferences

Once you choose to create a slideshow, Elements presents you with the Slide Show Preferences dialog box before you get to the actual Slide Show Editor. You can click right past this dialog box if you like, but it has some useful options for telling Elements how you want it to handle certain aspects of all your shows, like the duration of each slide and the background color. (You can change these settings for a particular show in the Slide Show Editor itself.)

In the Slide Show Preferences dialog box, you can adjust:

- Static Duration. This determines how long Elements displays each slide before it moves on to the next one.
- **Transition.** This setting tells Elements how to move from one slide to the next. You get many different styles to choose from, like a pinwheel effect or having the next slide move into view from the side. When you choose a transition from the pop-out menu, you can audition it in the little preview area, as explained in Figure 18-3.

 Slide Show Preferences Slide Show Default Options Static Duration: 5 sec Transition Duration: 2 sec Transition Duration: 2 sec Background Color: Apply Pan & Zoom to All Slides Include Photo Captions as Text Include Audio Captions as Narration Repeat Soundtrack Until Last Slide Crop to Fit Slide: Landscape Photos Portrait Photos 	<i>Figure 18-3:</i> You can set the slide duration and background color for all your slideshows in this dialog box, which is also a great place to audition different transitions. To see what a particular transition does, select it from the Transition drop-down menu and Elements plays it in the little preview area on the right. If you choose a transition here, then Elements automatically applies it to every slide. But you can override this setting for individual slides in the Slide Show Editor's storyboard by clicking the transition you want to change and choosing a different one.
Preview Playback Options Preview Quality: High Show this dialog each time a new Slide Show is created. OK Cancel	

- Transition Duration. Use this to set how fast the transitions happen.
- **Background Color.** If you want a different background color, click this square to bring up the Color Picker.
- Apply Pan & Zoom to All Slides. If you set up the Pan & Zoom feature (explained later in this chapter) for one slide, turn this on and the camera swoops around *every* slide.
- Include Photo Captions as Text. To display a photo's Caption field, turn on this checkbox. (This works in reverse, too—you can hide the captions by turning off this checkbox.)
- Include Audio Captions as Narration. If you've recorded audio captions for your slides (page 588), leave this checkbox turned on if you want your audience to hear them.
- **Repeat Soundtrack Until Last Slide.** Leave this checkbox turned on, and if the slideshow is longer than the soundtrack, Elements repeats your song(s) as many times as necessary.
- **Crop to Fit Slide.** Turn on either of these checkboxes (for landscape- and portrait-oriented photos), and, if your image is too large for the slide, then Elements chops off the excess. However, it's best to do any cropping (page 99) yourself before creating a slideshow.
- **Preview Playback Options.** This setting controls the quality of the preview you see while working on the show; it doesn't affect the quality of the final slideshow.

Once you're through setting these preferences, click OK. If you don't want to see these settings every time you start a new show, then just turn off the "Show this dialog each time a new Slide Show is created" checkbox. You can call up the dialog box again anytime you're in the Slide Show Editor by going to Edit→Slide Show Preferences.

Using the Slide Show Editor

After you click OK in the Slide Show Preferences dialog box, Elements launches the Slide Show Editor. It's crammed with options, but everything is laid out logically—in fact, it's pretty similar to the Full Edit window. You get a menu bar across the top, but most of the commands here are available elsewhere via a button or keystroke (like pressing Ctrl+Z to undo your last action).

The preview area on the left side of the window displays the slide you're currently working on. A panel bin (called the "Panel Bin" in the View menu) is on the right side of the screen, and you can collapse it just like the Full Edit Panel bin by clicking its left edge to get it out of your way. (Collapsing the bin makes the preview space expand across the window.) Click the hidden bin's edge again to bring it back.

At the bottom of the window is a strip called the *storyboard*, where Elements displays your slides and the transitions between them. (If you didn't preselect any photos, the storyboard just says "Click Here to Add Photos to Your Slide Show.") Click a slide or transition here and its properties (duration, background color, pan-and-zoom settings) appear in the panel bin. To hide the storyboard, go to the Slide Show Editor's View menu and turn off the checkmark next to its name. You can unhide it again there, too.

Tip: To add photos to your slideshow, click the Add Media button at the top of the Slide Show Editor window. The advantage to bringing photos in this way (as opposed to selecting them before creating your slideshow) is that you can pick photos, videos, and audio clips that *aren't* in the Organizer by clicking this button and then choosing either "Photos and Videos from Folder" or "Audio from Folder" and then navigating to the files you want. You can even edit your photos right in the Slide Show Editor. The disadvantage is that you have to choose each photo separately or you have no control over the order in which Elements brings them into the show.

The Slide Show Editor lets you finesse your show in lots of different ways. For instance, you can:

• Edit slides. In the preview window, just click an image, and then, using the choices that appear in the Properties panel (Figure 18-4), you can rotate the slide, resize it, crop it, and apply Auto Smart Fix (page 135) and Auto Red Eye Fix (page 133). If you want to do more substantial editing, then just click the More Editing button, and Elements whisks the slide over to Full Edit.

and you can then add whatever you want to it—like credits, for instance. Here's a rundown of what you can add to a blank slide (or to any slide, for that matter, as shown in Figure 18-6). Just click the relevant button (Graphics, Text, or Narration) in the Extras section at the top of the Slide Show Editor's right-hand panel to see these options:

• **Graphics.** Elements gives you a whole library of clip art you can add to slides. The art is divided into categories: animals, backgrounds, costumes, and so on. Use the backgrounds on blank slides, because they cover the whole slide; you can add the rest of the clip art to slides that already have something on them. To add a piece of clip art to a slide, just drag it into the preview area and it appears on the slide surrounded by a box. You can grab the corners of the box and drag them to resize the clip art, or use the Size slider in the Properties panel. You can also reposition the art by dragging it. To remove it, right-click it on the slide preview, and then choose Delete.

Tip: If you play around with Elements' clip art costumes (hats, outfits, and glasses that you can paste onto your friends' pictures), you may notice that you can't rotate the clip art on the slide. If you want to adjust the angle of any of the costumes, here's a workaround: All the art lives in *C:\ProgramData\Adobe\ Elements Organizer\10.0\Slideshow Graphics* if you have Windows 7 or Vista, or *C:\Documents and Settings\All Users\Application Data\Adobe\ Elements Organizer\10.0\Slideshow Graphics* if you have Windows 7 or Vista, or *C:\Documents and Settings\All Users\Application Data\Adobe\ Elements Organizer\10.0\Slideshow Graphics* in Windows XP. (Program Data and Application Data are hidden folders, so you need to turn on hidden folder viewing to see them—the Tip on page 604 explains how.) Open the slide in Full Edit, and then add the clip art there by importing it from the Graphics folder listed in the previous sentence. Then, use the Move tool to place the clip art just so, and use the transform commands (page 389) to adjust the shape as needed. When you're done, you can re-import the image into the Organizer as a version and then use that version in your slideshow. You can also open the clip art images themselves, change them, and then save them as PNG files under new names in the same folder as the originals; that way, they appear right in the Slide Show Editor's clip art section along with the originals.

• Text. You can add text to slides and apply a number of fancy styles to that text. Click the Text button at the top of the panel (the T), and then double-click the text style you like; the Edit Text window pops up (If the Elements launches the slideshow preview instead, just press Esc to get back to the Slide Show Editor and try again). Type in what you want to add to the slide and then click OK. The text appears in the slide, surrounded by a blue bounding box, which you can use to place the text. You can also drag a text style onto a slide and then, in the Properties panel, click the Edit Text button to enter your words.

Tip: When the Edit Text window is active, you can't click OK by pressing Enter-doing that just creates a line break in your text. You need to actually click the OK button with your mouse.

When you add text, the Text Properties panel appears at the lower right of the Slide Show Editor, where you can change the text's font, size, color, and style. You can even choose a different drop-shadow color here if you're using shadowed text. If you want to edit text later on, just click the letters on the slide to bring back the bounding box and the Text Properties panel.

• Narration. You can record narration for your slideshow by clicking the slide you want to add your voice to, and then, in the Extras panel, clicking the Narration button (the blue microphone). Elements then displays the recording window shown in Figure 18-7. (Of course, you need to have some kind of microphone hooked up to your PC to record your voiceover.)

If you want to send a slideshow to someone who doesn't have a way to view WMV files, your options are to create a PDF file as explained on page 580, upload your slideshow to YouTube (*www.youtube.com*) and send the link to your friends, or use other software to change the format to something your recipients have, like Quick-Time. (You can upload to YouTube right from the Organizer: Just go to Share→Share Video with YouTube.)

To see your Output options, click the Output button at the top of the Slide Show Editor window. Elements opens the dialog box shown in Figure 18-8, where you can choose from several ways to save and share your slideshow.

Figure 18-8: Choose what you want to do from the list on the left (vou always see Premiere Elements as a choice. even if vou don't have that program); the options on the right chanae to reflect vour choice. If vou're creatina a WMV file, then you aet a number of different slide size options. For items that offer PAL and NTSC variations. PAL is the format to choose if you plan on viewing the slideshow in Europe or China; choose NTSC for most other places, including the U.S.

- Save As a File. Choose this option to save your slideshow to your hard drive as a PDF or WMV file. If you select WMV, you get several choices for size and quality. Select the one that best suits how you plan to share the slideshow. (If you're curious about the various options, pick the one you want to know more about, and then click the Details button; Elements displays a pop-up window with info about that size and its suggested uses.) The PDF options are explained on page 580.
- Burn to Disc. You can use Elements to create a Video CD (VCD), a disc that plays in a DVD player just like a regular DVD, but you don't need a DVD recorder to create it (because you're just using a plain old CD). The downside is that VCD is a tricky format—the quality is awful, and you can expect to have problems getting the discs to play in many DVD players. If you want to send VCDs, you may want to make a short test slideshow for your friends to be sure they can watch one before you invest a lot of time in creating a large project.

Tip: If you'd like to check which players can handle VCDs, or if you just want to know more about the format, head over to *www.videohelp.com/vcd*, where you'll find information and links to lists of compatible players.

You can include more than one slideshow on the same disc if you turn on the "Include additional slide shows I've made on this disc" checkbox. Then click OK to bring up the "Create a VCD with Menu" window and select the slideshows you want to include. In that window, you have to pick between the NTSC or PAL formats for your disc. Choose PAL if you're sending the disc to Europe or China; choose NTSC for most other areas, including the United States. Then click Burn and Elements gets to work.

Note: If you also have Adobe's Premiere Elements program (and a drive that can create DVDs), then you can send your slideshow to Premiere Elements to make a *true* DVD. If you have a DVD burner but not Premiere Elements, you can output the slideshow, and then use any other DVD-authoring software you've got loaded on your PC. If you have a DVD burner, you almost certainly got some kind of authoring software with it.

• Edit with Premiere Elements. You can send a slideshow over to Premiere Elements for more editing. (You see this option even if you don't have Premiere Elements installed, but clicking it just produces the suggestion to install Premiere Elements.)

Note: If you'd like Elements to keep an editable version of your slideshow that you can work on later, save it as a project file by clicking Save Project in the Slide Show Editor. To edit an existing slideshow, in the Organizer, just right-click its thumbnail, and choose Edit from the pop-up menu. Elements opens it in the Slide Show Editor so that you can make changes. If you don't save the project file, you won't have an editable slideshow anymore. (You can't edit PDFs or WMVs in the Slide Show Editor.)

Flipbooks (Windows only)

In some ways, a *flipbook* is like a very simple slideshow without any transitions, audio, or fancy panning and zooming. After slogging through the last section, you may be thinking you've had enough of Elements slideshow options, thank you very much. But all that's different about a flipbook is the speed at which the images appear. A flipbook's *frame rate* (how long each image appears onscreen) is very fast. So if you put a stack of photos you took using your camera's burst mode into a flipbook, you can create an animation where the images change so fast it appears that your subject is moving.

Tip: Flipbooks are great for creating a time-lapse effect. For instance, if you take a photo of the building progress of your new house each day from the exact same spot, you can combine all the photos and watch the house go from an empty lot to finished structure in just a few seconds.

The flipbook effect is similar to an animated GIF (page 561), but you can use JPEGs in a flipbook, so the image quality is much higher than with GIFs. The downside is that you can't easily post a flipbook on a web page. Your completed flipbook is a Windows Media file, so all you or your friends can do is watch it like a movie or regular slideshow. That said, Elements does give you several different output sizes, so you can pick one that's suitable for watching on a regular TV (although you need Adobe's Premiere Elements or some other video-editing program to make a version that your TV understands).

You may also want to create a flipbook to use as a plain old slideshow, since they're quick to produce and easy to email. Regardless of how you plan to use your flipbook, here's how to get started:

1. In the Organizer, select the photos you want to include.

You have to choose at least two photos, or you'll see a warning (instead of the Elements Organizer Flipbook window) when you try to continue. You can't add or delete photos once you start creating a flipbook, so be sure you've selected *all* the photos you want before you start. You may want to make an album (page 66) to help you keep track.

Note: The flipbook displays your photos in order based on their filenames or numbering. For example, files with names like *img_0617.jpg*, *img_0618.jpg*, and so on, appear in numerical order. The only control the Elements Organizer Flipbook window gives you is that you can reverse the order of the whole group of images. (See page 302 for advice on renaming a batch of photos using a sequential number scheme.)

2. Go to Create→More Options→Flipbook.

Elements displays the window shown in Figure 18-9. You can preview your flipbook by clicking the Play button below the image area.

3. Adjust the settings.

You have only a limited number of options in the flipbook window. Because the images change so fast, flipbooks don't let you add transitions between slides. All you can adjust is:

- **Playback Speed.** This controls the number of frames per second (each photo is one frame). One frame per second is the slowest option, and even that's pretty zippy for a regular slideshow. The more frames per second, the faster and smoother the animation effect, and the shorter the total playback time.
- **Reverse Order.** If you want to see your slides from last to first, instead of first to last, then turn on this checkbox.

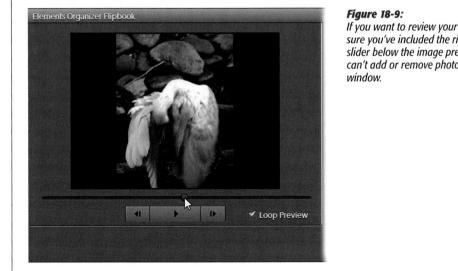

If you want to review your photos to make sure vou've included the right ones, move this slider below the image preview. However, you can't add or remove photos once you're in this

- . **Output Settings.** These settings determine the size of your flipbook file. You get a variety of formats to choose from. Computer Monitor is a good medium size that gives you a convenient balance between file size and image size. Web is a good format to use on a web page (assuming your viewers have broadband Internet connections). E-mail creates a tiny show that you can send to people with dial-up connections. You can also choose to create a flipbook in DVD-NTSC, DVD-PAL, VCD-NTSC, or VCD-PAL. NTSC is for video players in the United States and most other areas, and PAL is used in Europe and China. (If you choose any of these settings, then you need a program like Premiere Elements to create the final DVD for TV viewing. That's because, although you can create a flipbook in a format for use on a DVD player, Elements can't create the menus and extra files the DVD player needs to play the file.) Unfortunately, the VCD choices are subject to the quality limitations discussed on page 590. Figure 18-10 has more advice on choosing a setting.
- Loop Preview. Turn on this checkbox and, once you click the Play button, your preview plays endlessly until you stop it by clicking the Pause button.

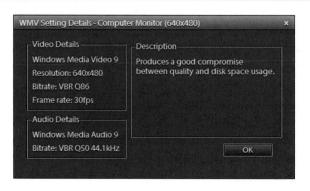

Figure 18-10:

If you're not sure which output format to use for your flipbook, click the Details button in the Elements Organizer Flipbook window. You then see a window like this one with more info about the size that's currently selected.

4. Create your flipbook.

When you're happy with how the flipbook performs, click Output. If you want to make big changes, like adding or removing photos, or if you decide you don't want to make a flipbook after all, then click Cancel. (You have to start from scratch to change which photos are included.)

When you click Output, Elements opens a new window where you can name and save your flipbook, which automatically gets added to the Organizer. Then you're all done.

A Few More Ways to Share

Elements' Share tab makes it simple to post your photos to several other sites besides Photoshop.com so your friends can view your photos online. You can quickly send photos to sites like Kodak Gallery and SmugMug right from within Elements. (The list of options in the Share tab changes depending on Adobe's current partnerships.) Once you post your photos, you and your friends can order not only prints, but also t-shirts, mugs, bags, and other items with your photos on them. (Exactly what you can order depends on which service you use.) Here's a quick rundown of what you can do with each site, and what it'll cost you:

- Flickr. This is a really popular photo-sharing site where you can create galleries and slideshows, and order different kinds of merchandise featuring your photos. Basic accounts are free.
- **Facebook.** To upload photos to Facebook page, just select photos in the Organizer and go to Share→"Share to Facebook."
- **SmugMug Gallery.** SmugMug is another site that offers a lot of different gift items that you and your friends can order. You can try it free for 7 days, and your friends can order prints and merchandise without a paid account. If you want to maintain a gallery here, it's \$40 a year for a basic account after the trial period expires.

- Share video with YouTube. You can send videos from the Organizer right to your YouTube account. (You don't need a YouTube account to watch videos on the site, but you do need a free account to upload videos there.) This option appears even if you don't have Premiere Elements installed.
- Send to a CEIVA Photo Frame. It's not exactly online sharing, but if you have a CEIVA-brand digital photo frame, Elements makes it easy to send your photos to it. (The CEIVA frame is an electronic gadget that looks like a regular digital picture frame, but displays photos you send to it digitally over a phone line or via WiFi, rather than using photos on a card you insert into it.) Just choose Share→More Options→"Send to CEIVA Digital Photo Frame" to connect and upload your photos. A basic CEIVA account that lets you send photos to someone's frame is free, but you have to sign up for it; the frames are pretty expensive. You can connect to the site from the Share menu or go to *www.ceiva.com* to learn more.
- Kodak EasyShare Gallery. Besides ordering prints from Kodak Gallery (page 526), you can upload your photos here so friends can view them online. Once your friends set up free accounts, they can order prints directly from Kodak. This site also offers a wide variety of gift items with your photos on them, like mugs, bags, shirts, and more. It's free except for the cost of what you order.
- iPhone/iPod/iPad. If you use Windows and you have an iPhone, an iPod Touch, or an iPad, Elements makes it easy to share your photos that way, too. If you used your iPhone to take pictures and you want to get them into Elements or if you're using your iPod, iPhone, or iPad to move photos from another device to your computer, just connect your i-gadget to the computer and then use the Photo Downloader (page 42) to send them straight to the Organizer, or download them in Windows Explorer and use File→Get Photos in the Organizer. (For Macs, the way is still via iPhoto/iTunes.)

To send photos or albums to your iPod, iPhone, or iPad, either to show them off to your friends or to transport them to another device or computer, connect the i-gadget to your computer, and then go to iTunes \rightarrow Photos \rightarrow Sync photos from \rightarrow Photoshop Elements.

To upload a photo to any of these sites, just select the image in the Editor or the Organizer, click the Share tab (and then More Options, if necessary), and then choose the one you want. (You can also select and upload more than one photo at a time.)

You'll be asked to sign in if you already have an account, or to create one if you don't. Each site has a simple-to-use wizard that walks you through the sign-up process, and they also have tours so you can look around before you decide to join. If you aren't sure which one(s) to try, ask your friends which one they like. Each site has pros and cons, so you may want to try them all before you decide.

Part Six: Additional Elements

Chapter 19: Beyond the Basics

CHAPTER 19

Beyond the Basics

So far, everything in this book has been about what you can do with Elements right out of the box. But as with many things digital, there's a thriving cottage industry devoted to souping up Elements. Of course, signing up for a Photoshop.com account (page 21) gives you access to some extra goodies from Adobe, but there's a ton of other stuff available, too. You can add new brushes, shapes, Layer styles, actions, and fancy filters. Best of all, a lot of what's out there is free. And many of the tools are designed to make Elements behave more like Photoshop.

This chapter looks at some of these extras, how to manage the stuff you collect, and how to know when you really need the full version of Photoshop instead. You'll also learn about the many resources available for expanding your knowledge of Elements beyond this book.

Graphics Tablets

Probably the most popular Elements accessory is a *graphics tablet*, which lets you draw and paint with a pen-like stylus instead of a mouse. A tablet is like a souped-up substitute for a mouse: You control the onscreen cursor by drawing directly on the tablet's surface—an action that many artists find offers them greater control. If trying to use the Lasso tool with a mouse makes you feel like you're trying to write on a mirror with a bar of soap, then a graphics tablet is for you.

Note: Some deluxe-model graphics tablets act as monitors and let you work directly on your image—but you need to budget close to a thousand dollars for that kind of convenience.

Most tablets work like the one shown in Figure 19-1, where you use the special pen on the tablet just as you would a mouse on a mousepad. Any changes you make appear right on your monitor.

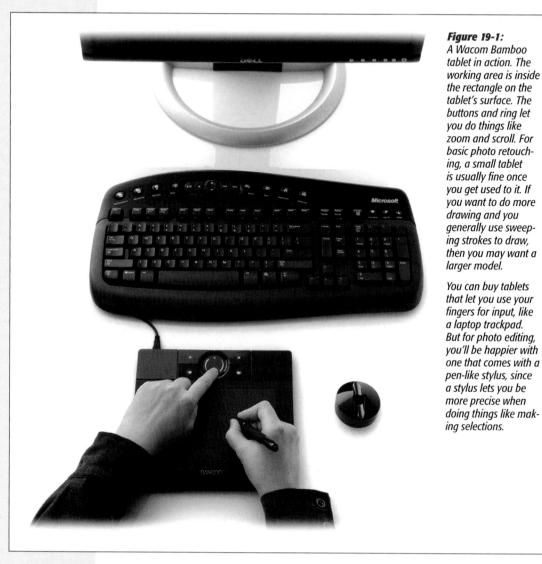

For most people, it's much easier to control fine motions with a tablet's stylus than with a mouse. And when you use a tablet, many of Elements' brushes and tools become *pressure sensitive*—the harder you press, the darker and wider the line becomes. So a stylus lets you create much more realistic paint strokes, as shown in Figure 19-2.

Figure 19-2: Two almost identical paint strokes, startina with fairly hard pressure and then easina up. Both were made using the same brush and color settinas. The only difference is that the stroke on the left was drawn with a mouse and the one on the riaht came from a tablet. You can see what a difference the pressure sensitivity makes.

When using the Brush tool, you'll see a tiny triangle in the Options bar just to the right of the Airbrush setting; that lets you access the tool's Tablet Options. Many brushes and tools are automatically pressure sensitive when you hook up a tablet. The Tablet Options settings let you choose whether to let the pressure control the size, opacity, roundness, hue jitter, and scatter for the brushes. (See page 399 for more about Brush settings.)

With a tablet, you can also create hand-drawn line art—even if you don't have an artistic bone in your body—by placing a picture of what you want to draw on the surface of the tablet and tracing over it. And, if you find constant mousing trouble-some, you may have fewer hand problems when using a tablet's stylus. Most tablets also come with a wireless mouse, which works only on the surface of the tablet. Or you can use your regular mouse on a mousepad or on your desk the way you always do, and just switch back and forth between the stylus and mouse.

Tablets now start at less than a hundred dollars, a big drop from what they used to cost. There are lots of different models, and their features vary widely. Sophisticated tablets offer more levels of sensitivity and can respond when you change the angle at which you hold the stylus.

Wacom, one of the big tablet manufacturers, has some pretty nifty tablet demos on its website (*www.wacom.com*) if you click on the various product tours. You can't actually simulate what it's like to *use* a tablet, but the animations give you a good idea of what your life would be like if you were to go the tablet route.

Stuff from the Internet

You have to spend some money if you want a graphics tablet, but there's a ton of free (and not free) stuff—tutorials, brushes, textures, and Layer styles, for example—available online that you can add to Elements. (Most of these add-ons say they work with Photoshop, but since Elements is based on Photoshop, you can use most of them in Elements, too.) Here are some popular places to go treasure hunting:

- Adobe Exchange (*www.adobe.com/cfusion/exchange*). On Adobe's own website, you can find hundreds and hundreds of downloads, including more Layer styles than you could ever use, as well as brushes, textures, and custom shapes to use with the Shape tool. Many are free once you register. This site is one of the best resources anywhere for extra stuff, although these days it's horribly confusing to navigate. About 99 percent of the items listed are made specifically for Photoshop, but Photoshop's brushes, swatches, textures, shapes, and Layer styles work in Elements, too. See this book's Missing CD page at *www.missingmanuals.com/cds* for help installing your finds.
- **Simple Photoshop** (*http://simplephotoshop.com*). Home of the popular (not free) Elements+ add-on tools and some tutorials.
- **MyJanee** (*www.myjanee.com*). You'll find lots of tutorials and free downloads on this site.
- Sue Chastain (*http://graphicssoft.about.com*). Another site with lots of down-loads and many tutorials.
- **Panosfx** (*www.panosfx.com*). Panos Efstathiadis produces some wonderful actions (see the next section for more about actions) for Photoshop, and he has adapted many of them for Elements as well. Some are free; some cost a few bucks.
- **optikVerve Labs** (*www.optikvervelabs.com*). This is the home of virtualPhotographer, one of the most amazing plug-ins (add-ons) for Elements. Best of all, it's free. Alas, this plug-in only works in Windows, not on Macs.
- **Grant's Tools** (*www.elementsvillage.com*). This has long been the most popular set of free add-on tools for Elements. These days, it's easiest to find the most up-to-date version via the forums at Elements Village.
- **onOne Essentials** (*www.ononesoftware.com*). This company makes a popular suite of plug-ins for Elements that's just been updated for Elements 10. It includes a number of image effects, as well as resizing, framing, masking, and retouching modules. The suites aren't cheap and you can do most of what they do in other ways, but lots of people like the convenience of these plug-ins. There's a discount coupon for the suite in each boxed version of Elements 10, or you can find it by going to *www.ononesoftware.com/elements10*.

- **ShutterFreaks** (*www.shutterfreaks.com*). This website has a number of Elements add-ons. Some are free, but most cost a few dollars. You'll find tutorials here, too.
- **CoffeeShop** (*www.thecoffeeshopblog.com*). Offers free brushes, frames, patterns, and tutorials for Photoshop and Photoshop Elements.
- The Pioneer Woman (http://thepioneerwoman.com/photography/category/ photoshop-elements). Here you can find very popular free Elements actions for special image effects.
- Texas Chicks (*www.texaschicksblogsandpics.com*). Another site with lots of great actions and tutorials for Elements.
- Alibony (*www.alibony.com/index.php*). Lots of Elements tutorials, actions, brushes, and effects, many of which are geared for scrapbooking projects.

If you're willing to pay a little bit, you've got even more choices. You can find everything from more elaborate ways to sharpen photos to really cool collections of special edges and visual effects. Prices range from "donationware" (pay if you like it) to some sophisticated plug-ins that cost hundreds of dollars. You can also buy books like the ones in Peachpit Press's *Wow!* series, which have loads of illustrations showing the styles available on the included CD.

Note: Elements 10 is based on Photoshop CS5, so CS5 downloads are compatible with it. Plug-ins and other goodies designed for older versions of Photoshop or Elements usually work with newer versions, but not the other way around. For example, a brush made for Photoshop CS5 works in Elements 10 but not in Elements 3. Also, remember that Mac plug-ins don't work in Windows, and vice versa, but many plug-ins offer two versions, one for each platform.

When downloading a plug-in, check with the developer to make sure it will work with Elements 10, especially if it costs money. If you're using Windows Vista or Windows 7, check the plug-in's compatibility with them, as well. Mac folks, remember that Elements doesn't run in Rosetta (see page 50), so any plug-ins you buy need to be Intel-native, meaning they're not written for older PowerPC Macs. (This shift away from Rosetta doesn't have any effect on actions, Layer styles, shapes, brushes, and gradients—only plugins.) So most plug-ins that are more than a few years old won't work with Elements 10.

With so many goodies available, it's easy get overwhelmed trying to keep track of everything you've added to Elements. Your best bet is to make backup copies of anything you download, so you'll have them if you ever need to reinstall Elements. Elements also includes a Preset Manager (Figure 19-3) that can help you keep track of certain kinds of downloads. To launch it, go to Edit→Preset Manager.

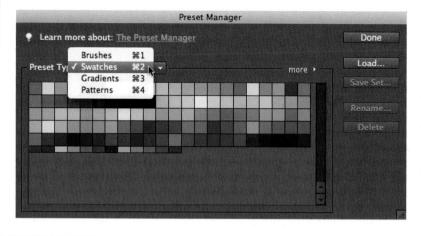

Figure 19-3: Elements' Preset Manager is a nifty feature that lets you see all your brushes, swatches, gradients, and patterns in one place. You can use it to change which groups are loaded, add or remove items, and so on—the same way you would when using the Brush tool.

Tip: In Windows, you have to turn on hidden files to see some of Elements' folders. In Windows 7, go to Control Panel—Appearance and Personalization—Show Hidden Files and Folders. In Vista or Windows XP, it's Classic View—Folder Options—View—Show Hidden Files and Folders.

When You Really Need Photoshop

You can do a ton with Elements, but some people need the full version of Photoshop instead. For example, if you want to write your own *actions* (little scripts, like macros, that automate certain things in Photoshop) or if you have to work extensively in CMYK mode, then you need Photoshop.

Note: You still can't record actions easily in Elements, but if you're the kind of übergeek who's comfortable with scripting languages, Elements includes the Adobe ExtendScript Toolkit CS5, so you can create and run scripts. You need to know Visual Basic (Windows) or AppleScript (Mac), though. In Windows, the Toolkit is in C:\Program Files [Program Files (x86) for 64-bit systems]\Adobe Utilities - CS5\Extend-Script Toolkit CS5. On Macs, it's in Applications—Utilities—Adobe Utilities-CS5—ExtendScript Toolkit CS5. Both versions include an extensive ReadMe file to help you get started. If you want to learn more about AppleScript, check out AppleScript: The Missing Manual. And you can find lots of books about Visual Basic on *www.oreilly.com*.

CMYK is the color mode used for commercial printing—it stands for Cyan, Magenta, Yellow, and blacK, which are the colors professional printers use. When you send a file to a print shop, the printer usually tells you it needs to be a CMYK file. You can't convert files to CMYK in Elements, so if you need CMYK files on a regular basis, it's worth the extra price of Photoshop to avoid the aggravation. If you only occasionally need CMYK, you might just ask the print shop about converting the file for you for an additional fee.

Photoshop gives you more of everything: more choices, more tools, more settings, more types of adjustment layers, and so on. But for most people, Elements is probably plenty.

Note: If you download actions, check to be sure that they're compatible with Elements 10. It's safest to use actions written specifically for Elements, but actions for Photoshop will work as long as they don't include steps Elements doesn't understand. (Incidentally, many of the add-on tools you can download are based on actions.)

Beyond This Book

You can do thousands of interesting things with Elements that are beyond the scope of this book. The Elements Inspiration Browser and Help menu give you access to dozens of interesting tutorials right from within Elements. Also, bookstores have loads of titles on Elements and Photoshop, and a lot of tasks are the same in both programs. And you can find all kinds of specialized books on everything from color management to making selections to scrapbooking.

In addition, you'll find hundreds of tutorial sites on the Web. Besides those mentioned earlier in this chapter, other popular sites include:

- Adobe (*www.adobe.com*). You'll find plenty of free online training for Elements here, and you can get to a lot of it from the Help menus in the program itself.
- **Photoshop Roadmap** (*www.photoshoproadmap.com*). This site has tutorials and plug-ins for Photoshop, but there's a big section of Elements tutorials, too.
- **Photoshop Support** (*www.photoshopsupport.com/elements/tutorials.html*). Despite the name, this site isn't run by Adobe. It has a whole section of Elements tutorials.
- YouTube (*www.youtube.com*). Yep, that's right: You can find videos about almost *anything* on YouTube, including lots of Elements tutorials.
- Photoshop Elements User (*www.photoshopelementsuser.com*). This is the website for a subscriber-only print newsletter, but it includes some free video tutorials, a forum, and a good collection of links. This is the only publication specifically for Elements. Their forums, the most active ones out there for questions about creative projects in Elements, are hosted at *www.elementsvillage.com*.
- **Graphic Reporter** (*http://graphicreporter.com*). The website of Photoshop maven Lesa Snider includes many well-written Elements tutorials.
- LVS Online (*www.lvsonline.com*). This site offers popular, inexpensive online courses in Elements (the same ones that used to be hosted at *www.eclecticacademy.com*).

Beyond This Book

If you search around online, you're sure to find a tutorial for any project you have in mind. Although many of them are written for Photoshop, in most cases, you can adapt them for Elements. If you get stuck or need help with any other aspect of Elements, there's an active online community that will have an answer for you. Besides the sites already mentioned, try:

- Adobe Support forum (*http://forums.adobe.com/community/photoshop_ele-ments*). This is the official Adobe Photoshop Elements User-to-User forum. It's your best bet for getting answers without calling Adobe support.
- **Digital Photography Review** (*www.dpreview.com*). This site has a bunch of camera-specific forums. You can also get a lot of Elements answers in the Digital Darkroom forum if you specify in your question that you've got Elements rather than Photoshop.
- **RetouchPRO** (*www.retouchpro.com*). The forums here cover all kinds of retouching and artistic uses of Elements and Photoshop. They also host frequent webcasts about digital imaging.
- **Photoshop Creative Elements** (*www.photoshopcreative.net*). Another forum for Elements enthusiasts.

Many sites are devoted to scrapbooking using Elements. A good place to start is Scrapper's Guide (*www.scrappersguide.com*), a commercial site run by Linda Sattgast.

No matter what you're looking for—add-ons, tutorials, communities—try a Google search, and you'll no doubt find a site that has what you want.

There's no question about it: Once you get familiar with Elements, it's addictive. Lots of other folks have found out how much fun this program is, so you shouldn't have any trouble finding the answer to any question you have.

The only limit to what you can do with Elements is your imagination. Enjoy!

Note: If you'd like to learn how to add Layer styles, shapes, and actions to Elements, head to this book's Missing CD page at *www.missingmanuals.com/cds* for the lowdown.

Part Seven: Appendix

Appendix A: Installation and Troubleshooting

Note: Head to this book's Missing CD page at *www.missingmanuals.com* to download two more appendixes: Appendix B, "The Organizer, Menu by Menu" and Appendix C, "The Editor, Menu by Menu."

APPENDIX

Installation and Troubleshooting

E lements is easy to install and is pretty trouble-free once it's up and running. This appendix describes some things you can do to ensure a smooth installation and provides cures for most of the little glitches that can crop up once you're using the program.

Like printing, installing Elements works quite a bit differently depending on whether you have a Windows computer or a Mac. This is partly due to the differing ways the two platforms install programs. But another big difference is that, on a Mac, you get asked to create an Adobe ID (see page 613) during the installation process; the installer then registers your copy of Elements. In Windows, on the other hand, you create an Adobe ID from the Welcome screen or from within Elements itself when you run the program for the first time (see page 22).

Regardless of what kind of computer you have, you need to install Elements when you're logged into an administrative account on your machine. (If you've never done anything to change your account and you have only one account on your computer, it's almost certainly an administrative account.)

Note: If you have a previous version of Elements on your computer, you don't need to remove it before installing Elements 10. All versions of Elements run completely separately, so you can keep older versions if you want.

Make sure you have your Elements serial number handy before you start the installation process. You can install Elements without a serial number, but only as a 30day trial; when your 30 days are up, the program stops working. If you have a retail version of Elements, the serial number is on the label on the install disc's case. If you got the program bundled with something else (maybe with a scanner you bought, for example), you'll usually find the serial number on the paper sleeve the disc is in. (It's not a bad idea to write the serial number right on the disc so you'll always have it around if you need to reinstall.) Regardless of where you bought the program, the box contains both the Mac and Windows versions of Elements 10. Just insert the disc for the version you want to install. (If you buy Elements online and download it, you can only use it on *one* platform, either Windows *or* OS X. So if you have both kinds of computers, buy the boxed version instead. If you buy the Mac App Store version, you can install it on as many Macs as you own, but no Windows computers.)

Tip: Once you install and register Elements, Adobe hangs onto a record of your serial number, so if you ever misplace the number, you can get it from Adobe. Also, when Adobe releases new versions of Elements, they usually offer a rebate for registered owners of previous versions. And if you agree to let Adobe send you email, they often offer discounts on other programs, like on the full version of Photoshop, in case you want to move on to that later.

Installing Elements in Windows

Before you install Elements, it helps to make sure your PC is ready to receive its newest addition. First of all, if your computer is on a network, take it off the network temporarily. (You can go back on as soon as you've installed Elements.) Also, it's important to disable any antivirus software, as well as *any* products from Symantec, whose programs tend to quarrel with Adobe software during installation. You can turn all these programs back on as soon as you've finished the installation.

If you have other versions of Elements on your computer, it's a good idea to make a complete backup of the Organizer catalogs for those versions before you start, just in case (see page 81 for info on backing up). After you do that, here's how to run the installer:

1. Put the install disc in your computer's drive, or, if you downloaded Elements, expand the file by right-clicking it and choosing Extract.

The disc window should open automatically. If it doesn't, then double-click the disc's icon or right-click it and then choose Open.

If you have the downloaded version, double-click the extracted Elements 10 folder. Then double-click Setup.exe to start the installer. (In Windows 7, you won't see the .exe extension, but the file type says Application.)

2. Choose a language and then click OK.

This (not surprisingly) determines the language the installer uses. After you click OK, the installation wizard (a series of guided question-and-response screens) opens.

3. In the installation window, click Next and then decide whether to remove any older versions of Elements.

If you already have one or more versions of Elements on your computer, it's up to you whether to keep the old ones or toss them. You can keep as many older versions as you want, but it's not a good idea to run more than one version at a time.

If you do want to jettison your older versions, click No to cancel the installation, and then remove the older versions yourself before starting the Elements 10 installer again. (In Windows 7 or Vista, you do this by going to Start→Control Panel→"Uninstall a Program." In Windows XP, it's Start→Control Panel→"Add or Remove Programs.") You can choose which versions to leave or to remove— it's not an all-or-nothing decision. You need to uninstall each version individually, if you decide to remove the old ones.

Click Yes to keep your old versions and to continue installing Elements 10.

4. In the License Agreement window, select the language you want Elements to use and accept the license agreement.

Elements is multilingual, so pick the language you prefer to use for the program itself.

5. Enter your location and the serial number you got with Elements.

Choose your country from the drop-down list. If you don't have a serial number, you can only run Elements in trial mode for 30 days. Once you've entered your info, click Next.

6. Choose where you want the installer to put Elements.

Unless you have a specific reason not to (if you install all your programs on a separate drive, for example), just go with the location the installer suggests by clicking Next.

7. Click Install to begin the installation.

The installer gets to work. When it's done, click Finish to exit the installer, and then you may want to restart your computer. Restarting isn't mandatory, but it's a good way to make sure everything is tidied up, especially in Windows XP.

8. Register Elements.

You do this by launching the program for the first time, as explained next.

Installing Elements on a Mac

The installer creates a desktop shortcut to Elements. To launch the program, doubleclick the shortcut or right-click it and then choose Open.

The first time you start Elements, you see a button on the Welcome screen labeled "Create Adobe ID." Click it and enter your info to register Elements and sign up for your free Photoshop.com account (page 21). Elements also needs to activate itself (see page 614), but you don't have to do anything about this except let the program connect to the Internet at least once.

If you aren't in the U.S., the registration process works a little differently. You get a registration screen at the end of the installation process. If you don't register, the window keeps popping up each time you start Elements, but after a few times you'll see a Never Register button at the bottom of the window. Click it to make the screen go away forever if you don't want to register. If you change your mind later, go to Editor→Help→Registration to call up that window again so you can register.

Note: Elements stores your catalog of images separately from the actual program files. That means you can install and uninstall Elements as many times as you like without damaging or losing your existing catalog (if you have one from a previous version of Elements). However, as mentioned above, it's a good idea to back up any existing catalogs from older versions before installing Elements 10.

When you first install Elements 10, if the Organizer doesn't find your existing catalog, go to File—Catalog—Open. Then navigate to your catalog (usually called something like "My Catalog") and open it. Elements automatically makes a backup copy of the catalog and adds "-1" to its name (My Catalog-1, for example). The program then uses your existing catalog (the one *without* the -1 in its name). Just remember that any changes you make in Elements 10 won't appear in the old version of the catalog (the one *with* "-1" in its name).

Installing Elements on a Mac

There's not much you need to do prior to installing Elements on a Mac, but if you have any antivirus software or any Symantec/Norton products running, you should disable those before you start. (Remember to turn them on again when you're through installing Elements.)

If you want to remove very old versions of Elements (Elements 4 or earlier) from your computer, just drag their folders from Applications to the Trash. For more recent versions, you have to remove them by running their uninstallers. For Elements 6, the uninstaller is the same as the installer. In the first installer screen, simply choose Remove Adobe Photoshop Elements Components, click Next, and then click Install. (If you don't have the disc or download file to get to the installer, there's an emergency uninstaller in Applications \rightarrow Utilities, but it's much better to use the Elements disc's installer if you can.) For Elements 8 or 9, you'll find the uninstaller in Applications \rightarrow Adobe Photoshop Elements [8 or 9] \rightarrow Uninstall Adobe Photoshop Elements [8 or 9].

Note: if you bought the Mac App Store version of Elements, it installs automatically when you download it. And you don't have to activate your copy of Elements (page 614), either; you can download and install it on every Mac where you use the same App Store account.

To install Elements 10:

1. Put the install DVD in your Mac's DVD or combo drive, or double-click the .dmg file you downloaded to expand it.

Double-click the DVD icon or the .dmg file to see the disk's contents.

- 2. Double click the Adobe Photoshop Elements 10 folder.
- 3. Double-click the Install folder.
- 4. Choose the language you want to read software agreement in.

Give the agreement a quick read and then click Accept.

5. Enter your serial number and select a language for Elements, and then click Next.

If you have a retail version of Elements, the serial number is on the label on the install disc's case. If you got the program bundled with something else (a graphics tablet, for example), you'll usually find the serial number on the paper sleeve the disc is in. (It's not a bad idea to write the serial number on the disc itself so that you'll always have it around if you need to reinstall.) If you downloaded the program, Adobe emailed you the serial number. (You can install Elements without a serial number, but it will only run as a trial for 30 days, and then stop working.)

Elements has a multilanguage installer. Choose the language you want Elements to use.

6. Create an Adobe ID if you don't have one, or enter your Adobe ID if you do.

After you're done, click Next. If you aren't ready to do this, you can click Skip This Step instead, or just click Next without typing anything. (If you don't do it now, you see a reminder screen when you start Elements.) Creating an Adobe ID (or logging into an existing one) registers Elements for you, so it's a good thing to do, as explained in the next section.

7. Adjust your settings, if you like.

The Install Options screen lets you change where the installer puts the program on your computer, but unless you have a specific reason to do so (if you install all your programs on a separate drive, for instance), just agree to the location the installer suggests, which is the main Applications folder on your Mac. The Elements updater always expects to find the program there, so you'll have fewer problems with updates if you don't change anything on this options screen.

8. Click Install.

Enter your OS X account password when the installer asks for it. The Elements installer does its thing, which takes a few minutes (you can watch its progress in the window).

9. Click Done to close the installer or click the Adobe Photoshop Elements 10 button to start using Elements.

Clicking the Photoshop Elements button takes you to the Welcome Screen, explained on page 16.

Tip: It's a really good idea to repair your Mac's permissions after installing Elements. (Repairing permissions is a simple housekeeping task that helps make sure everything runs smoothly.) Go to Applications—Utilities—Disk Utility; in the list that appears on the left, click your hard drive's name and then click Repair Permissions. In OS X Leopard (10.5), this can take half an hour; it's much faster in Lion (10.7) and Snow Leopard (10.6).

To launch Elements, go to Applications \rightarrow Adobe Photoshop Elements 10, and then double-click the Elements program icon (the dark blue square with the outline of two photos on it), or if you're using 10.7 (Lion), go to the Dock \rightarrow Launchpad and single-click the Elements icon. To keep Elements in the Dock, simply click and hold the program's Dock icon while Elements is running and choose Options \rightarrow "Keep in Dock" from the pop-out menu (if you're running OS X 10.5.8 [Leopard], it's just "Keep in Dock"), or drag the program—*not* the whole Elements folder—into the Dock when Elements *isn't* running. If you add Elements to your Dock and then change your mind about having it there, just drag the program's icon out of the Dock and watch it vanish in a puff of smoke.

Note: If you're in the US, the first time you log into your Adobe account from Elements, you see a window that lets you set up a Photoshop.com account (page 21). If you aren't, you see a window where you can register Elements.

Activation

In addition to installing Elements, you also need to *activate* it. That's a process where Elements collects information about the computer you install it on and sends that info to Adobe. Why? Because your installations are physically tied to the computers Adobe knows about. Adobe lets you install your copy of Elements on two different computers. If you want to install it on a third computer, you have to *deactivate* it on one of the other two first. This is a change from early versions of Elements, where your license to use the program had the same restrictions but Adobe didn't actually do anything to keep you from installing Elements on 20 computers.

You don't have to *register* Elements (though the benefits of registering include free space on Photoshop.com and a record of your serial number [see page 610]), but you do need to *activate* it. The good news is that you don't have to do anything special to activate Elements except let the program go online at least once. (If you don't normally allow your computer online or you have a firewall that blocks outgoing connections, make sure that Elements can connect or the program will stop working after 30 days.) To check whether your copy of the program has been activated, open the Editor's Help menu; if it contains a Deactivate item, you're all set.

You can run Elements for a while without activating it, but it just runs as a 30-day trial, and when your month is up, that's it unless you activate it. If you uninstall Elements, remember to deactivate it first. To do that, in the Editor, go to Help \rightarrow Deactivate. After that, you won't be able to use Elements on that machine again until you reactivate it by reentering your serial number and letting Elements contact Adobe again.

It's especially important to deactivate Elements if you're selling your computer or replacing your hard drive so you don't go over the two-computer installation limit. You *can* uninstall and reinstall Elements on the same machine without deactivating it first, but it's safest to deactivate each time you uninstall. That way, if something happens before you reinstall, like a major system crash that requires you to get a whole new hard drive, you won't have any problems.

If you run into any problems activating your copy of Elements, the only solution is to contact Adobe.

Scratch Disks

The calculations Elements makes behind the scenes are really complex, and it needs a place to write stuff down while it's figuring out how to change your image. If the task at hand is too heavy-duty for your system's main memory to cope with alone, Elements uses what's called a *scratch disk*—unused space on your hard drive—when it's busy making your photos gorgeous.

You probably have just one hard drive in your computer, and in that case Elements automatically uses that drive as its scratch disk. That's fine, and Elements can run very happily like that.

Tip: If you use Windows, you can make Elements *really* happy by keeping your hard drive defragmented and making sure there's plenty of free space available for the program to use. To defragment in Windows 7 or Vista, go to Control Panel—"System and Security"—Administrative Tools—"Defragment your hard drive." In Windows XP, it's Control Panel—"Performance and Maintenance"—"Rearrange items on your hard disk to make programs run faster."

If you're fortunate enough to have a computer with more than one internal drive, you can designate a separate disk as your scratch disk to improve Elements' performance. Just keep in mind that the scratch disk needs to be as fast as the drive Elements is installed on, or there's no point in setting up a special scratch disk. If you have a USB external drive, for instance, forget it—USB isn't fast enough, even USB 2.0, so just leave your main drive as the scratch disk.

To assign a scratch disk, in the Editor, go to Edit \rightarrow Preferences \rightarrow Performance/Adobe Photoshop Elements Editor \rightarrow Preferences \rightarrow Performance and choose your preferred disk. You can select up to four disks to use as scratch disks.

Troubleshooting

If Elements behaves badly from the moment you install it, something probably went funky during installation. That's easy to fix: Uninstall Elements and reinstall it.

To uninstall Elements, first deactivate it (in the Editor, select Help \rightarrow Deactivate, or just use the Deactivate checkbox on the Uninstaller's first screen). Then, in Windows 7 or Vista go to Control Panel \rightarrow "Uninstall a Program" (in Windows XP, Control Panel \rightarrow "Add or Remove Programs") and remove Elements. On a Mac, go to Applications \rightarrow Adobe Photoshop Elements 10 \rightarrow Uninstall Adobe Photoshop Elements 10. Then reinstall the program.

Fortunately, Adobe makes good software that looks after itself pretty well. There is, however, one simple procedure you can perform if Elements starts acting funny: delete your *preferences file*, which is where Elements keeps track of your preferred settings for the program. Deleting this file fixes the overwhelming majority of problems you may develop. You'll most likely need to delete the preferences file when dealing with Editor-related problems.

Note: There's one downside to throwing out your preferences file: Once Elements supplies you with a replacement (which it generates automatically), you'll have to redo any changes you made to things like window behavior and other preferences. Your panels also go back to their original locations, so you'll need to rearrange them if you pulled any of them out of the bin. But deleting the preferences file doesn't affect your image files at all.

Here's how you delete your preferences file:

1. Quit the Editor if it's currently running, and then restart the Editor while pressing the super-secret keyboard combination: Ctrl+Alt+Shift/#-Option-Shift.

You have to press and hold those keys *before* you launch the Editor, and keep holding down them down as you start the Editor until you see the window described in Step 2. Also, make sure you launch *only* the Editor, not all of Elements. If you haven't set Elements so that the Editor opens automatically when you start the program, then open the Welcome Screen (you can press the little house icon in the Editor's top bar before quitting it) and click the Edit button there. (If you launch the Welcome Screen while pressing those keys, you only get a Properties window.)

2. Delete your preferences.

A window appears asking if you want to delete the Elements Settings file. Click Yes. If you don't see the window, quit the Editor and try again.

That's it!

It's much less common to need to reset the Organizer's preferences, but if you want to do that, it's easy, too: When you're in the Organizer, go to Edit \rightarrow Preferences \rightarrow General, and click the Restore Default Settings button at the bottom of the window.

Tip: If you have a Windows computer, John Ellis's website (*www.johnrellis.com/psedbtool/photoshop-elements-6-7-faq.htm*) is an excellent source of troubleshooting help for Organizer problems. It's mostly about Elements 6, 7, and 8, but much of the info there is useful for Elements 10, too, although many of the links to Adobe's support documents don't work anymore.

Ask If Original (saving option), 76 aspect ratios, cropping to, 99, 103 audio files, 46 slideshows, 581 Auto Analyzer, 63 Auto Color, 129, 140, 303 Auto Color Correction, 251 Auto Contrast, 129, 303 Auto Erase option, 409 Auto Levels, 129, 244, 303 Auto Sharpen, 129, 143, 303 Auto Smart Fix, 40, 129, 136, 303 Average Blur filter, 252, 443, 448

B

Background brush, 170, 171, 173 Background color, 254 switching with Foreground color, 255 Background Eraser tool, 190, 418, 420–422 activating, 420 settings, 422 Background layer, 190-191 backgrounds, choosing, 54-56 backing up files, 81-87 online, 82-83 Organizer and, 83-85 to CDs/DVDs, 86-88 Backup dialog box, 84 Balance panel, 141 barrel distortion, 386 batch-processing photos, 298-306 Adjustment lavers and, 217 Auto Color, 303 Auto Contrast, 303 Auto Levels, 303 Auto Sharpen, 303 Auto Smart Fix, 303 choosing files, 300 Compatibility checkboxes, 302 File Type, 302-303 Image Size, 302-303 Labels, 304-306 Quick Fix, 303 renaming files, 301-302 watermarks, 304-305 before-and-after image preview, 554 Bevels, 457 Bin Actions, 30 bit depth, 285 Bitmap color mode, 54 Black And White - High Contrast tool, 144 black-and-white photos colorizing, 356-363 Colorize, 360-364 Content panel tint effects, 360

Layer styles, 359-360 tinting whole photo, 358-364 tips, 358 converting color photos to, 345-352 creating black-and-white areas in color photos, 351-355 erasing colors from duplicate laver, 353 removing color with Hue/Saturation Adjustment laver, 354-355 Blacks slider (Raw Converter), 280 blank document, 52-56 background, 54-56 Bitmap mode, 54 color mode, 54 Gravscale, 54 picking file size, 53 Preset menu, 53 resolution, 53 RGB Color, 54 transparency, 54-56 blemishes (see fixing blemishes) **Blend Images Together option** (Photomerge), 369 blending exposures, 290-296 (see also Photomerge Exposure) blend modes, 199-200, 400, 413-415 Color Burn, 414 Color Dodge, 414 Difference, 414 Dissolve, 413 Gradient tool, 463 Normal, 414 Paint Bucket, 410 Saturation, 414 using instead of Dodge and Burn tools, 415 Vivid Light, 414 Bloat tool (Liquify filter), 488 blowouts, 231 Blur filters, 440 Average Blur, 448 Depth of Field, 445 Gaussian Blur, 445-446 Orton Effect, 445 Radial Blur, 447-448 Surface Blur, 449-450 blurry photos, fixing, 263-265 BMP (.bmp) files, 75 Border command, 180 borders, drawing, 458 Brightness/Contrast Adjustment layers, 219 Brightness/Contrast exposure problems, 229 Brightness slider (Raw Converter), 280 Bring Forward command, 201 Bring to Front command, 201 Browser Dither setting, 560

brush-on textures. 3 Brush Strokes filters. 440 Brush tools Additional Brush Options, 401, 403-405 Airbrush, 401 Angle setting, 404 Auto Erase option, 409 blend modes, 400 Brushstroke thumbnail, 399 Brush Tablet Options, 401 calligraphic brush, 405 Caps Lock key and, 402 chalk brush, 405 Color Replacement tool, 399 cursor changing from circle to crosshairs, 402 Eraser tool, 401 Fade setting, 403 graphics tablet, 402 Hardness setting, 404 Hue litter setting, 403 Impressionist Brush, 399, 408 Keep These Settings checkbox, 405 Mode setting, 400 modifying, 403-405 saving settings, 405-406 Opacity setting, 400 Options bar settings, 399 overview, 399-406 painting techniques, 401 Pencil tool, 399, 408-409 pop-out menu, 399 Scatter setting, 403 Size setting, 400 Spacing setting, 403 Specialty brushes, 406-408 Burns, Ken, 588 Burn tool, 347, 410-413 activating, 413 using blend modes instead of, 415 buttons, creating for Web, 563

С

calibrating monitor, 239–241 calligraphic brush, 405 Camera Raw Converter (see Raw Converter) canvas, 122–124 Caps Lock key and Brush tool, 402 captions, 305–306 Cascade window arrangement, 220 catalog, 58,612 categories, 62–65 albums, 67 CDs/DVDs backing up files to, 86–88 burning to, 526

albums, 575 CD-creation program, 526 jackets, 521 labels, 521 CEIVA digital photo frames, 595 centering moved layer, 223 chalk brush, 405 Chastain, Sue, 602 Clarity slider (Raw Converter), 281 clip art, 587 clipping masks, 206-208 clipping point, 290 Clone Stamp, 309, 315-320 activating, 317 settings, 317-320 tips for using, 319 troubleshooting, 319 CMYK files, 604 CMYK mode, 4 CoffeeShop, 603 Collage option (Photomerge), 368 collages (see photo collages) color colorizing black-and-white photos, 356-363 Colorize, 360-364 Content panel tint effects, 360 Laver styles, 359-360 tinting whole photo, 358-364 converting color photos to black-and-white photos, 345-348 creating black-and-white areas in a color photo, 351 erasing colors from duplicate layer, 353 making colors more vibrant (see saturation) removing color from photos, 348-350 removing color with Hue/Saturation Adjustment layer, 354-355 spot (see spot color) Color Burn blend mode, 414 color casts, 251-254 color channels and Levels, 244 color-correction tools, 254-260 Average Blur filter, 448 Background color, 254 color cast (see color cast) Color Picker, 256-257 Color Swatches panel, 259-260 saving colors, 259 Eyedropper tool, 257-259 Foreground color, 254 gradients, 472 resetting default colors, 255 switching Foreground and Background colors, 255

Color Curves tool, 249, 327-330 Adjust Color Curves dialog box, 327, 328 settings, 329-331 Color Dodge blend mode, 414 Color Halftone filter, 440 Color Handling setting (printing), 541 colorimeters, 239 Colorize checkbox, 360-364 color management, 239-244, 534, 536, 540-543 calibrating monitor (see calibrating monitor) Color Handling setting, 541 color spaces (see color spaces) easiest way to set up, 542 Image Space setting, 541 Printer Profile setting, 541 profiles, 239 converting, 244 Rendering Intent setting, 541 color modes, 54 **Color panel**, 140–142 Color Picker, 257 color correction, 256-257 web-safe colors, 558 Color Replacement tool, 335-341, 339-341, 399 Anti-alias setting, 341 Brush options, 340 Hue/Saturation Adjustment laver, 336-337 Limits setting, 341 Mode setting, 341 Replace Color dialog box, 337-339 Tolerance setting, 341 Color Settings dialog box, 241-242 Color slider (Raw Converter), 285 Color sliders (Color panel), 140 color spaces, 241-244 Adobe RGB, 241 Always Optimize Colors for Computer Screens setting, 243 Color Settings dialog box, 241-242 sRGB, 241 **Color Swatches panel** color correction, 259-260 saving colors, 259 color tags, 243 Color Variations dialog box, 251, 253-254 columns (Tools panel), 33 Compatibility checkboxes, 302 Complex Laver styles, 457 CompuServe GIF (.gif) files, 77 conflicting resolution settings, 222 Contact Book, 566, 567 contact sheets Mac, 547-549 Windows, 544-545

Content panel, 28 Create projects and, 522-524 downloading extra goodies, 21 effects, 450 text effects, 485-486 tint effects, 360 Contract command (selections), 178 Contrast setting, 138 high-contrast black-and-white images, 144 in Raw Converter, 281 Convert Mode (removing color), 348 Convert to Black and White command, 346, 348, 353, 354 Cookie Cutter tool, 106, 430-432 activating, 432 Commit button, 432 Geometry Options, 432 transparency checkerboard, 432 copying and pasting objects and layers, 192 Copy Merged command, 152 Correct Camera Distortion feature, 383-388. 439 applying changes, 386 Edge Extension settings, 388 Horizontal Perspective slider, 388 making adjustments, 385 other uses, 388 Perspective Control, 387 Remove Distortion slider, 386 Vertical Perspective slider, 387 Vignette setting, 386 when to use, 384 Create Clipping Mask command, 207 Create projects, 505-524 CD/DVD jackets, 521 CD/DVD labels, 521 Content panel and, 522-524 Favorites panel and, 524 greeting cards, 520 photo books (see photo books) photo calendars, 520-521 photo collages (see photo collages) crop overlays, 3 cropping photos, 99-106, 129 Crop tool (see Crop tool) Marquee tool, 104–106 printing and, 526 to aspect ratios, 99, 103 **Crop tool**, 100–104, 130 activating, 100 clearing, 103 cropping to exact size, 103 Golden Ratio option, 102 Grid option, 101 None option, 101

Rule of Thirds option, 101 troubleshooting, 103 turning off Snap To Grid, 103 cursor changing from circle to crosshairs, 402 Curves tool (see Color Curves tool) Custom Shape tool, 428–429 Cylindrical option (Photomerge), 368

D

Date view, 56,69 Deardorff, Scott, 416 defragmenting, 615 Delete Adjustment command (Smart Brush), 236 deleting layers, 193 Depth of Field (Guided Edit), 445 Deselect Everything command, 153 dialog box links, 34 Difference blend mode, 414 Digimarc filter, 441 Digital Negative (.dng) files, 78 Digital Photography Review, 416,606 Disable Laver Mask command, 213 Display & Cursors preferences, 402 Dissolve blend mode, 413 Distort filters. 440 distortion barrel, 386 pincushion, 386 (see also Correct Camera Distortion feature) **Distort** option Free Transform, 393 Transform, 389, 391 distributing objects, 203 Divide Scanned Photos command, 90-92 DNG Converter, 274, 287-289 Dock, keeping Elements in (Mac), 614 Dodge tool, 347, 410-413 activating, 412 using blend modes instead of, 415 download settings, 555 downsampling, 121 drawing tools Brush (see Brush tools) Cookie Cutter (see Cookie Cutter tool) Eraser (see Eraser tools) Shape (see Shape tools) driver plug-in (scanners), 49 Drop Shadows Layer styles, 457 Duplicate Image dialog box, 39 duplicating layers, 193-194 exposure problems and, 229 Dust & Scratches filter, 316

E

Edge Extension option, 388 Edit Album button (Albums panel), 575 "Edit in Progress" icon, 48 Editor, 17, 23-39 Full Edit mode, 23 grid, 96 Guided Edit mode (see Guided Edit mode) guides, 96 image windows, 30 Panel bin (see Panel bin) Project bin (see Project bin) Ouick Fix mode, 24,60 rulers, 96 effects, 450-456 actions, 452-454 Content panel, 450 creating new layers, 451 Effects panel, 450 flattening or simplifying image, 451 gradients (see gradients) Guided Edit mode (see Guided Edit mode) Laver styles (see Laver styles) Photo Effects, 433 Rainbow Map, 471 versus filters, 433 Effects panel, 28,450 filters, 435, 436 Laver styles (see Laver styles) Eismann, Katrin, 215 Elements email features, 563 getting started, 15-18 installation (see installation) new users. 8 Premiere Elements, 6 quickest way to get started, 39-40 the one rule of, 38-39 versions, 16 versus Photoshop, 4 what's new in version 10, 3-12 what you can do with version 10, 2-12 why use, 2 workflow, 18 Ellipse tool, 425 Geometry Options, 425 Ellis, John, 617 email, 563 attachments, 563 individual attachments, 564-566 PDF slideshows, 564, 568-570 Photo Mail (Windows only), 564, 566-568 photos, 563-569

email. continued resizing photos for, 115-123 saving images for, 554-561 sharing albums, 574 emphasizing certain details, 347 Enhance Details option (Style Match), 382 Equalize effect, 342 Eraser tools, 418-422 Background Eraser, 418, 420-422 erasing colors from duplicate layer, 353 Magic Eraser, 418, 419-420 settings, 418 EXIF (Exchangeable Image Format) data Ignore EXIF setting, 240 Save For Web and, 554 Expand command (selections), 178 Export New Files dialog box, 527 Export to CD/DVD option (Windows only), 576 Export to Hard Disk option, 576 exposure, 228-237 blending exposures, 290–296 (see also Photomerge Exposure) blowouts, 231 Brightness/Contrast and, 229 Camera Raw Converter and, 228 correcting part of an image, 233-237 duplicate layers and, 229 fixing major problems, 229-231 Multiply layers and, 228-230 **Ouick Fix**, 228 Screen layers and, 228, 229 Shadows/Highlights, 228, 229, 231-233 Smart Brush and, 229, 233-237 settings, 237 Smart Paint options, 234, 236, 238 Smart Fix and, 228 understanding, 228 Exposure Merge feature, 229, 231, 269, 279, 292,376 Exposure slider (Raw Converter), 279 eyedroppers Levels, 247-248 Smudge tool, 417 **Evedropper tool** color correcting with, 257-259

F

Facebook, 594 face recognition, 64–65 Add Missing Person button, 65 Faces feature, 365, 373–376 Alignment Tool button, 375 features to move, 375 Liquify filter, 376

Transform commands, 376 (see also Photomerge Faces) Fade command, 199 Brush tool, 403 Faux Styles (text), 476 Favorites panel, 524 feathering, 153, 160, 165, 223 file formats, 49,75-81,78 changing, 81 opening obscure, 79 files creating new, 52-56 layers and file types, 191 saving, 76 storage, 612 file-size optimization feature Save For Web, 556, 557 Fill layers, 216-220 adding, 217-220 deleting, 219-220 gradients, 216 Fill Light slider (Raw Converter), 280 Filmstrip format, 79 Filter Gallery, 435-440 adding new filter layer, 439 adjusting view of image, 438 changing filter layer's content, 439 changing filter layer's position, 439 choosing new filter, 439 deleting filter layers, 439 filter layers, 437 hiding filter layers, 439 Filter menu, 436 filters, 433-451 Add Noise, 444-445 Adjustments, 439 applying, 435-439 repeatedly, 435 Artistic, 440 Average Blur, 443, 448 Blur, 440 Brush Strokes, 440 categories, 439-441 Color Halftone, 440 Correct Camera Distortion (see Correct Camera Distortion feature) Digimarc, 441 Distort, 440 Effects panel and, 435, 436 Gaussian Blur, 445-446 Noise, 440 Other, 441 performance hints, 441 Pixelate, 440 Radial Blur, 447-448

Remove Noise, 442 Render, 440 Sharpen, 440 Sketch, 440 Stylize, 440 Surface Blur, 449-450 Texture, 440 versus effects, 433 Video, 440 Find bar, 69 Finger Painting setting (Smudge tool), 417 fixing blemishes, 307-320 Clone Stamp, 309, 315-320 dust and scratches, 316 Healing brush, 309, 312-315 Spot Healing brush, 309-312 tears and stains, 320 water-damaged photos, 308 Flatten Image command, 210 Flickr, 594 Flip4Mac.com, 51 flipbooks, 571, 591-594 creating, 594 JPEGs, 592 Mac, 571 settings, 592-594 flipping photos, 93 Flip Selection Horizontal, 320 floating panels, 29 floating windows, 107-109 folders, watching, 47 Font Style, 476 Foreground brush, 170, 172, 173, 174 Foreground color, 254 switching with Background color, 255 forums, 605-606 frame rate (flipbooks), 591 Free Rotate Laver command, 97-98 Free Transform, 390, 391, 393 FTP, uploading albums via, 575 Full Edit mode, 23 Allow Floating Documents in Full Edit Mode setting, 109, 220 rotating photos, 92 Full Photo Edit command, 271 Full Screen view, 60-61 for slideshows, 577-579

G

Gaussian Blur filter, 445–446 Geometric Distortion Correction option (Photomerge), 369 GIF files, 554 animated, 561–563,592 Save For Web file format option, 559 Glass Buttons Laver styles, 457 Gradient Editor, 465-469 adding color to gradients, 467 changing colors in gradients, 466 color transitions, 466 Gradient Type setting, 466 noise gradients, 468-469 opacity stops, 467 removing color from gradients, 467 saving gradients, 470 Smoothness setting, 466 transparency, 467-468 Gradient Fill layers, 461, 463-465 Gradient Map Adjustment layers, 219, 471 Gradient Map effect, 342 gradient maps, 435, 470-472 gradients, 216, 435, 460-470 color correction, 472 editing (see Gradient Editor) text effects, 486-487 Gradient tool, 461-463, 487 activating, 462 choosing colors, 462 color transitions, 461 Gradient Editor, 462-463 gradient types, 462 settings, 462-463 Grant's Tools, 602 Graphic Reporter, 605 graphics tablets, 402, 599-601 Gravscale color mode, 54 greeting cards, 520 grid feature, 96 Group Shot feature, 365, 376-377 Grow command (selections), 178 Guided Edit mode, 3, 24, 34-35, 450, 454-461 Line Drawing, 455 Lomo Camera Effect, 455 Old Fashioned Photo, 455 Orton Effect, 455 Out Of Bounds, 455 Picture Stack, 455 Pop Art, 455 Reflection, 456 Saturated Slide Film Effect, 455 guides, 96

Η

Hand tool, 111, 113–114, 130, 173 in Photomerge Exposure, 296 in Raw Converter, 273
HDR (High Dynamic Range) images, 296
Healing brush, 309, 312–315 activating, 313 Pattern mode, 320, 321–322 settings, 314–315

Help, 33-37 dialog box links, 34 Guided Edit mode, 34-35 Help menu, 33 Inspiration Browser, 35-37 tooltips, 34 tutorials (see tutorials) Hidden tags, 65 Hide Selection command, 212 Hide/View a Selection command, 153 High Contrast (black-and-white option), 144 Highlights slider, 140 Highlights tool, 139 High Pass filter, 265-268, 441 Histogram in Full Editor, 246 in Raw Converter, 273 Levels and, 246-247 Horizontal Type Mask tool, 474 Horizontal Type tool, 474 settings, 475-478 hue, 331 Hue Jitter setting (brushes), 403 Hue/Saturation Adjustment layer, 187, 219, 336-337 removing color with, 354-355 Hue/Saturation dialog box, 331-333, 350 Hue slider (Color panel), 141

I

ICC Profiles, 243 IFF (Interchange File Format) files, 79 Ignore EXIF setting, 240 Image Effects Layer styles, 457 image formats and the Web, 553-554 "Image from Clipboard" command, 52 images adding text to, 474-482 creating text, 478-480 editing text, 480-482 cropping (see cropping photos) download settings, 555 emailing, 563-569 exposure problems (see exposure problems) positioning, 536 previewing and adjusting colors for web browser, 559-561 resizing (see resizing photos) rotating (see rotating photos) saving for email or the Web and, 554-561 resolution, 554 sharpening (see sharpening images) storing, 612 straightening (see straightening photos) tabs (see image windows or tabs)

viewing data about, 71 windows (see image windows or tabs) (see also photos) Image Size dialog box Bicubic Sharper, 118 calling up, 118 Constrain Proportions, 118 Document Size, 115 Pixel Dimensions, 115, 118 Resample Image options, 118, 119 Image Space (print setting), 541 image well, 58 image windows or tabs, 30, 107-111 Actual Pixels option, 110, 111 Arrange menu, 110 Bring All to Front command (Mac only), 110 Cascade option, 109 Consolidate All to Tabs option, 110 Fit on Screen option, 110, 111 Float All in Windows command, 110 floating, 107-109 Float in Window option, 110 Match Location, 110 Match Zoom, 110 Match Zoom and Location, 110 Minimize command (Mac only), 110 New Window, 110 Print Size option, 111 Tile option, 109 window management hints, 112 Zoom In/Out, 111 importing photos, 41-47 Impressionist Brush, 399, 408 Inner Glows Layer styles, 457 **Inner Shadows Layer styles**, 458 Inspiration Browser, 35–37 installation, 15-16,609-618 Mac, 612-614 uninstalling, 616-618 Windows, 610-612 Interactive Layout (Photomerge), 368 Internet (see Web) Invert Adjustment lavers, 219 Invert effect, 342 iPad/iPhone/iPod, Elements and, 595 ISO settings, 283

J

JPEG 2000 files, 80 JPEG files, 77, 553 about, 80 artifacts, 442 layers, 191 Save For Web and, 554 Save For Web file format option, 557 Matte menu, 558 Progressive checkbox, 558 transparent areas, 558 justification (text), 476

K

Ken Burns effect, 588 keyboard shortcuts, 9 keyword tags, 62, 69, 71 Kloskowski, Matt, 308 Kodak EasyShare Gallery, 595 Kodak Gallery, 518, 519, 527–529 panoramas, 366

L

Lasso tools, 166-169 activating, 166 basic Lasso tool, 166-167 Magnetic Lasso, 167-169 Polygonal Lasso, 169 launching Elements, 614 Laver From Background command, 190 lavers, 185-224 active, 189 adding, 192 adjusting opacity, 197 Adjustment (see Adjustment layers) aligning and distributing, 203-204 Background, 190-191 Background Eraser and, 190 blend modes, 199-200 Bring Forward command, 201 Bring to Front command, 201 centering moved, 223 clipping masks, 206-208 copying and cutting, 194-196 creating, 191-196 deleting, 193 deselecting, 206 dragging, 222 duplicating, 193-194 file types and, 191 Fill (see Fill layers) flattening, 210 grouping, 206-208 hiding, 196, 212 invisible, 189 IPEGs and, 191 linking, 204-206 locking, 198-199 Magic Eraser and, 190 masks, 211-215 adding, 212 applying, 213

black mask view, 214 deleting, 213 disabling, 213 editing, 213-215 Hide Selection command, 212 painting on with black or white, 213 Reveal Selection command, 212 unlinking, 213 merging, 208-210 Move tool arranging layers with, 202 distribute feature, 203 naming, 195 New Laver via Cut/Copy commands, 194, 195 objects (see objects) overview, 186-191 rearranging, 200-203 Reverse command, 202 selecting, 206 Send Backward command, 201 Send to Back command, 201 Shape tool and, 424 Similar Layers command, 206 Stamp Visible command, 210 Layers panel, 28, 188-189 active laver, 189 controls, 192 Duplicate Layer command, 194 invisible lavers, 189 managing layers (see layers, managing) Layer styles, 435, 456-460, 602 Bevels, 457 Bevel setting, 458 colorizing black-and-white photos, 359-360 Complex, 457 Drop Shadows, 457 Drop Shadow setting, 458 editing, 458 Glass Buttons, 457 Glow, 458 Image Effects, 457 Inner Glows, 457 Inner Shadows, 458 Lighting Angle, 458 Outer Glows, 458 Patterns, 458 Photographic Effects, 458 removing, 459 Strokes, 458 Stroke setting, 458 Visibility, 458 Wow Chrome, Neon, and Plastic, 458 leading (text), 476 lens blur, 263

Levels, 138, 244-250 Auto Levels, 244 color casts and, 251 color channels and, 244 Curves and, 249 evedroppers, 247-248 Histogram and, 246-247 Input sliders, 248–250 Levels Adjustment lavers, 219 lighting, combined images and, 223 Lighting Effects filter, 440 Lighting panel, 138-140 Line Drawing (Guided Edit), 455 Line tool, 427-428 Liquify filter, 487-490 Lomo Camera Effect (Guided Edit), 455 Luminance setting (Raw Converter), 284 LVS Online, 605

M

Mac

customizing picture packages, 551-552 Display Calibrator Assistant, 240 fancy slideshows and flipbooks, 571 installation, 612-614 Organizer, deciding whether to use, 57 printing photos, 533-536, 546-552 contact sheets, 547-549 picture packages, 549-552 repairing permissions, 614 Standard Macintosh Color setting, 560 Magic Eraser tool, 190, 418, 419-420 Magic Extractor, 169–175 Foreground brush and, 170, 173 settings, 171-173 Magic Wand, 163-165 settings, 164 Magnetic Lasso, 167-169 settings, 168 Make Dull Skies Blue tool, 143 marching ants (selections), 152 Marquee tools, 153 activating, 104 Anti-alias checkbox, 154 cropping photos, 104-106 to an exact size, 106 feathering, 153 Fixed Ratio setting, 105, 154 Fixed Size setting, 154 Normal setting, 154 Rectangular Marquee tool, 153 Transform Selection setting, 154 Width and Height boxes, 154 masks, 161 (see also Type Mask tools)

Matte menu (Save For Web), 558 maximum print resolution, 536 Media Browser, 19, 56, 58-61 albums, 59 Organize bin, 59 tags, 59 Task pane, 59 Merge Down command, 208 Merge Visible command, 208 metadata, 44, 47, 68, 71 searching for photos by, 70 Midtone Contrast slider (Shadows/ Highlights), 233 Midtones slider (Shadows and Higlights tools), 140 motion blur, 263 Move tool, 180–182 arranging layers with, 202 distribute feature, 203 objects, 222 resizing selections with, 182 rotating selections with, 182 Move View tool (Photomerge), 373 movie files, 46 Multiply layers, 228-230 My Catalog file, 58 MyJanee.com, 602

Ν

naming layers, 195 Navigator panel, 111 negatives, 342 New Album Category, 67 new crop overlays, 3 New Layer via Cut/Copy commands, 194, 195 noise Add Noise filter, 444–445 Reduce Noise filter, 442 Noise filters, 440 noise gradients, 468–469 noise reduction, 283–287 Normal blend mode, 414

0

objects copying and pasting, 192, 222 distributing, 203 moving between images, 220–223 centering moved layer, 223 conflicting resolution settings, 222 feathering, 223 lighting, 223 Object search feature, 70–73 Ofoto.com, 527 Old Fashioned Photo effect, 455 online albums (see albums) **Only Web Colors checkbox setting**, 558 onOne Essentials, 602 opening image files, 47-49 optikVerve Labs, 602 ordering prints, 526-529 Organize bin, 59 Organizer, 19-21, 56-68 avoiding, 61 backing up files using, 83-85 catalog, 58 categories, 62-65 creating tags in, 61-65 Date view, 56 face recognition, 64-65 Add Missing Person button, 65 Full Screen view, 60-61 Mac, deciding whether to use, 57 Media Browser, 19 My Catalog, 58 Photo Browser, 19 Photo Downloader, 20-21 preferences, resetting, 617 printing photos from (Windows), 536 Quick Edit panel, 60 Quick Fix tools, 129 Quick Organize panel, 60 rotating photos in, 92 saving work (see Save As dialog box) search, 4 Side by Side view, 60 starting, 17 Tag Cloud view, 60 tags entering, 62 keyboard shortcut, 62 Keyword Tags panel, 62 removing, 63 Timeline, 59 originals, working on, 38-39 Orton Effect (Guided Edit), 445,455 Outer Glows Layer styles, 458 outlines, drawing, 430 Out Of Bounds (Guided Edit), 455 overlays, new crop, 3

P

Page Setup dialog box, 539 Paint Bucket tool, 409–410 palettes, 26 Panel bin, 26–29 combining two or more panels, 28 pulling panels out of, 27 Quick Fix window and, 128,129 panels, floating, 29 panoramas, 365 creating, 366-373 layered, 370 Photomerge (see Photomerge) Recompose tool, 370 shooting tips, 370 size limitation, 366 Panosfx.com, 602 Pan & Zoom setting, 588 Paste vs. Paste Into Selection, 155 pasting objects and layers, 192 paths, text on, 3 patterns, applying, 320-323 Healing brush, 320, 321-322 Patterns Layer styles, 458 Pattern Stamp, 320, 322-323 PCX files, 79 PDF files, 49 multipage, 50 photo collages, 510 PDF slideshows, 564, 568–570, 579–580 simple slideshow, 579 Slide Show Editor (Windows only), 579-580 Peachpit Press's Wow! series, 603 Pencil tool, 399, 408-409 Perspective Control sliders (Correct Camera Distortion feature), 387 perspective distortion, 96 Perspective option Free Transform, 393 Photomerge, 368, 373 Transform, 389, 391 photo books, 517-519 adding pages, 519 entering number of pages, 518 ordering, 518-519 touching up photos, 519 Photo Browser, 19, 58 photo calendars, 520-521 photo collages, 505-517 Add Blank Page command, 515 adding filter to photo, 511 adding graphics and text, 512-513 adding photos, 511 Add Page Using Current Layout command, 515 adjusting photos and frames, 509-511 Advanced mode, 514 Autofill with Selected Images option, 508 backgrounds, 512 Basic layout, 509 Basic mode, 514 customizing, 510-515 file formats, 510, 516, 517

photo collages, continued frames, 512 adjusting, 509-511 editing Layer style, 511 removing, 511 resizing, 511 rotating photo in, 510 graphics, 512 layouts, 508 multipage documents, 515-517 ordering prints, 509 Smart Objects and, 514 text in, 512-513 themes, 507 **Photo Downloader**, 20–21, 41–47 Apply Metadata command, 47 audio files and, 46 Automatically Fix Red Eves option, 46 Automatically Suggest Photo Stacks option, 46 Automatic Download (Windows only), 44 Create Subfolder(s) setting, 43 Delete Options, 44 "Get Photos from" setting, 42 Import into Album setting, 47 Location setting, 42 Make 'Group Custom Name' a Tag option, 47 Open Organizer when Finished (Windows only) option, 44 Preserve Current Filename in XMP setting, 44 Rename Files setting, 43 Show Duplicates setting, 46 Show/Hide Images setting, 45 video files and, 46 Photo Effects (see effects) Photo Filter Adjustment layers, 216, 219 Photo Filter effect, 297–298, 343 applying, 297 color casts and, 252 Density slider, 298 Photographic Effects, 458 Photography Effects, 455 Photo Mail (Windows only), 564, 566-568 Photomerge, 365 Blend Images Together option, 369 Collage option, 368 Cylindrical option, 368 filing in empty edges, 369 Geometric Distortion Correction, 369 Interactive Layout, 368, 371-373 Navigator, 373 Perspective option, 368, 373 Reposition Only option, 373 Reposition option, 368 shooting tips for good merges, 370

Show Regions/Strokes settings, 376 Snap to Image setting, 371 Spherical option, 368 Vignette Removal option, 369 Photomerge Exposure, 291-296, 365 activating, 292 aligning photos, 294 Automatic Merge option, 291–293 Edge Blending setting, 295 Hand tool and, 296 HDR (High Dynamic Range) images, 296 Highlight Details slider, 292 manual merges, 293-296 Saturation slider, 293 Shadows slider, 292 Show Regions, 296 Show Strokes, 296 Simple Blending option, 292 Simple Merge, 293 Smart Blending option, 292 Transparency setting, 295 Zoom tool and, 296 Photomerge Faces, 373–376 Alignment Tool button, 375 (see also Faces feature) Photomerge Group Shot, 376-377 Photomerge Panorama, 367 Photomerge Scene Cleaner, 377–379 Photomerge Style Match, 379-382 choosing style to copy, 380 painting-like effects, 381 settings, 381-382 photo paper, 526 Photo Project Format (.pse) files, 77, 510, 516, 517 troubleshooting, 517 photos Correct Camera Distortion feature, 96 cropping (see cropping photos) Divide Scanned Photos command, 90-92 editing in other programs, 58 exposure problems (see exposure problems) flipping, 93 getting from scanner, 51 Image from Clipboard command, 52 importing, 41-47 merging automatic merges, 291-293 blending exposures, 290-296 Copy Merged command, 152 Exposure Merge feature, 229, 231, 269, 279, 292, 376 layer masks and, 213 layers, 206, 208-210, 363

locked lavers and, 198 manual merges, 293-296 Merge Down command, 208, 358 Merge Visible command, 208, 358 panoramas, 366-373 Simple Blending merge option, 293 Style Merge feature, 412 (see also Photomerge; Photomerge Exposure) opening, 47-49 Editor, 48 Organizer, 47 other programs, 48 perspective distortion, 96 processing multiple (see batch-processing photos) Raw Converter (see Raw Converter) red "locked" band, 48 resizing (see resizing photos) rotating (see rotating photos) saving, 76 scanning, 49-51 searching for, 68-73 sharpening (see sharpening images) Straighten and Crop Image command, 91 straightening (see straightening photos) viewing data about, 71 zooming (see zooming) (see also images) Photoshop Quick Mask feature, 215 versus Elements, 4 when you really need, 604 Photoshop 2.0 files, 79 Photoshop.com, 21-23 accessing photos via, 21 account, 16 signing up, 22-23 albums, 572-575 drawbacks to posting, 575 backing up and syncing photos to, 21 connecting through Welcome screen, 18 creating own website, 21 downloading extras from, 21 free advice, 21 printing photos, 529 tutorials, 21 Photoshop Creative Elements, 606 Photoshop Elements 5 Restoration and Retouching, 308 Photoshop Elements User, 605 Photoshop EPS (.eps) files, 77 Photoshop Masking & Compositing, 215 Photoshop PDF (.pdf) files, 78

Photoshop (.psd) files, 75 lavers and, 191 Photoshop Raw format, 79 Photoshop Roadmap, 605 Photoshop Showcase, 1,21,575 Photoshop Support, 605 PICT (.pct) files, 78 picture packages Mac, 549-552 Windows, 545-546 Picture Stack (Guided Edit), 455 pincushion distortion, 386 PIXAR format, 79 pixelated images, 119 Pixelate filters, 440 pixel dimensions, 116 plug-ins, purchasing, 603 PNG files, 78, 554 Save For Web file format option, 559 Point Eraser tool, 173 Polygonal Lasso tool, 169 Polygon tools, 425 Pop Art (Guided Edit), 455 Posterize Adjustment layers, 219 Posterize effect, 342 preferences deleting, 616-618 Organizer, resetting, 617 Premiere Elements, 580, 590, 591, 592, 593 Preset Manager, 603 Preset menu (New dialog box), 53 presets, 131-132 Preview checkboxes, 227 Printer Profile setting, 541 printing, 525-552 at home, 530-543 Mac, 533-536 Windows, 530-533 color management (see color management) cropping, 526 economically, 540 Export New Files dialog box, 527 Mac, 546-552 contact sheets, 547-549 picture packages, 549 ordering prints, 526-529 Page Setup dialog box, 539 photo paper, 526 positioning image, 536-539 preparing to print, 526 resizing photos for, 119-122 resolution and, 526 Windows, 543-546 contact sheets, 544-545 Picture Package tool, 545-546

Print window settings, 537-538 Border settings, 539 Color Management, 536 custom print size, 538 Flip Image checkbox, 539 guidelines, 539 image positioning, 536 Iron-on Transfer option, 539 making image and print size the same, 538 making image fill paper, 538 Max Print Resolution setting, 536 More Options button, 538 Photo Details settings, 539 Print Crop Marks checkbox, 539 repositioning photo in box, 538 resizing photo, 538 rotating photo, 537 Process Multiple Files command, 217, 298–306 adding captions with, 305-306 adding watermarks with, 304 File Type settings, 302-303 Image Size settings, 302–303 profiles, Raw Converter, 288 Program Files (x86) folder (Windows), 10 Progressive checkbox (Save For Web), 558 Project bin, 29-30 rotating photos in, 92 Pucker tool (Liquify filter), 488

Q

Quick Edit panel, 60 Quick Fix mode, 24, 60, 127-150 accessing from Editor, 128 Adjust Color for Skin Tone, 147-150 Auto Color, 129 Auto Contrast, 129 Auto Levels, 129 Auto Sharpen, 129, 143 Auto Smart Fix, 129, 136 batch-processing photos, 303 before and after views, 132 Black And White - High Contrast tool, 144 Color panel (see Color panel) Crop tool, 129, 130 exposure problems, 228 Hand tool, 130 Lighting panel (see Lighting panel) Make Dull Skies Blue tool, 143 Organizer and, 129 presets, 131 Quick Fix window (see Quick Fix window) Quick Selection tool, 130 Red Eye Removal tool, 129, 130, 133–135

rotating photos, 92 Smart Fix, 135–137 suggested workflow, 146–147 Touch Up tools, 143–146 Whiten Teeth tool, 143 Zoom tool, 130 **Quick Mask feature (Photoshop),** 215 **Quick Organize panel,** 60 **Quick Reorder feature,** 585 **Quick Selection tool,** 130, 156, 156–159, 160 activating, 157 settings, 159 versus Selection brush, 130 **Quicktime (.moy) files.** 52

R

Radial Blur filter, 447-448 Rainbow Map effect, 471, 487 rasterizing vector shapes, 426 rating photos, 65 Raw Converter, 270–289 adjusting view, 273-275 bit depth, 285 Blacks slider, 280 Brightness slider, 280 Camera Raw Defaults option, 282 Clarity slider, 281 color cast, 251 Color setting, 285 Contrast slider, 281 cropping with, 276 Custom Settings option, 282 defaults specific to camera settings, 283 DNG Converter, 274, 287-289 exposure problems, 228 Exposure slider, 279 Fill Light slider, 280 finishing up, 287 Full Screen view, 273 Hand tool, 273 histogram, 273 Image Settings option, 282 Luminance setting, 284 moving to the Editor, 271 noise reduction options, 283-287 opening files in, 271 opening multiple files, 272 Preferences dialog box, 283 Previous Conversion option, 282 profiles, 288 Recovery slider, 280 reverting to original settings, 282 rotating photos, 92, 276 Saturation slider, 281 Save New Camera Raw Defaults option, 282

sharpening with, 283-287 shooting information, 274 Show Files selected in Organizer, 271 straightening, 276 Straighten tool, 96 Temperature slider, 277 Tint slider, 277, 278 tone, 278-281 updates to, 270 using, 271-276 Vibrance slider, 281 view percentage, 273 white balance settings, 276-278 White Balance tool, 278 Zoom tool, 273 Raw file format, 270, 275 merges and, 368 non-Raw files in Raw converter, 286 Recompose tool, 323-327, 370 activating, 325 settings, 326 Reconstruct tool (Liquify filter), 488 recording actions, 604 Recovery slider (Raw Converter), 280 Rectangle and Rounded Rectangle tools, 424 Rectangular Marquee tool, 153 red band with lock icon, 48 Red Eve Removal tool, 129, 130, 133-135 alternatives, 135 settings, 134 Refine Edge setting, 159–160 Reflection (Guided Edit), 456 Reflection tool (Liquify filter), 488 Release Clipping Mask command, 208 Remove Color Cast command, 251, 252 Remove Color command, 349 Remove Distortion slider, 386 Remove from Selection tool, 173 Remove Noise filter, 442 Render filters, 440 Rendering Intent setting, 541, 543 Replace Color dialog box, 337-339 Hue, Saturation, and Lightness sliders, 338 Reposition Only setting (Photomerge), 373 Reposition option (Photomerge), 368 resampling, 118, 121 Reselect command, 153 resizing photos, 115 adding canvas, 122-124 for email and Web, 115-123 for printing, 119-122 resolution and, 115 resolution blank document, 53 font size and, 479

printing photos and, 526 saving images for Web, 554 resources, 602-604, 605-606 retouching photos, 227-268 Adjustment layers, 341 applying patterns (see patterns, applying) color cast (see color cast) color correction (see color correction) Color Curves tool (see Color Curves tool) color management (see color management) Color Replacement tool (see Color Replacement tool) exposure problems (see exposure problems) Levels (see Levels) making colors more vibrant (see saturation) Preview checkboxes, 227 Recompose tool (see Recompose tool) sharpening images (see sharpening images) special effects, 341-343 RetouchPRO.com, 606 **Reveal Selection command**, 212 Reverse command, 202 **RGB Color mode**, 54 Rotate Image tool (Photomerge), 372 rotating photos, 91-94 90° Left or Right, 93 180°, 93 Custom, 93 Flip Horizontal, 93 Flip Vertical, 93 Roundness setting, 404 rulers, 96

S

Sattgast, Linda, 606 Saturated Slide Film Effect (Guided Edit), 455 saturation, 331-335 Hue/Saturation, 331-333 Sponge tool, 334-335 Saturation blend mode, 414 Saturation slider, 141 Saturation slider (Raw Converter), 281 Save As dialog box, 74-80 Save For Web, 554-561 animated GIFs, 561-563 before-and-after image preview, 554 Browser Dither setting, 560 download settings, 555 EXIF data and, 554 file format options, 557-559 file-size optimization feature, 556, 557 JPEGs and, 554 launching, 556 Standard Macintosh Color settings, 560 Uncompensated Color setting, 560 Use Document Color Profile option, 560

Index

Save Over Current File (saving option), 76 saving options, 76 scanning photos, 49-51 scantips.com, 115 Scatter Brush tool, 403 Scene Cleaner, 365, 377-379 Scitex CT files, 79 Scrapper's Guide, 606 scratch disks, 615-616 scratches, fixing, 316 Screen layer, fixing exposure problems with, 228, 229 Search for Duplicate Photos command, 73 searching for photos (see photos, searching for) Select All command, 152 Select Destination Drive dialog box, 84 Select Image tool (Photomerge), 371 Selection brush, 156, 160-162 Alt-dragging/Option-dragging with, 162 settings, 161-162 versus Quick Selection tool, 130 selections, 151-184 Add to selection setting, 156 Border command, 180 Contract command, 178 controlling selection tools, 155-156 copying then moving copy, 182 Copy Merged command, 152 creating, 152-170 Deselect Everything command, 153 Expand command, 178 Grow command, 178 Hide/View a Selection command, 153 Intersect with selection setting, 156 inverting, 175-176 irregularly sized areas, 155-156 Lasso tools (see Lasso tools) layers, 206 Magic Extractor (see Magic Extractor) Magic Wand (see Magic Wand) marching ants, 152 Marquee tools, 153–155 Move tool, 180-182 moving selected areas, 179-182 New selection setting, 156 Paste vs. Paste Into Selection, 155 Quick Selection tool (see Quick Selection tool) Refine Edge (see Refine Edge setting) removing objects from background, 169–175 Reselect command, 153 resizing, 177-179, 182 rotating, 182 saving, 182 Select All command, 152

Selection brush (see Selection brush) Similar command, 178 Smooth command, 180 Subtract from selection setting, 156 Transform Selection, 154, 177-179 Send Backward command, 201 Send to Back command, 201 Send to CEIVA Digital Photo Frame command, 595 Settings button (slideshows), 578 Set Vanishing Point tool (Photomerge), 372 Shadows/Highlights exposure problems and, 228, 229, 231-233 tips, 233 Shadows tool, 139-140 Shape Picker, 428 Shape Selection tool, 430 Shape tools, 422–430 activating, 423 Custom Shape tool, 428-429 Ellipse tool, 425 layers and, 424 Line tool, 427 outlines and borders, 430 Polygon tool, 425 Rectangle and Rounded Rectangle tools, 424 selecting shapes, 423 Shape Selection tool, 430 Simplify button, 424 Share tab Facebook, 594 Flickr, 594 iPhone/iPod/iPad, 595 Kodak EasyShare Gallery, 595 Send to CEIVA Digital Photo Frames, 595 SmugMug Gallery, 594 sharing albums, 572-575 Allow Viewers to, 574 Display in My Gallery, 574 Message, 574 other ways to share, 575-576 Send Email To, 574 Share to Photoshop.com, 574 View Online, 574 slideshows, 589-591 Sharpen filters, 440 sharpening images, 260-268 Adjust Sharpness feature, 263-265 High Pass filter, 265-268 lens blur, 263 motion blur, 263 Sharpen tool, 268 Smart Sharpening, 265 Unsharp Mask, 261-263

Sharpen tool, 268 Sharpness panel, 142-143 Shift Pixels tool (Liquify filter), 488 Show Asian Text Options setting, 482 Show Open Files setting (Project bin), 29 Shutterfly, 525, 527-529 photo books, 518, 519 photo collages, 507 ShutterFreaks.com, 603 Side by Side view, 60 Similar command (selections), 178 Simple Blending merge option, 292 Simple-Photoshop.com, 602 Sketch filters, 440 Skew option Free Transform, 393 Transform, 389, 390, 391 skin tones, adjusting, 147-150 Slide Show Editor (Windows only), 576-595 adding special effects, 585-589 Burn to Disc option, 590 changing slide durations, 584 editing slides, 583 Edit with Premiere Elements, 591 Palette Bin, 583 PDF slideshows, 579-580 picking transitions, 584 Premiere Elements, 580, 590, 591, 592, 593 Save As a File option, 590 saving and sharing, 589-591 Slide Show Preferences, 581-583 storyboard, 583, 584 using, 583-585 Video CD (VCD), 580, 590 Slide Show Preferences dialog box, 582-583 slideshows, 576-591 adding special effects, 585-589 choosing best option, 582 format options, 581 Full Screen view, 577-579 long, 585 narration, 587 new blank slide, 585 on computer, 581 PDF (see PDF slideshows) **Ouick Reorder feature**, 585 saving and sharing, 589-591 Settings button, 578 sharing, 589-591 templates, 573 transitions, 578, 581, 582 Web, 581 with audio, 581, 582 (see also flipbooks; Slide Show Editor (Windows only))

Smart Albums, 66, 66-68, 67 Smart Blending merge option, 292 Smart Brush tools Add to selection setting, 237 applying patterns, 320 brush-on textures, 3 Brush Picker, 237 creating black-and-white areas in color photos, 351-353 exposure problems, 229, 233-237 Delete Adjustment, 236 invert a selection, 235 Smart Paint options, 234, 236, 238 Inverse option, 235, 237 New selection setting, 237 painting with, 357 Rainbow Map, 487 Refine Edge setting, 237 Smart Paint, 237 Solarize adjustment, 330 Subtract from selection setting, 237 textures, 320 Smart Fix, 135-137 exposure problems and, 228 Smart Objects, 514 Smart Paint options, 234, 238 changing, 236 Smart Sharpening, 265 Smart Tags, 63 Smooth command, 180 Smoothing brush, 173 Smudge tool, 416-417 SmugMug Gallery, 594 Snider, Lesa, 605 Soften Stroke Edges (Style Match), 382 Solarize adjustment, 330 sound effects, 573 soundtracks, adding to slideshows, 588 special effects, 341-343 special tags, 65 Specialty brushes, 406-408 Define Brush from Selection, 408 making custom brush, 407-408 Selection brush in Mask mode, 407 Selection tools, 407 Spherical (Photomerge), 368 Sponge tool, 334–335 spot color, 350-355 Spot Healing brush, 309-312 activating, 311 settings, 311-313 sRGB color space, 241 stains, fixing, 320 Stamp Visible command, 210

Standard Windows/Macintosh Color settings, 560 storyboard (Slide Show Editor), 583, 584 Straighten and Crop Image command, 91 straightening photos, 89-91 contents of photo, 94-98 Free Rotate Laver, 97–98 Straighten tool, 94-97 Raw Converter and, 96 settings, 95 straightening only active layer, 95 strokes (Layer styles), 458 Style Match feature, 365, 379–382 choosing style to copy, 380 painting-like effects, 381 settings, 381-382 sliders, 380 Style Merge feature, 412 Stylize filters, 440 Supplementary Editing Application setting, 58 Surface Blur filter, 449-450

Т

tablets, graphics, 599-601 tabs, 29 Tag Cloud view, 60 tags, 59 Auto Analyzer feature and, 63 creating, 61-65 entering, 62 face recognition, 64-65 Add Missing Person button, 65 Hidden, 65 keyboard shortcut, 62 Keyword Tags panel, 62 Ratings, 65 removing, 63 Smart Tags, 63 special, 65 Targa TGA or Targa files, 79 tears, fixing, 320 Temperature slider, 141 templates albums, 572 World Travel, 573 slideshows, 573 Texas Chicks website, 603 text adding to images, 474-482 creating text, 478-480 editing text, 480-482 anti-aliasing, 481, 482 Asian Text Options, 482

creating outlined, 492-495 effects, 485-490 Content panel, 485-486 gradients, 486-487 Liquify filter (see Liquify filter) making text outline shape, 498-500 on custom path, 500-502 photo collages, 512-513 resolution and affecting font size, 479 warping (see Warp Text Command) Text on Custom Path tool, 474, 500-502 Text on Selection tool, 474, 496–498 moving starting point, 498 resizing text, 498 Transform Selection, 498 Text on Shape tool, 474 Text Orientation button, 482 Texture filters, 440 textures, 320 brush-on, 3 The Pioneer Woman website, 603 Threshold Adjustment layers, 219 Threshold effect, 342 TIFF files, 77 layers and, 191 Tile option (windows), 220 Timeline, 59 Tint slider, 141 tools, 31-33,602-604 activating, 31 with keyboard shortcuts, 32 hidden drawers, 31 selecting, 33 subtools, 32 Tools panel, 32 tooltips, 34 (see also specific tools) Tools panel, 31-33 Recompose tool, 325 Touch Up tools, 131, 143–146 Transfer Tones option (Style Match), 382 Transform commands, 389–393 Distort, 389, 391 Faces, 376 Free Transform, 390, 391, 393 Perspective, 389, 391 Reference point location, 391 Rotate, 392 Scale, 392 Scale, W, H, Constrain Proportions, 392 Skew, 389, 390, 391, 392 Transform Selection command, 154, 177-179, 498

Transitions button (slideshows), 578 transitions, slideshow, 581, 584 transparency, 54-56 Cookie Cutter tool and, 432 gradients and, 467-468 JPEGs and, 558 troubleshooting Clone Stamp, 319 Crop tool, 103 defragmenting, 615 deleting preferences file, 616-618 disappearing cursor, 402 PSE files, 517 resolution and font size, 479 scratch disks, 615-616 Type tool turning photos red, 475 uninstalling Elements, 616-618 Turbulence tool (Liquify filter), 488 tutorials, 36,602-604 Photoshop.com, 21 Retouching forum at Digital Photography Review, 416 **TWAIN interface**, 49 driver, 50, 51 Twirl Clockwise/Counterclockwise tools (Liquify filter), 488 two columns (Tools panel setting), 33 Type Mask tools, 475, 490-495 activating, 491 Commit button, 492 creating outlined text, 492-495 Type tool, 474 activating, 478 Horizontal (see Horizontal Type tool) Text Orientation button, 482 troubleshooting, 475 turns photo red, 475 Vertical (see Vertical Type tool)

U

Undo command, 37 Undo History panel, 37 Unsharp Mask, 261–263,440 settings, 262 upsampling, 121 Use Document Color Profile setting, 560

V

vanishing point, 372 versions of Elements, 16 Vertical Type Mask tool, 474 Vertical Type tool, 475–478 Vibrance slider (Raw Converter), 281 video capture tool, 52 files, 46 Frame From Video command, 52 frames, 51-52 getting video from scanner, 51 importing, 52 Video CDs (VCDs), 580, 590 Video filters, 440 viewing flexibility, 109 View menu, 111 Vignette Removal option (Photomerge), 369 Vignette sliders (Correct Camera Distortion), 386 virtualPhotographer plug-in, 602 Visibility Layer styles, 458 visual searches, 70-73 Vivid Light blend mode, 414

W

Wacom Bamboo tablet, 600 website, 601 Warp Text command, 477, 482–485 Warp tool (Liquify filter), 488 Watch Folders command, 47 water-damaged photos, 308 watermarks, 304-305 Web creating buttons for, 563 image formats and, 553-554 previewing images and adjusting colors for, 559-561 resizing photos for, 115-123 resources, 602-606, 605-606 saving images for, 554-561 slideshows, 581 web-safe colors, 558 Welcome screen, 16-18 connecting to Photoshop.com, 18 Edit button, 17 getting rid of, 18 Organize button, 17 Whiten Teeth tool, 143 Windows 64-bit version of, 10 defragmenting hard drive, 615 installation, 610-612 screen resolution fix, 4 Windows Media (.wmv) files, 51 World Travel album template, 573 Wow Chrome, Neon, and Plastic, 458 Wow! series (Peachpit Press), 603

X

XMP files, 44, 283 Raw Converter and, 283

Y

Yahoo maps, 573 **YouTube,** 605

<u>Z</u>

zooming, 106–114
floating windows, 107–108
image views, 107–111
keyboard shortcuts, 111
Zoom tool, 111–113, 130, 173
in Photomerge Exposure, 296
in Raw Converter, 273
Photomerge, 373
settings, 113
using keyboard instead, 113